PAINTING POLITICS FOR LOUIS-PHILIPPE

PAINTING POLITICS

FOR

LOUIS-PHILIPPE

Art and Ideology in Orléanist France, 1830–1848

Michael Marrinan

Yale University Press

New Haven and London

Publication of this book has been aided by
a grant from The Millard Meiss Publication Fund
of the
College Art Association of America.

MM

Designed by James J. Johnson and set in Walbaum types
by Keystone Typesetting Co. Printed in the United States of America by
Vail-Ballou Press, Binghamton, N.Y.

Library of Congress Cataloging-in-Publication Data

Marrinan, Michael.
Painting politics for Louis-Philippe.

Includes index.
1. Painting, French. 2. Painting, Modern—19th
century—France. 3. Art and state—France. 4. Politics
in art. 5. Art and society—France—History—19th
century. 6. France—Cultural policy—History—19th
century. 7. Louis-Philippe, King of the French,
1773–1850. I. Title.
ND547.M27 1987 759.4 87–6120
ISBN 0–300–03853–4 (alk. paper)

The paper in this book meets the guidelines for permanence
and durability of the Committee on Production Guidelines
for Book Longevity of the Council on Library Resources.

1 3 5 7 9 10 8 6 4 2

For Janet

"Well, I thought I'd start by going to Paris. . . . I don't know why, but I've got it into my head that there everything that's muddled in my mind would grow clear. It's a funny picture, it gives you the feeling that there you can think out your thoughts to the end without let or hindrance. I think there I may be able to see my way before me."

From *The Razor's Edge* by W. Somerset Maugham

Contents

PART IV
Shadowboxing Napoleon's Glory: The Orléanist Revival of Imperial Imagery

PART V
Two Revolutions in View: Historical Conditions of a Style Louis-Philippe

Illustrations

Titles of illustrations are given in English throughout the text and notes. Print captions and the titles of pictures listed in the Salon *livret* are provided below in the original language.

1 Louis Hersent (aquatint by François Girard): *Portrait en pied du Roi*, original exhibited at Salon of 1831. Paris, Bibliothèque Nationale, Cabinet des Estampes.

2 Paulin Jean-Baptiste Guérin (dit Paulin-Guérin): *Portrait du Roi Charles X*, Salon of 1827. Toulon, Musée d'Art et d'Archéologie.

3 Antoine-François Callet: *Portrait du Roi Louis XVI*, Salon of 1789(?). Clermont-Ferrand, Musée Bargoin.

4 Nicolas Gosse: *Portrait en pied du Roi*, Salon of 1831. Saint-Denis de la Réunion, Musée Léon Dierx.

5 Francis Conscience: *Portrait de Louis-Philippe*, 1830. Besançon, Musée de Granvelle.

6 Eugène Lami: *Louis-Philippe à cheval*, n.d. Paris, private collection.

7 Ary Scheffer: *Portrait équestre du Roi*, Salon of 1831. Versailles, Musée National du Château.

8 Ary Scheffer: *Le Lieutenant-général du royaume reçoit à la Barrière du Trône le 1er régiment de hussards commandé par le duc de Chartres, le 4 août 1830*, 1835. Versailles, Musée National du Château.

9 Méry-Joseph Blondel: *Louis-Philippe Ier, Roi des Français*, 1832. Versailles, Musée National du Château.

10 Nicolas Gosse: *Le Roi à la revue de la Garde Nationale, le 29 août 1830*, 1831. Dreux, Musée d'Art et d'Histoire.

11 Horace Vernet: *Portrait en pied du Roi*, Salon of 1833. Versailles, Musée National du Château.

12 Auguste DeBay: *Le Roi rencontrant un blessé le 6 juin 1832*, Salon of 1835. Eu, Musée Louis-Philippe.

Acknowledgments

This book has accumulated many debts during the nearly nine years of its writing, but one stands far above the others: from the very first days of my research, Janet Jones has been both a gentle, reassuring source of strength and a no-nonsense, hardworking partner. Her unflagging belief in the project has sustained me through many a week of doubt and discouragement. Her good judgment and willingness to listen provided the most important sounding board for major parts of the finished text. She has been, at various times and often all at once, critical reader, editor, typist, and muse of the following pages. Her support, persistence, and unselfish sharing of her time, energy, and expertise have been instrumental in bringing this work to press. For all of that, and much more, the book is dedicated to her and to our very special life together.

The book began as a doctoral dissertation at the Institute of Fine Arts of New York University, where I had the good fortune to work with Robert Rosenblum. He was the best of advisors: encouraging without indulgence, constructive in his criticism, and always open to new avenues of inquiry. His scholarship has been my yardstick while writing this book, and if its weaknesses are my doing, its strengths derive from classes and discussions with him at the Institute. Gert Schiff and Colin Eisler were patient, careful readers of the dissertation manuscript. Their comments and suggestions guided my revisions around numerous errors and pitfalls in the original; the final text is stronger for their interest and enthusiasm.

Paris can seem intimidating to a newly arrived scholar, but I benefited from the generosity of many people who eased the transition. Geneviève Monnier, Curator at the Cabinet des Dessins du Musée du Louvre, has been a constant friend who arranged essential contacts with French museums and government agencies. At the Louvre, Pierre Rosenberg, Curator of the Département des Peintures, welcomed me warmly and introduced me to important museum resources, and Jacques Foucart supported my work at the Service de Documentation by granting me free rein amidst the vast holdings under his care. I was able to search the files on provincial museums at the Direction des Musées de France, thanks to the efforts of Isabelle Julia, Curator of the Musée Hébert. Marie-Claude Chaudonneret, Researcher for the C.N.R.S. at the Louvre, graciously shared her expertise and

introduced me to other scholars working in related fields. Across town at the Musée Carnavalet, the curators Jean-Marie Bruson and Sylvain Le Combre aided me enormously in my research of that museum's important collection. Thérèse Burollet, Chief Curator of the Musée du Petit Palais, located several key pictures stored in the city's reserves at Ivry so that I might photograph and study them first-hand. And finally, both Jean Adhémar and Maurice Sérullaz aided me at crucial points in my work. To all of these Parisian professionals and their staffs I extend my most sincere thanks.

Paris was the political capital of France during the reign of Louis-Philippe, but Versailles became its artistic hub: my research brought me back time and again to the Château and its collections. It is fortunate that Claire Constans, Curator at Versailles, shares my enthusiasm and curiosity about these pictures, which are so often ignored; without her generous patience before my many requests for information, or access to galleries normally closed to the public, the book could not have been written. Roland Bossard, Chief of Documentation at Versailles, was extremely helpful during several months of work amidst the museum's dossiers. I am grateful to them and to the entire staff at Versailles for making my work possible.

During the fall and winter of 1978–79 I made a series of excursions across France to visit museums and study pictures commissioned by the July Monarchy. These visits entailed recovering paintings from storehouses, locating documents, and meeting many museum professionals. I must express my gratitude to those individuals whose special efforts and enthusiasm have remained a vivid memory: Paul Allard (Annonay), Martine Bailleux-Delbecq (Eu), Pierre Barousse (Montauban), Eric Bonnet (Vannes), M. Castera (Bagnères-de-Bigorre), Félix Davoine (Gray), Françoise Debaisieux (Caen), Marie-Pierre Foissy (Montpellier), Catherine Gendre (Versailles, Musée Lambinet), Marguerite Guillaume (Dijon), Gérard Hubert (Rueil-Malmaison), Françoise Maison (Arras), Denis Milhau (Toulouse), Anne-Marie Scottez (Lille), and Françoise Soulier-François (Besançon).

Research cannot be conducted without libraries, and I have taxed more than once the patience of librarians on both sides of the Atlantic. I must thank collectively the many professionals at the Archives Nationales and at the Bibliothèque Nationale, in particular the Cabinet des Estampes, for their essential and much appreciated assistance. I extend a special thanks to Denise Gazier, Chief Librarian of the Bibliothèque Doucet, and to her staff for their unwavering helpfulness. At the Archives du Louvre, Chief Curator Nicole Villa provided invaluable guidance to the documents in her charge. The librarians at the Institute of Fine Arts—Chief Librarian Evelyn Samuels, Francis Bondurant, and Robert Stacey—dispatched many special requests with efficiency, good humor, and tact. I could always depend upon the staff of Avery Library at Columbia University—especially Christine Huemer, Roberta Blitz, and the recently deceased Bella Baron—to handle with a minimum of fuss all types of bibliographic crises.

The years required to write the book were supported financially by a number of important grants. While at the Institute of Fine Arts I held a Robert Lehman Fellowship, a Robert Goldwater Fellowship, and several Institute summer travel awards. I was able to conduct additional research in France during the fall of 1984, thanks to a Fellowship for Recent Recipients of the Ph.D. awarded by the American Council of Learned Societies, under a program of support for young scholars funded by the National Endowment for the

Humanities. Grants from Columbia University's program of Research Assistance for Non-Tenured Faculty helped defray the costs of preparing the manuscript for publication. The Millard Meiss Publication Fund of the College Art Association of America provided a generous, much-appreciated subsidy for the inclusion of color plates in the book.

I feel very fortunate to have found in Yale University Press a publisher committed to excellence at every level, and I am especially grateful for the intelligence, patience, and loyal support of Senior Editor Judy Metro. Stephanie Jones, Manuscript Editor, admirably performed the unenviable task of bringing a final order to my manuscript. My insistence upon a neo-nineteenth-century design for the book was perfectly translated by James J. Johnson into a handsome finished product. Every author's first book should have the advantage that Yale has given to this one.

Finally, I want to thank those close friends whose support was there when it was most needed: George Bauer, Dawson Carr, Joseph Mandel, and Michael Mezzatesta have had a greater hand in this book than they might ever know.

<div align="right">

Paris
November 1986

</div>

PART I

Introduction

1. SCOPE OF THE PRESENT STUDY

THE JULY MONARCHY was neither the first nor the last in the parade of powers to guide France during the one hundred years following the fall of the Bastille. Although it was both ushered in and swept away by revolutions, the regime which ruled over the eighteen years from July 1830 to February 1848 was nevertheless one of the longest-surviving governments to appear during the course of that tumultuous century. At the very least, this life span attests to the tenacity with which the leaders of the July Monarchy clung to the reins of power; at the most, to their capable managerial talents. History would no doubt place the truth somewhere between these two extremes, but it must concede at least one point of originality to that government: the July Monarchy marks the only moment when modern France was governed by a constitutional king who was not a direct, legitimate descendant of Saint-Louis (Louis IX). Louis-Philippe d'Orléans, who took the title King of the French (*Roi des Français*) rather than King of France, hoped to mediate the paradox of founding a new dynasty on the rubble of a revolution which had chased one king from the throne and demanded an end to the legitimist principle of divine right.

Difficult as these conceptual problems might be, they proved less pressing than the political realities of the hour. Domestic tranquillity was frequently jarred by civil disorder and economic imbalance caused by the rapid industrialization and urbanization of France's traditionally agricultural society. On several occasions international relations heated almost to the point of war, despite Louis-Philippe's policy of peaceful coexistence with the other courts of Europe. With few exceptions, those courts still believed in the treaties of 1814 which had returned the Bourbons to the throne of France, and they made few attempts to hide their disdain for the usurper, whom they dubbed King of the Barricades.

Yet the government survived, and France inched toward the modern era. New roadways and canals, followed by railroads and telegraph systems, knit the country more closely together. Important legislation established public elementary schools in 1833, and by 1848 the level of illiteracy had been sharply reduced. French heavy industry—especially mining

1

and iron-making—had long lagged behind that of other countries, notably England, but during this period the gap narrowed markedly.[1]

Alongside the material advances made by France under the July Monarchy went an incredible vitality in the arts, especially the visual arts. After initial fears that the end of the Bourbon court and its seemingly limitless funds would mean the end of commissions, artists soon found them multiplying at a rapid rate. Sculptors were put to work completing the Arc de Triomphe de l'Etoile and the church of La Madeleine, while painters were asked for pictures to fill the immense and ever-growing galleries of the museum being installed at Versailles.[2] One of Louis-Philippe's first official acts on behalf of the arts was to make the Salon an annual event.[3] Except for the cancellation caused by a cholera epidemic in 1832, the Salon opened regularly each year in early March. Not since their inception had the Salons been held so frequently. The number of objects submitted each year documents the growth of the art world during the 1830s and 1840s: 3,112 works were presented to the jury in 1834; 3,996 in 1840; and 4,883 in 1847.[4] The production of these objects required an army of artists, whose numbers increased proportionally during the same decades.

Despite this potentially rich material, art history has virtually ignored the "establishment art" of the July Monarchy, partly because the major work dedicated to these years, Léon Rosenthal's *Du Romantisme au Réalisme*, is an excellent and intimidating predecessor.[5] Furthermore, the available pool of objects is so vast—with seventeen Salons and several special exhibitions, each containing thousands of numbers—that the historian's task is extremely complicated. This book attempts to circumvent some of these difficulties by adopting a narrow, yet historically justifiable, scope. The discussion is limited to history painting, more specifically, to those official commissions which cast the events of French history after the Great Revolution in a way that might explain and legitimize the ideology of the July Monarchy. Within these rather precisely drawn parameters, I develop a four-tiered analysis of official art in France for the years 1830–48: first, to explain the iconography of officialdom and the specific imagery it invokes; second, to articulate the relationship of this imagery to the demands of official ideology and contemporary political events; third, to measure whether the vocabulary of history painting taught by the Ecole des Beaux-Arts was able to produce a viable propaganda for the government; finally, to discover the alternative visual forms pressed into service by painters who recognized that the traditional values of history painting were not relevant to the task at hand.

Although these issues often overlap, they occasionally digress and sometimes even diverge. As a result, my argument is structured in a manner which may seem peculiar to some art historians, and the informed reader will note that it ignores large parts of the contemporary art scene: I have included very little discussion of landscape and religious painting, for example, both of great importance during the 1830s and 1840s and each demanding a study of its own. On the other hand, I have turned my inquiry toward secondary forms of art—engravings, lithographs, and modestly sized canvases—to set the "semantic context" for understanding the specific character of the government's commissions, and I refer frequently to historical material which lies outside a traditional interpretation of what constitutes art history. I have tried to keep in mind that for any art form to qualify as "official," whether the patron be a government or a corporation, a special relationship must exist between the message (covert or overt) of the object and the desired

public image of its patron. Since the patron's nonaesthetic motives will influence a commission's elaboration, my analysis (which hopes to be historical) must wander afield to pinpoint the factors which shaped the work of art. I can perhaps best summarize my modus operandi simply by affirming my respect for Frederick Antal's observation that "art history is a piece of history and that the art historian's task is primarily not to approve or disapprove of a given work of art from his own point of view, but to try to understand and explain it in light of its own historical premises; and that there is no contradiction between a picture as a work of art and as a document of its time, since the two are complementary."[6]

Indeed, questions of content come first to mind when thinking about official art, and it makes sense that we begin our investigation by raising them at the outset. The next section will discuss the portraiture of Louis-Philippe—perhaps the most official of art forms—to outline the major political and pictorial directions of his imagery and to serve as the keystone to a broader understanding of the ideological demands placed upon painting by the Orléans monarchy. Finally, I will trace the contours of a lively contemporary debate which posed a question crucial to our study: was history painting still capable of fulfilling its traditional role as the most ambitious form of pictorial representation?

2. PORTRAITS OF LOUIS-PHILIPPE: AN IDEOLOGICAL MODEL

The first portraits of Louis-Philippe display a marked sensitivity to the peculiar combination of events which brought him to the throne. Louis Hersent's portrait—probably the first to be commissioned by the July Monarchy government—established the precedent of a simplified royal image (fig. 1).[7] Louis-Philippe stands close to the picture plane upon a low platform, but one which does not raise him above the viewer's eye level. He wears the rather plain uniform of a National Guard commander and his only military decoration is the medal of the Legion of Honor. A small tricolor ribbon adorns his hat. In the background, an unassuming throne echoes the austerity of Louis-Philippe's uniform: apart from the griffin legs and arm rests, the only bit of political iconography is the newly reinstated emblem of the Gallic cock.[8] Finally, a simple drapery closes the space.

Hersent's image of the new ruler seems deliberately to eschew all references to conventional emblems of royal authority: neither the crown, the baton, nor the hand of justice is included. Even the arrangement of the throne room in the Palais-Royal (the royal family did not move to the Tuileries until October 1831) reinforces the portrait's unpretentious character. Rather than affording a more traditional view of monumental architecture or deep outdoor vistas, Hersent's simple presentation situates the king in an intimate locale and, where the draperies open at the far left, we see that a group of dark-suited bourgeois citizens are being admitted to the king's presence.[9] This slice of secondary action makes explicit the message implied by the formal organization and iconographic system of the portrait as a whole: Louis-Philippe is an accessible monarch, a true Citizen-King. In fact, approachability was an integral part of the new monarch's persona, and none of the popular biographies which flourished during the months following the July Revolution failed to mention his unassuming and even ordinary life-style: "If, by chance, you meet in the streets of Paris a tall and erect man who seems both martial and gentle, note carefully; if he is walking alone, dressed in a simple overcoat with an umbrella tucked under his arm, and is

greeted by everyone with a respectful informality to which he responds with a pleasant and confident smile, approach this man and offer him your hand, he will shake it: he's the King."[10] Hersent's portrait encodes precisely the same meaning by its lack of pretentious detail, the king's spatial proximity to the viewer, his dignified but unstylized pose, and the artist's descriptive, nonidealized rendering which treats the royal visage with the same impartiality as the wrinkles of his trousers.

The special character of Hersent's image can best be gauged by comparing it to a portrait of Louis-Philippe's immediate predecessor, Charles X. When Paulin-Guérin represented the Bourbon, he was expected to invoke the portrait tradition of the Ancien Régime (fig. 2).[11] Charles appears in the sumptuous regalia of his coronation at Reims: ermine, gold fleurs-de-lys, silk stockings, and fine lace all contribute to the conscious recreation of an iconography which looks back to family predecessors such as Antoine-François Callet's portrait of Louis XVI (fig. 3).[12] The white plumes of the Bourbon family, the conspicuous placement of the crown, and the distancing effect of the stairs upon which the king stands impress upon the viewer that this individual is not to be approached by the average citizen. Whereas the Paulin-Guérin portrait strives to emphasize the distance between sovereign and subjects, Hersent's systematically undermines that impression and thus constitutes a major rupture in the tradition of royal portraiture in France. Between these two images lies the July Revolution; to understand why they are so dissimilar is to grasp in an instant the political tenor of the newly installed Orléanist dynasty.[13]

The primary influence upon the direction of Louis-Philippe's royal portraiture was Orléanist propaganda disseminated by his partisans during the power struggles of 30 and 31 July, when the character of the postrevolutionary government was far from resolved.[14] A key document containing the main thrust of this propaganda is the proclamation jointly authored by Adolphe Thiers, François Mignet, and Jacques Laffitte and distributed all over Paris on the morning of 30 July:

> Charles cannot reenter Paris, for he has spilled the people's blood. A republic would threaten to divide us terribly and would isolate us from the rest of Europe. The duc d'Orléans is a prince who is devoted to the ideals of the Revolution. The duc d'Orléans has never fought against us. The duc d'Orléans was at Jemmapes. The duc d'Orléans carried the tricolor into battle, and only the duc d'Orléans can wear its colors now; we will not have any others. The duc d'Orléans has committed himself: he agrees to the kind of constitution we have always wanted and accepted. His crown will come from the French people.[15]

This litany of praise for the duc d'Orléans established the basic contours of Orléanist iconography. It emphasized the fact that he had served in the republican armies of 1792 and had refused to join the émigré armies in their fight against the National Convention.[16] It associated the duc d'Orléans with the tricolor, reinforcing his position among the insurgents of 1830 who had adopted that flag as the symbol of their irrevocable rejection of the Bourbons and their flag of fleurs-de-lys.[17] Finally, this decree argued against the reestablishment of the republic and promised that the duc d'Orléans would uphold the Constitution (that is, the constitutional monarchy). Rather than change the government, the Orléanists proposed that France *invite* a liberal prince who had never betrayed his

homeland to occupy the throne vacated by the fleeing Bourbon family. Enter Louis-Philippe d'Orléans. Since the Citizen-King's crown would come from the people, he would rule by social pact rather than divine right.[18]

Hersent's portrait expresses this arrangement by its purposeful stripping away of protocol-bound iconographic formulas and its attempts to establish a colloquial vocabulary for the new king's imagery. The tricolor ribbon on Louis-Philippe's hat recalls his declaration of 31 July to the Parisians that "when reentering the city of Paris I wore with pride the glorious colors you had taken up again and which I myself had worn long ago."[19] It also recalls the fact that Article 67 of the revised Constitution officially returned the tricolor to France. The Legion of Honor medal that he wears is the honorific order of merit established by Napoléon and retained by the Bourbon Restoration, but only after the effigy of the Emperor had been replaced with Henri IV and all vestiges of imperial emblems had been removed. One of Louis-Philippe's first acts as king was to redesign this prestigious order: his changes to the medal reinstated the tricolor and added the motto *Honneur et Patrie*, further signalling to Frenchmen that the glory of their youth was once again something in which to take pride.[20] The king's National Guard uniform carries a double signification. First, he had worn it at one of the most crucial moments of the July Revolution, the afternoon of 31 July when he met Lafayette at the Hôtel-de-Ville: only by obtaining Lafayette's endorsement for the continuation of a constitutional monarchy (as opposed to the founding of a republic) were the Orléanists able to muster support among those who had fought in the streets. Since Lafayette was nominally the commander-in-chief of the National Guard, Louis-Philippe wore his guardsman uniform that day in a gesture of deference to the older man.[21] Second, the National Guard, which had been disbanded by Charles X in 1827 and provisionally reestablished during the July Revolution, would be completely restored as the most important domestic peace-keeping force of the kingdom by the law of 22 March 1831.[22] The Guard was composed of ordinary citizens (although the expense of the uniform effectively limited its ranks to members of the middle class) who served to maintain order during civil strife. Time and again the July Monarchy called upon this civilian militia to extinguish popular revolts, and the government fell in 1848 mainly because the National Guard had abandoned it. In 1831, however, Louis-Philippe wore the uniform of these citizen-soldiers in a conscious effort to forge a bond between the new dynasty and the law-abiding members of the French bourgeoisie.

The second official portrait to date from the early months of the July Monarchy closely follows the type established by Hersent. Nicolas Gosse's portrait was commissioned after the one by Hersent but finished first (fig. 4).[23] Louis-Philippe wears the same uniform and is again pictured in the Salle du Trône of the Palais-Royal, but the throne itself is even more innocuous, and the entering visitors have been eliminated. Since this picture offers virtually no visual clues that it represents a reigning king, one might say that Gosse has pushed the nonmonarchic premise to its most radical formulation. The portrait by Gosse was copied only a few times, and these reproductions were hung primarily in the Palais-Royal. This suggests that even the government found his solution a bit too low-key.[24]

The iconographic similarities between the two images just discussed and the fact that they were occasionally copied and placed in government offices suggest that they correspond to an officially approved identity.[25] But other portraits executed without a govern-

ment commission frequently project a somewhat different image of the new monarch and provide us with a more "grassroots" conception of the post-July reign. Francis Conscience's very stripped-down portrait is one example (fig. 5).[26] The duc d'Orléans is shown with an enormous tricolor in one hand and the closing phrase of his declaration to Paris in the other. He wears the already familiar National Guard uniform, but this time he is outfitted with riding boots. On the low horizon one finds landmarks of the Paris skyline (the Pantheon, Notre-Dame) to emphasize the capital's important role in the July Revolution. The complete lack of monarchical reference in this portrait suggests that Conscience has painted Louis-Philippe as *lieutenant-général* of the kingdom, the "caretaker" title he assumed on 31 July. While it is possible that the picture was completed before Louis-Philippe's investiture as king on 9 August (in which case it is historically accurate rather than deliberately nonmonarchic), Conscience's extraordinary emphasis on the tricolor leaves some doubt about the work's meaning: is it celebrating the return of the republican banner or the arrival of the duc d'Orléans on the political scene? As we shall see, during the early years of his reign Louis-Philippe had a special interest in manipulating the ambiguity of just this issue so that he would emerge as the defender of liberty and heir to the principles of the Great Revolution.

The political complexities of the July Revolution inform a second "nonofficial" portrait of Louis-Philippe, usually attributed to Eugène Lami (fig. 6).[27] Ostensibly a portrayal of the duc d'Orléans as he appeared on the afternoon of 31 July while riding on horseback from the Palais-Royal to meet Lafayette at the Hôtel-de-Ville, Lami has the Duke saluting (and being cheered by) the crowds on the barricades.[28] Among these we find a mix of top-hatted, dark-suited bourgeois and more roughly dressed workers.[29] The Vendôme column—bronzed concretion of the Napoleonic era and newly sporting a tricolor flag—emerges from the background haze at the left as an oversized testament to the power of the Napoleonic legend in 1830: fired by the reappearance of the tricolor, bonapartist sympathizers and Imperial veterans played an important role in the July Revolution.[30] Bonapartist influence continued to grow after 1830, and for many years it remained a threat to Louis-Philippe because its ability to mobilize a large, popular power base constituted a potentially disruptive social force.[31] Thus Lami's picture of the king, produced to be the model for a lithograph similar to many others which could be cited, reflects a "nonofficial" but precise public evaluation of the precarious combinations which propelled the 1830 Revolution: bourgeoisie and workers, monarchists and republicans, Bonapartists and Orléanists joined together in a defense of Liberty (the revolt) and a call to Order (the new king).[32]

The last pair of apparently conflicting ideals was especially dear to the new regime because it circumscribed the publicly acknowledged raison d'être for founding the Orléanist dynasty. François Guizot, a leading political figure in several July Monarchy cabinets, succinctly summarized this explanation when he wrote of the 1830 Revolution:

> Its impetus and its aim were very complex; begun to defend laws which were violated, it was lead by its slogans and its first actions to reestablish promptly the civil order which had received, however, a serious blow from the royalty. But the Revolution issued from much more than the immediate cause of its explosion, and carried in its wings ambitions quite apart from the reestablishment of law and order. At the same time and without delay it was asked to complete an important liberal advance

and to erect a legal and reassuring power. It had simultaneously to extend public liberties and found a government. Having resolved not to submit to the July ordinances, France wanted a revolution which would not be revolutionary and which would give it, all at once, public order with liberty.[33]

Not surprisingly, we discover that an expression of these antipodal concepts regulated the several modifications made to Ary Scheffer's 1831 equestrian portrait of Louis-Philippe (fig. 7).[34] The central section of this work, exhibited at the 1831 Salon and bought by the Crown, depicts an event of 4 August 1830: Louis-Philippe (not yet king but already lieutenant-général of the kingdom) met his eldest son (then the duc de Chartres) at the Barrière du Trône when the latter led his regiment of cavalry into Paris.[35] At this critical moment, these troops were needed at the Palais-Royal because Louis-Philippe was worried by the prospect of an unguarded household just as he was to be declared king. The newly arrived troops—loyal to his son—could be depended upon to protect the Orléans family against any public demonstration of opposition to the impending accession.[36]

Yet this strategic meaning was virtually invisible in Scheffer's original image which, according to the dimensions recorded in the 1831 Salon registers, included little more than Louis-Philippe and his two sons (the duc de Nemours accompanied his father and elder brother that day).[37] Nor were these practical considerations made any more obvious by subsequent enlargements of the canvas. On the contrary, the changes served to develop a more general political interpretation of a relatively inconsequential event. The first enlargements were apparently executed just after the Salon, because the dimensions of the picture were already slightly different when it was inscribed on the registers of the Royal Museums.[38] By that time, strips of canvas had been added to the top and bottom edges of the painting—alterations which probably responded to certain Salon critics who felt the original image lacked spatial depth.[39] The width was also increased at the left edge to permit the addition of a tricolor. Although contemporary descriptions imply that the flag had always been present, the original dimensions allowed only a thin sliver of it to show along the picture frame.[40] In its second configuration, Scheffer's portrait conveyed a message similar to that already found in the works by Conscience and Lami: an emphasis on the allegiance of the newly organized Orléans power base to the ideals represented by the tricolor.

The final additions to this canvas—extra soldiers at the left and figures at the right—were not made until 1839 and were actually derived from a second Scheffer painting commissioned in 1835 (fig. 8).[41] This portrait, specifically destined for the Salle de 1830 at Versailles, depicted the same event as the 1831 original, but with minor adjustments to the central group: notably, the duc de Nemours was moved to the right and made more visible. Scheffer's original work (fig. 7) was then expanded at both sides to include figures present in the later work (fig. 8) and to show Louis-Philippe acclaimed by the forces of order (the royal troops who signify their allegiance to the Orléans family) and a contingent from the popular sector of the July uprising (the crowd at the right). Thus Scheffer, who was a personal friend of the Orléans household and undoubtedly familiar with the iconographic desires of the new regime, placed Louis-Philippe squarely between two antagonistic social forces, but showed him being applauded by both.[42] In their reconfigured states, Scheffer's renderings of the event of 4 August 1830 make Louis-Philippe the physical embodiment of the compromise government he headed by mapping out literally the idea that he was the

mediator capable of giving to France both Liberty and Order. As we shall see, this problematic dual concept—essential to the rationale of the July Monarchy's existence—became a major theme of its iconography.[43]

Méry-Joseph Blondel's 1832 monochrome imitation of a sculpted relief extends this same idea to architectural decoration (fig. 9).[44] Replete with heroic connotations generated by its neoclassical relief formula, this image hovers between historic narrative and edifying allegory to express the requisite ideals of Liberty and Order. The presence of troops at the far left again suggests that the new king has the allegiance of civil peace-keeping forces. The saber-wielding young man at the right—significantly, a well-dressed, middle-class freedom fighter rather than a poor worker—applauds the rising political fortunes of Louis-Philippe. Between the horse's legs, paving stones and timbers recall the barricades of July, while the broken chain should be understood as an emblem of the nation's newly acquired liberty. Finally, a large flag (no doubt a tricolor), marked with Louis-Philippe's pledge to maintain the Constitution, forms a politically appropriate backdrop for this image of the new sovereign.

Blondel's work compresses the remnants of several episodes and portrait types into one frame. Its similarity to Gosse's portrait of Louis-Philippe reviewing the National Guard on 29 August 1830 suggests a narrative link to contemporary events (fig. 10),[45] while its reworking of elements found in the portrait by Lami (fig. 6) implies an encoding of political values beyond a simple narrative. At the same time, Louis-Philippe's prancing steed and extended arm recall vaguely the equestrian Marcus Aurelius in Rome, a revered prototype from tradition certainly appropriate to Blondel's radically classicized rendering.[46] By using a learned, elitist style to combine these scraps of message-bearing ciphers drawn from memory, direct observation, and the popular folklore of the recent revolution, Blondel created a nonspecific image which might be called a storied allegory. His process removes the scene from everyday existence and strives to achieve an aggressively idealized vision of the new government. Yet Blondel's picture also raises the question of whether it was still possible at that time to produce meaningful allegories of contemporary events: the degree to which standard formulas retained their potency and the modifications required by 1830s historicism are two aspects of this issue to which we will return in discussing other allegories of the July Revolution.[47]

It is also significant that Blondel's picture exhibits the nonmonarchic tenor characteristic of the other portraits of the king examined thus far. We have seen that this iconography, descended from Orléanist propaganda of July, stressed the fact that Louis-Philippe was an accessible, unpretentious leader, a Citizen-King. The year 1832, however, marks an important turning point in the development of royal imagery, one that goes hand in hand with the evolving political situation. The very speed with which the July Monarchy was founded tended to undermine its authority during the following months: the new government only partially controlled Paris and faced the even larger task of extending its rule throughout France. Forced to extinguish revolutionary fervor in the provinces and to consolidate its grip on the capital, Louis-Philippe's government began to look more and more reactionary to those patriots who believed that the July Revolution had not yet fulfilled its promise of real reform. The paradox of Liberty *and* Order meant that some Frenchmen soon began to feel that the reestablishment of order was clipping their newly acquired liberty at the roots.[48]

In many respects, the most difficult struggles were fought and the real revolution in government was implemented only during 1830–32, and this realignment of power resulted in a series of conflicts on both international and domestic political planes.[49] The gradual clarification of Louis-Philippe's foreign policy of nonintervention was hastened by the crises in Belgium and Poland.[50] In both cases, the French Left called for direct military intervention; the king's refusal gave rise to stiff political resistance and personal attacks.[51] On the home front, an economic collapse after the 1830 revolution threw thousands of workers into abject poverty. The plight of these already poor masses led to civil disorders and, in some cases, armed riots. Because the new government was both unequipped and unwilling to engage in massive relief efforts, it did little more than take measures to benefit business which, it was hoped, would ultimately aid workers over the long term by providing jobs.[52] Challenged by these persistent problems at home and abroad, the government was forced into a defensive posture which seemed to demand that it definitively "take charge" of the situation. In the eyes of many contemporaries, this was accomplished when Casimir Périer became president of the cabinet (more or less equivalent to the position of prime minister) on a politically conservative platform of *résistance*: order at home and nonintervention abroad.[53]

The new cabinet took measures to distance the monarchy from "the people," thinking that familiarity was breeding disrespect. In October 1831, under pressure from Périer, Louis-Philippe moved his family from the Palais-Royal to the Tuileries: ostensibly, the latter was more easily defended in times of trouble, but the fact that the palace was the traditional residence of the king gave the move a symbolic meaning.[54] Louis-Philippe's advisers also made him abandon his habit of walking unaccompanied in the capital: once installed in the Tuileries, the king was dissuaded from strolling in the gardens, and an underground passage was constructed to link the palace with a terrace overlooking the Seine so that he could walk there without attracting attention.[55]

In May 1832, the comte de Montlosier submitted to Louis-Philippe a personal report on the domestic situation in which he delicately reemphasized the need to establish a certain distance between the monarch and his subjects:

> In today's society, where might one find the *virem quem*—and if it were found, what authority would it have to compel? In Rome, whose religion and morals were surely not austere, if a vestal virgin happened to cross the forum to reach the Capitoline, everyone parted and lowered their eyes. Is it possible to imagine this happening today? Nevertheless, if the power chose to be a bit more reserved, if it chose to reduce the frequency of its contacts, if it elected to remember that maxim of the ancients— *major e longinquo reverentia*—a dignity with its aura of power could be recovered. Obviously this guideline excludes neither relations of intimacy nor those of confidence; it simply wants the power to retain its glow of grandeur even when intimate, so that intimacy appears to be a favor and not a right acquired by virtue of some vague "popular" equality.[56]

Montlosier's comments were made in the context of suggesting measures which should be taken to strengthen governmental authority and curb antigovernment opposition; his other recommendations included a stricter control of the press and a more concerted effort to

place promonarchy judges in the court system. The fact that such significant steps could be suggested in the same breath as adjustments to royal comportment only underscores the seriousness with which the problem of Louis-Philippe's public image was being treated.

The first royal portrait to exhibit the new tendency toward a more regal presentation of the king is the one painted in 1832 by Horace Vernet for the French Embassy in Rome, a copy of which was sent to Paris (fig. 11).[57] Much of the iconography remained unchanged from that found in pictures already discussed: the king wears the same National Guard uniform, a tricolor cockade adorns his hat, the throne is a simply styled armchair. Similarly, the background is formed by a group of tricolor flags upon which the key words *liberté* and *ordre* are visible. Now, however, Louis-Philippe conspicuously holds the Charter of 1830, while the most important additions are the overt emblems of royal power: the crown, baton, and hand of justice. Finally, military force is suggested by an oversized sword which the king holds in his right hand. "I don't know why Horace has supported the king on a large cavalry sword," wrote Jal cryptically; "this equestrian equipment does not go with the crown of diamonds and the green volume of the Charter."[58] With an understanding of the "authority crisis" of the years 1831–32, we are in a better position to appreciate why Louis-Philippe might be so well armed. It is also intriguing to learn that Vernet made a number of changes to the work upon express orders of the king; while the exact nature of these alterations is unknown, we do see that the highest authorities were now taking an active role in the management of royal imagery.[59]

At the same time, it must be admitted that Vernet's portrait stops far short of overwhelming the viewer with a monarchic presence. Since the crown is literally sandwiched between the charter and the sword, we might be led to interpret the king's pose as yet another variation on the double theme of liberty (the constitution) and order (the armament). Within this semantic network, Louis-Philippe might be either the protector of the Crown or its possessor, and legitimist critics did not fail to exploit this ambivalence with such belittling commentaries as that found in *Bagatelle*: "But this is not the portrait of the King of the French. At best, it's that of an officer of the National Guard charged with defending the throne: he holds neither scepter nor baton of justice, no royal robe over his shoulders, no crown on his head."[60] Apparently, Vernet's portrait also failed to convince the administration, because it remained a unique image which was neither copied nor engraved: despite the king's impatience for the picture to arrive from Rome, it never became a standard effigy of the Roi des Français.[61]

Louis-Philippe's search for an appropriate image during these first years of his reign was more than a question of vanity, insofar as he suffered from a serious identity problem in most of the outlying regions of the kingdom, where the cathartic explosion of the Paris revolution had seldom rippled the status quo of local administrations.[62] He made two tours of the provinces in 1831 to improve his reputation outside of the capital.[63] Not surprisingly, his government was also planning a concerted effort to place royal portraits in public buildings all across France. In September of 1831 the *Journal des Artistes et Amateurs* indignantly reported that Charles-Emile Champmartin had been selected to paint a model portrait which would be recopied eighty-six times and sent to the administrative headquarters of every *département* in France.[64] The journal's anger lay in the fact that Champmartin's "romantic" prototype would not only be painted "according to a phony system, with an

imprecise drawing and a greasy touch," but also recopied by provincial artists. "The decadence," it warned, "which, up to now only threatened the studios of the capital, will simultaneously expand its influence across the entire face of France!" Ultimately, there was little to worry about, because the grand project was never realized. In November this same journal rather gleefully followed up its original story with a note to the effect that Louis-Philippe "has not at all decided to pose" for Champmartin, and hinted that the scheme might founder.[65] Founder it did: while Champmartin received an initial payment in June 1832, the open account was still on the books in 1835; although the portrait was eventually completed, nothing came of the eighty-six copies at this time.[66]

The July Monarchy's plan to distribute portraits of the sovereign was not new: a similar program had been standard practice during the Empire.[67] The portrait scheme was no doubt conceived along the Napoleonic model as a kind of public relations project, and its cancellation probably had more to do with subsequent political and economic developments than with second thoughts about the artist selected to execute the prototype picture. We have noted that in 1831–32 a number of serious social shocks necessitated a realignment of governmental priorities and led to the establishment of Casimir Périer as cabinet president. Périer's concept of constitutional monarchy envisioned a king who reigned but played only a minor role in the actual operation of government.[68] This arrangement, patterned on the British system, prefers a regal monarchy which holds itself above everyday political conflicts: as we have seen, Périer encouraged Louis-Philippe to adopt a less familiar public comportment. Yet Périer's kind of government would be ill-served by strong sentiments for the king at a local level, because it presupposed an allegiance to a *form* of rule rather than to a personality.[69] Within this framework, the proposed diffusion of royal portraits would have been singularly counterproductive.

More immediately, the worker riots at Lyon in November 1831 underscored the fragility of the central government. Although the incidents were local and primarily economic in nature (the main issue was daily wages), national troops had to be called in when the municipal authorities proved unable and even unwilling to end the disorders.[70] Louis-Philippe was not alone in his astonishment when he wrote about the conduct of Dumolard, the prefect of Lyon: "It is remarkable that he spoke of neither the King nor the king's government in his first proclamations . . . it is clear to me that he was treating with the leaders [of the uprising] and that he was not working loyally with his government before the events. . . . I believe that Dumolard must leave Lyon as soon as possible."[71] The king's surprise is justified in light of the measures which his government had taken to strengthen its hold on the provinces. The new regime had effected a massive purge of provincial bureaucrats in 1830, and Périer had demanded new proofs of their loyalty in March 1831.[72] The alarming lesson of the Lyon riots was that the government could not yet fully depend upon the fidelity of its own appointees. Given these political realities, the idea of sending royal portraits to the provinces must have seemed premature and even unduly provocative; consequently, the project was allowed to slip quietly into oblivion.

By 1835 the political climate had changed somewhat. Périer had died in the 1832 cholera epidemic, which meant that the ministerial check on Louis-Philippe's personal role in government was now less strong, and the king moved deftly into the ensuing power vacuum in order to reestablish a more direct rule.[73] Moreover, Louis-Philippe's self-

confidence had been greatly buoyed by the warm reception he received from both the National Guard and the general public after the Paris uprisings in early June 1832,[74] an experience which directly inspired the commission awarded less than three months later to Auguste DeBay. DeBay's painting represents the king meeting one of those wounded on 6 June during a review of National Guard units stationed along the Seine and the principal boulevards of the Right Bank (fig. 12).[75] Even politically hostile observers had admired the courage of this excursion across the still dangerous city and had noted Louis-Philippe's solicitude for the wounded.[76] DeBay presents us with an illustration of the king's concern: Louis-Philippe stops his horse before a dying guardsman to console his despairing spouse and little boy, while an aide at the far right obtains the victim's name and address from a comrade, undoubtedly to ensure that the stricken family will be aided by the government. Clearly, the way that Louis-Philippe's gallop is abruptly interrupted by his response to this scene of familial grief was designed to recall the long pictorial tradition of rulers moved to clemency by female tears.[77] Perhaps the most relevant examples of this type are the pictures of Napoléon by Charles Lafond (fig. 13) and Guillaume-François Colson (fig. 14), especially since the latter had recently been shown in the 1830 Luxembourg exhibition.[78] Unlike the democratic imagery of the Citizen-King, DeBay's work celebrates the king's personal courage and popularity with the people (who cheer at the far left) by placing him in the company of soft-hearted sovereigns from time past to link symbolically the events of 1832 Paris with a grander history.

It is not surprising to discover that soon afterward a new portrait type of the king was commissioned, one which projected his increased personal stature and was destined to become the first standard emblem of the July Monarchy. In late 1833, François Gérard delivered a portrait of Louis-Philippe to decorate the Chamber of Peers in the Palais du Luxembourg.[79] The picture must have pleased the king, because duplicate originals were soon ordered for the Louvre, the Hôtel-de-Ville of Paris, and the king's daughter Louise, queen of the Belgians.[80] Significantly, still another original was commissioned to become a prototype at the Ecole des Beaux-Arts.[81] There, for a standard fee of eight hundred francs, paid by the Interior Ministry, students executed copies which were dispatched to various parts of the kingdom.[82] It can hardly be fortuitous that the administration revived the scrapped portrait program of 1831 at the very moment when the king's personal prestige and real political power were on the ascent.

Gérard's image builds upon royal iconography already in place before 1833 (fig. 15).[83] The king's National Guard uniform, the tricolor cockade on his hat, and the Legion of Honor medal on his breast all belong to the imagery developed at the beginning of his reign. Gérard also reused an idea introduced by Vernet (see fig. 11) and gave the Charter a conspicuous place in the portrait: Louis-Philippe places his hand on the open document as if recreating his oath of 9 August 1830 to maintain and respect that text.[84]

It is interesting to see the Charter emerge as a major element of official portraiture at this time, because discussion of that document also dominated contemporary political discourse about the goals and ideals of the July Monarchy. The opposition Left mounted a campaign to discredit Louis-Philippe's government by claiming that the king had agreed to a reform-oriented policy in his meeting with Lafayette in 1830 but was now reneging on his promises and leading the nation down an ever more conservative course. They openly

accused him of subverting and diverting the hopes and ideals of the July Revolution.[85] The king's response to this criticism is most succinctly summarized in his autograph transcript of a conversation held with three opposition leaders on the evening of 6 June 1832, only a few hours after he had triumphantly crossed the city on horseback (fig. 12):

> The goal of the July Revolution had been to resist the violation of the Charter, and not only has the Charter been preserved intact, but it has also been amended. M. Laffitte, who is right there, can tell you how and by whom these amendments were proposed, and that the preparatory work was done in two hours in my office at the Palais-Royal . . . the Charter of 1830 has thus become my compass, because what I promised, what I swore to uphold is there . . . the public knowledge of my engagements and the fidelity with which I have observed them should have spared me from all the tales fabricated about the supposed program of the Hôtel-de-Ville. . . . I said it more than once to M. de Lafayette, and it doesn't trouble me in the least to say to you now that this supposed program is a complete invention and an absurd falsehood.[86]

Louis-Philippe's argument clearly reveals his conviction that the Charter delimited the operating parameters of his government: reform not included in that text was beyond consideration, and civil strife directed against the authorities who conscientiously fulfilled their charter-defined responsibilities must and would be repressed.[87] By this date, the delicate balance between Liberty and Order had become decidedly heavy on the side of Order, while the Charter, interpreted as an inviolable document, became the keystone of policy. It is only natural that the Charter became an important component of royal iconography. Gérard—as if concretizing the king's own words—tempered Louis-Philippe's visionary gaze into the distance with a tactile reference to that primal document of government.

Gérard's portrait also includes a number of subtle but definite departures in formal presentation and secondary iconography which distinguish it from its predecessors. Although Louis-Philippe is once again positioned close to the viewer's space with virtually no intervening obstacles, Gérard slightly lowers our eyepoint so that the king dominates the scene—and us—with an imposing presence not found in the portraits already considered. For the first time, Louis-Philippe has been given a throne which forces its royal connotations upon the viewer: it is now a massive piece of furniture situated two steps up from the foreground, rigidly frontal to the picture plane, and decorated with the crown, hand of justice, royal baton, and a large "LP" monogram. A similar grandeur informs the rest of the background, where a cluster of oversized, high-based columns and pilasters at the left and an opening at the right—framed by an imposing complex of architectural elements—situate the king in an appropriately important setting. This solution, which recalls standard Ancien Régime formulas (it was really a Baroque invention), illustrates how attempts by the July Monarchy to reinforce the sovereignty in royal portraiture inevitably led to reincorporation of aspects of the pictorial tradition jettisoned at the time of the 1830 Revolution. One might say that this borrowing is the iconographic analogue to the rightward drift in favor of a strong monarchy which characterized the government's political choices during the same period. The result was a hybrid image which encoded a number of not always compatible ideals, and did so without promoting one over another; insofar as it achieved

this delicate task, Gérard's portrait was emblematic of the dynasty's ideological contradictions yet perfectly suited to become the standard portrait of the king.

In fact, the appropriateness of Gérard's image meant that the evolution of royal portraiture, which had proceeded rapidly between 1830 and 1835, stagnated during the later years of the decade. The consolidation of the monarchy's imagery mirrors the economic and political consolidation of the period. Historians note that the end of the 1830s marks a decisive turning point for the country.[88] Economically, the depressed financial situation of the late 1830s was relieved in 1840 by a surge of business activity and good harvests. The ensuing period of national growth and development extended into the 1850s and faltered only once, in late 1847, when a recession fueled the discontent which led to the 1848 Revolution. Militarily, the late 1830s and early 1840s brought a series of French victories in Algeria—successes which handsomely repaid Louis-Philippe's government with respect from foreign powers and increased domestic pride.[89] On the home front, the king's competent handling of several ministerial crises added luster to his image as a capable leader.[90] Finally, the cabinet established in October 1840 brought to power a stable coalition which would endure until the 1848 Revolution.[91] In the person of François Guizot, Louis-Philippe acquired a political advisor who was also an expert parliamentary tactician, able to dominate the Chamber of Deputies and to implement his belief that the government should steer a conservative course. Unlike the power struggles which had marked Périer's ministry in 1831, Guizot and Louis-Philippe worked together to formulate policy; under their tutelage, the Orléans dynasty finally achieved an unchallenged control of the ship of state. After almost a decade of struggle, and despite its revolutionary origins, the government had achieved maturity by becoming decidedly reactionary and monarchist.

Louis-Philippe now seemed eager to forget the role of Citizen-King, and his behavior increasingly reflected traditional dynastic concerns. His agents worked to arrange advantageous marriages for the Orléans princes and princesses: Louise married Léopold Ier of Belgium in 1832, while the most important nuptials took place in 1837 when Ferdinand-Philippe, duc d'Orléans and heir to the throne, married Hélène de Mecklembourg-Schwerin. Louis, duc de Nemours, was joined to Victoire, duchesse de Saxe-Cobourg-Gotha, in 1840, and in 1846 Antoine, duc de Montpensier, took the Infanta Louise-Fernande of Spain as his bride. The politicking around these marriages was intense, as each Orléans link to the network of European aristocracy had far-reaching diplomatic consequences. Montpensier's, for example, was so bound up with Franco-British rivalries for influence in Spain that Louis-Philippe's carefully nurtured relationship with England was virtually demolished when his son married the Infanta.[92]

Thus economic, political, and cultural forces coalesced around 1840 to lend an unprecedented strength to the Orléans dynasty. A new portrait of the king was adopted at just this time, and it is no accident that it reflected the contemporary cresting of Louis-Philippe's personal prestige (fig. 16).[93] Like Gérard's picture of 1833, much of the iconography of François Winterhalter's portrait recalls earlier images of the Roi des Français: Louis-Philippe again wears the uniform of a National Guard commander decorated with the Legion of Honor, and he carries a bicorne hat with tricolor cockade—although the national colors nearly disappear behind gold braid. But, while the Charter dominated Gérard's portrait, here it is only identified by title on the spine of the discreet volume closed under the

king's hand: the degree to which it now shares center stage with the explicitly represented Crown and other accessories of royal authority measures the political rebalancing which had actually occurred in the power relationship between the king and the Constitution.

Although the throne has disappeared in Winterhalter's portrait, the locale in which the king stands more than adequately compensates for the loss. Louis-Philippe clearly occupies the Tuileries Palace, for the background of the picture opens onto a view of the gardens. Moreover, the king's strategic placement in one of the geographically symbolic rooms on the axis which runs from the Arc du Carrousel in the courtyard of the palace to the Arc de Triomphe de l'Etoile is established by details visible in the small triangle of space below his right arm. There, we discern the obelisk of Luxor at the place de la Concorde and, beyond that, the triumphal arch: two landmarks which not only locate the king's privileged position on the symbolic centerline of Paris but also remind us of the prosperity of his rule, since both were completed during his reign.[94] In this new image, Louis-Philippe is clearly portrayed at the epicenter of power.

Yet the Winterhalter preserves one important trait descended from the 1830 Revolution: to the extent that no artificial barrier separates the king from the viewer, Louis-Philippe retains a seemingly accessible physical presence. Within the tradition of official portraiture in France, this characteristic—which was anathema under the hierarchical aristocracies of the Ancien Régime and Bourbon Restoration—established a pattern for the imagery of later sovereigns, notably Louis-Napoléon.[95] To be sure, some components of this imagery—such as an unidealized description of appearances with subtly politicized accessories—hark back to certain pictures of Napoléon, for example, Jean-Auguste-Dominique Ingres' 1804 portrait of him as First Consul.[96] But where Napoleonic portraiture soon assumed a form which expressed the acquired absolutism of the Emperor, that of Louis-Philippe never left the concrete realm of the material present.[97] This obvious rupture with formulas long accepted as necessary for official portraits gives us a model for understanding how imagery was freed from tradition during the July Monarchy under the pressure of establishing a new kind of rapport between the government-sponsored work of art and its public. As we shall see, the dynamics of this evolving relationship directly affected the principal stylistic and thematic transformations evident in history painting during the 1830s and 1840s.

How did a viewer in 1839 react to a portrait like this? While an aggregate answer can be found in published Salon criticism, historical interpretation of what was said requires us to keep in mind the context and the readership of the journal cited. For example, Jules Janin, writing in *L'Artiste*, said of the Winterhalter portrait:

> This year's portrait is one of the best ever made of His Majesty. The head is studied with scrupulous care: the artist has perfectly understood and expressed every aspect of this temperament so full of intelligence, of this piercing glance, of this royal simplicity so difficult to render. The artist has not made his sitter look older or younger. He has rendered him as he is: solid and upright, robust and unambiguous. Above all, the painter has refrained from showing us a king who is sad, preoccupied and melancholic, or overly optimistic. Best of all, he has made him serene.[98]

Janin's adulation may at first seem incongruous on the pages of an aesthetically "advanced" magazine like *L'Artiste*, but it is less so when we remind ourselves that it was a

relatively expensive journal whose readers were rather well-to-do.[99] The political in-
stability of the 1830s had not only taxed the strength of the regime but also frightened the
growing, property-conscious middle classes—exactly the readership of *L'Artiste*. More
than anything, these citizens wanted a monarch who could rule effectively, with dignity and
patience; Janin was speaking *for* them as well as *to* them when he admired the serenity
given Louis-Philippe by Winterhalter.

The selection of Winterhalter as the official portraitist of the royal family can itself be
related to the new national mood of the 1840s. He had established his reputation at the 1837
Salon with the *Decameron*, a picture which Janin remembered in 1839 as having distinct
aesthetic allegiances to the art of the eighteenth century.[100] Winterhalter's brilliant colors
and his delight in painting the rich accessories of fashionable life are the stylistic compo-
nents of a presentation which produces an aristocratic aura sometimes read by modern
critics as nouveau riche.[101] Similarly, nineteenth-century viewers occasionally complained
that the royal portraits "only served as a pretext for the accessories" and that Louis-Philippe
appeared "painted less for himself than for his handsome polished boots."[102] Nevertheless,
characterizations of the royal family amidst the luxury of court life became the accepted
norm, and Winterhalter's picture—in which iconography and style strike a balance be-
tween the concepts of sovereign and citizen yet register the growing self-confidence of the
Orléans dynasty—became the official portrait of the new decade. The government moved
quickly to disseminate this new image with an expanded program of commissioned copies
implemented by the Interior Ministry: Winterhalter was paid in 1840 for a second original to
be used as the prototype, and he received honorariums in 1840 and 1841 to supervise the
copyists and control the quality of their work.[103] But the important point is that the 1840s
had brought the prosperity and political tranquillity which stimulated the invention of a
new portrait image and its nationwide distribution.

This ease was brutally shattered in 1842 by the accidental death of the crown prince
following a fall from his carriage.[104] The duc d'Orléans had been a popular figure of noted
liberal leanings, and many historians believe that if he had assumed power the dynasty
could have avoided the disaster of February 1848.[105] His death suddenly darkened the
optimistic future of the monarchy with the prospect that Louis-Philippe would leave the
kingdom in the hands of a young boy and a governing regent. The Regency itself became a
political fight in which the opposition Left tried to establish an elected regent rather than
support Louis-Philippe's plan to appoint the duc de Nemours as hereditary successor.
Paradoxically, when the question was put to a vote, the king's plan carried by a wide
majority and actually served to strengthen temporarily a dynastic sentiment among the
deputies.[106]

Louis-Philippe, then seventy years old, became increasingly concerned about the
uncertain future facing all that he had struggled to establish since 1830. No doubt pressured
by the tragic turn of events and the loss of the heir he had been carefully grooming to rule
France, the king became more doctrinaire in his policies and less willing to leave even
minor details to others.[107] The circle of power tightened around the throne and a handful of
trusted advisors, fewer outside opinions were polled in making decisions, and critics found
more reason to believe that the constitutional monarchy had degenerated into an autocratic
personal rule of the king.[108] Even long-standing friends who tried to raise the issue of

possible reforms—especially electoral reform—were rebuffed by the aging monarch. When the comte de Montalivet, one of the most intimate members of the royal inner circle, raised this delicate subject, Louis-Philippe lashed out that he would sooner abdicate than expand the vote because it would mean "war, even more so than in 1840. It is the defeat of my political program, it is risk and ruin; that's your reform! I repeat: you will not have it!"[109]

Without digressing into a general history of the final years of the July Monarchy, a task best left to specialists, one can point to a number of factors in 1846–47 which tended to increase pressure on the Orléans reign. The harvest of 1846 was poor; despite large imports of grain from Russia, the price of bread rose almost 60 percent. Simultaneously, the potato crop was seriously damaged by a blight which spread to France from Ireland. Because the peasant and working classes still drew the bulk of their diet from these staples, they were seriously afflicted by the shortages: in the absence of social welfare programs, starvation among the poorest members of society inevitably led to desperation and social unrest. The government's emergency grain purchases taxed the economy and created a credit panic that forced many small companies into bankruptcy, throwing many already poor workers into the complete poverty of unemployment.[110] A financial scandal involving two former ministers—both members of the peerage—turned public attention to corruption at the highest levels of government, and the murder of the duchesse de Choiseul-Praslin by her husband and his subsequent suicide in prison only confirmed popular belief that the ruling class was ravaged by moral decay.[111] Thus, economic difficulties and a diminishing respect for the established centers of power combined to convince even ordinary citizens that essential reforms were necessary. Leaders of the reform movement campaigned across France to focus this sentiment into a call for expansion of the electorate.[112] Ultimately, the political banquets of February 1848—organized to effect this reform which Louis-Philippe so vehemently opposed—became the sparks which ignited the revolution and toppled the monarchy.

In the thick of the 1846–47 crisis, Louis-Philippe commissioned a major equestrian portrait from Horace Vernet (fig. 17, pl. 1).[113] As we shall see, this picture expertly manipulates subtle secondary significations to generate a dynastic visual rhetoric with which the Orléans monarchy hoped to counter increasing public criticism. Vernet represented the royal entourage as it left the main courtyard of Versailles to pass in review of the National Guard, but he collapsed the spatial perspective of the scene to bring the Gabriel wing of the palace artificially close to the picture-plane: a sleight-of-hand which enables the viewer to read clearly the textual reminder—*à toutes les gloires de la France* (to all the glories of France)—that Louis-Philippe had recycled the edifice into a national museum.[114] To insure that the public would not fail to make the desired correlation between the Orléans monarchy's solicitude for Versailles and the château's most famous benefactor, Vernet skillfully spaced his royal subjects to afford a glimpse of Louis XIV in bronze.[115] As surely as the viewer's eye—gently nudged by the analogy of poses—shifts from the King of the French to Louis the Great, his imagination is encouraged to recognize the tradition of munificence which links the two monarchs and permits Louis-Philippe to bask in the glow of the Sun King.

Another detail in this picture further accents the neodynastic tenor of Louis-Philippe's response to the mounting social and political questioning of his personal authority. Because

the king has just passed through the principal gateway of Versailles, one *could* cite "narrative truth" to explain Vernet's prominent representation of the coat of arms which had been banished from France with Charles X: here, for the first time since the July Revolution, the fleurs-de-lys are included in a royal portrait.[116] Few critics failed to note the reappearance of this emblem of absolute monarchy. "Note above the king's head," remarked Thoré with irony, "the cartouche with three fleurs-de-lys that the revolutionaries of 1830 forgot to efface."[117] Legitimist writers, indignant that the ad hoc monarchy dared to appropriate the symbol of the royalty's elder branch, did not hesitate to suggest Louis-Philippe's opportunism: "We have noted in this canvas a strange anachronism which we can hardly believe is accidental: it is the appearance of the three fleurs-de-lys placed at the apex of the gate through which the royal family has just passed and which, by their location, almost crown the king's head . . . has the painter forgotten that since the July Revolution only French embassies abroad are embellished by fleurs-de-lys, or has his inspiration come from higher up?"[118] Lacking specific documentation, we are unable to judge definitively this insinuation. Documents do show, however, that Louis-Philippe personally followed the picture's progress by paying several visits to Vernet's studio during the second half of 1846.[119] We must therefore assume that he played an active role in developing the politically significant connotations which permeate the work. Moreover, our assumption is supported by the fact that Louis-Philippe is flanked by his *five* sons; the duc d'Orléans, in a picture painted four years after his death, rides at the king's right side. According to contemporary accounts, Louis-Philippe specifically ordered Vernet to include the deceased heir in this portrait: his request not only resulted in an image of the royal family intact—and the king with a guaranteed successor—but also revealed the dynastic preoccupations of the commission.[120]

For those who remembered that neither Louis XVIII nor Charles X had left a Bourbon heir to the throne, this handful of healthy, active males suggested that only the Orléans side of the royal family possessed the vigor needed to govern France.[121] The virility of these princes was enhanced by Vernet's manner of portraying them. Repeating a conceit which had won great praise in 1845, Vernet arranged all of their mounts in remarkably arresting frontal poses: the equine energy captured in the tangle of galloping legs kicking up little clouds of dust, the horses' varied expressions of eager impatience, and the masterful rendering of their movement in depth received acclaim from critics. "The five portraits are good likenesses and are posed with a remarkable sense of spontaneity and truth," wrote Alphonse Karr, "but the horses are quite simply alive. The king's white horse steps right off the canvas and out of the frame, and when you look at him a bit you can see his nostrils flare."[122]

Vernet's portrait is charged with subtle social and political allusions and enigmatically challenges twentieth-century viewers—historically preconditioned to prefer the shock value of paintings by members of the modernist avant-garde—for an evaluation. We know that persistent rumors circulating in 1847 speculated about the king's poor health and his threats to abdicate if pressed into accepting reforms. In certain quarters, notably the Chamber of Deputies, these reports elicited grave concern about Louis-Philippe's capacity to rule.[123] Thus the royal family had a very real need to reaffirm its credibility before the public. Vernet, evidently in concert with the king, strove to counter the whispers of public

doubt with a robust image of attractive, self-confident Orléans princes who claimed their place among the great rulers of France. In light of the way contemporary political leaders use media-oriented "photo opportunities" to polish their public images, should this attempt surprise us? On the other hand, if we compare Jacques-Louis David's portrait of Napoléon crossing the St. Bernard pass to Vernet's picture of Louis-Philippe, our first reaction might be to condemn Vernet's apparent lack of enthusiasm and vigor. We tend to excuse and even praise David's rhetorical devices because we understand the immediate political goals of his picture.[124] A close reading of the situation in 1847 has suggested that we are perhaps only partially fluent in Vernet's visual language, and that it was both appropriate and carefully conceived. Without a lengthy explanation we might overlook the secondary meanings in Vernet's portrait of Louis-Philippe and his sons. Yet all these nuances were immediately apparent to nineteenth-century viewers. Writing even before the Salon opened, Ernest de Calonne remarked after a visit to Vernet's studio:

> Every year the Court watches with scorn as, at the expense of His Majesty, some devilish newspapers slip vague democratic cruelties into their reviews of the opening session of the Chamber of Deputies: one insinuates unkindly that he has aged, that his health has weakened, that his features have changed. Calumny! cries the *Débats*: old age respects rulers. Nevertheless, the naive public has more confidence in the *National*. To efface and disavow these essentially subversive rumors, Horace Vernet will give us this year a royal portrait painted without flattery which will be able to serve, if need be, as a bulletin of good health.[125]

Like today's television images, which might affect opinion polls but seldom alter the course of history, the rejuvenation built into Vernet's portrait was unable to arrest the inexorable march of time. Paradoxically, Vernet could paint what Louis-Philippe most needed but would never have: a capable young head to carry the crown. With an eye to the revolution of February 1848, we must ultimately assess Vernet's optimistic affirmation of the Orléans monarchy as the desperate visual swan song of a doomed dynasty.

3. THE POLEMIC ABOUT HISTORY PAINTING AFTER 1830

There can be little doubt that most critics of the 1830s and 1840s felt *la grande peinture* was in decline, but the term as they used it had various shades of meaning.[126] Nearly everyone agreed, however, that the causes of this decline lay within a series of displacements in the complex system of social, economic, and political forces which had supported ambitious painting in the past. First, and perhaps most important, were the abrupt changes in patronage which followed the July Revolution. The Restoration of 1815 had endowed the Bourbon household with an almost unlimited budget which could be used at the discretion of the monarch. After the July Revolution, the Chamber of Deputies voted an allotment for the Crown's expenses which was considerably smaller than that awarded prior to 1830. Although the king remained relatively free in his use of the money, the element of public accountability tended to discourage courtly extravagance. Artists naturally feared that an era of royal patronage had ended; this was especially felt to be the case for large-scale history paintings.[127] In 1831, the critic Jal echoed the private sentiments of many artists when he wrote: "Poor history painting! Relegated to a few churches, consumed by damp-

ness, that indifferent Christians almost never visit; denied the material support of those rich collectors who had once made it flourish; reduced to begging a few thousand francs from the Chamber of Deputies where it is put—like Liberty—on a minimum subsistence budget; it can only die out. Before long, history painting will be dead."[128] In certain quarters this plaint was sharpened with the barbs of political satire. *La Mode*, a legitimist, pro-Bourbon periodical, blamed the decline of art on the new social order:

> Before *July*, art was the expression of a monarchic and religious society, of an elegant, lively, and refined existence ... art and poetry were poised for flight, spreading their glowing wings over that abyss of skepticism, disbelief, and dim-witted positivism which threatened to devour so many young talents. ... And then came the revolution ... Frenchmen gored Frenchmen ... atop these bloody victims, to the sound of blasphemies, a few men propped up a suitcoated royalty nearly devoid of authority and lacking power ... a royalty like themselves, made for them and by them. And, presiding over all this, a court bourgeois, vulgar, ill at ease.[129]

Moving quite freely from the realm of the arts to that of politics, *La Mode*'s rhetoric links the decline of art to the fall of the old social order. Other legitimist writers went so far as to state that great art could be produced *only* under the protection of an aristocratic monarchy endowed with well-bred tastes and a generous purse.[130]

If neither the government nor the Court seemed capable of providing the massive support apparently required by *la grande peinture* (in its most literal sense), to whom might aspiring artists turn? The most obvious source of potential commissions was the growing class of wealthy merchants and professionals who were materially secure and thus able to indulge in the "luxury" of art. Yet such a shift in patronage was bound to affect the direction of painting because, wealthy as they might be, patrons of this social stratum usually lacked the motivation to finance large-scale works: their galleries were small and their homes comfortable, but not palatial. "In our modern democracies," observed Alexandre Barbier in 1836, "where the wealth is spread out, where the real power actually lies with the middle class, it is essential that art, despite itself, accommodate the taste of its new masters: it must reduce itself to their economic level and it must size itself to the dimensions of their dwellings—or die of chronic illness."[131] Théophile Gautier voiced these new priorities even more bluntly in the opening lines of his article on the 1842 Salon:

> We are not going to concern ourselves here with those immense official canvases or large paintings done for palaces and public monuments, one of which would suffice to decorate completely the walls of a modern apartment. This is not to say that we find large paintings and vast dimensions unworthy of attention; rather, we are guided by this geometric axiom: the contents must always be smaller than the container. This is an axiom that our artists too often seem to forget when they take up their brushes because—with all good will—one cannot knock down the walls of a house to move in a picture.[132]

According to Gautier, artists hoping to please their modern Maecenas would be well advised to work in formats appropriate to the "decoration" of a bourgeois home.

Gautier's advice also opens onto the more serious contemporary debate concerning the *ability* of the bourgeoisie to respond effectively as patrons of the arts. Critics and artists shared and frequently expressed the deep-rooted belief that these new collectors were

essentially purveyors of bad taste who lived only to make money.[133] Charles Farcy articulated the supposed linkage between the rise of middle-class patronage and the decline of artistic quality when he ascribed the lack of "high style" at the 1835 Salon to "the accurate expression of the idea that dominates nearly every aspect of our epoch. We are not at all heroic, we are essentially bourgeois. This explains much and especially accounts for the confusion of artistic genres."[134] Farcy's logic depends axiomatically upon the hierarchy of pictorial types descended from classifications established in the seventeenth century by the Academy: his joining of bourgeois antiheroicism to the confusion of genres illustrates how issues of aesthetic value in the 1830s remained intimately connected to questions of cultural power.

Although it is true that the rigid Academic structure had been relaxed somewhat by the French Revolution,[135] the value-laden categories of history paintings, portraits, genre scenes, landscapes, and still-lifes continued to provide the essential evaluative framework for the bulk of 1830s criticism. From this point of reference, easel-sized paintings geared to bourgeois collectors could hope to obtain little more than paternalistic critical tolerance: assigned a priori to an inferior rank by virtue of being "merely genre," the fact that they found homes in middle-class collections only seemed to support the claim that higher levels of taste and expression were beyond the capabilities of the bourgeoisie. "Genre painting has the rights of a bourgeois among us [that is, the arts]," wrote Paul Merruau in 1838; "we must welcome it according to its rank as a bourgeois, but on condition that it will stay in its place and realize that it fundamentally lacks nobility. Nobility guards its rank in matters of art; this is always a virtue."[136]

Yet, by the early 1840s, this rather harsh evaluation had softened remarkably in most critical circles. Perhaps the single most important act to effect a steady erosion of the traditional critical framework was the institution of annual Salons, for their punctual return tended to move the discourse of criticism and the process of evaluation from the specialized world of connoisseurs into a broader public arena.[137] During the July Monarchy, the opening day of the Salon each March came to be an anticipated social event, and attendance at the exhibitions rose annually.[138] Although certain observers felt that such frequent exhibitions forced artists to rush works to completion, the government understood the annual Salons' popular appeal and remained firmly committed to them. At the Salon, the public could review practically all the major works produced by French artists during the intervening year. What they saw was an ever-increasing number of objects, but an ever-smaller percentage of history paintings, a trend frequently lamented by contemporary critics. "There is surely as much talent today as ever," admitted Charles Calemard in 1843:

> In genre or easel-sized pictures one finds many good things and a general improvement can be discerned; landscape painting maintains the high level it has achieved during the past decade. But let's look around for works of temperament, those large, noteworthy compositions which reveal an admirable tendency to idealized beauty, let's look for high style. Finally, let's adopt the high standards and demanding criteria that future generations will use for the legacy of our epoch: we will soon wonder if there is not a warning to give our contemporaries.[139]

Obviously, Calemard regretted the absence of large-scale Greco-Roman history pictures which previously had been expected from Academic masters trained in the Davidian

tradition. We have explored some reasons as to why that type of picture had become unprofitable. The Salon statistics corroborate our observations by showing that artists were very understandably painting pictures that would sell. Portraiture was a natural alternative, as it satisfied the middle-class patron's sense of self-importance and provided ready income for needy artists.[140] Similarly, the rising demand for easel-sized pictures to be placed in private homes could easily be filled by painting landscapes, still-lifes, or "low-life" genre scenes, and each of these categories found both adherents and masters.

Calemard was not alone in his failure to recognize that certain painters, eager to depict great men and edifying events, had arrived at a kind of picture not easily accommodated by the traditional categories. The roots of this development go back to the liveliest moments of Romanticism in the 1820s, when historical themes of Gothic England and medieval Europe had first inspired some artists to break the Greco-Roman stranglehold on heroic subject matter.[141] While painters such as Eugène Delacroix, Ary Scheffer or Louis Boulanger rendered these stories in a suggestive painterly style, others worked in a taut hyper-realism descended from the *style troubadour* which had been patronized by Josephine during the Empire.[142] Within this group, great emphasis was placed upon the precise description of archaeologically correct details, an impulse which actually led some artists to mimic the polished realist manner of the Dutch genre painters they admired. The point is that painters like Pierre Révoil, J.-A.-D. Ingres, and Paul Delaroche had already produced, in the second decade of the century, a new picture-type where subjects drawn from the annals of history were rendered on modestly sized canvases with a style of jeweler's precision.

Despite the fact that these prototypical elements were well developed by 1830, they had not—with few exceptions—been used to depict events from recent French history. It required the political events of 1830 to open fully the Salon to subjects from the Great Revolution, the Empire, and contemporary events.[143] The July Revolution generated a two-pronged effect upon the arts: on one hand, the flush of victory on the barricades fired a demand for paintings celebrating the heroic events of the *Trois Glorieuses Journées*;[144] on the other, the government born of the revolution quickly demonstrated its intention to lift Restoration censorship of certain subjects from modern French history. Within three months of Louis-Philippe's coronation, the curators of the Royal museums reexhibited a number of important Napoleonic paintings,[145] and, when subjects were chosen for pictures to decorate the Chamber of Deputies, the episodes selected were from the annals of 1789 and 1795.[146] The Napoleonic legend, clandestinely kept alive in the popular arts during the years of Bourbon Restoration rule, guaranteed that pictures of the Emperor would now receive an especially warm public reception. As we shall see, he was repeatedly depicted in paintings destined for the galleries at Versailles.[147] Many people shared the opinion expressed by the critic for *L'Artiste* in 1834: "With regard to regrets that our epoch would never provide artists with subjects for pictures, the remark is ridiculous when directed to a generation born of the French Revolution and the magical epoch of which Napoléon was the hero—the greatest events and the greatest name the world has seen since the fall of the Roman Empire."[148] Recalling that the middle-aged art public of the July Monarchy had grown up during the revolutionary and Napoleonic years will help us understand the

author's proud assessment of "our epoch": not only did that era elicit feelings of French nationalism, but it also conjured up fond memories of lost youth. In much the same spirit, Louis-Philippe adopted the tricolor as the national flag in 1830—at once soliciting popular support from the cachet of a gilded age and reinstating the banner for which he himself, as a young officer, had fought in 1792.[149]

In effect, the July Revolution facilitated a reintegration of the recent past into middle-class culture by making it respectable, a part of official iconography. The result, as Victor Schoelcher noted, is that retrospection became a national pastime and history a public passion: "History is the significant phenomenon, the principal occupation of the century . . . all the popular writings of our epoch are, in fact, historical works. Thierry does history; Guizot, Mignet, Michelet, Capefigue do history; Gros does history; Cuvier, in the revolutions of the globe, also does history. A great number of artists have followed this route: some, as we say, without thinking about it and others with careful premeditation."[150] Thus patronal, stylistic, and iconographic pressures joined forces after the July Revolution to encourage a relatively new kind of picture in which an established pictorial strategy—originally evolved from an emulation of Flemish and Dutch masters—was adapted to represent historical scenes of great public interest in affordable formats.[151] Moreover, the conscientious exactitude built into the style of this picture-type was perfectly suited to the accurate narration demanded by an expanding art public, many of whom had lived through the episodes represented.

Neither a new class of patrons nor more frequent Salon exhibitions can fully account, however, for a lessening of the entrenched critical bias which tended to ignore (as Calemard had) or devaluate as "merely genre" these pictures of modern history painted on easel-sized canvases. To understand this phenomenon a third term, one intimately connected to both the larger art-buying public and more frequent public exhibitions, must be factored into our discussion: the vast increase, in both quantity and importance, of critical writing about each Salon. The flowering of Salon criticism during the 1830s was directly related to a remarkable growth of the periodical press, and especially of journals which accepted advertising in order to reduce the cost to the reader.[152] By making publications more affordable, this innovation widened readership to include the same middle classes who were just beginning to patronize the arts. Brisk competition among the rival publications meant that editors controlled copy content to ensure that the sensibilities of the journal's "targeted" audience would not be offended; for example, after lavishly praising Delacroix's picture of *The 28th of July*, the republican Barthélémy Hauréau was fired by the editor of *Le Mercure du Dix-Neuvième Siècle* and replaced by an author more in tune with the bourgeois readership of the magazine.[153] At the same time, critics began to acknowledge the power of the crowd's aesthetic preferences.[154]

It is possible to trace the gradual integration of a nomenclature for small-scale history pictures into the critical lexicon by scanning the Salon literature. At the Salon of 1833, Charles Farcy—an adamant supporter of Academic Davidianism—remarked that "paintings of *history* are a small minority at the current exhibition much as they have been for the past few years—at least if one excludes from this category the many pictures of historical subjects treated as *genre* paintings."[155] At this point Farcy, whose remarks appeared in the

aesthetically conservative *Journal des Artistes et Amateurs*, sustains the categorical distinctions of the Academy while nevertheless admitting that they were being violated by many artists.

The following year, Chatelain—writing for a middle-class public in *Le Voleur*, one of the first low-cost weeklies—astutely summarized the problems of history painting when he noted:

> It is no longer the case that to be called a history painter one must limit oneself to working on enormous canvases exclusively dedicated to the representation of Greek or Roman history. Today, more attuned to the evolution of society, we group under the general rubric of "historical compositions" those paintings which recount an actual event, from whatever history it may have been taken or however large or small its frame. We do not intend to explore here why large-scale compositions are being abandoned: it would be too simple to answer this question by demonstrating that potential buyers for such pictures no longer exist.[156]

Chatelain's text encapsulates in one statement nearly all the points we have enumerated to show that by 1834, and for certain critics, neither the size nor the subject defined a priori the limits of history painting.

Although Chatelain had put his finger on the newly flexible parameters of pictorial classifications, it appears that the key term *genre historique* was not generally employed much before 1835, the year in which Ambroise Tardieu wrote, somewhat paternalistically, about Delaroche's picture of the *Assassination of the duc de Guise at the Château of Blois*: "Without a doubt, this work should not be judged as a history painting [*tableau d'histoire*], as a painting of high style; it would be unfair to see in it anything more than a work of *genre historique*. If one moves down to the rank which the artist himself intended for the picture, everyone recognizes its superiority over its competitors at the Salon. None other, it seems to us, has more completely fulfilled the conditions of genre painting."[157] A common-sense appropriateness guaranteed that the negative overtones attached to Tardieu's use of this term would be quickly set aside. By the 1836 Salon, certain critics were using it in a completely descriptive manner: for example, we read in the *Journal des Beaux-Arts* that "genre historique painting, namely representations of historical subjects on easel-sized canvases, should assume a new significance today, since one can only infrequently produce large-scale images. With small works, especially, one must follow this maxim: *Parvus videri, sentiri magnus*—objects painted small must be made to feel large."[158] A general acceptance of both the mode of painting and the terminology is further demonstrated by Desessarts' series of articles on the 1837 Salon for *Le Voleur*, an installment of which dealt specifically with the genre historique.[159]

I have sketched out the extent to which the art world of the 1830s was opened socially on several fronts at once: new patrons, more exhibitions, and new forms of critical discourse worked together to break down the received Academic values and "clubby" environment of privilege which had previously reigned. The resulting displacement profoundly influenced public expectations of what constituted "serious" painting, and a new kind of image—the genre historique, with its modern history subjects, authentic costumes,

and entertaining episodes rendered in a style of precise, clearly readable forms—came to center stage as the most appropriate picture for the modern collector. Genre historique, like most viable art forms, had more than a stylistic history; it emerged as the necessary product of a complex set of social, political, and technological changes.

The reader may be wondering how these introductory comments relate to the topic of official art. To answer this, we need only keep in mind that a government's official imagery will always be concerned to some extent with its constituency: we now have some idea as to the type of picture that was both interesting to and approved by the nonspecialized Salon visitor of the 1830s and 1840s. On the other side of official art stands the government: what kind of picture would appeal to the King of the French? The comte de Montalivet tells us that Louis-Philippe "liked neither the historical novel in literature nor an allegorical style in the arts. Above all, he pursued practical ideas in the world of business, the meaning behind style in literature, truth in painting. He condemned the conventions of gestures and staging inspired by the manic respect for some rules. He went even further: he wanted the characters to be exactly those of the epoch which the painter was to represent; he wanted the physical representation of real events to be as truthful as history."[160] Apparently, the king was predisposed to prefer those artists who worked in a manner most attuned to the accurate representation of historical facts, who made pictures in which detail and narrative clarity played the central part. If Louis-Philippe had been merely a bourgeois collector, his personal inclinations no doubt would have led him to buy genre historique. Possessing the great galleries of Versailles, and determined to use art as a veritable weapon of political defense, he demanded large-scale works which turned the easy readability and attractive familiarity of the genre historique picture-type to an overt propagandistic purpose. Royal intentions and public preference are thus united in the July Monarchy's support of an official art which, in spite of its genre-based strategy of representation, became—by virtue of its patron, its ambitions, and its public appeal—a new kind of history painting which retained the traditional status of *la peinture d'histoire*.

4. SUMMARY

I have traced Louis-Philippe's portrait tradition from the first to the final months of his reign, and have shown how the evolution of that imagery can be said to share and shadow the general historical development of the Orléans regime. Early pictures broke sharply with established norms of royal portraiture and stressed Louis-Philippe's position as Citizen-King. This solution emerged at just the time when the new government was struggling to establish its authority after the disruption of the July Revolution. Around 1840, a new image of the king—more conventional in nature and reassuring to the viewer—was commissioned and copied to be sent throughout France: a reflection of the increasing bureaucratic and economic stability of the monarchy. Finally, the last official portrait of Louis-Philippe—designed to quell criticism with a show of dynastic power and an optimistic outlook for the future—employed a rhetorical strategy that mirrored the regime's blind spot for the social changes which ultimately led to revolution.

The preceding pages have touched upon political subjects, aesthetic issues, and

cultural constraints which will be rediscovered in the following sections. I have elected to explain by example the methodology which will be used to analyze and interpret pictures, elucidate their importance to the government, and explain their place in the story of official art during the July Monarchy. The story begins by returning to the origins of that government and focusing upon the events of 1830 and the imagery of the July Revolution.

The July Revolution:
Events, Images, and Louis-Philippe's
Search for Legitimacy

1. DAYS OF REVOLUTION AND POLITICAL INTRIGUE

HISTORIANS generally agree that both the economic slump which plagued France in the late 1820s and the increasingly conservative ideological position of the Court contributed to widespread public dissatisfaction with the status quo and propelled the July Revolution once it erupted.[1] But the event which sparked this uprising was much more specific: on 25 July 1830, Charles X signed four proclamations which were tantamount to a coup d'état against the constitutional form of government established by the 1814 Charter. Charles, who lived uneasily with the memory of his brother's unhappy end on the guillotine, was eager to stem the tide of liberalism and reaffirm the Crown's authority lest he risk a similar fate. The cabinet, led by prince Jules de Polignac, was composed of ultra-royalist aristocrats who shared the king's reactionary views. Yet the country seemed to be slipping from their grasp: in March, Charles had been forced to adjourn the 1830 session of the Chambers because it was apparent that his cabinet did not command a parliamentary majority. Rather than retire his hand-picked ministers, Charles scheduled new elections for early July; but, when the returns came in, the liberal opposition had actually increased its majority.

Faced with this unmanageable situation, the king had to choose between compromise and coup d'état: on 25 July, he took the latter route. A long justification accompanying the ordinances argued that France was being led into anarchy by a seditious public press and scheming opposition politicians. The four ordinances were expressly designed to crush these two troublesome problems.[2] The first reinstated a law of 1814 which required censorship of any periodical publication of less than twenty pages; daily newspapers would henceforth be subject to prepublication scrutiny by the government. The second ordinance dissolved the politically unfavorable assembly which had just been elected. The third reorganized the electoral system by empowering the most heavily taxed 25 percent of the electors to choose one-half of the deputies to the National Assembly; it also excluded taxes paid on businesses, doors, and windows from the tabulations made to compute an elector's

total taxation. These measures were designed to disenfranchise urban voters in favor of wealthy landed electors, whose aristocratic political leanings tended to favor a strong, autocratic monarchy. The fourth ordinance scheduled new elections for September.[3] Charles thus hoped, in one fell swoop, to silence political opposition and guarantee a legislative body which would faithfully support his political program and ideological orientation.

Somewhat surprisingly, the ministers had taken few precautions to ensure order after the coup: the timing of the king's move was a closely guarded secret, and they had evidently preferred to preserve that secrecy rather than tip their hand by ordering unusual troop and police movements.[4] Polignac also believed that, since the number of eligible electors was small (even before the coup), most citizens would remain indifferent to the ordinances, especially as they were aimed at the parliament more than the general population. He did, however, select the duc de Raguse (Auguste de Marmont) to be commander-in-chief of the Parisian military district in the event that his assessment was wrong. But Marmont himself was unaware of the impending coup and, as we shall see, he turned out to be an unfortunate choice which only aggravated the uprising.[5]

The ordinances appeared in *Le Moniteur* on Monday morning, 26 July, and did indeed take the country by surprise. The first public responses were muted and subdued because then, as today, most shops were closed on Mondays and Paris was relatively quiet. Even the printers, who would be most directly affected by press censorship and the inevitable elimination of some partisan newspapers, had Mondays off. Meeting informally in cafés and bars, many of them decided to strike the next day, and urged other skilled workers (stonemasons, carpenters, and so on) to join their protest.[6] A few hardy souls read the ordinances aloud to crowds strolling in the garden of the Palais-Royal, but without eliciting any militant activity. At midnight the streets of Paris were calm.[7]

Tuesday, 27 July, brought more ominous developments. Printers and typographers, out of work either by choice or because their shops had remained closed, organized protest demonstrations in the garden of the Palais-Royal, where numerous illegal newspapers were circulated. A few blocks away, police officers seized the presses of *Le Temps* and *Le National* for having printed a protest penned the night before by a group of liberal journalists.[8] When this seizure became known among the Palais-Royal crowds, anger and tension mounted. Shortly after noon, the police cleared the garden, locked the gates, and forced the demonstrators into the adjoining streets. When shopkeepers in the neighborhood closed their stores (out of fear of looting), more idle workers joined the crowd. A contingent of Royal Guards attempted to disperse the throng at about 4:00 P.M.; the demonstrators responded with taunts and a hail of stones. Exasperated, some soldiers fired into the crowd, killing and wounding several people. These first victims were paraded through the streets to cries of "Death to the Ministers!" and "Death to Polignac!" Even though the city slept quietly on Tuesday night, the revolution had entered a new phase.[9]

On Wednesday morning, Marmont, who had hurriedly assumed his command with little opportunity to make serious preparations, wrote to the king that angry crowds "even larger and more menacing were reforming—This is no longer an uprising, it's a revolution."[10] In fact, crowds had been gathering throughout Paris since the early hours of dawn and had blocked many of the city's narrow streets with makeshift barricades. The situation

did not improve when the public learned that martial law had been declared and the duc de Raguse named supreme commander. Many Frenchmen remembered Raguse as the general who had defected to the invading Allied armies in 1814 and who, by abandoning Napoléon in that crucial hour, had forced the emperor to abdicate.[11] They were thus ill disposed to respect Raguse's authority and were angered that Charles should have selected this man to turn on his fellow citizens once again.

Popular ire against Marmont was further fueled by the reappearance of a powerful and provocative symbol: when some insurgents captured the Hôtel-de-Ville near noon, a tricolor flag was hoisted to replace the Bourbons' flag of fleurs-de-lys. Soon this emblem of the 1789 Revolution and the Empire fluttered from the towers of Notre-Dame. Conjuring up memories of heroic valor and imperial power, the tricolor focused the frustration lingering from France's 1815 defeat into a singleminded opposition to the restored Bourbons. It quickly became the banner of July's streetfighting—a shorthand expression of the public's desire for revenge as well as change.[12]

The 28th of July was the bloodiest of the *Trois Glorieuses*, as the three days of fighting soon came to be called. Fierce battles were fought at the Hôtel-de-Ville, the Fontaine des Innocents, porte Saint-Denis, place de la Bastille, and in the rue Saint-Antoine. Throughout the day, Marmont received reports that his soldiers were either refusing to fire on the Parisians or deserting their companies to join the other side. His plan to send three large columns of troops across the city ended disastrously when his heavily equipped men—trapped by barricades in the narrow streets and unable to take cover—became sitting ducks for sharpshooters who took aim from protected windows and rooftops. The army's food, drink, and ammunition supplies were nearly exhausted by nightfall, and civilian guards were preventing new deliveries from entering the city. Tired, hungry, and discouraged, the royal troops spent the night in camps on the Champs-Elysées and the esplanade des Invalides.[13]

Correctly gauging his problems, Marmont informed the king that he could not attempt further offensive operations in the city and that he would henceforth assume a defensive posture to guard the Tuileries, the Louvre, and the Champs-Elysées while awaiting reinforcements from the provinces.[14] Although the insurgents were unaware of this important shift in strategy, they were not disposed to lose the tactical advantage they had won in the streets. Throughout the night they constructed thousands of barricades, not only in the inner sections of the capital around the Hôtel-de-Ville, but also in the Latin Quarter and the most fashionable sections of the faubourg Saint-Honoré.

By daybreak of 29 July the city was almost entirely in the hands of the revolutionaries, and the government could no longer depend on the loyalty of its troops: for example, two regiments stationed at the place Vendôme broke rank to join the insurgents, leaving Marmont's left flank dangerously exposed. Marmont continued to pin his hopes on the loyalty of the Swiss Guards and their ability to hold the Louvre. But at about 11:00 A.M., a mix-up in orders—which should have moved fresh Swiss troops into the Louvre colonnade—briefly left that vital position unguarded. The Parisians seized this opportunity and mounted a direct assault. Caught by surprise, the Swiss were forced to retreat into the Louvre's courtyard; when regular troops stationed there saw the Swiss hurrying for cover, panic gripped their ranks. Marmont was forced to abandon the Tuileries and was able to

muster his troops only after they had fled through the Tuileries Gardens and past the place Louis XVI (Concorde) to the Etoile, at the far end of the Champs-Elysées. On the evening of 29 July, all of Paris belonged to the Revolution.[15]

While the Parisians were invading the Tuileries Palace and helping themselves to the king's wine, a concerned group of government and military leaders, businessmen, and journalists were meeting at the house of the banker Jacques Laffitte, where a mixture of surprise, elation, and alarm charged the air as reports filtered in of the government's defeat.[16] Among the notables present, two schools of thought jockeyed for position: those who felt that the revolution should be contained in light of its success against Marmont and those who wanted to continue the struggle but orient it specifically toward establishing a new form of government.[17] This seemingly slight difference of opinion actually masked a fundamental disagreement about the nature and scope of the July Revolution which, as we shall see, would become more pronounced in the following seventy-two hours. But, for the moment, both camps agreed that the popular uprising should be reined in so that its street violence would not degenerate into general anarchy.

Marmont's retreat left Paris in disorder and without any organized peace-keeping (and property-protecting) force. The marquis de Lafayette arrived at Laffitte's house about noon of the 29th to announce that he had been asked to assume command of the National Guard, a civilian force disbanded in 1827 by Charles X but now reforming to take over the responsibility of policing the city. The group gathered at Laffitte's supported this move and also decided to appoint a Municipal Commission to organize the city's defense and coordinate efforts to reopen the markets and distribute bread—these essential services had been halted since the 27th. Lafayette and the members of this commission marched in triumph from Laffitte's house to the Hôtel-de-Ville, where they set up headquarters and hoisted (once again) the tricolor.[18]

By virtue of his long association with liberal and republican causes, Lafayette's name was a touchstone in 1830 for those who wanted to found a true republic. He appeared at the Hôtel-de-Ville in his uniform of 1789 and was enthusiastically acclaimed by the crowd. Younger republicans gravitated to the ad hoc power center around Lafayette, hoping to convince him to proclaim the Republic, establish a provisional government, and institute universal suffrage. Since Lafayette could muster the armed support of both the milling throngs and the National Guard, the republicans' hopes hinged on the direction he would personally endorse. But, on the evening of 29 July, Lafayette remained undecided as to which card should be played.[19]

Meanwhile, other political factions began to emerge. The tricolor had been Napoléon's banner, and many people on the barricades were heard to cry "Long live Napoléon!" in the thick of the fighting. Several leaders of the Empire were in Paris at the time: amidst the confusion at the Hôtel-de-Ville, they issued a call for public support. But the Bonapartists were severely handicapped by the fact that Napoléon II—their natural choice as sovereign—lived far from Paris under the watchful eye of the anti-Napoleonic Austrian court. The Bonapartist solution, despite a certain grassroots strength, thus never really had a chance to develop in 1830, although it appeared threatening to those who did not share its ultimate aim of restoring the Empire.[20]

Nor could Charles X be ignored, because he still commanded a formidable and well-equipped army: a large force was stationed around the palace at Saint-Cloud not far from Paris, and he could easily summon the victorious Army of Africa from Algiers. The more realistic of the king's partisans (notably the Peers Vitrolles, Sémonville, and Argout) hastened to Saint-Cloud to press Charles into changing his ministers and rescinding the four troublesome ordinances. Finally obtaining these concessions about 4:00 P.M., they raced back to Paris but, given the state of confusion there, were unsure who should receive the news. Lafayette met with the trio but declared that he had no right to negotiate for the revolution. The deputies at Laffitte's house insisted on written credentials and the presence in Paris of Charles's new prime minister, the duc de Mortemart. While the three frustrated peers returned to Saint-Cloud to obtain both the documents and Mortemart, another group moved into high gear.[21]

Laffitte and his friends, especially the journalists Thiers and Mignet, viewed the stagnating situation with alarm because it kept alive the possibility of a reconciliation with Charles. They were also worried because many deputies seemed unwilling to recognize that popular resistance to any accommodation with Charles would be strong. More important, they too had a specific solution in mind: the establishment of a new dynasty headed by Louis-Philippe d'Orléans. Fond of drawing historical parallels, the Orléanists saw Louis-Philippe as France's William III—a capable person near the throne who would assume the crown abandoned by Charles and rule within the framework of an elected parliamentary government. Paradoxically, the main obstacle blocking this solution was the duc d'Orléans himself: Louis-Philippe had remained outside of Paris during the *Trois Glorieuses*, and his aides at the Palais-Royal seemed anxious to leave the impression that he wished to remain aloof.[22]

On the evening of the 29th, Thiers went to Neuilly to explain the urgency of the situation to Louis-Philippe and convince him to come at once to Paris. The journalist arrived only to discover that his would-be leader, fearing a possible seizure by Charles, had fled to Le Raincy. In a famous and dramatic discussion with Adélaïde d'Orléans (the duke's sister), Thiers obtained the promise of Orléans support.[23] Returning shortly after midnight to Laffitte's house with this second-hand show of enthusiasm, Thiers found a group of deputies waiting for Charles's newly appointed minister, Mortemart. The Orléanist ringleaders—Laffitte, Thiers, Mignet, Sébastiani, and Larréguy—decided to move immediately and preempt Mortemart's attempt to form a new government. It was at this juncture that Thiers composed the Orléanist declaration already discussed: by dawn, thousands of copies had been distributed throughout the capital.[24]

A new phase of the 1830 Revolution—less violent but every bit as contested as the street fighting—opened on 30 July. With Charles's efforts to regain control discredited, the struggle for power intensified between the deputies (who had moved about noon from Laffitte's house to their more official locale at the Palais-Bourbon) and Lafayette's group at the Hôtel-de-Ville. The latter received the Orléanist preemptive move with anger, and prorepublican agitators among the crowd gathered on the place de Grève were quick to point out that Orléans was also a Bourbon. The Municipal Commission deliberately overstepped its original mandate by appointing interim heads for the national ministries,

issuing orders to the royal army, ordering the creation of a special army to protect the frontiers from foreign invasion and in general behaving like a provisional government bent on establishing a full-fledged republic.[25]

Across town at the Palais-Bourbon, a handful of deputies (40 out of an elected 430) were arguing the merits of inviting the duc d'Orléans to become lieutenant-général of the kingdom. Although this was to be technically a caretaking position required by Charles's forced incapacity to rule, no one failed to recognize that this thinly veiled acknowledgment of the collapse of Bourbon authority meant that the monarchy itself was up for grabs. Those deputies who remained loyal to the concept of divine right and the Bourbon family did their best to complicate and extend the debate in an attempt to buy time for Charles. Odilon Barrot appeared at the tribune to read a threatening letter from Lafayette which established the demands of his group at the Hôtel-de-Ville. Finally, the Orléanists, posing as mediators but playing upon the collective fear of general anarchy, argued that, while the revolution demanded a change of some kind, their solution of a new dynasty was the only sound course of action. Laffitte stiff-armed Charles's last attempts at reconciliation by refusing to accept—in the name of his colleagues—the king's recision of the ordinances. Rather, he called for an immediate vote on the proposal to "invite" Louis-Philippe d'Orléans to become lieutenant-général; thirty-seven of the forty deputies voted for the measure, and a delegation was chosen to present it to the duke.[26]

The next day, 31 July, was the dénouement of these political struggles. After some hesitation, Louis-Philippe—who had arrived in town during the night—accepted the role of lieutenant-général and echoed the propaganda of his partisans by promising "to do everything in my power to prevent civil war and anarchy."[27] The assembled deputies (now numbering ninety-five) drafted a statement to the nation which both announced and justified the appointment.[28] Not everyone shared the vision of these newly emboldened parliamentarians: Orléanist posters were torn down in neighborhoods near the Hôtel-de-Ville, and the Municipal Commission headquartered there issued an inflammatory proclamation which promised Parisians that "you will have a government which will owe its existence to you; morality belongs to every class; every class has the same rights; these rights are guaranteed!"[29] Obviously, this rift in opinion would have to be breached if Louis-Philippe's authority was going to prevail.

What followed was probably the most daring and dramatic unarmed act of the revolution: the duc d'Orléans, on horseback, led a group of about ninety deputies on foot from the Palais-Royal to the heart of the republican epicenter, the Hôtel-de-Ville, in order to read the deputies' announcement of the Orléanist solution. They were greeted by a hostile mob but received sympathetically at the doorway by Lafayette.[30] Moving inside, they read the declaration and Louis-Philippe pledged his adherence to the guarantees it contained. Outside, the crowd chanted "Long live the Republic!" and "Down with the duc d'Orléans!"[31] Although accounts differ as to who took the next step, Louis-Philippe and Lafayette appeared on the balcony overlooking the place de Grève, a large tricolor fluttering around them. The multitude responded with "Long live Lafayette!" and, when the old general warmly embraced Louis-Philippe, the crowd's hostility was transformed into shouts of "Long live the duc d'Orléans!"[32]

While this embrace could not guarantee the future of Louis-Philippe's reign, it did

invest him and the deputies with the bargaining power to deal with Charles X and establish a regular government. The balcony episode was thus a doubly crucial turning point: on one hand, Lafayette's embrace rallied the people; on the other, it ended the republican threat, since the general's support for Louis-Philippe meant that the only person capable of declaring a new republic had decided against it. Later, this dual aspect would be collapsed into a single meaning when the crowd's spontaneous accolade was reinterpreted by Orléanists as a kind of ad hoc plebiscite for retaining a constitutional monarchy: in this new guise, images of that afternoon would become core elements of July Monarchy iconography.

Once they held the reins of power, the Orléanists moved quickly to establish a government and present a united front against Charles X. The Bourbon court had moved from Saint-Cloud to Versailles during the night of 30–31 July and to Rambouillet the next afternoon when troop defections and a hostile Versailles populace threatened the king's security. From Rambouillet, Charles tried to regain the upper hand by naming Louis-Philippe lieutenant-général of the kingdom; the duke responded that he could not accept the title from the king because he already held it from the deputies. The same day, 1 August, Louis-Philippe preempted a major royal prerogative by summoning the Chambers of Peers and of Deputies into session. When Charles formally abdicated on 2 August, he held so little real power that Louis-Philippe could safely ignore the deposed ruler's instructions to declare his grandson, the duc de Bordeaux, as king Henri V.[33]

The chambers convened on 3 August and—under the combined leadership of Laffitte, Guizot, and Broglie—quickly implemented the Orléanist dynasty. In a final affront to republican aspirations, the Charter was modified rather than rewritten: this tactic acknowledged the fact of the revolution but severely limited its extent by ensuring that a monarchy would be retained.[34] On 7 August the two chambers adopted resolutions which declared that the throne was vacant and invited Louis-Philippe to accept the crown as King of the French—provided that he swear to abide by the amended Charter.[35] Two days later, in a simple ceremony far removed from the elaborate pomp of Charles X's coronation at Reims five years earlier, Louis-Philippe d'Orléans stood before the two chambers assembled at the Palais-Bourbon, accepted "with neither restrictions nor reservations the acts and commitments" of the modified constitution, and solemnly swore to rule within the framework of its provisions.[36] The new dynasty was launched.

2. THE FOLKLORE OF VICTORY: ANECDOTES AND POPULAR IMAGES OF THE TROIS GLORIEUSES

Precise knowledge of the events of the 1830 Revolution enables us to understand how a wide range of commemorative images came to be produced. It is now apparent, for example, that the July Revolution actually occurred in two parts: the popular uprising of the Trois Glorieuses (27, 28, and 29 July), which chased the Bourbon government from the capital, and the political infighting from which the Orléanists emerged victorious to form a new government. Each of these chapters had its heroes and partisans, and each was given a characteristic kind of pictorial representation. Our task is to seek in the relevant imagery an idea of how the ethos of each phase was recorded by artists while the postrevolutionary social situation continued to evolve.

The victorious Parisian combatants of July were quick to congratulate themselves on their rout of Marmont's troops, and a host of popularly priced histories of the events repeated a litany of heroic anecdotes.[37] These stories quickly became the publicly accepted folklore of the Trois Glorieuses, and many of them were translated into low-cost images destined for mass circulation. The tale of the revolution's first victim, for example, can be found in a whole range of media. Popular histories tell us that this person—a young woman killed at the place des Victoires—was carried through the streets by a muscular baker crying "Vengeance!" who so intimidated the king's soldiers with his grisly spectacle that they threw down their arms.[38] Several prints recounted the episode: Edouard Swebach's (fig. 18) depicts her death and the idea to use her as a call to arms, while Delaporte's (fig. 19) shows the baker haranguing the troops.[39] Alexandre Decamps' small drawing focuses upon the man's anger by emphasizing his display of physical strength apparently fired by a desire for revenge (fig. 20).[40] In this work, the artist's republican sympathies undoubtedly played a role in his transformation of the baker into a heroic figure whose vitality celebrates the surging energy of "the people." Farther up the aesthetic hierarchy, the same story was illustrated in a drawing by Bordier exhibited at the *Amis des Arts* exhibition and retold by Alexandre-Evariste Fragonard at the Musée Cosmopolite in what must have been a major painting.[41]

Another often-repeated episode—that of a student from the Ecole Polytechnique who braved a fusillade to capture a cannon singlehandedly—is found in several printed histories, in a cheap colored print (fig. 21), and in Pierre Martinet's more elaborate lithograph (fig. 22).[42] A critic for the *Journal des Artistes et Amateurs* suggested it as a subject worthy of history painting and, not surprisingly, the story soon appeared in a large painted format.[43] This example, like the baker's tale above, shows how the desire to illustrate a specific, almost iconic narrative moved the subject freely and quickly from text to popular image to Salon painting. This interchangeability of formats—demanded and hastened by contemporary events—graphically supports my earlier analysis that the confluence of new subjects and the demand for an accessible, literal style led to the emergence of a novel kind of history painting at just this time.

One more example from the annals of July 1830 will further illustrate this phenomenon. During the afternoon of 28 July, the Parisians mounted several assaults on the bridge connecting the Left Bank to the place de Grève in an attempt to recapture the Hôtel-de-Ville. Their efforts were thwarted by a government cannon stationed on the opposite riverbank. Suddenly, a boy of about fifteen years of age charged the bridge while brandishing a tricolor. Exhorting his comrades to follow, he shouted: "If I die, remember that my name is Arcole!" Planting his flag near the enemy, he was riddled by gunshot and struck down. Although the "coincidence" of an Arcole leading the charge was really an enlightened fiction, we have seen that the tricolor, the exploits of Napoléon, and the heroics of July were inextricably intertwined in 1830, and we can understand why the story was widely believed.[44] It was also enthusiastically recorded in written histories and rendered in popular prints, some of which take pains to distinguish Napoléon's victory in Italy from the 1830 replay (fig. 23).[45] Whether these images use a wide-angle view to include the city hall on the opposite bank (fig. 24), close in upon the dramatic incident with landmarks impossibly located (fig. 25), or collapse all of the above into a compact summary (fig. 26), they share

a number of key characteristics.[46] Whatever Arcole's supposed position in the spatial construct of these prints, he always leads the attack near the middle of the image field, close by the arch of the bridge and easily identifiable by his prominent tricolor. Such popular images, which appeared almost immediately after the event, used the elemental grouping of hero, flag, and arch to fix in the public's eye the "visual shorthand" for the Arcole story.

In the picture exhibited by Amédée Bourgeois at the 1831 Salon, we find a higher level of journalistic exactitude, but no new inventions (fig. 27, pl. 2).[47] Rather, the painting reiterates the formulaic vocabulary of popular imagery—architectural landmarks, figures brusquely cropped by the frame, and a mix of tragedy, pathos, and fortitude in the foreground—to generate a kind of instant accessibility. More important, Bourgeois did not alter the matter-of-fact structure of these familiar images in order to aggrandize the hero's presence: he situated Arcole in the middle distance and accepted his diminutive size as the natural consequence of pictorial truth. Indeed, the painter's only concession to composition seems to have been the selection of a viewpoint which placed the bridge's median arch in the *exact center* of the canvas, so that the diagonal span measures the distance between the warring factions and isolates Arcole from both. The resulting arrangement compensates for its apparent lack of a rhetorically charged structure (like that traditionally expected in history painting) by clearly and centrally restating the triple theme of hero, tricolor, and arch—the exact combination valorized by the popular arts. Bourgeois' direct references to the iconography of the Trois Glorieuses enabled his picture to resonate with an emphatic historical import despite its modest size, fussy detailing, and unheroic structure. Moreover, his work exemplifies how the genre historique emerged as a distinct mode from the seemingly unrelated complex of contemporary political events, "low" art forms, and the unpretentious genre format. Its purchase by the Crown, on the other hand, shows that a taste for just this type of picture existed in the most official sectors of Louis-Philippe's new government.[48]

An investigation of some recurrent motifs in popular imagery from July 1830 will reveal other social and pictorial factors informing painted representations of the revolution. We mentioned that the Parisians achieved their victory by barricading the streets and firing upon Marmont's troops from protected positions. These barricades were assembled from whatever material was at hand: omnibuses, carriages, paving stones, furniture, and felled trees were some of the objects used to seal off the narrow thoroughfares.[49] Often the barrier was only a foot tall, just enough to hamper the passage of horses and cannons; but in other instances it rose to over six feet, a major obstacle to both men and equipment. The barricade, constructed ad hoc by men, women, and children, was transformed by popular imagery into a symbol of the insurgents' communal resourcefulness and an emblem of their victory. Lithographs of barricade building emphasized, for example, both the wide range of materials and the broad spectrum of characters involved in the construction (fig. 28).[50]

Barricades were also where most of the fighting occurred, and their defense inevitably brought together men and women of many classes and ages.[51] After the revolution, this social bonding under fire became a leitmotif of popular imagery, even though recent historical studies have shown that it was more fiction than fact.[52] It was the folklore, however, which shaped the iconography of barricade battle scenes, and all kinds of prints—

from Denis-Auguste-Marie Raffet's spirited 1830 lithograph published by Gihaut (fig. 29), later remade into a cheap, colored woodblock by a provincial publisher at Montbéliard (fig. 30), to the big colored print published by the Pellerin firm at Epinal (fig. 31)—exploited the idea that the fighting had been waged by all good citizens.[53] In these works, women and children, top-hatted bourgeois gentlemen and shirt-sleeved laborers, Napoleonic veterans and students of the Ecole Polytechnique fight side by side to defend the embodiment of their collective resistance: the barricade. The same mythology informs anecdotal histories of the July Revolution, for they take special care to distribute the heroic action among all social and economic classes, including dissidents from the Bourbon's own aristocracy.[54] Certain illustrated editions, like *Les Enfans de Paris*, combine word and image to fix the intended meaning.[55] Here, for example, we read of "The Young Printer's Apprentice" (subtitled "The Barricades"), the story of a fifteen-year-old patriot who planted the tricolor on a barricade while his brother (aged six) used his apron to carry bullets to the combatants. The accompanying print shows that the valor of this virtuous, skilled worker and his brother was matched by a colleague wearing the captured armor of a Royal Guard, a well-to-do student in a top-hat, and a woman attending the wounded (fig. 32). In this context, the young man's exhortation to battle becomes a call to a patriotic unity which cuts across distinctions of class and gender.

The folklore of the July Revolution did provide some distinct hero-types, however, and none are more ubiquitous than students of the Ecole Polytechnique, a venerable Napoleonic institution founded to train artillerymen for the Imperial army. On 27 July students of the Polytechnique had sent a delegation to offer their services to Lafayette, while others prepared weapons for combat: fencing swords were converted into sabers by sharpening their tips on the flagstones of the school's courtyard. The Ecole was officially closed the next morning, but only about sixty of the nearly three hundred students actually joined the fighting—the rest apparently spent the unexpected vacation time in the safety of family homes. The number of *polytechniciens* in the streets was therefore quite small and nowhere near that implied by their frequent appearance in popular images and anecdotal accounts.[56] But students of the Ecole had distinguished themselves in 1814 by leading the defense of Paris (and the tricolor) against the Allies and the same traitorous Marmont who headed Charles's army in 1830; throughout the Restoration, they made no attempt to hide their scorn for the Bourbons.[57] These associations help to explain why students of the Ecole became such an important part of the imagery of the July Revolution: their appearance in the combats of 1830 was understood to be a kind of replay of 1814 and a chance finally to wreak their vengeance on the family brought back to rule by foreign bayonets.

Prints usually represent a polytechnicien—recognizable by the bicorne hat and dress uniform of the Ecole—close to or holding a tricolor while leading the charge (often over a barricade) of a rag-tag army (fig. 31). We find them in action at the porte Saint-Martin (fig. 33), the Marché des Innocents (fig. 34), the Louvre (fig. 35), and the Tuileries (fig. 36).[58] Predictably, their followers are drawn from several social strata. We see, then, that the iconography of the polytechniciens during the Trois Glorieuses provides a rich repertory of images in which a mixed cast of characters rally around the tricolor and a charging figure of known anti-Bourbon sentiments.

This particular image-type, with its encoding of crisscrossing passions and political meanings, lent itself to a special adaptation which became a kind of pictorial metaphor for the success of the July Revolution. Bellangé's *A Man's Home is His Castle* (fig. 37) and a colored woodblock variant entitled *Paris Fighting* (fig. 38), share the essential elements of barricade, tricolor, and mixed social classes that characterized the prints already discussed.[59] A related print entitled *Solidarity and Liberty* (fig. 39)[60] combines the same iconographic components, but all signs of the actual fighting have disappeared and are replaced by a celebration of the united effort which had animated the struggle and guaranteed its final outcome. "Heroes all around; admirable actions all around; noble words all around; everywhere civic ardor joined to a soldier's courage," exclaims the text beneath *Paris Fighting* (fig. 38), but the imagery of all three examples implies that the victory of the barricades belonged to everyone: Napoleonic veterans, polytechniciens, workers, and bourgeois youths fraternally share the triumph. An identical brotherly tone is the theme of the vignette on the title page of Eymery's *Les Enfans de Paris*, where three young men— bourgeois, worker, and polytechnicien—stand arm in arm before a tricolor (fig. 40). The accompanying text claims that the vignette evokes "the complete unanimity which had reigned during the three memorable days among the working class, the business and shopkeeping classes, and the class of young professors and school teachers, especially those from the Ecole Polytechnique."[61]

These works, which depart from reportage to develop a political critique of the July Revolution, raise questions about the intent of their makers. Some ideologically engaged art historians use a class-conflict model to explain such imagery: Marxist analysis, for example, describes a working class which saw itself as instigator of the revolution from which it derived no benefit and then labels images which promote the notion of a communal, mixed-class struggle as bourgeois propaganda designed to justify the Orléans monarchy.[62] Social historians, on the other hand, argue that the Trois Glorieuses were not fought by ragpickers and their colleagues, as the republican sympathizer Honoré Daumier seems to imply, but that respectable and respected worker-artisans formed the main body of combatants (fig. 41).[63] More important, the latter groups proved far more trusting of the Orléanist government and hostile to the agitation of left-wing republicans than a simplified class-struggle schema would suggest. If one wanted to characterize the politics of this group in 1830, the available data requires that we call them Bonapartists before republicans; the return of the tricolor and national self-esteem meant more to them than universal suffrage.[64] This was no longer true in 1832 when political polarization had hardened along class lines, but during the July fighting—and for almost a year after—the historical evidence suggests that the spirit of class unity was more than a bourgeois pipe dream.[65] This means that the themes of solidarity found in the popular images discussed above reflect some generally held views about the Revolution of 1830 and form an essential visual vocabulary of the events that remained valid at least through the spring of 1831. From this foundation, the presence (or absence) of variations on these themes in Salon paintings and government commissions will enable us to detect whether special inflections were demanded of artists and to determine if the "official" retelling of the revolution built upon or reshaped the imagery which characterized the euphoria of victory.

3. *LIFE INTO ART: PAINTINGS OF THE RECENT REVOLUTION*

Many of the paintings celebrating the July Revolution which were shown at the several exhibitions between August 1830 and the close of the next Salon on 16 August 1831 are lost to scholarship. Others—executed by relatively obscure artists and often catalogued today as "author unknown"—are almost certain to remain question marks, given the paucity of surviving descriptions. Enough documented works do survive, however, to establish a useful sampling of the range of painted images which were inspired by the events. The most prosaic of these recount the action of the Trois Glorieuses in a manner almost indistinguishable from that of the popular prints. The two pictures sent by Hippolyte Lecomte to the 1831 Salon describe the fighting at the porte Saint-Denis (fig. 42) and in the rue de Rohan (fig. 43).[66] The Salon *livret* indicates that both were owned by the engraver Alexandre Jazet, and both were eventually printed by his firm: not surprisingly, they exhibit a structure and narrative already found in popular prints.[67] The distinguishing architecture of each site—Louis XIV's arch at the porte Saint-Denis and Louis XVIII's incomplete addition to the Louvre, visible at the end of the street—is rendered with a careful precision. Both works include an intrepid polytechnicien, saber in hand, who leads the attack over the requisite rubble of a barricade. Specific narrative details are also faithfully recorded: Lecomte shows the insurgents at the porte Saint-Denis harassing royal cavalrymen by hurling rocks from atop the arch, and he carefully depicts the murderous gunfire of government troops positioned in a hatmaker's shop overlooking the rue de Rohan (note the hat on the corner of the building).

For all this literalism, however, the two works are structured to do more than merely record the events, because the foreground of each is rendered more crisply and in more saturated hues than the rest of the image. In *Fighting at the Porte St-Denis*, the rupture of perspectival space between the foreground figures and the middle ground tends to throw the former into sharp relief and reduce the rest of the work to a kind of flattened backdrop. Similarly, a thick haze of smoke in the *Fighting in the rue de Rohan* emphasizes the foreground by blurring the focus of the middle ground. Finally, the lighting of both works is engineered to model the foreground figures boldly using strong contrasts, while the further regions of the picture spaces are bathed in an even, almost shadowless light. The result is that the primary visual focus of each work is *across* the image, in the plane closest to the viewer, while the space beyond becomes little more than an historiated background/ backdrop to the principal foreground action.

The shallow, horizontal scan forced on the viewer by this structure is not controlled by a formal focus to unite the figures in a single action; rather, it is broken up serially into a number of discrete anecdotal episodes, each unfolding in its own envelope of time and space. In this atomized world where narrative—in the dramatic sense of the word—cannot develop, meaning is carried by a cast of stock characters whose costumes and gestures invest the picture with a familiarity keyed to the viewer's contemporary experience.[68] Although the characters share anti-Bourbon sentiments, they take aim, reload their weapons, or care for the wounded in vignettes so detached from one another that the croppings effected by the frames could have been put almost anywhere without essentially altering the information conveyed by each image. Yet there is a particular message woven into these

minidramas, one related to the mythology of popular participation discussed above. The porte Saint-Denis, at the faubourg end of the rue Saint-Denis, was the outstanding land-mark of a worker's neighborhood—not an urban ghetto, but a residential neighborhood for many of the printers employed in the nearby newspaper district (around the place des Victoires). Lecomte dutifully populated his picture of that locale with a preponderance of roughly clad, shirt-sleeved workers. The rue de Rohan, on the other hand, crosses the rue de Rivoli and the rue Saint-Honoré near the Palais-Royal, an elegant, upper-class part of town. Here Lecomte's crowd contains many more top-hatted bourgeois combatants, while his tragic scene in the lower right is played by a finely dressed woman grieving over a dying gentleman whose silk shirt and cravat state clearly that he is not a manual laborer. Viewed as pendants, Lecomte's pair of pictures not only reports journalistically but also signifies that no class or neighborhood withheld its support from the July uprising. In other words, the paintings generate a meaning—one with contemporary currency—by staying close to the prototypes offered by popular prints and without invoking the standard narrative devices taught in the art schools of the Academy. It is no exaggeration to say that works like these wrought a revolution in history painting, while their anti-connoisseurship accessi-bility illustrates perfectly their potential value as carriers of premeditated propaganda.

The same type of picture, although painted with somewhat more verve, can be found in the *Assault on the Barracks in the rue de Babylone* by Jean-Abel Lordon (fig. 44).[69] This event of 29 July was an especially bloody confrontation between the revolutionaries and a group of Swiss Guards protecting their barracks. Unable to dislodge the mercenary de-fenders, the insurgents set fire to the building, and those Swiss who were unable to flee by the back door were shot on the spot when the Parisians stormed the structure.[70] Lordon's painting of the episode includes typically veristic details, like the Swiss Guards, protected by mattresses, who fire on the Parisians from upper story windows, or the scene on the street below of kindling straw to begin the blaze by the front door. In the background, the smokescreen clears just enough to allow a microscopic view of the polytechnicien Vaneau being removed on a stretcher—he was killed during a charge on the lateral side of the barracks in the street which now bears his name.

A comparison to Victor Adam's prosaic lithograph of the scene shows that the painting faithfully records the site in the rue de Babylone (fig. 45).[71] It also reveals how Lordon, to check our tendency to read spatial depth, seems to have cropped his image arbitrarily and filled the narrow street with great billows of smoke, thus forming a shallow, stagelike arena for his figures. This is significant, because we discover here a painter who willfully blunts Renaissance perspective yet adopts neither an Academically approved, idealizing strategy based on the example of classical relief sculpture nor the more personal, expressive surfaces of the Romantics. Like Lecomte, Lordon opts for the illustrational, two-dimen-sional space of print images, and the reportorial freshness of his work is actually aided by the fact that he unites disparate places and moments into a single frame without the artificiality of "art": the work's fragmented narrative derives credibility from a wealth of stage props and costuming details rather than from the compelling rhetoric of a rigorous, overarching design. But, unlike both the humble print images it resembles and Lecomte's paintings (which are essentially lithographic designs bridging the gap from "low" art forms to those of the Salon), Lordon's picture is really a new construct which incorporates both

structural and functional aspects of popular art without relinquishing the superior status of serious painting.

Not surprisingly, this subversive aspect was overlooked by the conservative critic Ambroise Tardieu—an archenemy of Delacroix's painterly Romanticism—precisely because the only aesthetic questions to which he responded concerned the "high art" rivalry between the Classicists and the Romantics. Thus, he faulted Lordon's "scintillation of too many different colors" and cautioned the young artist to "resist an exaggerated enthusiasm for the slack handling of certain innovators who scorn a consistent facture," but he praised the work's "faithful rendering of this glorious military episode."[72] What Tardieu did not see was that Lordon's *Assault*, which hovers between traditional *categories* as well as styles, was an entirely new picture-type, one that emerged from the intersecting crosscurrents of history, schools, and patronage that followed the July Revolution. As we know, later critics would name this kind of picture *genre historique.*

In contrast, Jean-Louis Bézard's depiction of the Parisians' attack on the Louvre colonnade draws upon the iconography of the 1830 Revolution as established by popular prints but restructures it with the sonorous gravity of a studied Academic vocabulary to make it conform to the traditional canons of history painting (fig. 46).[73] Thus, Bézard's crowd of insurgents includes the familiar figure of a polytechnicien in full dress uniform leading the charge to the accompaniment of a billowing tricolor held by a shirt-sleeved worker who, in turn, is fraternally embraced by a well-dressed bourgeois. A tasteful blend of top-hats and caps, suitcoats and work shirts throughout the left side of the picture portrays the revolutionary crowd as a mix of social classes. However, Bézard locks this section in place with an obvious triangular design which rises sharply from the lower left corner of the canvas to the tip of the tricolor's staff, and then descends diagonally to the lower right. The rushing crowd, a salvo of gunfire, and various hand-to-hand combats are all subordinated to the geometric constraints of this compositional device which is itself firmly anchored by the massive, vertical architecture of the colonnade.

Bézard's work also exhibits an apparent spatial rupture which isolates the triangular phalanx of insurgents from its surroundings. The Swiss Guards who retreat at the right, for example, exist in a completely different sphere, for neither their expressions nor their gestures seem appropriate to men being shot at from only a few meters' distance: the Guards are little more than props who stand literally in the wings of the main group and—like the slice of Lescot's courtyard facade at the far right—localize the action. While it is obvious that this problematic space is stagelike and thus logically similar to Lordon's, it is also apparent that Bézard has imposed a hierarchy upon both his space and the action unfolding there according to formulas descended from Poussin. Thus, the little three-man struggle of frozen, impossible poses in the left foreground is pushed into a triangular silhouette: the subplot "locks into" the larger triangle and remains subject to its control.

Given these observations, it is not surprising to discover—via a smaller but nearly identical version of the final composition which is signed and dated "Rome 1832"—that Bézard conceived the image far from the streets of Paris.[74] His image exemplifies how an artist who remained firmly attached to the traditions of the Academy might approach the problem of contemporary history in the early years of the July Monarchy. Finally, and

especially in comparison to Lordon's picture, Bézard's becomes a foil against which the pictorial transformations of the genre historique can be more clearly understood.

The same contrast exists between two works that recount the grisly aftermath of July's street fighting. The cadavers left by the Trois Glorieuses needed to be disposed of quickly because they decomposed rapidly in the midsummer heat, but the network of barricades still blocking the city streets hindered transport of the bodies to cemeteries near the periphery. Some neighborhood groups dug mass graves at the Marché des Innocents and near the Louvre colonnade, and the prefect of police ordered that all unclaimed bodies at the morgue should be ferried down the Seine to the Champ-de-Mars or the pont de Grenelle for burial.[75] When the latter event was painted by Louis-André Péron, this former pupil of Vincent and David transformed it into a moonlit image of almost monochromatic browns and blacks, and he heightened its drama by boldly juxtaposing areas of light and shadow (fig. 47).[76] Completely unlike the popular prints already discussed, Péron's painting suppressed anecdotal details of the setting to achieve an architectural landscape of stark wall surfaces, blank window openings, and spare geometric volumes, all of which contribute to the somber mood. The isolated groups of generalized spectators do not personalize the scene, although the trio at the far right—polytechnicien, worker, and bourgeois—typifies the social alliance deemed responsible for the successful uprising.

On the other hand, Péron opted for a pictorial geometry which placed the barge parallel to the picture plane and centered on the canvas so that the heap of naked bodies—only partly covered by a rough cloth—forms a front-and-center compositional triangle which dominates and controls the entire image. The adjacent pont Saint-Michel throws half of this morbid mass into deep shadow, while the sharp edge of moonlight accents the only bright spot of color in the visual field: a green laurel crown placed atop the deathly cargo. Péron's dramatic luminary structure, which plunges the barge into shadow just as its lugubrious downstream journey gets underway, also suggests that the passage transcends its explicit historical references. This generalized secondary reading is reinforced by the strikingly highlighted, open-shirted and dark-skinned helmsman who stands beneath a black flag of death: he is a modern-day Charon ferrying the dead across the Seine (Styx) in the eerie moonlight. Seeking a timelessness within the narrative of recent history, Péron cloaked his image of 30 July in a mantle of mythological meaning.

Turning from the Péron to Jean-Alphonse Roehn's picture of the impromptu burial service at the Louvre is akin to moving from the world of broad generalizations to that of the specific and incidental (fig. 48).[77] Roehn portrayed the crowd assembled at the foot of the Louvre colonnade where Father Paravey, a priest from Saint-Germain-l'Auxerrois, blesses the mass grave with holy water. A worker supports a large black cross—inscribed *à la mémoire des Français morts pour la patrie*—and a tricolor rises just behind it, boldly visible against the grey stone of the Louvre. The massive architectural backdrop of the colonnade, suggestively riddled with pockmarks from the previous day's battle, both delimits the picture space and blocks the setting sun so that the funeral occurs in an appropriately somber light. But the resulting spatial compression is not relieved by the vista opening at the far left, because an impossibly close view of the Institut denies the actual width of the Seine, a fault of perspective noted by Salon critics.[78] Once again a compositional structure

creates a stagelike foreground space which is perspectively disjunct from the rest of the world. A similar artificiality informs the lighting: although the scene ostensibly occurs in the shadow of the Louvre, the foreground is inexplicably bathed in a light as strong as that in the open ground at the far left.

Roehn's selection and placement of secondary figures contribute to a serialized atomization of the whole. The left side of the image is closed by a weeping woman (no doubt newly widowed by the revolution), the politically charged vignette of a wounded bourgeois contemplating the cadaver of a rudely dressed (but highly idealized) worker-combatant, and the unloading of bodies from a makeshift hearse, "which earlier in the day was used to carry bread into Paris."[79] The high sentimentality of this grouping is rediscovered in the right corner, where a young woman throws herself across the body of a victim. Here, too, politics and pathos overlap: the four witnesses of this tender drama—a polytechnicien, a bourgeois, a strong-armed worker, and a National Guardsman—are united in an alliance of sentiment that mirrors their earlier unity of action on the barricades. These flanking episodes of neo-Greuzian sentiment give the work an expressive accessibility, bracket the historical part of the action and confine it to the front and center of the image, yet remain narratively separate from the advertised subject. Although the resulting composition—a semicircular arrangement of figures in a shallow space—mimics the structural type preferred by Greuze, no single moralizing storyline emerges from Roehn's string of independent minidramas.

Given its chronological location in the midst of French Romanticism, the heightened appeal to *sensibilité* evident in this work is not surprising.[80] What is rather remarkable, however, is the way the agglomeration of discrete moments and episodes is effected with few adjustments toward establishing a formal hierarchy that would suitably underscore the supposed subject of the picture. The figures immediately adjacent to the priest, for example, apparently listen to his words (although the National Guardsman at his left looks at us rather than at the reverend). The affective subplots in the wings, on the other hand, rupture the internal coherence of the narrative: the group at the right, for instance, literally turns its back on Father Paravey. Similar distraction is found throughout the crowd, where people talk, gesture, and remain generally oblivious to the religious ceremony.

Roehn's structural atomization is restated throughout the image by his careful particularization of individual physiognomies, expressions, and accessories. Many Salon critics found this wealth of detail to be the work's most endearing quality. "One finds there many details," wrote Charles Lenormant, "all of them carefully studied, expressive, and sharing that truthfulness which is the principal merit of any picture whose subject we have recently witnessed firsthand."[81] Others, however, saw past this aspect to the structural premises of Roehn's uninflected horizontality and compressed space: "One sees a lot of faces, but they are insufficiently isolated from one another. It seems to me that they have been tossed helter-skelter onto the canvas. Nevertheless, there is some talent in certain parts of the painting, although the figure of Father Paravey does not sufficiently stand out from the others."[82] These are, of course, exactly the kinds of criticism levied in 1850 against another, more famous burial scene: Gustave Courbet's *A Burial at Ornans* (fig. 49).[83] In fact, if we imagine away the neo-Greuzian vignettes from Roehn's work, what remains is as anti-Academic a formal skeleton as Courbet's later icon of Realism. This comparison suggests

that a recognition of how genre historique undermined the axioms of the Academy without alienating conservative tastes might change our art-historical account of the period.

The sentimental sweetness which masks the subversive structure of Roehn's picture was part and parcel of contemporary manners: the charged sentiment of his vignettes appealed to a wide audience during these years of high Romanticism, and similar tales season nearly every popular history of the July Revolution.[84] If Roehn's burial scene suggests that displays of heartrending charm were welcome at the Salon, the critical response to Philippe-Auguste Jeanron's picture, *The Young Patriots*, at the 1831 exhibition makes it clear (fig. 50).[85] Although often thought to be inspired by *Les Enfans de Paris* (fig. 40), the expression of Jeanron's work bears little resemblance to that civic-minded pamphlet.[86] Instead of well-scrubbed social types, Jeanron's children of the street are dressed in tatters. And quite unlike the intrepid gamins who actively participated in the Trois Glorieuses, Jeanron's youngsters are playing at being soldiers with equipment undoubtedly scavenged from victims of the fighting.[87] Poised atop a barricade, they ape the behavior of militiamen: the standing boy takes his turn at sentinel duty while one of his comrades relaxes with a pipe and a third naps. In the background, dead bodies and a barricade battle fix a historic setting appropriate to the high seriousness imprinted upon these young faces, especially the one looking out at us.

The tragicomic irony of these children soberly reenacting the behavior of their elders delighted Salon critics. "Some sections of this small painting are full of sentimentality, while its overall impression is nothing less than charming," wrote Charles Lenormant, an appreciation echoed by other observers.[88] Innocently mirroring deadly history in their childhood games, Jeanron's young freedom fighters are cloying witnesses on the periphery of the 1830 Revolution, updated equivalents of those precocious little people who set the sentimental tenor for so many of Greuze's moral dramas.[89] The fact that Jeanron, who was usually inclined to a more socially critical posture, would paint—for whatever reasons—such a neo-Greuzian view of the recent revolution documents the strength of this current in 1831.[90] Moreover, a behind-the-scenes glimpse of the artist's fortunes at the Salon that year shows how the government sanctioned this type of sentimentalized history. Jeanron apparently submitted two other works to the Salon jury: one, entitled *1830*, showed a wounded worker on a barricade; the other, a pendant in which the same figure has died of hunger in his garret apartment, was called *1831*. The combined message of this pair—that the July Revolution had done nothing for the poorest of its supporters—is much more akin to what we know of Jeanron's later politics. Predictably, the Salon jury found his social critique too seditious to be shown at the Louvre.[91] In marked contrast, *The Young Patriots* was not only admitted to the Salon but, as if to encourage the artist to follow a less strident course, it was also one of the few pictures of the revolution bought by Louis-Philippe's government that year.[92]

A different kind of eighteenth-century retrospection informs those works which recount episodes of exemplary behavior during the Trois Glorieuses. These pictures of *exemplum virtutis* in contemporary dress differ from the barricade scenes already discussed insofar as their main purpose was to illustrate the moral fiber of their heroes rather than to recount a specific episode of the revolution. Very often drawn from the self-serving anecdotes which circulated after July, works like the picture (now lost) by Paul Carpentier

at the 1831 Salon extolled the virtues of working-class heroes who, when raiding the ammunition sacks of dead government soldiers, took needed bullets but disdainfully kicked any money they found into the gutter.[93] Likewise, a painting executed by François Latil in 1831, but not shown until the 1835 Salon, illustrates *Morality of the People in a Moment of Lawlessness: July 1830* (fig. 51).[94] A group of self-styled peace-keepers—recognizable as workers from their rough garments and strange assortment of plundered armament—have been patrolling Paris under the aegis of a tricolor banner. They come upon a scene of dubious integrity beneath the heavy vaults of what appears to be a bridge or sewer (to judge from the foreground water): a looter in ragged clothing is burning stolen papers and sorting his booty. A member of the group discovers that the thief is a convicted criminal, and shows his comrades the red mark of a chain gang (the initials *TF*, which stand for *travaux forcés*) tattooed onto the culprit's shoulder. Quick and severe punishment will soon follow, as is evident from the crook's exaggerated cowering and the instructions which the group leader is apparently giving to the riflemen at the left. Latil may have been inspired, as were some printmakers, by actual instances of looters being shot on the spot (fig. 52).[95] But where a print might celebrate the swift paramilitary punishment dispensed by a veteran of Napoléon's Imperial Guard, Latil truncated this gruesome climax to focus our attention upon the upright honesty of July's worker-combatants without raising the moral question of their vigilante justice.

Latil's historicized morality painting evokes the world of Greuze with its style even more emphatically than with its theme. An unnatural, theatrical light pierces the gloom of the heavily vaulted locale and provides a luminary center within which the main drama unfolds. The figures are arranged in a semicircle at the edge of this bright area so that the full range of gestures and physiognomies emerges clearly to support the picture's moral thesis. If we recognize that Greuze's well-known multi-figure compositions of the 1750s and 1760s turned an identical strategy to a similar end, we not only specify the historical dimension of Latil's work but also isolate the genre-painting character of its pedigree.[96]

In contrast, higher orders of meaning and ambition were sought by Pierre Senties in his large-scale rendering of an episode from the chronicles of 29 July (fig. 53).[97] The story capitalizes upon one of those poignant ironies of revolution: an insurgent, who had distinguished himself in leading the people against Charles's troops, was shot in combat and carried by his faithful "troops" to the Tuileries so that he might die upon the deposed king's throne. Several variants of this touching story circulated after the Trois Glorieuses; Senties chose the one that made the victim a former member of Napoléon's elite Imperial Guard to explain handily the hero's military expertise and appeal to the groundswell of Bonapartist sentiment present in 1830.[98] The characters in this melodrama are an assemblage of standard 1830 types: a polytechnicien who stands over the hero's body, a top-hatted bourgeois to the left, many workers, and even a defector from Charles's army (kneeling in homage at the lower right). This artist, however, glossed the historical narrative with a covert Academic allusion: the cadaver, the polytechnicien's upright saber, and the convergence of outstretched arms combine to reformulate the oath sworn by Brutus over the body of Lucretia.[99] Senties evidently hoped to ennoble this contemporary event by resurrecting the high-minded morality of eighteenth-century oath-taking: his didactic aspirations are clearly stated in the right section of his canvas, where a bald-headed older man

(whose off-the-shoulder garment suggests a philosopher's toga more than a worker's blouse) shows the scene to a young boy, and undoubtedly draws the appropriate moral lesson for his protégé.

Unlike his venerable predecessors, Senties used a glassy, impersonal hand to render his close-eyed concern for costume detail and physiognomy: although the literalism which results is surely appropriate for depicting an event of 1830, it supports poorly the lofty connotations of the picture's structure, and the combination produces a kind of pictorial schizophrenia which was singled out for attack by Salon critics on both sides of the Romantic/Classicist controversy. "This painting is spoiled by an overly pretentious air and a contrived composition which freezes it completely," complained Delacroix's friend Victor Schoelcher in *L'Artiste*; "one would think that the author has studied with an Academician."[100] Likewise, Ambroise Tardieu, defender of aesthetic conservatism and a stiff critic of Delacroix, used almost exactly the same words to discuss the Senties: "There is a strong coloration and a purity of drawing in this large painting which is nevertheless spoiled by a pretentious composition.... This serious fault chills the viewer so that the singularly pathetic story fails to move him at all."[101] The cool reception accorded Senties' picture cuts across stylistic schools and registers the extent to which critical categories and evaluative criteria were in flux during these years. It also underscores the methodological difficulties facing those artists—like Senties, Bézard, or Péron—who longed to portray contemporary history with the accepted style and strategies of history painting.

Lying roughly between the artistic ambitions of Latil and Senties, yet still celebrating the *exemplum virtutis* of July's revolutionaries, is Léon Cogniet's small *July 1830* (fig. 54).[102] Stories telling how soldiers of Charles X were spared a certain death by the heroic intervention of concerned citizens were commonplace in popular histories of the revolution, and the favorite version seems to have been the one Cogniet painted: a young worker-combatant opposes the crowd's vengeance and saves the life of a hated Swiss Guard mercenary. Ignoring his own wounds, the hero places himself between the terrified, disarmed soldier and the bayonets, bullets, hatchets, and clubs of his erstwhile comrades.[103] A glimpse of LeVau's Institut in the background suggests that the action occurs at the Louvre, but more specific historical data are suppressed in favor of emphasizing the human dimension of the hero's courage and generosity. Thus Cogniet's work differs from its most obvious thematic ancestor, LeBarbier's 1795 *Heroic Bravery of Désilles*; in that picture, the precisely rendered architecture supports the documentary enterprise by creating a deep, believable space where real deeds occur in a specific locale at Nancy (fig. 55).[104] Because the viewer understands that LeBarbier's figures have a *potential* for movement, Désilles' position at the point between the groups arranged binarily in the image is accepted as specifically relating to the story line. Cogniet's figures, on the other hand, exist in the compressed, flattened world of illustration, where stock types and poses culled from popular images— such as *The Waterloo Grenadier* by Charlet (fig. 56)—replace specific heroes.[105] Even though Cogniet dynamically structured his crowd on a diagonal—perhaps emulating a paradigm of dramatic confrontation from the grand tradition, such as Suvée's *Admiral de Coligny Confronts His Murderers* (fig. 57)—his picture remains attached to modest ambitions and isolates a vignette of courage rather than proclaiming a timeless virtue.[106] Granted, there is only so much one can do on a very small canvas: because his picture

measures a mere 39 by 46 centimeters, Cogniet would have been presumptuous to make it do more. But it is important to see that the work's temperance (both in style and ambition), its contemporaneity via the popular art context of the July Revolution, and its sentimental, moralizing tone connect it to the contours of what came to be called genre historique. Finally, its middle-ground position vis-à-vis Latil's neo-Greuzian *Morality of the People* and Senties' Greco-Roman *29th of July* offers an example of where this kind of image stood within the traditional hierarchy of genres; the fact that Louis-Philippe bought it from the Salon illustrates where it stood relative to the new king.[107]

Thus far, we have considered only images inspired by the actual events of the July Revolution, but works celebrating the uprising in a more generalized, allegorical manner were also created. One of the more clever of these was shown in the *Amis des Arts* exhibition at the Louvre. Léon Cogniet's *Four Flags* chronicled the tricolor's reappearance as an evocative, three-step transformation of the Bourbon's white flag: against a blue sky, the Bourbon banner is shot through by gunfire (27 July), thus becoming blue and white, then stained with blood (28 July) to yield the color trilogy of the new national flag.[108] Obviously, Cogniet's formulation appealed to the cult of the tricolor that was so central to the revolutionary meaning of the Trois Glorieuses. Later, his painted image was reproduced for mass circulation as a colored lithograph, further testifying to the widespread enthusiasm generated by the flag's return (fig. 58).[109]

A considerably more complex iconography informs Octave Tassaert's lithograph, *Apotheosis of the Victims of 27 and 28 July* (fig. 59).[110] Its airborne conceit, including the old bard, Ossian, among the clouds at the upper left, depends upon a Romantic nationalism resurrected from Girodet's *Apotheosis of French Heroes* (fig. 60).[111] To the right of Ossian, Tassaert depicted France's heros of 1814—including a polytechnicien—who had died defending the homeland against the Allied invasion. Further right, ghosts from the armies of the Republic recall the great French military victories during the early years of the French Revolution. Spirits of the most recent national heroes—the victims of the Trois Glorieuses—rise up from below. All four of these airborne groups converge near the center of the image, where they are greeted by Maximilien Foy, a general of the Empire who had argued eloquently in 1819 on behalf of the veterans of Napoléon's army against a Bourbon Restoration proposal to reduce their pensions. While addressing the Chamber of Deputies, the general had dared to evoke the victories and the leader of these heroes who had peacefully returned to civilian life after 1815.[112] Foy instantly became the darling of the liberal opposition, an ardent spokesman against French military intervention in Spain and Charles X's efforts to curtail essential liberties. When the general died in November 1825, his funeral drew one hundred thousand mourners.[113] Thus, Foy's central position in Tassaert's lithograph reflects not only his role as champion of the Napoleonic veterans who appear in the background, but also his career as a liberal opponent of the Bourbons, a man worthy to receive the victims of July 1830 who had lost their lives in chasing Charles X from the throne.

Two other prominent liberals of the 1820s accompany Foy in the clouds above the Tuileries Palace: Jacques-Antoine Manuel (at Foy's side) and François de la Rochefoucauld, duc de Liancourt (third to the right of Foy). Manuel, a volunteer of 1792 who had advocated calling Napoléon II (rather than Louis XVIII) to rule after the defeat at Waterloo, was

elected to the Chamber of Deputies in 1818. This fiery orator of the Left refused to leave the Assembly when his ultra-royalist colleagues voted to eject him in 1824; when armed soldiers arrived to effect his removal, Manuel was carried in triumph through Paris by a crowd of supporters. When Manuel died in August 1827, his funeral, like that of Foy, was a national affair.[114] The duc de Liancourt, on the other hand, was best known for his nocturnal visit to Louis XVI in 1789 (14–15 July), during which he reported the fall of the Bastille and described the agitated state of Paris. "What an uprising!" exclaimed Louis, to which Liancourt made the legendary reply: "Sire, call it a revolution!"[115] Although Liancourt was made a duke by Louis XVIII, his liberal tendencies placed him among the opposition during the reign of Charles X. Liancourt's funeral in 1827 was also an opportunity for the Left to manifest its strength among the people and to register its discontent with the policies of Charles's ultra-royalist government.[116]

In the heavens with these three recently deceased liberals of the 1820s Tassaert placed four important heros of the first, liberal phase of the French Revolution who had been guillotined by the radical revolutionary government of Danton and Robespierre: Jean-Sylvain Bailly, the Girondin leaders Marguerite Guadet and Charles Barbaroux, and Charlotte Corday, the assassin of Jean-Paul Marat.[117] Tassaert's print willfully fused ideals of a liberal democracy, the highly charged nationalism of France's past military glory, and an evocative, Romantic representation of the contemporary valor shown by the combatants of July into a single ethereal vision of the 1830 Revolution far removed from actual events in the streets of Paris. Nevertheless, the animating spirits behind the separate components of his combinatory imagery were very much part of the forces which propelled the popular revolt and toppled the throne of Charles X.

Not surprisingly, allegories of the July Revolution attained their most learned emblematic formulations in the hands of a few staunch Academicians.[118] Méry-Joseph Blondel, for example, seems to have entertained the idea of a major allegorical composition; although it was never completed, we can follow the direction of his thoughts from the related works which survive. The small picture Blondel sent to the Luxembourg exhibition celebrated the tricolor's return in a rarefied, idealized manner (fig. 61).[119] An allegorical figure of Force—personified as a dewy-eyed, bust-length nude who wears an oak wreath (a symbol of strength)—casts her eyes upward in an unfocused expression of rapture probably meant to suggest quiet self-satisfaction. She clasps to her bosom a laurel wreath wound with a ribbon inscribed *27, 28, 29 juillet 1830*. A tricolor forms the picture's background and drapes over one of the figure's shoulders. Nevertheless, the work's historical dimension has been so hermetically encoded by Blondel's flawless, idealized modeling and the neutral, insipid expression of his figure, that a casual viewer depends almost entirely upon the textual postscript to decipher the artist's message.

Rather more interesting, if no less abstruse, is Blondel's sketch for a complex allegory of the revolution (fig. 62).[120] A nude female personifying Truth (*La Vérité*), isolated from the gloom of a mountainous, moonlit background by a halo of light, holds a light-emitting mirror in one hand and the tablets of the Charter in the other: a combination inspired by the Orléanist slogan, *La Charte sera désormais une vérité* (from now on the Charter will be a reality).[121] Just below the tablets, a Gallic cock grasps a sword (symbol of Force) in its claws. In the foreground, three allegorical figures recoil before the resplendent nude: Discord, at

the right, brandishes a flaming torch and a coil of snakes; Hypocrisy, at the left, pulls out a dagger while trying to recover the cloak of deceit upon which Truth walks; directly below, despotic Monarchy lies dying, his chains of oppression broken and the crown slipping from his head. In the right background, one sees the fires of anarchy, while at the left, two undecipherable figures slip into the shadows. Precisely because none of Blondel's imagery is particularly original (he simply used stock-in-trade emblems taught at the Ecole des Beaux-Arts), his sketch can serve as one example of the pictorial "mold" thought appropriate by an Academy-trained painter to shape a high-minded allegory of 1830: a triumphant figure who tramples underfoot the symbols of the old order.[122] As such, the schema employed by Blondel will figure in a discussion of other, more important works.

Jean-Auguste-Dominique Ingres experimented with a nearly identical mold on a sheet of sketches for an allegory of the July Revolution which was never executed (fig. 63).[123] Each of the three ideas traced on this sheet is dominated by a standing male nude who leans on a club-like implement in a pose loosely derived from the Farnese Hercules. This main figure would represent the people, "young, strong, and beautiful," as the artist noted: Ingres' identification of Hercules with "the people" recalls explicitly the iconography of the revolutionary festival decorations erected in 1793–94 by his teacher, Jacques-Louis David.[124] At the top of the sheet, Ingres indicates that a flying Victory would crown the hero, while the words *journées des 27 . . . 28 juillet* and *honneur au peuple* are clear references to the recent revolution. For this same sketch Ingres indicated fleeing figures, cadavers and a scene of charity at the left, scenes of compassion (*humanité*) and death at the right, and underfoot a figure of Despotism cast to the ground: thus his idea seems to have called for a mix of emblematic and realistic figures. This conclusion is corroborated by his note near the hero's elbow, where a mirror is indicated just above a woman who wears a contemporary dress rather than Truth's chaste nudity.

In the lower right of this sheet, Ingres consolidated much of his larger first idea into a single standing figure who still rests on a club but now also holds a spear in his left hand. At his feet are figures of *générosité*, *humanité* and *douceur* (well-being), while the lowest register is marked *le trône cassé* (the throne destroyed). In this version the contemporary references have been replaced with a generalized symbolism more like that of Blondel's sketch. The smallest design on the sheet carries this direction even further: a female nude holding a mirror accompanies the hero and a winged Victory still lays a crown on his head, but other historical references have been eliminated. Surely, Ingres' gradual progression from the specifics of history to general concepts agrees with what we know of his temperament, priorities, and training.[125] Had Ingres completed (or even started) a major allegory of the 1830 Revolution, it would have exemplified an interest in contemporary subjects that he had not shown since his pre-Roman paintings of Napoléon, and it would have supplied an almost too perfect textbook comparison to *The 28th of July* by Delacroix. Nevertheless, his experimental sketches chronicle a more important struggle than the sterile quarrel of styles which simmered between "papa Ingres" the Classicist and Delacroix's brand of Romanticism. The July Revolution had sparked a conflict in Ingres' imagination which eventually forced him to make an essential professional choice: the reductionist direction outlined on this sheet of sketches and his eventual abandonment of the project suggest that, although he might still be moved by current events, the Ingres of 1830 deliberately opted for

the rarefied, elitist world of "high art" and definitively closed the door of his studio to subjects from modern life.

4. *ART INTO PROPAGANDA: GOVERNMENT-ENDORSED RENDERINGS OF JULY 1830*

Few of the works discussed thus far can be called "official," if we adhere to the strict definition which requires that the government either commission or purchase them. Official neglect of pictures like the Bézard (fig. 46) or Péron (fig. 47), both completed and exhibited several years after the July Revolution but still commemorating the violence of 1830, was mainly a question of bad timing: experience had forced Louis-Philippe's government to reorient its priorities between 1831 and 1835 in a way which precluded any official endorsement of civil unrest. The monarchy had faced sporadic street riots in Paris and a major insurrection in Lyon during the last months of 1831, troubles at Grenoble in March 1832, and a Parisian uprising in June.[126] During the spring of 1833 government informers reported that the *Société des droits de l'homme*, a militant republican organization, was fomenting unrest among the working classes to prepare a series of demonstrations (and perhaps a revolution) during the summer.[127] In response to these developments, the government founded by a revolution in 1830 began to plan legislation limiting the revolutionary press and caricatures criticizing the regime.[128] It is no wonder that images of the Trois Glorieuses were left to languish in artists' studios and that one of the few critics to comment on Bézard's painting in 1833 was the reviewer for a staunchly legitimist, pro-Bourbon journal.[129]

Even a widely praised and seemingly innocuous work like *The 30th of July* by Roehn (fig. 48) could present politically difficult problems not always apparent to us today. Memories of the sacking of Saint-Germain-l'Auxerrois and the archbishop's residence next to Notre-Dame were still fresh when the 1831 Salon opened on 1 May: altars, statues, precious manuscripts, and crosses had been stolen, broken, and thrown into the Seine during a two-day rampage on 14 and 15 February.[130] Although the outburst had been sparked by a legitimist gathering in honor of the duc de Berry's birthdate, its explosive character was fed by the anticlericalism which had been an integral part of the July Revolution.[131] Louis-Philippe's government did little to limit the looting, and the mobs freely pillaged church property under the eyes of the police and the National Guard. This nonaction was no doubt fostered in part by a fear of offending the armed citizenry and possibly turning the sack into a new revolution; at the same time, many Orléanists believed that the Church harbored a lingering allegiance to the Bourbons and secretly wanted a return to rule by divine right in which religion played a natural and powerful part. Even Louis-Philippe adopted a very circumspect policy toward the Church, avoided public references to "Providence" and "religion," and took care to distance himself from the clerical establishment—much to the chagrin of his pious queen.[132] Predictably, the July Monarchy blamed pro-Bourbon agitators for the sack rather than accusing the Parisians of willful wrongdoing. Given these circumstances, Roehn's image of *The 30th of July*, in which a priest of Saint-Germain-l'Auxerrois blesses the mass grave at the Louvre, would have been an imprudent selection for the king's picture gallery.

The government understandably avoided subjects which might exacerbate the preju-

dices evoked by the change of regime in favor of an imagery which would foster coopera-
tion and reconciliation: healing the wounds left by July's fighting is very much the point of
the painting sent by Nicolas Gosse to the 1833 Salon, *The Queen of the French Visiting Those
Wounded in July*, and the Crown demonstrated its approval of this sentiment by purchasing
the work at the close of the Salon (fig. 64).[133] The picture records one of the visits made by
the royal family to one of the infirmaries established during the revolution: Queen Marie-
Amélie, accompanied by Louis-Philippe's sister Adélaïde, her daughters Louise and Marie,
and her son, the prince de Joinville, are shown gathered around the bed of a long-haired
convalescing worker.[134] On one level, this image argues the virtues of visiting the sick or
dying and recalls a pictorial tradition which, like works already discussed, returns to the
world of Greuze (fig. 66).[135] The implied moral lesson of Greuze's *A Young Lady Learns
Charity*—that children of wealth and rank should see suffering firsthand to develop chari-
table habits—was inflected by Gosse to emphasize that the new royal family ascribed to the
idea with an eye toward training the nation's next generation of rulers. One popular history
explicitly articulates this salutary effect with the story that when the queen was asked
"whether she feared that the spectacle of so much suffering might make too strong an
impression upon her children," she replied that "it was good for princes to witness first-
hand the evils wrought by civil wars."[136] Hand in hand with this moral lesson goes the
political signification that such royal visits manifested the monarchy's desire for a general
reconciliation which would end revolutionary unrest and secure the new social order.
Writers took pains to note that the queen removed her gloves to touch the wounded
personally, and that she "took care to speak to the soldiers of the Royal Guard [of Charles X]
and encouraged them to forget their mistakes."[137] In making his picture, Gosse dutifully
recorded the bare-handed queen greeting a M. Julien, who was not, however, a Bourbon
soldier, but a veteran of Napoléon's Imperial Guard.[138]

 Louis-Philippe and his advisors fully understood the propaganda value of these family
excursions, and Gosse must have been instructed to consider this issue when making his
picture of the Queen.[139] A comparison between his preliminary sketch of 1830 (fig. 65) and
the finished picture reveals that he made a number of politically important alterations
when elaborating the scene.[140] Although the architecture and general layout of the com-
position remained unchanged, Gosse moved the two princesses to the exact center of the
image and called attention to their presence by upgrading the patriotic text of *Vive la Charte*
from mere wall graffiti to the legend of the large tricolor just overhead. The final picture
makes a point of stressing that even these delicate royal personages had no qualms about
fraternizing with the unfortunate heroes of July. More subtle are the several changes made
by Gosse to the social status of certain figures, yielding a final image more attuned to the
ideal of class unity stressed by the official ideology of the new regime. In his sketch, for
example, the standing figures near the center are frock-coated bourgeois, while in the large
version they have become roughly dressed workers. An opposite transformation occurs at
the far right: the sketch suggests a wounded worker comforted by two women; he finally
appears in a fine, collared shirt attended by a very well-attired gentleman and an elegantly
dressed woman. Just behind this group, Gosse added a woman and another victim with a
Jesuit emblem across his chest. The Jesuits, especially distrusted because of their powerful
place in the entourage of Charles X, were frequently persecuted after the July Revolution:

that their sign was allotted a conspicuous place in this image underscores its conciliatory tone.[141] Gosse introduced an even more important adjustment at the far left: the sketch shows a wounded civilian, but in the large picture he becomes a royal soldier—identifiable by his uniform on the nearby chair and the knapsack under his bed—who hides his face in shame before the new queen. Finally, a foreground still-life of medical implements and bandages implies that July's victors generously treated both partisans and former enemies, while the little dog's attentive pose directs our eye toward the soldier's embarrassed gesture to guarantee that we will grasp the work's message of political healing.

The pictorial tradition of rulers visiting the sick is especially rich,[142] although we are naturally led to compare Gosse's work to its most famous precursor, Gros's *Plague Victims of Jaffa*, the more so because the Gros had just reappeared at the Luxembourg exhibition after a fifteen-year exile in the Louvre's warehouse (fig. 67).[143] Thus, this stunning image was newly visible during the months when Gosse sketched and elaborated his own picture. Juxtaposing the two works, however, underscores how much had changed in the interim. Gros presented Napoléon as a Superman, unafraid of death amidst the carnage of disease, bathed in light from an inexplicable source, and metamorphosed into a contemporary miracle-worker.[144] Gros's larger-than-life scale and transcendent meanings had been the stuff of Empire, but they were patently inappropriate for the fragile mandate of the July Monarchy. Where Gros's *Jaffa* consciously cultivated the other-worldly allusions of its pictorial heritage, Gosse systematically denied them by choosing to record the scene and its participants with a doggedly pedantic literalness: even though his image was "doctored" to show that Orléans solicitude was unpretentious and evenhanded, these secondary significations remain firmly locked to a system of minutely described details and exact portraits which defeats timelessness by precisely fixing an appointed time and a specific place.

From a purely stylistic point of view, the Gosse is more closely related to the prosaic literalism of Roehn's *The 30th of July* (fig. 48) than to the bold coloristic and compositional effects of Gros's *Jaffa*. The all-over, glassy precision with which Gosse describes physiognomies and costumes, a contrived lighting that subtly accents his royal subjects without appearing antirational, the horizontally dominated composition which not only refuses to be read hierarchically but also dissipates at the edges in figural croppings and movement out of the picture-space: these traits also characterized Roehn's composition. Likewise, both works present a neo-Greuzian moral spirit within the narrative of current events, and both manifest the intrusion of "popular art" clichés. This mélange, as we suggested earlier, circumscribes the genre historique picture-type, although Gosse's work is rather large (265 by 240 centimeters). In other words, the genre historique, taken to the princely proportions of traditional history painting, has become the officially sanctioned picture-type of the July Monarchy.

The link between this kind of image and official taste is further demonstrated by considering the only two pictures of the Trois Glorieuses bought in 1831 by the royal museums. One of them, Bourgeois' *Capture of the Hôtel-de-Ville* (fig. 27), already entered our discussion of Arcole's heroic charge across the Seine.[145] The other Crown purchase to represent the July fighting was of the same event from a different point of view, *The 28th of July at the Hôtel-de-Ville* by Joseph Beaume (who painted the figures) and Charles Mozin (responsible for the architecture) (fig. 68).[146] This picture, more correctly a view painting

than a battle scene, is characterized—as is the Bourgeois—by an overwhelming accuracy of locale; the various landmarks are rendered with an almost mechanical exactness. Beaume populated the expanse of space delimited by these familiar structures with hundreds of tiny figures who tell many simultaneous stories: fallen heroes are mourned, others are nursed, and several battles rage across the place de Grève. The tricolor plays its accustomed role throughout the image, for it is brandished in the foreground, hoisted atop the Hôtel-de-Ville at the left, planted upon the Arcole bridge arch in the background, and flutters atop Notre-Dame on the horizon. Perhaps to knit all these separate incidents together, the artists compromised accuracy when arranging the overall lighting: although the Hôtel-de-Ville was captured near noon, their scene is bathed in the long rays of late afternoon.[147] As a result, dark shadows stretch across the foreground, the sky displays the blue-orange coloring of a clear summer evening, and the architectural details of the Hôtel-de-Ville's Renaissance facade stand out in the crisp chiaroscuro of a limpid, golden light to generate a coloristic unity which tends to blunt the patchwork effect of the atomized narrative.

Attempts by contemporary critics to reconcile this work's popular appeal with its layout and format verbalize how such a picture challenged the traditional categories of painting. A conservative observer like Ambroise Tardieu, for example, reveals himself to be committed unflinchingly to the old order:

> Of all the pictures for which the glorious July Revolution has supplied subjects, this one is unquestionably the most worthy of comment. It is an outstanding work. One can only praise it, even if telling its story in miniature causes us to regret its small scale. Accuracy of details, life and truth in the figures, a thorough-going exactitude in the architecture that is not stiff, limpidity in the background depths, an exquisite coloration and overall impression: all of these combine to make the picture a masterpiece of genre painting. Perhaps it would lose this perfection if it were larger. M. Beaume excels in small figures; he is no longer himself when he blows up their scale. Let him be content, therefore, to remain the best among our young practitioners of the genre exemplified by Teniers.[148]

Despite his profound admiration for the picture, Tardieu wants to fix Beaume's rank of genre painter as firmly as the Academy had blocked Greuze's bid for "upward mobility" in 1769.[149]

In contrast, Victor Schoelcher—writing for the aesthetically "advanced" journal *L'Artiste*—thought a large-scale reproduction of the Beaume/Mozin effort would *improve* it:

> In our last article, when speaking of the *Hôtel-de-Ville* by MM. Beaume and Mozin, we especially wanted to praise its superb coloration, the accomplished composition, and the noteworthy manner with which the architecture is rendered. We did not have time to deplore the fact that this magnificent battle of liberty against injustice was not elaborated on a larger scale: it would be worth the effort. However much talent the artists have expended, one's eye is lost in these many details so close together, and since these details are so interesting, generate such strong feelings, and already elicit so many memories, they are worth representing at least half life-sized.[150]

Unlike Tardieu, Schoelcher's proposition assumes that the picture is not merely *genre*, but even in its present form a legitimate history painting. For him, the test of a *peinture*

d'histoire was the strength of its emotional impact, not whether its style or subject fit preordained categories or expectations. By acknowledging the work's larger aspirations despite its restrained size, Schoelcher realized that the Beaume/Mozin existed between traditional genre types; without explicitly naming it, he put his finger on the challenge of the genre historique.

Schoelcher's suggestion that Beaume's figures should be "at least half life-sized" raises an issue concerning the picture's structure: calculating its present ratio of figure size to image size, half life-sized figures would mean an enormous canvas over seven meters tall and ten meters wide.[151] Spreading the work's episodic narrative across such a vast surface would yield something like a panorama and would force viewers to "read" the scene by turning their heads or walking the length of the canvas. Panoramas existed in Paris long before this time, of course, and, although these huge canvases are lost to us today, their popularity and astonishing impact are recorded in contemporary accounts.[152] In fact, Louis Daguerre's Diorama opened an exhibition on 22 January 1831 representing *precisely* the scene of 28 July later painted by Beaume and Mozin.[153] Published descriptions of this spectacle indicate that Daguerre portrayed the scene under the raking light of a late afternoon sun, and some critics at the Salon noted that Beaume and Mozin "have adopted a point of view from the end of the rue du Mouton and consequently have rendered the locale from exactly the same angle as the creator of the Diorama."[154] Thus, it seems that the later painting closely resembled the popular panorama mounted by Daguerre in early 1831. More important, Louis-Philippe was especially fond of Daguerre's Diorama; he visited the installation of *The 28th of July at the Hôtel-de-Ville* before the public opening and found it thoroughly engaging.[155]

We must ask why, among the most ambitious pictures of the Trois Glorieuses, Louis-Philippe chose only those by Beaume/Mozin and Bourgeois to hang in the royal collections. The answer now seems to be twofold. First, because they are both constructed like miniature panoramas and immediately appealing for their popular art syntax of sentimentally engaging, highly veristic, episodic action: Louis-Philippe probably admired these paintings for the same reasons that he liked the Diorama. Second, both of these works show "the people" triumphant at the Hôtel-de-Ville. Louis-Philippe's singleminded selection of this specific battle means that the whole violent phase of the July Revolution was reflected in official imagery by the 28th of July at the Hôtel-de-Ville. Obviously, this strategy sets the stage for the king's own triumph there on 31 July and, by extension, for an imagery which could show him taking charge of the popular revolt to head a new government. We will discover that this is precisely the line of explanation which official iconography—formulated under the king's watchful eye—would eventually present as the "true story" of the 1830 Revolution.

We know that the July Revolution occurred in two phases: a popular, violent one waged in the streets, and an elitist, diplomatic phase engineered by professional politicians. It should come as no surprise that Louis-Philippe would direct the arts toward consecrating the second phase, the one responsible for installing the Orléans monarchy. The first major commissions personally awarded by the king went to his long-favored artist Horace Vernet, who was director of the French Academy at Rome when he was asked to paint two scenes from the annals of July: *The duc d'Orléans Arrives at the Palais-Royal, 30 July 1830* (fig. 69) and *The duc d'Orléans Proceeds to the Hôtel-de-Ville, 31 July 1830* (fig. 70).[156] The latter

picture was commissioned in March 1831, to judge from a letter written by the king to his ambassador in Rome, the comte de Sainte-Aulaire. Louis-Philippe asked the count to inform Vernet of the desired dimensions and included an eyewitness watercolor by the architect Pierre Fontaine to aid the painter who, of course, had seen nothing of the revolution.[157] The other picture must have been requested later, although well before July 1832—the date of a letter from Vernet to the king in which the artist explains that he has been awaiting some further information before completing the two works.[158] The picture of 31 July was finally sent to the 1833 Salon, while that of the 30th was shown at Paris the next year.

This second picture was destined to form part of Louis-Philippe's picture gallery at the Palais-Royal—a cycle of paintings designed by the king to recount the most important historical events related to the Orléans family mansion, from its construction by Richelieu in the seventeenth century to its role in contemporary politics.[159] The sober, didactic nature of this decorative program was echoed by the prosaic literalism of Vernet's picture. A quite accurate rendering of the background street scene suggests that Vernet's request for information was filled by sending him drawings or lithographs of the site: it is the same corner reproduced in Lecomte's *Rue de Rohan* (fig. 43), with pockmarked walls and broken windows above the hatmaker's shop serving as grim reminders of the battle that had raged there on 29 July. Worker-soldiers and bourgeois gentlemen mix in discussion on the barricades, while in the next block a picket of armed citizens patrols the street to prevent looting. A diffuse glow of golden candlelight flickers from windows across the entire scene, the veristic record of how the streets were lighted in the absence of working streetlamps.[160]

The most astonishing aspect of Vernet's picture, however, is its utter lack of heroization. Although the duke's first proclamation to the Parisians had been, "I did not hesitate to come and share your danger, to place myself amidst your heroic population,"[161] we know that he had been in hiding from the 26th to the 30th of July, and that his partisans had to insist upon his presence before he would act. And, despite the duke's boast that "when entering the city of Paris, I proudly wore the glorious colors" of the tricolor, we know that he slipped into the city disguised as a bourgeois. At no point, however, did Vernet leave the banality of real life in favor of Orléanist proselytizing: transcribing the scene without embellishment, he showed the duke surreptitiously entering a side door of the Palais-Royal, completely unnoticed by the people manning the barricades.

Vernet's literalism was almost universally condemned at the Salon. Gustave Planche called it and the picture of Camille Desmoulins (fig. 139) "two vulgarities unworthy of wallpapering a village inn," while Decamps said it was painful "to witness this deterioration of a talent which was once so alive, so rich, and so inspired."[162] Even conservative critics found the work curiously unstructured and singularly unheroic and regularly described it as a genre painting rather than a history painting.[163] Yet Louis-Philippe was evidently pleased with Vernet's picture: he paid handsomely for it, included it in his gallery, and had a copy made for the galleries at Versailles.[164]

One cannot help thinking that the rupture between the work's critical appraisal and the king's appreciation of it measures the monarch's personal beliefs about how official pictures ought to work. The reviewer for *L'Artiste*, on the other hand, provided the following glimpse of how the Salon public responded to the Vernet: "We have seen many people full of

admiration in front of this canvas, where a good bourgeois, cloth hat in his hand, seemed ready to exclaim: 'Long live the lieutenant-général of the kingdom!' But such people speak of something quite different from painting. I believe that, when composing his picture, M. Vernet was also thinking of something quite apart from making a work of art."[165] The 1834 Salon opened on 1 March, only a few days after a week-long series of street fights between left-wing agitators and the police; in less than six weeks, Lyon and Paris would explode in major worker riots.[166] The king and his government were sitting atop a powder keg. One can well imagine how any image able to elicit a favorable cry from "a good bourgeois" might be thought to possess an important, albeit non-art, virtue which would affect its "official" evaluation.

Historically and politically more important than Louis-Philippe's arrival in Paris was his trip from the Palais-Royal to the Hôtel-de-Ville on 31 July (fig. 70). We already know that this personal gamble paid off handsomely when Lafayette endorsed him, and that contemporaries interpreted Louis-Philippe's triumph as a turning point in the revolution. Understandably, the king wanted to fix this memorable day for posterity: "It's a subject that I am determined to have, and quickly," he wrote in his instructions for Vernet.[167] And, in order to heighten the flattering effect while still remaining within the boundaries of historical fact, Louis-Philippe asked Vernet to paint the beginning of his trip, when the cortège was just leaving the Palais-Royal: eyewitness accounts tell us that the future king was greeted with enthusiasm near the Orléans mansion, but that as he approached the Hôtel-de-Ville the crowd became ever more hostile and even dangerous.[168] The narrative selected for Vernet would show Louis-Philippe cheered enthusiastically from all sides as he crossed the obsolete barricades with the help of now-peaceful workers.

Vernet's geographical location in Rome meant that he had to rely on secondary sources to recreate his Parisian scene. The crisp linearity with which he rendered the specific character of every column, arch, and balustrade of the Palais-Royal facade doubtless reflects the influence of the Fontaine watercolor sent to him. He probably received other verbal or visual descriptions of such salient details as the two *chaises à porteurs* visible in the crowd: the one just behind the duc d'Orléans contained Jacques Laffitte and the other, farther back, Benjamin Constant.[169] The equestrian figure of Louis-Philippe bears a strong resemblance to the picture by Eugène Lami discussed earlier (fig. 6); Vernet might have had a copy of the print variant from which to work. Although the exact sources are impossible to verify, it is certain that the mixed cast of characters explicitly rendered in the foreground—three workers, a dapper bourgeois, and a Napoleonic veteran walk arm-in-arm—was a conceit derived from one or more popular prints of the revolution (such as figure 37 or 39). Vernet took great care to extend this social mix throughout the crowd and included many women so that the duc d'Orléans would be acclaimed by all interested citizens.

Like the formal structure of humble print-images, Vernet's composition emphasizes the foreground incidents to such a degree that the historical "message"—and the duke himself—are nearly lost in the middle ground. The eye is distracted from the main character by the plethora of highly individualized physiognomies and secondary incidents: for example, the workers who struggle to open the barricade for the procession, the bourgeois in the center foreground who makes a charitable contribution to a fund for the wounded, or

the comic relief of the standard-bearer who carries the still-unfamiliar tricolor upside down, with the red band attached to the staff. As we have seen, this manner of treating contemporary history—employing popular visual forms, disconnected sentimental or moral minidramas, a precisionist obsession with incidental details, and a diffuse, non-rhetorical structure—both defined genre historique and denied many accepted expectations of history painting.

This definitional flux can be gauged from the bewilderment of critics before the picture. Gustave Planche faulted Vernet for allowing a prosaic literalism to displace so completely any poetry in his canvas that the picture destroyed his still-fresh memories of July's victory.[170] Others accused Vernet of doing just the opposite; that is, turning away from reality by trying to paint what he had not seen: "Horace did not see the July days: if he had been in Paris one would have seen him everywhere fighting like a trooper and, during the lulls, reproducing for posterity the noble actions of this three-day war.... Instead of painting from nature he has painted from written accounts, and his picture resembles those newspaper articles written by critics who have not even seen the production they are reviewing."[171] These opposing evaluations must be understood as equally genuine responses to a picture-type which could not be quantified or categorized with the standard critical vocabulary of the early 1830s. We will discover that, once the genre historique became more familiar and better understood, this apparent critical confusion disappeared.

To grasp more fully the pictorial revolution being wrought during these years, we need only consider Guillon Lethière's version of 31 July (fig. 71).[172] Whereas the crowd in Vernet's picture appears to have been arranged by chance, this aged Academic master—trained in the principles of the late eighteenth century—shaped his image with a rigorous design logic.[173] Rather than presenting the famous balcony scene preferred in popular prints,[174] Lethière chose to show Lafayette greeting the duc d'Orléans on the steps of the Hôtel-de-Ville: although chronologically before the most dramatic moment, his arrangement permits a closer integration of the protagonists and the people. Lethière's sense of design made him place Louis-Philippe in the exact center of the visual field, monumentally accented by the door opening, the large flanking columns, and the dominating presence of Henry IV in the equestrian relief overhead. Finally, despite its supposed ardor, the crowd politely opens before the duke even as the people salute him left and right with hats and outstretched arms. Add the figures in the windows and the fluttering tricolors, and one can scarcely avoid recalling David's *Oath of the Tennis Court*—an allusion which was probably not accidental (fig. 72).[175]

When the *Journal des Artistes et Amateurs* announced Aubry-le-Comte's lithograph of Lethière's picture, it noted that "one can criticize a bit the repeated parallels" in the composition.[176] Indeed, Lethière's left/right symmetry approaches the limits of credibility, even before one notices a segregation of classes in the foreground which puts workers to the left of center and bourgeoisie to the right. In the 1780s, David and his contemporaries had conceived their crisp pictorial geometries as emblems of their search for the universal truths and ideal virtues locked in nature, and next to the austere standards of David's great oaths—the *Tennis Court* or *The Horatii*—Lethière's solution might seem believable. By 1831, however, those shopworn myths of the Enlightenment were far less compelling, and a too-rigid picture structure simply lacked *naturel*. In this case, Louis-Philippe's personal

taste can best be revealed by example: even though the Crown bought sixty copies of Aubry-le-Comte's print, Lethière's original—which was owned by the king—was placed in an obscure part of the Palais-Royal reserved for the Orléans children.[177]

Understandably, 31 July remained a vivid memory for Louis-Philippe, and images of that day continued to appear in his plans for picture cycles. One such decorative scheme was outlined for the Salle des Sept Cheminées of the Louvre as a tribute to François Gérard. The king and his architect Fontaine planned to unite two of Gérard's most important pictures—*The Battle of Austerlitz* (fig. 195) and *Henri IV Welcomed by the City of Paris in 1594* (fig. 73)—and two new paintings: *The State of National Emergency in 1792* and *A Reading of the Deputies' Resolution and Proclamation of the Lieutenant-général of the Kingdom at the Hôtel-de-Ville, 31 July 1830* (fig. 74).[178] Commissions for these last two works were awarded in October 1831, but well before the first was completed in 1835 Louis-Philippe had turned his attention toward the Château de Versailles and the creation of a vast museum to commemorate every aspect of French national pride and glory (*à toutes les gloires de la France*). Absorbed by this large-scale project, the king abandoned nearly all of his plans for the Louvre, including the proposed Salle Gérard.[179]

5. *HISTORICAL REVISIONISM AND THE* SALLE DE 1830 *AT VERSAILLES*

The July Revolution was obviously destined to have a place of honor at Versailles, and near the end of 1833 work had progressed far enough to begin planning a lavish and monumental Salle de 1830.[180] One of the château's most beautiful locations was chosen for this special gallery: the former apartments of Madame Elisabeth (sister of Louis XVI) at the extreme southern end of the south wing, with views south over the Orangerie and the small lake built by the Swiss Guards and west across the flower gardens toward the Grand Canal. By January 1834, the eighteenth-century spaces had been destroyed to create one large room which would receive direct natural light from midmorning to sunset.[181] Although little more was done here until September, when work began again Louis-Philippe closely monitored its progress.

Frédéric Nepveu, resident architect at Versailles, proposed to finish the room with a mock Renaissance coffered ceiling, an equestrian statue of Louis-Philippe, and a suite of pictures retelling the most important episodes of the king's life.[182] Clearly, this loyal functionary envisioned the Salle de 1830 as an homage to the personage of his sovereign in the manner of traditional court flattery. Louis-Philippe had rather different ideas: on 18 October the king abruptly informed Nepveu that his plans were not approved, and he ordered the architect to Paris where he would receive his "definitive instructions." The next morning at the Tuileries, Nepveu learned that Louis-Philippe wanted to cap the room with an elliptical vault which would necessitate raising the ceiling well into the old attic area.[183] The evidence suggests that this expensive architectural change was prompted by more than the king's private vanity, for Nepveu tells us that near the end of a subsequent visit to Versailles, Louis-Philippe entered the incomplete room at sunset: "At that moment the only light came from the upper-story windows. After having observed very carefully the effect which the setting sun produced, His Majesty asked several times if the gallery would retain enough natural light to illuminate the large paintings planned for it. I withheld any

reply and let M. Fontaine assure His Majesty that the daylight would be sufficient."[184] The king was as concerned about the quality and quantity of the gallery's light as he was with the architectural monumentality of the vaulted space, and this episode especially reveals the strong didactic impulse behind this most near and dear of the king's projects. Far from the emotional and material bombast of Napoleonic overstatement, Louis-Philippe's planning was committed to literal clarity and logical argument—characteristics to keep in mind when evaluating the painted imagery that resulted.

More important, the king also stipulated during his visit of 18 October that "pictures of the principal events of the July Revolution" would decorate the Salle de 1830.[185] Louis-Philippe's next trip to the château provides us with concrete evidence that he personally orchestrated the pictorial program, for Nepveu reports that the king traced the ensemble of pictures to decorate the gallery on the floor of the unfinished space.[186]

Gérard's partially completed picture of Louis-Philippe at the Hôtel-de-Ville naturally found a place in the Salle de 1830, although its dimensions were changed slightly to accommodate the proportions of the new space (fig. 74).[187] The scene occurs in the Salle du Trône of the Hôtel-de-Ville, where the deputy Viennet, reportedly a superb orator, read the declaration inviting "a Frenchman who has never fought except *for* France, the duc d'Orléans, to exercise the functions of lieutenant-général of the kingdom," and concluding with the guarantee that "from now on the Charter will be a reality."[188] Gérard fixed the moment just after this reading, when the duke affirmed his commitment to the measures contained in the declaration. Avoiding any direct allusion to the crowds outside—which were chanting "Long live the Republic! Long live Napoléon!" and "Down with the Bourbons!"—the picture's nearly horizontal row of heads lends the image a stilled, specific, and documentary character which emphasizes the gentlemanly agreement depicted, an expression reinforced by the inexplicable shaft of light which pinpoints the contractual text held by Viennet.

In contrast, the painting literally "marginalizes" the lack of a political consensus that day. On the extreme right, a scowling young man, whose bandaged arm evokes his role on the barricades, listens to a National Guardsman who gestures toward the center group as if explaining why the common good will best be served by the duke's arrival on the political scene. At the far left, two armed, roughly dressed witnesses push forward to hear, although the younger of them looks searchingly to the Guardsman at his side for an explanation of the evolving political situation. In the background, tricolors flutter and people perch on windowsills and furniture to catch a glimpse of the proceedings, but this suggestion of tumult is completely dominated by the center group of dignitaries, each a distinct portrait.[189] Thus, one might conclude that the picture's stylistic literalism and structural directness were designed to "seduce" future viewers into believing that this polite image presents what "really" happened, even though it is less than candid with history.[190] However, we will reserve judgment on this key issue until after the other pictures of the Salle de 1830 have been introduced.

Across the room from Gérard's picture, Louis-Philippe placed yet another image of 31 July: *The duc d'Orléans Arrives at the Hôtel-de-Ville* by Charles-Philippe Larivière (fig. 75).[191] If size is a measure of importance, Larivière's enormous canvas would qualify as the keystone of the gallery's pictorial scheme, for it completely covers the north wall of

the room and receives the best natural light throughout the day. The subject continues the story begun by Vernet's earlier picture (fig. 70) to show Louis-Philippe's reception by the Municipal Commission at the Hôtel-de-Ville: Lafayette, Dupin, and Delaborde stand outside on the steps to greet him. Larivière even seems to have reused some of Vernet's characters and anecdotal devices to achieve a kind of iconographic continuity among these official images of 1830, for example, the workers who clear a path for the future king and the top-hatted man with a moustache who leads the way. A great many portraits—generally recognizable as faces peering out at the viewer—are scattered among the crowd, and Larivière took care to include the two *chaises à porteurs* carrying Laffitte and Benjamin Constant.[192]

Larivière also tapped the folklore imagery of the July Revolution which has informed our discussion at every turn: a group of saluting polytechniciens stand between Louis-Philippe and Lafayette, the group under the central tricolor is composed of workers and bourgeois arm-in-arm, and a widow consoling her two sons provides a bit of sentiment for the immediate foreground. Finally, the way in which Larivière kept the main characters close to the viewer and spread across the canvas—a concession to "readability"—is a key structural characteristic found in both popular prints and genre historique paintings.[193] Blown up to these gigantic proportions, however, the characteristic additive structure of genre historique becomes a visual field of disconnected details—a point frequently made by critics at the Salon.[194] With Larivière's picture, then, we can begin to understand better the stylistic lineage as well as the material limits of the evolving mode of "official" painting for the July Monarchy.

Any useful evaluation of the relationship between Larivière's official image and the popular iconography of the July Revolution must take into account that during the period 1834 to 1836, when the artist worked on his canvas, that well-worn imagery wore out. Social and political schisms splintered the élan of 1830 and discredited the familiar myths of the revolution.[195] Many kinds of opposition to Louis-Philippe now flourished, from sarcastic caricatures to secret societies and even violent acts. The "September laws" of 1835 were designed to rectify what the government saw as a runaway situation: an unsuccessful attempt on the king's life in July had produced eighteen deaths and a lingering horror which enabled the laws to pass by sizeable margins.[196] Two of the three measures provided for changes to jury procedures so that the government might obtain a better conviction rate against agitators. The third, most hotly debated law placed stringent new limits on the press. Whereas the declaration sworn to by Louis-Philippe in Gérard's picture guaranteed a jury trial for infractions of the press laws, the new ordinance classed all insults directed against the king, his family, or his policies as attacks against the State and henceforth subject to trial before the Chamber of Peers, not a civil jury. As a hedge against fines, publishers were required to deposit large security bonds with the government, and every engraving, lithograph, and medal had to be approved by the Interior Ministry before publication. Although abiding by the letter of the Charter's guarantee of press freedom, the spirit of the September laws was clearly repressive. Opposition orators such as Royer-Collard now accused the government of being less than frank and of promulgating "legislative fantasies where deception lives."[197]

Given this background, it is no wonder that critics at the 1836 Salon only infrequently

addressed the fiction of Larivière's huge machine, a fiction supported by the "truth" of its many portraits, its exact detail, and its appeal to the popular pictorial legacy of 1830. Following the official line used to justify the Orléans dynasty, Larivière dutifully portrayed Louis-Philippe as the only reasonable political compromise: he is cheered by the popular revolt and welcomed by the would-be leaders of a rival democratic government. But six years after the fact, many viewers saw something quite different in this familiar formula:

> In this crowd of people, most of which are good portrait likenesses, appears the calm and confident figure of General Lafayette . . . the sunlight painted by M. Larivière is exaggerated, and equally exaggerated is the good will and naive trust of many men who are now disenchanted. Paving stones ought to appear in this subject of 31 July: thus, under Louis-Philippe's feet we meet a worker with his sleeves rolled up hastening to unpile the stones and make a space for the duc d'Orléans. Unfortunately, the gesture of this man is so false and forced that he looks like a magician [*escamoteur*] in the middle of his routine. We are forced to interpret this as an allegory of the larger sleight-of-hand [*grand escamotage*] which—at about the same time—was being prepared with infinite finesse.[198]

Only by weighing the historical facts of 31 July and the circumstantial realities of 1836 can we see how official imagery had become politically artificial even as it remained rooted in an easily assimilated, popular iconography—in short, to see how it had become propagandistic. Unfortunately, the censorship imposed by the September laws prevents us from knowing how many visitors to the Salon saw Larivière's picture with Tardieu's eyes: "After five-and-a-half years, one will admit that to recount the origins of the new monarchy, to represent one of its first acts, and to dump us among the torn-up streets of July roughly jolts our memory and awakens many faded recollections—memories which surely ought to be fresh, but which have been systematically corrupted and deformed."[199] Tardieu was careful not to mention the king personally, but because we know that Louis-Philippe had a direct hand in developing the imagery for the Salle de 1830, we must conclude that, at the very least, the king approved Larivière's gerrymandering of the facts and endorsed the picture's ever more estranged imagery of 31 July.

The west wall of the gallery, perpendicular to the works by Gérard and Larivière, was reserved for Ary Scheffer's equestrian portrait of Louise-Philippe and his sons entering Paris on 4 August 1830 (fig. 8). We have already discussed how the iconography of Scheffer's portrait presents the king acclaimed by the forces of both order and revolt. My argument here, that pictorial references to the violence of the Trois Glorieuses were systematically suppressed in the Salle de 1830, might seem at odds with those earlier conclusions. A close scrutiny of documentary evidence will not only clear up the difficulty but also reinforce both hypotheses.

According to the Louvre archives, Scheffer was awarded the commission for the Versailles picture on 31 July 1835, although as an intimate of the royal family he could have been personally informed well before the commission was officially recorded.[200] The king evidently wanted a work which would resemble the artist's 1831 portrait (fig. 7) but which would show his sons to greater advantage: in the later version, the princes flank their father rather than riding behind. If 31 July is the correct commission date, Scheffer finished the picture in record time, because he was paid in full on 18 September 1835—nine days after

the "September laws" were enacted.[201] Moreover, the picture—whether completely finished or not—was already at Versailles on 17 August when the king saw a preliminary installation of the gallery.[202]

Eleven months later, Scheffer was commissioned to paint a reduced version of the portrait, for which he was paid on 4 August—the six-year anniversary of the event depicted (fig. 76).[203] This small work reproduces the large-scale picture as it was originally executed for the Salle de 1830; I say "originally" because the large picture was modified once more before its final installation in late October 1836.[204] Comparing the picture as it appears today (fig. 8) to Scheffer's reduction (fig. 76), executed during the summer of 1836 before these alterations, permits us to determine the extent of the changes. What we discover is that the right side of the image was cropped and the left side reworked: most of the workers at the right were eliminated, while the soldiers' uniforms at the left were more clearly defined and corrected (for example, regimental markings and hats were changed). These alterations effected a shift of focus which reduced the role of the people in the image while enhancing that of the soldiers. No doubt Scheffer initially designed his picture to reflect the received myth of Liberty *and* Order which had been so prominent in the jargon of July 1830. During the epoch of the "September laws"—when neoconservatism became official policy—the picture was synchronized with the "revisionist" history of Louis-Philippe's new gallery by recalibrating the popular part of the 1830 Revolution to emphasize that Louis-Philippe had been welcomed by those charged with keeping the peace.

The fourth picture in this privileged sanctuary dedicated to the new regime covers the far wall opposite Scheffer's portrait: Eugène Devéria's *Oath of Louis-Philippe before the Peers and Deputies* (fig. 77).[205] Devéria had not won the competition for a picture of this subject to decorate the Chamber of Deputies, but he exhibited his entry sketch at the 1831 Salon, where it was admired and bought by the king (fig. 78).[206] When a large-scale version of the subject was decided upon for Versailles, Louis-Philippe awarded the commission to Devéria. Devéria's sketch must have pleased the king, because the finished work includes very few changes: some costume corrections, an increase in the number of portraits, and slight adjustments to the architecture account for nearly all the visible differences. Given the static subject and the evident need to record properly the individuals present, one can hardly blame Devéria if this large work achieves little more than a literal transcription of the scene.

In one sense, the picture's political rhetoric is intimately tied to its flat-footed literalism. From their first declarations, the Orléanists touted their hero as a monarch who would accept the limits of his constitutional powers.[207] Unlike the restored Bourbons—whose claim to the throne was shrouded in the mystical concept of divine right and who benignly *permitted* a constitution and an elected assembly—the Orléans family *acquired* the right to rule by signing a legal (and earthbound) accord with France's elected deputies.[208] This no-nonsense contractual agreement—understood as the expression of the new dynasty's enlightened liberalism and the embodiment of its claim to legitimacy—could hardly find a more appropriate commemoration than in a no-nonsense, businesslike visual record.

For those who might think that a prince's word is a meager foundation upon which to build a government, the fifth image included in the cycle evoked the physical strength of the July Monarchy. Joseph-Désiré Court's picture of *The King Distributing Battalion Standards*

to the National Guard (fig. 79, pl. 3) was hung on the south wall adjacent to Devéria's *Oath.*[209] Court's painting recounts Louis-Philippe's first review of the National Guard on 29 August 1830, when almost fifty thousand guardsmen assembled on the Champ-de-Mars to receive their tricolor banners from the new king. A small picture by Etienne-Jean Dubois records the scale of the ceremony during which battalion commanders were received beneath a small canopy atop a raised platform specially erected in front of the Ecole Militaire (fig. 80).[210] The day was a grand success, as Eugène Delacroix's enthusiastic letter to his nephew makes clear: "At the review on Sunday 29 August there were already more than fifty thousand armed and newly equipped men, both infantry and cavalry, and it was really one of the most magnificent spectacles you could imagine . . . in addition to the king's sincerity, of which everyone is convinced, the general situation will be protected by the truly admirable discipline and order of the National Guard."[211] The significance of this day went beyond its pageantry, however, because the ceremony formalized the link between the new dynasty and the formidable power base represented by the armed citizens of the National Guard. Delacroix understood clearly how much Louis-Philippe's success depended upon this civilian militia, and so did Cuvillier-Fleury when he wrote of the review on 29 August:

> What a memorable day! The king, who had been elected by the Chamber of Deputies and accepted by the people on 31 July, was *consecrated* on this day (and that's the right word to use) by the cheers of those fifty thousand armed bourgeois . . . it was a great relief to have left behind the anxieties of the popular movement which had founded the new social order; in my opinion, one was free of them on the day that the armed Parisian bourgeoisie proclaimed the king. The King himself felt it, for he returned to his palace with an enthusiasm born of confidence and warmed by a feeling of well-being.[212]

The king himself reportedly embraced Lafayette after the ceremony and exclaimed, "That was worth more to me than an investiture at Reims!"[213]

There was good reason for this effusion of enthusiasm for the National Guard because, for many months following the Trois Glorieuses, it was the only organized peace-keeping force that was really respected: regular troops, policemen, and even firemen would venture out on duty only if accompanied by a squadron of guardsmen.[214] Moreover, the National Guard soon proved to be a bastion of staunch support for the new monarchy since its middle-class members were deeply committed to maintaining law and order: they insured the tranquillity of Paris during the trial of Charles X's ministers in December 1830, squashed a series of public disturbances in 1831, aided the army in putting down the June 1832 Parisian uprising, and, in addition, provided several thousand guards every day for duty at major public buildings such as the Louvre, the Bourse, and the Hôtel-de-Ville.[215] The zeal shown by the National Guard is even more surprising when we realize that no wages were paid, that members bought their own uniforms, and that a large number of them were ineligible to vote in parliamentary elections.[216]

Although the National Guard had been reassembled ad hoc during the heat of the July Revolution, it quickly became such an integral part of public order that its existence was guaranteed by Article 69 of the revised Charter.[217] A law formalizing the organization of the National Guard was adopted in March 1831; the first article of that key measure inextricably

intertwined the fortunes of the monarchy and the responsibilities of this corps of citizen-soldiers:

> The National Guard is established to protect the Constitutional Monarchy, the Charter and the rights which it accords; to maintain the respect for laws, to preserve or reestablish public order and tranquillity, to reinforce the regular army in defending the borders and coastlines, to assure the independence of France and the integrity of her territory.[218]

The law further specified that all Frenchmen between the ages of twenty and sixty-five (with certain exceptions) were required to serve a regular tour of duty. It is small wonder, given the enormous benefit he derived from the National Guard, that Louis-Philippe went out of his way during the early months of his reign to establish a close personal rapport with its members: he frequently assisted in public reviews, received numerous provincial deputations of guardsmen, invited their officers to royal balls, and adopted their uniform as his official mode of dress.[219]

Court's image of the ceremony of 29 August extends this rapprochement between the Citizen-King and his citizen-soldiers to the iconography of the Salle de 1830. Rather than opting for a vast spatial panorama and microscopic figures like those of Dubois' bird's-eye view, Court placed the viewer under the tent to afford a firsthand view of Louis-Philippe personally presenting the banners—in a sense, to recreate the ceremony in a way that most of those fifty thousand guardsmen never saw it. Like the other pictures in this room, Court's work seems to be most concerned with a direct, unembellished retelling of the story: its clear horizontal of faces, crisp detailing, and tight, polished style speak with a believable literalism. Among the portrait presences are the king's eldest sons—the duc d'Orléans and the prince de Joinville—and, on the balcony behind, the rest of the royal family. A host of other known personalities completes the scene.[220]

Again like the other pictures in the Salle de 1830, the literalness of Court's painting masks its secondary level of propagandistic meaning. In August 1830, Lafayette—not Louis-Philippe—was commander-in-chief of the National Guard. Among many sectors of the population, Lafayette's power and popularity surpassed by far the king's own, and the armed guardsmen heeded Lafayette's orders before all others: it is not surprising that the king and his ministers watched him with a wary eye.[221] The protocol for the ceremony of 29 August reflected the marquis' power by calling for the king to pass the standards to Lafayette, who in turn presented them to the battalion commanders.[222] When retracing the scene for Versailles, however, Court reversed this protocol and hid Lafayette in the background, leaving little more than his face visible (just to the king's left). This singular departure from fact exaggerates Louis-Philippe's historical role at Lafayette's expense, but, since the general had died a few months before Court received the commission, he was unable to protest the slight.[223] The picture also reflects the fact that the two men who embraced on 31 July had parted ways by the end of 1830: Lafayette's republican leanings and overtly antimonarchic entourage became increasingly unwelcome amidst Louis-Philippe's growing concern to replace revolutionary turmoil with a stable and monarchic social order. When the Chamber of Deputies, encouraged by the king's ministers, voted in December 1830 to abolish the post of commander-in-chief of the National Guard, Lafayette

resigned and henceforth allied himself with republican political groups.[224] Quite obviously, Louis-Philippe could never give the place of honor in this picture to the doyen of the opposition.

More iconographically significant is the fact that slighting Lafayette—and with him, the personification of republican aspirations—enabled the Orléans heirs to share center stage with their father. A sketch for the painting shows that Court brought the facade of the Ecole Militaire forward and nearly parallel to the picture plane in the final version—an adjustment which emphasizes the rest of the royal family by centering them above and behind the main action (fig. 81).[225] Court's pictorial reformulation of the ceremony of 29 August established the Orléans family as the focus of both the image and, by extension, the assembled guardsmen's enthusiasm. Ignoring the political crosscurrents of 1830, the picture presents the National Guard as it was defined by the law of 1831: defender of the royalty and the constitution. Rhetorically, the picture would flatter the vanity of the thousands of guardsmen who might pass through Versailles by reminding them that they were a pillar of the monarchy. And finally, placed by the king in this gallery celebrating the official myths of 1830, Court's painting would remind Louis-Philippe's political opponents on both the Right and the Left that the Orléans dynasty was built not upon shifting sands but on a secure foundation supported by thousands of armed Frenchmen.

Whereas the pictures of the Salle de 1830 discussed thus far have been reportorial in character, the ceiling decoration of this gallery is an allegorical representation of the benefits wrought by the 1830 Revolution. François-Edouard Picot was commissioned to provide three separate panels on this theme: a large centerpiece representing *Truth, Flanked by Justice and Wisdom, Protecting France from Hypocrisy, Extremism, and Discord* (fig. 82), and two side-panels imitating sculpted reliefs—*July 1830: France Defends the Charter* (fig. 83) and *The Constitutional Monarchy Preserves Order and Liberty* (fig. 84).[226] Lacking only some final touches, the three sections were in place by 17 August 1835, despite the fact that Picot had made the side-panels too small and they had to be redone by Jean-Louis Bézard.[227]

The ceiling triptych speaks with a visual language quite unlike the lower cycle of paintings. In this sphere of lofty, generalized meanings, we rediscover the idealized figural style and cryptic imagery previously seen in the aborted allegories of Blondel and Ingres (figs. 62, 63), now revived on a grand scale to serve the new regime. Picot's central panel includes three airborne figures striding over an horizon marked "France." In the middle, a nude, surprisingly sensual Truth displays her light-emitting mirror and gazes upward. She supports herself on the shoulder of Justice, a robed female who holds a sword in one hand and clasps her balance scale in the other. Supporting Truth's left arm is Wisdom, whose masculine features and armament suggest a connection to Minerva, goddess of both wisdom and war. Wisdom directs a wide-eyed, vigilant gaze toward the cowering figures who fall out of the lower right corner of the work. These are the personifications of Discord (a shadowy grotesque carrying a fiery torch of anarchy and the mask of deceit), Hypocrisy (blindfolded and clasping a back-stabbing dagger), and Extremism (who holds a staff of authority but also the chains of despotism). In the background, dark storm clouds at the right give way to sunlight (Apollo's chariot) and blue sky at the left. Here, the trumpet-blaring, winged figure of Renown brandishes a tricolor and announces the fruits of the

revolution to the world. Thus, Picot's image tells us that post-1830 France promises to be a land where truth will replace hypocrisy, wise and temperate force will supplant the repressive excesses of power, and fairminded justice will prevail where deceit and chaos had sown dissension among citizens. But the point worth underscoring here is that, while the history paintings on the walls of the Salle de 1830 explore and exploit new strategies of representation and meaning derived from popular imagery, the ceiling allegory can do no more than reiterate a familiar Academic idiom. The blame lies less with Picot, however, than with the exhaustion of his vocabulary—an exhaustion which might account for the fact that there were so few completed and convincing allegories of the July Revolution. We will return to this issue, which raises the general question of "how to do" an allegory of contemporary history in 1830, when discussing Delacroix's picture *The 28th of July.*

The conquest of national danger was also summarized by one of the side-panels flanking Picot's main composition (fig. 83). In this work, France is enthroned beneath the zodiac signs of Leo (July) and Virgo (August). She supports the Charter with her left hand and in her right wields a sword against a faltering, blindfolded figure with a crown—a personification of Charles X's blind attempt to usurp the Constitution and establish absolute personal power. On the other side, a masked figure reaches for the Charter: in the installed (second) version of the panel by Bézard, this figure's face is highly idealized, although in Picot's too-small original a grotesque, haggard face generates the idea of a grand deception (fig. 85).[228] At the extreme right, a wolf—symbol of cunning and evil—reinforces the reading that danger lurks behind the deceiving mask. Who or what does this character represent? Bézard's larger, installed panel gives us further clues: the fragments of antique column and entablature conjure up the image of a ruined classical civilization. Recalling that the wolf was also a symbol of republican Rome, this masked figure would seem to represent the republican alternative in 1830—attractive to many, but fraught with the dangers of anarchy, disorder, and ultimate ruin. Thus France, clothed in a lionskin—symbol of strength, but also of the July Monarchy—repels both of these undesirable options in favor of a third, more orderly alternative. Naturally, this choice was the Orléans dynasty.[229]

Complementing this apology for the new regime, Bézard's other side-panel celebrates its primary benefits via the theme of Liberty and Order (fig. 84). Here, the enthroned figure of Constitutional Monarchy extends her protection to Liberty, an idealized female clearly identified by her Phrygian bonnet. A pot of fire shows that Liberty brings the means to channel energy toward useful purposes. Grouped around Liberty are other consequences of her influence: a right to vote (the urn), freedom in the arts (the sculptor's mallet, chisel, and the painter's palette), and a guarantee of individual liberties (the Charte de 1830, faithfully guarded by the dog). On the other side of the composition, Order is similarly protected by the central figure. Her attributes—a baton of authority and a set of calipers—suggest that her power is never excessive but always measured according to need. Under her reasoned guidance, society will prosper (hence the bursting cornucopia) and function smoothly (note the plow and chariot in good repair, in contrast to the broken wheel next to the blindfolded monarch of the opposite panel).

Considering the highly placed origins of the Salle de 1830, there is nothing especially surprising about this flagrantly propagandistic symbolism, but the ceiling imagery does

suggest that the real purpose of Louis-Philippe's gallery at Versailles was to justify and legitimize the new regime, not to commemorate the revolution. The allegories of the triptych provide an overlay of signification which knits the historical scenes into a coherent fabric of political meaning (fig. 86). The central panel divides into two parts: to the right, in the guise of the defeated figures, allusions to the revolut.. ; to the left, Renown stands for the new political order. The side-panel of *July 1830* (fig. 83) finds its earthborn equivalent in the western end of the room, where half of Larivière's huge image and the pictures by Gérard and Scheffer embrace the viewer on three sides. France's response to the coup of Charles X (blind monarchy) was the call to Louis-Philippe (Gérard's painting, fig. 74), while the temptation of the would-be republic was laid to rest by Louis-Philippe's reception at the Hôtel-de-Ville (the left half of Larivière's work, fig. 75). And like Picot's allegory, which shows France, cloaked with the mantle of the Orléans dynasty, choosing a course between two evils, these two scenes flank Scheffer's equestrian portrait of the Orléans males being cheered most visibly by troops once loyal to Charles X (fig. 8): they are the leaders who will steer France clear of both despotism and anarchy.

The opposite panel extolling the benefits of the constitutional monarchy (fig. 84) is heralded by Renown's trumpet and the restored tricolor (fig. 86). The panel's message is echoed at the other end of the gallery, where Devéria's picture of Louis-Philippe's oath and accession is the concrete embodiment of Constitutional Monarchy; once again, the royal princes are a prominent part of the scene (fig. 77). Finally, the allegorical pair of Order and Liberty find their historical equivalents flanking the king's oath: Liberty in the harmonious postrevolutionary mingling of social classes around the tricolor in the right section of Larivière's picture (fig. 75), Order in Court's image of the National Guard, where members of that peace-keeping citizens' militia pledge their loyalty to the new royal family (fig. 79).

In the Salle de 1830, then, Louis-Philippe addressed the problem of legitimacy for both his family and his government. The gallery's decorative program makes only oblique reference to the violence of the Trois Glorieuses, while it argues that proclaiming the Orléans dynasty was the most expedient way to restore order and civil liberties without compromising France's basic form of government. Not surprisingly, Louis-Philippe used precisely the same line of reasoning to justify his "usurpation" to the other, "legitimate" courts of Europe—witness his letter of 19 August 1830 to Czar Nicholas I of Russia:

Since 8 August 1829 the makeup of the new cabinet had worried me seriously. I sensed the extent of the nation's antipathy and suspicion of this arrangement, and I shared the widespread concern about what we might expect from it. Nevertheless, lawfulness and love of order have made such headway in France that resistance to this government surely would have remained legislative had not this cabinet itself, in its delirium, authorized illegality by adopting the most brazen violation of the Charter and abolishing every guarantee of our national freedom—guarantees for which nearly every Frenchman would be ready to shed his blood. Absolutely no abuses followed this terrible struggle.

But it was difficult to imagine that some shakeup of our social state would not result from this; the same excitement of temperaments which had turned people away from serious disruptions simultaneously led them to tentatives in political theory which would have launched France, and perhaps Europe, into horrible disasters. This was the situation, Sire, when everyone turned to me. Even the losers

believed I was essential for their well-being. I was needed, perhaps even more, so that the victors would not allow the victory to degenerate. Thus, I accepted this noble and disagreeable task: I set aside every conceivable personal consideration which presented itself in order to free myself from them, because I felt the least hesitation on my part could have compromised the future of France and the tranquillity of our neighbors. The title of lieutenant-général, which left everything in doubt, provoked a dangerous lack of confidence. The temporary state of affairs had to be resolved quickly, as much to generate the requisite confidence as to save that Charter so essential to preserve—the importance of which the recently deceased Emperor, your venerable brother, understood completely—and which would have been extremely compromised if everyone had not been promptly satisfied and reassured.

The perspicacity and great wisdom of Your Majesty will not fail to grasp that, to attain this worthy end, it is highly desirable that the developments in Paris be seen in their true light and that Europe, recognizing the sincerity of my motives, surround my government with the confidence which it has the right to expect.[230]

In the uncertain months of 1830, the fiercely pro-Bourbon Czar Nicholas responded to Louis-Philippe's conciliatory explanation in a blatantly irreverent manner,[231] while the unauthorized publication of Louis-Philippe's message elicited a cry of protest from French leftists, who saw it as a confirmation of their suspicions that the king was secretly devoted to the status quo.[232] But, by the time the Salle de 1830 took shape at Versailles, the July Monarchy had established its credibility abroad and almost completely silenced its critics at home.[233] Only then could Louis-Philippe's elaborate rationale—which exonerated him of any conspiratorial motives, justified his accession, yet maintained the monarchic principle which would guarantee a throne for his son—be publicly imaged and enshrined for future generations of Frenchmen as the official story of the July Revolution.

6. *CONTEXT AND CREATION: DELACROIX'S PICTURE OF* THE 28TH OF JULY

It is not an accident that we have considered nearly every possible image-type of the 1830 Revolution before turning to the most celebrated of them all, Eugène Delacroix's *The 28th of July: Liberty Leading the People* (fig. 87, pl. 4).[234] Alone among the pictures inspired by the Trois Glorieuses, Delacroix's painting has provoked a continuous, 150-year commentary from critics and historians. I intend neither to summarize this enormous bibliography nor to preempt it. Rather, the preceding "universe of discourse" can serve as the political and pictorial context which will enable us to discuss Delacroix's picture without recourse to analysis shaped a priori by an ideological system.[235]

Delacroix made passing reference to *The 28th of July* in a letter of 12 October 1830 to his brother.[236] While he may have planned to send the picture to the special exhibition at the Luxembourg Palace, where he is listed in the fifth (and last) supplement of the *livret* with a picture entitled *A Barricade*, no reviews of the exhibition mention this subject by him; one assumes that the painting would have elicited some response had it appeared there.[237] It is more likely that even if Delacroix finished the picture in early December—as his letter of 6 December to Félix Guillemardet seems to indicate—he decided to withhold it from the Luxembourg exhibition, which was about to close, in order to present it at the more "official" Salon of 1831.[238]

I will pass momentarily over the critical reception given *The 28th of July* at the Salon to clarify a few details concerning the government's purchase of the work. One often reads that Louis-Philippe bought the painting so as not to displease republican sympathizers, but that the price of 3,000 francs—a paltry sum—was a sign of the official disfavor elicited by Delacroix's proletarian vision of the July Revolution.[239] Others report that the painting was destined to hang in the Salle du Trône of the Tuileries but, once acquired, was banished instead to some dark corridor of the Louvre.[240] This evidence has been used regularly by writers to shore up the claim that the picture was politically too dangerous to be seen by the public. Seldom underscored, however, is the fact that Delacroix's work was brought on 8 September 1831 by the Interior Ministry, not by the Crown (*Maison du Roi*).[241] This means that the picture was never destined for the Tuileries, because the Interior Ministry only purchased works for placement in the Luxembourg Museum, public or religious buildings, and provincial museums. Works of art for the royal collections—in both residences and museums—were always financed by the Crown.[242] Furthermore, it is unrealistic to presume that the Interior Ministry would clear all of its purchases with the king. In other words, to accuse Louis-Philippe of buying the picture in order to appease his opposition and then burying it in his museum's reserves is to miss the point: the king *never* showed an interest in acquiring the Delacroix, just as he had little time for most of the pictures inspired by the violent phase of the 1830 Revolution.[243] If we evaluate Louis-Philippe's spurn of the Delacroix within the larger framework of his "politics of acquisition," we see that the subject of 28 July was in itself enough to warrant his neglect, and we need not seek a reason in the manner in which it is painted or the character-types who populate it. The Interior Ministry, on the other hand, evidently bought the picture in good faith, because it was shown at the Luxembourg Museum during 1832.[244] Its subsequent removal was less a specific act than the reflection of a general trend in which growing political strife and a hardening of the government's conservatism under Périer spurred a drive to suppress all potentially seditious images.[245] This may seem a moot point, but it clarifies the relationship between Delacroix's picture and Louis-Philippe's patronage—a relationship which has recently been muddled by writers who hope to develop a political critique of *The 28th of July* without accounting for the nuances of the political situation.

To be sure, ambiguity surrounds Delacroix's motives for painting *The 28th of July*. A good place to begin a discussion of them is with the artist's own words. Writing to his nephew, with whom the barriers of pretension would seem to be inconsequential, Delacroix spoke at length about the July Revolution:

> What do you think of these events? Isn't this the century of unbelievable happenings?—we who have seen it can scarcely believe it. One should, I suppose, begin by recounting all the exaggerated stories. But if, as I suspect, you receive French newspapers, they will give you a fairly exact idea of what happened. For three days we lived amidst cannon shot and rifle fire, because there was fighting everywhere. An ordinary pedestrian [*promeneur*] like myself ran the same risk of stopping a bullet as did the improvised heroes who marched on the enemy with pieces of iron lashed to broomsticks. Up to now everything is going splendidly. Anyone with some common sense hopes that the professional republicans [*feseurs* (sic) *de république*] will agree to keep still.[246]

A simple *promeneur* during the Trois Glorieuses, Delacroix makes his desire for political calm quite clear, and later in the same letter he expresses his belief that the National Guard and the king's good faith will save the general situation.[247] It is difficult to read disenchantment or disillusionment over the outcome of the July Revolution in these lines of August–September 1830. Less than three weeks later, Delacroix requested the paints that would be used for *The 28th of July*,[248] so it seems that the picture took shape during a time when the artist's written opinions and his physical presence in the National Guard revealed support for the government born in July—hardly the circumstances under which he would have painted an image to challenge that government by espousing a left-wing analysis of the situation. Clearly, Delacroix thought that those who had made the revolution were different from him, and his letter is careful to say that he had not taken part. But, if the painter identified with these "others" when creating his image, did he also want to give them a specific *political* coloration? And, even if so, whose: his? theirs? what he thought was theirs? These are questions which we might be able to answer if we look carefully at how the picture took shape.

Many studies of the sources for Delacroix's painting have considered the issue of intention by using the traditional art-historical tools of iconographic and stylistic analysis.[249] We have seen that a favored popular image of the July Revolution combined a barricade, the tricolor, and a charging figure—usually a polytechnicien. This formula was so much a part of the iconography of 1830—and Delacroix was surely familiar with much of it—that it seems counterproductive to argue for the primacy of one source over another. Nevertheless, those prints which combine the imagery of street battles with a more celebratory résumé of the outcome—such as Bellangé's *A Man's Home is His Castle* (fig. 37) or its woodblock equivalent (fig. 38)—do unite the specific and the general in a synthetic statement similar to the spirit of Delacroix's picture, while the resemblance of Delacroix's foreground cadaver to the dead soldier in the left corner of these two images seems too strong to be purely coincidental.[250]

Yet the peculiar power of Delacroix's picture cannot be sufficiently explained by citing specific models. What triggered *this* image and not another? There is good reason to believe that popular poems, written in the élan of the revolution, helped Delacroix conjure up his vision of

> ... une forte femme aux puissantes mamelles,
> A la voix rauque, aux durs appas,
> Qui, du brun sur la peau, du feu dans les prunelles,
> Agile et marchant à grands pas ...
>
> [... a powerful woman with substantial breasts,
> A grating voice and heavy features,
> Who, with sun-darkened skin and fire in her eyes,
> Agile and striding ...][251]

Less earthy than Barbier's *forte femme*, but no less evocative, the reappearance of the tricolor also had a profound impact upon Delacroix who, like many of his contemporaries, was an enthusiastic aficionado of all that the tricolor stood for: the Empire, Bonaparte, and unfettered nationalism.[252] Thus, it is not historically impossible that the imagery of Casimir

Delavigne's *Une Semaine de Paris*—a poem evoking the ghost of Napoléon, the tricolor, and the reappearance of Liberty—might have fused in Delacroix's imagination with Barbier's vision of physical womanhood to become the image of his heroine.[253] We also know that anecdotal histories of the revolution frequently recounted the stories of young women who climbed the barricades to take part in the fighting.[254] Many of these heroines were celebrated in popular art: they figure prominently, for example, in a card game inspired by the events of the July Revolution (fig. 88) and were heralded in Delaporte's lithograph *Parisian Women of 27, 28, and 29 July* (fig. 89).[255] That such women were widely admired is revealed by one of the many published attacks upon *The 28th of July*: two argot-speaking, working-class viewers note wryly that Delacroix's Liberty looks nothing at all like Marie Deschamps, a real-life heroine.[256] The point, however, is not to insist on a one-to-one correspondence between these figures or poems and Delacroix's picture, but rather to stress the idea that this imagery—like that of social mixing on the barricades or the role of the polytechniciens (examples of both are in the Delacroix)—reflect aspects of the folklore which circulated as the conglomerate vision of the July Revolution. Wanting to paint a modern subject, Delacroix naturally invoked an imagery which would be both current and comprehensible.

That being said, the finished picture still presents a vexing riddle: while its iconography is nearly commonplace, its meaning possesses a coloration which remains elusive even today. Salon critics greeted the picture with both praise and blame couched in a gamut of political and artistic jargon which forces us to ask what they saw to warrant such responses.[257] To be sure, few people in 1831 questioned the appropriateness of the subject (the king might be an exception), but the way Delacroix reshaped this recent history generated a heated controversy. How do his characters differ from others we have seen? They differ first of all in scale, because the ratio between the size of the figures and the size of the canvas is much different from, for example, that of Beaume and Mozin's *The 28th of July* (fig. 68) or Roehn's *The 30th of July* (fig. 48). Delacroix's streetfighters fill the large canvas from top to bottom and left to right: they are giants in the visual field who possess an energy which strains the frame and is visually expressed by croppings at each edge. The viewer confronts these charging citizens close to the picture plane so that virtually no space separates us living beings from the dead at their feet. And, because the picture's perspective presupposes an eye level near Liberty's foot, the viewer is forced to take his or her place *among* the dead, on the verge of being run over by the barricade fighters. This aggressive picture, unlike the works already discussed, refuses to yield up space to a viewer/witness; rather, Delacroix's viewer runs the risk of becoming the next victim.

Suddenly, in the midst of this onslaught of dirt, sweat, and blood, Liberty appears with the tricolor. Delacroix's poetic juxtaposition of living and dead, and the stirring connotations of the flag, seem to prophesy his own words about a picture which he must have had in mind when painting *The 28th of July*:

> The village of Eylau still burns at the right ... the Russian, the Frenchman, the Lithuanian, the Cossack with a beard trimmed and laden with ice crystals, fallen one upon the other, look like little more than shapeless heaps under their blanket of snow. Here lies a useless sword close to a hand which can no longer seize it; there, the cannon upon its shattered mount and buried in the ice along with the artilleryman who perished defending the piece, and whose curved arm still encircles it. ...

This sinister painting, composed of a hundred scenes, seems to call out to the eye and mind from every side at once; but all this is only the frame for the sublime figure of Napoléon.[258]

Delacroix had no doubt rediscovered with pleasure *Napoléon Visiting the Battlefield of Eylau* (fig. 90) and Gros's other great Napoleonic paintings which went on view at the Luxembourg exhibition just as he started work on his own picture of modern history.[259] Even though Delacroix wrote about *Eylau* much later, studying the work in 1830 probably made him realize how it "call[s] out to the eye and mind from every side at once" and forces the viewer to be more than a passive observer. During these crucial weeks of planning *The 28th of July*, Delacroix certainly would have sensed anew the compelling power of Gros's rugged poetry: "Gros dared to make real cadavers . . . he knew how to paint sweat . . . close to a pile of bodies, whose forms one vaguely perceives amidst the muck, the painter reveals an abandoned rifle whose bayonet is rusted and covered with tiny blood-stained crystals of ice. I insist upon this poetry of details."[260] The enthusiasm and thoughtfulness of Delacroix's 1848 essay on Gros suggest that his admiration was long-standing: it is not unthinkable that in 1830 Delacroix, challenged artistically by Gros's newly visible works and historically by the heat of the revolution, rose to meet Gros on his own terms and to "do battle" with his idol by painting an epic canvas of modern history.

Delacroix's appreciation of Gros was always associated, both biographically and artistically, with his regard for Géricault.[261] Both the triangular structure of *The 28th of July* and the cadavers of the foreground owe a debt to Géricault's *Raft of "La Méduse"* (fig. 91).[262] The victim on the left, a worker stripped of his shoes and pants, introduces a rather shocking nudity into this street scene which led Jal to speculate ironically: "I don't at all know why he is already stripped, since he still wears a sock and his shirt; it's probably because M. Delacroix wanted to draw and paint some thighs and legs."[263] The position of this cadaver, its strangely discolored skin, eerie lighting, and location in the picture all echo the left corner figure of Géricault's *Raft*, and the remaining sock is a macabre touch which recalls the corpse held by the old man in the Géricault. The pose of the second cadaver in the Géricault seems to have been the figural basis for Delacroix's dead soldier in the center-right foreground. This figure's clothing, the uniform of a Royal Guardsman, cannot be explained simply by saying that Delacroix was concerned with historical accuracy: although the soldier's coat is correctly detailed, his mustard-colored pants in no way conform to military regulations.[264] Rather, Delacroix's halfhearted costume correctness "opens" the meaning of his figure by invoking a tragic sense which transcends the specificity of Paris in 1830 and shows how the tandem presence of Gros and Géricault could spark Delacroix's imagination while he worked on *The 28th of July*. We know that Delacroix admired the way Gros had contrasted nude flesh and military uniforms in the painting of *Jaffa* (fig. 67), especially when the uniform—emblem of power and virility—encased a weak and dying body to create a striking image of death and misery.[265] Delacroix, a dandy who fretted over the tailoring of his own National Guard uniform,[266] surely understood how a uniform both defines the man and hides his human frailty: one minute it makes him a hero-soldier of Napoléon's campaign in Egypt, the next its power shrivels when the body falls victim to a plague; one minute a uniform makes the man a guardian of peace and royal authority, the next it turns him into an enemy target, dead in the gutter and overrun by the streetfighters

of 1830. Unlike Louis-Philippe's official images, Delacroix's picture does not avoid the special tragedy of civil war, in which the Frenchman who died defending Charles X was essentially no different from the revolutionary who had killed him. What had changed was the meaning of the victim's uniform, that set of emblems which shaped his role. Delacroix graphically reminds us that, when a revolutionary destroyed a uniform without a moment's remorse, he also unwittingly destroyed the human underneath, with whom he had no quarrel. As Gros and Géricault had done before him, Delacroix sought to find with his picture of Liberty triumphant a place for human values within the annals of an ever more anonymous modern world.

Finally, might we find a special tribute to Géricault at the far right? The dead soldier only half into the picture seems to recall the painted portrait which Delacroix saw at Géricault's studio in 1823 (fig. 92).[267] Delacroix's soldier wears the same uniform and has the same finely chiseled nose, broad eyebrows, moustache, and mutton chops of the Géricault. The fact that among the drawings for *The 28th of July* this figure is only represented by a glove-study—the one detail not in his friend's picture—tends to reinforce the idea that Delacroix worked from an existing image.[268] When recounting his visit to the dying Géricault on the day he noticed this portrait, Delacroix drew a morbid contrast between the emaciated body of his idol, who could no longer "turn himself one inch in bed without the help of someone else," and the powerful beauty of the art around him, "which had been made with all the vigor and reckless energy of youth." Clearly, *The 28th of July* is propelled by a dramatic clash of life and death and saturated with memories of Géricault's greatest picture: in these circumstances, Delacroix's thoughts would have easily returned to one of the last times he saw Géricault alive and to the picture which had so impressed him that day.

If Géricault and Gros dominate the foreground of *The 28th of July*, they do not dominate the image. Delacroix was not so enamored of his two heroes that he abandoned criticism, and he especially faulted Gros's tendency to let the carnage of his foreground "take over" the composition. Writing about *The Battle of Aboukir* (fig. 175), he noted: "Another drawback, which one would be even more justified in pointing out in the *Battlefield of Eylau*, is the imprecision and grossly exaggerated scale of the foreground figures. Gros lacked the savoir-faire to mask the importance of the foreground, and these figures capture our attention at the expense of the main action: this part of the painting requires the greatest finesse when arranging the overall effect."[269] To avoid this fault in his own picture, Delacroix made his standing figures larger than those in the foreground and linked them to the lower corners of his canvas with a pronounced triangular design. The result is a spatial compression which literally pushes the middle ground toward the viewer. Upon this ambiguous terrain, we find those characters who elicited the most hostile comments at the Salon: "the people" of Paris, aggressive and very much alive. Who are they?

Curiously, few studies for any of these figures survive—if they ever existed—and those that we do have are for the most part fragmentary and incomplete.[270] Because the 1830 Revolution coincided with an important lapse in Delacroix's *Journal*, we can only speculate whether this "ordinary pedestrian" made sketches of the "improvised heroes who marched on the enemy with pieces of iron lashed to broomsticks."[271] Somewhat better armed in his picture, their physiognomies, details of dress, and vital energy are so suc-

cinctly captured that Delacroix must have thought about them a great deal—or had help. Where might he have discovered "the secret of joining grandeur to sincerity ... when representing everyday subjects whose models are right before us"?[272]

A most convincing answer to this question can be found in the work of Nicolas-Toussaint Charlet, about whom Delacroix would write in 1862, "by depicting only soldiers, workers, and urchins of Paris, he was able to discover quite striking differences in manner and dress ... far from being caricatures, these are veritable portraits which only lack names."[273] Especially significant is the fact that shortly after the 1830 Revolution Charlet published his own version of 28 July, titled *The Allocution* (fig. 93).[274] The points of contact between this lithograph and Delacroix's painting are striking: a partial view of Notre-Dame over the rooftops at the right, the rubble of a barricade and a tricolor backdrop for the figure who, like Liberty, grasps a rifle and turns to encourage his troupe. This relationship is even more apparent in the characters themselves, for a remarkable family resemblance exists among Delacroix's saber-rattling figure at the far left, the weaponry of Charlet's leftmost figure, and the physiognomy and dress of the man who holds the tricolor in the Charlet. The same can be said of Delacroix's suitcoated rifleman and the comparable figure by Charlet—even down to the jaunty angle at which each wears his top-hat and scarf. Furthermore, Delacroix's top-hatted combatant brandishes a hunting rifle of the same sort which Charlet's group leader grasps so boldly.[275] Delacroix rehearsed Liberty's grip on her weapon with two sheets of drawings, each containing a partial sketch of this rifle drawn vertically on the page—as if he had been copying directly from *The Allocution* by Charlet.[276] There are changes and adjustments, to be sure; for example, Charlet's central young man wearing a fez and a wide-eyed look is moved to the far left of *The 28th of July*. The young man with pistols silhouetted next to Liberty is an amalgam of Charlet's group leader (the short-barreled pistols and open-mouthed expression) and the vested youth under the leader's arm. Delacroix's character sports an important added accessory: his ammunition sack, supposedly stolen from a Royal Guard, was derived from one of the few sketches made by Delacroix of actual military details (fig. 94).[277] Thus, the visual evidence suggests that the specific characters and their special "earthiness" depend less upon the painter espousing a particular political cause than upon his profound admiration for Charlet, an artist he later compared to the two great literary masters of character, Molière and La Fontaine.[278]

Because we have been especially concerned with the exchanges between "high art" forms and popular imagery in 1830, the Charlet seems a perfectly appropriate model for Delacroix. There is among certain art historians, however, a lingering reluctance to admit that Delacroix might have been inspired by the plebian imagery of popular prints or by so humble an artist as Charlet: the most recent studies of *The 28th of July* all but ignore *The Allocution* in favor of arguing for dubious high art prototypes such as LeBarbier's 1778 picture of *Jeanne Hachette of the Siege of Beauvais*.[279] Similarly, it has seemed more palatable to explain away any perceived relationship between Delacroix's picture and popular prints by simply suggesting that both were grounded in a real-life experience of the July Revolution.[280] This argument, which makes the painter a kind of proto-Realist, has been supported in the past by a drawing in the Fogg Museum that carries Delacroix's signature and represents the popular episode of Arcole charging the bridge near the Hôtel-de-Ville (fig. 95).[281] A recent analysis of ink types, however, has cast doubt on the attribution

of the Fogg sheet and, by extension, on the idea that *The 28th of July* was originally inspired by an episode witnessed firsthand.[282] The structure of the Fogg's drawing also argues against an attribution to Delacroix, for it resembles many of the print images we have discussed in the way the figures are kept close to the front plane with the narrative fragmented and strung across the width of the sheet. Within this shallow space, the emphasis is on individual figure-types and physiognomies, while the level of detailing and focus drop off sharply as we move into the space across the bridge. In other words, to assume that the relatively unstructured, yet carefully detailed Fogg drawing is the springboard from which *The 28th of July* was launched runs counter to all that we know about Delacroix's method of composition: to seek first the general form and only later add the descriptive detail.[283]

Indeed, there is no equivocation in the structural underpinnings of Delacroix's picture, for it is clearly organized by a large triangle, its apex in the tricolor and clenched fist of the heroine, its baseline formed by the foreground cadavers. Nor is there anything revolutionary about this structure: Blondel (fig. 62), Ingres (fig. 63), and Picot (fig. 82) all built their allegories upon a similar triangular armature. What must be stressed, it seems, is Delacroix's singleminded commitment to a pictorial syntax intimately linked to the high art seriousness of history painting as practiced by the Academy, despite his supposed "outsider" status as a Romantic painter.[284] Recent research, which reveals that *The 28th of July* was built upon ideas that had been germinating for almost a decade, further reminds us that Delacroix's manner of working was to pass the immediate experience of 1830 through a filter of the traditional strategies of heroic history painting.[285] As a result, *The 28th of July* is as much a critique of his own earlier attempt to forge a monumental art from the facts of modern history—his 1827 picture of *Greece on the Ruins of Missolonghi* (fig. 96)—as a record of the July Revolution.[286]

Far from decreasing the importance of Delacroix's picture, this optic allows us to grasp both its immediate historical context and the extent to which it was a watershed work in his career. Although he was pressed by the recent revolution to energize *The 28th of July* with contemporary events, Delacroix literally did not know how to stalk everyday life in the streets of Paris. Charlet, on the other hand, was a master at rendering contemporary events in a way which Delacroix easily understood as "art." When we recognize that Charlet functioned as a "cultural mediator" for Delacroix by standing between the street battles of 1830 and the enterprise of creating a Salon painting, we can grasp more clearly Delacroix's essential commitment to the idea that "high art," whether inspired by current events or not, must *reform* those events and not merely relate them. Understanding the kind of role played by Charlet in the generation of Delacroix's image also helps to explain why the extant drawings for *The 28th of July* form such a fragmentary set. Charlet's earthbound characters could be of little help to Delacroix when he struggled with that point in the picture where a real-life character actually *sees* Liberty, where the historical reality of 1830 meets with an invented, incarnate ideal. Not surprisingly, the number of drawings for Liberty and the figure at her feet far exceeds that of any of the others and suggests that this synthesis was especially difficult to master.[287] Delacroix had skirted the same problem in his earlier picture of *Greece on the Ruins of Missolonghi* by eliminating all the survivors.[288] His stubborn return to it in *The 28th of July* testifies to another, more urgent struggle which

was an invisible but central reason for wanting to paint a barricade: Delacroix was asking himself whether it was still possible, using the established strategies and ambitions of high art, to represent contemporary history. We have already discussed how this question was faced by other painters using the hybrid picture-type of *genre historique* and how the doctrinaire Ingres simply dropped his project for a picture of 1830 and never returned to modern life as a subject. Delacroix's attempt to reassert the privilege and priority of traditional history painting was a unique, heroic effort in the aftermath of the 1830 Revolution and one which was, as we shall see, doomed to failure.

We have not yet addressed the issue of whether it is politically significant that Delacroix fashioned his Liberty as a working-class woman (*femme du peuple*). The question is actually less important than it originally appears and a definite answer remains virtually impossible to obtain. Among Delacroix's drawings for the picture, however, Liberty's appearance is exclusively divine and otherworldly: her features are idealized and her drapery suspiciously antique in character, although the turbulent figure is already depicted bare-breasted (fig. 97).[289] Only in the finished picture does Liberty appear in strict profile—an indication that Delacroix made crucial decisions about her appearance *while painting*.[290] Delacroix was particularly concerned with pictorial harmony, and we know that he defined this goal in a broad way to include both style and content.[291] Delacroix's concept of harmony would never permit a clean-scrubbed, idealized figure of Liberty to appear in the midst of a barricade battle. Should we be surprised, then, to find that his Liberty—surrounded by the dust and blood, powder and people of the July Revolution—shares this environment? In the final analysis, the question of Delacroix's political intention ultimately turns on whether he painted a *femme du peuple* as Liberty in the interest of politics or Liberty as a *femme du peuple* in the interest of art. Given our present discussion, neither the artist's own words nor the picture's elaboration can recommend the first alternative.

Obviously, this line of reasoning does not preclude the possibility that the cultural encoding of Delacroix's picture would generate a spectrum of politically motivated responses, especially in the contentious social climate of Spring 1831. My argument, that *The 28th of July* belongs as much to Delacroix's struggle with the issue of how to make a "modern art" in 1830 as with the events of 1830 necessarily limits the possible benefit that might be derived from sifting and sorting Salon criticism. To be sure, the analysis of critical writings can tell us a great deal about the Salon public of 1831, but as an attempt to crack the code of the picture's politics it is a futile, positivist activity: because the picture addressed more than an historical event, it signified polyvalently, and it was acclaimed or condemned by critics all across the political spectrum depending upon whether they understood its specialized ambitions.

It may be more useful to turn from the written word to a consideration of the four components—or the four personalities—introduced here: Gros, Géricault, Charlet, and Delacroix himself. Delacroix knew these artists personally and admired them openly. They, like him, were children of the Empire, enamored of its memory and its tricolor banner.[292] They had put their art in the service of a heroic nationalism that the young Delacroix longed to emulate. In May 1824 he had written: "I felt a need for painting of the real world; the life of Napoléon would furnish subjects. . . . The life of Napoléon is the epic poem of our century for all the arts! But one must get up in the morning."[293] One must get up in the morning to

face the world of the "new" Ancien Régime, the restored Bourbons. When his *Death of Sardanapalus* was sharply criticized at the 1827 Salon, Delacroix called it his "retreat from Moscow, if one might compare small things to large ones."[294] The Bourbon government's Director of Fine Arts, Sosthène de La Rochefoucauld, summoned Delacroix to a conference where the artist was told that "if I wanted to share in the government's largesse, I would ultimately have to change my style."[295] Rather than arguing with this head of official favor, Delacroix turned on his heel and walked out. He describes the result: "The consequence of this act was regrettable: no more pictures bought, no more commissions for more than five years. *A revolution like that of 1830 was needed* to pave the way for other ideas. The issue of money aside, imagine what such a forced inactivity was for me, at a time when I felt capable of covering entire cities with paintings."[296] "Other ideas"—a new government, new patrons, a new freedom of expression—were all part of the élan following the Trois Glorieuses. For Delacroix, the July Revolution meant the rebirth of an opportunity to paint the great subjects of his time and secure a place alongside those artists he admired, artists who had immortalized modern life by transforming it into an heroic art: Gros, Géricault, and Charlet.[297] Delacroix's picture of *The 28th of July* is a painting of contemporary history, but not simply a record of that history: inspired by a political event which seemed to signal a new era of liberty, it is also energized by a personal ambition which makes it a résumé of Delacroix's career, a manifesto of his belief in the privileged place of high art in culture and his declaration of artistic freedom. Little did he know that Louis-Philippe's demand for a didactic official style—derived from the literal prose of genre historique and able to fix a political meaning with the minutiae of fact—would destine *The 28th of July* to be his *last* great picture to celebrate current events with the ambitious—but politically ambiguous— high art poetry of Romanticism.

PART III

History as Propaganda: Themes of Revolutionary France in the Service of Political Reaction

1. LOUIS-PHILIPPE, HERO OF 1792

WE HAVE ALREADY NOTED that the turbulent historical events between the fall of the Bastille (1789) and the final defeat of Napoléon (1815) were systematically censored from the arts during the Bourbon Restoration. In particular, paintings and sculptures commissioned by that government tended to be religious subjects or historical episodes which championed members of the Ancien Régime.[1] Following the July Revolution, however, this proscription no longer made political sense, and tales of Napoléon and the Revolution soon abounded in literature and on the stage. The sheer novelty of these subjects following fifteen years of ostracism guaranteed wide popular success for such ventures, even though conservative circles often greeted them with reserve.[2] The July Monarchy had as many reasons to tolerate and even encourage these revivals as the Bourbons had to suppress them: established by a revolution but, as we have seen, not truly revolutionary, the Orléans dynasty sought to strengthen the illusion of change and new-found liberalism by allying itself with popular enthusiasms for the 1789–1815 era, just as it had embraced the tricolor during the Trois Glorieuses. Here we will explore the ways the July Monarchy incorporated imagery of the Great Revolution into its official iconography and ultimately redirected it to support the status quo; in part IV we will pursue a similar line of investigation with regard to the imagery of Napoléon.

We know that, from the first Orléanist manifesto to appear in Paris on 30 July, partisans of the duc d'Orléans took great pains to emphasize the fact that their hero had fought under the tricolor of the first Republic and had never betrayed his allegiance by joining the émigré armies against France. As duc de Chartres, Louis-Philippe had played important roles in two battles won by General Dumouriez in 1792: at Valmy (22 September) and at Jemmapes (6 November). These were the first important victories of the young Republic's volunteer army against her European enemies, and they held a mythic place in French history well into the nineteenth century.[3] Shortly after these triumphs, however, Louis-Philippe's military career was shattered by the behavior of his general: Dumouriez

was appalled by the execution of Louis XVI (21 January 1793) and secretly plotted with his Austrian enemies to march on Paris, overthrow the National Convention, and reestablish the monarchy. Although not an active participant in these machinations, Louis-Philippe was aware of them; when the plot collapsed he was accused of treason and forced to flee with Dumouriez into exile.[4] Despite this unhappy turn of events, Louis-Philippe retained fond memories of these two victories, and during the Bourbon Restoration—when talking of 1792 was scandalous behavior for a prince—he commissioned Horace Vernet to paint *The Battle of Valmy* (fig. 98) and *The Battle of Jemmapes* (fig. 99) for the gallery of the Palais-Royal.[5]

The two pictures achieved a politically charged fame in 1822 after they were refused by the Salon jury because of their revolutionary subjects but exhibited by Vernet in his studio.[6] We know that Louis-Philippe's participation in these battles was used to justify his allegiance to the tricolor and to link him to the complex nationalist feelings which erupted at its reappearance in July 1830, and both *Valmy* and *Jemmapes* were conspicuously reexhibited at the 1831 Salon as a rhetorical gesture to highlight the changes in the political and artistic climates wrought by the July Revolution.[7] It was not an accident that Vernet's pictures figured prominently within the images commissioned by Louis-Philippe to commemorate the events of July which had occurred at the Palais-Royal: his signature of the act making him lieutenant-général, by Court (fig. 100),[8] and the two paintings by François-Joseph Heim illustrating his call to the throne by the Deputies (fig. 101) and the Peers (fig. 102).[9] Amidst the solemn splendor of the Palais-Royal gallery, Vernet's familiar battle scenes provided a discreet commentary upon the future king's republican pedigree.

Even though political cartoonists like Daumier would one day mock Louis-Philippe's repeated invocation of Valmy and Jemmapes (fig. 103),[10] the aura of these military exploits still served the king well in June 1831, when he made a trip through the provinces and visited the Valmy battle site. Near the rebuilt windmill which he had defended (and close to the tomb of General Kellermann), an impoverished veteran who had lost an arm in the famous battle appealed to the king for aid. Moved by the man's situation, Louis-Philippe removed his own Legion of Honor ribbon and presented it to the veteran amidst a general public acclaim.[11] When Jean-Baptiste Mauzaisse was commissioned by the Interior Ministry to paint this touching scene of memories and devotion, the completed picture was sent to Carcassonne (at the opposite end of the country) in an apparent attempt to spread far and wide word of the king's good will (fig. 104).[12]

It is evident that Mauzaisse's scene of royal solicitude situates Louis-Philippe in the same pictorial tradition as Hersent's *Louis XVI Distributing Alms to the Poor* (fig. 105), Lafond's *Clemency of His Majesty the Emperor in Favor of M^lle de Saint-Simon* (fig. 13), or *General Bonaparte's Entry into Alexandria* (fig. 14) by Colson.[13] But comparing the Mauzaisse to these earlier works also permits us to gauge its unique character. We find, for example, none of the crushing movement and exaggerated supplications of Colson's picture—characteristics reminiscent of Gros's *Eylau* (fig. 90) which nearly mask Napoléon's gesture of clemency for the family at the left. The glassy precision and stilled movement of Lafond's work is closer in spirit to the Mauzaisse, although Lafond retains a peculiar drama with his strange polarity between a rearing horse and a pathetic woman. Hersent's Bourbon Restoration painting, on the other hand, pushes a saccharine, neo-Greuzian sentiment to an

extreme by showing Louis XVI elbow-to-elbow with his hapless subjects and relieving their midwinter misery. This is a transparently propagandistic image which illustrates the unlucky king's supposed generosity toward the most common of Frenchmen so as to emphasize the wrong that was committed by sending him to the guillotine.

Quite unlike these three images, the picture of Louis-Philippe at Valmy *appears* remarkably free of pictorial rhetoric, even though its subject was politically charged. Anecdotal subplots (like the soldier shooing the children at the far right) and a host of picturesque "country types" among the crowd tend to fracture the narrative into a series of discrete episodes. Where Louis XVI and Napoléon each occupy the pictorial focus of their respective canvases, Louis-Philippe is subjected to the earthbound, piecemeal representation of his image: his mount remains perfectly tractable and the king is nearly lost amidst the crowd and the expansive landscape. In short, the modestly sized Mauzaisse offers a combination of style and structure in the service of contemporary history which differs rhetorically from earlier, thematically related configurations and corresponds to what we have called *genre historique*. The history of this commission can also illustrate how the emerging "official style" of the July Monarchy was partly dependent upon the character of the subjects selected by the administration, because the Interior Ministry had originally awarded the picture of Louis-Philippe's Valmy visit to Delacroix. Apparently uninterested in painting the prosaic news bulletin of the king's voyage in France, Delacroix never began the work; rather, he spurned the government's offer in order to pursue a more private vision, and departed for the exoticism of Morocco.[14]

2. *THE COMPETITION OF 1830 TO DECORATE THE CHAMBER OF DEPUTIES*

Touting Louis-Philippe's youthful exploits of the 1790s invoked the French Revolution as a means of enhancing Orléanist claims to the throne. This tactic—strictly personal in character and limited by the extent of the king's participation in the heroic past—soon became little more than a repetitive jingoism fixed on Valmy and Jemmapes. Rather more interesting are the iconographic schemes which sought to interweave the events and ideals of the Great Revolution with those of the 1830 Revolution so as to explain and legitimize the latter within the heroic historical framework of the former.

The most ambitious of these programs was developed to complete the decoration of the Salle des Séances for the Chamber of Deputies at the Palais-Bourbon. The renovation of this assembly hall, which is still used today, was initiated by Charles X in November 1829.[15] Jules de Joly, resident architect of the Palais-Bourbon, designed the new room as a hemicycle of desks descending to the president's rostrum, an interior arrangement which provided for a long wall behind the speaker's platform (facing the deputies' desks) to support paintings and sculpture.[16] The Bourbon government planned to embellish this prominent space with a decorative program celebrating the benefits of the Restoration, and the monarchic message was to be anchored with colossal statues of Charlemagne and St. Louis.[17] Obviously, the 1830 Revolution rendered this project obsolete, and the July Monarchy moved quickly to formulate an iconography which would reflect the changed political situation and the ideology of the Orléanist regime.

On 25 September 1830, François Guizot, Louis-Philippe's first Minister of the Interior,

obtained the king's approval of subjects for three of the five paintings destined to hang in the Chamber of Deputies.[18] Predicting that the important location of these major works would be certain to "provoke the competitive spirit of the most distinguished artists," Guizot proposed that recipients of the commissions be decided by a competition (*concours*) so as to "avoid special claims and satisfy everyone's ambitions." The idea also responded to the libertarian aspirations which circulated during the first months of the new regime, when many artists believed that the Institut's long-established monopoly over the most lucrative commissions would at last be broken.[19] A few months later—and with the hindsight of experience—almost no one wanted to renew the competition experiment: Delacroix railed against the practice in an open letter to *L'Artiste*, bureaucrats of the Direction des Beaux-Arts condemned the 1830 concours in their reports, and even Guizot later implied that it had been imposed upon his better judgment.[20] Whatever his true feelings, Guizot's plan was remarkably democratic: each competition was judged separately by a jury composed of seven government-appointed members, eight selected by the contestants themselves, and six more chosen by the first fifteen. The jurors could be artists or collectors, and all of the sketches presented for each competition were publicly exhibited for three days after the final vote—presumably to allow interested parties to gauge the wisdom of the jury's decision.[21] As Albert Boime has shown, these reasonable operations masked an intense struggle between entrenched Academic interests and the more liberal, independent ideas of artistic methods and criteria which circulated outside the official art establishment.[22] While it must be admitted that the administration's choices for its seven jurors—two politicians and five members of the Institut—suggest the government was doing its best to confine the decision making to the smallest possible circle, these issues of art politics are not central to our purpose.[23] Rather, we shall discuss the 1830–31 concours by outlining the selected subjects, weighing some of the stylistic options suggested by the range of entries, and, finally, analyzing the political meaning behind Guizot's decorative program for the legislative chamber.

The first subject is already familiar to us from the Salle de 1830 at Versailles: Guizot specified that the ceremony of Louis-Philippe's oath on 9 August would occupy the place of honor (above and behind the speaker's rostrum) in the Salle des Séances. A sign of both the inviolability of the Constitution and the moment of the new monarchy's birth, Louis-Philippe's oath was doubly qualified to symbolize the new era which began for France in 1830. But the political importance of the king's oath—the contractual binding together, for the common good, of the new monarch and the nation's elected representatives—demanded that both the deputies and the oath-taker be shown. This programmatic constraint to illustrate the protocol-bound, formal ceremony offered few opportunities for dynamic visual effects and presented the artistic problem of rendering hundreds of figures "uniformly decked out in a hopeless black suit and symmetrically ranged on the benches of an amphitheater."[24] Nevertheless, twenty-six artists submitted sketches of this subject before the closing date of 1 December.[25]

It is important to note how recent memory tended to condemn those sketches which deviated too widely from the experienced "reality" of 9 August. Antoine Ansiaux's allegorical representation (now lost) was thought to have abandoned the idea of winning in advance, because the situation demanded real history (*la véritable histoire*), not inven-

tion.[26] Similarly, Félix Auvray's sketch was doubly faulted for its exaggerated departures from "truth": on one hand, because Louis-Philippe seemed to dominate the assembly inordinately and upset the contractual balance; on the other, because the deputies' unbridled enthusiasm was inappropriate to the requisite solemnity of the moment (fig. 106).[27] One critic pointedly remarked that some painters "have thought that the poetry of the subject consisted of loading their sketch with a lot of movement, many raised arms, and friends embracing one another. This proves that they knew David's sketch for *The Oath of the Tennis Court* but that they were not present at the royal séance, where the enthusiasm would have had a completely different character."[28] The implication—that artists should be inspired by life more than art—alludes to the tension between fact and convention which was an important force in the evolution of an official style after 1830.

Most of the artists who participated in the first competition avoided this problem by confining themselves to a straightforward transcription of the ceremony of 9 August. Since few painters were present that day, most of the contestants had recourse to written descriptions—like those in *Le Moniteur Universel*—or similarly reportorial images of the room and the participants.[29] Popular prints therefore played an essential role in the elaboration of many sketches: for example, Blanc's lithograph of the ceremony (fig. 107) may have influenced directly the way Joseph Court (fig. 108) interpreted the scene.[30] Despite the fact that the viewpoint, characters, poses, and architecture of Court's lithograph seem derivative, his sketch was praised for its lack of pretension—an indication of the degree to which critics allied artistic merit and narrative accuracy.[31] The same criterion of truthfulness emerged clearly in the critical response to Eugène Devéria's sketch (fig. 78): "What one wants above all from a historical painting—we are not speaking about a History Painting—is truth. We ask all those who were at the royal séance to remember that day: who saw these svelte, trim, and elegant physiques with which the painter has endowed our representatives? One would have trouble finding such a charming group of fashionables in a club for the rich and famous: these ministers dressed in the very latest 'look' and so exquisitely posed."[32] The same writer goes on to fault the "sixteenth-century color," the "stylish women" in the galleries, and the "warm, rich tones" of Devéria's sketch which "everyone would like to see elaborated as a painting, but whose subject could just as easily be the next ball at the British Embassy as the accession of the King of the French." In this case, Devéria's *style* is attacked by appealing, whether explicitly or implicitly, to the "reality" of 9 August as remembered by the participants. Our discussion of genre historique in part I emphasized the growing importance of "literalness" as a critical value. The texts generated around the 1830 concours reveal that a double standard of truth—one for "History Paintings" and another for "historical paintings"—shaped contemporary evaluations of an important picture that few would hesitate to label historic in the most noble sense of the word. Over the next few years, Louis-Philippe's repeated requests for pictures like the *Oath* would redouble the pressure on this traditional, two-tiered critical schema and ultimately collapse it by forcing the recognition of a new modality of government-sponsored history painting.

A glimpse of this evolution is already evident in the picture executed by the winner of the first competition, Amable-Paul Coutan (fig. 129).[33] Situated among the deputies, we are drawn into Coutan's scene by the many faces turned to meet our eye, while Louis-Philippe's

nonchalant pose and self-confident expression add to the projection of intimacy and common purpose which supposedly characterized the social pact being solemnized. Obviously, a degree of artistry and arrangement selected this particular viewpoint and collapsed the barnlike spaces of the meeting hall so that both actors and witnesses might remain close to the picture plane and clearly visible to the viewer. But this tampering with nature is masked all across the surface by a painting style which renders each detail and the peculiarities of every physiognomy with an obsessive concentration. The resulting image seems to move in two directions at once: while the structure appears fortuitous and nonhierarchic, the handling exhibits a tightly controlled, microscopic vision of the world. It is no wonder that this giant group portrait astonishes us today with its "pre-photographic" look, even down to those faces who turn away from the main action to fix their places in the visual record.[34] At once intimate and familiar, Coutan's arrangement makes programmatic sense if we recall that the picture was designed to hang in the Chamber of Deputies: both incumbents and newcomers to the Chamber would be perpetually welcomed and invited by this group of colleagues and predecessors to take a place in the "clubby" gathering which had launched the July Monarchy.

More important to our purpose is Guizot's selection of two episodes from the French Revolution to flank the picture of Louis-Philippe's oath. The subject of one—drawn from the annals of the Estates-General of 1789—recounted the Third Estate's refusal to disperse when ordered to do so on 23 June by the marquis de Dreux-Brézé, Louis XVI's master of ceremonies. The political significance of Guizot's choice can only be appreciated, however, if we understand the historical background of this moment.[35] Under the Ancien Régime, French society was divided into three orders: Nobles, Clergy, and the Third Estate, which, in theory, included anyone not in the first two. Faced with a disastrous economic crisis and a staggering budget deficit, Louis XVI convoked the Estates-General—an assembly of representatives elected by the three orders—to rectify the problems by instituting reforms in government spending and taxation. While the king hoped to retain the traditional organization of this assembly by orders (a caste system of rank and privilege which placed an inordinate amount of power in the hands of the Nobles and Clergy), the bourgeois members of the Third Estate—among whom Enlightenment ideals of equality and freedom were sacrosanct—sought recognition as equal social partners and were ill disposed to be the servile rubber stamp of the king's wishes.[36] The Estates-General, soon mired in procedural questions of voting and verifying credentials, became a test of wills which pitted the orders against one another. Newsletters sent by Third Estate representatives to their home districts spread the word of the parliamentary impasse and, in general, electors encouraged their delegates to hold firm.[37] In an effort to unblock the situation, the Third Estate proclaimed itself a National Assembly on 17 June and immediately preempted the power to fix and collect taxes. Three days later, when members of this assembly arrived at their usual meeting place in the Hôtel des Menus-Plaisirs at Versailles, they found the hall locked and guarded. Rumors of the king's intent to dissolve the Estates-General had been circulating freely, and the delegates concluded that the unannounced lockout was a deliberate step toward that end. Moving to a nearby tennis court (*jeu de paume*) they took a common oath "never to disperse, and to meet wherever circumstances might require, until the Constitution of the kingdom is set up and supported by firm foundations."[38]

Louis XVI had no intention of permitting these impertinences to become policy

without a fight. At a royal session of the Estates-General on 23 June, he presented a detailed set of ordinances designed to reassert his authority. The king declared that the acts of the National Assembly were null and void; ruled that, although the Estates-General could vote by head (as the Third Estate representatives had demanded) in certain cases, the traditional orders and privileges must be retained; and proposed a number of important reforms which guaranteed personal liberties and freedom of the press, reorganized the tax system, the militia, and the courts, and empowered the Estates-General to establish a national budget. But the conciliatory tone of these concessions, blanketed by a presentation which stressed that they were the king's last offer, was overshadowed by the specter of privileges still granted to the Nobles and Clergy. Finishing his speech with a threat to dissolve the Estates-General if they refused to submit to his will, Louis XVI commanded the three orders to reconvene separately the next day and then summarily walked out of the hall.[39] In the ensuing silence, the Nobles and most of the Clergy hastened to leave, but the angered Third Estate refused to move. When the marquis de Dreux-Brézé reminded the delegates that they had been ordered to disperse, Mirabeau—fulfilling the pledge he had made on the tennis court—dramatically responded: "Go tell your master that we are here by the will of the people and will only be removed by the force of bayonets!"[40] Thus Mirabeau's reply not only represented the first time that the National Assembly openly refused to obey the king's authority but also demonstrated the Third Estate's resolve to reject any solution which did not redress the inequalities of France's social stratification. Since the king remained firmly committed to maintaining the traditional hierarchies, the breach in royal authority opened on this day became a crucial moment in the unfolding of the French Revolution.

It should be obvious that, since the importance of Mirabeau's refusal to obey the king was so intimately linked to external historical conditions, any artist who hoped to capture this significance in one image would face serious problems.[41] Not surprisingly, most of the thirty-eight artists who submitted sketches before the deadline of 1 February realized that a high degree of historical exactitude might offset the dearth of dramatic action.[42] The extant competition entries show that painters regularly consulted eighteenth-century engravings of the Estates-General to establish the veracity of their architecture and detailing. The flat ceiling, oval window, and royal canopy of Delacroix's sketch (fig. 109), for example, follows closely Helman's print of the assembly hall (fig. 110), although the overall space is much reduced in the painting.[43] Moreover, the crisp drawing style, careful finish, and muted coloration of Delacroix's sketch show that he was forced to make important adjustments to his personal style in order to capture the specific details which were essential to any rendering of the otherwise actionless subject. Delacroix's shift is strikingly apparent when the presentation version is compared to his preliminary study of the subject—a small work of broad effects and a bold painterliness (fig. 111).[44] While the abrupt change in manner seemingly announced by Delacroix's competition entry was greeted with an evident self-satisfaction by conservative critics,[45] his stylistic compromises were not sufficient to carry the day in the concours. One important reason is that Delacroix's image lacked the episodic readability (*lisibilité*) which was thought by critics to be an essential part of the enterprise:

> In our opinion, the viewer must understand the following when looking at such a picture: that the meeting hall of the Constituent Assembly had once contained the King, the Clergy, and the Nobles; that the King has just left, and that both the Clergy and Nobles have followed him; that only the Third Estate has remained; that the

Chief of Protocol arrives to deliver to this part of the assembly the King's order to disperse, and that Mirabeau answers him: Go tell your master, etc. Thus, any picture which will not render the subject very clearly by its arrangement and by the gesture accompanying the words—which the painter obviously cannot make audible—will have missed the mark.[46]

Imagining the subject as a series of episodes is quite unlike the "significant moment" usually sought by Academic history painters, but it is exactly the kind of image obtained by the "additive structure" characteristic of genre historique painting. In this case, critics apparently felt that the subject itself required such a treatment, and here we see once again how the critical parameters of history painting could be realigned in response to new types of subjects. Delacroix, for his part, made numerous anti-Romantic stylistic concessions in preparing his sketch, but he retained a traditional sense of composition which focused on one moment and a single action: even his partisans wished he had been "more energetic, more varied in the arrangement of his figures, more picturesque."[47] Delacroix's failure to please with his Mirabeau sketch further suggests that the evolving critical issues cannot be reduced to a neat dichotomy of such surface aesthetics as "sketch" versus "finished."[48] I argued in part I that history painting was itself being redefined so that accepted patterns of style and structure, subjects and patronage were undergoing simultaneous and interdependent modifications. We will ultimately discover that this total reorganization gave rise to a critical schema in which the old categories of *peinture d'histoire* (that is, History Painting) and *genre historique* were stylistically and functionally indistinguishable from one another.

A survey of the reception given other Mirabeau concours sketches can clarify the emerging critical framework. Alexandre-Evariste Fragonard apparently also turned to prints dating from 1789 while preparing his entry (fig. 112), because the immense barrel vault enclosing his version of the assembly hall seems inspired by Moreau's engraving of the Estates-General (fig. 113).[49] But Fragonard sought to resuscitate the static narrative by turning the scene into an eerie fantasy of light and shadow in which Louis XVI's throne is nearly lost in the darkness beneath the enormous semicircular window while an impossible shaft of light spotlights the two protagonists. Although the artist took pains to capture the exact moment—the throne and the ministers' chairs are empty, but some Nobles and Clergy are still in their seats—he violated decorum by standing Mirabeau unceremoniously on a bench amid the waved hats and excited gestures which second the orator's famous refusal to disperse. Predictably, critics ignored Fragonard's efforts at exactitude to dwell on his "effect of fantasy, which should be barred from an important historical subject so close to us in time that it has all the advantages—or, one might say, the disadvantages—of concrete facts which do not need the help of overly imaginative special effects. In this work neither the room nor the men in it have the look of truthfulness appropriate to the representation of an historical text."[50]

A similar charge was leveled against Paul Chenavard's version of 23 June, but in this case critics pointed to a too radical atomization of the narrative rather than specifics of details or surface texture (fig. 114).[51] Only a small part of the assembly hall is visible in Chenavard's nightmarish version of the scene, and figures roam freely through this fragment of space, some listening to Mirabeau's response, others talking in small groups. In the

background, several workers busily dismantle the throne—a sign that no more compromises with the monarchy are possible—while Mirabeau confronts Dreux-Brézé in the foreground amid overturned benches, animated gestures, and a general chaos. Chenavard's sketch tends to dissipate the principal action because nothing in the overall design directs the viewer toward the critical interchange: if critics admitted that the work lacked neither verve nor movement, they also found it "confused, lacking a focus of effect and interest."[52] Finally, when Farcy discounted the fact that many of Chenavard's characters were recognizable portraits and suggested that the painter nevertheless "can expect the award for the bizarre and eccentric" rather than for the commission, he registered the acceptable limits of decorum, beyond which even historical veracity was unable to offset the work's unbridled fantasy.[53]

Joseph Court's sketch for the Mirabeau competition contains many of the same episodes as the Chenavard, but it is more hierarchically organized so that the anecdotal subplots—such as the three men drafting a text in the left corner, the monk at the right, or the workers dismantling the throne—remain peripheral to the primary action (fig. 115).[54] The sketch, structured with the same "high art" pedigree used by David in his *Consecration of the Emperor Napoléon* (fig. 176), locates its two main characters in profile at the center of the visual field, bathes them in bright light, and allows the potentially distracting foreground to drop off into shadow. Mirabeau's black suit cuts a dramatic silhouette against the sunlit background galleries, while Dreux-Brézé's crimson coat and white stockings stand out against the sombre dark suits of the Third Estate onlookers. Finally, Mirabeau's resolve is expressed not only by his gesture but also in his placement before the background column—a conceit which tends to cast the orator as a pillar of strength against the monarchy. Unlike Chenavard's strategy of atomizing the narrative, Court clearly orchestrated the color, lighting, and layout of his sketch to maximize the visual impact of Mirabeau's dramatic act. Since this would seem to be exactly what the subject demands, it is surprising to read the critics' remarks that "M. Court could have been less theatrical" and that "there is pomp in his overall composition; maybe even too much."[55]

Within our necessarily restricted analysis of the interplay between recorded history and pictorial invention, the thematically similar sketches of Chenavard and Court can be seen as fixing the formal and narrative limits deemed acceptable by the critical standards of 1831: whereas Chenavard moved too far toward personal invention and lost the essential action, Court emphasized the story but stayed so close to standard formulas of representation that his effort seemed artificial and theatrical. The sketches and comments generated by the Mirabeau competition suggest that concern for the eternal or poetic possibilities of the prescribed story—aspects traditionally touted as central to the most ambitious painting by artists on both sides of the Romantic/Classic controversy—were now less important than the task of clearly retelling the facts. By grouping Fragonard's fantasy work with the Chenavard, recognizing that Delacroix's austere composition is as tradition-bound as Court's, and laying out our four examples in a hypothetical spectrum from the aesthetically most conservative (Delacroix) to the most imaginative (Fragonard)—with the works of Court and Chenavard bracketing the middle range—we can predict what the preferred candidate might look like: it should provide a historically accurate rendering of the setting and chronological moment with an accent (but not to an extreme) on the indignation of Mirabeau's response.

In fact, the picture executed by Auguste Hesse—the winner of the Mirabeau con-cours—falls within the expected middle sector of our stylistic schema (fig. 128).[56] Like the other entries discussed here, his work exhibits a high order of historical and visual re-search. Hesse adopted, for example, the coffered barrel vault, Doric colonnade, and royal canopy of the 1789 engraving by Moreau (fig. 113), and the most clearly visible of his figures are carefully studied portrait likenesses: his Mirabeau is a near-copy of the orator's ap-pearance in the full-length portrait painted by Boze in 1790 (fig. 116).[57] Hesse undoubtedly justified this overt borrowing on the grounds that the Boze was an authentic period-piece, and his point would have been strengthened by one of the pamphlets—titled *Reponce à M. Le Marquis de Brézé*—placed by Boze near Mirabeau's feet. For modern viewers, this kind of borrowing raises questions about originality which apparently did not trouble painters of the period: a fact we must keep in mind when attempting to evaluate these works historically.

Accompanying Hesse's diligent search for the truth of casual details is a reverential respect for the separate parts of the story. The empty throne in the background certifies that Louis XVI has already left the room. Nobles and Clergy head for the exit to freeze the pictorial time at the moment just following the end of the séance, while the Third Estate delegates are still seated—stupefied by the imperious tone of the king's discourse. Bailly rises from his chair to reply to Dreux-Brézé (who is seen from behind), but Mirabeau has already jumped to his feet and blurted out his obstinate refusal to leave, pointing to the floor to emphasize his position. The episodic structure of Hesse's picture exemplifies the read-ability demanded by contemporary critics, and its avoidance of artificially contrived con-ceits is matched by the conscientious, evenhanded rendering of Hesse's tightly drawn, no-nonsense manner. Although the image seems locked into an allover "literalism," it is actually built upon a primal concession to narrative functionalism: by locating the main characters close to the picture plane, Hesse was obliged to seat the delegates with their backs to the throne. Rearranging the room in this manner allowed the artist to keep the principal actors large and clearly visible while relegating to the background all the props needed to establish the appropriate setting and chronology. The point is that the image may, at first glance, seem more "natural" and hence more compelling than the other sketches, but it is really no closer to an "objective truth." On the contrary, the picture's stagelike structure, costume-piece allure, and narrative clarity remind us once again of Greuze's moralizing pictures, and this is significant because, as we shall discover, Guizot planned the entire Chamber of Deputies program with a specific moral lesson in mind. For the moment, we can register the *Mirabeau* by Hesse as one more major government painting which uses the formal devices peculiar to genre when relating a story inspired by modern history.

The third episode designated by Guizot to decorate the Salle des Séances was also culled from the history of revolutionary France, this time from the year 1795. Unlike the other two subjects of the competitions, this third picture promised to be full of fast-moving action.[58] Indeed, the scenario of the event was both dramatic and simple: a rioting crowd invaded the National Convention, killed a deputy, and presented his head at the end of a pike to the president, François Boissy-d'Anglas. According to legend, the president's calm sense of duty was unshaken by this savage spectacle: he saluted his fallen comrade but refused to yield his chair to the revolt. To obtain the commission for this picture, a painter

had only to render the fateful moment when Boissy-d'Anglas singlehandedly faced the insurrection and its bloody trophy. But, before discussing the pictures produced for this concours, we must supplement our thumbnail sketch of the narrative with a fuller historical account, because Guizot's reasons for choosing this particular story depend upon secondary social implications that will be comprehensible only if we are conversant with the general context of Boissy-d'Anglas' day of glory.

The bread riots of 1795 were causally linked to the coup d'état of 27 July 1794 (9 Thermidor AN II) which had toppled Robespierre's revolutionary government and beheaded him, along with twenty-one of his supporters, in a final spate of bloodshed before the guillotine fell silent and the Great Terror ended.[59] Amidst a general euphoria and sense of relief, the Convention took up the task of dismantling Robespierre's highly centralized and tightly controlled governmental machinery: bureaucrats who had implemented the Terror were purged, the once-powerful Committee of Public Safety was stripped of its authority, and freedom of worship was reinstated.[60]

On the economic front, it was believed that repealing the wage, price, and foreign-trade controls of 1793 would alleviate the serious shortages afflicting the country. Although official markets were regularly bare, the black markets (whose prices were obviously not subject to controls) were bursting with goods, and increased imports now seemed to be the only way to cover the shortfalls of French production. Few people realized that Robespierre's strictly controlled economy had served to support the value of assignats—the government's paper money—at artificially high levels. Once free-market pricing and unrestricted international trade were reestablished, the true worth of this currency became painfully apparent: during the spring of 1795, it lost over ninety percent of its face value to skyrocketing prices and runaway inflation.[61] Assignats were so worthless that both peasant farmers and city merchants refused to accept them, and they demanded to be paid in metal-based currencies with an assured, fixed value. The lower and middle classes suddenly found themselves hopelessly unable to buy provisions, while they watched unscrupulous speculators amass enormous fortunes by selling goods to those fortunate enough to hold cold cash.[62]

The result—widening famine—naturally led to social unrest, and the discontent turned political in late March, when the government brought Fouquier-Tinville (the Terror's chief prosecutor) to trial along with fifteen former members of the Revolutionary Tribunal. The *sans-culottes* of Paris' working classes, who had fervently supported Fouquier-Tinville's brand of justice, increasingly felt that the policies of the post-Thermidor Convention were specifically designed to crush the popular arm of the revolution by starving the masses and denouncing their leaders. Throughout the spring of 1795, workers took to the streets under the slogan "Bread and the Constitution of '93"—graphic evidence of how material and political issues were intertwined during this difficult period. Crowds formed nearly every day in the working-class neighborhoods of Paris to circulate petitions calling for an end to the food crisis and government repression. On 1 April, a mob led by women demanding bread invaded the National Convention: it was quickly dispersed by National Guardsmen summoned from the wealthy western sections of the city, and the government reacted by ordering the arrest of left-wing deputies and imposing martial law in the capital.[63] Fouquier-Tinville's execution on 7 May further angered the people, and

plans for a major demonstration were openly prepared during the next ten days. On 19 May, an anonymous pamphlet which outlined the program and the modus operandi of the imminent uprising appeared throughout Paris under the inflammatory title *L'Insurrection du peuple pour obtenir du pain et reconquérir ses droits*.[64]

Early the next morning (20 May), the tocsin sounded throughout working-class sections of the capital.[65] Led by women, crowds bearing an assortment of weapons ranging from pikes to cannons converged on the Tuileries about eleven o'clock—the hour when the Convention normally opened its session. The women attempted to pack the galleries but were removed by guards. Just past noon, the growing crowd stormed the Convention, but troops brandishing whips turned back the attack. They regrouped, and in a second assault crashed through a door to the Chamber and reached the Convention floor before a contingent of National Guardsmen from the wealthy Grenelle district managed to force them out without any bloodshed. Finally, near four o'clock, the insurgents launched a third attack with the help of new, heavily armed reinforcements from the outlying suburbs. They charged through the broken door, burst into the hall, and were once more met by soldiers and guardsmen. This time, however, shots were exchanged and a young deputy named Féraud was killed while trying to protect Boissy-d'Anglas. In a moment of vicious enthusiasm, his body was dragged outside, decapitated, and the head placed on a pike. After parading with this bloody trophy for several hours, the crowd presented it to Boissy-d'Anglas.

Contrary to the popular version of the story, the president's calm salute of the bloody head did not end the revolt. Boissy-d'Anglas turned the president's chair over to a colleague at nine o'clock that evening, but the insurgents actually remained in the Chamber until midnight, when two fully armed columns of National Guardsmen arrived to clear the hall. Once relieved of their unwelcome visitors, the Convention voted to arrest those left-wing deputies who had sought an accommodation with the mob. Two days later, twenty thousand government soldiers encircled the faubourg Saint-Antoine and demanded that the inhabitants either deliver the riot's ringleaders or face an artillery barrage. Starved and basically unarmed, the neighborhood submitted.

The social background of 20 May reveals that the incident had roots and immediate causes which might justify its horror. If we remember that public assistance did not exist in the nearly bankrupt France of 1795, we can begin to appreciate the material plight of those who participated in the uprising. On the other hand, the political consequences of that day were of a different and far-reaching nature: sapped of its energy by famine and deprived of its leaders, the popular wing of the revolution was permanently crippled.[66] We shall presently discover that these results were of a special significance to the decorative scheme developed by Guizot for the Chamber of Deputies, where their enshrinement will illustrate how the July Monarchy reinterpreted history to further its own political ends.[67]

The Boissy-d'Anglas subject proved to be the most inspiring of Guizot's trilogy: fifty-three artists presented works for the competition before the closing date of 1 April.[68] The surviving sketches suggest, however, that the range of style and invention which characterized the first two concours was essentially repeated for the third, despite its more lively subject.[69] The desire for historical veracity was no less appropriate for this picture than for the other two, and many artists consulted available eighteenth-century engravings of 20 May 1795—notably those by Helman (fig. 117) and Berthault (fig. 118)—so that the

architecture and accessories of nearly every sketch owed a debt to one or both of these images.[70]

This borrowing is especially apparent in the works submitted by Adolphe Roëhn (fig. 119) and Auguste Vinchon (fig. 120).[71] Both of these sketches reveal a scrupulous study of Helman's engraving of the scene in the construction of the tribune, the arrangement of wall-hangings, and even the style of the assembly hall's lamps. Unlike some contestants, Roëhn was more careful to use the Helman engraving as a sourcebook rather than a model. In addition, he quite neatly wove the subject's underlying theme of "order versus anarchy" into his composition by having Boissy-d'Anglas and an open-shirted popular leader transfix one another with intense glances of unflinching confrontation only broken by the head of the unfortunate Féraud. Skillfully combining fearlessness and fascination, Roëhn portrayed the president as transfixed by the bloody spectacle and thus appropriately unmoved by the clamor around him. Not surprisingly, this sketch was thought by many to be one of the best.[72]

Rather unlike Roëhn's focused narrative, Vinchon's sketch offers a host of secondary scenarios and amusing narrative diversions. Some are culled from history: the wounded man who tries to stop the charging crowd is an officer named Mally, about whom Vinchon might have read in Thiers' *Histoire de la Révolution française*. From the same source he could have learned that the crowd had broken down a door on the president's left—a fact which explains the rubble in the picture's lower right corner.[73] The robust woman who leads the people up the tribune's steps is meant to be Aspasie Migelli, the person who reportedly performed the surgery on Féraud's corpse, and this explains why she brandishes such a large knife. To add to the tumult, a group of rioters in the background taunts the foreign diplomats who are seated in the gallery and doubtless appalled by the spectacle before them. Although several critics ridiculed Vinchon's decision to keep Boissy-d'Anglas seated at the critical moment, the artist could have justified his choice on the historical evidence of Helman's engraving (fig.117). In contrast, the character who dangles Féraud's detached head before the president seems to have been a bit of pure fantasy which graphically establishes the bloodthirstiness of the crowd.[74] But the artist saved his most flagrant caprice for the lower left corner, where two foreign agents—their presence implausible in the Convention's meeting hall—pass a few pieces of silver to a rioter and instruct him how best to disrupt the French government. Could Vinchon have been seriously suggesting that a few normally law-abiding but desperately poor Frenchmen had been induced to riot by the money of outside agitators? Charles Farcy evidently thought so:

> Another detail for which the artist deserves our thanks is to have put in one corner of the painting a poor wretch accepting money from an agitator—sent either by England or the émigré faction—to commit the crimes with which he and his kind are presently disgracing themselves. It was important to accept as true, in a picture of this type, a point which the researches of Dulaure, a scholar and patriot, have proven beyond any doubt; in this way the painting clears the majority of Parisians of any wrongdoing.[75]

Needless to say, such an addition changes the political tenor of the representation and raises a host of interpretative problems to which we shall return when discussing the overall meaning of Guizot's program.

Many of the other sketches presented for this third competition were apparently close variants of the two just discussed, although some were clearly less successful. Nicolas-Sébastien Maillot, for example, made Boissy-d'Anglas tip his hat to Féraud's head as if to bid it good morning, and the painter included a young sans-culottes playing with a toy guillotine to suggest that the crowd's bloodthirsty temperament was a deepseated childhood aberration (fig. 121).[76] At the same time, the relatively accurate architecture of this unhappy vision shows that the artist sought to build his picture upon a bedrock of historical "fact" even when his imagination lapsed into mawkish contrivances. Benoît-Benjamin Tellier's version of the story is only slightly more satisfying: his characters resemble well-scrubbed peasants more than abject city dwellers, and they so lack movement that we scarcely recognize the urban riot within this innocent procession (fig. 122).[77] Almost as afterthoughts, Tellier included a few frightened deputies and unnamed agitators at the left, along with a broken bust labeled *Démocratie*, to remind us textually of the political stakes being wagered on the floor.

Some contestants adopted what might be called a neo-Rococo manner to paint the scene with verve yet remain historically "correct" by using a style consonant with the late eighteenth-century date of the episode.[78] One sketch recently on the Paris art market harks back to the world of Jean-Honoré Fragonard with its bravura handling, pronounced highlights of pure white pigment, and figures of twisting, boneless bodies rendered in a fluid, freely brushed *facture* (fig. 123).[79] By coupling a sensually arresting surface with a configuration which places the viewer at the crowd's eye level, the author of this work seems consciously to have been striving for a solution which would win over the jury with its striking visual effects.[80] And, just three days after the Boissy-d'Anglas commission was awarded, administration officials were already arguing against further competitions precisely because a brilliant sketch by a second-rate artist might win the prize.[81] But the point to note is that the author of this example looked to the history of styles for formal guidance rather than to the aesthetically flashy methods of his contemporaries, the Romantics. In his search for a model which would serve well in the mechanics of the competition yet be factually justifiable, our artist circumvented the Classic-Romantic dichotomy with a choice which should remind us of the intellectual dangers lurking behind a too-rigid characterization of this historically self-conscious period.

In contrast, Thomas Degeorge's *Boissy-d'Anglas* is an example of how a doctrinaire Davidian envisioned the episode of 1795 (fig. 124).[82] Proceeding from a now-familiar historical accuracy in the arrangement of the room, Degeorge divided his composition into three parts: at the right, Boissy-d'Anglas surrounded by insurgents; in the center, the crowd parading Féraud's head; and, at the lower left, a rear view of the upper amphitheater seats where some frightened deputies try to flee the threatening mob. While not intrinsically unusual, Degeorge ignored the incongruities of scale and space produced by this arrangement in favor of maintaining a clear distinction between the parts—a strategy near and dear to any Classicist for whom Poussin was a model. Degeorge's crisply drawn and tightly painted figures seem frozen in place, and many ape the gestures and expressions of an Academy life-class. Their costumes are equally disconcerting: how might we explain, for example, the long, finely pleated robe and flowered crown worn by the centrally placed woman without supposing that Degeorge had antique goddesses on his mind when paint-

ing the radical, working-class women of 1795? Similarly, his bourgeois suitcoats and workers' shirts display the pleats and folds of antique togas more than the cut of modern dress. Yet Degeorge apparently was not alone in his predilection for an antique aura, as the criticism levied against the now-lost sketch sent by Guillaume Lethière, another old-guard neoclassicist, makes clear: "M. Lethière, the only member of the Academy who entered the competition, draws attention to himself with a beautiful, spacious layout and an adjustment of parts which only a man of talent can claim. But certain school habits have compelled him to endow the revolutionaries . . . with some studio poses and costumes that are half Roman."[83] Less charitable reviewers cryptically noted that Lethière "has remade his *Brutus* and in a terribly maladroit way" and that he "seems to have signed a contract for life with Brutus' toga."[84] That a painter of Lethière's professional rank could merit such a cool reception from artistically conservative publications like the *Journal des Artistes et Amateurs* and the *Revue de Paris* (neither of which even mentioned Degeorge's sketch) demonstrates that in 1831 the establishment's critical standards were already more committed to "historical truth" than to preserving the stylistic hegemony of any one school.

We have repeatedly observed that the other side of this concern for accuracy tended to limit invention, because critics invoked accuracy when condemning images in which imagination rivaled the narrative. The Boissy-d'Anglas competition was no exception to this trend: one can cite the sketches of both Alexandre-Evariste Fragonard and Eugène Delacroix as cases in point. Fragonard, we remember, had submitted a Mirabeau sketch (fig. 112) which was roundly denounced for its fantasy of expression, but his entry for the third competition manifested the same qualities (fig. 125).[85] As in his earlier sketch, a dramatic shaft of daylight boldly splits his cavernous vision of the Convention's chamber: Boissy-d'Anglas stands in the direct light and Féraud's head is portrayed in crisp silhouette against a sundrenched background wall, while in the deep shadows of the left side frightened deputies flee the people's fury. This luminary arrangement mottles the center image area to spotlight dramatically the picturesque grimaces and extreme gestures of the insurgents. The eerie emptiness of the foreground and starkness of the walls produce a strange, nightmarish aura—an effect strengthened by the viewer's low eye level. Predictably, Fragonard was accused of operating "in the imaginary realm of fiction," although the strongest criticisms were directed at his inaccuracies of costume and his overaged Boissy-d'Anglas.[86]

The issue of *lisibilité* versus *poésie* came to a head in the critical response to Delacroix's *Boissy-d'Anglas*, a picture quite unlike any of the other representations discussed thus far (fig. 126).[87] Boime has correctly argued that there is a biographical dimension to the relationship between Delacroix's *Mirabeau* sketch (fig. 109), his letter to *L'Artiste* condemning the practice of concours, and his picture for the third competition. Feeling that he had compromised himself artistically in his effort to obtain the Mirabeau commission, Delacroix vented his frustration in print and then reentered the competitive fray with a work that made no stylistic concessions to the jury's taste.[88] To modern eyes, the resulting sketch is a masterpiece of color and movement which captures the essential poetry of the moment even as it neglects to relate all the historical details.

This does not mean that Delacroix approached the prescribed subject with a cavalier disregard for the facts. On the contrary, he made a detailed drawing of the Convention's hall (fig. 127) in which the viewpoint, croppings, and accessories are exactly those of Helman's

engraving (fig. 117)—minus the figures.[89] In his final sketch, the viewpoint of this sheet was reversed so that we see the tribune from the president's left and—contrary to history—the National Guardsmen also enter the chamber from this side. Why this turnabout? Delacroix was probably aware of the fact that occidental viewers tend to scan a picture from left to right; reversing his image means that our eyes will trace the same path as the rushing rioters and be stopped—like them—by the implacable figure of Boissy-d'Anglas.[90] Thus our habits of perception physically reinforce the expressive power of Delacroix's reversed rendering of the scene.

Completely embracing the stylistic qualities for which he was so often criticized, Delacroix abandoned the tightly drawn manner of his *Mirabeau* in favor of a fabric of color woven from broadly brushed strokes to suggest rather than particularize the crowd. Especially in the background, individual faces are constructed from blobs of light-toned pigment on a darker ground—mere ciphers of figures offered to the viewer's imagination. In the foreground, discrete spots of color congeal from the background's reddish glow to become a sea of red Phrygian bonnets, red flags of anarchy, and red details on the military uniforms of the beleaguered National Guardsmen. Overhead, the reds, whites, and severely muted blues of three enormous flags introduce the national colors without disturbing the overall color balance. Boissy-d'Anglas faces the public's onslaught just beneath these emblems of the imperiled nation: his standing pose and the brilliant white of his shirt against the dark ground direct our attention to his pivotal role in the unfolding drama.

Whereas most contestants strongly emphasized the horror of Féraud's detached head, Delacroix made it but one small incident in the larger scene of confusion and disorder. Consequently, our eye is equally attracted by the confrontation in front of the tribune where a defender (perhaps Mally) staves off several attackers, or by the incident just above in which a gesticulating deputy is grabbed by the throat and pulled down from the speaker's platform. Other episodes—such as the woman hiding her face in the lower left corner, the man firing a pistol behind her, or the drummer boy near the center—show that Delacroix did not completely break with the narrative atomization of his contemporaries, nor did he establish a clear hierarchy of importance among the separate events. But Delacroix differs from his colleagues with a concern to reunify his image using the devices of high art: a radically compressed color range, pronounced orthogonals, and—most important—a visible, self-assertive, and patently biographical surface texture of paint. Expertly manipulating these accepted conventions of "serious" painting, Delacroix reasserts his belief that the material concerns of picture-making should take precedence over a journalistic concern for narrative fidelity.[91]

None of this, of course, is foreign to our received notions about the subjectivism and formal devices of French Romanticism, especially as it was elaborated by Delacroix's pictures of the 1820s.[92] But the tone taken by Delacroix's usual admirers toward his *Boissy-d'Anglas* shows that, while they had wholeheartedly celebrated his manner of painting stories from Byron, Dante, or Walter Scott, they were forced to perform feats of rhetorical gymnastics when defending his representation of recent French history. *L'Artiste* wrote, for example:

> The moment selected by the artist is a possible moment, but not one recorded by
> history. Boissy-d'Anglas, according to contemporary accounts, did not stand up and

grab his bell when he saw Féraud's head. He remained seated, unmoving and calm; he saluted the victim's head, and the specter of bayonets directed toward him did not extort a single word of fear. But the scene which M. Delacroix has understood and composed, even if it is not recorded by history, is extremely believable and consequently, for art, extremely true. To think and speak otherwise would be petty and pitiful nitpicking: if we mention it, it is certainly not to show off a vulgar and shallow knowledge of the facts, but only to head off any objections.[93]

Given the historical constraints of the commission and Delacroix's loose interpretation of the story, *L'Artiste*'s recourse to a "true-for-art" variant on an "art for art's sake" argument is good strategy, but it ignores the didactic intent of the program. Contemporary viewers were certainly free to admire or despise Byronic poetry, but no patriotic Frenchman of 1831 would have admitted that the great moments of the French Revolution lacked heroism. Consequently, Delacroix's solution was open to the kind of attack leveled by Farcy, who granted that the artist had given Boissy-d'Anglas a gesture which was "natural and ordinary" only in order to reply that "Boissy-d'Anglas had not performed an ordinary act—it was sublime. His calm was a hundred times more grand than the bravado with which M. Delacroix has endowed him. It was not worth the effort to step outside the program— and historical truth—in order to substitute something with less grandeur and nobility."[94] Similarly, the artistically conservative *Revue de Paris* praised the picture's "generous dose of poetry," but asked, "the one time that a program has recommended poetry, why repudiate the program? Why not salute this bloody head that is presented to the Assembly president? The art of painting is especially successful when it can summarize like this, with a single gesture, the action of an entire story. Hasn't the fear of conformity been a poor guide in this case?"[95] After fifteen years of Bourbon suppression, certain subjects drawn from the annals of post-1789 France seemed intrinsically heroic and capable of expressing the most lofty patriotism without the help of artifice or invention. In this context, the suggestive and sensually supercharged style of Delacroix's *Boissy-d'Anglas* seemed simply superfluous and even distracting: perhaps even Delacroix himself understood that these subjects demanded a different kind of art than he was willing to produce, for this sketch was to be his last picture inspired by an episode from modern history.

The eventual winner of the third competition was Auguste Vinchon, whose completed picture (fig. 130)[96] differs only slightly from his sketch (fig. 120). All of the subplots of the sketch were retained in the final version, including the bribery scene at the lower left. Vinchon replaced the elderly, grey-haired Boissy-d'Anglas with the historically correct image of a younger man and effected other minor adjustments to enhance the picture's truth value: even more insurgents wear red bonnets of the sans-culottes, and the background (blackened today by fire damage) once included many portraits of deputies who had been witnesses to the spectacle of 20 May.[97]

Nevertheless, the frozen poses and wealth of incidental details in this picture give it more the air of a *tableau vivant* than of an urban bread riot. We should now readily understand that the jury's selection of Vinchon's sketch involved more than the triumph of bad taste. The 1830 concours has permitted us to assemble a number of works which date from the same moment, depict the same subjects, and thus summarize how artists approached the task of painting modern history during the important early months of the July

Monarchy. We have seen that painters produced a range of sketches for each competition that cannot be described with an aesthetic continuum which links Classics to Romantics. Rather, the sketches reveal a complex of tensions existing between the forces of factual accuracy versus invention, "naturalness" versus artistic convention, and didactic readability versus aesthetic elitism. Such considerations move the discourse of discussion from purely formal issues into socially sensitive ones.[98] The winning piece in each competition displays a high regard for historical accuracy rendered in a tight, precise style and a structure that allows independent events to occur simultaneously across the image. While the victorious sketches do seem to occupy a middle ground among those presented, we should recognize that the mode of painting which they represent is not simply a compromise style mediating a supposed Romantic/Classic dialectic but an original synthesis of the social and artistic forces operating in the early 1830s. I suggested earlier that this same complex of forces had led to a dissolution of the traditional hierarchies of painting in which the higher aspirations of History Painting were ultimately fused to the special documentary concerns of the genre historique picture-type: our study of the 1830 concours has allowed us to detail the first steps of that process.

Needless to say, the issues just discussed were but one aspect of Guizot's project to decorate the Chamber of Deputies. They are clearly spinoffs of the competition but are not intimately related to the iconographic meaning of the ensemble as it was planned by Louis-Philippe's minister. Armed with a detailed understanding of the separate subjects proposed by Guizot's program, we can now turn to a discussion of why they were selected and how they relate to one another and to the political climate of 1830.

3. LESSONS FROM THE PAST: FRANÇOIS GUIZOT'S POLITICS AND THE ICONOGRAPHY OF REVOLUTION

There can be no doubt that François Guizot intended to invest the decorative program for the Salle des Séances with a didactic message, for his "Report to the King" of 25 September 1830 clearly states that the subjects had been chosen with an edifying purpose in mind: "Wanting to submit my ideas to Your Majesty for approval, I thought I should limit myself to our legislative history during the French Revolution. It is there that the deputies ought to look for role models, and there that France, pressing forward to hear her deputies, will find reasons for a commitment to constitutional institutions."[99] In light of its problematic legitimacy, the July Monarchy was especially eager to promote an aura of legality by means of historical example.[100] Guizot's invocation of the French Revolution continued the pattern established by pro-Orléanist propaganda during the July Revolution. On one level, any images celebrating events long-censored by the Bourbons would have registered the idea that a new era had begun for France. More profoundly, linking the government of 1830 with the world of the Great Revolution could transform the politically charged sentiments generated by the tricolor's return into an approbation of the new dynasty by suggesting that, when France chased the Bourbons from the throne, she not only recovered the spirit and ideals of a lost age but also fulfilled the historical destiny first charted by the liberal leaders of 1789.

These allusions were an especially prominent component of the July Monarchy's

logic of self-justification during the first months of its existence. Guizot reiterated them in a major policy address only twelve days before announcing the Chamber of Deputies decorative program. "Thanks to the conquests of 1789," he declared, "the social state of France had been renewed; thanks to the victory of 1830, her political institutions received in one day the principal reforms which they needed."[101] We should note, however, that when Louis-Philippe's Minister of the Interior concluded that the new government had recovered the ideals of 1789, he carefully catalogued the events of July 1830 as reformist rather than revolutionary. This distinction is far from innocent, for it reveals how the July Monarchy would seek to deflect the signification of revolutionary imagery and transform it into celebration of the new status quo.

The iconography of the Chamber of Deputies program is an archetypal example of this transformation in operation. On the surface, Guizot's juxtaposition of Louis-Philippe's oath (fig. 129) with the scenes of 1789 (fig. 128) and 1795 (fig. 130) seems to suggest that the new dynasty considered itself the heir of the Revolution. But Guizot prefaced his choice of subjects with the observation that "opposition to despotism and opposition to insurrection determine the limits of a deputy's responsibilities," explained the scenes as "the two most striking examples of the fulfillment of these two duties," and justified them as "the most appropriate ones to accompany the solemn act of the king's oath"—the pact which had "closed with dignity the series of events by which our political rights are guaranteed."[102] In this new semantic context, Mirabeau's refusal to leave is no longer the opening moment of the French Revolution but an instance of legislative opposition to sovereign arrogance. Similarly, Guizot's scheme treats the economic and political causes of the 1795 riots as historically irrelevant in order to elicit a signification which enshrines Boissy-d'Anglas' resolve not to surrender his power to the forces of insurrection. Through this selective reading of history, Guizot neutralized the radical connotations of these two incidents and generated a more politically appropriate meaning to accompany Louis-Philippe's oath: far from fostering a revolutionary ardor, they became historical exhortations for the deputies to safeguard the compact formed with the Orléans family in the aftermath of the Trois Glorieuses.

The motives behind Guizot's reinterpretation of these key episodes of the French Revolution transcend a prosaic moralizing. In a very real sense, his program strove to articulate that vision of the 1830 Revolution which would most forcefully justify the existence of the new dynasty. Guizot was but one liberal observer among many who saw that any parallel between the governmental crisis of 1829–30 and the situation in France during the early summer of 1789 must account for the fact that France had changed drastically in the interim.[103] For him, the real revolutionaries in 1830 were, not his Liberal friends, but those members of the Court who would deny the social progress made since 1789 by analyzing the situation in 1830 as if it were a replay of a past in which France was still attached to the old order of king and nobility. Guizot understood that Charles X had asked Polignac to head the cabinet because the king was "worried, not only about the security of his throne, but also about what he felt was his inalienable right to the Crown," and that when Charles turned to the Ultras for support the issue became "a question of political dogma and a point of honor between France and her king."[104] For Guizot, Liberals were not to blame if similarities existed between Louis XVI and Charles X, because Charles had

foolishly obeyed "his Ancien Régime obsessions" and polarized the nation along the same dangerous proroyalty-antiroyalty lines which had prevailed in 1789.[105]

Charles certainly seemed to view his situation as analogous to that of his brother. While weighing with his ministers the pros and cons of a coup d'état, he remarked, "Unfortunately, gentlemen, I have more experience than you. You were not old enough to be able to evaluate the early days of the Revolution. I remember what happened. Louis XVI's first concession signaled his ruin . . . if I give in to similar demands we will all suffer the fate of Louis XVI. We will not be led to the scaffold, but we will die fighting."[106] Charles X responded to these pressures with the same attitude shown by Louis XVI toward the Third Estate. His ordinances assumed his absolute right to rule and to impose his wishes upon France's elected representatives. Emulating Mirabeau, Guizot and his colleagues refused to submit to the caprice of royal will which hoped to disband the Chamber: "On 30 July we went to the Palais-Bourbon, gathered in the assembly hall of the Chamber of Deputies, and invited our absent colleagues to join us there to reestablish the branch of government of which we were the scattered members."[107] Reclaiming their share in the political process, the deputies urged the duc d'Orléans to assume the post of lieutenant-général of the kingdom and cast Charles as the villain by adopting a political rhetoric which stressed that "an authority which would usurp our rights and disturb our peace was threatening both liberty and public order."[108] The deputies had justified their actions in July by claiming to resist tyranny; in September, Guizot's project to cast Mirabeau as the ideal deputy historicized and legitimized their claim.

Only a week passed, however, before the same deputies declared the throne vacant and invited Louis-Philippe to rule.[109] In light of their stand against Charles X, we might reasonably ask why these politicians proved eager to retain the monarchy and install a replacement king. Whether or not rooted in fact, Guizot's own reasons for choosing the Orléanist solution are relevant as background to his decision to pair the Mirabeau story with that of Boissy-d'Anglas in the Chamber of Deputies. In his memoirs Guizot summarized the 1830 situation: "It is neither reasonable nor fair to ignore the real causes of events when one no longer feels their pressing urgency. The necessity which weighed on everyone—royalists as well as liberals, the duc d'Orléans as well as France—was the need to choose between the new monarchy and anarchy. In 1830 this obligation was the deciding factor, among honest men and independent of the role played in it by revolutionary passions, for a change of dynasty."[110] The logic of Guizot's argument turns on the assumption that the bloodshed of the Trois Glorieuses risked becoming uncontrollable if some semblance of power was not promptly established. Always the historian, Guizot drew his lesson from the past, because no true patriot would have wanted the revolutionary violence of 1792–94 to be repeated in 1830. Guizot's line of reasoning was shared by other Orléanists—Laffitte used it on 29 July in his attempt to elicit a positive show of support from the duc d'Orléans, and Thiers reiterated it on the 30th in appealing to Madame Adélaïde d'Orléans at Neuilly—and we know that it became part of Louis-Philippe's official proclamation to the Parisians on 31 July and an entrenched component of the July Monarchy's rhetoric.[111] The underpinnings of Guizot's position are obvious: the politicians who ultimately profited from the new dynasty viewed their course of action as a means of short-circuiting the revolution in the streets, because their much-feared anarchy was none other

than the specter of Paris' rebellious workers left to their own resources. This had been exactly the attitude of the Thermidoreans toward the sans-culottes, and in 1830 the government of 1795 (of which Boissy-d'Anglas had been a prime mover) was remembered more for having ended the Reign of Terror than for its disastrous economic policies. Guizot's ideological position would have encouraged him to read Boissy-d'Anglas' legislative resistance to anarchy as both the prefiguration and the historical excuse for founding the Orléans dynasty in 1830.

At this juncture, we should review Guizot's own précis of the July Revolution. He emphasized that "it was asked to complete an important liberal advance and to erect a legal and reassuring power," and that "France wanted a revolution which would not be revolutionary and which would give it, all at once, public order with liberty."[112] Proceeding from this understanding of July 1830, we recognize in Guizot's three images a covert, history-invoking legitimization of the legislative maneuvers which created the Citizen-King. At the left, Mirabeau's defiant response to Dreux-Brézé becomes the prestigious historical model for the deputies' refusal to submit to the ordinances of Charles X. On the right, Boissy-d'Anglas' refusal to yield to the rioters of 1795—a key moment in the Thermidorean effort to contain the political power of the working classes—is an irreproachable exemplar of the 1830 power-brokering which strove to erect quickly a government capable of staving off the tide of anarchy. These two events chronologically bracket a dark moment in the history of France when foreign invasions and the guillotine cast long shadows over the land. In Guizot's plan for the Salle des Séances, however, the specter of the Great Terror never materializes; rather, the episodes of revolutionary France which flank the oath of Louis-Philippe generate an important secondary signification by suggesting that the nation had learned the lessons of history and did not make the same mistakes in 1830 that she had made in 1792. Writing to Nicholas of Russia in defense of his accession, Louis-Philippe emphasized that "absolutely no abuses followed this terrible struggle" of the Trois Glorieuses; with a parallel rhetoric, Guizot's carefully orchestrated pictorial program recast the specifics and the allusions of French revolutionary history as an elaborate apologia for the new regime.

Sculptural decoration for the Salle des Séances was conceived to reinforce the conceptual bridge between the historical subject matter of the paintings and the propagandistic signification of the ensemble. Guizot announced the iconographic program with a politically charged commentary which made his intention clear: "At each side of the picture destined to represent the conclusion of the social pact, two allegorical statues of women expressing the two fundamental ideas of our constitution: Liberty, Public Order."[113] For reasons now obvious, the colossal statue of Liberty was destined to stand between the images of Louis-Philippe and Mirabeau, while Public Order would take her place alongside Boissy-d'Anglas (fig. 131).[114] *France Lavishing Its Patronage on the Sciences, the Arts, Commerce, Agriculture and Industry*, an allegorical bas-relief located beneath the picture of the king, summarized the material benefits promised by the new monarchy.[115] Smaller bas-reliefs at each side of this large central work depicted two important moments in the founding of the new government: beneath the statue of Liberty, Etienne Ramey's sculpture represented *The Arrival of the duc d'Orléans at the Hôtel-de-Ville*; under Public Order, a pendant relief by Louis Petitot showed *The King Distributing Battalion Standards to the*

National Guard.[116] According to Guizot, the first subject illustrated "how the new dynasty came to support the ideal of liberty," while the second was selected so that "the idea of public order would receive its most complete and accessible expression."[117] Although somewhat heavy-handed, Guizot's juxtapositions vividly demonstrate how the new government used the event of 31 July at the Hôtel-de-Ville as proof of its popular investiture and courted the loyalty of the National Guard as its best guarantor of social tranquillity. These same significations were discussed in part II apropos of the Salle de 1830 at Versailles, but they were first explicitly articulated in the Chamber of Deputies as part of a coherent system of meaning and decoration in which the act of creating the July Monarchy—a precarious mix of rebellion, legislation, and repression—was heralded as the historically appropriate and practically expedient solution to the political crisis of 1830.[118]

4. ODILON BARROT'S IMAGERY FOR THE HOTEL-DE-VILLE

The Chamber of Deputies program was an especially costly and complex ensemble, but it was not the only instance of the authorities sponsoring pictorial schemes which would argue the legitimacy of the new dynasty with the rhetoric of revolutionary France. As early as 15 August 1830, plans were circulating for a cycle of paintings to hang in the Hôtel-de-Ville, and when originally announced, it consisted of four episodes from the July Revolution: *The Attack on the Louvre, The duc d'Orléans and Lafayette on the Balcony of the Hôtel-de-Ville, The duchesse d'Orléans Visiting the Wounded at the Hôtel-Dieu,* and *The Oath of the King of the French.*[119] Obviously, such subjects are simply reports of recent events and make no appeal to the Great Revolution. But in November the program was reshaped and invested with a clear political intention by Odilon Barrot, the newly appointed prefect of the Seine.[120] The unifying thread of Barrot's scheme was the Hôtel-de-Ville itself, for the pictures were to trace four episodes—two from 1789 and two from 1830—which had occurred at the city hall. Paul Delaroche was commissioned to paint *The Takers of the Bastille at the Hôtel-de-Ville* (fig. 132); Léon Cogniet was awarded the subject of *Bailly Proclaimed Mayor of Paris* (fig. 133); Jean-Victor Schnetz obtained *The Fight for the Hôtel-de-Ville, 28 July 1830* (fig. 134); and Michel-Martin Drolling's subject was *The Meeting between the duc d'Orléans and General Lafayette at the Hôtel-de-Ville* (fig. 135).[121] In light of our discussion of the Palais-Bourbon decorations, we might reasonably conclude that Barrot's pairing of 1789 and 1830 simply shares in the revolutionary revival fostered by the July Monarchy during the fall of 1830. Although this would be correct on a general level, the underlying political premises of the Hôtel-de-Ville program are rather different from those promulgated by Guizot in the Chamber of Deputies. These differences reflect diverging views about the very nature of the Orléans dynasty, and comparing the two ensembles will show how the 1789 Revolution could be used in 1830 to advance essentially incompatible political positions. An explication of Barrot's four subjects will reveal their interdependent meanings and the significance of their juxtapositioning.

Delaroche's picture (fig. 132) recounts an episode of 14 July 1789 just after the fall of the Bastille. The crowd marched from the fortress to the Hôtel-de-Ville to announce the victory to municipal leaders (the council of electors) and to hand over the marquis de Launay, commander of the Bastille. As is so often the case with Delaroche's history paint-

ings, this picture bears the imprint of conscientious historical research.[122] A young officer named Elie is carried in triumph by the crowd, much as Bailly had described the scene in his memoirs.[123] The same literary source would have indicated that the prison's silver service and register were also brought to the Hôtel-de-Ville, and Delaroche dutifully included them on the strong shoulders of two men in the left part of his picture. The wounded French Guardsman in the left-center foreground who wears a laurel wreath and is supported by two fellow citizens undoubtedly came from Thiers' version of the story.[124] Similarly, Delaroche placed at the right a grimacing worker who displays a bloodied cape in much the way Thiers had described "a bloodied hand, raised above the crowd, show[ing] off a collar buckle: it belonged to Governor de Launay, who had just been decapitated."[125] Although Elie and his accomplice Hulin had tried to save the marquis from this unfortunate fate, the angry crowd dispatched him just before reaching the Hôtel-de-Ville.[126]

Shortly after the revolutionaries entered the building, they began to hurl accusations against Jacques de Flesselles, the *prévôt des marchands* and senior municipal official. De Flesselles was suspected of colluding with de Launay by purposely refusing to supply the Parisians with arms in a stall for time while royal troops assembled outside Paris. When the insurgents threatened to hang him on the spot, he demanded the right to plead his case before the tribunal at the Palais-Royal, but he was shot and killed by a young man while on his way there.[127] Thus, Delaroche's image depicts a curiously unimportant moment of 14 July, one which includes none of the significant acts of that historic day. As we shall presently discover, however, this otherwise banal scene was essential to the political purposes of Barrot's complete ensemble.

In one sense, Cogniet's painting (fig. 133) continues the narrative begun by Delaroche. After the murder of de Flesselles, the municipal government needed a new chief, and Jean-Sylvain Bailly was appointed on 15 July by a spontaneous voice vote of the Paris electors at the Hôtel-de-Ville. Bailly, as we know, was a delegate to the Estates-General meeting at Versailles, and his presence at the Paris city hall that day constitutes a story in itself which relates to the historical meaning of Cogniet's scene.

News of the Bastille's fall convinced Louis XVI that his hard-line bargaining position with the Third Estate was not going to obtain the upper hand, especially because his troops seemed ill disposed to kill their countrymen in defense of the Crown's intractability.[128] On the morning of 15 July, therefore, the king paid a surprise visit to the National Assembly (he addressed it with that title for the first time) to announce that he had ordered a withdrawal of his troops from Paris and Versailles and that he had no intention of forcing the Assembly to dissolve. Louis asked the delegates to take his assurances to Paris and—as if charting a new direction for the future—declared, "I put my trust in you!"[129] The effect of the king's apparent volte-face was profound: the assembled delegates frequently interrupted Louis' words with applause, and they escorted him back to the château of Versailles amidst a general public approbation. Bailly himself summarized the implications of the king's discourse: "From this moment on, if one had still feared for the results of the revolution, he could now consider it a fait accompli. The king had recognized the creation of the National Assembly . . . now it was only a question of fixing the powers with a Constitution."[130] The National Assembly immediately selected eighty-eight members to announce the monarch's new policy in the capital. Word spread quickly: all along their route, the delegates were

applauded with cries of "Long live the Nation!" Once in Paris, they passed on foot from the place Louis XV (place de la Concorde) to the Hôtel-de-Ville. Throughout this impromptu parade, large crowds cheered from the curbs and windows and showered the delegates with tricolor cockades.[131]

The deputation's appearance at the Hôtel-de-Ville generated a parallel enthusiasm among the Paris electors.[132] Upstairs in the Salle du Trône, Lafayette garnered enough attention to announce the king's message of peace and to plead for public calm. The comte de Lally-Tolendal delivered a stirring plea for civil peace which elicited such profound admiration that a laurel crown was placed on his head and he was carried to the window to receive cheers from the crowd below.[133] Two important appointments then followed. First, Lafayette was selected by voice vote to become *commandant-général* of the Paris militia (soon to be called the National Guard): the marquis drew his sword, swore to "devote his life to the preservation of this liberty so precious," and accepted the responsibility of defending it.[134] Next, Bailly was named *prévôt des marchands* (the post had been vacant since de Flesselles' unfortunate end) and, in view of the sovereign municipal government promised by the now-expected constitution, his title became mayor of Paris. Lally-Tolendal passed his laurel crown to the new mayor in homage to the man who had presided at the tennis court near Versailles on the day the National Assembly had sworn to give France a representative government. Bailly modestly tried to remove the wreath, but the archbishop of Paris insisted that it remain in place.[135] This is the subject of Cogniet's picture, but Bailly's presence, appointment, and reception were all tied to a more important event: Louis XVI's new tone of conciliation and seeming acceptance—at least in principle—of a monarchy which would share the power with a body of constitutionally elected representatives.

Cogniet's elaboration of the image reveals some important concessions to the shifting political climate of the early 1830s. The museum in Lille owns an early drawing for the composition (fig. 136) in which the characters and episodes are rather differently arranged than in the final canvas (fig. 133).[136] The drawing suggests that Cogniet planned to include a figure at the right with a drawn sword, and a second sheet devoted solely to this personage indicates that he was of some importance (fig. 137).[137] An early oil sketch follows the Lille drawing quite closely and reaffirms the presence of this figure (fig. 138).[138] If we note the figure's prominent sword, the friendly handclasp which he offers to a roughly dressed worker, and the close proximity of a tricolor banner with staff capped by a Phrygian bonnet, we are led to conclude that Cogniet meant this to be Lafayette, who, as noted above, also had a role in the proceedings of 15 July.[139] We also know that Lafayette had become a persona non grata in official imagery by the end of 1832, and we should not be surprised to find his importance much reduced in the final version of Cogniet's picture, where he appears in civilian dress to Bailly's right, gesturing toward the mayor with one hand and holding a sword in the other.[140] The workers who were so prominent in Cogniet's first sketches are nearly invisible in the large painting: the shoeless young man and his elder companion (at the lower right) are the picture's only representatives of the victors at the Bastille, and they are so well-scrubbed as to be scarcely noticeable among the fine suits and powdered wigs of their neighbors. Finally, in Cogniet's drawn and painted sketches the archbishop of Paris appears prominently with Bailly, much as his role was recorded by eyewitnesses.[141] In the final version, however, the archbishop is relegated to near obscurity behind the mayor:

recalling that the archbishop's house had recently been sacked by a Parisian mob in an explosion of anticlericalism might explain why Cogniet altered his first idea. Significantly, it is only the lowly still-life—the basket of silverware, keys, and the register brought from the Bastille—which relates this picture to the pendant by Delaroche and reminds the viewer of the revolutionary context of both images. The function of this peculiar inflection will become clear when we turn to the propagandistic purposes built into Barrot's pictorial program.

As might be expected, the two pictures of Barrot's cycle destined to commemorate the events of July 1830 offer little formal or iconographic invention beyond that discussed in part II. Schnetz's painting of *The Fight for the Hôtel-de-Ville, 28 July 1830* (fig. 134, pl. 5) includes both characters and episodes championed in popular images of the July Revolution. The main figure—a young man loosely defined as a student but clearly from a well-to-do family—leads the charge over a barricade and supports a working-class comrade who, though dying, continues to grasp an enormous tricolor. To the right, we find the requisite group of disparate social classes united in combat: an urchin as an ersatz drummer boy, top-hatted heroes of the bourgeoisie alongside roughly dressed workers, and the ubiquitous polytechnicien. To the left of center, a wounded worker-combatant passes cartridges to his still-healthy colleague, and the immediate foreground displays the victims—a worker and the remarkably splayed cadaver of a Swiss Guard. Finally, the background monuments—a glimpse of the Hôtel-de-Ville's facade and the towers of Notre-Dame—localize the action at the place de Grève.

A comparison between Schnetz's picture and Delacroix's version of *The 28th of July* (fig. 87) illustrates how the two artists began with a similar narrative and general structure but ended with radically different expressions. Both painters concentrate their principal characters in a shallow slice of space near the picture plane, and both use a large compositional triangle to link figures and focus attention on the tricolor. The comparison also permits us to gauge how Delacroix's tightly framed image—in which croppings truncate both figures and flag—exaggerates the scale and energy of these revolutionaries who seemingly burst through the boundaries of the canvas. In contrast, Schnetz's figures fail to challenge the size of the frame (despite croppings at the right edge) and remain rooted in the picture-space. Finally, we can appreciate how Delacroix's decision to make his figures charge *out* of the image engages the viewer existentially while Schnetz's painting, where the action is directed across and into the picture space, never asks that the viewer be anything more than a passive observer.

The relationship established in each picture between the tenor of the compositional schema and the style is similarly revealing. Delacroix's billowing banner and animated description of Liberty's gown, his rubble and victim-strewn foreground, and the imprecise spatial relationships among combatants, cadavers, and spectators generate a collective energy of irresistible movement in his work. Similarly, Delacroix's painterly manner maintains a material unity throughout the image: from broadly brushed foreground details to smoke-blurred background vignettes, the paint surface is a continuous fabric of interwoven colorist effects. Schnetz, on the other hand, avoided these evocative blurrings by clarifying his foreground spaces, rationalizing his lighting, and tightening his contours. These tactics, and the crisp, sharp-focus style which they bring, are used to display carefully

each episode of the foreground, but they give way beyond the crest of the barricade to a shorthand manner which takes few pains with modeling, lighting, or spatial coherence. The result is a two-part image—a type familiar to us from popular prints and easel-sized pictures like Lecomte's (fig. 43)—which transforms the July Revolution into a costume piece played before a stage set.[142] It makes no sense to believe that Schnetz purposely set out to achieve this unhappy effect. Rather, comparing these two versions of *The 28th of July* reveals once again the extent to which programmatic demands for a precisely controlled readability in history paintings required that Delacroix's subjective, holistic pictorial construct be atomized into prosaic, episodic tableaux like the one painted by Schnetz.[143]

The last picture of Barrot's cycle, *Louis-Philippe and Lafayette at the Hôtel-de-Ville*, was never completed.[144] What remains of Drolling's part in the original scheme is the sketch prepared by him which now belongs to the Musée Carnavalet (fig. 135). This working study shows that both the moment and the locale of the picture were to be identical to the painting by Gérard included in the Salle de 1830 at Versailles (fig. 74). The sketch also indicates that Drolling planned to emphasize the accord between the duc d'Orléans and Lafayette by showing them in a friendly handclasp, perhaps the instant before they appeared together on the balcony and received the crowd's acclamations. Other aspects of the image—such as the National Guardsman who keeps the crowd at bay, or the prominent tricolor flag—function, as in Gérard's version of the scene, to suggest that the role of the people in the revolution was now giving way to agreements among politicians and that a regular form of government was emerging. Nevertheless, we shall discover that "the people" retained a more important role in the political rhetoric which shaped Barrot's picture cycle than either Louis-Philippe's apologia in the Salle de 1830 at Versailles or Guizot's decorative program for the Palais-Bourbon had dared to allow.

5. A PLACE FOR THE PEOPLE: BARROT'S ORLEANISM AND THE PROMISES OF 1789

Louis-Philippe's supporters were the best-organized faction to emerge from the Trois Glorieuses, but they did not always agree about the kind of government they had founded. A trivial but telling manifestation of their discord appeared around the formal publication of Louis-Philippe's proclamation of 31 July to the Parisian citizenry.[145] The duke's words, as they appeared throughout the city on hastily printed placards, terminated with the phrase *La Charte sera désormais une vérité* (from now on the Charter will be a reality). But when the text was reprinted in *Le Moniteur Universel* of 2 August, his phrase became *Une Charte sera désormais une vérité* (from now on *a* Charter will be a reality). Around this substitution revolved the issue of how one viewed the recent events: were they the beginning of a profound reform of French society, or should reform end with a simple change of dynasty? While adherents of both positions supported a constitutional monarchy, their differences hardened into antagonistic political factions: the revisionists came to be called *le mouvement*, and those who wanted to minimize the changes were labeled *la résistance*.[146] Guizot was the acknowledged leader of the résistance. Barrot, who endorsed the positions that "one should not have been afraid of expanding the results" of the July Revolution and that "it was no longer a question of continuing the Restoration, but of separating oneself from it radically," emerged as a leader of the mouvement despite his recent efforts to establish

Louis-Philippe's throne.[147] Barrot was also a close friend of Lafayette who, as noted earlier, exercised considerable personal influence in late 1830. Partly to please Lafayette and partly because he took special care during this transitional period to make potential opponents feel needed, Louis-Philippe appointed Barrot as prefect of the Seine (equivalent to today's mayor of Paris).[148] The new prefect was not content, however, to drown himself in the bureaucratic morass of running the capital; rather, he achieved popularity among the working classes by publicly espousing his liberal politics despite conservative admonitions from Guizot who, as Minister of the Interior, was Barrot's immediate superior.[149]

The two men's ideological differences became especially noticeable during the Parisian disorders of 17–18 October 1830. Louis-Philippe's government wanted to avoid executing the ministers of Charles X (Polignac and others) on charges of treason—a delicate task in light of the Parisians' desire for revenge. It was finally decided on 8 October that the deputies would "invite" Louis-Philippe to propose abolishing the death penalty, with the understanding that, if he acted before the ministers were brought to trial, his motion would be quickly approved and made law. A few days later, when this roundabout deal was announced, public anger flared. Louis-Philippe was accused of plotting to spare the traitors who had spilled the blood of honest citizens during the Trois Glorieuses. Crowds gathered in the streets, marched on Vincennes in an unsuccessful search for the prisoners, invaded the Palais-Royal, and actually reached the king's private quarters before National Guardsmen could stop them.[150]

Throughout this two-day tumult, Odilon Barrot and Lafayette treated the insurgents as if their complaints were fully justified: they openly expressed sympathy for the rioters' grievances, blamed the government for causing the situation, and tacitly recognized the people's right to demonstrate by negotiating with their leaders. When peace was restored, Guizot and his conservative colleagues in the cabinet demanded that Barrot be removed from office. Lafayette responded that he would resign (and create a messy public uproar) if that happened: the result was that Guizot resigned and Barrot stayed.[151]

These were some of the immediate circumstances and political sympathies which informed the iconography of the prefect's decorative program for the Hôtel-de-Ville when it was announced in late November. In this context, it is significant that two of the pictures commemorate popular riots and that their pendants illustrate the *positive* fruits of these uprisings. The fall of the Bastille on 14 July 1789, which spurred Louis XVI to adopt a more conciliatory tone toward the National Assembly, generated both the promise of a constitution and the enthusiasm which led to the proclamation of Bailly as mayor of Paris. In July 1830, the people had once again taken up arms, and their triumph in the streets had broken Charles X's military power to pave the way for the Orléans dynasty. Neither image of public disorder portrays the Parisians as threatening, because both episodes were purged of any compromising atrocities when retold on canvas. Thus Barrot's four paintings imply that revolt could be a positive force to effect social and political change. It need hardly be added that this allusive coloration is quite unlike the one found in Guizot's Chamber of Deputies program, where the people enact a gruesome scene of carnage and represent a threat to peace and order: far from being capable of effecting good, they represent a dangerous force which must be resisted at all costs.

More important, Barrot's pairing of incidents from the Great Revolution with those

from July 1830 also depended upon the historical arguments used by certain pro-Orléanist theorists even before the July Revolution. As early as February 1830, Thiers and others had publicly drawn parallels between the current situation in France and the political climate of England in 1688.[152] Such a comparison was tempting: like James II of England, Charles X was the second ruler of a restored monarchy and personally committed to the Catholic Church.[153] The French, just like the English, suspected their king of being subject to Jesuit and Papal influence: James had appointed Catholic partisans as his key advisers much as Charles had insisted on the Catholic and Royalist Polignac ministry. A reflection of James's decision to maintain a large permanent army—many of whom were Irish Catholic mercenaries—was seen in the hated Swiss Guards who protected Charles. In 1685, after Parliament refused to vote funds for his army and to repeal the laws forbidding Catholics to hold office, James dissolved the assembly and set the stage for revolution—an act parallel to the first of the Bourbon's infamous July Ordinances. And as with Charles's other three ordinances— whose justification lay in the belief that the king's will transcended the law—James had appealed to the concept of royal prerogative when formulating the 1687 Declaration of Indulgence, a document which essentially subordinated all laws to the king's will.[154]

George Trevelyan notes that the most revolutionary legal aspect of the 1688 revolution was Parliament's being summoned to select a king (after James fled England before the forces of William of Orange), because the English constitution presupposed accession by divine right and made no provisions for a situation without a monarch.[155] When Parliament met without a king, the primacy of law over bloodlines was established, as well as the guarantee that Parliament would be free to exercise its functions independent of royal intervention. Thus, this "second" revolution (as distinct from the King/Parliament split of 1642 which had led to civil war) codified and regularized the relationship between the two powers even as it summoned a related—but not direct—heir to the throne. "Henceforth," observed Michael Gruber, "the future of the British nation would not turn on the whims of the king, but on a vote in Commons."[156] The Orléanists of 1830 hoped to establish just this kind of relationship in France, and they clearly charted their actions according to the English model. The duc de Broglie, for example, referred explicitly to 1688 England when recalling his own concerns in 1830, and even Louis-Philippe spoke of himself as a modern-day William of Orange.[157]

Barrot's pictorial program for the Hôtel-de-Ville extended the English analogy to the visual arts by proposing that the 1830 Revolution both continued and completed the work begun in 1789. The strict parallelism of locale, the repeated presence of "the people," and the departures from Ancien Régime principles—represented by Bailly's appointment as mayor of Paris and Louis-Philippe's designation as lieutenant-général of the kingdom— imply that the two epochs were politically and strategically related. In both cases, the Bourbons are present by their absence: Bailly's "coronation" followed Louis XVI's conciliatory posture in the face of the Bastille's fall to the Parisians; Louis-Philippe's presence at the Hôtel-de-Ville was made possible by armed popular resistance to Charles X's disregard for the constitutional limits of his authority. Between these two scenes, France had tried a gamut of political experiments: the course of the great liberal revolution of 1789 had been diverted by the National Convention and the Republic, frustrated by the rise of Napoléon, and short-circuited in 1815 when the Allies imposed the Bourbons on a defeated nation.

Now, under the guidance of Laffitte, Barrot, and other Orléanist supporters, France—like England in 1688—would acquire an independent, elected assembly and a king who would respect its mandate.

It is also significant that Barrot's program represents Louis-Philippe *before* he became king. Although members of the mouvement supported the idea of a constitutional monarchy, they invoked the English model when arguing that the lieutenant-général should only rule provisionally while a national assembly—chosen by an expanded electorate—devised a new constitution and selected a permanent king.[158] Leaders of the mouvement especially objected to the summary debate and constitutional amendments hastily effected in August 1830 by a scant majority of deputies.[159] Guizot, as we know, justified this pace on the grounds that the pressing dangers of anarchy demanded it. Barrot and his friends, who believed that popular pressure was a useful political force, interpreted Guizot's haste as a conservative retreat into a status quo which feared to consult the people on matters affecting their lives.[160] This is an important reason why the Hôtel-de-Ville pictures offered a vision of the July Revolution which stopped short of acknowledging the existence of the Orléans dynasty. Barrot's four scenes capitalized upon the oft-cited historical parallels with 1688 England to link causally the Great Revolution of 1789 with the events of July 1830. His cycle implied that the ideals of the eighteenth century might yet materialize in a new, liberal form of constitutional monarchy, but it conspicuously refrained from celebrating the duc d'Orléans as king.

Finally, the personalities depicted in the Hôtel-de-Ville program resonate with the timbre of contemporary politics. No Frenchman would have failed to remember that Bailly's popularity evaporated in 1791 when he ordered the National Guard to fire upon a workers' demonstration, and that the crowd had obtained its revenge in 1793 when the ex-mayor was tried by a revolutionary tribunal and guillotined.[161] Might not the duc d'Orléans, so clearly paired with Bailly in the program, learn from history that the people do not take kindly to being doublecrossed? At the same time, the pictures of Bailly and Louis-Philippe originally featured Lafayette—the only public figure who actually participated in both episodes and who happened to be a friend and protector of Odilon Barrot. The project acquired a political notoriety from the disorders of October 1830 and Lafayette's public support for Barrot as prefect of the Seine. Originally designed to articulate the mouvement's view of the July Revolution, its imagery suddenly seemed to advocate the two entities most feared by conservative elements of the new regime: the power of the people and the marquis de Lafayette. Consequently, we should not be surprised that this ensemble never graced the Salle du Trône of the Paris town hall.

6. END OF THE ILLUSION: THE JULY MONARCHY SUPPRESSES ITS REVOLUTIONARY ORIGINS

Unfortunately, neither of the picture cycles under discussion was entrusted to artists who hastened their canvases toward completion. All three of the works for the Chamber of Deputies (figs. 128–130), for example, were begun by the end of 1831 but not finished until several years later.[162] Vinchon was the most speedy: his *Boissy-d'Anglas* was exhibited at the 1835 Salon, to mixed reviews.[163] A report filed in 1833 by a member of the Fine Arts

administration indicates that illness had prevented both Hesse and Coutan from working on their canvases, and a report from 1836 estimates that these pictures were only three-quarters completed.[164] When Coutan died in the spring of 1837, Court was selected to finish the *Oath of Louis-Philippe*, which he did in September.[165] Hesse, on the other hand, did not finish the *Mirabeau* until 1838, when it was shown at the Salon.[166] By that date, and for reasons we shall discuss below, the government had already decided that the picture would never hang in the Salle des Séances.[167]

Similar delays plagued the Hôtel-de-Ville series (figs. 132–35). Schnetz's completed picture was exhibited in its appointed space for the third anniversary of the July Revolution, and later it was shown at the 1834 Salon.[168] The painting of *Bailly* by Cogniet never appeared at the Salon, and a dearth of surviving documents makes it impossible to ascertain its completion date.[169] Delaroche finally finished *The Takers of the Bastille* in 1839 with the help of Robert Fleury and, as suggested earlier, Drolling's picture was apparently cancelled before the full-scale canvas had been advanced very far.[170]

Even as the artists inched their works forward, the designers of the two programs left the offices from which the commissions originated. Guizot, as we know, was forced out of the cabinet in October 1830 and only returned in 1832; Barrot resigned as prefect in December 1830 in order to run for a seat in the Chamber of Deputies.[171] Conceived amidst the élan of the July Revolution by politicos involved in its events, the programs were orphaned when their sponsors moved on to other responsibilities and different priorities. Yet this does not explain why neither was installed as planned: to understand that phenomenon, we must look to the evolving social context of 1830s France.

Charles Farcy, writing about Schnetz's painting at the 1834 Salon, offered the following observation:

> This important work is new proof that pictures of circumstance—those which recount contemporary political events—have little hope of lasting fame, especially when those events are rooted in civil wars. Such pictures are perfect in the first moment of enthusiasm for the winning side, but after several months temperaments cool. Just as one would not want to see civil war perpetuated in real life, so too one is disinclined to see it perpetuated in painting. . . . This is no doubt the reason why M. Schnetz's picture, originally placed in the large salon of the Hôtel-de-Ville, had been relegated to an unused room as soon as it was a question of holding a reception in the large salon. This is also why the pictures of *Mirabeau* and *Boissy-d'Anglas*, awarded by a competition and executed for the Chamber of Deputies amidst the effervescence of the 1830 Revolution, will probably never be placed there.[172]

Despite the antagonistic ideological premises of the picture cycles for the Palais-Bourbon and the Hôtel-de-Ville, Farcy speaks of them in the same breath and relates them both to an unseemly celebration of civil war. Is it possible that the political climate had changed so radically by 1834 that the revolutionary themes of the two programs—whatever their political inflections—were thought to be both outdated and dangerous? In our search for an answer to this question, we will see how the "republican revival," a crucial component of Orléanist propaganda in 1830, was jettisoned from the official iconography of the dynasty when it became a political liability.

The date of Farcy's commentary—23 March 1834—is significant, for it was published

at a time when two laws designed to curb radical political activity were being debated by the deputies, and just before the outbreak of violent protests against their passage. The first law limited the number of public criers, who were believed to be mouthpieces for secret political groups and the principal means by which dangerous rumors and political plots spread through working-class neighborhoods. Enacted in February, the government's law required each crier to obtain a permit and specified that infractions would be tried by an appointed judge rather than a jury (a ploy to improve the conviction rate).[173] The second piece of legislation sought to strike a fatal blow against secret associations: it outlawed any group of more than twenty people, exposed rank-and-file members to the same penalties as their leaders, and mandated that all violators would be tried by government judges rather than juries. The repressive nature of this measure guaranteed a long and impassioned parliamentary debate; nevertheless, on 10 April 1834 it was voted into law.[174]

While politicians argued in the Chamber of Deputies, republican clubs in Paris and Lyon openly prepared to do battle: arms and powder were gathered, battlestations were assigned, and firebrand orators excited the political passions of the working classes. Expecting trouble, the government took care to arm and provision its own troops.[175] Thus, France seemed poised on the brink of civil war when the 1834 Salon opened its doors and when Farcy wrote about Schnetz's picture of *The Fight for the Hôtel-de-Ville*. At the Salon's close on 30 April, Louis-Philippe's government had already weathered the storm: the anticipated revolt erupted in Lyon on 9 April but was completely crushed by the evening of the 13th. In Paris, Adolphe Thiers—then Minister of the Interior—ordered the arrest of all the known leaders of the radical *Société des droits de l'homme*. As a result, on the expected day of revolution (the 13th of April), Paris insurgents lacked a strong leadership with which to face the army, and government troops had completely mastered the situation by noon on the 14th.[176]

Both cabinet ministers and members of the royal family realized that the insurrections of April 1834 were quite unlike those of 1831 or 1832. Whereas the earlier uprisings had been fueled by worker discontent over low wages and a miserable standard of living, the 1834 demonstrations were engineered by revolutionaries with the aim of toppling the monarchy and reestablishing a republic.[177] Directly challenged by the rhetoric and the activity of groups who sought to emulate—not merely commemorate—the Great Revolution, Louis-Philippe's government was forced to adopt policies of law and order in the interest of self-preservation.[178] Under the combined pressures of popular revolt and the politics of reaction and repression, the revolutionary scenes so central to the meanings of the Chamber of Deputies and Hôtel-de-Ville pictorial programs could not avoid becoming iconographic anachronisms.

None of the surviving official documents relative to the Chamber of Deputies program explicitly state that the installation was scrapped because of its revolutionary subjects. Nevertheless, in May 1834—on the heels of the April uprisings—an interoffice memo to the Interior Minister pointedly asked whether the Salle des Séances was an appropriate place to hand Vinchon's nearly finished picture of Boissy-d'Anglas, in light of the "bloody episode which it contains."[179] An exchange of letters between Montalivet (then Minister of the Interior) and the Quaestors of the Chamber in August and September 1836 suggests that private discussions were held concerning the pictures, and on 20 September Montalivet

announced that only *The Oath of Louis-Philippe* (fig. 129) would be installed.[180] Montalivet implied that his decision was prompted by the Quaestors' impatience over the delayed delivery of the planned works, but a letter written by Vinchon in 1843 suggests a more pressing reason. Vinchon solicited a commission from the government by reminding the Interior Minister that he had obtained the commission in 1830 for a picture in the Salle des Séances, but that "deliberations entirely motivated by the subject-matter which had been imposed upon me changed its destination and, once completed, it was sent to Annonay, birthplace of Boissy-d'Anglas."[181] It seems safe to assume that the revolutionary subject-matter—which had become politically problematic due to the July Monarchy's domestic difficulties—was the major, albeit unstated, factor in the decision to shelve the program developed by Guizot in 1830.

The Hôtel-de-Ville cycle would have been a victim of the same set of circumstances. Although apparently no documentation survived the 1870 fire of the Hôtel-de-Ville, Farcy clearly believed that the subject of Schnetz's work had prompted its banishment to an unused back room. Likewise, the changes made by Cogniet to minimize Lafayette's place in the *Bailly* (fig. 133) were contemporary with the general's disappearance from Petitot's relief for the Chamber of Deputies and prefigured his marginal presence in the Salle de 1830 at Versailles.[182]

We are now able to understand more clearly where the version of the 1830 Revolution retold by Louis-Philippe's gallery at Versailles fits within the overall development of that specialized iconography.[183] The designers of the ensembles for the Chamber of Deputies and the Hôtel-de-Ville had both hoped to manipulate the "republican revival" first excited by the tricolor's return and used to great advantage by Orléanist theorists during the political maneuvers of the July Revolution. Yet the fragile links between 1789 and 1830 were almost immediately susceptible to varying interpretations, as shown by our discussion of the ideological differences between Guizot's program and the one commissioned by Barrot. The social unrest of 1830–34, and the July Monarchy's ever more repressive response to this challenge, tended to bankrupt the linkage between 1789 and 1830 by underscoring how little Louis-Philippe's regime had in common with the optimistic liberalism of 1789. When these political differences came to outweigh the propagandistic benefits of the association, the government naturally scuttled the planned installations altogether. During these same years, the government rejected Delacroix's vision of *The 28th of July* by hiding the picture away. The result was that for a brief time the July Revolution had no official image: it was possible for the king to fill this iconographic vacuum with a set of hand-picked images precisely because they would encounter virtually no resistance in the existing semantic void. In October 1834, when Louis-Philippe sketched his plan for the pictures of the Salle de 1830 on the floor of the raw gallery space at Versailles, the time was ripe for a new vision of the July Revolution and, like the government itself, this new image was purged of all that could be called a republican revival.

7. *HISTORICAL PAST/POLITICAL PRESENT: THE* SALLE DE 1792 *AT VERSAILLES*

Disentangling the spirit of the French Revolution from the events of July 1830 did not mean that Louis-Philippe completely renounced the former as a subject for official commissions.

On the contrary, severing the political ties between these two epochs provided a historical distance from which one could commemorate the Great Revolution without posing embarrassing questions about the contemporary situation. The historical survey envisioned by Louis-Philippe for the galleries of Versailles enters our discussion at this point, because the king, with his project to transform the château into a museum, sought to create there a great illustrated volume of French national history.[184] In contrast to recent Bourbon Restoration policy, the presence of paintings commemorating the French Revolution would seem to signify that Louis-Philippe's view of history was impartial and politically liberal.[185] I have suggested that the French Revolution was in no way a neutral subject. It is appropriate, therefore, that we look more closely at the imagery produced for Versailles and ask whether the political events of the Revolution were presented with an unbiased historical perspective, or if the episodes were selected and depicted with a self-serving purpose in mind.[186]

Before turning to Versailles, we must note that Louis-Philippe had developed a precedent for representing the Great Revolution within a historical context at the Palais-Royal, where a suite of pictures retold the most important events in the history of the Orléans family residence.[187] Two of these works bear upon our investigation. The first, by Horace Vernet, showed *Camille Desmoulins Haranguing the Crowd at the Palais-Royal, 12 July 1789* (fig. 139).[188] On that fine Sunday afternoon the garden of the Palais-Royal was filled with people strolling, many hoping to hear the latest news of Louis XVI's ministerial rearrangements.[189] Word arrived in late morning that Jacques Necker had been removed as Minister of Finance. The dismissal of Necker, who was widely liked for his efforts to control food prices and stabilize the kingdom's shaky economy, seemed to indicate that Louis XVI had opted for a minister who would rubber-stamp the Crown's wishes at the expense of the nation's well-being. Although many impromptu orators expressed their personal indignation to the milling crowd, one took a place in history. "A young man, born with an impressionable yet charismatic character and since known for his republican ardor, Camille Desmoulins climbed a table, waved his pistols while shouting 'To arms!', tore a leaf from a tree to made a cockade, and exhorted everyone to do likewise."[190] The crowds incited by Desmoulins moved en masse from the Palais-Royal, forced many theaters to cancel their Sunday performances (as a sign of support for Necker), and violently clashed with royal troops in the place Vendôme and the jardin des Tuileries. Two days later, this civil unrest culminated in the fall of the Bastille.

Because Vernet's painting of Camille Desmoulins arrived from Rome near the very end of the 1831 Salon, few critics were able to include it in their reviews.[191] Among those who discussed the picture, however, we discover several overlapping criticisms about the way Vernet depicted the scene. Victor Schoelcher, for example, wrote in *L'Artiste*:

> First of all, let's agree that the characters of this drama are drawn with talent and grouped with finesse, but they completely lack force and energy. The scene is apathetic, episodic, with neither élan nor passion. Each figure is egotistically concerned with himself and, at first glance, the ensemble strikes you with a grey and correct tonality, with a wallpaper-like appearance which leaves you cold. Of that spontaneous emotion which induced everyone to seize a green leaf as a sign of solidarity and to wear it as a new cockade full of hope, of that electric spark which the young revolutionary's eloquence had enkindled in every heart, the painter has not preserved for us the least little bit.[192]

Schoelcher was especially troubled by a disjunction between the revolutionary fervor of the story and Vernet's prosaic, piecemeal manner of representing it. Gustave Planche ridiculed Vernet's "lamentable and incomprehensible patchwork of coquettish and phony colors, of affected and hypocritical gestures," and concluded his tirade with the rhetorical question, "I am wondering what political eloquence is worth, what energy and strength of character mean if they subject in this way the memory of a defenseless man to the profanities of a frivolous and superficial art. Poor Camille Desmoulins, here you are dying a second time!"[193] We might have expected Schoelcher and Planche to find Vernet's work detestable, for they both had recently written enthusiastic reviews of Delacroix's *The 28th of July* (fig. 87). With that work as their yardstick of merit, they naturally found false the elegantly dressed bourgeois who pass as revolutionaries in Vernet's *Camille Desmoulins*.[194]

Ambroise Tardieu—by contrast a steady admirer of Vernet and a severe critic of Delacroix's *The 28th of July* in 1831—appeared to be similarly perplexed by the *Camille Desmoulins*. But, rather than questioning Vernet's savoir-faire, Tardieu blamed the designers of the Palais-Royal gallery for commissioning pictures which were too narrow for their height.[195] The result, he explained, is that the Vernet seems to be only "a corner of a painting. Nothing in the action justifies the fear of this young and charming woman who implores her husband to take her away from this scene which hardly resembles an uprising: a large empty space opens in front of her, and to her left one sees completely peaceful and attentive spectators." More important, Tardieu also recognized that Vernet's cropped figures and pockets of empty space produce a relaxed, casual image ill suited to the historical urgency of its narrative: "This passionate élan, which should have inflamed all hearts, has remained in the artist's head for lack of a place to express it correctly. Nothing indicates that this spark of revolutionary fire, hurled among the people by a courageous young man, would lead to the taking of the Bastille two days later and to the beginning of that fight to the death in which the monarchy would succumb."[196]

In short, both admirers and detractors of Horace Vernet believed that his *Camille Desmoulins* denatured the significance of its story. David's *Oath of the Tennis Court* (fig. 72), the canonical picture of modern history, was willfully structured to lock every participant into the collective passion of the moment, but Vernet's image fragmented its moment into a myriad of incidental details and transformed one of the first incidents of the Great Revolution into a fashion plate of 1789. To the extent that the large scale and historically exciting subject matter of the *Camille Desmoulins* seemed travestied by a formal vocabulary devoid of intellectual rigor, it challenged the hierarchy of pictorial categories implicitly sustained by high art critics on both sides of the Romantic/Classic controversy. Vernet's work, historically one of the first serious genre historique pictures to be shown at the Salon, confused both friend and foe because it spoke with an essentially undefined vocabulary.[197] Its importance lies in its royal patron, its place in an elaborate historical cycle, and because its genre-like manner of representing history emerged as the mode most useful to the underlying motives of the new dynasty.

On the surface, the second picture of revolutionary France included in the Palais-Royal cycle—Auguste DeBay's *The Nation in Danger, or the Voluntary Enlistments of 1792*—is as straightforward as it is high-minded: a spontaneous display of patriotism in which ablebodied men sign up for immediate military service (fig. 140).[198] The need for this

drastic action in September 1792 goes back to April, when a French military offensive in Belgium failed to score quick victories against the Austrian and émigré armies.[199] Her forces stymied, France reacted with alarm to the news that Prussia had joined Austria in the war, was moving eighty thousand regular troops toward the border, and could be expected to reach Paris in six weeks.[200] Convinced that only drastic measures would save the country from this peril, the National Assembly formally declared a state of national emergency (*La patrie est en danger*) on 11 July 1792: a measure which automatically required all government bodies to sit in permanent session, summoned the National Guard to arms, and opened a new campaign for volunteer enlistments.[201] The 22nd and 23rd of July were designated as special recruiting days in Paris, during which municipal officers crisscrossed the capital to read the declaration of national emergency and direct volunteers toward centers where they could sign up for a tour of duty.[202] DeBay's painting for the Palais-Royal was supposed to recreate the fervor at one of those centers as patriotic Frenchmen came forward to defend the fatherland (*la patrie*).[203]

The official program for these recruiting days specified that each registration center would consist of a raised platform upon which "a table, laid across two drum bodies, will serve as a desk to receive and register the citizens who come forward."[204] This historical detail allowed DeBay to integrate his subject with the narrow, vertical format dictated by the Palais-Royal gallery: he placed the recruiting table in the upper background of the composition and marched his volunteers across and up the image toward that elevated focal point. The resulting zig-zag—directed from right to left and then turned back toward the center by a careful orchestration of gestures—yields a dynamic movement similar to that found in countless altarpieces inspired by the Italian Baroque.[205] A view of the Palais-Royal at the upper right localizes the scene, while a sentimental vignette in the opposite corner fills the void left by the diagonal rush of movement. There, a weeping woman with a child in her arms unmistakably argues that the heroes of 1792 responded to the call for volunteers by selflessly placing national duty above all private or familial responsibilities. Finally, DeBay's image conspicuously suggests that these spirited patriots were drawn from a broad cross-section of the population, because men in top-hats and fine suits march alongside those dressed in workshirts and well-worn jackets. In short, everything about this picture is engineered to tell us that the outpouring of support for the nation in 1792 was spontaneous, selfless, and universal.

Where Vernet had been chastized for stylistically deconstructing the story of Camille Desmoulins, critics at the Salon generally applauded DeBay's neo-Baroque structure as a sincere attempt to express the patriotic enthusiasms of the moment. "M. DeBay has treated the *Voluntary Enlistments of 1792* with vigor and fervor," observed Charles Farcy; "there is an impetuous ardor in the brushwork which accords well with that of the subject."[206] Echoing this point, the author of *Lettres sur le Salon de 1834* wrote, "the brilliant and impetuous brush has put enthusiasm into the patriotic subject it was commissioned to represent . . . at that time France rose up en masse to turn back the invasions of the European coalition. Movement, feeling, and interest are united in this work: it is an accurate image [*une image fidèle*] of the men and opinions of the time."[207] If we believe that the threat of invasion was the sole reason for the 1792 declaration of the state of emergency, DeBay's picture of the popular response to that threat might qualify as *une image fidèle*. But

what if the Austro-Prussian army was only partially responsible for the state of emergency? A brief foray into the history of 1792 will reveal that France was embroiled in an internal power struggle every bit as dangerous as the foreign invasion because it threatened to bring down the constitutional monarchy. By understanding this context we shall see why Louis-Philippe—another constitutional monarch—might harbor a special desire to mask the politically problematic background with a singleminded emphasis on patriotic devotion.

The internal political troubles of 1792 stemmed from Louis XVI's attempt to flee the country in June 1791—an act which underscored his lack of enthusiasm for reigning as a constitutional monarch.[208] Many Frenchmen were duly suspicious of this king who seemed so ill disposed to accept his appointed role in government: Louis XVI's return to Paris under heavy guard was greeted with new demands that the monarchy be eliminated completely, although no one doubted that declaring a republic would prompt the other courts of Europe to launch an immediate attack against France. In mid-July, moderate leaders of the National Assembly managed to defuse the situation by fabricating a kidnap plot and "absolving" Louis of any wrongdoing when the police produced the king's supposed abductors. The constitutional monarchy was granted a temporary reprieve and, on 14 September 1791, Louis XVI accepted the Constitution and was restored to the throne.

The first legislature of the new government was dominated by deputies who fervently supported the revolutionary reforms of the Constitution and whose distrust of Louis XVI was fueled by the specter of the king's émigré brothers actively urging foreign powers to attack France.[209] The dismal failure of the French offensive in April 1792 only aggravated tensions among the branches of government: Louis was privately delighted by the rout, but he dared not admit it; generals blamed the king's cabinet for their ill-equipped and undisciplined army; and the Assembly suspected the Court—and especially the queen—of secretly treating with the enemy.[210]

The majority Gironde party opened a legislative campaign designed to force the king to show his true colors by formulating three controversial laws and passing them to Louis for approval or veto.[211] The first, dated 27 May, stipulated that any priest who refused to swear allegiance to the Constitution would be deported automatically if twenty citizens denounced him for antigovernment activity. Two days later, a second measure, arguing that the king's personal military guard was both larger and less democratic than permitted by the Constitution, proposed that the corps be dissolved. Finally, on 8 June, the Assembly requested that a military camp of twenty thousand men be established near Paris. Although ostensibly the force was to protect the capital from invasion, it was clear that it would be loyal to the Assembly and would enable the legislators to bully the king and protect themselves against his suspicious intentions. Few observers expected Louis XVI to approve any of these measures directed so pointedly at his religious beliefs and his personal safety. Indeed, the Assembly's purpose was to provoke a situation in which the king would be obliged to take a clear stand for or against the new social order of France.[212] Louis did veto the first and third proposals, but he approved the dissolution of his Constitutional Guard when Dumouriez—then prime minister—reminded him that his devoted and well-trained Swiss Guards would remain intact.

While this parliamentary battle unfolded, a powerful and unpredictable third party began to demonstrate its political strength. Spurred on by a deteriorating economic climate

and the humiliation of April's defeats, popular discontent erupted in the provinces as people demanded grain and a ceiling on runaway prices.[213] On 20 June 1792, a demonstration organized to commemorate the three-year anniversary of the tennis court oath became an invasion of the Tuileries, during which the crowd insulted Louis XVI and forced him to don a red Phrygian cap as a sign of good faith.[214] Paradoxically, this unruly show of popular strength frightened the deputies as much as it threatened the royal family, and the king's cool handling of the crowd earned him a brief moment of renewed respect.[215]

Despite this pressure, Louis steadfastly refused to rescind his two other vetoes. In the Assembly—which had been discussing the idea of declaring a state of emergency well before the Prussian troop movements became known—speakers regularly accused the king of frustrating the smooth operation of government and impeding national defense. Some, like Vergniaud, even went so far as to suggest that the king's contrary behavior constituted a de jure abdication of the crown.[216] When finally formulating its declaration of the state of national emergency, the Assembly short-circuited any royal interference by making it a legislative proclamation which would take effect without Louis' approbation.[217] This tactic bears upon our discussion, for the Assembly's declaration changed the balance of power in 1792. "The real significance," note Furet and Richet, "was political rather than military: the Assembly had assumed sovereign executive power."[218]

DeBay's single picture for the Palais-Royal cannot be expected to summarize such a complex and changeable political milieu. We can question, however, the motives which selected this subject rather than another from the annals of 1792. The political situation was so interconnected with the state of emergency, for example, that Louis-Philippe discussed it at length in his personal memoirs, which include a long section on the effects of Louis XVI's vetoes; in contrast, he treated the voluntary enlistments of July very briefly.[219] And, rather than praising the troops raised by the emergency sign-up or emphasizing the notion of multiclass participation seen in DeBay's picture, Louis-Philippe recalled:

> The recruitments of 1792, carried out after the declaration of war and amidst a great political turmoil, yielded quite different results, unfortunately even less satisfactory than those of the 1791 call-up.... At this time, when the invasion of Brunswick's large army seemed imminent, some people claimed that a new army should be created, one independent of those protecting our borders and especially designated to defend Paris. In other words ... they wanted to have at their disposition—in Paris or somewhere not far away—a completely *revolutionary* military force.[220]

Louis-Philippe later reiterated that the spontaneous and ill-planned method of recruitment in July yielded "a large number of ruffians who were even more undisciplined and dangerous when gathered together"—a point he underscored by describing the camp near Châlons (where most of the volunteers were stationed) as "a veritable mob scene [*cohue*], lacking any discipline whatsoever."[221] Given Louis-Philippe's comprehensive analysis of the 1792 political context, the state of emergency, and his opinion of the volunteers who came forward at that time to join the army, we must interpret the DeBay commission as a conscious attempt to recast the moment in the commendable mold of a patriotic, spontaneous, and multiclass response to foreign aggression. The completed work tailored an explosive moment of the Great Revolution for the history of France—now being personally

rewritten by the Citizen-King—by stripping the event of its problematic political allusions and reformulating it with a neo-Baroque pictorial syntax, an anodyne pathos, and an optimistic political iconography borrowed from the imagery of the 1830 Revolution.

DeBay's picture was hanging in the 1834 Salon when Louis-Philippe returned to 1792 as a source of inspiration for a major gallery at Versailles. In the course of a visit to the château on 6 March 1834, the king outlined an iconographic program which would transform the former antechamber of the Swiss Guards into a Salle de 1792 (fig. 141).[222] The king reserved major parts of this ensemble for the two icons of Orléans pride already discussed: larger-than-original copies of *Valmy* (fig. 98) and *Jemmapes* (fig. 99) by Horace Vernet were placed at opposite ends of the rectangular room.[223] The long walls and window casements became a portrait gallery of France's generals in 1792, including Louis-Philippe as duc de Chartres, strategically placed so that it is the first portrait seen when a viewer enters the gallery (fig. 142).[224] Finally, the king specified that "a panel on the back wall of the room will receive a picture depicting the epoch of 1792 when everyone took up arms in a moment of peril."[225] Obviously, the general theme of this installation was to be the heroic defense of the nation against the Prussian army—a campaign which culminated in the French victory at Jemmapes and the subsequent occupation of Belgium.

Léon Cogniet was commissioned to paint *The Parisian National Guard Leaves for the Front in September 1792* (fig. 143, pl. 6).[226] Although this might seem to depict the same subject as DeBay's painting, it is actually a different story and demonstrates how the king selectively read history for this important gallery. While we know that Louis-Philippe had little respect for the rag-tag army of undisciplined volunteers who joined the war in July 1792, he greatly admired the "general call-up of the Parisian National Guard which assembled in three days forty-eight battalions of national volunteers, each carrying the name of their respective neighborhood. They were animated by a completely different esprit de corps than the federal recruits, and they improved daily."[227] September's dramatic display of Parisian patriotism was engendered by bulletins reaching the capital on 26 August that Longwy had fallen to the Prussians. The National Assembly immediately requested thirty thousand new volunteers from the Paris region and, on 1 September 1792, passed a law empowering the small administrative units of the capital to organize and equip the volunteers.[228] Using the city's bureaucratic infrastructure to handle the fresh recruits promoted increased efficiency, and the new battalions tended to be better disciplined than the July volunteers because they were comprised of men who were neighbors and friends. An impassioned municipal proclamation of 2 September exhorted all Frenchmen to "surrender our cities only when they are reduced to a pile of ashes," closed the barriers of Paris, requisitioned all serviceable horses and weapons for the army, and ordered the immediate disarmament of any suspicious or cowardly citizens who refused to serve.[229] Public response to these drastic measures was remarkable: between the 3d and the 15th of September, more than eighteen thousand Parisians left their homes and families to join the armies at the frontier.[230]

Obviously, Cogniet's task in his picture of *The Parisian National Guard* was to capture the spirit of this astonishing mobilization. He located the scene at the Pont Neuf, with the Seine, LeVau's Institut, and the Louvre presenting a quintessentially Parisian backdrop.

Cogniet fused this landscapist view of the city to the historical specificity of his subject by placing the viewer two or three stories above the street, a compositional device which works here much as it does in later Impressionist paintings. Neither engulfed by the action nor soaring remotely above it, the viewer sees more than the average man in the street yet remains near enough to experience the individual episodes.

The tent in the right middle ground reveals the kinds of documentary sources used by Cogniet, for it follows rather closely the description of the recruitment tables discussed above in the context of DeBay's painting. Turning to Berthault's eighteenth-century print of 22 July 1792 (fig. 144), we discover the inspiration for the locale, the viewpoint, and the ceremony as portrayed by Cogniet.[231] In both images, a cannonade roars over the Seine while volunteers enlist under the canopy and municipal officers on horseback, preceded by cannons and accompanied by troops, announce the state of national emergency.[232] This means that, although the middle ground of Cogniet's picture is rooted in history, it does not actually represent the September departure of the Parisian National Guard. We shall presently discover how this "untruth" about 1792 could serve the political purposes of the 1830s.

Repeating a formula seen often in the course of our investigation, Cogniet filled his foreground with a series of anecdotal episodes. The narrow quai de l'Horloge is choked by a column of impeccably uniformed National Guardsmen who march in a crush toward the viewer while families and loved ones line the route to say their goodbyes. At left center, for example, a young man kisses his mother, shakes his father's hand, and ignores the entreaties of a younger sister in a vignette of family pathos which seasons the general confusion with a tearful, moralistic sentimentality harking back to the eighteenth century.[233] Across the street, elegantly dressed young ladies strew laurel wreaths and roses before the departing heroes. The picture's luminary structure—arranged so that shadows cast by the buildings at the left stop just short of the curb—"naturally" highlights the brilliant dresses and flowered hats of these female admirers and makes this charming group the most conspicuous part of the foreground.[234]

Cogniet's image contains almost no reference to the ominous military and political background of the hour. Only in the lower left corner, where some men distribute rifles from a munitions wagon while others saddle up its horses, do we find an allusion to the drastic measures contained in the city council's call to arms of 2 September. Across the street, a few unsmiling individuals along the quai wall at the lower right seem impervious to the patriotic effervescence all around: wearing neither uniforms nor civilian finery, the sullen expressions of these roughly dressed sans-culottes are the only clues that political unanimity did not exist in 1792. History tells us, however, that from the 2d to the 6th of September—the first days of the Parisian march to war—a horde of sans-culottes swept through the city's prisons, organized kangaroo courts, and summarily executed nearly fourteen hundred prisoners.[235] This wholesale bloodletting was fueled by rumors that royalist sympathizers were plotting prison riots to destabilize the capital and topple the revolutionary government. The popular line of reasoning was simple: no one in his right mind would leave his family at the mercy of "the aristocrats, enemies of the people who would slaughter your wives and children while you were at the front."[236] Although scarcely

one-fourth of the prisoners were priests or other politically suspect individuals, the crowds felt justified in killing them all beforehand: insofar as the government was unable or unwilling to halt the bloodshed, France experienced her first Reign of Terror.

Louis-Philippe clearly expressed an evaluation of this strange explosion of barbarism and patriotism in 1792 when he wrote, "It was amidst this execrable explosion of anger that the people of Paris incited that sublime élan which then swept the nation to defend its independence and push back the foreign invasion. . . . But what a difference for France as well as for every civilized nation if, when manifesting such a glorious commitment, the French people had not fallen, by abusing their freedom, into that state of anarchy and disruptions I have just described, and whose horrors were but the opening act!"[237] Should we be surprised, then, to find that the image of this epoch for Versailles stresses the story's "sublime élan" and makes only oblique references to its more sordid aspects? Critics generally recognized that Cogniet had produced a skewed version of the scene, and even Fabien Pillet—writing in the government's official newspaper—remarked on the picture's "slight implausibility" (*légère invraisemblance*): "The women . . . are too modishly, too coquettishly dressed in close-cut garments. Those who saw Paris in the difficult times which this picture brings to mind know very well that the most funereal terror pervaded the capital. Simultaneously menaced by foreign forces and by the murderers of September, our good citizens thought only to dress themselves in the most coarse clothing, hoping to find there a safeguard against the revolutionary furies."[238] It seems that this sleight-of-hand was largely ignored by the general Salon public because, as *L'Artiste* observed, "the crowd has not stopped coming to see his [Cogniet's] picture. . . . One finds there characteristics which are easily appreciated by the public; namely, a perfect clarity in elaborating the subject, a variety of episodes which are full of interest and well distributed, and lots of exactitude in painting the enthusiasm which animated the nation at that time."[239] This is precisely the kind of response that Louis-Philippe would have wanted both the picture and its gallery to elicit among the "good citizens" of the 1830s.

Two further details of Cogniet's picture unlock yet another dimension to the meaning of the image and its place in the Salle de 1792. The first is the enormous tricolored banner inscribed *Citoyens la Patrie est en danger* which flutters over the pedestal on the Pont Neuf. Berthault's engraving shows that a statue of Henri IV had overlooked the bridge on 22 July (fig. 144). Where had it gone by September? This banal question leads us directly to the popular revolt of 10 August 1792, when an army of citizens invaded the Tuileries Palace and forced the royal family to seek shelter in the National Assembly.[240] Bending to the pressure of Paris' increasingly republican crowds, the legislators were unable to protect the king: they voted to suspend the monarchy, convoked a National Convention to decide the future of the nation and the deposed monarch, and established an Executive Council to run the government during the interim.

The so-called "second revolution" of August 1792 brought the people into the political process: who were the leaders of this new social force? In general, the sans-culottes took their cues from the steering committee (*conseil général*) of the Paris Commune rather than the National Assembly, partly because the Commune was best able to communicate with and mobilize the masses through its links to neighborhood-level administrative units.[241] The Commune leaders who emerged during the weeks just prior to the August uprising

were radicalized Jacobins—men like Maximilien de Robespierre, Jean-Paul Marat, and Jacques-Louis David—whose ideas of democracy and a French republic most closely conformed to the political aspirations of the sans-culottes.[242] Under their leadership the people's victory on 10 August sounded the death knell of the Ancien Régime and, even if the monarchy was not officially abolished until the National Convention began its sessions in late September, public sentiment about the issue soon became clear: on 11 August, royal effigies throughout Paris were pulled from their pedestals and, like the monarchy itself, came crashing to earth.[243]

This is why the statue of Henri IV is missing in Cogniet's picture. Its absence is the work's only direct reference to the cataclysmic political changes of August 1792. A second allusion, almost as invisible as Henri IV, is inscribed on the tarpaulin covering the wagon in the lower left corner of the picture. There we find that the logo Fque Rale D'ARMES de St. Etienne (Fabrique Royale d'Armes de St. Etienne) has been haphazardly crossed out and NATIONALE stenciled over Rale in a discreet textual reference to the demise of the monarchy.

In summary, the imagery of Cogniet's picture was largely inspired by the pompous recruitment ceremonies of 22 July 1792, even though it ostensibly records an event of the following September. It almost exclusively attributes a stylish enthusiasm and patriotic devotion to a city racked by bloodletting of the most vicious kind. In its conception and its expression, we recognize that Cogniet's picture collapses together the imagery of July and September to "forget" the day when the Ancien Régime became merely a memory: the 10th of August—a semantic "black hole" referenced by the missing Henri IV—is only present by its absence. We shall see that the strategy of layered meanings found in this image, so conspicuously placed by Louis-Philippe at eye level in one end of the Salle de 1792, contains the key to understanding the logic behind the king's iconographic program for the gallery.

It is certainly true that Valmy and Jemmapes were personally important to Louis-Philippe, although biography only partially explains his configuration of the gallery at Versailles. Historians agree that the French victory at Jemmapes on 6 November was both stunning and decisive, but Louis-Philippe himself characterized the battle of Valmy as "an ordinary cannonade which lasted all day and only ended when nightfall had made it impossible to continue any longer."[244] Disrupted supply routes and dysentery were the most compelling factors in Brunswick's decision to retreat from French soil.[245] Keeping in mind the way in which Cogniet's painting (fig. 143) concealed one "truth" behind another, might we not see the king's insistent coupling of Valmy and Jemmapes as something more than personal ego? "It was Thursday, 20 September 1792 (the same day as the battle at Valmy)," remarked Louis-Philippe, "that the National Convention began its lamentable career."[246] The very next day, this new legislative body officially abolished the monarchy and declared a republic in France.[247] Like the departure of the National Guard, Valmy performs a crucial place-holding function in Louis-Philippe's iconography of 1792 by occupying a milestone date in the history of the First Republic and masking the politically charged content of that day with a conciliatory sign of national patriotism. In fact, the entire Salle de 1792 carries us through the last half of that fateful year on a tidal wave of national pride: from the July/September volunteers to Valmy in late September and on to Jemmapes in November, the whole orchestrated by France's victorious generals. Through it all, not

one word is spoken of the revolution of 10 August, the prison massacres, the founding of the Republic, or men like Danton, Robespierre, and Saint-Just. The gallery clearly tells an historical tale, but a very special one indeed.[248]

To explain this gerrymandering, we must return to 6 March 1834—the day on which Louis-Philippe outlined his plans for the Salle de 1792. We have already seen that this was a particularly tense period for the July Monarchy during which opposition groups openly planned a revolt aimed at founding a new republic.[249] Their inspiration was none other than the Jacobins of 1792: the *Société des droits de l'homme*, for example, named its individual sections after heroes like Marat and key dates such as *Vingt et un janvier* (21 January, day of Louis XVI's execution in 1793), and it had caused a scandal in October 1833 by publishing a manifesto that invoked Robespierre as the group's patron.[250] Surely, the king viewed these developments with an eye conditioned by his own memories of 1792 and the specter of France's first constitutional monarchy falling before republican agitation. When laying out the iconographic program of the Salle de 1792, the king had a special interest in avoiding all but the most circumspect references to the episodes which were personally painful (his own exile and his father's execution among them) and politically inflammatory within the social climate of 1834. Both scrupulously historic and rhetorically charged, the gallery program conceals the grim facts of a France racked by civil strife and social upheaval behind a narrative of national unity and patriotic fervor related in a credible, seemingly journalistic manner. The result—specially edited for the "good citizens" of the July Monarchy—is an optimistic image of 1792 in which the army and the National Guard rise heroically to defend the endangered French nation. In the final analysis, what more appropriate message could Louis-Philippe address to the many citizen-soldiers of his kingdom who so frequently donned their own National Guard uniforms to protect the Orléans throne from its republican adversaries?

8. THE FEDERATION OF 1790: CONSTITUTIONAL MONARCHY AGAINST DESPOTISM AND DISORDER

Skeptics might argue that the preceding analysis of the interaction between certain pictorial configurations and Louis-Philippe's political motives is too circumstantial, naively literal, and overly informed by a retrospective understanding of the period. Auguste Couder's *Federation of National Guardsmen and the Military on the Champ-de-Mars at Paris, 14 July 1790* offers a concrete example, supported by eyewitness accounts and relevant documentation, of how royal intervention influenced both the narrative and the style of a picture inspired by the Great Revolution (fig. 145).[251] The subject of Couder's picture is the great pageant held in Paris to celebrate the one-year anniversary of the fall of the Bastille. Each of the eighty-three administrative districts of France sent a delegation of National Guardsmen to the capital, where they joined similar deputations from the various armies, the National Assembly, the clergy, and the king himself in a solemn oath to uphold and defend the Constitution.[252] During the weeks prior to 14 July, the Champ-de-Mars was transformed into a vast amphitheater by thousands of workers who excavated a central arena with sloped embankments at its edge. A temporary bridge over the Seine led from the Right Bank to the triumphal arch "gateway" erected at the riverbank end of the amphitheater (where the Eiffel Tower stands today). An enormous, pyramidal altar dedicated to the

nation was constructed in the center of the field and, in front of the Ecole Militaire, a canopied viewing stand was built for Louis XVI and the deputies of the National Assembly.

On the morning of the 14th, four hundred thousand civilian spectators were on hand when the sixty thousand members of the armed forces entered the Champ-de-Mars. The archbishop of Autun (Talleyrand) then celebrated Mass at the apex of the altar, assisted by three hundred priests in tricolored sashes and an orchestra of twelve hundred musicians. After the Mass, Lafayette received the text of his oath from the king, rode on horseback to the center of the field, climbed the altar and, on behalf of the thousands of assembled troops and guardsmen, swore to defend the nation and the constitution. Next, the president of the Assembly—symbolically seated on a chair alongside the king—repeated the oath. Finally, Louis XVI rose and swore "to use the power, delegated to me by the constitutional document of the state, to uphold the constitution ordained by the national assembly and accepted by me." Amidst this great ceremonial mingling of courtly pomp, democratic ideals, and religious piety, France seemed to be at one with her king and her revolution.

Obviously, Couder's greatest difficulty when representing this grandiose celebration was how to choose an appropriate viewpoint and narrative moment, the more so because Louis-Philippe wanted a large image more than four meters tall and eight meters wide. Specific details of the site and ceremony, on the other hand, were easy to obtain via several well-known prints, like that by Berthault and Prieur (fig. 149), and Couder owned a small 1790 oil of the same subject by Hubert Robert (fig. 150)—a work which he later gave to Louis-Philippe.[253] The fact that the ceremony was divided between the Ecole Militaire (oaths of the king and president) and the pyramidal altar in the middle of the parade ground (the Mass and Lafayette's oath) complicated the painter's problem: he could either depict one of the sites in large scale at the expense of the other or adopt a sweeping wide-angle view of the locale (much as Hubert Robert had done) which would necessarily reduce individual figures to microscopic proportions.[254] Designers of contemporary popular prints had faced the same dilemma: a print by Swebach-Desfontaines and LeCour explained why it offered a limited point of view and apologized for the impossibility of including the throne where the king had taken his oath (fig. 151).[255]

According to the comte de Montalivet, Couder originally focused his composition on the viewing stand (where Louis XVI and the National Assembly were seated) and upon the crowd, "which seemed ready to rush the altar and promise to die for the fatherland—a favored divinity of revolutionary rhetoric. Here, not far from the members of the national assembly, men, women, and citizens of every social class, in different costumes and from diverse locales, crowded together: it was a powerful impression drawn from a considerable disorder."[256] Upon reviewing Couder's sketch, Louis-Philippe reportedly remarked, "Monsieur Couder, you like disorder; we will discuss it later." The painter, apparently missing the significance of these words, began work on the full-scale canvas. With the coming of spring, Louis-Philippe moved his residence to Neuilly and then to Saint-Cloud, so that several months passed before he returned to the Louvre; consequently, the picture was nearly finished when the king revisited Couder's studio and, according to Montalivet, passed a fatal sentence on it:

> It's a lovely painting, but this is not the Federation of 1790. You have confused epochs, Monsieur Couder: in '90, the minority had not yet become master of the Revolution.

Anarchy was in the background; why have you put it in the foreground? All the people there seem to want to climb the throne or overturn the altar of the nation: they will do it only too soon. Where are the one hundred and thirty thousand actors of this great production, deputations streaming from many parts of the land? Where is that solemn acclamation from a large organized force which was, at that time, more national than revolutionary? I was there, Monsieur Couder, I saw everything which I have just recalled for you, and my account is more useful than those which have come afterward. There is the truth of your subject: approach it straightforwardly and start your picture anew.[257]

To judge from Louis-Philippe's *Mémoires*, where he says that "nothing could have been more solemn and more beautiful" than the 1790 Federation, Montalivet does not seem to have exaggerated the king's concern for a stately version of the day.[258]

Couder vainly resisted the order to restart his picture from scratch by arguing that a view of the whole scene threatened to "offer the cold spectacle of the mass of dignitaries crowded into the reviewing stand, and the monotony of these soldiers deployed in long parallel lines the entire length of the Champ-de-Mars."[259] Even monetary pressure failed to shake the king's resolve to have another picture: when it was pointed out that the twenty-five-thousand-franc canvas was nearly paid for, Louis-Philippe replied that he was willing to pay for it a second time.[260]

Turning to the finished work, we immediately sense the extent to which Couder ultimately fulfilled the king's wishes. The principal actors of the *Federation*—Louis XVI standing with an outstretched arm to signify his adhesion to the oath, Lafayette on horseback before the king witnessing the royal act, and Talleyrand atop the altar of the nation— are all microscopic figures in the vast visual field and they are further dwarfed by an immense expanse of grey sky. "One looks in vain for the center of action," lamented Thoré, "the eye gets lost in the details without being able to grasp the entirety."[261] What we *are* drawn to, however, is the rhythmic repetition of the assembled battalions who circle the parade ground and articulate its sweeping spatial recession, the crisp and disciplined precision of the troops lining the perimeter, and the good behavior of the civilian spectators.[262] Like the revolutionary themes previously discussed, the *Federation* for Versailles judiciously avoids the tumult of radical France. This particular example graphically reveals that, because Louis-Philippe monitored not only the *subjects* to be included in his museum but also the political expression of *how* they were imaged for posterity, his dictates could directly influence the structure and style of a commission.

With the principal action concentrated in the distance (by order of his patron), Couder faced the special problem of how to handle the foreground. A point of view from the arena's perimeter places the viewer in one of the hundred little groups "of women, of priests, of stylish gentlemen located in the picture's near ground" which "nothing connects together"[263] other than their presence at the ceremony. Couder's foreground is thus stylistically and narratively separate from the principal action of his enormous canvas and inadvertently contrasts its casual variety of colors, types, and episodes to the pervasive uniformity of appearance and attention requested by the king. Thoré understood this foreground/background disjunction when he complained that "one notes only the coquettish and splendid little figures of the foreground who stand upon the bleachers: the episodes

mask the principal point."[264] Essentially the same perception led Blanc to exclaim, "What delicious genre paintings one could make with these picturesque fragments!"[265]

Augmenting our own analysis with critical comments from 1844 yields a characterization of Couder's picture which is already quite familiar. It is an image of recent French history which appeals to the viewer with a consciously reportorial manner built around an atomized, episodic structure. This configuration has recurred in our discussion as the essential component of genre historique painting. The example offered by Couder's *Federation* explicitly documents Louis-Philippe's active role in promoting the genre historique picture-type at Versailles by encoding it with a pointed political nuance and pushing it to the dimensions and programmatic pretensions of History Painting, the most ambitious imagery of the day.

The issue of an "official" style is also raised by the last major picture of the French Revolution to be completed for Versailles before the 1848 Revolution. Although many of Louis-Philippe's commissions were barred from the 1848 Salon (which opened only weeks after the demise of the July Monarchy), *The Oath of the Tennis Court* (fig. 146, pl. 7) by Couder was admitted because its subject seemed especially appropriate for the first exhibition of the Second Republic.[266] But, before turning to the issue of Salon politics, let us examine Couder's manner of depicting the scene.

The artist's greatest obstacle was probably the memory of David's unfinished picture of the event, for both the working drawing (fig. 72) and an engraving by Jazet were well known.[267] Very much in the spirit of his *Oath of the Horatii*, David built *The Oath of the Tennis Court* around a simple geometric armature which binds the participants, their oath, and the locale into a single visual structure.[268] Bailly stands in the center of the image, his head at the vanishing point of the architecture. Hundreds of arms converge toward his head and culminate in the stark silhouette of his open palm against the bare back wall. A rush of attention and excitement from the farthest corners of the work builds toward the center with a force echoed by the wind-blown draperies at the upper left. Finally, and quite unlike the *Horatii*, all of this energy turns outward through Bailly's gaze to meet the viewer and directly challenge him to join forces with the Third Estate in their struggle to shape a new France.

To the apparent intellectualization of David's pictorial skeleton must be added the evidence of his sketchbooks and the extant fragment of his unfinished picture, because they underscore the role of tradition in David's creative process.[269] All of his figures began as nude studies or heroic figures in Greco-Roman armor, and close analysis of the sketches has shown that many of the poses were not based upon direct observation but were inspired by past art—including that of Michelangelo, Raphael, and Poussin.[270] The resulting image, purposefully forged from contemporary history with the tools of the Academy, strives to transcend factual journalism and achieve a high art monumentality without sacrificing its political timeliness.

Couder's picture is notable for its radical departures from the Davidian prototype. Gone is David's nearly perfect integration of figures, space, and action, for Couder rejected an inclusive rectilinear structure of taut control in favor of partial views, multiple croppings, and skewed angles. The center of his image is marked by one corner of the room, the line traced by a woman who coquettishly waves her handkerchief from the gallery above,

and the figure below who seems to be Rabaut de Saint-Etienne. The latter's nonchalant gesture of adhesion is a remarkable study of instantaneous action in the midst of a general tumult, and it offers a telling contrast to the hieratic posture and placement of Bailly at the center of David's image. Couder's Bailly is moved to the right side, his arm and head seen in profile against the grey wall. But, even here, the mortar lines running diagonally to the picture plane undermine the permanence of his position in the pictorial space, and we realize that this Bailly is perfectly capable of turning around should he choose to do so.

David's special concern for the viewer's participation had led him to present Bailly with his back to the crowd. Couder, for whom verisimilitude was evidently a virtue, stood Bailly on a chair off to the side, thereby freeing the table for use by those deputies who come forward to sign a written copy of their oath.[271] The same literalness meant that Couder's canvas is populated by a host of portrait likenesses. The four prominent figures across the room from Bailly who stand head and shoulders above their neighbors include Robespierre (center, in high-lighted profile) and Dubois-Crancé (to the left). In the left foreground, Mirabeau gestures extravagantly: his pose is a mirror image of the one David had given him, but he is much less handsome. Couder probably considered this an improvement, because his homely Mirabeau reflects fairly accurately the likeness recorded in the portrait by Boze, circa 1789 (fig. 116). The young man near the table holding a quill pen and looking over his shoulder is apparently Barère de Vieuzac: David had also included him taking notes of the proceedings, and the finely chiseled features which Couder gave this figure seem to accord well with Laneuville's portrait of him.[272] Just to the right, the roughly dressed old man barely able to raise his hand is the *père* Gérard of folklore who insisted upon wearing his country breeches to all the meetings: Couder probably modeled his figure of Gérard directly from the painted portraits which David had made of him.[273] Finally, at the far right edge of the canvas, Martin Auch expresses his refusal to endorse the oath with a gesture described by one critic as "more a vulgar anxiety than the grand and poignant indecision of a truly patriotic soul."[274] It is likely that detective work could uncover the identities of many more figures in this painting, but the central point would remain the same: the painter took great pains to invest his picture with a semblance of authenticity and history.

Couder's serious effort to achieve a measurable veracity is seconded by a tight rendering of uninflected, nearly photographic intensity which treats the figures no differently than the period furniture or the abandoned tennis racket in the lower left corner. Despite this, his work generates a casualness which must finally be ascribed to the absence of an all-encompassing organizational logic. The discontinuous spatial structure and its concomitant informality depend largely on the fact that we view the scene from only slightly above the eye level of the participants. Consequently, most of the background figures disappear behind the screen of bodies closest to the picture plane, and only a sea of hands testifies to the attendant crowd. But the expected crush of humanity has inexplicably parted to produce a shallow, empty space between the viewer and the wall of engaged personalities. The result is yet one more example of the stagelike structure which has appeared repeatedly in our discussion: the picture is read *across* (toward Bailly) by an observer, and the most important characters facilitate this activity by standing close to the front plane or rising artificially above the crowd to assert themselves. Although more grand—in both

subject and size—than a moralizing family drama such as *The Father's Curse* by Greuze (fig. 152),[275] Couder's *Oath* uses the same set of genre-based pictorial principles to tell its story with a convincing material tactility and elicit an edifying empathy in a sentimental—but politically passive—viewer. Although we cannot prove that Couder lifted the general disposition of his figures and architecture from Ary Scheffer's illustration to the 1834 edition of Thiers' *Histoire de la Révolution française* (fig. 153),[276] the fact remains that his conscientiously researched image recounts the oath with the loose-jointed, anecdotal, and literary formulas that have less in common with David's ascetically compelling structure (fig. 72) than with a humble lithographic vignette. An example of *genre historique* in action, Couder's painting narrates a pivotal moment of modern history with the plain-speaking manner of genre to mediate the ideological distance between an 1830s public and the political ideals of 1789.

If a compromise is involved here, it is not between the aesthetic forces of Classicism and Romanticism; rather, it is a *functional exchange* between the rhetoric of art and the meanings of history. Had Louis-Philippe truly wanted to evoke both the spirit of 1789 and the vicissitudes of 1791, he could have installed at Versailles David's original, unfinished canvas—bought by the Crown in 1835 along with two of David's sketchbooks.[277] The fact that he commissioned a new painting which illustrates *The Oath of the Tennis Court* with so little of David's heroic paraphernalia suggests that Louis-Philippe was motivated by something other than a simple desire to aggrandize this crucial episode of the Great Revolution. A close reading of the relevant documents reveals the existence of a thematic schema in which the oath of the deputies was invested with an historical meaning of special significance for the Orléans monarchy.

Records at the Archives du Louvre indicate that the *Oath of the Tennis Court* was originally commissioned from Joseph Court on 30 April 1838 and transferred to Couder on 21 August 1839.[278] On the same day in 1838, commissions were given to Couder for the *Federation of National Guardsmen* (fig. 145), to François Bouchot for *The 18th of Brumaire* (fig. 147), and to Auguste Vinchon for *The Opening of the Legislature and Proclamation of the Constitutional Charter, 4 June 1814* (fig. 148).[279] Because these pictures were completed at different times and exhibited at different Salons, one can easily overlook their common date of commission and the fact that they are dimensionally related: each of the four is 421 centimeters tall, and Couder's *Tennis Court* is exactly the same size as the Vinchon. To this group should be added a fifth picture, *The Return to Paris of the Parliament Called by Louis XVI*, which was commissioned from Jérome-Martin Langlois but never completed.[280] These pictures were destined to hang together in what was known during the 1830s as the fourth gallery of the Pavillon du Roi, located on the first floor of the North Wing at Versailles. A reasonable reconstruction of this nearly square space—and one consonant with later numeration of the pictures—would place the *Tennis Court* opposite Vinchon's picture of 1814, Couder's *Federation* perpendicular to these two and, across the room, the two smaller pictures hanging side by side.[281]

With the gallery so arranged, the pictures offer a special history of post-1789 France. The centerpiece of the ensemble is Couder's *Federation* (fig. 145), the largest image and the only one in which the entire nation—from ordinary citizens to the king himself—is joined together in a common pledge of support for the constitutional monarchy. The surrounding

pictures, each with a specific reference to modern France, illustrate alternatives to this national harmony and establish a politically value-laden viewing context for the *Federation*. The *Return of the Parliament* would have shown Louis XVI in 1787 forcing his will upon the nation's representatives: Louis had exiled the Paris assembly to Troyes after it refused to accept new stamp and land taxes, and he only recalled it when he was in a position to force acceptance of new loans with which to keep the government solvent.[282] The *Oath of the Tennis Court* (fig. 146) depicts a body of national representatives actively defying royal authority and claiming power for themselves. In *The 18th of Brumaire* (fig. 147), Napoléon extinguishes democracy with a coup d'état and browbeats the nation's lawmakers into submission to his military might and personal ambition.[283] Finally, Vinchon's picture of 4 June 1814 (fig. 148) recalls the Bourbons' return to power and the day Louis XVIII read to the Chambers the Charter *octroyée*—that is, granted by him as a favor. Although this fact is not specifically referenced in the picture, no Frenchman would have forgotten that the Charter and the government of 1814 had been imposed on a defeated France by Royalists and opportunists in the military supported by the occupation armies of England and Russia.[284] Had the gallery been completed, the five pictures would have outlined the changing power relationships between elected legislators and the chief executive in France: from the first stirrings of representative government in 1788–89, through its flowering in 1791 and crippling by Napoléon in 1799, to its severely limited form in 1814 under the restored Bourbons. Finally, the genre-derived, descriptive clarity and standardized format of these images facilitate such a comparative reading, because the minimizing of formal differences actually encourages the viewer to overlook the historical circumstances of each moment when attempting to grasp the logic of the ensemble.

According to Louis-Philippe's abbreviated history of this period, the short-lived constitutional monarchy of 1790–91, illustrated by Couder's image of the *Federation*, implemented liberal reform yet maintained social order: Louis XVI pledges allegiance to the Constitution before an enormous crowd of elected representatives, National Guardsmen, and citizens who both witness and second his oath. Not by accident, this image of 1790 contains the same general enthusiasms and specific actions that figure in another gallery at Versailles dedicated to liberty and public order: the Salle de 1830. Although never permanently installed, this suite of pictures would have argued that the liberal, contractual, constitutional monarchy of 1790 was the most egalitarian government to emerge in France between the collapse of the Ancien Régime and 1830. In the context of this historical construct, the Orléans dynasty would have shone as the true heir of that utopian moment of the Great Revolution when all of the nation's social partners—nobles and clergy, military men and civil servants, bourgeoisie and peasantry—harmoniously shared a vision of the new social order.

A comprehensive view of the programmatic intentions attached to Couder's *Oath of the Tennis Court* also explains how this subject could appear in an official commission during the last years of Louis-Philippe's reign. We know that the king became increasingly rigid in his old age and adamantly opposed all electoral reforms.[285] Orators at political banquets during 1847 regularly invoked the men and ideals of the Great Revolution as the most appropriate models for opponents of the Orléans regime. At a gathering to celebrate the success of Lamartine's *Histoire des Girondins*, for example, the guest of honor ha-

rangued his hosts: "My book needed a conclusion: it is you who are making it!"[286] Similar political banquets in Dijon, Lille, and Autun during the fall of 1847 were marked by toasts and statements eulogizing the most radical leaders of the French Revolution, and discussions frequently turned from questions of reform to calls for outright rebellion.[287]

This seems hardly an opportune moment for a major commission to immortalize an important episode of the Revolution. We now know, however, that the king's original project dated from April 1838, and Couder's image makes perfectly good sense within this corrected time frame. The months just after the triumphant inauguration of Versailles and gala marriage of the duc d'Orléans (10 June 1837) were a far cry from the political tumult of 1847. To many observers, Louis-Philippe finally seemed to wear a secure crown: the country was calm, the economy strong, and French ambassadors were reporting that previously hostile sovereigns were now praising the sagacity of the King of the French.[288] Louis-Philippe hastened—as suggested by the closing words of his address to the Chambers in December 1838—to link this comfortable situation with the form of his government:

> The florescent state of the country is due to the constant support which the Chambers have given me for eight years, and to the perfect accord between the principal powers of the State. Let us not forget that this is our strength. May this accord become daily more complete and permanent! May the free and regular operation of our institutions prove to the world that the constitutional monarchy is able to unite the benefits of liberty to the stability which makes a state powerful![289]

Even as he spoke, Couder, Bouchot, and Vinchon were working on the pictures for the gallery which would concoct a visual apologia for the constitutional monarchy by restructuring history so that the political enemies of Louis-Philippe's regime—republicans, Bonapartists, and Bourbon legitimists—would be cast as the enemies of liberty and order, tranquillity and prosperity.

Although this line of reasoning might have seemed valid in 1838, very few people would have found it compelling ten years later, when opposition to the Orléans dynasty was at an all-time high and the economy was in severe recession.[290] In the next section I will demonstrate that the July Monarchy often closed the Salon to politically sensitive pictures of the Great Revolution. Given the social context of 1848, it is quite possible that Couder's image of opposition to royal authority would have been barred from the Louvre, even though it was a royal commission and part of a decidedly nonrevolutionary ensemble. What happened, of course, is that the revolution moved from oil-on-canvas to the streets, the monarchy itself was swept away, and the Second Republic hung *The Oath of the Tennis Court* in a place of honor.

9. OFFICIAL HISTORY, POLITICAL CENSORSHIP, AND THE SALON

The pictorial cycles of the French Revolution established by the July Monarchy sift and refine the raw data of history to establish a meaning compatible with the political status quo and make only the most discreet allusions to "that terrible year" of 1793, "so cruelly bloodied and soiled by so many crimes."[291] On a strictly biographical level, in 1793 Louis-Philippe was forced into exile, his family in France was placed under arrest and, finally, his

father died on the guillotine. No wonder he received the news of Robespierre's fall on 28 July 1794 (9 Thermidor) with elation: "We wait impatiently for further news from Paris," he wrote to a friend, "but the important ball has hit its mark because the Jacobins are destroyed. Hallelujah! Hallelujah! Hallelujah!"[292] Later, Louis-Philippe would condemn the National Convention as "the execrable system which bloodied the Revolution, changed its course, and produced those deplorable excesses before which every civilized nation has been justifiably disgusted and terrified."[293]

Not everyone shared the king's aversion to the more sordid events of the 1790s, and the July Revolution marked the beginning of a virtual explosion of scholarly interest in post-1789 France. Although histories and personal memoirs of the Great Revolution had appeared at regular intervals during the first three decades of the century, the publication of Thiers' authoritative *Histoire de la Révolution française* during the last years of the Bourbon Restoration set the stage for increased public scrutiny of the revolution after 1830.[294] Despite the fact that few historians seriously read Thiers today, his text was the standard account during most of Louis-Philippe's reign and his authority was not challenged before 1847, when the works of Michelet, Lamartine, and Blanc offered alternative versions of the Revolution.[295] Thus, the frequent references to Thiers in this study is not only historically justified but also artistically relevant, because the fourth edition of Thiers' *Histoire*—published in 1834, the year its author was received by the Académie Française—was elaborately illustrated with over one hundred prints by well-known artists such as the Scheffers (Ary and Henri) and the Johannots (Tony and Alfred).

Along with a closer and more systematic analysis of the Revolution came the historian's responsibility to admit its failures while celebrating its triumphs. Thiers himself acknowledged this new duty at the outset of his text:

> But if we are obliged to support the same cause [as the revolutionaries], we do not have to defend their conduct. We are able to separate out the idea of liberty from those who have served it well or poorly, at the same time that we have the advantage of having heard and watched these old men who, still full of their memories and moved by their feelings, show us the spirit and character of the parties involved and teach us how to understand them. Perhaps the moment when the participants are about to die is the most appropriate for writing history: one can collect their accounts without sharing all their passions.[296]

Unlike the heroic grandeur forever locked in the remote texts of ancient history, the Revolution became increasingly mundane as historians discovered that events had more often responded to petty jealousies than to noble principles. Painters striving to depict faithfully these events naturally turned to the histories of Thiers and others for inspiration and documentation. What they found were stories of human frailties which, in response to the contemporary critical clamor for veracity, became images that accurately transcribed the demythologized historical sources. As we shall see, the most adaptable and appropriate vocabulary with which to render this new, morally complex vision of the French Revolution was the hybrid picture-type of genre historique.

It is not surprising that the political events of 1793–94 were recorded only once in a picture commissioned by Louis-Philippe. This work, painted by Mauzaisse for the gallery of the Palais-Royal and destroyed in 1848, represented the arrest of Louis-Philippe's younger

brother, Louis-Charles, comte de Beaujolais, on 4 April 1793 (fig. 154).[297] The episode unfolds in a small room of the Palais-Royal overlooking a narrow side street. Mauzaisse portrayed the arrest as an interruption of domestic activity in which two red-bonneted republicans, a pair of soldiers, and a government representative disrupt the young man's daily lesson. The Count's tutor (Lecouppy) and governor (Lebrun) look on in resignation while the central figure reads from a prominently displayed piece of paper inscribed *La Loi*—textual reference to the government decree of 4 April which ordered the arrest of all members of the Bourbon family (including the Orléans branch).[298] It was the start of a long ordeal for the young man: when the Orléans family was proscribed on 6 April, Louis-Philippe was able to go into exile, but the comte de Beaujolais began a forty-three-month incarceration during which he developed a tuberculosis that would kill him in 1808.

There is a curious lack of drama in the Mauzaisse which transforms the struggle between the revolutionary government and a discredited noble family into a simple legal procedure. When narrated this way, the story seems scarcely capable of sustaining the viewer's interest, much less meriting the rubric of History Painting (*peinture d'histoire*). But perhaps the picture's familiar paradox between formal expression and historical intent should not be ascribed to the artist alone, for Mauzaisse surely obtained essential information about the episode from the king and doubtlessly received approval of his sketch before setting to work on the full-size canvas.[299] To understand its final configuration, we ought to investigate why Louis-Philippe might have commissioned the picture in the first place.

The historical issues leading to the arrest of the comte de Beaujolais stemmed from the behavior of General Charles Dumouriez, commander of the French army in Belgium. Angered by the inept war management and growing radicalism of the National Convention (especially after the execution of Louis XVI), Dumouriez began secret peace talks with the Austrians aimed at joining forces for a march on Paris to reestablish the monarchy under the 1791 constitution.[300] Both contemporary observers and later historians (including Thiers) believed that the general planned to place an Orléans on the throne, perhaps even his brilliant young officer, the nineteen-year-old Louis-Philippe.[301] Louis-Philippe steadfastly denied any complicity in the machinations of Dumouriez, took special care in his memoirs to convince the reader that the general had planned to install the young Bourbon heir, Louis XVII, and said that Dumouriez "admitted to me that he almost would have preferred that I were not in his army, both to distance himself from any suspicion of wanting to place me on the throne and to clear me of having designs on it. But since I was in his army before all of this, he absolutely did not want me to think about leaving . . . he did not ask me for any help in the political steps which he might take, he counted upon my discretion, and he hoped that I would remain at my post in the army, continuing—as in the past—to dedicate myself exclusively to the fulfillment of my military duties."[302]

Whatever the truth might be, we know that in 1830 Louis-Philippe had touted his claim of faultless personal patriotism during 1793, when other royal princes had led armies against France. Presumably innocent of any treasonous wrongdoing, Louis-Philippe was shocked by the warrant for his arrest. According to his version of the events, the plight of the comte de Beaujolais in 1793 was typical of the entire Orléans family: disinterested patriots, they were struck down by the false charges of malevolent political infighters.[303] What better way to remain within the limits of history yet illustrate the belief that enemies of his father

had engineered an unjustified condemnation of the Orléans than to show the arrest of an obviously innocent thirteen-year-old schoolboy as if he were a threat to the state? In this way, the peculiar, low-key representation of history adopted by Mauzaisse makes sense: *The Arrest of the comte de Beaujolais*—a seemingly insignificant episode rendered with an emphasis on costume and setting rather than action—exhibits a narrative and a stylistic logic which suggest that it was neither haphazardly conceived nor negligently elaborated.

The Mauzaisse never appeared at the Salon, a notable absence in light of its size, patron, and the fact that every other picture for the Palais-Royal history cycle was shown at the Louvre—including the revolutionary episodes by Vernet and DeBay discussed earlier. How might we explain this singular occurrence? The answer must be related to its subject—however inoffensive the representation—and the government's (or the king's) belief that the political climate of 1834–35 could not recommend exhibiting a state-financed picture recounting the antiroyalty excesses of the First Republic. The decorative program for the Chamber of Deputies was stripped of its revolutionary subjects during this same period, and Mauzaisse was paid for his picture only two months after the civil disorders of April 1834.[304] While no documents specifically establish this causal relationship, circumstantial evidence suggests that some kind of Salon censorship was behind the artist's failure to exhibit his picture at the Louvre.

An incident from 1835 supports the thesis that Louis-Philippe took a personal interest in the kinds of revolutionary subjects exhibited at the Salon. Paul Chenavard submitted a large drawing to the jury that year which represented the National Convention just after its vote condemning Louis XVI to death. When the piece was refused, the painter sent it to an alternative exhibition held in the Galerie Colbert on the rue Vivienne. A number of journals described the picture, and *L'Artiste* explained that Chenavard failed to obtain the honors of the Louvre because he "thought that the deference which any artist ought to manifest for the ruling family did not include forgetting the figure of Philippe-Egalité among those of the most famous members of the National Convention. A faithful historian, he thus placed the troublesome royal prince in the foreground of his composition . . . near to the royal prince he put Marat, who addresses his colleague informally to seek the protection of his popularity. This was sufficient grounds for the work to be stopped at the door of the Salon."[305] Based on this description, the refused work apparently resembled Chenavard's painted sketch of the same subject, especially if we assume that the tall, aristocratically dressed gentleman at the right of this canvas is the duc d'Orléans (or Philippe-Egalité, as he was known in 1793), and that the short, roughly dressed figure with his head wrapped in a towel represents Marat (fig. 155).[306]

More to the point are the rumors that "the drawing by M. Chenavard was refused not, perhaps, by the jury but by a more highly placed determinant which, it is rumored, has more than once head off the Academy's judgments in order to impose its own."[307] While such anti-Louis-Philippe gossip might be exaggerated by the republican-minded Decamps, it is harder to ignore when the *Journal des Artistes et Amateurs*—conservative and usually well-informed—refers to "subjects excluded for political reasons, and by an authority which is said to be greater than the jury's own."[308] Thus, the available evidence indicates that Louis-Philippe did indeed keep an eye on those subjects dealing with Orléans participation in the

radical phase of the French Revolution which, if shown at the Salon, might generate politically troublesome public discussion.

Instances of the government monitoring specific kinds of revolutionary imagery can be found as early as 1831, even though the July Monarchy professed enthusiasm for commemorating the Revolution and initiated projects like Guizot's plan to decorate the Chamber of Deputies. Louis Boulanger's picture of the execution of Bailly on the Champ-de-Mars in 1793, for example, was refused by the Salon jury in 1831 (fig. 156).[309] It represents a group of sans-culottes taunting the discredited ex-mayor of Paris before claiming their revenge for his "crime" of declaring martial law in 1791 to quell disturbances after Louis XVI's unsuccessful flight: Bailly had ordered troops to fire on demonstrators at the Champ-de-Mars on 17 July 1791.[310] Bailly's executioners were particularly pitiless, for they forced the old man to walk from the Cité to the Champ-de-Mars amid insults and physical abuse, and then marched him around for several hours in the cold and rain while the guillotine was erected. When the fatal blade finally fell, the machine mockingly sported the same red flag of martial law that Bailly had carried in 1791.[311] Boulanger responded to the legendary cruelty of Bailly's executioners by portraying the old man as weakened and defenseless against the robust, open-shirted (and somewhat caricatured) furies of the Terror. Despite his sympathetic portrayal of the elder statesman's plight, it was not the right moment to recall the gruesome excesses of 1793: Louis-Philippe may have boasted to Nicholas of Russia that no such excesses followed the July Revolution, but tempers were not yet so cool that his government would admit those of 1793 to the Louvre. Boulanger was thus forced to show his *Bailly* much later, at an exhibition organized at the Bazaar Bonne-Nouvelle in 1843 to benefit the victims of an earthquake in Guadeloupe.[312]

Other painters who ventured into the more gory chronicles of the Terror also found themselves locked out of the July Monarchy's Salons, even when their works did not condone the bloodletting. A case in point is Auguste DeBay's 1838 picture of *An Episode of 1793 at Nantes* (fig. 157), which was exhibited at the 1850–51 Salon; the *livret* explained that the subject was inspired by a passage from the *Histoire de Nantes* published in 1839 by Ange Guépin.[313] A native of Nantes, DeBay would have harbored a natural curiosity about this history of his hometown, and Guépin's graphic descriptions of the mass executions and orgiastic debaucheries engineered at Nantes during 1793 by Jean-Baptiste Carrier—who was sent to the Vendée by the Convention to punish rebel factions—are lurid enough to inspire any number of compelling images.[314] DeBay did not fix upon the cruelty or bloodshed, however, but isolated a scene of touching sentiment which Guépin had described as "worthy of antiquity" among the stories of executions on the place Bouffay. The guillotine stands ready while a mother and her daughters prepare for death by singing canticles together; their songs pierce the revolutionary gloom like bolts of lightning. The legend continues, "the people stir. At the intonations of the young virgins they rediscovered a vestige of pity in their hearts. The religion of their ancestors, that religion which consecrated their first steps in life with imposing ceremonies and is now no more than a memory, envelops them in its splendors. The executioner himself succumbs to its poignancy. Nevertheless, he carries out the orders he had received—two days later he is dead of horror and remorse."[315]

DeBay's image of this melodrama steadfastly directs our sympathy toward the plight of the victims and refuses to comment on the historical circumstances. The five principal characters—spotlighted in the foreground despite the storm clouds overhead—collapse together in a lugubrious, despairing swoon which rivals the best of Greuze. As the women raise their voices in song, figures throughout the picture turn in startled recognition of the familiar hymns: the sans-culottes tying the hands of a victim at the left, the executioner standing above, and soldiers and spectators in the crowd respond involuntarily to these angelic voices. At the far right, a young boy's comments are stopped short by an older man, presumably to prevent the youth from earning a place on the waiting line. DeBay's anecdotal episodes are supported by a careful study of the costumes and locale of 1793 Nantes, so that the picture retains an aura of historicity even as the narrative refuses to become historical: offering no clues as to whether the victims were royalist sympathizers who might have deserved their fate, the image generates a sympathy for their plight which suggests that their execution was unwarranted.

It is not likely that DeBay's politically conservative meaning would have raised an objection from the authorities of the July Monarchy. Nor is it likely that the style of his picture was thought to be outré, for it closely resembles the scene of 1792 which he had painted for the Palais-Royal (fig. 140). Paradoxically, DeBay's desire to depict the executions of 1793 with a conscientious accuracy was just the reason his picture was refused by the jury of the 1839 Salon. "The primary—or, better yet, the sole—reason for this refusal," noted one critic, "is that M. DeBay put in his picture a guillotine rendered with an exactitude that makes you shudder. The jury's philanthropy wanted to spare the public's sensibility."[316] An 1887 catalogue of the museum at Nantes explains that the picture now lacks this bit of compelling detail because the canvas was trimmed slightly at the left edge to remove the guillotine.[317] It is important to understand that the fate of DeBay's *Episode of 1793* turned upon the too graphic rendering of a minor detail, for it reminds us of how literally pictures were "read" in the 1830s. We have seen that contemporary habits of looking were conditioned by a respect for narrative "truth" and often supported by texts. Any form of "official art" which hoped to speak effectively to this kind of viewer would be forced to adopt a syntax capable of supporting the public's fragmented and nonhierarchical reading and viewing habits. DeBay's case illustrates two points: first, the kinds of interpretative difficulties which will be encountered if we separate the question of an "official style" from issues of content and meaning; second, why the kind of picture called genre historique— understood in the 1830s as a *fusion* of style and content which operated culturally in new ways—has figured so importantly in this study.

If DeBay's rather tame image of the Terror warranted banishment from the Salon, then Marcel Verdier must not have been surprised when his picture of the 1792 prison massacres was barred from the Louvre in 1841 (fig. 158).[318] Verdier transports us to the corpse-littered courtyard of the Abbaye prison, where we witness a terrifying example of filial piety. A kangaroo court has just condemned Charles-François de Sombreuil, governor of the Invalides, and handed him over to the gang of self-appointed executioners in the courtyard. Moved to desperation, Mlle de Sombreuil throws herself into the fracas to plead for her father's life. The would-be assassins, momentarily halted by the sight of this delicate young woman who braves their wholesale carnage, quickly concocted a horrible test of her

resolve: "'Drink,' they said to this high-minded young girl, 'drink the blood of aristocrats!' as they passed her a flask full of blood. She drank and her father was saved."[319] Verdier recounts the climax of this gruesome encounter, when Mlle de Sombreuil—empty glass in hand and a red tint on her lips—turns to the roughly dressed mob of sans-culottes with an expression of triumphant calm. Her father seems stunned by what he has seen, while the crowd's leaders hold back their bloodthirsty colleagues and gape with a mixture of horror and admiration.

Verdier was not the first to celebrate Mlle de Sombreuil's heroism, for Joseph-Alexandre de Ségur had included her story in his 1803 history of great women through the ages, and the episode was popular enough to be illustrated in the 1834 edition of Thiers' *Histoire de la Révolution française* (fig. 159).[320] This engraving by Ary Scheffer helps to explain more fully the premises of Verdier's picture, because it resonates with the memory of David's 1799 *Sabines*.[321] Scheffer's heroine occupies center stage and throws herself into the fray with the same selfless dedication as David's Hersilia. With Davidian decorum, Scheffer chose the moment *before* Mlle de Sombreuil actually drank the blood so that her noble courage would not be tainted by the horror of her test. Verdier, on the other hand, shifted the story's focus from ideal bravery to the pathetic tragedy of a well-bred woman reduced to near barbarism. His Mlle de Sombreuil does not exhibit the disinterested sense of public virtue found in such related modern subjects as Cogniet's *July 1830* (fig. 54) or LeBarbier's 1790 picture of Désilles at Nancy (fig. 55): these offer sternly principled behavior in the face of social pressure yet remain uncomplicated by the moral ambiguities of Verdier's scene. To adjust for this change of ethos, Verdier replaced the taut binary structure of the earlier images with a casually organized, centralized image more conducive to casting his heroine's filial devotion in sharp relief against the harsh historical circumstances. The background of stark prison wall, relieved only by a play of shadows from neighboring buildings, establishes a claustrophobic space appropriate to the episode. A mass of humanity is packed into this restricted space but the main actors of the scene—Sombreuil, his daughter, and the nearby sans-culottes—detach to form a tableau unto themselves. Many of the surrounding characters remain indifferent to the foreground drama and really only serve to set the stage for the primary action. The resulting pictorial fragmentation, aided by a spotlight on the main group, isolates the single episode from a larger tumult and reconciles the work's intimate, genre-scale expression with its large-scale format. Verdier's work illustrates how artists of the July Monarchy responded to historical themes which offered something other than a black-and-white morality by adopting the more supple, less structured form of representation which we have called genre historique. We have seen how this type of loose-jointed, emotion-packed image was used by Louis-Philippe at Versailles to bend history to his purposes. Verdier's picture, on the other hand, shows how the same formal schema, when freed of an official propagandistic function, could express the complex and ambivalent morality of modern history.

Other, less gruesome images of the Terror were occasionally admitted to the Salons of the July Monarchy. Melchior Péronard, for example, made his Salon debut in 1831 with a picture representing the Girondins Valady, Louvet and Barbaroux (fig. 160).[322] The story, which comes from the memoirs of Jean-Baptiste Louvet de Couvray, concerns three of the twenty-nine Girondin deputies condemned as traitors by the Jacobin-controlled Conven-

tion on 2 June 1793.[323] Louvet and his two friends were among the Girondins who successfully fled Paris in June and eluded capture for nearly a year by living a nomadic, underground existence. Péronard offers us one of the trio's most physically difficult moments. A sympathetic priest had hidden them in a hayloft so full of new, warm hay that "there remained barely two feet of space for the fresh air which could enter only by a single, very small skylight." But when their protector was sent out of town without being able to announce his departure, the three Girondins were left with neither food nor water for more than forty-eight hours: parched, hungry, and despairing, Louvet and Barbaroux silently contemplated their pistols and a final end to their misery. Valady, suddenly sensing the impending violence, stopped the double suicide with the words, "Barbaroux, you still have a mother; and you, Louvet, Lodoïska is waiting for you!"[324]

Valady steeled his friends' will to live by invoking their personal lives (mother and wife) rather than the political ideals for which they were suffering. Following the literary source, Péronard emphasized the internal psychological processes of his desperados by spotlighting them amidst the darkness of the hideaway so that they loom before the viewer with a sinister and dramatic presence. Completely circumscribed by the personal limits of physical and psychological endurance, Louvet's narrative is a vignette of private pathos within the grand story of the Revolution. Péronard's picture—a pathos-riddled combination of fact and feeling noticeably lacking the noble public virtues thought essential to History Painting—is the visual end product of the new way to read and relate modern history.

Pictures of the Terror became relatively more common at the Louvre during Louis-Philippe's second decade of rule, and one is tempted to think that this greater tolerance for revolutionary history, like the shifts in Louis-Philippe's official portraits discussed earlier, was spurred by the increased self-confidence of the Orléans dynasty after 1840. These new pictures tended toward a narrative manner related to the Péronard of 1831 in their emphasis on the personal and emotional dimensions of the historical situation. Thus, Joseph Robert-Fleury's painting of *The Children of Louis XVI Imprisoned in the Temple Tower* (now lost?) at the 1840 Salon stressed the irony of the royal children studying a map of France, "because their father's kingdom has already ceased to exist except on paper."[325] Critics dwelt almost exclusively on the tender sentiment of this work, which seems to have excelled in a tragic empathy not unlike the wildly popular picture of *The Children of Edward* by Delaroche, which hung in the Luxembourg at this time.[326]

The next year Auguste Lebouis sent to the Salon a picture representing *Marie Antoinette at the Conciergerie*.[327] Our present analysis of how the Revolution was reevaluated during these years is supported by Wilhelm Tenint's remarks about *Marie Antoinette*:

> Like inactive cemeteries, upon which one cannot build for a certain number of years after their closure, it seems that up to now one had respected this great ossuary of the revolution. No epoch is more rich in contrasts. . . . Nevertheless, poets and artists have generally neglected this mine where gold is mixed with a lot of muck. It is only in 1841 that, thanks to our dear and learned friend Augustin Challamel (Jules Robert), one will have a dramatic—I would almost say a physiognomic—history of the Revolution. It is likely that painters will borrow useful ideas from it. This year M. Lebouis is the only one who has addressed these terrifying subjects: *Marie Antoinette*

at the Conciergerie is quite well conceived. Poor woman! The greatest kindness they could show her was to guillotine her.[328]

Tenint's commentary, which groups together high drama, painting, and the Revolution, mirrors the kind of amalgamation which we are discovering in these images of history more sensitive to emotional states than heroic acts. Finally, our analysis of how these works related to traditional image-types is confirmed by what the *Journal des Beaux-Arts* said of Lebouis' picture: "Here's a touching subject, that of this queen, this daughter of kings, once so powerful and beautiful, now thrown into a dark cell, subjected to the cruelest privations, and constantly under the eyes of these guards. This subject, so solemn and rich in emotions, would have been worthy of a large canvas: M. Lebouis only dealt with it as an easel painting, but he rendered it well. The contrast between the prisoner and the men who guard her is perfectly perceived."[329] This critic found the subject worthy of "a large canvas," but his judgment rested almost entirely on conditions other than the historical or moral importance of the depicted action. The principal attraction of the story lay in its contrast of a beautiful, aristocratic woman in jail and subject to continuous surveillance by rough-mannered guards. In other words, we have an example where the personal sentimentalism of genre has displaced the sublime public acts of History Painting as the basis for the critical evaluation and classification of pictures.

An important effect of the breakdown in traditional expectations was an increased opportunity for so-called "marginal" artists to broach historical themes which might otherwise have been closed to them. It is a fact that History Painting—the pinnacle of Academic ambition and achievement—was almost never open to women painters, no matter how talented.[330] But, as the hegemony of this most noble mode eroded before the social pressures of shifting patronage and a critical approbation of historicized genre, the old rationalizations for sexual bias became increasingly impotent. We can measure this shift by the number of revolutionary subjects painted by women and exhibited at the Salon. Elise Journet, for example, sent a picture of *Lavoisier in Prison* to the Salon of 1843.[331] Her work received extensive press coverage, including long discussions by *L'Artiste* and Jules Janin.[332] Journet's subject was inspired by an anecdote about Antoine-Laurent Lavoisier's final hours: condemned to death by the revolutionary tribunal because he had been a tax collector (*fermier général*) for the king, Lavoisier was supposedly conducting one last experiment in his cell when the executioner appeared at the door.[333] Journet's picture showed the chemist surrounded by the scientific instruments he had invented and so involved in his notes that he waved the jailer away without looking up from his desk. The dim light of a candle enabled one to perceive "a horrible man with base features and a crooked nose, stocky and covered with hair—one of those savages to whom Danton, Marat, and Robespierre confidently entrusted the surveillance of their victims. He approaches Lavoisier. He reaches out; this monstrous hand is going to descend on the shoulder of this man of science: it's all over."[334] Colorful contemporary descriptions like this suggest that Journet's painting sought a pathos supported by a panoply of props from 1794. Most critics stressed her concern for historical accuracy and the fact that she had painted the actual instruments from Lavoisier's laboratory.[335] Finally, to underscore that this picture was

substantively different from the rest of Journet's oeuvre, *L'Artiste* added, "We will say nothing about the manner with which the background and accessories of this painting are rendered, for one has seen, in Mlle Journet's pictures of still-life, that she knows how to deal with these things; anything we could say on that subject would be superfluous."[336] Journet's example of how an established female still-life painter could successfully exhibit a picture of modern history at the Salon illustrates the kind of "upward mobility" one might expect as public enthusiasm grew for the genre historique formula of a modest format and explicit sentimentality.

Journet's *Lavoisier* is apparently lost today, but two works shown at the 1846 Salon by Louise Desnos can serve as characteristic examples of this same phenomenon. We know that Desnos referred to Thiers' history by the entries for her pictures in the Salon *livret*, which included excerpts from that text. *The Evening Paper* (fig. 161) owes a rather obvious debt to Thiers, for it follows closely the text and Alfred Johannot's print of the subject from the 1834 edition (fig. 162).[337] The story is set in a Parisian prison during June and July 1794, the most active months of the Terror. Each evening, jailors would pass through the cells to read the names of those who would be transferred to the Conciergerie for an appearance before Fouquier-Tinville's expeditious tribunal in the morning. Those whose names appeared on the jailors' list—nicknamed "the evening paper" (*le journal du soir*)—could expect the worst: "These unfortunates . . . trembled to hear their name called by the court clerks. When they had been named they embraced their companions of misfortune and accepted final farewells. One often saw the most painful separations: here a father from his children; there a husband from his wife."[338] Both Desnos and Johannot included the entire range of expressive possibilities described by Thiers: anxious listening at the left, familial separation at right center, a parting embrace in the background, and a moribund father and daughter at the right who have probably lost a wife/mother on some earlier evening and now seem to hear their own names called. Although we might question the inventiveness of Desnos' picture, we cannot mistake the language used to relate this tragedy of modern history: its combination of a shallow, stagelike space, evocative and unnatural lighting, tightly controlled handling, and a wide emotional range falls squarely within the representational parameters of the bourgeois family drama invented by Greuze in the eighteenth century.

Much the same must be said about the *Interrogation and Condemnation of the princesse de Lamballe*, Desnos' second picture at the 1846 Salon (fig. 163).[339] This unfortunate princess, reputedly one of the most beautiful women at Court, met her end during the prison massacres of September 1792. The story of her death recommended itself as a tragic martyrdom by reason of the extreme violence of its finale: after she was struck down by the ersatz executioners of September, parts of her mutilated corpse were carried on pikes through the streets and paraded outside the window of the queen's cell in the Temple Tower.[340]

For this picture, Desnos invented an image which closely follows Thiers' text to illustrate the crucial moment of Lamballe's "trial" when a sympathetic bystander tried to save her life. The revolutionary inquisitor awaits a response to his demand that the princess swear to love liberty and equality and to hate the king, queen, and all other royalty. "I will take the first oath," answers Lamballe, "but I cannot make the second, for my heart is not in

it."[341] Her reply explains why Desnos portrayed the princess with one hand on her breast and the other extended in aversion as a sign of her determined royalism. Similarly, Lamballe effects a strange off-balance pose with a dreamy facial expression because that was how Thiers described the situation: "'Swear then,' whispered one of the witnesses who wanted to save her. But the unfortunate princess saw and heard nothing more."[342] Although doggedly faithful to the letter of its historical text, Desnos' picture is silent about the fury and passions so evident in September 1792: her would-be sans-culottes—as well-scrubbed as the princess is elegant—behave with such a polite serenity that the extra-legal proceedings of their kangaroo court seem perfectly respectable. The principal focus of attention here is the genteel creature who nobly responds with her heart but lacks the physical stamina to profit from the moment and save both her life and her honor. Stripped of its political ramifications, the picture shifts the tragedy of September 1792 from the public sphere of a society turned against itself to the private realm of sentiments and individual frailties. Once again, modern history has been recast in the domesticated, intimate mold of genre.

It is equally significant that Desnos' *Lamballe* was well received by critics, who noted that it was justifiably hung in the Grand Salon of the Louvre because "it is painted with an exactitude and a force which is surprising. A woman's hand usually does not have such vigor."[343] This comment, not an isolated reference to the sex of the picture's author, supports the claim that the changing standards of "serious" painting fostered critical praise for painters previously excluded from serious consideration. Thus, *La Revue Nouvelle* paid a compliment to Desnos which must have pleased her, given the male-dominated art world of the 1840s: "A woman's natural penchant for touching scenes has induced Madame Desnos to depict an epoch which, for the edification of France and mankind, should never be forgotten. She has turned it to her profit: the bloody facts of the revolution have not been so well expressed in painting since the *Charlotte Corday* of M. Scheffer. There is a virile talent in the composition, drawing, and execution of the two pictures by Madame Desnos."[344] This comment closes our discussion of Louise Desnos, for it not only illustrates contemporary understanding of how serious subjects could be painted by women but also invokes the *Charlotte Corday* of Henri Scheffer—one of the best-known pictures of revolutionary France to date from the July Monarchy and the centerpiece of our next section.

10. CHARLOTTE CORDAY: *OFFICIAL PATRONAGE AND POLITICAL INTENT*

Heretofore I have used the imagery of the French Revolution produced during the July Monarchy to explain why artists turned to the principles of representation which define genre historique. I have also argued that the pictures of revolutionary France commissioned by Louis-Philippe are formally related to genre historique but have, in addition, a dimension of meaning outside historical time which links them with some immediate social signification. I am suggesting, in fact, that the July Monarchy's official art can only be distinguished from the thousands of other contemporary objects by asking how its characteristic subject-matter and identifiable style functioned politically within a specific time frame. In this context, Henri Scheffer's 1830 painting of *Charlotte Corday* graphically

illustrates how form and content could intersect with the political concerns of a moment to obtain official favor (fig. 164).[345]

The morality of Charlotte Corday's claim to fame—her murder of Jean-Paul Marat on 13 July 1793—has always been difficult to judge, and her place in history has varied widely.[346] Marat, a chief proponent of the Terror's organized violence, did not lack enemies who secretly rejoiced when Corday permanently removed him from the political arena. That his killer was a young and rather pretty farm girl possessing a quiet yet firm resolve fostered a pro-Corday sympathy among many people. Displaying dignity and a calm composure during her trial and a noble resignation when sentenced to the guillotine, Corday elicited public admiration which soon developed into a kind of cult, placing her in the company of such great female avengers as Joan of Arc and Judith. In this light, the unabashed, pro-Marat rhetoric of Jacques-Louis David's compelling *Marat Dying* should not be construed as a "true" picture of the assassination (fig. 165).[347] Where David's partisan image of the murder had singlemindedly ignored Charlotte Corday, the growth of her cult—itself a function of the new vision of the Revolution elaborated by historians like Thiers—is central to an understanding of Scheffer's 1830 painting.

Popular images from 1793 often exhibit both fascination and sympathy for Charlotte Corday, as evidenced by the engraving which Quéverdo supposedly drew from life (fig. 166).[348] The main section of this print shows Corday in prison writing a farewell letter to her father. Her opening line—*Pardonnez-moi mon cher papa, d'avoir disposé de mon existence* (Forgive me, dear Papa, for having thrown away my life)—is clearly legible, while her crime, represented in the small oval below, is apparently much less important. The print plays to the public's interest in the personality and character of Charlotte Corday and demonstrates that she was more than just another murderer. Whereas Pâris—the former Royal Guard who assassinated Michel LePeletier de Saint-Fargeau, the other great Jacobin martyr of the period—was always depicted as a murderer, many of the dozens of prints representing Charlotte Corday made no reference to her crime.[349] Her popularity was so great that on 22 July 1793, only five days after her execution, a memo from the Committee of Criminal Investigations (Sureté Générale) addressed to Fouquier-Tinville observed, "we have received the deposition and the official copies of documents from the trial of Charlotte Corday. The committee thinks that it is pointless and perhaps would be dangerous to give too much publicity to the letters of this extraordinary woman who already has aroused only too much interest among troublemakers."[350] It is revealing to discover that a committee close to the heart of revolutionary radicalism could not mask a tinge of admiration for "this extraordinary woman," and that it clearly recognized the problems which the "myth" of Corday might present to the government.

Obviously, even the most discreet admiration of Charlotte Corday's calm resolve would detract from the sense of national tragedy with which David and the Jacobins hoped to surround Marat's death: this politically deleterious effect is especially apparent in Louis Brion de la Tour's print, *Assassination of J. P. Marat* (fig. 167).[351] Brion's composite image represents two distinct actions, neither of which is the actual murder: at the right, Marat's body is moved to a bed from the shoe-shaped tub in which he was soaking when Corday stabbed him; at the left, an angry crowd of Marat sympathizers prepares to lead the murderess away from the scene. Grieving women establish an appropriate emotional tone

to connect the two actions, while the essential icons of the murder—Corday's forty-sous knife and tall hat, Marat's wooden-plank writing desk and quill pen—are prominently displayed in the foreground. Brion's image is charged with heroic and religious associations culled from tradition. His use of a shallow, friezelike arrangement of assistants moving Marat's half-naked corpse refers self-consciously to the heroic funeral processions of Greco-Roman reliefs that were an essential part of the late eighteenth century's pictorial vocabulary. This arrangement also paraphrases well-known images of Christ's burial—the Louvre's Titian, for example—to energize Marat's deposition with a transcendental meaning.[352] Nevertheless, Marat shares this image with his assassin: Brion's depiction of her subdued resignation counters the angry words and gestures being hurled by her captors without suggesting that she is deranged or horrible. The expression of this contrast, heightened by the whiteness of Corday's Sunday-best dress, must have been inspired by her unflinching and respected sangfroid during the trial and execution.[353]

The cult of Charlotte Corday grew auspiciously from these humble beginnings in direct proportion to the infamy heaped on Marat by posterity. In 1803, Joseph-Alexandre de Ségur noted that "among the women who played a role in the Revolution, one of the most extraordinary is Charlotte Corday," and he sympathetically described her crime as having "freed the world of a monster."[354] Later, Thiers interrupted his fast-moving historical narrative to develop the character and background of Charlotte Corday, detail her resolve to murder Marat, emphasize her "unshakable self-assurance" at the trial, and note that she "submitted to her conviction with the serenity which had never left her. She responded to insults from the vile populace with the most modest and dignified bearing. However, not everyone insulted her: many people felt sorry for this girl—so young, so pretty, so disinterested in her behavior—and accompanied her to the scaffold with a look of pity and admiration."[355]

Scheffer's picture (fig. 164), an engraving of which illustrates the 1834 edition of Thiers' text, is an extension of the image-type formulated by Brion de la Tour (fig. 167) in that Corday is led off to the left while figures attend to Marat's body at the right. Unlike the 1793 print, however, which split the narrative between the protagonists of this bloody encounter, Scheffer literally relegated Marat to the background shadows and focused his work on Corday: she stands at the physical center of the canvas and at the focal point of a luminary structure which spotlights her fair skin and elegant dress amidst the ruddy browns of her captors' rough clothing. By reworking Brion's "balanced" narrative to show Corday patiently enduring the threatening gestures and taunts of the red-bonneted sans-culottes, Scheffer's picture elicits a sympathy for the murderess which measures the growth of the Corday cult since 1793 and creates a politically conservative image of her crime.

Even if Scheffer seems more interested in the peripheral drama of Marat's murder than in the crime itself, he was not completely cavalier with history. Scheffer's version of the story is supported by many verifiable details: for example, the cut (if not the fabric) of Corday's dress was carefully modeled on the historical evidence provided by Quéverdo's engraving (fig. 166). Once again, an obsession with the truth of details and an appeal to sentimentality mask the picture's moral and political acceptance of Marat's murder. The viewer's attention is shifted to Corday's plight by the painter's spotlighting of her and by

keeping the main characters close to the picture plane so that an alternative reading cannot develop. The overturned chair which anchors the lower right corner of the image reinforces this narrative closure by guaranteeing that Marat remains a secondary prop in this story of his assassination.

I have argued that genre historique emerged from the material and social conditions which prevailed in France after the 1830 Revolution, and Henri Scheffer's *Charlotte Corday* seems to fall within the working parameters of that type. In addition, the critical dilemma experienced by the *Journal des Artistes et Amateurs* before Scheffer's picture suggests that this analysis is correct:

> In this gallery the history paintings [*tableaux d'histoire*], always in the minority, offer very little food for thought. That by M. Scheffer is the only one which attracts much attention. *Charlotte Corday* . . . presents a scene of great interest. Maybe this subject needed to be treated life-sized, or perhaps in the usual dimensions of genre painting. There is a vague, undefined phenomenon which generally avoids the scale of half or one-third life-size as being too close to the real world yet giving, at first glance, a false sense of it. One does not run this danger with figures seven or eight inches tall.[356]

This critic, writing only four months after the Trois Glorieuses, had probably never confronted the combination of format, historical literalness, high sentimentality, and modern subject offered by Scheffer's *Charlotte Corday*. Like the observers who wrestled with Vernet's *Camille Desmoulins* (fig. 139) at the same Salon, this writer could not decide how to "classify" *Charlotte Corday*, and his indecision is the best indication that our characterization of this new picture-type is on target. As we have seen, it was during the 1830s and 1840s that genre historique became the preferred mode of representing all types of modern history subjects. By 1846, critics understood this development well enough to group Scheffer's *Corday* with the paintings of Louise Desnos (figs. 161, 163). What remains is a question of patronage: if Scheffer's image is essentially the same type—in formal, expressive, and narrative terms—as the pictures of the Terror discussed in the previous section, how might we account for the fact that Louis-Philippe's government bought the *Charlotte Corday* but not all those others?[357]

Few critics at the 1831 Salon failed to recognize the historical reorientation effected by Scheffer's *Corday*. Victor Schoelcher, for example, complained that "in this terrible drama Marat incontestably shares the leading role," and argued that Scheffer had committed "a serious mistake in having pushed this important figure into the background." Schoelcher did not, however, advocate an image which would portray Corday as the demon of reactionary politics that the Jacobins of 1793 believed her to be; rather, he wanted Scheffer to depict graphically the victim in order to strengthen the expression of "this courageous girl": "the blood of her enemy, far from making her blanch, should, on the contrary, carry her ardor to the highest point of paroxysm; led away by the people, and still burning with a satisfied vengeance, she should celebrate her triumph!"[358] The sentimental mystique of Charlotte Corday was so established in 1831 that even a left-wing, republican critic like Schoelcher could implicitly request a conservative reordering of history so that this anti-Jacobin assassin might be depicted with the radiant flush of exultation and triumph.[359]

When he opted for a less extreme formulation of Corday's personality, Scheffer

remained closer to those historical accounts which stressed her lack of political stri-
dency.[360] This too is a fiction, of course, an image tailored by the folklore of the Corday cult
and the shifting historical evaluation of the Great Revolution. How might this tranquillized
figure of Charlotte Corday fit the needs of the Orléans dynasty in 1831? An answer lies in the
political coloration with which some critics read Scheffer's sympathetic portrayal of his
heroine:

> Charlotte's face has an admirable expression: dignified without arrogance, emo-
> tionally excited without fear, pale because she has given birth to a crime, resigned to
> a death which morality and the law call ignoble but which political extremism makes
> into a triumph. Everything about this character is superb. Two working-class men
> [*hommes du peuple*] who are seen in front of Charlotte are very well conceived: the
> atrocious character [*caractère atroce*] of their physiognomy; their brutal gestures
> [*gestes brutaux*] (for one can guess what they are saying to their prisoner); all this is
> felt, composed, and rendered with spirit and force.[361]

This text clearly articulates the latent political conservatism of Scheffer's image: Corday's
act may be morally ambiguous, but there is nothing ambivalent about her adversaries—
they are *atroces, brutaux*, a lower order of life. Charlotte shines among these foul-mouthed
hommes du peuple and dominates them by her dignified demeanor. In short, the usual
moral code about murder has been reversed to achieve a reactionary political statement:
law-abiding *hommes du peuple* are villainous because they are friends of Marat; the
murderess is noble because she has killed a radical revolutionary in cold blood and is glad
for it.

More important, Scheffer's was not an isolated case of this flip-flop moral view of the
French Revolution. In 1831 the July Monarchy faced a threat not unlike the one which
Scheffer had opposed to Charlotte Corday in his picture: the people had wrought the
revolution which brought Louis-Philippe to power, and they were beginning to agitate for
tangible benefits from the Orléans government in the form of higher wages and more
jobs.[362] The Revolution, long censored by the Bourbon Restoration, reappeared on stage
and in books to offer revived and rehabilitated popular heroes like Marat, Robespierre, and
Fouquier-Tinville.[363] It was certainly in the new government's self-interest to temper this
popular euphoria with reminders that some aspects of France's revolutionary past—most
notably the outbursts of public disorders, violence, and anarchy—were best forgotten. In
September 1830 Guizot had selected the story of Boissy-d'Anglas to decorate the Chamber
of Deputies because it was an event in which an unflinching governmental commitment to
social order had opposed the furious masses of the Revolution. Louis-Philippe purchased
Scheffer's *Charlotte Corday* from the 1831 Salon because it encoded a similar meaning: it
reformulated Marat's murder with the imagery of Corday's legend to portray her as the
levelheaded peasant girl who delivered France from a bloodthirsty tyrant and his pack of
republican furies. Understanding the picture's political conservatism explains how the
king's purchase accords perfectly with the "strategy of acquisition" practiced by the July
Monarchy during the first few years of its existence.

We have seen that the political troubles of the mid-1830s exerted considerable pres-
sure on the government's decision to drop the *Boissy-d'Anglas* and its *Mirabeau* pendant

from the Chamber of Deputies decorative scheme, and to scuttle Barrot's 1789/1830 installation at the Hôtel-de-Ville. Later, Louis-Philippe took up the events of the Great Revolution at Versailles, but no longer with the idea of establishing a direct link between his crown and the policies or politics of that earlier epoch. By the time that the galleries at Versailles began to take shape, pictures like the *Charlotte Corday* by Henri Scheffer had fallen out of official favor for at least two reasons: first, because their political references to the events of radical, republican France were potentially dangerous springboards for public debate in a social climate where opposition to the Orléans dynasty was increasingly fierce; second, because the king had established an alternate and highly specialized "official" history of the Revolution which was self-contained, politically inert, and systematically purged of the Terror. During the 1840s, the exigencies of the former became less pressing, but the iconography of the latter—carefully structured to *reconcile* rather than equate the Orléans dynasty with the nation's revolutionary past—remained forever closed to both the heroes and the villains of the First Republic.

PART IV

Shadowboxing Napoléon's Glory: The Orléanist Revival of Imperial Imagery

1. THE MAKING OF A LEGEND: NAPOLEONIC ICONOGRAPHY BEFORE THE JULY REVOLUTION

THE ENTHUSIASTIC RECEPTION of the tricolor's return to public life in July 1830 was fired, in part, by the nationalistic memories of military glory attached to the banner of Napoléon.[1] The tricolor's appearance on the barricades of July had a special significance for the seasoned Napoleonic veterans who figured largely in the fighting of the Trois Glorieuses: when these former soldiers battled the troops of Charles X, they were as interested in avenging France's defeat in 1815 as in preserving their constitutional freedom.[2] Cries of "Long live the Emperor!" and "Long live Napoléon II!" were heard frequently among the Parisian insurgents and, like a talisman, Napoléon's name carried powers of safe-keeping amidst the fighting.[3] On the morning of 30 July, while making his way across Paris toward Neuilly to solicit Louis-Philippe's cooperation in establishing a new monarchy, Adolphe Thiers was so often greeted with pro-Napoleonic exclamations that he feared the Bonapartists had already carried the day.[4]

Although the barricade fighters of 1830 were united by Bonapartist sympathies, the potential leaders of a Bonapartist *political* force were disorganized, unable to agree on a course of action, and incapable of competing with the Orléanists for control of the revolution.[5] The biggest obstacle to any such initiative was the fact that its nominal leader, Napoléon's son, lived a guarded existence in Vienna, under the watchful eyes of Metternich. The Bonapartist situation in 1830 presented a strange paradox: it enjoyed tremendous support among those citizens who nourished a lasting devotion to the memory of the Emperor, yet it lacked the leaders and the program to marshal this sympathy into an effective political entity. Conversely, the Orléanists had well-organized parliamentary leaders but only a slim base of popular support. Many of the behind-the-scenes negotiations which took place between 30 July and Louis-Philippe's coronation on 9 August involved convincing would-be Bonapartists that their cause was hopeless and that they should rally to the duc d'Orléans: in the end, numerous Napoleonic sympathizers accepted posts in

Louis-Philippe's government.[6] Converting Bonapartist "professionals" to Orléanism was relatively simple, however, compared to the task of defusing the deep-rooted (and potentially dangerous) public sympathy for Napoléon. Not surprisingly, the July Monarchy attempted to tap this contemporary grassroots popularity by annexing the imagery of Napoléon and awarding him a prominent place in the iconography of official art. What are the characteristics and meanings of this government-sponsored Napoleonic revival?

Actually, the word *revival* must be used with reserve, because the legend of Napoléon had never completely disappeared from France.[7] Despite the prodigious efforts of the Bourbon Restoration regime to suppress public references to the usurper Buonaparte (as they insisted on spelling his name to make it seem more Italian than French), a brisk trade in all types of objects bearing the likeness of Napoléon or his son flourished throughout the 1815–30 period.[8] Nor was this popular imagery limited to a clandestine existence in France: Napoleonic objects, poetry, and theater also flourished in countries where political circumstances allowed greater tolerance than the Bourbons dared to permit—including those nations which had lived under the yoke of the Emperor's despotism.[9] Finally, Napoléon's cult was seconded and reinforced all across Europe by the thousands of narrators who had been members of the Emperor's army, participants in his rise to power, and victims of his catastrophic fall. Repetition of their stories propelled a conglomerate vision of the acts, gestures, and attitudes of Napoléon by clarifying the most remarkable episodes of the Napoleonic legend, circumscribing its narrative limits, and defining its essential iconography.[10] This typological evolution is historically important because Napoléon's imagery, unlike that of the French Revolution, was already fixed in the public mind before 1830. The July Monarchy was relatively free to invent a representation of the Revolution which served its political purposes, but it was compelled to walk a fine line between the familiar devotional imagery of the Napoleonic legend and a meaning which would flatter the Orléans dynasty without endorsing the Bonapartist cause.

Paradoxically, the event which most served to fix the contours of Napoléon's popular cult was the death of its hero on 5 May 1821.[11] So powerful was Napoléon's allure that many of his devotees—especially among the rural and urban poor—simply refused to believe that *L'Homme* (a favored sobriquet which the Bourbon censors could not suppress) was dead. Pierre-Jean Béranger's poetry was wildly appreciated throughout the 1820s for sentiments like the following:

> O Dieu puissant, qui le créas si fort
> Toi qui d'en haut l'as couvert de ton aile
> N'est-il pas vrai, mon Dieu, qu'il n'est pas mort?

> [Oh powerful Lord, who made him so strong
> You who from on high sheltered him under your wing
> Is it not true, My Lord, that he is not dead?][12]

One index of the popularity of such effusions is the fact that a collection of Béranger's songs extolling Napoléon, published in 1821 after the Emperor's death, sold eleven thousand copies in one week.[13] Five years later, Heinrich Heine's reverie on the death of Napoléon was both a gauge of current public opinion and an ominous prophecy for the Bourbon regime:

The Emperor is dead! His solitary grave is on a desolate island of the Indian seas and *HE*, for whom the world was too small, lies peacefully under a tiny hillock where five weeping willows sorrowfully let their long green locks fall, and close to where a gentle stream trickles with a melancholy babbling. His tombstone carries no inscription but Clio, with her equitable quill, has written invisible words upon it which, like spiritual music, will continue to echo for thousands of years. . . . And Saint-Helena is the Holy Sepulchre to which people of the Eastern and Western hemispheres will make pilgrimages in bunting-bedecked ships, their courage fortified by powerful memories of the Savior's temporal existence and of the suffering under Hudson Lowe, as it is set down in the gospels of Las Cases, O'Meara, and Antommarchi.[14]

Heine clearly understood that any Napoleonic pilgrims who might travel to the Emperor's tomb on Saint-Helena would be prepared spiritually by texts which had come to them in the guise of memoirs and diaries dutifully kept by Napoléon's comrades-in-exile. During the 1820s, works by O'Meara, Doctor Antommarchi, the generals Montholon and Gourgaud, and the British sea captain Maitland enabled European readers to share intimately Napoléon's exiled captivity and to hear him speak for all time about his lasting accomplishments and his dashed dreams.[15] Each of these texts helped to order and codify the Napoleonic folklore, but none wrought so profound an impact on the future political direction of the legend as the *Mémorial de Sainte-Hélène*, published in 1823 by Emmanuel de Las Cases.[16]

Las Cases, an intimate of the exiled Emperor, had joined the entourage of his hero on the day Napoléon left Malmaison forever, 29 June 1815.[17] They remained together until 25 November 1816, when Las Cases was arrested and deported by the English authorities of Saint-Helena for trying to smuggle letters to Bonapartist sympathizers in Europe. During these seventeen months, Las Cases kept a daily record of his conversations with Napoléon—from complaints about their everyday treatment by the English to insights concerning the great moments of the Empire. Hudson Lowe, the governor of Saint-Helena, confiscated these notebooks when he deported Las Cases, and they remained in the hands of the English until after the Emperor's death. The papers were finally returned to Las Cases in 1822, at which time he settled at Passy—under the surveillance of the Bourbon government's police—to begin work on the *Mémorial*.[18]

When the eight volumes of Las Cases's text first appeared, their success was so remarkable that a second printing was immediately announced, an English-language edition was simultaneously published in London, and German editions appeared in Stuttgart and Dresden.[19] Even more important than this numerical success was the influence of Las Cases's text upon the legend of Napoléon—an effect with two significant consequences for this study.[20] First of all, the *Mémorial* offered reliable eyewitness testimony of Napoléon's physical, material, and psychological suffering at the hands of his English jailors.[21] These detailed and documented accounts argued that England had treated Napoléon as a common criminal rather than as a prisoner of war who had nobly surrendered his sword. Beyond merely evoking a public sympathy, the revelations of Las Cases awakened in France a feeling of endured injustice which intertwined the plight of Napoléon with that of the nation itself—both defeated at Waterloo, one condemned to exile on a desolate island, the other to the indignity of an old-style dynasty imposed by the armies of foreign invaders. Second, the *Mémorial* provided an international rostrum for Napoléon, speaking from

beyond the grave, to evaluate his achievements and shape his place in history.[22] Precisely because of their isolation from the political intrigues and realities of Europe, Napoléon had leisurely recounted to Las Cases a history which honored the Emperor's dedicated defense of liberal ideals rather than his military might.[23] In the text of the *Mémorial* Napoléon speaks with passion of his role as consecrator of the French Revolution: "from this moment nothing would be able to destroy or erase the basic principles of our Revolution; these important and admirable truths should remain forever, for we have woven into them so much éclat, so many monuments, and such extraordinary achievements that we have drowned their first infamies in waves of glory: from now on they are immortal!"[24] Later, as if responding to those critics who found little of this idealism in Napoléon's implacable conquest of Europe, Las Cases records the Emperor's dream of a postwar idyll of peace and tranquillity:

> Back in France, amidst a nation that was large, strong, magnificent, at peace, and resplendent, I would have proclaimed that its borders were permanent, that any future war would be strictly *defensive*, that any further enlargement would be *antinational*. I would have brought my son into the Empire: my *dictatorship* would have ended and his constitutional reign would have begun.... Paris would have been the capital of the world, and Frenchmen the envy of nations! Then, during the royal apprenticeship of my son, my free time and old age would have been devoted to visiting leisurely—accompanied by the Empress and, like a real peasant couple, on our own horses—all the far corners of the Empire: hearing complaints, correcting wrongs, on every side and everywhere disseminating monuments and good works.[25]

It is no accident that Napoléon took care to paint himself into this dream world as a solicitous father figure, and this domestic tone returns at several points in the *Mémorial*. Las Cases tells us, for example, that while Napoléon admitted he was not religious he did so "with regrets, because it [religion] was no doubt a great solace," and quickly adds that Napoléon's skepticism "came from neither contrariness nor libertarianism, but simply from the power of his mind."[26] Nevertheless, this heir of Enlightenment rationalism revealed strong and morally impeccable feelings about the place of religion in society: "once I had the power, I hastened to reestablish religion. I used it as a starting point and a root. To my mind, it supported a general morality, true principles, and good behavior. And, furthermore, mankind's anxiety is such that he needs this undefined and supernatural realm which religion offers. It is better that men find it there than go looking for it ... among fortune-tellers and crooks."[27] In instances like this we recognize that the paternalistic image of Napoléon presented by the *Mémorial* was a carefully groomed apologia. The main issue, however, is not that these patent manipulations were an integral part of the *Mémorial* but that their aura of authenticity generated a profound public impact in the 1820s. Henceforth, the Napoleonic legend—previously existing as an unfocused sentiment in favor of the exiled Emperor—would speak with a sharpened historical perspective and a visionary social character. In short, the legend had acquired the vocabulary of an active political program.

Even before the various diaries of Saint-Helena were known in Europe, there was a visible rapprochement in the French political arena between Bonapartists and the liberal opponents of Bourbon rule—a union which set aside ideological differences to mount a

combined attack, protected and promoted by Napoléon's name, against the Restoration government.[28] The death of Napoléon in 1821 actually strengthened this alliance in two ways. First, as we have seen, it permitted full disclosure of the Emperor's innermost thoughts and last privations. Second, with Napoléon relegated to history, liberal leaders felt newly able to turn both the nostalgia for the Empire's glory and the sentiments evoked by the Emperor's tragic death-in-exile against the Bourbons without losing control of the situation.[29] The *Mémorial* of Las Cases played a crucial role in this process of political fusion between Bonapartists and liberals by heightening the tragedy of Napoléon's death and seemingly certifying his political liberalism.

The lines of common cause between these two factions were maladroitly encouraged by Charles X's repeated manifestations of extreme ultra-royalism. His police maintained a continuous watch over the political activities of the ex-officers and *demi-soldes* (discharged soldiers on half pay) of Napoléon's Grand Army who lived in the capital.[30] In December 1824, the king dismissed from the armed forces 56 lieutenant-generals and 111 brigadier-generals, most of whom were veterans of the Napoleonic wars and had not yet reached retirement age.[31] Many of Charles's courtiers had careers dating from the Empire, but the king pointedly avoided references to their service for Bonaparte.[32] When Charles X appointed Jules de Polignac as Prime Minister in August 1829, he put at the head of his cabinet not only a like-minded royalist, but also an émigré who was a former enemy of the nation and a battlefield opponent of Napoléon's army. Other appointments in the Polignac cabinet were no less odious to the liberal-Bonapartist opposition. Charles selected François de La Bourdonnaye as Minister of the Interior and Louis de Bourmont to head the War Ministry: the first had led a purge of the government after Napoléon's defeat in 1815, and the second had deserted the Emperor on the eve of Waterloo.[33] If we weigh the combined effect of these appointments, the repeated affronts delivered by Charles X to the Emperor's memory, and the liberal political coloration acquired by the Napoleonic legend after 1821, we can begin to understand why Napoléon—and his tricolor banner—emerged in July 1830 as the most potent popular symbols of the revolution which toppled the Bourbon regime.[34]

After the Trois Glorieuses and the end of Bourbon censorship, the current of enthusiasm for the cult of Napoléon became a torrent of images in all the arts, but nowhere did it emerge more quickly and decisively than on the stage.[35] Beginning on 31 August 1830 with the *Passage du Mont Saint-Bernard* at the Cirque Olympique, theaters throughout Paris mounted productions extolling the life and exploits of Bonaparte and his circle: from leading a snowball fight in grade school to making his triumphal entry into Berlin, from the story of his abdication and exile to that of his son's semicaptive existence in Austria.[36] Entrepreneurs were quick to claim a share of this euphoria, and the director of the Théâtre de l'Odéon—jealously eyeing the profits being reaped by his rival at the Porte-Saint-Martin—commissioned a script from Alexandre Dumas which would relate the high points of Napoléon's stormy career from the battle of Toulon to Saint-Helena. Dumas himself admitted that *Napoléon Bonaparte ou Trente ans de l'histoire de France* was far from brilliant, but its title alone guaranteed profitability during these months of feverish *napoléonisme*.[37]

A key to the success of these productions was a believable representation of the principal character, and actors who had the good fortune to bear a physical resemblance to

the Emperor became overnight sensations. The most famous of these—Gobert at the Porte-Saint-Martin and Edmond at the Cirque—were coached by former intimates of the Imperial court to perfect their renditions of the Emperor's most familiar habits: his clipped speech, hands clasped behind his back or fondling a lorgnette, and his famous bicorne hat (*petit chapeau*) worn at just the right angle.[38] The words spoken by L'Homme on stage, as Heine observed, were chosen with care to strike the desired emotional chords:

> There are couplets which include watchwords that stun the French mind like the recoil of a cannon or work like onions on their tear ducts. Everyone cheers, weeps, becomes fired up at the words: the French eagle, the sun of Austerlitz, Iéna, the pyramids, the Grand Army, honor, the old Imperial Guard, Napoléon. The enthusiasm reaches its peak when the man himself, *L'Homme*, appears at the end of the play like a deus ex machina. He always wears the magical chapeau, has his hands clasped behind his back, and speaks as laconically as possible.[39]

The evocative power on stage of certain key words, gestures, and costume details depended quite obviously upon their relationship to the iconography codified during the 1820s by proponents of the Napoleonic legend. Not surprisingly, playwrights plagiarized the legend's primary texts (such as the *Mémorial de Sainte-Hélène*) to lend their scripts an air of authenticity, and the Emperor's theatrical stand-ins adopted prints like Nicolas-Toussaint Charlet's *Napoléon in Bivouac* as exemplars (fig. 168).[40] Such stage practices demonstrate that, although political restrictions on plays about Napoléon had been relaxed after the July Revolution, important typological constraints continued to be imposed by the very tradition which charged the representations with contemporary meaning. The relatively fixed and emotionally loaded imagery of the Napoleonic legend both provided these productions with a vocabulary to speak directly and effectively to their audiences and served as a measure of their "correctness." In the following discussions we shall discover that a similar situation prevailed in the visual arts, and that Napoléon's appearances in the official commissions of the July Monarchy were stylistically and semantically tempered by a functional relationship to the popular, "low art" formulas of representation established by his legend.

2. *FROM MYTH TO POLITICAL PROGRAM: THE IMAGERY OF* NAPOLEON DU PEUPLE *AFTER 1830*

The newly launched Orléans dynasty was in no position to oppose the flowering of Bonapartist sympathy just after the July Revolution and actually took steps to ally itself with the general élan: the royal museums resurrected many paintings of Napoléon for the exhibition that opened in October 1830 at the Luxembourg Palace; Louis-Philippe's government announced in April 1831 that a statue of Bonaparte would once more stand atop the Vendôme column; and, also in April, the king made a special visit to the Diorama to view Daguerre's newest installation, *The Tomb of Napoléon on Saint-Helena*.[41] Yet Louis-Philippe was certainly aware of the political dangers involved in flirting with the powerful emotions elicited by the memory of Napoléon, and he displayed much greater reserve when Bonapartism became the subject of government policy. The law of 11 September 1830, for example, authorized repatriation for most of the Napoleonic civil servants banished during

the Restoration, but it maintained the Bourbon's proscription of the Bonaparte family.[42] Similarly, in October 1830 the Chamber of Deputies rejected a proposal to have Napoléon's remains returned to France and enshrined at the base of the Vendôme column.[43] Although numerous public petitions supported this measure, Louis-Philippe's ministers quashed it on the grounds that it was politically too sensitive. The government's timidity drew the censure of many Bonapartists, including Victor Hugo, who addressed these famous lines to the spirit of Napoléon:

> Oh! qui t'eût dit alors, à ce faîte sublime,
> Tandis que tu rêvais sur la trophée opine
> Un avenir si beau
> Qu'un jour à cet affront il te faudrait descendre
> Que trois cents avocats oseraient à ta cendre
> Chicaner ce tombeau!

> [Oh! Who would have said to you then, at this pinnacle sublime
> While you imagined, atop the trophy, to have accorded it
> A destiny so grand
> That one day you would have to descend to this indignity
> That with your remains three hundred lawyers would dare
> To bicker for this tomb!][44]

The effervescence of nationalism which accompanied this resurrection of Napoleonic sympathy soon proved to be completely at odds with Louis-Philippe's foreign policy. When popular revolutions erupted in Belgium (August 1830) and Poland (December of the same year), French public opinion supported direct aid to the rebels in the name of fraternal solidarity—especially because the battle cry at Brussels had been "Let's imitate the Parisians!"[45] The Belgians, whose land had been annexed by Holland under the treaties of 1815, were now trying to rectify that humiliation much as the French had done when they ousted the Bourbons in July. Louis-Philippe realized, however, that any military response would bring the entire coalition of 1815 into the fray—Nicholas I of Russia had offered William of Holland the use of sixty thousand troops—and he adopted a "principle of nonintervention" by which France pledged to remain neutral unless some third power became involved in the Dutch-Belgian conflict adjacent to her borders.

Louis-Philippe's principle of nonintervention clearly indicated that the Poles could expect no military help from France, which left the Russians free to crush the fledgling Polish revolution. The czar's forces occupied Warsaw on 7 September 1831, and when news of the fall of Warsaw reached Paris on 15 September, it created an angry stir: theaters and businesses closed, marches were held, the government's position was heatedly debated in the Chamber of Deputies, and a few barricades appeared in the streets.[46] During the following four days of Parisian unrest cries of "Long live Napoléon II!" and "Long live the Poles!" were mixed in an important confluence of opinions, in which Bonapartists and prorevolutionary republicans discovered a common ground from which to attack the July Monarchy government.[47] The two camps joined forces under the banner of Napoléon—the leader who had dared to export the Great Revolution to the rest of Europe—and denounced Louis-Philippe's concern for maintaining the continental status quo as a refusal to

acknowledge his own revolutionary origins. In this development of the early 1830s—the fruit of the liberal policies which had been grafted to the Napoleonic legend during the preceding decade—Napoléon's imagery assumed the attributes and attitudes of a "man of the people" (*homme du peuple*) and became the signboard of left-wing, republican opposition to the Orléans dynasty.[48]

This neoplebeian Napoléon was necessarily cast in decidedly nonimperial roles, and one of the best known was inspired by Béranger's chanson of 1828, *Les Souvenirs du peuple*: during the 1814 Allied invasion of France, Napoléon and a small number of officers appear at the door of a farmhouse in search of a meal. While his hostess serves watered-down wine and coarse bread, Napoléon dries himself by the fire and naps briefly before recommencing the futile struggle to save the Empire.[49] Béranger's song enjoyed immense popularity during the 1830s and provided the ideal pretext for popular prints sympathetically portraying the great man comforted by a humble hearth (fig. 169).[50] Two examples from 1835 illustrate the continuing popularity of this episode, for in that year variants of it were produced at opposite ends of the pictorial spectrum: a cheap woodblock print was published at Metz to accompany Béranger's lyrics (fig. 170) and a painting (now lost) was exhibited by J.-L. Dulong at the Salon.[51]

A related image by Hippolyte Bellangé, one which resonates within a long tradition in the history of art, appeared in 1830: Napoléon again naps in a humble cottage, but now a young boy immortalizes the Emperor's visit by tracing the imperial silhouette cast on the inn wall by a hidden candle (fig. 171).[52] The Bellangé updates late eighteenth-century images of the "origin of painting" while retaining the sentiments and mood of its classical model: like the Corinthian maiden who affectionately captured the silhouette of her departing lover in antique versions of this story, the young man's tracing exhibits a devotion informed by the knowledge that Napoléon would soon be permanently exiled from France.[53] The lugubrious lighting and humble surroundings of Bellangé's print successfully evoke the dark months during which Napoléon valiantly defended the fatherland against the Allies and allude to the Emperor's shadowy presence in French public opinion of the 1830s—freely moving among the common folk and inspiring their simple yet genuine admiration.

This romantic image of Napoléon as an homme du peuple sometimes acquired a religious coloration, and the Emperor began to look suspiciously like a modern-day savior of the common man. An anonymous 1833 print, *Soldier Spare the Effort, for I Am amidst the People* for example, represents Napoléon being acclaimed by the Parisians in March 1815 shortly after returning to France from his first exile (fig. 172).[54] The admonition addressed by Napoléon to his soldier is but a thinly disguised, secular version of the biblical story of Christ rebuking his disciples for shooing away a group of children.[55] This print reformulates the episode to suggest that Napoléon was not threatened by grassroots contact with his subjects. In fact, when Napoléon recounted these days of 1815 to Las Cases, he expressed a belief that "the fury of the crowd" was only held in check by his careful weighing of every word and gesture, and contemporaries recalled that he was "terrified by the energy of everything around him . . . he found none of the former obedience, profound respect, nor Imperial etiquette."[56] The spontaneous self-assurance so manifest in this 1833 print is thus less rooted in historical reality and Napoléon's actual feelings about the masses than in the

political rhetoric required by the growing rapprochement between Bonapartists and republicans at this time.[57] In short, the political fiction of this print borrows a biblical narrative to present covertly the messianic promise offered by Napoléon's name and cause.

The existence of an almost sacrilegious cult of the Emperor can be corroborated by both literary and pictorial documents from this period. In 1833 Balzac offered a detailed account of Napoléon's life—significantly titled "The Napoléon of the People"—as it was told in popular folklore.[58] Goguelat (Balzac's narrator) emphasizes that under the Emperor's fair-minded meritocracy "sappers who knew how to read became nobles," and that "a sergeant and even a private could say to him 'my Emperor,' like you say to me sometimes, 'my good friend.' Moreover, he responded to explanations that were given to him, he slept in the snow like the rest of us and almost seemed to be an ordinary man."[59] Goguelat is quick to add, of course, that Napoléon was far from ordinary. We are told that when Napoléon spoke to his troops "his word fired us up" to the point that "dying men tried to raise themselves up to salute him and cry 'Long live the Emperor!' . . . is this natural? Would you have done that for an ordinary man?"[60] Later, Goguelat says that at the time of Napoléon's first abdication in 1814 he "was resolved to die. Rather than see Napoléon defeated, he took enough poison to kill a regiment because, like Jesus Christ before his passion, Napoléon thought himself abandoned by the Lord and by his lucky star. But the poison did nothing at all."[61] In the event that the supernatural allusions of this tale failed to impress the nonbelievers in his rural audience, Goguelat adopts a more earthbound political rhetoric to assure them that the Emperor is not really dead and that such reports are but rumors spread "to dupe the people and keep them docile in their hut of a government." Joining these two notions at the end of his story, Balzac's narrator couples a benedictional observation with a politically charged exclamation: "it is not to the child of a woman that God would have given the right to draw his name in red as he [Napoléon] wrote his across the earth, which will always remember it! Long live Napoléon, father of the people and the soldier!"[62] Bellangé's contemporary lithograph of 1835, *Look Here Father, for Me That's Him, the Heavenly Father*, carries the religious fervor of Balzac's peasantry from literature to visual imagery (fig. 173).[63] In it a peasant—undoubtedly a veteran of the Grand Army—professes to the local priest a nearly blasphemous faith in Napoléon while gesturing to an image of his idol: the print's strategic location on the hearth and the attentive presence of the man's children convey the sincere attachment to the Emperor's memory which is nurtured by the daily habits of this simple family.

A picture exhibited by Bellangé at the Salon of 1833, *The Peddler of Plaster Figurines*, offered a variant on this neo-Christian Napoleonic sentiment (fig. 174).[64] A country blacksmith and his family inspect the wares of a young salesman, whose selection of statuettes includes some traditional madonnas and a number of miniature Napoléons. The conscientious mother shows one of the religious pieces to two of her sweet, neo-Greuzian children. Her husband, on the other hand, holds one of the Napoléons aloft and contemplates it with a quiet reverie: the little statuette seems to hold him in a spell and tap a personal bond which no doubt dates from his days as a soldier. The parallelism between husband and wife of poses, gestures, and icons underscores Napoléon's nearly divine status among the peasant-veterans of Imperial France in the 1830s. Bellangé, like Balzac, brought this humble devotion to the public arena of the Parisian art world. Unlike a work of literature, however,

the partisan expression of a Salon painting can be appropriated by a collector attuned to the power of rhetorical gestures. Given the widespread sympathy for the sentiments celebrated by Bellangé and the Orléans dynasty's self-interested desire to short-circuit the threat posed by the politicizing of Napoléon's popular prestige, it is not surprising that Louis-Philippe bought this picture from the Salon.[65] The king's seemingly anachronistic acquisition reminds us how ancillary pressures rooted in public opinion and politics could converge at this time to recommend "official" status for a picture which is undeniably historical in character but genre in form and politically complex in expression.

We must also recognize that the republican-Bonapartist coalition opposed to Louis-Philippe's rule could be aided and abetted by such public endorsements of the legend presenting Napoléon as an homme du peuple.[66] The serious civil disorders of June 1832 and April 1834 demonstrated the fragility of Louis-Philippe's mandate and prompted major reorientations in the iconography of recent history as recorded in official art, especially at Versailles. Not surprisingly, a parallel adjustment—and the development of an imagery which would walk the tightrope between simple commemoration and approbation—can be traced in the works inspired by Napoléon's epoch and commissioned by the July Monarchy. The frequently incompatible aspects of this development will be our next concern.

3. FROM GENERAL TO EMPEROR: A CITIZEN-KING RECALLS BONAPARTE'S POLITICAL AMBITIONS

On 29 August 1833, Louis-Philippe ordered Frédéric Nepveu, his architect at Versailles, to begin a total renovation of the "large *salle des gardes* on the first floor of the palace's main central structure."[67] The project was authorized one week before the official announcement of the king's plan to remake Versailles into a museum, and it was the first actually begun at the château.[68] Although the earliest documents do not specify the iconographic program for the large gallery, Nepveu's journal entry for 6 March 1834 indicates that it was to be "dedicated to the Imperial epoch and consequently to a single man."[69] The "single man" referred to is Napoléon, and it is clear that Louis-Philippe planned the room known today as the Salle du Sacre at the very outset of his building campaign. The king's sense of priorities should not strike us as unusual: the tide of Napoleonic enthusiasm sweeping France at this very moment certainly required that any museum dedicated to "all the glories of France" would accord a prominent place to the glory of Napoléon. As we shall presently discover, however, the Napoléon enshrined in the new gallery was rather different from the *Napoléon du peuple* discussed above, and the images installed by Louis-Philippe reveal his now-familiar aplomb when balancing historical facts and propagandistic political motives.

Construction in the Salle du Sacre began immediately upon receipt of the king's order, and the work was enough advanced by 8 April 1834 for the king to see "the large frames and that of the ceiling."[70] The pictorial program must have been formulated early in the planning because the architectural decorations were designed to frame the pictures—in this case, images painted during the Empire and already owned by the Royal Museums. Louis-Philippe personally supervised the selections, and Nepveu arranged a makeshift

presentation of the gallery on 7 May 1834 so that the king might preview the installation during his visit that day.[71]

The Salle du Sacre, like all of the history galleries at Versailles, was conceived as an iconographic whole in which an underlying logic dictated the choice and sequencing of its images. Each of the three long walls of the room supports a single large painting: on the north, *The Battle of Aboukir* by Gros (fig. 175); on the west, Jacques-Louis David's *Consecration of the Emperor Napoléon* (fig. 176); and on the east, David's *Oath of the Army Made to the Emperor* (fig. 177).[72] The ceiling was completed by enlarging an allegory of *The 18th of Brumaire* painted by Antoine-François Callet in 1801 (fig. 178).[73] Finally, on the day that Louis-Philippe first saw the entire gallery free of scaffolding, he ordered the emplacement of two portraits between the windows of the south wall: an existing image of *Napoléon Ier, Emperor of the French* by Robert Lefèvre, and a *Napoléon Bonaparte, General-in-Chief of the Army in Italy* commissioned from Jean Rouillard (fig. 179).[74] Since all but one of the pictures for the Salle du Sacre were "second-hand," a discussion of their stylistic characteristics is largely irrelevant to our analysis. We might note, however, that the historical pedigree of the canvases placed in the gallery would, like a badge of authenticity, guarantee the veracity of their imagery in a manner completely consonant with the formal vocabulary of uninflected literalness preferred by Louis-Philippe throughout Versailles.

To understand the *nature* of the images selected for this gallery is crucial to our discussion. The two Davids unambiguously record and aggrandize the pomp and splendor of Napoléon's investiture as Emperor of the French in 1804: he is surrounded by the elite of government and clergy while crowning Josephine in the *Consecration*, and he receives the enthusiastic pledge of victory or death proffered by his military commanders in the *Oath*. Yet the Emperor stands at the narrative center of each picture and remains the focus of attention despite the riot of realistic details and hundreds of portrait likenesses all around. It would be difficult to imagine a Napoléon more unlike his contemporary popular image as an homme du peuple than the one advanced by these two works hanging face to face in the Salle du Sacre; as legitimate historical documents, however, the Davids present irrefutable evidence that an imperial Napoléon had, indeed, existed. If Louis-Philippe intended only to evoke the ostentation of Empire with this gallery, he could easily have found a third picture to complement the Davids among any number of candidates languishing in the reserves of the Louvre.[75] On the other hand, if the king's purpose was simply to gather together the most brilliant examples of French painting during Napoléon's reign, we might agree with his choice of Gros's *Aboukir* but wonder aloud why, when qualitatively "greater" pictures were readily available, he installed a mediocre portrait of the Emperor by Lefèvre and commissioned a third-rate, unknown painter to execute the painting of General Bonaparte.[76] The fact that Louis-Philippe selected the *Aboukir* (in which Bonaparte does *not* appear) for a gallery supposedly dedicated to "a single man" forces us to seek reasons for his choice within the structure of the gallery's iconography. As has so often been the case with Versailles, an understanding of the king's historical perspective will provide the key to unlock the underlying meaning of the Salle du Sacre.

Although Napoléon is not represented in Gros's picture, he was the commander-in-chief of French forces at the battle of Aboukir on 25 July 1799—a decisive victory that was to be his last in Egypt. Napoléon's ambitious military campaign along the Nile had begun in

May 1798 with the departure from Toulon of an enormous flotilla comprising over three hundred ships and nearly fifty thousand men.[77] Once in Egypt (1 July 1798), the French scored an impressive string of victories at Alexandria (2 July), the Pyramids (21 July), and Cairo (23 July). On 1 August, when an English armada under Nelson completely destroyed the French fleet at anchor in the harbor of Aboukir, the French army suddenly found itself victorious on land but stranded far from home. During the next twelve months, Napoléon established French control throughout the Nile delta and busied himself with an expedition into the Holy Land against nomadic Muslim armies in the service of the English-Turkish alliance. The English continued to pressure Napoléon, however, and landed a large Turkish army at Aboukir on 17 July 1799. The French mercilessly annihilated the Turks at the battle of Aboukir one week later, but Napoléon was tiring of this interminable war in the Middle East. Reports of political turmoil in Paris—seconded by rumors of Josephine's infidelity—convinced him that he must return immediately to Europe. On the night of 22 August 1799, Napoléon and a handful of his trusted generals secretly slipped a hastily armed freighter past the English fleet and set sail for France.

In a letter of instructions to Jean-Baptiste Kléber, the general who assumed command of the army in Egypt, Napoléon wrote that "the interest of the nation, her glory, a sense of duty, and the extraordinary events which have recently occurred in France—they alone persuade me to leave."[78] Napoléon's argument was never very convincing: neither Kléber nor the army completely accepted his rationale, English caricaturists of the time were quick to portray Bonaparte as a deserter, and modern historians have harshly judged his sincerity.[79] Thus, Napoléon's victory at Aboukir was tarnished from the very beginning by suspicions that he had placed personal ambition before the good of his men.

Gros's picture in the Salle du Sacre reopened this question in a new context. It also reminded the visitor to Versailles that Napoléon had won this victory (like all the others) with the heroic assistance of many brilliant generals.[80] More important, Louis-Philippe generated a second order of historical meaning in the Salle du Sacre by juxtaposing the battle of Aboukir with scenes of Napoléon as Emperor. Aboukir was Napoléon's last victory as a general in the French army. Upon his return to France (he landed at Fréjus on 9 October 1799), Bonaparte was enthusiastically hailed as the savior of the Republic and the one man capable of rallying the floundering armies. No sooner had Napoléon reached Paris (16 October) than he began to plan a power grab: the sophisticated historical logic of the Salle du Sacre at Versailles joins historical fact at just this point.[81] The gallery articulates Napoléon's titular transformation from general in 1799 (represented by Gros's *Aboukir*) to Emperor in 1804 (the two Davids) and closes the chronology with Callet's allegorical representation of the coup d'état of 9 November 1799 (18 Brumaire An VIII) installed on the ceiling (fig. 178). In this work, an airborne warrior-goddess leans on an Egyptian sphinx and is transported inland by figures of renown (who herald the landing with beribboned trumpets); their élan forces shadowy hulks to cower with fear in the right corner and dissipates the dark clouds to welcome the conqueror. Callet's obsequious allegory had been designed in 1801 to glorify Napoléon's rise to power, but within Louis-Philippe's program for the Salle du Sacre its original meaning was neutralized when the picture was reused as the connective tissue to join the other images of the gallery into an historically coherent whole. The iconography of the Salle du Sacre represents, in effect, *two* Napoléon Bo-

napartes: the dashing young general of the Italian and Egyptian campaigns and the autocratic Emperor who built his power upon military might. The south wall of the gallery (fig. 179) explicitly articulates the two careers of Bonaparte's biography and reiterates the point by calling attention to his two wives: a medallion above the portrait of the general presents the passion of his youth in the smiling figure of Josephine, while an image of Marie-Louise—the Austrian bride arranged by treaty who ultimately abandoned her husband in his defeat and exile—crowns the picture of Emperor Napoléon.[82]

Louis-Philippe's strategy of clearly separating the two careers of Napoléon achieved a three-fold propagandistic signification. First, it distinguished between the irreproachable military achievements of the general and the self-aggrandizing habits of the Emperor to fix the idea that not all of Napoléon's ambitions were altruistic. Second, it clarified the distinction between political Bonapartism—which sought to reestablish the Bonaparte family's dynasty—and a patriotic Napoleonism which admired the exploits of the general but was not particularly inclined to reinstate imperial rule. Louis-Philippe's contemporaries understood that a convenient blurring of this important ideological distinction made it possible for Bonapartists and republicans to work in concert against the Orléans regime; the program of the Salle du Sacre attacked this political coalition by exposing and underscoring its basic incongruity.[83] Finally, the iconographic logic of Louis-Philippe's gallery counters the myth of Napoléon as an *homme du peuple* with the historical fact that the essential link between the Nile and the *Sacre*—the elixir of Bonaparte's transformation from general to Emperor—was the coup d'état of 18 Brumaire. Even staunch believers in the creed of Napoléon as a protector of republican principles had difficulty reconciling their faith with their hero's complete circumvention of the Constitution in a coldly calculated military coup.[84] By spotlighting this moment, the Salle du Sacre lays bare the delusion of Napoléon's republicanism by recalling that he alone had stolen absolute power in France with a show of military force.

For nineteenth-century visitors to the museum at Versailles, the Salle du Sacre began a trajectory which culminated in the Salle de 1830. The imagery of Napoléon's political rise at the beginning of this historical journey contrasts sharply with Louis-Philippe's accession depicted at the journey's end: where the Emperor personally crowns his queen and receives an oath of undying loyalty from his troops, Louis-Philippe is *invited* to accept his crown, pledges *his* fidelity to the Charter, and enlists the support of the National Guard, a militia of civilians rather than professional soldiers. In short, the juxtaposition of these two galleries elicits the conclusion that the cult of a single personality had yielded in 1830 to a monarchy which respected the principles of liberalism and ruled within the limits of a contractual constitution.

A few years later, Napoléon was presented even more explicitly as a strong-arm leader in the series of pictures commissioned by Louis-Philippe to document the "evolution" of post-1789 governments in France. Unlike Callet's generalized allegory discussed above, François Bouchot's picture of *The 18th of Brumaire* records a specific moment of the coup d'état (fig. 147). The picture's title does not really accord with the event portrayed, however, for the coup was actually a two-day plot during which Napoléon worked in concert with his brother Lucien, president of the Council of the Five Hundred (*Conseil des Cinq-Cents*), and Emmanuel-Joseph Sieyès, a moderate leader intensely interested in crushing the left-wing

Jacobin party.[85] These three circulated rumors of an imminent terrorist uprising aimed at reestablishing a radical state modeled on Robespierre's government of 1793–94. Using this ruse, the trio convinced the two government assemblies—the *Anciens* and the *Cinq-Cents*—to move from their "threatened" quarters in Paris to the safety of the château at Saint-Cloud. Napoléon, who had been illegally appointed commander of the Parisian military garrison, was invited to "protect" the government during its move and after its installation at Saint-Cloud. The plotters' strategy was to instigate a situation in which Napoléon could isolate the government from the capital and bully it with his formidable army of six thousand loyal troops. Preparations for the move to Saint-Cloud were completed on 18 Brumaire (9 November 1799) and the representatives were instructed to reconvene the next day in their new, "safe" quarters. As for the five Directors who comprised the executive branch of government, Sieyès and Roger Ducos were already involved in the coup, and the others were now quickly disposed of: the corrupt Paul Barras was bribed into tendering his resignation, while Gohier and Moulin—two minor Jacobins—were placed under military arrest when they refused to be similarly persuaded. By the evening of 18 Brumaire, and with a minimum of fanfare, Napoléon controlled all of the real power in France and needed only to obtain a veneer of official approval.

When the *Anciens* and *Cinq-Cents* opened their respective sessions around two o'clock on the afternoon of 19 Brumaire, everyone sensed what was afoot. Passionate debates in both chambers indicated that the representatives were disinclined to rubber-stamp Bonaparte's coup with a belated legitimacy. Napoléon decided to address each group personally, although he took care to appear in the company of a large retinue of army officers. He first menaced the *Anciens*, who were quick to see his point of view. The *Cinq-Cents*, however, were another matter: when Napoléon entered their hall, cries of "Down with the tyrant!" filled the air, a group of Jacobin deputies pushed him around, and he was hastily rescued by a squadron of his troops.

This is the moment represented in Bouchot's painting. A crowd of angry deputies (wearing their ceremonial red togas) demand with insistent gestures that the young upstart general leave their presence. Behind Bonaparte, two soldiers physically grapple with the onslaught, while bayonets and shakos to the left suggest a second scuffle in that part of the room (most of Napoléon's companions had remained at the doorway when he entered). Although in Bouchot's painting Bonaparte appears untroubled by this tumult, accounts tell us that he was extricated with great difficulty; once outside, he had to send a squadron of soldiers back into the fray to retrieve Lucien. Reunited, the Bonapartes harangued the troops with a story of a nearly successful assassination attempt by Jacobins armed with daggers.[86] Duly outraged by these tales, even previously skeptical soldiers proclaimed their trust in the two Bonapartes. "Soldiers, I have lead you to victory," cried Napoléon; "Can I count on you?" They responded with cries of "Yes! Yes! Long live the general!"[87] Orders were given to clear the meeting-hall: with drums rolling the charge and bayonets drawn, the troops advanced on the assembly and finished the job in a matter of minutes. The coup was over, and Napoléon was in charge.

The interesting point about Bouchot's representation of this event is his reduction of the entire two-day drama to the tense—and unsuccessful—first confrontation between Napoléon and the *Cinq-Cents* on 19 Brumaire. The artist probably took his clue from such

early nineteenth-century prints of the episode as those by Helman (fig. 180) or Descourtis (fig. 181), originally produced to corroborate Napoléon's tale of danger and thus emphatically including daggers poised to strike the general.[88] Napoléon actually awarded a pension to a soldier named Thomas Thomé for sustaining a knife wound while protecting his commander on 19 Brumaire, but later historians generally treat the story as a bit of enlightened ad hoc rhetoric invented to elicit unswerving devotion from the troops.[89] When painting this episode for Louis-Philippe, Bouchot eliminated the daggers and gave Bonaparte a rather more firm countenance than he reportedly displayed at the moment when the coup's success seemed to hang in the balance.

Critics at the 1840 Salon immediately grasped the historical bias of Bouchot's image. Jules Janin, for example, complained that "Bonaparte occupies all the space: he is calm and strong; one would say that he is fulfilling a duty . . . the picture's effect gains by this, even if the historical truth is diminished."[90] Charles Blanc clearly wanted the coup *to be* a coup when he asked rhetorically, "What is an 18 Brumaire without soldiers?" and faulted Bouchot for having "made us arrive an hour before the event."[91] Thus, contemporaries realized that, while the Bouchot cut through the mythology of 18 Brumaire, it also adjusted history to portray the event as a vivid and unequivocal confrontation between the constitutionally elected representatives of the nation and the enterprising soldier of fortune who knew that military might was on his side. Bouchot's bifurcation of the narrative, which assigns to Napoléon the principal role in the coup d'état and minimizes that of his accomplices, is reinforced by the picture's other formal devices. The sunlight streaming through the background windows, for example, gives way to an unnatural pool of light in the foreground which spotlights Napoléon amidst his adversaries. Conversely, the tribune at the upper right (where Lucien Bonaparte holds out against an onslaught of menacing gestures) inexplicably disappears in shadow so that the viewer's attention remains riveted on the antagonists at the front and center of the image. Similarly, Bouchot's crisp detailing of the immediate foreground—including the suggestively overturned chair—develops the principal action with a tangible directness while, as Tenint observed, "the background areas are a bit unclear and powdery."[92] The result—an artificiality of lighting and a costume-piece, stagelike structure—prompted Eugène Barbeste to remark that "the composition of this painting is theatrical and pretentious."[93] Other critics joined in faulting the picture's melodramatic representation but also suggested that the form had been imposed upon the artist: "There is enough evidence of talent in this work," noted Planche, "that one is permitted to think that M. Bouchot, if left alone, would have produced a picture far superior to the one we see."[94] In order to understand why Bouchot might have been instructed to transform documentary prints of Napoléon imperiled into an image of his emerging imperialism, we must return to the time frame within which the picture was commissioned.

What might have been Louis-Philippe's purpose in specifying an iconography which explicitly cast Napoléon as the chief instigator and principal benefactor of the political machinations of 1799? Two pertinent documents are found among the king's personal correspondence with comte Louis Molé, his prime minister from April 1837 to March 1839. The first, dated 1 June 1838, is an expression of astonishment: "It is quite remarkable," wrote Louis-Philippe, "that Lucien Bonaparte could have disappeared from Mannheim on

23 June without anyone knowing where he went or where he is now."[95] One month later, the king requested that Molé take some specific action: "I pass along to you [the evidence] that Bonapartist intrigues are very active. I believe that Montalivet should have the borders along the Rhine and Switzerland watched carefully, and you would do well to write a few dispatches to Germany on the same subject."[96] These private memos underscore Louis-Philippe's anxiety about Bonapartist political activity during the summer of 1838, just two months after he had commissioned the picture from Bouchot. In fact, the specter of a Bonapartist coup had haunted Louis-Philippe's government since October 1836—the date of Louis-Napoléon Bonaparte's miserable failure at Strasbourg to rally the army against Orléans authority.[97] Not wanting to sensationalize this affair before the public eye, the government had arrested the would-be usurper and deported him to the United States— after first providing him with fifteen thousand francs in spending money! Bonaparte's accomplices in France were brought to trial in January 1837 before the court of Strasbourg.[98] Ironically, they were defended by the brother of Odilon Barrot—a name already mentioned in our study—and, much to the government's chagrin, all of the conspirators were acquitted on 18 January.[99] To celebrate this verdict, leftist leaders sponsored a great banquet; a number of the jurors were noted among the guests. Baron Pasquier reportedly offered a blunt assessment of the situation to Louis-Philippe: "Sire, the memory of the Emperor is so deeply rooted in the heart of France that if it was his son who had returned instead of his nephew, Your Majesty would be dethroned immediately."[100] Pasquier's analysis was not unique, and his conclusion must have troubled Louis-Philippe's sense of security.

Louis-Philippe's government was still smarting from these embarrassing acquittals when word came in late 1837 that Louis-Napoléon Bonaparte had left America and returned to Switzerland. Bonaparte ostensibly wanted to be near his dying mother, but he had not abandoned his struggle against the Orléans dynasty.[101] Among the projects hatched in his new locale was a book-length apologia for the attempted coup in Strasbourg that appeared in June 1838 as the work of Armand Laity, one of Louis-Napoléon's partisans.[102] Laity claimed that the attempt of 1836 had very nearly succeeded, and he extolled the latent power of Bonapartist sentiments in France. Louis-Philippe's government immediately prosecuted the author of this seditious tract and brought him to trial in July 1838 before the Chamber of Peers, at that time the highest court in France. Incredibly, the government had not reckoned that trying the case before such an important tribunal would provide the defendant with precisely the public forum he sought. During the trial, Laity argued his innocence with a defense of Bonapartism and, when he was found guilty, fined ten thousand francs, and sentenced to ten years in prison, public opinion tended to side with the defendant.[103] The government was chastised for hypocritically punishing this poor Bonapartist zealot, not only because it had sent Louis-Napoléon on his way with a full purse in 1836, but also because many of the Peers who condemned Laity's Bonapartism owed both their titles and their fortunes to Napoléon Ier.

The effect of Laity's trial was less than happy for the prestige of Louis-Philippe's government and only sharpened the efforts of the king and his ministers to neutralize any Bonapartist political threat. Most directly, they increased pressure on Louis-Napoléon Bonaparte by officially demanding that Switzerland expel him. Although France had begun

in early 1838 to make discreet complaints about Bonaparte's presence in Switzerland, it was only after the Laity fiasco—on 1 August 1838—that Molé passed a bluntly worded diplomatic note to the Swiss which expressed an astonishment that "after the events in Strasbourg and the act of generous clemency of which Louis-Napoléon Bonaparte had been the beneficiary, a friendly country like Switzerland—with whom former good-neighbor contacts have recently been so felicitously reestablished—would have permitted Louis-Bonaparte to reenter its territory and, despite all the obligations which gratitude demanded of him, allowed him brazenly to renew criminal intrigues there."[104] Molé's scolding tone elicited a lively discussion in Switzerland, especially because Bonaparte claimed citizenship in the canton of Thurgau; Molé's initiative seemed to imply that France reserved the right to interfere with the sovereignty of a Swiss state. Leftist journals on both sides of the Franco-Swiss border railed against the impunity of Molé's pressure (which was undoubtedly instigated by Louis-Philippe) and the diplomatic situation deteriorated when Thurgau authorities upheld Bonaparte's claim of citizenship. In September, with the National Assembly in Berne deadlocked in debate over an appropriate response to the French note, Molé (with Louis-Philippe's assent) ordered twenty-five thousand troops to mass near the frontier as a show of force and determination. Suddenly, on 22 September, Bonaparte announced his intention to leave Switzerland for England—a move which allowed the Swiss to save face, France to obtain her desired end, and spared Louis-Napoléon the embarrassment of going to war (as a Swiss citizen!) against the country whose throne he claimed as his own. As with the trial of Laity, the publicity which swirled around this farce tended to confirm rather than neutralize Louis-Napoléon's position as the heir apparent of the Bonapartist movement.[105]

It is clear that throughout 1838 the principal leaders of the July Monarchy acted to insure that the political schemes of Bonaparte would remain ineffectual. Even though many of their efforts backfired, the same phobia of Bonapartism which shaped policy and informed Louis-Philippe's memos to Molé must have affected the choice of images commissioned in April 1838 for the fourth gallery of the Pavillon du Roi at Versailles.[106] In that context, Bouchot's picture would present Napoléon's personal takeover as an elitist military action in which charisma defeated the pluralistic constitutionalism enshrined by Couder's immense *Federation* (fig. 145). The contemporary implication of Bouchot's picture was that, because Napoléon had come to power by the force of bayonets, the claims of his descendants should be questioned, and Louis-Napoléon's abortive coup at Strasbourg demonstrated again that illegal force was a bad habit of the Bonaparte clan. Louis-Philippe's commission for an explicit image of Napoléon's undemocratic rise to power was part of a larger counteroffensive waged against the politicized Bonapartism of 1838, its jargon of left-wing ideology, and its nominal leader of Louis-Napoléon Bonaparte. Like the program of the Salle du Sacre, Bouchot's image would isolate and elucidate Napoléon the politician as a character rather different from the *homme du peuple* of popular folklore upon whom Louis-Napoléon based his credibility.

One might ask at this point if Louis-Philippe could be expected to patronize anything *other* than a negative and self-serving view of Napoléon. In fact, one of the great paradoxes of official art during these years is that the above polemic is but one aspect of the Napoleonic imagery actively promoted by the July Monarchy. In 1838 Metternich had warned

Louis-Philippe's ambassador to Vienna about Louis-Napoléon's notoriety: "Be careful there ... this extravagant young man acquires importance by the mistake you make in France of coddling and admiring excessively everything connected to the Emperor Napoléon. You will end by creating a belief in the future of a Napoleonic dynasty."[107] To understand Metternich's concern, we must turn our attention to the "other" Napoléon of official art and describe the important place accorded by the July Monarchy to the image of the "little corporal" (*petit caporal*).

4. *THE* PETIT CAPORAL: *A CONTESTED ICON OF POPULAR DEVOTION*

Even during the most protocol-bound years of the Empire, Napoléon judiciously avoided imperial ostentation before his army. Realizing that its remarkable esprit de corps was nourished by minimizing the customary barriers between officers and ordinary soldiers, Napoléon insisted that commanders share the rigors of war alongside their men.[108] To further this essential rapport, he instituted the Legion of Honor—the Empire's most prestigious service award—and presented it with an egalitarian spirit which did not distinguish between aristocrat and peasant, simple soldier and commanding officer.[109] Napoléon took special care not to distance himself from his men: he addressed them with the familiar *tu* in his speeches, made frequent rounds in camp, and habitually appeared in the simple uniform of a footsoldier of the Imperial Guard, protected from the elements by a well-worn grey frock coat (*redingote grise*) and the plumeless bicorne hat (*petit chapeau*) of a corporal. Napoléon's unpretentious regalia of a simple corporal carried a special meaning among the troops: according to legend, the nickname *petit caporal* had been bestowed upon him by army veterans during the triumphant Italian campaign of 1796.[110] While it is likely that the army's endearing sobriquet was inspired by the general's diminutive physical stature, Napoléon adopted the name and appearance of the *petit caporal* as a kind of personal trademark and emblem of his solidarity with the army. Artists working for the honor and glory of Napoléon were encouraged to portray him in this outwardly self-effacing yet instantly recognizable costume. From images of blatantly propagandistic adulation such as Gros's *Eylau* (fig. 90)—where the bitter winter cold required a fur-lined greatcoat—to more journalistic pictures like Girodet's *Napoléon Receiving the Keys to Vienna* (fig. 182) or Gros's picture of Napoléon and Francis II of Austria after Austerlitz (fig. 183), the Frenchman's supposed taste for simplicity is suggested by the contrast between his recognizable yet unpretentious attire and that of his defeated foes.[111]

The well-established, anecdotal iconography of the petit caporal was susceptible to exploitation by the myth-makers of the Napoleonic legend during the 1820s and 1830s. In fact, the petit chapeau and redingote grise figure prominently in popular prints extolling Napoléon as the concerned general and friend of the common soldier. One of the most famous of these, Debucourt's *No Passage!* of 1828, illustrates an episode from the night before the Emperor's triumphal entry into Vienna: stretching his legs in the garden behind his billet, Napoléon was stopped by a sentry who failed to recognize his commander-in-chief beneath his unassuming greatcoat (fig. 184).[112] The legend tells us that Napoléon, rather than bristling at this affront, decorated the soldier for his responsible sense of duty.

Much the same spirit of camaraderie reigns in Raffet's 1832 lithograph, *My Emperor,*

It's the Most Cooked! (fig. 185).[113] Napoléon has come upon a bivouac where a group of his soldiers are eating and smoking. Spotting the chief, a soldier digs in the coals of the fire to retrieve a potato, which he offers with the familiar "My Emperor." Napoléon is seen from behind, but his characteristic uniform needs no further explanation: Raffet's expression of camaraderie perfectly captures the nostalgia of patriotic fraternalism which accompanied the image of the petit caporal during the 1830s.

The July Monarchy's first steps to capitalize upon the latent power of this imagery date from 1831. On 8 April of that year, Louis-Philippe approved Casimir Périer's project to reinstall the figure of Napoléon atop the Vendôme column.[114] The original statue by Chaudet, which depicted Napoléon in the guise of a Roman emperor wearing a toga and a crown of laurel leaves, had been removed from its perch by the restored Bourbons in April 1814, melted down, and recast as the equestrian statue of Henri IV now standing on the Pont Neuf.[115] Périer made it clear, however, that the July Monarchy did not intend to recreate the imperial Napoléon of Chaudet, for he was careful to separate his government's orientation from the policies of the Empire:

> The general and popular principles upon which the constitutional government of Your Majesty is founded permanently protect France from the evils associated with absolutism and the political program of conquerors. But, by honoring a great reputation, by re-erecting the monument which hallows a memory from which France derives great glory, the King forges, in a way, one more link between the country and the throne. I go so far as to believe that the decision which I submit for royal approval will be regarded both as a well-founded homage rendered to the public conscience, and as a striking and new proof of the power and justice of an entirely national government.[116]

Five days later, Louis-Philippe approved a suggestion made by the comte d'Argout (the Minister of Commerce and Public Works) that a competition be held to select a sculptor for the new Napoléon.[117] The details of this competition included the important observation that "the figures on the bas-reliefs of the column being in French military garb, the statue should likewise be in military dress."[118] Thus, without actually forbidding artists from presenting a sketch of Napoléon as Emperor, the government let it be known that it expected an image of him as a military leader in a modern uniform. The composition of the jury was publicly announced on 12 June 1831, and three days later, from a field of thirty-six entries, Emile Seurre was declared the winner.[119]

It is obvious that Seurre's creation (fig. 186) is none other than a sculptural incarnation of the petit caporal as he was defined by popular art forms—whether print images by Raffet (fig. 187) or figurines sold as devotional objects (fig. 174).[120] Seurre's Napoléon wears the famous greatcoat and bicorne hat, grasps a lorgnette in one hand while tucking the other into his vest, and carries the sword of his victory at Austerlitz. The authenticity of these accessories was assured by General Bertrand, who lent to Seurre the uniform and objects actually used by Napoléon.[121] A group of cannonballs at the hero's feet establishes a battlefield locale, so that Napoléon seems to scrutinize the distance as if following the progress of his troops and the tide of some eternal conflict. In short, the new Napoléon deliberately avoided imperial connotations and sought the broadest possible public approbation by directly appropriating the imagery of popular art.

Seurre's statue was inaugurated as part of the festivities held on 28 July 1833 to mark the three-year anniversary of the July Revolution, and the odd mélange of catchwords and sentiments invoked in the dedication ceremony perfectly illustrates how the king hoped this grand public gesture would cement popular support for his dynasty.[122] Louis-Philippe led a parade of National Guardsmen from the Etoile to the place de la Bastille, and then they assembled—along with the troops and guardsmen who had lined the parade route—in the place Vendôme. Thousands of spectators jammed neighboring windows, rooftops, and chimneys and strained to see the green, star-studded shroud atop the column. Near two o'clock, Louis-Philippe and his military aides took up positions facing the Vendôme column, and at the king's salute—ironically, a "Long live the Emperor!"—the shroud fell away to reveal the petit caporal. Exclamations of "Long live the Emperor! Long live the King!" and "Long live the Republic!" mixed indiscriminately in the ensuing élan, and the whole was accompanied by a military band playing the anthem of the First Republic, *La Marseillaise*.

Since the mix of enthusiasms generated by this event were politically volatile, Louis-Philippe's official enshrinement of the petit caporal was rather astute, for it legitimized the nationalistic cult of Napoléon's military genius while deftly avoiding any allusions that might be construed as endorsing the despotic war-mongering of Imperial France. At first glance, this result may seem to contradict the one developed for the Salle du Sacre; in fact, the July Monarchy's strategy underscores the complexities faced by any attempt to harness the popular support mobilized by the Napoleonic legend. The legend, as we know, circumscribed an ill-defined agglomeration of ideas and ideals, some purely nostalgic in character, others actively engaged in the political arena. During the very years that Seurre worked on his sculpture for the Vendôme column, the petit caporal emerged as the preferred emblem of Louis-Philippe's opponents and acquired a revolutionary coloration. In this context, the singleminded martial tone established by the column and seconded by the inaugural ceremonies of 1833 should be understood as the Orléans dynasty's bid both to annex the image of the petit caporal and to alter its social signification by institutionalizing it within the closely cropped historical frame of past military glory. Such a strategy seconds the propagandistic message of the Salle du Sacre—which categorically debunked the myth of Napoléon as an homme du peuple—by neutralizing the politically loaded imagery of Napoléon without denaturing its ability to elicit a desirable nationalistic fervor.

The rationale of this delicate reorientation became clearer as the galleries of Versailles dedicated to the exploits of the Empire took shape. The trick at Versailles was to commemorate Napoléon in as politically inert a manner as possible without alienating the chauvinism surrounding his memory. Louis-Philippe might expect to reap a favorable public response to the history recounted in his galleries if Napoléon could be imaged within the parameters established by the popular folklore of the legend. This tactic was only possible, however, after the "trademark" of the legend—the petit caporal—had been purged of its dangerous connotations and incorporated into the vocabulary of official art: the government's "restoration" of the Vendôme column in 1833 was designed to effect just such a purge.

We can chart the resistance to the government's appropriation of the petit caporal in a

group of images produced during this crucial 1833–34 period. A print executed by Victor Adam for the inauguration of Seurre's statue documents the extent to which the ceremonies were permeated with the mysteries of the Napoleonic cult (fig. 188).[123] Dark storm clouds part to reveal the new statue atop the column, rays of sunlight emanate from behind, and an illustrated rainbow appears overhead with vignettes of key episodes from the hero's biography.[124] This and similar prints graphically illustrate how the act of replacing Napoléon's effigy upon the column was popularly linked to the mythology of his legend, while the triumphant scenario of parting storm clouds suggests the transcendent coloration attached to Napoléon's reappearance—colorations that Louis-Philippe's government would soon strive to dispel, discredit, or disregard.[125]

The allusive themes of this print were overtly politicized in a lithograph by Tassaert, which was probably designed about the time Seurre's statue was dedicated but was apparently not published until sometime later (fig. 189).[126] Tassaert locates the viewer above the rooftops of Paris where Napoléon and his son, the duc de Reichstadt (who died on 22 July 1832 in Vienna), circle the bronze at the summit of the Vendôme column.[127] Behind these two, the imperial eagle and airborne figures of the Generals Foy, Lamarque, and Kléber appear among the spirits of the Grande Armée. The accompanying text focuses the mysticism of this image upon a real-life debate by having Napoléon's spirit exhort Frenchmen to fulfill one last request: "I await a final proof of your affection. Far from the tender shores of France, my captive remains claim their right to a tomb worthy of me under the base of this column." Tassaert's print called for the return of Napoléon's body to France from its lonely resting place on Saint-Helena, and he used the Vendôme column as the lynchpin of its appeal. Throughout this period, however, Louis-Philippe and his ministers purposefully stonewalled any proposals that would effect Napoléon's posthumous return, precisely because they feared that such an event would touch off a new wave of civil disorders; the government's stand probably explains why the print was not circulated in 1833. This policy of official reserve was quite warranted, insofar as the serious Paris riots of 1832 had been precipitated when the funeral cortege of Lamarque (visible in Tassaert's print) made a ceremonial detour around the Vendôme column.[128] Republican agitators worked the crowd's passions with rumors and inflammatory rhetoric until the parade became an outright battle with the police. The ensuing two-day riot made it clear that Bonapartists and left-wing radicals were collaborating in the struggle to topple the Orléans regime. Tassaert's appeal for Napoléon's return reaffirmed the opposition's contention that the petit caporal belonged to the entire nation and challenged the attempt by Louis-Philippe's government to coopt their most potent emblem by means of a single bronze statue.[129]

Even outside the rarified circles of political partisanships and ideologies, the quasi divinity of the petit caporal was so firmly entrenched in the mythology of the Napoleonic legend that the July Monarchy's strategy to ground it in simple military chauvinism encountered stiff cultural resistance. *The Apotheosis of Napoléon*, a colored Epinal print executed in 1834, summarizes the popular view of Napoléon's celestial status by representing his welcome in the heavens before a host of history's greatest military leaders (fig. 190).[130] Once again, Napoléon's totemic costume and pose charge the petit caporal with a divine coloration. At the same time, the Vendôme column (in the upper left corner of the

image) is linked to the extraterrestrial signification of the central scene by a network of heroic allusions—pyramid and obelisk, trumpet-blowing angels and Ossianic bards—decidedly at odds with the prosaic historical message promulgated by Louis-Philippe.

A picture arguing the deification of Napoléon appeared at the Salon just months before the official unveiling of Seurre's statue atop the Vendôme column. *Napoléon: An Allegorical Picture*, exhibited by Mauzaisse in 1833, shares more than a passing similarity with the imagery we have been discussing and illustrates how painters who hoped to tap the Napoleonic legend were necessarily obliged to use the prevailing vocabulary which had been defined and nurtured for nearly two decades by the "popular" rather than the "fine" arts (fig. 191).[131] In this rather curious picture, Mauzaisse has Napoléon soar above the sea on an unusually dense cloud. The hero writes upon a large tablet inscribed CODE NAPOLÉON while staring full-faced towards the viewer, as if writing the Code by direct inspiration from some higher authority. Father Time finds the work remarkable and awards a laurel crown to the Emperor as a sign of the Code's immortality. Mauzaisse further embellished this arcane allegory with multiple icons of Napoleonic folklore: the grey frockcoat and bicorne hat partially cover an eagle-tipped standard of the Imperial Army and a tricolor flag; nearby sprigs of palm and laurel symbolize the Emperor's many military victories, while the dead eagle recalls the Empire's disastrous end; finally, in the far distance, a silhouette of a barren, rocky island reminds the viewer of Napoléon's solitary exile on Saint-Helena.

To complement these accessories common to the Napoleonic faith, Mauzaisse depicted the Emperor with an erudite historicism based upon David's 1812 picture of *Napoléon in His Study* (fig. 192)—a borrowing which makes sense in that David's formal portrait also cast Napoléon as the architect of the Code.[132] But where David's photo-realist vision of the Emperor's private study was designed to seduce the viewer into believing that Napoléon worked late into the night for the good of his subjects, Mauzaisse turned a similarly literal rendering into a schizophrenic image where fantasy clashes with an airless, hard-edged clarity. Surely, if "eclectic" describes a kind of painting (as some insist), this hybrid picture must count as a prime example: a learned academic manner to serve a romantic, visionary meaning; a theme equally rooted in popular folklore and contemporary history; an ambitious, cosmic allegory on a modestly sized canvas.[133] Given the quintessential compromises of the picture's style and tone, Louis-Philippe's failure to reward Mauzaisse with a purchase can tell us something about the complexities of official patronage. I have argued that such a transcendental treatment of Napoléon would have been an anachronism in the king's galleries at this time. In the cultural war being waged over the right to claim the petit caporal, we should read the government's indifference toward the Mauzaisse as part of an overall strategy of official patronage which did not simply reflect a zeitgeist of Eclecticism but was subtle, focused, and sociologically pragmatic.

Indeed, the first picture of Napoléon officially commissioned by Louis-Philippe perfectly illustrates this strategy in operation. Just two months after the inauguration of Seurre's statue, Méry-Joseph Blondel was appointed to paint *Napoléon Visits the Palais-Royal* for the historical galleries of that palace discussed earlier (fig. 193).[134] The episode illustrated, which occurred in 1807, followed directly from one of Napoléon's several acts to consolidate his personal political power after the victorious summer campaign in Germany and the treaty of Tilsit. On 16 August 1807, he announced the creation of a new nobility

whose titles would be conferred as rewards for service to the nation and whose rights could be passed from father to son.[135] Three days later this frontal assault on the most sacred achievement of the Great Revolution—the abolition of inherited privilege—was seconded by a Senate-approved imperial decree (a *sénatus-consulte*) which also dissolved the *Tribunat*—the government body responsible for the discussion and debate of laws proposed by the *Conseil d'Etat*.[136] As one historian, writing in the 1830s on Napoléon, wryly remarked, "The Tribunat, in spite of the care it had taken to initiate monarchic legislative motions, was abolished: its name alone would have sufficed to bring disaster upon itself. An institution whose origin and designation instantly recalled the republican system of government could not long be tolerated in the entourage of the dukes and princes which the imperial munificence had miraculously resuscitated around its throne."[137] Blondel probably meant to evoke the historical background of Napoléon's growing personal power in 1807 with the graffiti-like markings on the plaque at the upper right of his picture, where a fleurs-de-lys (no doubt dating from before 1789) and a crudely carved *VIVE LA RÉPUBLIQUE* are partially effaced reminders of the regimes now discredited before Napoléon's rising political prestige.

Because the Tribunat had met in the Palais-Royal, its dissolution freed the palace for some other purpose. Blondel's picture commemorates Napoléon's tour of the building with the architects Fontaine and Beaumont to discuss possible uses for the newly available space. The Salon *livret* of 1834 described the moment recorded in the painting: "the unexpected appearance of M. Fabre de l'Aude, president of the Tribunat, ran counter to [Napoléon's] wish to be alone. He abruptly ended his visit without wanting to examine the plans of the palace and without going as far as the Tribunat's meeting hall: he left still harboring his prejudices against the Palais-Royal." Far from expressing a noble sentiment, the Blondel offers us little more than an example of the Emperor's famous and quick temper.

We immediately recognize that Blondel's Napoléon is a scrupulous rendering of the *petit caporal*, but the figure of legend now acts a scene of imperial petulance. Significantly, the picture drew fire from Salon critics precisely for its debunking of Napoléon's mythic stature:

> Does M. Blondel really think that the redingote grise, since become so popular, was a part of the Imperial dress on that day? Even more, does he suppose that to go *like a neighbor* from the Tuileries to the Palais-Royal Napoléon would have put on his tall riding boots equipped with long spurs? that he would have dressed in his uniform of Austerlitz or Champaubert? All this foolishness of theater props, all this fictional dress may be fine in a boulevard comedy, but in a History Painting it manifests execrable taste. Moreover, if a subject which reproduced the colossal figure of the hero was absolutely necessary for the continuation of the history of the Palais-Royal, perhaps one could have chosen better and provided the painter with a different program.[138]

Contemporaries certainly knew that Blondel's program had come from the king himself, and the fact that the painting was exhibited at the Salon and listed as a royal commission in the *livret* suggests that it pleased the patron. The disparaging comparisons to popular stage

productions reinforce the thrust of our analysis, because the critic was responding to specific qualities deliberately built into the picture. Blondel's main figures are kept close to the front plane and are precisely rendered to yield a compelling immediacy. The illumination artificially spotlights the characters in this near space, and their highly particularized, quick-frozen gestures invest the action—itself culled from the anecdotal marginalia of history—with a strong stage sense. The combination of such formal devices with a seemingly inconsequential narrative has already been discussed under the rubric of *genre historique*—a kind of picture self-consciously striving for just the theatricality noted by critics. Thus, the Blondel taps into the highly charged popular imagery of Napoléon but relates an almost banal episode in a pedestrian, nonheroic manner.

One could hardly imagine an expression more unlike the *Napoléon* of Mauzaisse (fig. 191) than the one offered by Blondel: there, all was timeless and otherworldly; here, the concern is for a fleeting moment of personal pique. Within the cultural expectations shaped by the Napoleonic legend in the early 1830s, the Blondel seems to suffer from an inner tension which pits a nonconnoisseur style *against* an imagery dear to Napoleonic initiates. It should be clear that this kind of representation was ideally suited to the political purposes of Louis-Philippe. By relegating the petit caporal to the confines of historical anecdote, the image obtained a public appeal yet managed to remain politically safe. Again and again, the painters of the July Monarchy were called upon to perform the delicate task of locking Napoléon's familiar and awe-inspiring figure into an anecdotal narrative elaborated with an accessible style of everyday naturalism. To the extent that their hybrid configurations spoke to the public with an imagery steeped in history (the iconographic and gestural language of the Napoleonic legend) but with the formal vocabulary of genre, these painters were inadvertently subverting the traditional canons of History Painting (*peinture d'histoire*). We must realize, however, that this pictorial evolution did not depend upon conscious decisions made by individual artists to walk the stylistic tightrope of eclectic taste. Rather, it was shaped by the complex interaction of contemporary social, patronal and aesthetic pressures. The Blondel is one telling example of this transformation in operation: next we will explore these same functional and formal questions in the paintings of Napoléon commissioned for the great centerpiece of Louis-Philippe's museum at Versailles, the Galerie des Batailles.

5. *BETWEEN MYTH AND HISTORY: NAPOLEON IN THE* GALERIE DES BATAILLES

From the very beginning of his project to transform Versailles into a museum, Louis-Philippe planned the creation of a single large gallery where a suite of pictures would recount the most illustrious examples of French military genius.[139] It was not until June of 1835 that work actually began on the Galerie des Batailles—an enormous, windowless space obtained by gutting the first and second floors of the Château's southern wing, the whole capped by an iron-framed glass vault to provide natural light for the thirty large canvases built into the walls (fig. 194).[140] The gallery's imagery is inspired by events from medieval to modern times, but of the seven which refer to the post-1789 period, five are dedicated to Napoléon—numerical proof of his privileged place in Louis-Philippe's historiography of modern France.[141] We can now appreciate why this striking imbalance existed

in the 1830s; it remains for us to explore how Napoléon was represented in this Orléans-sponsored sanctuary of national glory.

The largest and most important of the Napoleonic pictures was inherited by the July Monarchy from the Empire: François Gérard's *Battle of Austerlitz* speaks with a compelling historical authenticity and champions the battle which retained a luster throughout the century as the single most brilliant and devastating victory of modern military strategy (fig. 195). At the same time, Gérard's *Austerlitz* set the tone for the flanking pictures of Napoléon commissioned by Louis-Philippe. Gérard had not attempted to paint the entire field of battle and thousands of ant-sized soldiers; rather, he offered a few large figures arranged to screen most of the landscape and suggest that we see only a small slice of a much larger event—a scheme adopted by painters working for Louis-Philippe in the 1830s. Napoléon, as Gérard's patron and the principal conductor of this symphony of carnage, figures prominently in the great canvas. Dressed in field uniform, mounted on a superb white steed, and surrounded by his military aides, Napoléon receives the good news brought posthaste by General Rapp that the seasoned veterans of the Imperial Guard have successfully routed the crack Russian troops of Alexander's guard. Among the thousands of historically worthy moments offered by the battle of Austerlitz, this one was especially significant, for it signaled the success of Napoléon's bold master plan to cut the enemy army in two and annihilate it by parts.[142] Gérard's picture, by isolating the instant when the brilliance of Napoléon's military strategy was revealed, shapes the battle of Austerlitz into a narrative that climaxes in a single significant moment.

Secondary aspects of the Gérard work in concert to pinpoint the locale and focus of the scene. The victims from several armies which litter the foreground, the group of captured Russian and Austrian officers at the right, Rapp's gesture toward a prestigious war prisoner (the Russian prince Repnin), and the flutter of several standards won from the enemy place Napoléon at the epicenter of the fray—on the hotly contested plateau called Pratzen—and surrounded by the spoils of his triumph. The large figures at the lower left, an Egyptian *mameluk* who abandons his dying horse and a mounted soldier of the Imperial Guard, pay homage to the two elite corps who sealed the victory, while a column of ordinary infantrymen at the extreme right edge attests to the valor of the lowly footsoldier. The devotion of Napoléon's troops to their leader is explicitly articulated in the left-center foreground, where a wounded cavalryman painfully raises himself to gaze at Napoléon when he hears of the success, and a dying soldier salutes the chief with his last ounce of strength.

Napoléon, calm and almost aloof in the center of this whirlwind of action and adulation, seems transfixed by the grandeur of his achievement. Gérard insured that the Emperor would be easily recognizable amidst the tumult by manipulating a raking light from the setting sun so that the hero's white horse and visionary gaze are brightly illuminated against the background of dark uniforms and the stormy, blue-grey sky at the picture's right side. Similarly, the key figures of the narrative—Rapp, Repnin, and certain of Napoléon's aides—are singled out by the light, and the otherwise littered foreground has been cleared artificially to permit an unobstructed view of Rapp's momentous announcement. We immediately recognize the degree to which the structure and the narrative of Gérard's picture function together to underscore the singular role played by Napoléon in this greatest of French military triumphs. Since the painting was commissioned by Napoléon, completed

during the heyday of Empire, and destined to decorate the ceiling of the *Conseil d'Etat* conference room in the Tuileries palace, Gérard's focused flattery of the Emperor is neither surprising nor egregious.[143] We might expect this rhetorical posture to be less desirable during the July Monarchy. Indeed, the illustrious provenance of Gérard's picture could excuse its carefully constructed heroization of Napoléon, but its companion pieces of the 1830s were fashioned, as we shall presently discover, upon rather different pictorial models.

Three of the paintings of Napoleonic battles commissioned for the Galerie des Batailles were exhibited at the 1836 Salon by Horace Vernet: *Iéna* (fig. 196), *Friedland* (fig. 197, pl. 8), and *Wagram* (fig. 198).[144] In each of them, Napoléon is located at the exact center of the visual field and represented in the now-familiar guise of the petit caporal, despite the fact—as some critics noted—that a greatcoat would have been impossibly hot under the summer sun which baked the battlefields of Friedland and Wagram.[145] Vernet exchanged literalness in these works for an imagery in which the Emperor appears at the front and center and in his most recognizable persona. The low horizon lines of the three pictures and Vernet's propensity to place his relatively large figures on a foreground rise allow the central and centered figure of Napoléon to cut a crisp silhouette against the sky and throw the famous petit chapeau into sharp relief.

Vernet obviously did not invent these pictorial tactics; we need look no further than Gérard's *Austerlitz* to find similar manipulations of the placement and scale of figures. Like Gérard, Vernet screened most of the battlefield action with his principal characters. Only at a great distance and through the seemingly accidental interstices of this screen do we glimpse the troops, smoke, and action of the fighting. Again like *Austerlitz*, Vernet's pictures suggest that we witness a single, isolated part of a much larger event; but Vernet intensified this impression with a series of arbitrary croppings—even more abrupt than Gérard's—in which the frame indiscriminately truncates men, beasts, and objects at the perimeter of the visual field. The picture of *Iéna* (fig. 196) offers the most radical examples: a soldier at the extreme right seems locked in a struggle with the frame to force his way into the picture, the horses of unseen military aides ride in from the left, and Murat's galloping horse in the foreground is caught in mid-air as it charges *out* of the image. In this closely cropped world of crisscrossing movements and truncated entities, the centralized placement of Napoléon becomes a stable presence that relentlessly rivets the viewer's attention. This was not a casual effect but a deliberate strategy devised to serve a particular rhetorical purpose.

At first glance, Vernet's paintings may seem very much like Gérard's picture of imperial flattery, even to their anecdotal martial iconography: wounded soldiers being carried to treatment in *Friedland* (fig. 197) and *Wagram* (fig. 198); captured enemy officers who stand mutely at the left of *Wagram*; the impetuous mounts, impeccably uniformed soldiers, and wealth of military hardware in *Iéna* rendered with a tour de force of detail to dazzle the viewing public. On one level, Vernet's pictures apparently continue a long-established tradition of military painting; however, they do differ from imperial predecessors like *Austerlitz* in an essential and significant way. Gérard had built his work upon a narrative intimately linked to the battle and to Napoléon's role in planning it, with Rapp's excited announcement constantly bringing that role to mind. In contrast, *none* of Vernet's pictures exhibit such a narrative unity. Like his cropped compositions and shallow

spaces—which imply that we witness only a momentary vignette of the historical event—Vernet's subjects are but fleeting instants singularly lacking any sense of climax. In *Friedland*, for example, the main fighting is over, the enemy has rendered his sword, and Napoléon instructs Oudinot not to lead a heroic charge into the fray but only to chase the fleeing enemy and create a maximum of havoc among their ranks.[146] Similarly, *Wagram* depicts Napoléon intently monitoring the effectiveness of an artillery barrage in the distance while nonchalantly handing a map of the region to an aide and remaining oblivious to the fact that only a few feet away the duc d'Istrie has just been wounded and his horse killed.[147] No one would deny that Napoléon dared to brave the dangers of war, but Vernet's episode was really a commonplace on the battlefield and certainly not a decisive moment in the victory that day. Finally, the picture of *Iéna* probably offers the most strategically trivial episode ever celebrated by a major painting: when Napoléon gallops past a contingent of the Imperial Guard held in reserve, a young soldier breaks rank and cries "Charge!" Stopping short his horse, the Emperor hurls the harsh reproach that it must be "a beardless young man who might want to prejudge what I should do. Let him wait until he has directed thirty organized battles before trying to give me advice."[148]

Salon critics were quick to attack Vernet's handling of these exploits cloaked in military glory, and they dismissed the pictures on the grounds that the painter had grossly misunderstood his assignment: "These are not battles," wrote Alfred de Musset, "first of all because no one battles in them; furthermore one never could, since the Emperor is there in person."[149] Charles Farcy observed that "the three so-called battles . . . are in the *livret* but not at all on canvas. I see only three groups where Napoléon appears on horseback, and the rest consists of little or nothing."[150] Other writers intimated that Vernet had purposely trivialized these great moments of national honor. Victor de Nouvion, for example, wondered out loud if Vernet had been obliged to "torture painstakingly the official bulletins of our conquests in order to discover among them incidents so stripped of grandeur and interest."[151]

A perceptible tug-of-war between the historical pretensions of Vernet's canvases and the nature of their imagery informs the commentaries of several Salon critics. *L'Artiste* articulated its discomfort with a line of reasoning already familiar to us: "The ideas upon which [Vernet] has focused his attention do not seem serious or solemn enough for the scale which was imposed upon him. The impression produced by viewing these three pictures falls far short of the gravity and grandeur of the events which they represent."[152] The implication of this analysis—that the Vernets somehow lacked the elevated spirit which might warrant their physical dimensions—was echoed by Fabien Pillet, who suggested that "M. Vernet has surely not done everything he could to heighten the importance of them. Reduce these pictures to a small scale and you will see nothing more than what makes for attractive vignettes."[153] And, in the same vein, the *Revue de Paris* flatly stated that many people would consider *Iéna* a genre painting (*tableau de genre*).[154] In sum, this discourse reveals a perceived incompatibility between contemporary expectations for pictures celebrating the heroic triumphs of Napoléon and the configurations produced by Vernet. To the extent that the criticisms of Vernet were couched in terms which localized his images somewhere between history and genre, my argument that genre historique had become the preferred formula for Orléans official art gains credibility.

If an artist suppresses the distinguishing historical markers of an event and isolates a charming but commonplace episode within the radically reduced frame of time and space which results, his representation will unavoidably forfeit its ability to refer to *any* specific chronological moment. Critics in 1836 recognized this problem in Vernet's pictures when they noted that "one can shift around indiscriminately the titles of Iéna, Friedland, or Wagram without causing historical truth to suffer any noticeable damage."[155] Installing such historically imprecise images in a series dedicated to retrospective history effects an important functional displacement: individual canvases become indifferent "placeholders" in the chronology rather than "representations" dedicated to rendering comprehensively an historical narrative. Among all the commentators at the 1836 Salon, Gustave Planche seems to have understood most clearly how Vernet's images would refashion history when transferred to the context of the *Galerie des Batailles* at Versailles:

> I am tempted to think that M. Horace Vernet, like a skillful courtier, wanted to prove to the sublime spirits of the Civil List that the programs written for the Versailles Museum, although naive to the point of foolishness, could be further perfected in an extraordinary way. He wanted to show that all the inoffensive, isolated episodes of the imperial epoch contained in themselves the germ of a dangerous disease called enthusiasm, and that he would have double the glory and double the profit by reducing all the scenes—whatever they might be—to the proportions of a chancellery report. . . . Vernet wanted to disarm history and to civilize it . . . I am confident that this picture [*Friedland*] will not awaken the military ardor of French youth, it will not generate enemies of the cabinet's political pacifism. . . . In all honesty, the longer I look at the battles of M. H. Vernet, the more I despair of understanding the goal he set for himself. Short of insisting upon the hypotheses which I have outlined, short of believing that he wanted to reduce the heroic history of the Empire to the most petty bourgeois proportions, I am compelled to abandon any explication of these illuminated enigmas.[156]

Planche's tirade blames the government for facilitating the process by which these enormous events were purged of all but their most inoffensive popular appeal. This accusation—one often voiced by critics[157]—is especially relevant to our investigation, because we know that the Orléans dynasty did have a vested interest in "disarming" and "civilizing" the memory of Napoléon without, however, diminishing the power of his legend. Press censorship probably ensured that Planche and his colleagues would remain rather circumspect when suggesting that the king had a hand in formulating this deflated imagery of Napoléon, but it was well known that in July 1835 Louis-Philippe had provided Horace Vernet with a studio only a few blocks from the Château of Versailles.[158] Vernet worked on his three pictures for the Galerie des Batailles in this new studio during late 1835 and early 1836. Even more important, Nepveu's scrupulous reports of Louis-Philippe's trips to Versailles during this same period tell us that the king made a point of visiting Vernet's studio to gauge the painter's progress and discuss the work at hand.[159] The documents enable us to conclude that Vernet's canvases took shape with Louis-Philippe's personal approbation and thus fulfill the most elementary criteria for "official" art. To get beyond this rather superficial truism we must ask why *this* type of picture emerged from the

discussions between the king and Horace Vernet as the most appropriate for the imagery of Napoléon at Versailles.

Our investigation has repeatedly shown that careful thought and pragmatic planning informed the development of the July Monarchy's official imagery, and the political stakes were nowhere higher than when this planning involved the volatile reputation of Napoléon. We have seen that the rubric *genre historique* can be applied to the pictures of Napoléon for the Galerie des Batailles insofar as they are inspired by history but categorically refuse to aggrandize the events or the actors represented. Reviews of the Salon suggest that critics understood this ploy, yet they were forced to admit that the public loved Vernet's pictures: from this seeming paradox emerges the secret of how the works functioned socially.[160] Vernet's large-scale renderings of incidental episodes were consciously designed to operate with the lexicon classified and valorized by the Napoleonic legend and the mythology of the petit caporal.[161] Napoléon's centralized, archetypal presence in each of the Vernets tapped into this preexisting vocabulary and struck the same emotional chords. Thus, prototypes for a work like *Iéna* (fig. 196) may not exist in the grand tradition of History Painting, but they can easily be located amidst the popular prints and small-scale paintings where anecdotal episodes from the life of Napoléon were piously recounted. One example, by coincidence also exhibited at the Salon of 1836, is *The Campaign of France*, a small picture by Emile de Lansac which was inspired by a story from one of the Emperor's last battles before his first exile (fig. 199).[162] Napoléon calms his anxious soldiers by placing himself between them and a live grenade; as usual, in this image the petit caporal exhibits courage, concern for his troops, and a desire to share their dangers. Without claiming any direct "influence," I am suggesting that the symmetries in narrative scope, formal structure, and melodramatic expression between the Lansac and Vernet's *Iéna* disclose crucial lexical similarities despite their obvious differences in scale and cultural ambitions.

Likewise, Napoléon's "action" in Vernet's *Wagram* (fig. 198) contains a minimum of historical interest. But by reproducing just the posture and gestures which abounded in popular images of the Emperor—such as the contemporary watercolor by Bellangé (fig. 200)[163]—Vernet invested his picture with an ideological connotation that is reinforced by Napoléon's front-and-center position in the image.[164] And the same type of rapport can be discovered between Vernet's *Friedland* (fig. 197) and any number of popular prints, among which *1807* by Raffet (fig. 201) is an example: in both, a generalized battle scene and an escort of military aides set the stage for the centralized, immobile, and ideographic presence of the petit caporal.[165] The Vernets manipulated (albeit in wide-screen technicolor) the same lexicon of honor and nationalism that the humble images of a Charlet or Raffet had sharpened and defined in the cultural forum shared by visitors to the Salon or to the king's gallery at Versailles. For images mobilized by the power of this lexicon, narrative is of little consequence because their commonality of signifiers (following Barthes) constitutes a cultural rhetoric which is, by definition, nothing other than a public affirmation of the group ideology. Thus, Napoléon's presence at Versailles—a presence rigorously shaped by the lexicon of his legend—carried all the signification that Louis-Philippe wanted to impart: in the context of the gallery, these pictures articulate the man's military genius yet suspend historical judgment of his exploits (and avoid any incriminating political choice)

by simply appropriating the accepted rhetoric of his imagery. This is essentially the same strategy which informed the July Monarchy's restitution of the petit caporal on the Vendôme column, but now we can better appreciate the degree to which the process of synchronizing Napoleonic imagery with the political goals of official art was subtle and nuanced. At the same time, we recognize that this process involved more than simply recycling subject-matter which had been censored prior to the 1830 Revolution, for we have seen that it required important modifications to the most sacrosanct ideas about the narrative, structure, and style appropriate to "high" art.

Skeptics may ask if this is too general a conclusion to draw from specific data offered by the works of only one artist. In addition to the parallels already discussed—Seurre's statue (fig. 186) and Blondel's *Napoléon Visits the Palais-Royal* (fig. 193)—the fifth picture of Napoléon for the Galerie des Batailles reinforces the conclusion that artists were enjoined to fashion their pictures of the Emperor in a particular manner. Félix Philippoteaux did not exhibit *The Battle of Rivoli* until the Salon of 1845 (fig. 202).[166] The event dated from Napoléon's early career, and Philippoteaux painted him as the romantic, long-haired hero of Arcole (a battle two months prior to Rivoli) whose image had been immortalized in the painting by Gros.[167] But even if he rejected the persona of the petit caporal, Philippoteaux was careful to position the figure of the hero at the exact center of the image and close to the viewer, before a backdrop of the Italian Alps in which a generalized view of the clashing armies fills the distance. Bonaparte's distinctive profile is crisply silhouetted against the neutral hues of the ice-capped mountains—an effect heightened by the pool of light which artificially envelops him.

Even a casual comparison with the earlier companion pictures serves to show that these formal devices, adjusted to insure Napoléon's primacy in the image, are descended from Vernet's prototypes.[168] So too is the character of Philippoteaux's narrative: despite the fact that three full pages of the Salon *livret* were devoted to an historical description of the fighting at Rivoli, *not one word* refers to the episode actually depicted in the painting. Philippoteaux represented Bonaparte remounting after a close call in which his horse was shot out from under him, and an aide offers a chestnut-colored replacement for the white steed which writhes in pain from the prominent bullet wound in its breast. In a replay of Vernet's *Friedland* (fig. 197), Napoléon remains oblivious to this equine suffering and reaches for his famous hat while fixing his gaze and attention on the progress of the distant battle. True to the mystique of his legendary charisma, those around Bonaparte—both his aides at the left and the wounded soldier at the lower right—press toward their chief to assure themselves that he is unscathed. Naturally, the viewer is also expected to breathe a sigh of relief at Napoléon's narrow escape, and it is only when we realize that our attention has been surreptitiously drawn to this single, localized episode of personal biography—and away from the bloody conflict in the background—do we grasp the extent to which anecdote has triumphed over history. We need hardly add that just such a shift was an integral part of the July Monarchy's program to domesticate and dominate the memory of Napoléon at Versailles.

Modern viewers, relatively immune to the enthusiasms kindled by Bonapartism during the 1830s and 1840s, may see few differences between the pictures of Napoléon in the Galerie des Batailles and such chronologically related counterparts as *The Battle of*

Zurich by François Buchot (fig. 203).[169] To our uninitiated sensibilities, this image celebrating the victory of General Masséna seems to share the style and structure of the pictures we have been discussing. But the crucial differences are connotative rather than formal: an identical gesture or an identical uniform would have generated vastly different meanings for the public of the 1830s if the hero in question was Napoléon and if the particular detail was linked to the emotionally charged lexicon of his legend. In short, it seems clear that an array of nonaesthetic factors located at the perimeter of the art object shaped the public's response to Vernet's pictures of Napoléon. It is not surprising, therefore, that Salon critics with allegiances to a traditional understanding of high art could not decode the imagery of these pictures, and that they complained that "the system of M. Vernet" equated events by uniformly packaging them: "A few main characters making a lot of fracas in the foreground with their horses; smoke, dust, a more or less disorganized melee in the background. Nearly all these pictures are like that: one could indiscriminately pass off any one for any other by changing some heads and some costumes."[170]

This kind of pictorial "leveling" is certainly what Léon Rosenthal had in mind when he concluded that Vernet, faced with the possibility of painting subjects "in which the remove of time and the scale of the victories were an incentive to paint ambitiously . . . had seemed disconcerted and had only saved himself by anecdotes."[171] Neither Rosenthal nor those Salon critics of the 1830s who approached Vernet's pictures with a critical apparatus attuned to the traditions of history painting seemed to grasp the relationship between these canvases and the "low art" vocabulary of images shaped by the legend of Napoléon. We have argued that Vernet's "system" was not born of an artistic timidity but was a focused and pragmatic program of representation developed in concert with Louis-Philippe. The task was at once simple and delicate, for it sought the means to present convincingly the colossal exploits of Napoléon as *part* of history rather than as towering *over* it. The de facto devaluation of Napoléon's mythic stature, implicitly required by the "evenhanded" historicism at Versailles, was masked by a reshaping of the parameters of history painting so that the official images would resonate with the evocative imagery of Napoleonic folklore. Where our modern eyes—unfamiliar with the pictorial lexicon manipulated by these works—see only crisply rendered anecdotes, or where critics of the period saw configurations which seemed to break all the accepted standards of ambitious, heroic painting, the general public of the 1830s eagerly discovered familiar—albeit formulaic—images of their beloved idol.

Looking beyond our modernist provincialism, we now recognize that the pictures for the retrospective historical panorama of the Galerie des Batailles evolved from a complex of issues involving the *how* of representation as well as *what* was to be depicted: insofar as this is true, we do the creators of these images a disservice if we deny that they invented a style.[172] We also understand the absolutely central role of the king and his political concerns in this process of pictorial experiment and invention. If the July Monarchy flirted with the legend of Napoléon at Versailles or at the place Vendôme, its infatuation with that powerful mythology was always tempered by the pressing political concern to remove Napoléon from legend and place him in history. In the next section, we will explore the other side of this process by considering some Napoleonic episodes which were systematically excluded from the official imagery of the Orléans dynasty: this discussion will set the

stage for our analysis of the government's role in the ceremonial return of Napoléon's body to Paris in 1840.

6. LOUIS-PHILIPPE RECOUNTS THE HUNDRED DAYS: REORDERING THE POLITICAL MAYHEM OF 1814

The direct effect of contemporary political developments upon Louis-Philippe's process of editing the visual historical record at Versailles can be clearly traced in his choice of pictures destined to represent Napoléon's triumphant return to France from his first exile in early 1815.[173] Banished to the island of Elba (near the Tuscan coast of Italy) in 1814 by the Treaty of Fontainebleau, Napoléon began almost immediately to plan his escape. Less than a year later, he left Elba with a flotilla of seven small ships, eleven hundred faithful soldiers of the Imperial Guard who had followed him into exile, four cannons, and the ambition to conquer France. The invaders landed near Antibes in the Golfe Juan on 1 March 1815, deployed their tricolor flags, and began a historic twenty-day march to Paris with exactly the success predicted by Napoléon when announcing his return to the army: "The eagle with the national colors will fly from steeple to steeple all the way to the towers of Notre Dame!"[174] Bonaparte's little band followed a difficult mountainous route from Cannes through the Alpes-Maritimes to Grenoble, then on to Lyon and the capital—a route purposely chosen to circumvent the powerful pro-Bourbon garrisons at Marseille and Toulon and to leave quickly the mainly royalist coastal areas for the support of Bonapartist populations further inland.[175] Indeed, as word of the Emperor's return spread, it obtained the results forecast by Napoléon's advance reports: soldiers, commanding officers, and local government officials all over France willingly abandoned the Bourbons' flag of fleurs-de-lys in favor of the tricolor.

Napoléon realized full well the magic of his name and was careful to appear in his most recognizable uniform, that of the petit caporal.[176] This sense of theater enabled him to prevail in the most serious encounter with pro-Bourbon forces faced by his troupe during their march to Paris. It was extremely important that the returnees be welcomed at Grenoble, for it was the first major city on their route and—like a gateway—led from the mountains to Lyon and the interior. Apollinaire Emery, a surgeon of the Imperial Guard and a native of Grenoble who had Bonapartist contacts there, was sent ahead to infiltrate the city, print Napoléon's declarations, and distribute them to arouse public ardor for the Emperor.[177] Although Emery successfully fulfilled his mission, the Grenoble garrison was led by a staunchly royalist general named Marchand who actively organized a defense and sent his most dependable troops to meet Napoléon at Laffrey, a village about twenty kilometers away.[178] These troops, commanded by one Colonel Delessart, blocked the road from a strong position reinforced on one flank by a steep slope and on the other by a lake. At about noon on 7 March, Napoléon's troops approached this point, with Polish lancers leading the way and the Guard following behind. From their positions, Delessart and his men could clearly recognize the petit chapeau and redingote grise of the Emperor on horseback. Sensing that the resolve and courage of his troops were fading, Delessart ordered them to fall back and regroup to face the enemy.

What the troops saw next would have made the heart of even the most tested French

veteran leap to his throat, for the Polish riders had turned aside to reveal the Imperial Guard—dressed in their legendary busbies, long blue coats, and bearskins—advancing under a fluttering tricolor like phantoms out of a mythic past. But they held their rifles at rest and, more important, a short man in a memorable uniform walked calmly at their head. "Soldiers of the Fifth Regiment," called Napoléon in a firm voice, "recognize me." And moving a few steps closer, he pulled aside his greatcoat and declared: "If there is a soldier among you who would want to kill his Emperor, he can do it. Here I am!"[179] In this supercharged moment of emotions and memories, who dared to shoot? Cries of "Long live the Emperor!" were the answer as the troops broke ranks. A tearful Delessart rendered his sword and was promptly embraced in consolation by the victor. The road to Grenoble was open. When Napoléon appeared under the walls of the city at seven o'clock that evening, Marchand could do nothing to prevent his troops from defying their orders and opening the gates to the conqueror.[180]

Clearly, this is the heady stuff of history from which popular myth is made, and it is not surprising to find the dramatic episode at Laffrey represented at the first Salon where pictures of Napoléon were once again permitted. A picture exhibited in 1831 by Charles Steuben shows the petit caporal—flanked by the generals Cambronne (with the tricolor) and Drouot—acknowledging the adulation of his former opponents who now literally fall at his feet in a rush of enthusiasm (fig. 204).[181] Steuben added to the legendary sentiment of the moment by including in the foreground a soldier who pulls from his knapsack an imperial eagle to prove to Napoléon that his allegiances had never really wavered. At the same time, the cheering civilians in the background suggest that the spontaneous élan at Laffrey was not strictly military.

Although Charles Lenormant remarked that the subject of Steuben's picture "guarantees in advance the popular success to which this artist aspires," relatively few critics commented on it in their reviews.[182] Perhaps they felt that Steuben's work was too "popular" to be taken seriously, for the Jazet firm had published an engraving in 1827 and exhibited an aquatint of it at the 1831 Salon; in short, the picture was already part of a commercial venture.[183] But the critical neglect is more surprising if we look closely at Steuben's composition. Despite his modest scale and project for publication, Steuben isolated and concentrated the essential action of his story with the pictorial schemata of Davidian history painting: a frieze-like disposition of large figures close to the picture plane; a rhythmic rush of diagonal movement from left to right that is stopped abruptly by the stable triangle formed by Napoléon and the tricolor; and a rendering of firm contours and tightly painted details in the service of rhetorical poses and extravagant gestures. Thus, to note Steuben's obvious dependency upon such large-scale period pictures of the Empire as *The Oath of the Army* by David (fig. 177) or Meynier's *Marshal Ney Returns to the Soldiers of the 76th Regiment Their Banners* (fig. 205) underscores both the high art parentage and the highminded ambitions which shaped the basic structure of his work.[184]

If neither the subject nor the formal pedigree of Steuben's picture are sufficiently objectionable to account for the critical indifference which greeted his work in 1831, it is reasonable to look *outside* the Salon for the causes of this critical neglect. We already know that a political and public debate had developed during the months following the 1830 Revolution over who was or was not "revolutionary": the government of Louis-Philippe

born of the revolution, or its adversaries? We have traced the effects of this debate in the subjects and forms of official art inspired by the July Revolution and its historical analogue, the Great Revolution. A parallel discourse about the social role and political meaning of Napoleonic imagery took shape during the early 1830s and, because no side was able to reinvent the iconography of the Emperor, a hotly contested struggle to control that imagery marked the mid-1830s. But in 1831 this debate was neither shaped nor politicized: with the political ramifications of Napoleonic imagery still to be discovered, Steuben's picture was dismissed at the Salon as yet one more example of familiar ephemera circulated by proponents of the Napoleonic cult throughout the Bourbon Restoration.

The extent to which this situation changed can be measured by comparing the lukewarm reception given Steuben's picture (fig. 204) to the extensive critical commentary and curious history surrounding Hippolyte Bellangé's picture of the same subject (fig. 206) exhibited at the 1834 Salon—the first to be held after the petit caporal reappeared at the summit of the Vendôme column.[185] When discussing this work, *L'Artiste* alluded to its popularity at the Louvre by noting that "even the *Jane Grey* of M. Delaroche did not have a more assiduous crowd of viewers around her than the *Return from the Island of Elba* by M. Bellangé," and the critic suggested that this effect was sustained as much by its manner of representation as by its subject:

> The name and memories of Napoléon retain a potential for power over the crowd. Moreover, the painter has shaped his composition with a simple and calm expression which contrasts most strongly with the melodramatic exaggeration in the picture of the same subject painted by M. Steuben, which the process of engraving has profusely distributed all across France. Obviously we are more willingly sympathetic to the unpretentious naiveté of M. Bellangé than to the ambitious fracas of M. Steuben; but, when carefully looking into ourselves, none of these fictions move us in a way consistent with the demands of our imagination.[186]

The author of this passage sets the conventional artifice of Steuben's picture against Bellangé's attempt to reveal the intrinsic poetry of the episode in a fresh, formula-free manner. His suggestion, however, that even Bellangé's naiveté falls short of the sublime expression demanded by such an extraordinary event invokes a measure of excellence shaped by an active enthusiasm for the story. As argued earlier, this kind of interaction between the historical narration of recent events and the biographical coloration they held for contemporary viewers fostered a critical situation in which genre historique emerged as the most appropriate manner of representing modern history precisely because it was suited to developing the sentimentality demanded by memory.

If Steuben enlisted the traditional devices of history painting for his picture, we might then ask where the origins of Bellangé's rather different image are to be found. At first glance, his composition appears to proceed from that landscape tradition which strove to capture the sublimity of nature by emphasizing her rugged and awe-inspiring splendor.[187] Capitalizing upon the season and geography offered by history, Bellangé established an expression of somber natural majesty by dedicating more than half of his canvas to the mist-shrouded mountains and winter-grey skies.[188] He also adopted an airborne point of view which suspends us in an imaginary space between our world and that of the picture—

a device favored by those romantic landscape painters who sought to strike an emotional chord by boldly confronting the viewer with an unmediated vista of nature's grandeur.[189] Not every critic in 1834 approved of Bellangé's attempt to slant the mood in this way. Alexandre Decamps, for example, complained that Bellangé's composition "is not felicitous; the principal character is scarcely visible amidst the greyish terrain in which he seems implanted."[190] Decamps completely ignored the fact that Napoléon cuts a clear silhouette against the background mists in order to register his discontent over the hero's diminutive presence in the overall image.

Bellangé's strategy of suspending the viewer over the scene and at a distance dictates that individual figures remain small and that the action—if distributed across the surface— will be fragmented and episodic. This effect is especially apparent among the troops at the left, where some soldiers have already manifested their decision to defect while others seem to hesitate before cheering the Emperor. Fabien Pillet, who felt that the artist had captured the scene with "a great veracity of expression," praised Bellangé's depiction of the episode as an *unfolding* action which the viewer discovers through a series of interrogations: "It was impossible to paint more perfectly the passage from a remaining bit of hesitation to the explosion of enthusiasm, and this admirable shift intensely touches the viewer's soul. That is not all: after taking pleasure in contemplating the ensemble of this eminently dramatic scene, one finds further charm by scrutinizing in succession its many details."[191] Not surprisingly, more conservative critics faulted both the configuration and focus of the picture: "The desire for exactitude in representing the site obliged M. Bellangé to paint a very large canvas in which the characters get too small a space. One hardly bothers with mountains and villages when the historical scene possesses such a strong interest; we therefore venture to find a defect in the relationship between the scale of the figures and that of the canvas."[192] The issue at stake in this critical discourse is one of the most sacrosanct concepts of traditional composition: the significant moment. The significant moment was understood as the instant of the narrative when physical and psychological forces were concentrated in the hero's gestures, expressions, and spatial location.[193] Facts might be added or deleted, storylines reworked, and characters invented to maximize the impact of the significant moment. But during the 1830s, when painters turned to the sagas of modern history, both critics and the art-going public expected more than the tired formulas of History Painting; they simultaneously demanded that details of the scene be faithfully recorded and that its intrinsic grandeur be compellingly expressed. This dual concern—which frets over minutiae and broad impressions at the same time—tended to undermine the hegemony of the significant moment and opened up a conceptual terrain between historical narrative and contemporary sensibilities where the genre historique could take root.

Although Bellangé's picture seems to be composed informally, it was not randomly plotted, for its structure directly reflects the shape of its narrative. The three principal protagonists of the story are clearly placed and spaced on the canvas: at the right, the Imperial Guard cheered by some country folk; at the left, the opposing Bourbon troops; squarely between these two poles, the single figure of Napoléon. The schematic layout works with the viewer's elevated vantage point to direct our eyes toward the center of the image and the solitary interlocutor who challenges the loyalty of the royal troops.

Bellangé's all-important middle term—isolated and inexplicably highlighted by a stray ray of light at the exact center of the canvas—possessed an allure completely *exterior* to the picture via the contemporary and newly ascendant political signification of the petit caporal. Yet it is interesting to note that critics were beginning to realize one could overwork the compelling imagery of the Napoleonic legend. "Thank heaven," exclaimed the *Revue de Paris*, "all the terrible plays done with the petit chapeau and redingote grise of the glorious Emperor have not been able to spoil for us the poetry of this grand drama."[194] Similarly, *L'Artiste*, whose critic generally praised the Bellangé, suggested that the established iconography of Napoléon might be incapable of expressing the epic quality of his life: "the Napoléons of slavishly correct costumes and pose have made a fortune in the theater but all of them, being flimsy illusions, belong to quite a different sphere than that of high art. M. Seurre was able to borrow inspiration from the Emperor's old clothes to work at absolute truth, but he was no more successful in showing us the great man. It is Napoléon's name which is on the Column, not his image."[195] By trying to distinguish between merely naming and truly representing the Emperor, this text articulates the suspicion that the familiar imagery was unable to transcend the anecdotal and fetishist predilections of the Napoleonic cult. It is particularly important that critics of the 1830s questioned the tendency to represent Napoléon in formulaic configurations derived from popular imagery. Their discourse suggests that the government of Louis-Philippe *also* understood the situation, thereby supporting my claim that pictures grounded in the popular imagery of the petit caporal were valued not only for their nonconnoisseur public appeal but also because they tended to lock Napoléon into legend and isolate his memory from current events.

Legend and real life sometimes became uncomfortably close, and the government's reaction can be vividly characterized by studying the circumstances surrounding the purchase of Bellangé's canvas. Although the picture was passed over by the administration at the time of its Salon appearance, archival records indicate that it was acquired on 4 February 1836 and paid for in June.[196] The archives also show that a second picture was commissioned on 4 February 1836 from Joseph Beaume, a *Departure from the Island of Elba* (fig. 207).[197] Beaume's completed canvas is a familiar type of image which shows Napoléon about to board the small boat which would carry him to the frigate *L'Inconstant* waiting in the harbor. The background vista of the town and port of Porto-Ferraio sets the geographic locale for the Emperor's departure on 25 February 1814 from his temporary kingdom of Elba. Little vignettes season the multifarious image with a purely anecdotal charm: the crowd of islanders assembled on the pier offers a picturesque range of figure types and gestures, while a boat at the lower right ferries a group of moustachioed veterans of the Imperial Guard in their full dress uniforms—one of whom is kissed for good luck by two women.

Beaume mapped out this sprawling narrative with a compositional scheme similar to that of the Bellangé just discussed. The viewer is again suspended above the foreground of the image, the main action occurs in a shallow slice of space near the center of the canvas, the figures are small on the visual field, and the flanking vignettes mix the everyday activities of genre with veristic details to establish the appropriate historical and sentimental contexts. The same hybrid qualities—argued here as coterminus with genre historique—are manifest in Beaume's picture of *The 28th of July at the Hôtel-de-Ville* (fig. 68), *The Parisian National Guard Leaves for the Front in September 1792* by Cogniet (fig. 143), and a

popular print of Napoléon's arrival in France from Elba (fig. 208).[198] Our recognition of this shared visual language underscores the ability of genre historique to mediate the traditional cultural gap between high and low art forms: its power of mediation explains why it became the perfect vehicle for Louis-Philippe's historical propaganda.

Returning to the question of propaganda value, we have seen that in February 1836 the king was planning to include Napoléon's return from Elba in the galleries of Versailles. As part of this program a painting by Baron Gros, *Louis XVIII Leaves the Tuileries Palace during the Night of 20 March 1815* (fig. 209), was transferred from Aix-en-Provence to Paris.[199] For Louis-Philippe to envision such an installation required some boldness, because the Emperor's return in 1815 had not spared him from personal difficulties: although Louis-Philippe had disapproved of many Bourbon policies, he too had been obliged to flee France in the face of Napoléon's march on Paris. Yet the king must have been encouraged by the favorable public response to Vernet's pictures of Napoléon at the 1836 Salon and increasingly convinced of the wisdom in his scheme to make Versailles an all-inclusive history of France. Political events, most notably the after-effects of Louis-Napoléon Bonaparte's attempted coup d'état at Strasbourg in October 1836, soon cast a pall over his ambitious plans.[200] This eruption of militant Bonapartism seems to have affected profoundly the suite of pictures designed to commemorate Napoléon's stormy return to power in 1815. When Beaume sent his work to the 1837 Salon, for example, it was received by the jury but withdrawn before the opening.[201] The most plausible explanation for this unexpected action is that it was thought politically imprudent to provide an occasion for public discussion of a picture of Napoléon's return to France: only a few months had passed since another Bonaparte had tried to repeat his uncle's triumph. The trial of Louis-Napoléon's accomplices ended just one month before the Salon opened, and their acquittal—undeniably a political embarrassment to the government of Louis-Philippe—was still too much of a sore point to risk reopening debate in the press.

Eventually, Beaume's picture was quietly installed at Versailles along with Gros's painting of Louis XVIII. The Bellangé, however, never hung in Louis-Philippe's galleries; it was relegated to the reserves and remained there until the 1850s when Napoléon III (Louis-Napoléon) gave it to the museum at Amiens.[202] Thus, the return from Elba was finally recounted at Versailles as a schematic and politically anodyne "cause and effect": Beaume's picture of Napoléon leaving Porto-Ferraio was hung alongside Gros's depiction of Louis XVIII fleeing Paris. By eliminating Bellangé's scene of the dramatic encounter at Laffrey, Louis-Philippe "erased" from the historical record every trace of the spontaneous popular enthusiasm which had greeted Napoléon during the "flight of the eagle" from Cannes to Paris, and in so doing short-circuited any contemporary inference that a Bonapartist coup d'état could be a significant historical event. My analysis, which has shown how this "censorship" occurred simultaneously with the formulation of anti-Bonapartist policies in response to contemporary political events, suggests once again that a serious propagandistic purpose lay behind all that appeared in the galleries at Versailles.

7. A NAPOLEON NOT SEEN IN OFFICIAL ART: ROMANTIC HERO OF MODERN TIMES

The July Monarchy's appropriation of Napoleonic imagery was always tempered by a concern to control and direct the potentially explosive power of the Emperor's legend.

When Napoleonic iconography entered the lexicon of Louis-Philippe's official art, it remained close to the military chauvinism surrounding the petit caporal or offered a didactic demonstration of the Emperor's political shortcomings. The legend's power was fueled by fixing upon the qualities which *separated* Napoléon from other men. To be sure, this special attraction depended upon the same "cult of genius" which led nineteenth-century Romantics to make heroes of those individuals whose innate gifts necessarily led to isolation from, and frequently persecution by, society at large.[203]

Staunch royalists frequently admitted that the usurper Bonaparte had, against all reasonable odds, dared to dream and to implement exploits on a scale which staggered ordinary minds. As early as October 1811 Chateaubriand—an ardent Romantic but an avowed enemy of Bonaparte—had manifested a grudging admiration for this giant among men: "the man who today gives a world empire to France only to crush her under his feet, this man whose genius I admire and whose despotism I abhor, this man envelops me with his tyranny like a further solitude. But if he smashes the present, the past defies him, and I remain free in all that preceded his glory."[204] During the July Monarchy, Chateaubriand described Napoléon as "a poet in action, an immense genius in war, an indefatigable spirit"; and a secret admiration colors his recollection that the Emperor "took a hand in everything; his mind never rested; he possessed a kind of perpetual vivacity of ideas."[205] Ironically, Chateaubriand's most enthusiastic appreciation of Napoléon as a Romantic hero incarnate emerges when the poet attempts to circumscribe the Emperor's personal stature:

> He is especially great for being born of only himself: for knowing how, without any authority other than that of his genius, to make himself obeyed by thirty-six million subjects at a time when absolutely no illusions surrounded thrones. He is great for having defeated all the armies, regardless of whatever difference there might have been in their discipline and quality; for having taught his name to savage as well as to civilized peoples; for having surpassed all the conquerors who had preceded him; for having filled ten years with such extraordinary events that one can scarcely comprehend them today.[206]

If an avowed legitimist like Chateaubriand could frame an appreciation of the usurper's indomitable will and boundless vision with the admiring language of Romanticism, the extravagant effusions of contemporaries sympathetic to Bonaparte's politics become more comprehensible. Thus, Victor Hugo both portrayed Napoléon as the consummate Romantic genius and endowed him with an allure actually intensified by captivity and exile:

> Qu'il est grand, là surtout! quand, puissance brisée,
> Des porte-clefs anglais misérable risée,
> Au sacre du malheur il retrempe ses droits;
> Tient au bruit de ses pas deux mondes en haleine,
> Et mourant d'exil, gêné dans Sainte-Hélène,
> Manque d'air dans la cage où l'exposent les rois!

> [That he is great, especially there! When, power broken,
> By English irons a miserable laughing-stock,
> He steeps his claims in misfortune's anointment;
> He keeps two worlds on guard with the sound of his footsteps,
> And, weakened by exile, confined to Saint-Helena,
> He suffocates in the cage where the kings expose him!][207]

The history of Napoléon's final days dovetailed perfectly with the cherished Romantic myths of innate genius, unavoidable isolation, and inevitable persecution. Not surprisingly, he was viewed with an admiring awe by the generation of writers whose careers had begun during the adventures of Imperial France and who matured during the exasperatingly calm reign of Louis-Philippe.[208]

Many prints produced during the July Monarchy carry the literary sentiments about Napoléon as archetypal Romantic hero into the visual arts. Raffet's well-known lithograph of 1834, entitled *The Idea* locates this spirit within the emotionally charged historical setting of the defense of France in 1814 (fig. 210).[209] Napoléon, dressed in his field uniform and warming his feet by the fire in a humble peasant cottage, is depicted deep in thought. Having turned his back on the map which offers the cold facts of the military situation, the Emperor silently ponders his options, mentally seeking the brilliant move which might crush the enemy and deliver the nation. The room, lighted only by the hearth and a single candle, is an appropriately lugubrious setting for the tempest of battles, troop movements, and carnage which rages in Napoléon's imagination. Finally, the impoverished locale—far removed from the glitter of Parisian court life—thoroughly expresses the Romantic notion that this man has been forced to suffer hardship by those who envy his unique vision and extraordinary talents.

During the campaign of 1814 Napoléon had, in fact, been quartered in makeshift surroundings, and Raffet's print thus rings with a degree of historical truth.[210] Napoléon spent the night of 22 February, for example, under the roof of a wheelwright's cottage in the hamlet of Châtres—an episode recounted in Béranger's poem "Les Souvenirs du peuple" and in prints of the Emperor's unpretentious presence among the common folk. But comparing *The Idea* by Raffet to the popular images used to illustrate Béranger's poem (figs. 169, 170) underscores the change in tone: Raffet's Napoléon is the solitary genius, completely immersed in his mental flights of daring. The companions of this Napoléon are to be found neither in the political iconography of *Napoléon du peuple* nor in the military anecdotes of the petit caporal; rather, the kindred spirits of this brooding visionary are the misunderstood men of genius like Michelangelo (fig. 211), Tasso, or Christopher Columbus, who were equally lionized by Romantic writers and poets during the reign of Louis-Philippe.[211]

It should be evident that this type of image was a ready-made model for pictures of Napoléon in exile at Saint-Helena. Méry-Joseph Blondel's undated sketch imagines the haunting visions which must have plagued the captive as he dictated his memoirs (fig. 212).[212] Napoléon broods over a battle plan while cloud-borne figures bearing the emblems of his greatest personal triumphs (the flag of Arcole and an Egyptian sphinx, Imperial eagles and the Legion of Honor) appear to remind him once again of his dashed dreams. Appropriately enough, the closing gloom of Blondel's scene is pierced not by the flickering light of the nearly extinguished candles but by the otherworldly glow which surrounds Napoléon's head and accents the feverish activity of his mind.

Although the drama is reduced to believable dimensions in Horace Vernet's rendering of *Napoléon on Saint-Helena* (fig. 213), the image encodes precisely the same sentiments as Blondel's sketch.[213] Vernet imagined the exile as an overweight plantation gentleman whose only escape from his rocky island prison is on the wings of reveries triggered by European newspapers whose familiar names and places propel his visions of things that

might have been. This print and Blondel's sketch fix two extremes of a popular pictorial tradition which portrayed Napoléon as an introspective and persecuted visionary. Without discussing individually the many existing variations on the theme, this pair allows us to grasp the general tenor of the imagery and to consider how and when this type of Napoléon appeared in more artistically ambitious painted representations.[214]

Louis Janet-Lange exhibited at the 1844 Salon an *Abdication of Napoléon at Fontainebleau* which attempted to carry the visionary motif we have been tracing to the realm of high art (fig. 214).[215] In this work, Napoléon is about to sign the second text of abdication (that of 6 April 1814), by which he renounced all claims to the throne for himself and his son; in other words, to disfranchise the dynasty he had created. After vainly trying to rally his marshals by proposing a counteroffensive on Paris or a march to Italy—and understanding that their icy silence was a refusal to follow him further—Napoléon realized that he had no choice but to sign the act of unconditional abdication.[216] Janet-Lange evidently sought to capture the moment of inner struggle when Napoléon weighed the ever-worsening military and political situation (including the defection of Marmont) against the daring alternatives proposed by his restless imagination. While we might agree with the *Journal des Beaux-Arts* that "nothing in this canvas makes us feel the man of vast genius nor the solemn act which he performs," the very terms used to criticize the picture suggest that the pose adapted by Janet-Lange from popular images carried visionary and Romantic connotations.[217] My claim that this sentiment enjoyed an important audience in the 1840s is buttressed by the fact that a number of deputies successfully lobbied the government to acquire this feeble painting on behalf of the museum at Tours.[218]

Whatever its aesthetic weaknesses, the Janet-Lange documents contemporary appreciation for works which cast Napoléon as a Romantic hero and leads our discussion of this tradition to the most potent example of the type produced during Louis-Philippe's reign: the 1845 picture of *Napoléon at Fontainebleau* by Paul Delaroche (fig. 215).[219] Delaroche takes us to the Emperor's private apartment in the château at Fontainebleau on the evening of 31 March 1814. For two days, Napoléon had been marching toward Paris to meet the advancing Russian and Austrian armies. He was too late: five miles from the capital, he learned that Paris had surrendered.[220] Napoléon immediately backtracked to Fontainebleau, arrived at the château near six A.M., and retired to the small room where we find him in the picture. The Emperor slumps indecorously in his chair—the petit chapeau dropped negligently on the floor, boots splattered with mud, still wearing the famous redingote grise—and seems entirely lost in his thoughts. Reminders of an era whose days are numbered lie all around: on the sofa at the left, scattered maps and papers; at the right, the legendary sword of Austerlitz; over his head, the imperial *N* which patterns the wallpaper of the background. While all of the accoutrements of the petit caporal are here, an essential element of that illustrious persona is missing: this Napoléon is alone, and the great armies who once cheered him are now scattered in defeat.

Napoléon nevertheless dominates the image with an imposing figure which both fills the frame and looms over us, since the viewer's eyepoint is low, near the level of the imperial paunch. Nor does our presence disturb his reverie: the unfocused gaze of his tired eyes—nearly lost in their deeply shadowed sockets—remains fixed upon some point lying outside the picture's space. While it is true that Delaroche imagined Napoléon "brooding on

the tragic turn of events which have made his abdication unavoidable," we need not suggest that the painter "seems to have identified with Napoléon" in order to understand the imagery.[221] The Delaroche clearly belongs to the family of Napoleonic images which eschews self-pitying tragedy in favor of a visionary Romantic sentiment—a tradition which links culturally a simple print like *The Idea* by Raffet (fig. 210) to an ambitious painting by a major master. To characterize the Napoléon of Delaroche as "tragic" registers one point of the work's expressive charge but fails to capture the splendor of the hero's isolated, though unbroken, spirit. Viewers of the 1840s would have immediately grasped this quality, for their perceptions were colored by familiar histories of Napoléon's last campaign in 1814. The account by baron Fain, which summarized the Emperor's return to Fontainebleau with a quote from Montesquieu, exactly circumscribes the mood of this canvas: "It is here that one must yield to the spectacle of humanity: to see so many wars waged, so much blood spilled, so many nations destroyed, so many magnificent actions, so many triumphs, so much politicking, perseverance, courage; to what end has it led?"[222] Delaroche's Napoléon is lost in a rumination where past glories mix with present futilities and where the resources of his imagination are pitted against the military might of his advancing enemies. The result is a powerfully evocative image, and one perfectly in tune with contemporary analyses of Napoléon as a Romantic hero. It is coincidental—but somehow appropriate— that Delaroche painted his brooding *übermensch* of a Napoléon for a German collector living in the same region of Saxony where, one year earlier, Friedrich Nietzsche had been born.[223]

Nothing we have discovered about Louis-Philippe's attitude toward the memory of Napoléon suggests that he would approve a subjectively heroic image like the Delaroche, but the artistic poverty of the picture by Gaëtano Ferri (fig. 216) destined to recount at Versailles the Emperor's 1814 abdication still stops us short.[224] Much of the slack handling and awkwardness of this painting probably resulted from Ferri's own inexperience: the commission was awarded in 1840 to François Bouchot, but Ferri—one of Bouchot's students—completed the picture after his master's untimely death in 1842.[225] Since the principal lines of the composition were established by Bouchot, it probably reflects the wishes of his royal patron. More important, if the finished work had genuinely displeased Louis-Philippe, a replacement could easily have been commissioned from a more established and accomplished artist.

Ferri's picture avoids in several ways all of the suggestive psychological implications which have characterized our other images of the abdication. First, and most apparent, is the fact that Napoléon is not alone: gathered around him are his field marshals, the military elite who formed the Empire's aristocracy but whose titles would soon become nostalgic trappings, as useless as the maps of Imperial France piled on the table. This coterie of notables seems to mill listlessly around their unsmiling chief much as baron Fain had described them: "the army chiefs of staff . . . found themselves assembled in the salon; they seemed only to await the end of this audience before mounting and leaving Fontainebleau. . . . The one thing which struck Napoléon was the discouragement of his old military comrades, and he yielded to what was described as the army's wish."[226] The presence of the marshals in Ferri's picture suggests what the Salon *livret* made clear: this is not a representation of Napoléon's unconditional abdication (6 April 1814), but the one of 4 April which

assumed that the "rights of his son, those of the Empress, and the laws of the Empire" would be maintained.[227] Rather than recounting the Emperor's final and most complete sacrifice of his rights, the picture depicts an intermediate step in which he yielded—against his better judgment—to the pressure of his trusted aides.[228] Even as these men urged Napoléon to give up the fight, General Marmont—whom we remember from the Trois Glorieuses of 1830—was making plans near Essonnes to defect and surrender his army to the Austrians.[229] The truculence and treasons which poisoned the atmosphere on 4 April 1814 find their way into Ferri's work: an expression of bitter resignation completely lacking in sublimity marks Napoléon's face as he disdainfully proffers his abdication. The remarkable indifference with which the marshals accept this act tends to further baron Fain's portrayal of them as courtiers sordidly jockeying for position and abandoning their defeated chief. In short, the psychologically suggestive and "romantic" admiration found in contemporary images of the Emperor's abdication was suppressed here by a perfectly historical narrative—but one which openly revealed the all-too-human ambitions and petulance of its principal actors.

It is true, however, that the picture hung alongside Ferri's canvas at Versailles projects a nobler, more affective sentiment, for it represents *Napoléon's Farewell to the Imperial Guard*, perhaps the single most moving event of 1814 (fig. 217).[230] The painting, a copy of an 1825 original by Horace Vernet, was given to Louis-Philippe in 1842 by Madame de Cambacérès, the wife of Napoléon's second-in-command during the Consulat.[231] Here we witness the closing moments of the military review in the *Cour du cheval blanc* at Fontainebleau on 20 April 1814.[232] The ex-Emperor was about to begin his journey to the island of Elba, and just before boarding his carriage he addressed an emotional farewell to the most illustrious and faithful of his soldiers, the Imperial Guard. Napoléon noted that he could not embrace them individually but did want to kiss the flag which had fluttered over so many of their glorious victories, and he ordered the regiment to present its standard. Suddenly General Petit, unable to contain his emotion, rushed to embrace his commander in a spontaneous expression of devotion that became the subject of Vernet's picture. True to baron Fain's eyewitness account that "the admiring silence which this noble scene inspired was only broken by the sobbing of the soldiers," several of the grizzled veterans ranged in the background wipe away their tears. The commanders who flank Napoléon and witness Petit's display of affection share the emotion of their soldiers: unlike the marshals who were, for the most part, in Paris on 20 April preparing to welcome Louis XVIII, these younger men of lesser rank remained with Napoléon to the very end. Finally, at the center of Vernet's image stands the impassive figure of Napoléon, his famous silhouette crisply etched in pure profile and his identity firmly established by the petit chapeau and green jacket of his cavalryman's uniform.

As we have seen elsewhere, the centered, stagelike composition, precise detailing, and brusque figural croppings at the edges of Vernet's canvas tend to fix the action with a specificity which rigorously prevents the subjective, open-ended "romantic" expression seen in the Delaroche (fig. 215). Vernet's effusions recall the sentimental bonds which existed between the Emperor and his soldiers, but they are carefully circumscribed within this "family." The picture thus satisfies the July Monarchy's concern to limit the official meaning of Napoleonic iconography to a militaristic signification. It probably found a place

at Versailles for yet another reason: Jazet had published an aquatint engraving of the original in 1829, when the Bourbon government began to relax its strict censorship policies.[233] The image therefore possessed a ready-made familiarity with an immediate public appeal and, since it spoke with the vocabulary of popular imagery, its presence at Versailles—just like the large Napoleonic pictures in the Galerie des Batailles discussed earlier—could signal to visitors familiar with Napoleonic folklore that the Orléans dynasty seemed to share their appreciation for the Emperor and his memory.[234]

The recourse to formulations of popular imagery in those cases when the emotional charge of an episode could not be firmly contained by a factual narrative is particularly evident in *The Apotheosis of Napoléon* by Jean Alaux, the picture commissioned by Louis-Philippe to mark the date of Napoléon's death (5 May 1821) in the chronology of Versailles (fig. 218).[235] The work offers a view of Napoléon's grave on Saint-Helena much as it was described in accounts reaching Europe: a plain, unmarked stone located under a group of willow trees and near to the small stream from which the exile had drawn fresh drinking water.[236] Overhead, cloud-borne phantoms of the soldiers and generals who had died serving Napoléon gather to pay their respects before the simple tomb, and a moon appears from behind clouds at the upper left to set an appropriate funereal mood.

At first glance, the supernatural cohort and misty darkness of this picture seem to negate all that we have said about the here-and-now literalness preferred by Louis-Philippe for his Napoleonic imagery. The commission documents demonstrate, however, the continuation of a familiar modus operandi rather than a change in policy. Alaux received the commission in April 1837 and was paid for the completed picture in July.[237] In early March, well before the artist even knew he would be asked to paint this work, an employee of the Royal Museums purchased two lithographs for the Crown: *The Apotheosis of Napoléon* (fig. 219) after Vernet, and *The Tomb on Saint-Helena* (fig. 220) after Gérard.[238] Vernet imagined Napoléon's tomb on a promontory by the sea—the petit chapeau and the sword of Austerlitz lying atop the fresh grave—with the survivors of Saint-Helena (Montholon, Bertrand, and Bertrand's family) consoling one another's grief over the Emperor's death. More relevant, however, is the host of cloud-borne mourners in the right section of the Vernet, for Alaux's canvas of 1837 literally recopies this group. Likewise, an exact replica of Gérard's imagined view of the tomb at Saint-Helena forms the basis of Alaux's picture. Yet to accuse Alaux of plagiarism would be to miss the point, because the administration had obviously acquired the two lithographs to be used as models by the artist who would execute *The Apotheosis of Napoléon* for Versailles.

The reason for such an officially sanctioned cut-and-paste approach to picture-making should now be apparent: to celebrate overtly the politically charged sentiments surrounding the Emperor's lonely death in exile would not have accorded with Louis-Philippe's calculated reluctance to perpetuate a "romantic" image of Napoléon. The particulars of Alaux's commission illustrate once again how the July Monarchy invoked the familiar iconography of the Napoleonic legend to produce an image which might correctly mark the gallery's historical chronology, strike an appropriate emotional chord among museum visitors, yet remain aloof from any specific endorsement of the sentiments involved. The meaning of Alaux's picture depends entirely upon the manipulation of pre-established emblems, and the image provides a striking example of why our analysis of

official art during this period has been concerned not only with the sacrosanct privileges of artistic invention and the language of high style, but also with the visual vocabulary of popular folklore. I have emphasized this interdependence in my discussion of Napoleonic imagery, because the popular tradition was so pervasive and because the Orléans dynasty purposefully maneuvered that imagery—and the public enthusiasm it engendered—to serve its own political ends. To complete our study of this phenomenon, we will examine the July Monarchy's orchestration and commemoration of a pageant charged with feelings of nationalism and offering the opportunity to invent a new iconography around the name of Napoléon: the ceremonial return of the Emperor's corpse to Paris in December of 1840.

8. THE RETOUR DES CENDRES: APOTHEOSIS OR APPEASEMENT?

We know the July Monarchy had provoked the ire of Victor Hugo and other Bonapartists in 1830 by refusing to act on public petitions calling for the repatriation of Napoléon's body, and our discussion of officially sponsored Napoleonic imagery has repeatedly demonstrated Louis-Philippe's intention to portray the Emperor as a great military leader but a political despot. Why, then, did the king apparently decide to change course in 1840 by according Napoléon a triumphal funeral and a magisterial Parisian tomb? The answer does not depend upon a radical shift of the king's political orientation or a reordering of the special biographical and historical perspective which selected the images for Versailles. The fact is that Louis-Philippe was neither the instigator nor an avid enthusiast of the plan to return Napoléon's corpse to the capital: documents show that the king only reluctantly agreed to this enterprise and was actually the last obstacle to its implementation. The real mastermind of Napoléon's return (referred to as the retour des cendres) was Adolphe Thiers, whose motives were as complex as they were distinct from Louis-Philippe's own ideas about how to formalize the memory of Napoléon. Before tracing the evolution of the decision to return Napoléon in 1840, we must briefly account for Thiers' presence among the king's inner circle.

Louis-Philippe summoned Thiers to form a cabinet in February 1840 after the one headed by Marshal Nicolas Soult had failed to carry the Chamber of Deputies when voting a dowry for the duc de Nemours.[239] Thiers—who sided with Liberals in the Chamber and actually helped to engineer the fall of Soult's government—assembled a politically centrist cabinet which avoided both leftist radicals and right-wing conservatives but which forced him to depend on an unstable parliamentary majority that cut across traditional party lines.[240] Thiers governed this coalition with considerable adroitness while preserving a marked deference to the demands of his liberal colleagues. Liberal newspapers lent him their support with the understanding that his ministry would enact many of their long-sought social and political reforms. In short, the Left wielded real political power for the first time since the early months of the July Monarchy.[241]

Thiers emphasized the new character of the coalition he headed by calling his ministry one of transaction (compromise), and he appeared to be succeeding: the first vote of confidence faced by his cabinet carried the Chamber by a healthy margin of 86 votes.[242] Conservatives were not about to abandon the parliamentary struggle, however, and the most curious of their many ploys to discredit Thiers and dislodge his coalition began on

28 March 1840 when a conservative deputy named Remilly deposited a proposal for parliamentary reform.[243] To understand the embarrassing effect caused by Remilly's project, we must imagine a situation in which the Left had sought—every year since 1830—to reform the regulations which allowed a deputy to hold simultaneously a government bureaucratic post and his seat in the assembly. Such positions were often used as bargaining chips to obtain an individual's legislative support: in exchange for a favorable vote, for example, a promotion or a raise could be "arranged"; this temptation was especially strong because deputies received no salary for their services in the legislature. The conservative majority had traditionally rejected the Left's proposals for reform on the grounds that they would ultimately lead to calls for an expansion of the vote—the one reform that completely terrified them and the king. Between 1830 and 1840, conservatives had followed a strict "no reform" policy which championed the closed, clubby atmosphere at which the liberal proposals took aim. Now, however, Remilly's project was sponsored by the circles regularly opposed to reform: had the conservatives undergone a change of heart? The answer, of course, was no: the project was only presented to force a rupture in Thiers' coalition by frightening the moderate conservatives who had rallied to his ministry. Such moderates, it was thought, would abandon the coalition and oppose the reform measure if it were put to a vote. Thiers' own liberal background, on the other hand, required that he not bury the reform in committee, for doing so would alienate his leftist supporters in the assembly. Either way, Remilly and his friends seemed to have Thiers in a trap.

Thiers did try to kill Remilly's proposal in its preliminary committee examination, but he was overruled on 7 April when the panel passed it to the floor by a wide margin. Much to his credit, Thiers supported the measure vigorously in public debate, causing its conservative initiators to lose their nerve and fear that their little escapade might backfire. When Remilly's proposal was passed to a study committee on 2 May, all parties involved had secretly decided to let it die before coming to the floor: conservatives now felt that they had pushed too far; liberals did not want to eliminate just yet their chances of obtaining plum government positions; and Thiers was not anxious to test his fragile coalition. As a result, the Remilly proposition quietly disappeared.

During April 1840, Thiers hatched his plan to distract public opinion from these parliamentary machinations with a truly national celebration: the return of Napoléon.[244] Rumors concerning Thiers' project first surfaced as the Remilly proposition was discussed in committee: on 7 April Dorothée de Lieven wrote to Guizot (then French ambassador in London) that comte Molé had spoken of secret negotiations with England to recover Napoléon's body.[245] Guizot, who would necessarily be involved in any such diplomatic discussions, immediately replied to his friend that "there is no talk at all of transferring Napoléon's corpse to France."[246] At this early date, the matter had not yet progressed to the point where Thiers needed to contact his ambassador, for he was still trying to convince the king that the idea was both useful and desirable. Far from initiating the return of the Emperor, Louis-Philippe received the scheme with hostility and suspicion. Finally, after nearly a month of indecision, Louis-Philippe gave his blessing to the project on 1 May 1840, and instructed Thiers to make arrangements with the English.[247] Thus, the idea to repatriate Napoléon's corpse—a bold act which sits uncomfortably with our understanding of Louis-Philippe's reserved and circumscribed appreciation of the Emperor—acquires a

logic when we know that it was actually initiated by Thiers, a life-long admirer of Bonaparte who would devote most of his energy during the 1840s to writing his monumental *Histoire du Consulat et de l'Empire.*

Having obtained the king's assent, Thiers wrote to Guizot in London on 4 May that he should pursue this "sentimental project" with "all your zeal because, if you succeed, it will bring as much honor to you as to us and I personally will be very grateful for the success."[248] Contrary to the recent characterizations of the subsequent negotiations as delicate and lengthy, they were neither: Guizot approached Lord Palmerston (the English Prime Minister) with the French request for Napoléon's body and finalized all the diplomatic details in three days.[249] Guizot was prompted to note on 10 May that "it is a pleasure to treat issues with Lord Palmerston when he agrees with you. He manages them efficiently and without complications," and Thiers' letter of thanks to Guizot dated 11 May proves that English agreement had indeed come readily and willingly.[250] Guizot underscored the smooth and swift accomplishment of these talks when he reiterated their chronology to Dorothée de Lieven: "Thiers spoke to me about it for the first time on Thursday 7 May. I saw Lord Palmerston on the same day. On Saturday the 9th he gave me the Cabinet's approval and wrote to Lord Granville that day. I informed Thiers of the news on Sunday the 10th by telegram. On Monday the 11th he received my letter and the report from Lord Granville of Lord Palmerston's dispatch."[251] To judge from this authoritative recapitulation of the negotiations, the nearly five-week delay between Thiers' first discussions of the project and the completion of arrangements should be ascribed not to diplomatic haggling but rather to Louis-Philippe's own hesitations.[252]

The speed and ease with which the negotiations were concluded contributed to the surprise and astonishment which greeted the announcement of Napoléon's imminent return. On 12 May, Charles de Rémusat, Minister of the Interior, mounted the tribune of the Chamber of Deputies to render the news public and to request a special credit of one million francs with which to finance the mission to Saint-Helena, the funeral in Paris, and a permanent tomb in the capital. The effect of Rémusat's speech on the deputies was immediate and achieved all that Thiers had hoped for: a lively spirit of nationalism moved the entire assembly to acclamations and applause.[253]

As word of Napoléon's return spread throughout Paris, the effect was no less electrifying. "Our announcement by parliamentary proposal of the transferral of Napoléon's remains produced an enormous effect," wrote Thiers on 13 May, and the next day Dorothée de Lieven exclaimed in a letter to Guizot that "people speak of nothing but Napoléon's ashes [*Cendres de Napoléon*]!"[254] The project quickly became the principal topic of conversations and newspaper editorials, but the general euphoria was short-lived as political factions hurried to turn the event to their particular advantage. Bonapartists, for example, fulminated against the allocation of a mere one million francs for the ceremony when two million was in their opinion the *least* that should be spent to fete their hero's return. Moreover, they interpreted the government's plan to transport the Emperor's body by boat from Cherbourg to Paris as a tactic intentionally adopted to discourage public demonstrations of homage—gatherings, needless to say, which might be useful to their own ends.[255] And, if conservative newspapers like the *Journal des Débats* attempted to calm public ardor by reminding its readers that posthumously honoring the Emperor did not amount to an endorsement of

imperial rule, leftist papers immediately retorted that the political legacy of Napoléon could not and should not be neutralized: "the conqueror, the legislator, the administrator, the missionary of the French Revolution, *these* are what we want to honor," remarked the *Courrier Français*.[256]

This increasingly political public debate inevitably found its way into the Chamber of Deputies. The committee appointed to examine Rémusat's request for funds decided he had been too frugal; a budget of two million francs was recommended, including provision for an equestrian monument to commemorate the Emperor's return.[257] The report elated both Bonapartists and the cabinet's right-wing political foes, for Thiers was once more caught in a double bind: if he wholeheartedly supported a doubling of the credit, the king would suspect him of unduly glorifying the Empire at the expense of the Orléans dynasty; if he refused to endorse the increase, he would appear ridiculously unenthusiastic about the project he himself had set in motion. Happily for Thiers, Alphonse de Lamartine delivered a brilliant discourse opposing the increase on 26 May, and he articulated the sentiments of many with his closing words: "by erecting this monument and, as a nation, collecting there this great renown, France wants this corpse to give rise neither to war nor tyranny, neither to claims of legitimacy nor pretenders to rule, not even to imitators!"[258]

Sensing Lamartine's success, Thiers tactfully made no attempt to rebut his eloquent appeal to reason and restraint. The assembly vetoed the committee's recommendation, reinstated the credit of one million francs originally proposed, and promptly earned the scorn of left-wing and Bonapartist journalists. Although newspapers eventually tired of haranguing the cabinet over this result, the discord and political disarray was far from what Thiers had hoped to obtain with his announcement of Napoléon's return. The political storm also revealed that one could not yet manipulate Napoléon's name and reputation without stirring feelings believed long dead. "Perhaps, in many ways," Lamartine had said, "this corpse was not yet cold enough to touch." Thiers certainly had been burned, and the correctness of Lamartine's observation underscores the political prudence of Louis-Philippe's historicized, low-key presentation of Napoleonic imagery in the picture galleries at Versailles.

Once the project to repatriate Napoléon was set in motion, concrete plans for the expedition to Saint-Helena and the Emperor's tomb in Paris had to be finalized. Rémusat observed in his memoirs that Louis-Philippe "did not like the Empire," and that "he was always assailed by the fear of effacing himself before this great renown and of overly encouraging feelings among the people which made them indifferent to the merits of his own government."[259] The Interior Minister's remarks suggest that Louis-Philippe always approached the *retour des cendres* with serious reservations, and Rémusat reports that the cabinet worked to allay these royal doubts: "It was thus necessary to arrange somehow that the homage rendered to the one would serve the other's sovereignty, and that the constitutional king would be able to take an empty pride in the honors accorded the absolute ruler. In this respect our interests coincided with his vanity. We were very careful to assign him a principal role in every aspect of this spectacle mounted for the Empire's benefit."[260] Thus, the king's opinion weighed heavily in the process of selecting a site for Napoléon's monument. Three possible locations were seriously considered: the base of the Vendôme column, the crypt of Saint-Denis, and beneath the dome of the Invalides church. The first was

least desirable from the government's point of view because its public location would always be susceptible to political demonstrations.[261] The cathedral of Saint-Denis (burial place for generations of French kings and queens) was no less problematic, because placing Napoléon there would seem to "legitimize" the imperial dynasty and lend credence to the claims of his heirs—notably Louis-Napoléon Bonaparte. Rémusat tells us that the Saint-Denis option was dropped because "the king was clearly strongly opposed to it."[262] The Invalides location appeared to offer the best combination of solemnity and ideological neutrality: Napoléon would lie among the war veterans who were especially attached to his memory and military glory, and the church could easily be closed to the public in case of political turmoil. Finally, the location perfectly fulfilled the Emperor's testamentary wish that "my remains repose along the banks of the Seine, amidst the French people whom I have loved so much."[263] Knowing that Louis-Philippe had long preferred a thematic orientation which championed Napoléon's military exploits and minimized his other political personas, we can understand why the king readily preferred the military context of the Invalides to any other site.

Louis-Philippe appointed his third son, François, prince de Joinville, to head the expedition to Saint-Helena.[264] Rémusat indicates that the king also selected the individuals who would accompany Joinville to Saint-Helena (including several companions of the Emperor's exile) and that pious Queen Marie-Amélie chose Félix Coquereau to be the presiding chaplain.[265] Nevertheless, Louis-Philippe's authority in making these arrangements was never absolute. Guizot wrote to Thiers on 21 May that English authorities were beginning to worry about a possible political embarrassment from permitting France to reclaim Napoléon's body.[266] To calm these fears, Thiers responded in a letter of 23 May:

> I am going to select a commissioner who will represent the French government and sign the report of the body's transferral. This commissioner will not be one of the four captives who accompanied Napoléon. . . . He will be a functionary of the State Department so as not to offend the touchiness of the English Tories. . . . There will be no speech, no demonstration. Anyone, such as painters or writers, who could make a noise is eliminated. The noise will be in France and as if among family. The English Cabinet will not be sorry for its behavior in this instance, and we will not expose it to any outbursts from the Tories.[267]

Thiers fulfilled this pledge by selecting Philippe de Rohan-Chabot as the government's emissary. Although only twenty-five years old, Rohan-Chabot had served the French embassy in London for three years and was known by English diplomats.[268] Thiers told neither Louis-Philippe nor Joinville that Rohan-Chabot was to be the official head of the mission, and he instructed his man to inform Joinville of the fact only after their ship had reached the open sea. Joinville recalled with justifiable indignation that "isolated from France, I was no longer able to object to the contradiction between these new instructions and the unambiguous orders which I had previously received."[269] From this little struggle for power around the mission to Saint-Helena Adolphe Thiers once again emerges as the mastermind and prime mover of Napoléon's repatriation.

Members of the expedition to Saint-Helena gathered at Toulon, where they boarded the *Belle Poule*, Joinville's frigate, and set sail on 7 July 1840.[270] The outbound half of the voyage was conducted at a leisurely pace, including a five-day stopover in Cadiz, Spain, six

days of island excursions at Tenerife, and nearly three weeks in Bahia, Brazil. Like everything else surrounding the expedition, the *Belle Poule*'s meanderings had a political motivation: "It had been suggested to me when leaving Paris," recalled Joinville, "that I arrange the mission's itinerary in such a way as to make the return of the corpse to Europe coincide with the opening of the Chambers at the end of December."[271] The expedition landed at Saint-Helena on 9 October and on the 15th—twenty-five years to the day after Napoléon had arrived on the rocky island—his body was exhumed and handed over to the French.

When Joinville arrived at the island he found the *Oreste*, another French warship, waiting for him in the harbor.[272] The captain of this vessel, which had left Europe on 30 July, informed the prince that diplomatic relations between France and Great Britain had deteriorated seriously since the *Belle Poule* had begun its voyage, primarily because of conflicting interests in the Middle East. Although it entails a slight digression, I must summarize this situation because it proved to have profound consequences for the government's reception of Napoléon in December.

France was the sole European ally of Méhémet-Ali, the Pasha of Egypt, whose French-trained and -equipped troops had crushed the Ottoman Empire army and occupied Syria in June 1839.[273] Less than two weeks later, the entire Ottoman fleet surrendered to Méhémet-Ali at Alexandria. The Pasha's ascendant brought France a military and diplomatic advantage in the region which the English were especially loath to accept. Lest the Ottoman sultan make peace with the Pasha and formalize the recent territorial adjustments, the five interested European powers—England, Prussia, Russia, Austria, and France—issued a joint resolution on 27 July 1839 which insisted that they be consulted on any formal treaty.[274] If France had the most to gain from Méhémet-Ali's military successes, we might ask why she supported this effort to limit the Pasha's growing political power. The answer is not hard to find. Since the treaties of 1815, the European powers had regarded France as a second-class nation riddled by dangerous revolutionary tendencies: the Revolution of 1830 had only confirmed their assessment. In 1839, by acting in concert with the other powers as an interested equal, Louis-Philippe's government was claiming its rightful place in international affairs. Although the accord was technically a reproach to their ally, French diplomats believed the military superiority of Méhémet-Ali's army would adequately support any demands he might eventually make at the bargaining table.[275]

Diplomatic negotiations on the Middle East question continued without much progress through 1839 and into the first half of 1840. During this time, Thiers was called to form a cabinet and had announced the *retour des cendres*. This change in government directly affected French foreign policy. Thiers followed a markedly more bellicose line in the Middle East than had his immediate predecessor, and his plan to enshrine Napoléon fueled public opinion with a militant nationalism and awakened the nation's dormant anglophobia.[276] Most important, Thiers was not convinced that French interests were best served by working with the other courts of Europe: while openly endorsing that policy, he pursued secret negotiations to effect direct peace talks between Méhémet-Ali and the Ottoman sultan *without* the other Europeans. In short, Thiers was consciously playing a dangerous game of diplomatic double-dealing.[277]

Lord Palmerston (architect of English diplomacy in 1840) apparently learned of Thiers' secret negotiations in early July, and Guizot assumed that lengthy meetings of the

English cabinet on the 4th and 8th of July were devoted to the Middle East. "Above all, he is acting behind closed doors," wrote Guizot of Palmerston; "he says that, since France has tried to establish a separate and selfish diplomacy, the other powers can surely do the same."[278] Palmerston's flurry of activity resulted in a treaty—signed on 15 July 1840—in which England, Russia, Prussia, and Austria threatened Méhémet-Ali with their combined forces if he refused to retreat from his conquests in Syria and affirm his vassalage to the Ottoman sultan.[279]

Immediate indignation and a general call to arms exploded in Paris when the details of this pact were made known on 25 July. Heine, for example, wrote from Paris on the 27th, "The proverb says that trouble travels in groups; here, bad news does not fail to arrive daily. But the latest and worst of all—the coalition of England, Russia, Austria, and Prussia against the Pasha of Egypt—has produced more an outburst of war fever than of consternation, not only among the people but also in the government."[280] Most Frenchmen viewed Palmerston's treaty as nothing more than a rejuvenation of the alliance against France which had toppled Napoléon in 1815.[281] "One has been able to see amidst this agitation," noted the radical newspaper *Le National*, "how much the treaties of 1815 weigh upon our country, how good it would be to efface their blots"; the conservative *Journal des Débats* argued on 31 July that "France will not back down . . . France cannot back down because to do so would be to let herself be ranked among second-class powers . . . it is essential that she prepare for war."[282] The same conclusions, more delicately phrased, echoed throughout diplomatic correspondence at the highest planes of government—witness Louis-Philippe's *franglais* explanation of his position to Queen Victoria in a letter dated 3 August:

> Keeping the general peace has been the basis and goal of my political policy and the limit of my ambition. I believed that our political method should be one of intimate union with Great Britain because *when France and England are agreed the world is quiet . . . but when one of these powers*, annoyed by an alliance which one calls *unproductive* because the other does not want to undertake impossible tasks, goes to Petersbourg looking for what cannot be gotten in Paris, *then the time is come for everyone to put himself on the* qui vivre [on the alert], *and to prepare for every sort of* eventuality.[283]

This crisis, which evolved during the weeks between the *Belle Poule*'s departure on 7 July and that of the *Oreste* on the 30th, was explained to Joinville when he arrived at Saint-Helena in early October. The prince decided to waste no time before obtaining the Emperor's body and beginning the return voyage, especially since English authorities on the island apparently had had no news from Europe since 8 July—the day they received their orders to release Napoléon from his last captivity. The formalities were arranged in less than a week, and exhumation began during the night of 14–15 October at the stroke of midnight.[284] The coffin was removed from the ground about nine-thirty the next morning, and when it was opened the witnesses were astonished to find an almost perfectly preserved corpse.[285] Satisfied that the coffin did indeed contain the remains of Napoléon, they resealed it and carried it to the harbor in a formal military procession. The sun had already set when Napoléon's remains were officially turned over to Joinville and put aboard the *Belle Poule*. Two days later, at dawn on 18 October, the ship slipped out of the harbor on a morning breeze and the Emperor left Saint-Helena forever.

During the forty-one-day return trip to France, Joinville anxiously sought news of the Middle East crisis from passing ships, and he prepared the *Belle Poule* by taking "every necessary precaution in case of war."[286] Meanwhile, Thiers advanced similar war preparations in France on a grand scale: conscripts from the graduating classes of 1836 through 1839 were called to active duty, emergency credits were established to purchase new weaponry and matériel, and construction was begun on fortifications to protect Paris.[287] Louis-Philippe's eldest son (the duc d'Orléans), who shared Joinville's readiness to fight and ardently supported Thiers' rearmament program, wrote to his sister on 19 September:

> I am working like a dog to help Thiers carry out his splendid military project . . . I will tell you that three months from now we will be ready *for any emergency*. We will have five hundred thousand men ready for battle; the organization, the armament and the materiel for an army of nine hundred and fifty thousand men . . . all our fortresses put back in shape and Paris protected. Then we will be free to do what we want with those who draw up the world map according to their short-sighted irrationality and who dream of a Europe without France.[288]

The king seemed inclined to be swayed by his son's enthusiasm, and he endorsed Thiers' saber-rattling with the hope of cracking Palmerston's European alliance. But when war fever in the public and the press spread to issues far removed from the Middle East— advancing French borders to the Rhine and marching to conquer Italy were two favored schemes—Louis-Philippe began to question the armament decisions that had already been made and sought to cool the militarist zeal of his cabinet.[289] He now argued that, if forced to choose between war with Europe or peace with a loss of face, he would readily endure the humiliation to save the peace. The king's stand put him at loggerheads with Thiers, led to divisions of opinion within the cabinet, and eventually caused a ministerial crisis.

The first phase of Thiers' military buildup had depleted the government's lines of emergency credit, and any additional funds had to be approved by the Chamber of Deputies.[290] The legislative session, normally scheduled to begin in mid-December, was advanced to the end of October in response to events in the Middle East. The cabinet, as was customary, prepared an address for Louis-Philippe to deliver at the opening meeting: it recalled the treaty of 15 July 1840, summarized the government's program to rearm, and exhorted the deputies to act quickly so that France would be "ready to act on the day she believed the European balance of power to be seriously threatened."[291] At the cabinet meeting of 20 October Louis-Philippe refused to accept this text because it seemed to stress unduly the nation's readiness—even willingness—to wage war. The Thiers cabinet responded by offering its resignation, which the king accepted. Louis-Philippe then contacted Soult and Guizot to form a less belligerent ministry, and a new cabinet was installed by 29 October. At the opening session of the assembly (moved to 5 November because of the cabinet crisis), Louis-Philippe's discourse stressed his desire for peace abroad and the need to repress the "anarchic passions" which raged at home.[292]

The government's new pacifist orientation had an immediate effect upon popular imagery, and it is nowhere more vividly illustrated than in the censorship problems encountered by Charlet after 5 November. During September and October of 1840 Charlet's printers had been issuing lithographic images which openly celebrated the bellicose policies of the moment: prints like *If I Had Signed the Treaties of 1815, I Would Cut Off My*

Hand encountered no censorship under the government of Thiers.[293] But, following the king's pledge to temper war fever and regain control of the internal situation, Charlet's works were repeatedly harassed by government censors. The print *To Arms Citizens! Form Your Battalions!* (fig. 221) was published on 14 November 1840 only after the censor had approved the title (which could be construed as an innocent rallying of the National Guard).[294] The threatening nationalism of Charlet's original caption, "Tremble, All You Enemies of France!", was perfectly consistent with Thiers' policy of armed, confrontational diplomacy, but it was found unacceptable after 5 November. Likewise, the torn piece of paper trampled by Charlet's foreground figures was originally inscribed *1815* (a reference to the alliance apparently reborn by Palmerston's isolation of France), but the censor forced Charlet to remove this inflammatory detail before publication. Other images of related political interest designed by Charlet during November and December 1840 were similarly censored and sometimes entirely suppressed by the government.[295]

The upshot of this two-pronged political development in late 1840—the change of cabinet and Louis-Philippe's decisive rejection of war and its concomitant nationalistic chauvinism—is that, when Joinville sailed into the harbor of Cherbourg on 30 November with the body of Napoléon, he was returning to a political climate quite unlike the one which had prevailed at his departure in July. Thiers' announcement of the *retour des cendres* in May had been the springboard for the effervescent nationalism now officially démodé. The problem facing Louis-Philippe's government in November was how to orchestrate the funeral and its attendant imagery in such a way that the Emperor would be laid to rest without rekindling the militarism which had recently carried France to the brink of war.

Rémusat's announcement on 12 May of Napoléon's return had sketched the general outline of the ceremony to welcome him, but the Thiers cabinet was actually responsible only for the naval expedition to fetch the body.[296] Preparations for the ceremonies in France did not begin in earnest until after 16 October 1840, when the architects Louis Visconti and Henri Labrouste were appointed to draw up projects for the ceremonies and to oversee their execution once approved.[297] The protocol for Napoléon's trip to Paris specified that his coffin would be transferred at Cherbourg from the *Belle Poule* to the steamship *Normandie*, transported to Rouen, and then towed to Courbevoie on a specially constructed funeral barge. There, the coffin would be loaded onto a horse-drawn carriage and paraded to the Invalides church via the Arc de Triomphe, the avenue des Champs-Elysées, the place and pont de la Concorde, the quai d'Orsay, and the esplanade des Invalides.[298] The entire trajectory within the city limits (that is, from the Arc de Triomphe on) was to be decorated, and the type of imagery used for those decorations will be the focus of our discussion. Contemporary popular prints remain our primary visual documents, since none of the decorations were designed to be permanent monuments (a point to which we shall return).[299]

Félix Philippoteaux's painting of the convoy's arrival at Courbevoie provides a rather dependable record of the preparations made to welcome the Emperor's return to French terra firma (fig. 222).[300] Contemporary descriptions of the site tell of a Greek temple erected to shelter the funeral carriage, like the one we find at the right of Philippoteaux's picture.[301] The pont de Neuilly, at the left of the painting, sported a colossal eagle-topped column

dedicated to Notre-Dame-des-Grâces: Visconti and Labrouste apparently felt that the patron saint of mariners—although not a Napoleonic icon—was an appropriate figure to greet Napoléon on his return from his island exile. It is characteristic of the last-minute planning for the funeral that this column was only completed two days *after* the cortege had passed, and since both "monuments" were constructed of painted wood they were actually little more than vaguely neoclassical theater props with a veneer of imperial heraldry.[302]

The same qualities distinguished the funeral carriage (fig. 223), which was also finished in haste at the last minute: it was not road-tested until 9 December and final adjustments were made on the 11th, leaving just four days for transportation to Courbevoie in time to receive the Emperor's remains.[303] This monstrosity—an enormous pile drawn by sixteen white horses and capped by fourteen plaster caryatids supporting a coffin—was draped in purple fabric strewn with embroidered bees and included a relief of eagles and figures of Renown in its lower register. Up front, two genii supported a sculpted crown, while groups of flags at the back represented the nations once ruled by the Emperor. The wagon's outward appearance was an elaborate sleight-of-hand, for Napoléon's coffin was actually carried *inside* the structure, prompting Victor Hugo to complain that "it hides what one wanted to see, what France had laid claim to, what the people were waiting for, what everyone is looking for: the coffin of Napoléon."[304] We can imagine why avid Bonapartists like Hugo found the final product disappointing, and he went on to note that "one clearly sees, in spite of the gilding already half-flaked off, the joints of pine planks. Another defect: this gold is only a surface covering. Pine and papier-mâché, that's the truth of it. I would have wanted for the Emperor's hearse a magnificence that was sincere." The caustic Alphonse Karr, less circumspect than Hugo, drew an especially damning comparison: "The wagon, built by the carpenter Belu, was made not to last—like a stage set. The funeral wagons of the duc de Berry and Louis XVIII are preserved in the government's furniture warehouse. The Emperor's has been demolished."[305]

The stage-prop mentality isolated and attacked by Hugo and Karr when discussing the funeral wagon was even more apparent at the Arc de Triomphe. An enormous figure of Napoléon in his coronation robes was erected atop the arch, along with allegorical figures of Glory and Grandeur and an accompaniment of eagles and smoking tripod fire-pots.[306] While these elements are clearly visible in Victor Adam's lithograph of the Etoile (fig. 224), it is again Victor Hugo who provides a veristic description of the ensemble: "This poorly gilded ornamentation overlooks Paris. By circling around the arch one sees it from the back. It's a genuine stage set: from the Neuilly side the Emperor, the Glories, and the Renowns are nothing more than roughly cut out scenery flats."[307]

The orientation of these trompe-l'oeil statues toward the avenue des Champs-Elysées emphasizes the rhetorical importance of the avenue in the funeral program. Because seating at the esplanade des Invalides was by ticket only, most Parisians would view Napoléon's cortege along the trajectory from the Etoile to the place de la Concorde (fig. 225).[308] The iconography of this impromptu parade ground was fixed by the triumphal arch and its colossal silhouette of the Emperor, and the decorations installed along the avenue shared that imagery: plaster statues of winged Victories, smoking urns upon pedestals constructed of wood and canvas painted to look like marble, and flag-draped columns capped by imperial eagles established an alternating rhythm of retrospective imperial

classicism.[309] Among these vaguely allegorical objects, the only explicit reminders of Napoléon's military reputation were the small plaques affixed to each column and inscribed with the name and date of a major victory. Thus, the decor framed the meaning of the funeral as the nation's homage to a former ruler and was quite unlike Napoleonic imagery at Versailles which, as we have seen, accorded all the honor to the general. Amidst the heated political and militarist passions of 1840, however, the government prudently elected to minimize Napoléon's military career, thereby avoiding unseemly comparisons with Louis-Philippe's renewed pacifism.

If the decorations of the Champs-Elysées only obliquely suggested the idea that France was honoring a returning dignitary more than the charismatic figure of a world conqueror, the message became explicit at the esplanade des Invalides. This was the ceremony's most important locale, and the grandstands erected along both sides of the parade route were reserved for those with great reputations, powerful connections, or both.[310] The endpoints of the site's longitudinal axis were anchored by decorative elements seen previously at the Champs-Elysées: painted canvas and black crepe transformed the main portal of the Invalides into a funereal triumphal arch, while a colossal statue of the Emperor (executed in plaster painted to resemble bronze) faced the Invalides from near the Seine (fig. 226).[311] An alley between these two markers was formed by thirty-two large plaster statues alternating with fire-pots, all installed upon gold-painted pedestals. The effect was completed by sixty masts ranged along the height of the grandstands, each trailing a long tricolored banner.[312]

The iconographic point, however, is that the statues represented a host of historic individuals, many of them anathemas to Bonapartism: Marshal Ney—supreme martyr of that cause—was joined by the Napoleonic generals Jourdan, Macdonald, and Mortier, but also by royalist heroes like François Ier, Jeanne-d'Arc, Henri IV, and Louis XIV.[313] The effect, as recorded in a sketch of the site, was to welcome the Emperor at his final resting place with a group of France's greatest military and civilian leaders (fig. 227).[314] Thus, the imagery implied that Napoléon was honored less for his specific achievements than because he too had once led the nation: once again, the Emperor was firmly fixed *in* history, not *above* it. Small wonder that Bourbon partisans preferred to watch the cortege from their posh *hôtels* on the Champs-Elysées rather than at the Invalides, where colossal statues of aristocratic heroes hailed the return of Bonaparte, the great usurper.[315] To insult legitimists was not the point, of course, but a nuance of meaning betwixt and between the political poles of Bonapartism and the claims of Ancien Régime privilege had indeed informed the July Monarchy's choice of imagery at the Invalides.

Inside the church, an enormous catafalque was constructed to receive the Emperor's coffin temporarily (fig. 228).[316] A traditional baldachino in classical guise, it included a false coffin, numerous eagles, allegorical figures, and a host of neo-Imperial motifs.[317] Like its counterparts, this conglomeration of wood, papier-mâché, and canvas was finished just in the nick of time.[318] The spectators seated in the Invalides—many of whom felt that "no one was thinking of the Emperor's memory"[319]—were drawn from the elite of interested society: the court, deputies, peers, high government officials, and "a few charming faces too well-known for one to doubt the kind of patronage which had gotten them in."[320] This august company of July Monarchy dignitaries witnessed Joinville's presentation of the

coffin to his father and Louis-Philippe's acceptance of Napoléon's corpse "in the name of France."[321] This transferral—terminus of the cortege and the point where the Orléans dynasty took credit for Napoléon's repatriation—was the culminating propagandistic gesture of the day. A mass with Mozart's *Requiem* closed the ceremony and the crowds dispersed quietly without incident.[322]

Many people were unhappy with the character of the government's preparations to welcome Napoléon. Even Joinville noted with some disdain that the ceremonies on Saint-Helena "had taken place with chivalrous gravity and dignity," whereas "in France, the transferral of Napoléon's remains took on a different character. It was above all a spectacle in which—as always happens with us Frenchmen—some people wanted to play an inappropriate, sometimes ridiculous, part."[323] Joinville was also struck by the contrast between the sublime enthusiasm of the crowds and the cheap decor provided by the government; Hugo quoted him as saying that "in this affair everything which comes from the people is grand; everything from the government is petty."[324] Later, Hugo offered an analysis of the day which is of special interest for us:

> It is undeniable that this entire ceremony had the conspicuous quality of sleight-of-hand [*escamotage*]. The government seemed to be afraid of the phantom it was conjuring up. They seemed to display and hide Napoléon at the same time. Everything which would have been too grand or too moving was obscured. The real and the imposing were concealed under wraps more or less splendid: the Imperial cortege was conjured away with a military parade; the army was conjured away with the National Guard; the Chambers were conjured away within the church of the Invalides; the coffin was conjured away with a cenotaph.[325]

To be sure, Hugo spoke from a strong personal commitment to the memory of Napoléon, but nothing we have seen in the ceremony would contradict his analysis. While the Emperor's great military victories were named, the style and iconography of the decorations were exclusively classic (or neo-Imperial) and lacked any references to the most potent Napoleonic imagery—the emblems of the legend and the petit caporal.

The singular lack of truly popular Napoleonic emblems at this important celebration can only be explained by reference to the government's fear of inflaming an already ardent public militarism beyond a tolerable (and controllable) limit. A letter written on 18 December by François Guizot, the moving force of Louis-Philippe's new cabinet, frankly admits that the inner circles of power had been expecting trouble during Napoléon's return: "The spectacle on Tuesday was fine. It was a pure spectacle. Our adversaries had counted upon two things: an uprising against me and a demonstration of war fever. Both schemes fell through. Everything was confined to a few cries clearly prearranged and not at all contagious. Their disappointment was profound because preparations had been very active."[326] With a pragmatic sense of political expediency, those planning the ceremonies and decorations of the funeral procession selected an anodyne imperial imagery which—as Guizot noted with relief—successfully transformed the *retour des cendres* into a "pure spectacle."

We have emphasized that none of the government's decorations for the ceremony of 15 December were made to last more than a few weeks. If the *retour des cendres* really had been thought to offer a lasting luster to the reputation of the Orléans dynasty, we might

expect Louis-Philippe—always eager to enhance the image of his reign in the galleries of Versailles—to have commissioned pictures to commemorate the day. In fact, two major commissions were awarded on 21 December: *The "Belle Poule" at Saint-Helena* to Théodore Gudin and *The Reception of Napoléon at the Invalides* to Horace Vernet.[327] From the perspective provided by our analysis, Louis-Philippe's selection of these two subjects is perfectly comprehensible, for they would do no more than document the role of the Orléans dynasty in effecting the Emperor's return.[328] While the need for a permanent and public resting place for Napoléon meant that the monument which now stands under the Invalides dome had to be completed, no such constraint obliged the king to commemorate the *retour des cendres* at Versailles. The fact that neither of the large pictures commissioned from Gudin and Vernet was completed leads us to believe that Louis-Philippe changed his mind about the need—or the desirability—of presenting the Emperor's return as a major achievement of his reign. Indeed, we shall see that the pictures which recall the funeral tend to treat it as a news item of passing interest rather than as a special moment in contemporary French history.

Less than three months separated Napoléon's return to France and the opening of the Salon, so that only a few small pictures of the December funeral were in the exhibition of 1841. The painting done by Pharamond Blanchard for Jacques Laffitte characterizes the modest aspirations of such works (fig. 229).[329] Laffitte probably wanted little more than a visual reminder of the passage of Napoléon's funerary flotilla near his château at Maisons, and Blanchard may have sketched this picture on the spot, since his image tallies with Joinville's description of the boat used for the journey from Rouen to Courbevoie.[330] We sense, however, that the directness of Blanchard's journalistic vision has been softened somewhat by a "romantic" interpretation in which the smoke and sparks billow dramatically from the ship's funnel, the paddlewheels generate an active mist of spray and steam, and an enormous tricolor emblazoned with a single *N* snaps crisply in the cold winter air. As a result, accuracy mixes with a dramatic solemnity to yield a thoroughly charming bit of pictorial reportage.

Louis-Philippe purchased from the 1841 Salon three pictures like the Blanchard which documented stages of Napoléon's journey from Saint-Helena to the Invalides. A small work by Auguste Mayer (apparently lost) represented the departure from Jamestown, when Napoléon's coffin was loaded onto Joinville's ship for the trip back to France.[331] A note in the Salon *livret* that the Mayer was "made from a sketch done on the spot by M. Chedeville" claimed for the picture an eyewitness pedigree and a high order of journalistic truth. We might speculate that the Crown bought this small canvas more for its documentary value than for its aesthetic merit.

The second painting acquired by the king in 1841 was Louis Morel-Fatio's *Transfer of the Remains of Emperor Napoléon at Cherbourg* (fig. 230).[332] This picture records the transfer on 10 December of Napoléon's coffin from the *Belle Poule* to the steamship *Normandie* for the journey to Rouen. Sailors carry the precious cargo across a gangplank between the two ships, with Joinville following behind. On the quai, troops ranged at attention lend a martial solemnity to the proceedings, while curious civilians crowd the boats in the foreground to complete the scene with a bit of spontaneous enthusiasm. Unlike the "romantic" expressiveness of Blanchard's picture, Morel-Fatio's hard and seemingly

airless style describes the event with an empirical crispness perfectly suited to the journalistic enterprise of his image. Morel-Fatio had previously published a very similar lithograph of the transferral at Cherbourg which was advertised as made from life (*d'après nature*): Louis-Philippe's acquisition of the painted version again suggests a desire to document the event at Versailles with a minimum of poetic coloration.[333]

Finally, Jacques Guiaud's 1841 canvas of the *Transferral of the Remains of Emperor Napoléon* offers a view of Paris on 15 December just after the funeral wagon entered the place de la Concorde (fig. 231).[334] While Guiaud rather negligently portrayed the crowd which reportedly overflowed the square on that day, one is inclined to agree with the *Journal des Beaux-Arts* that "the background is enriched by the sight of the buildings of the Navy headquarters and the national furniture storehouse, the obelisk, the fountains, the lightposts."[335] Indeed, Guiaud's precise rendering of these architectural elements—including the Madeleine church visible between the two principal facades—may explain why this modest canvas caught the king's eye. The moment represented here is relatively banal, but the picture situates Napoléon's funeral carriage in a landscape filled with testaments to the munificence of the July Monarchy: the fountains, other improvements to the square, and the facade of the Madeleine were all recently completed public works of Louis-Philippe's reign, while the obelisk—a gift to France from none other than Méhémet-Ali—had been ceremoniously erected by the government in 1836.[336] Whether seen as the record of a specific pageant organized by the government or as a catalogue of benefits bestowed by Orléans largess, Guiaud's canvas could not fail to flatter its royal owner.

If the three pictures of Napoléon's funeral bought by Louis-Philippe in 1841 seem to fulfill a prosaic documentary function not unlike popular prints, the same cannot be said for the painting he acquired at the following Salon: *The 15th of October 1840* by Eugène Isabey (fig. 232).[337] Isabey depicted the loading of the Emperor's coffin aboard the *Belle Poule* at Saint-Helena, but, quite unlike Morel-Fatio's clear-eyed, rationalist vision of its unloading at Cherbourg, his willfully truncated picture yields a murky, suggestive image. The rather large canvas is marked and measured by the crisscrossing forms of masts, riggings, and oars held at attention—a linear grid which locates and locks the suspended, crepe-draped coffin at the center of the image. Isabey's austere compositional geometry provides a taut two-dimensionality which compensates for the brusque croppings of the frame and obviates the need for a coherently articulated three-dimensional space. The cannonade salute offered to Napoléon by the *Belle Poule* justified clouds of thick smoke which obliterate the background vistas and neutralize any logical spatial development, and synecdochic partial views—of the ship at the right and Saint-Helena's rocky cliffs at the left—suggest a larger world without puncturing the cul-de-sac which enshrines the suspended coffin. Isabey's willfully controlled, non-Euclidean picture stills the potential for movement to present the great man's relics as a mysterious, quasi-religious icon.

Salon critics immediately sensed the reverence and dignity of Isabey's painting. Anatole Dauvergne described it for the readers of *L'Art en Province* as "noble and unpretentious, restrained and solemn. When passing before this canvas you stop in spite of yourself, you give in to it; you want to take off your hat. This coffin . . . suddenly engrosses your mind and eye; it commands respect; it makes you think!"[338] Alphonse Karr—usually a flippant Salon observer—called the Isabey "a splendid and noble composition full of mourning and

solemnity," and the Fourierist journal *La Phalange* claimed that, among all the pictures at the Salon, "the work of M. Isabey is surely the most deeply imprinted by feelings of lofty veneration and immortality."[339] A further measure of the work's high seriousness is the fact that some critics raised familiar questions about how to classify it: "A historical scene rather than a seascape," observed Louis Peisse, "its effect is grave, solemn, and religious."[340]

If, as suggested above, Louis-Philippe intended to minimize official commemoration of the *retour des cendres*, we might wonder why he purchased Isabey's picture, especially because its solemn simplicity was frequently contrasted in the press to the raucous pomp of the ceremonies orchestrated in Paris. "It is precisely the religious feeling which seizes the mind," wrote Wilhelm Tenint, who went on to note that "neither the gilded wagon, nor the arches of triumph, nor the tripods with green flames had had this poetic and gripping grandeur. . . . It is pervaded by a harmony of sadness, by an overall conception—at once pleasant and melancholic—which the ceremonies and pomp of triumphal funerals do not have."[341] There are at least two plausible explanations for why Louis-Philippe acquired the Isabey. The first is that the work's mix of sentiment and solemnity accorded well with the memories brought back from Saint-Helena by the prince de Joinville.[342] We know that he was distressed by the theatricality which greeted him and his cargo in France but was proud of the way his men had conducted themselves at Saint-Helena. Joinville, who is a principal figure in Isabey's painting, may have encouraged his father to acquire this picture which so clearly embodied the expression he felt appropriate to the occasion. Second, we must remember that the Isabey was not a commissioned work: following its triumph at the Salon, for Louis-Philippe to ignore it would have implicitly repudiated the whole process of Napoléon's repatriation, especially since the commission originally awarded to Gudin for the same subject had already been cancelled.[343] We have seen that a recurring strategy of Louis-Philippe's official art was to use popular and familiar imagery to shape history without seeming to do so, and the Isabey acquisition was no exception. When *The 15th of October 1840* became the keystone image of the historical storyline at Versailles, any differences between the Crown's private motives and official explanation for sponsoring the *retour des cendres* were blurred by the mediating power of the picture's preexisting public reputation.

Our discussion of Isabey's painting brings us back to the question of Louis-Philippe's role in the return of Napoléon to Paris. We have pursued a detailed analysis of this spectacle in order to demonstrate that the king's personal motives did not always coincide with those of his advisers, and that the *retour des cendres* need not be construed as marking a change in Louis-Philippe's concern to preserve his authority before the specter of Napoléon. Modern writers miss the mark with sweeping generalizations that the Emperor's memory "was revived during the July Monarchy in Louis-Philippe's glorification of Napoléon's military triumphs and the return of his ashes in 1840," or that "the most important move in the direction to gain the support of the Bonapartists . . . was the return of Napoléon's ashes."[344] In fact, the impetus to repatriate Napoléon originated with the politicking of Thiers, and its celebration was modified by an evolution of political events in which the king's peace-keeping priorities triumphed over the war-prone belligerence of the Thiers cabinet. Thus, the anesthetized iconography for the ceremony developed by the government after Thiers'

resignation is perfectly compatible with the equally circumspect imagery of Napoléon patronized by Louis-Philippe throughout the 1830s for the galleries of Versailles.

Nevertheless, a fundamental question remains: why did Louis-Philippe approve Thiers' plan to repatriate the Emperor? In the midst of the public élan following Rémusat's announcement of 12 May, and in response to the Austrian ambassador's skepticism, the king defended his assent by explaining that "sooner or later it would have been wrested by petitions. I preferred to grant it as a favor."[345] This response, although perfectly pragmatic, seems too pat to justify the politically and symbolically complex act of returning Napoléon to France. In our last section we learned that the king managed his images of Napoléon to minimize the positive emotions generated by sentimental or tragic portrayals of the Emperor as a type of romantic genius: could Louis-Philippe have harbored a related, more secret reason for agreeing to the *retour des cendres*?

Contemporary poets and writers believed in such a covert motive. We know that Victor Hugo found the ceremonies to be a premeditated sleight-of-hand, and he added that "the government's lack of organization had been extreme . . . it was in a hurry to be done with it."[346] Alphonse Karr, on the other hand, criticized the whole idea of Napoléon's repatriation on poetic grounds:

> As a poet and philosopher, I liked to imagine the tomb of Napoléon on Saint-Helena; this solitary tomb upon a rock beaten by the wind and sea had a grandeur that we will be unable to give it in Paris. All poetry is a regret or a desire: remorse over this exile after death and pity for a man of such great destiny mingled something of tenderness and affection with his memory. Napoléon on Saint-Helena was as far from us and as deified as if he had been in heaven.[347]

And, not surprisingly, the same sentiments echo through the lines penned by Chateaubriand after the ceremony of December 1840: "Deprived of his catafalque of rocks, Napoléon has come to bury himself in the refuse of Paris. In place of the ships which saluted the new Hercules consumed on Mount Oeta, the laundresses of Vaugirard will prowl about with the wounded nobodies of the Great Army. . . . Come what may, one will always imagine the real sepulcher of the conqueror to be amidst the high seas: to us the body, to Saint-Helena the eternal life."[348] Cognizant of the possibility that we may be stretching our evidence, might we ask whether Louis-Philippe *also* believed that to bring home the Emperor would break, once and for all, the magic spell of his memory? The political and diplomatic context in which the return was celebrated prompted Heine to remark: "The Emperor is dead. With him died the last of the old-style heroes, and the new world of the philistines draws a long breath, as if delivered from a glaring nightmare."[349] Heine's comment might be taken as a fortuitous prologue to Guizot's own sigh of relief after the funeral: "The general difficulties of the government, vast and always the same, continue to exist. The threatening incidents have been cleared up. Méhémet-Ali remains in Egypt and Napoléon is at the Invalides."[350] On 15 December 1840 the nationalistic enthusiasms so much a part of Napoléon's legend had not stirred, and future generations of the Emperor's zealots were doomed to contemplate his bones without poetic flights of the imagination; from that day forward, the pilgrimage was banalized and would require no more than a simple walk across town.

Obviously, if this interpretation of Louis-Philippe's rationale for agreeing to Thiers' scheme is correct, then the *retour des cendres* should be the closing act of the king's courtship with the Napoleonic legend. Archival records of the July Monarchy do in fact demonstrate that after 1840 not a single new commission was awarded by Louis-Philippe for an image of Napoléon. Apart from the four pictures of the funeral discussed above, final payments for commissions predating December 1840, and two inexpensive purchases at the Salon of 1843, the great flood of official Napoleonic images—acquisitions which had filled the ledgers of the 1830s—came to an abrupt end.[351] "The Soult cabinet had to make good the promise of the Thiers cabinet," wrote Alphonse Karr about the funeral of 15 December; "this had exactly the air, in fact, of something which one discharges. One wanted to be done with the Emperor."[352] Indeed, the political policies and the patterns of patronage adopted by the Crown after December 1840 suggest that Louis-Philippe, without subscribing to Karr's sarcasm, would willingly have agreed with his conclusion.

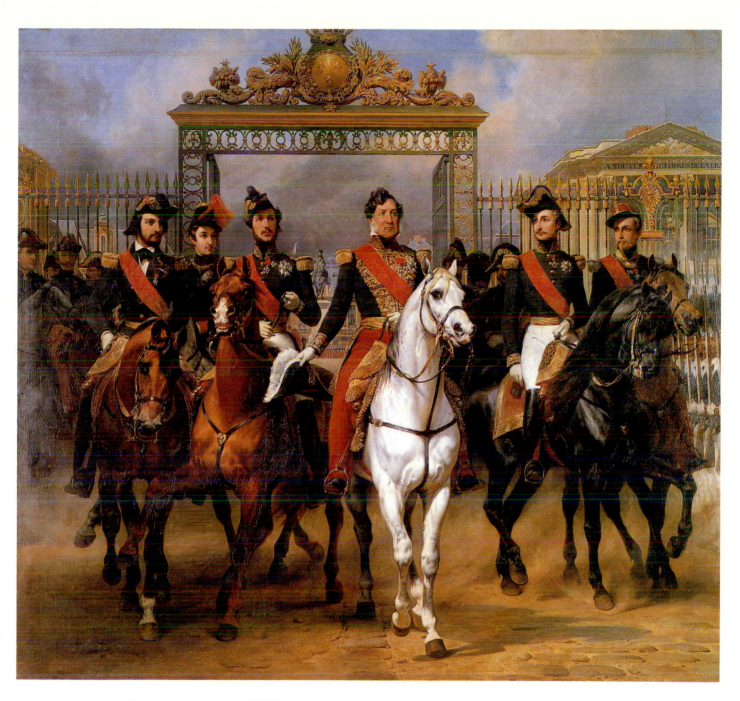

Plate 1. Horace Vernet: *Louis-Philippe and His Sons Riding Out from the Château of Versailles*, Salon of 1847. Versailles, Musée National du Château.

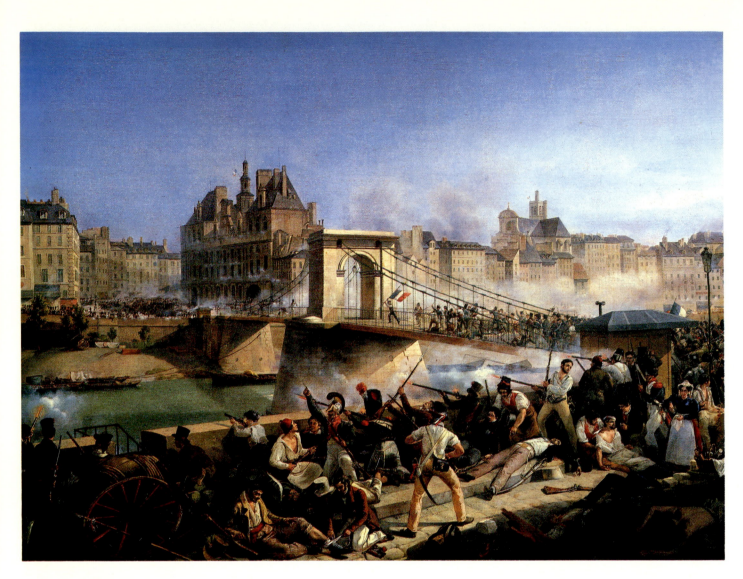

Plate 2. Amédée Bourgeois: *Capture of the Hôtel-de-Ville*, Salon of 1831. Versailles, Musée National du Château.

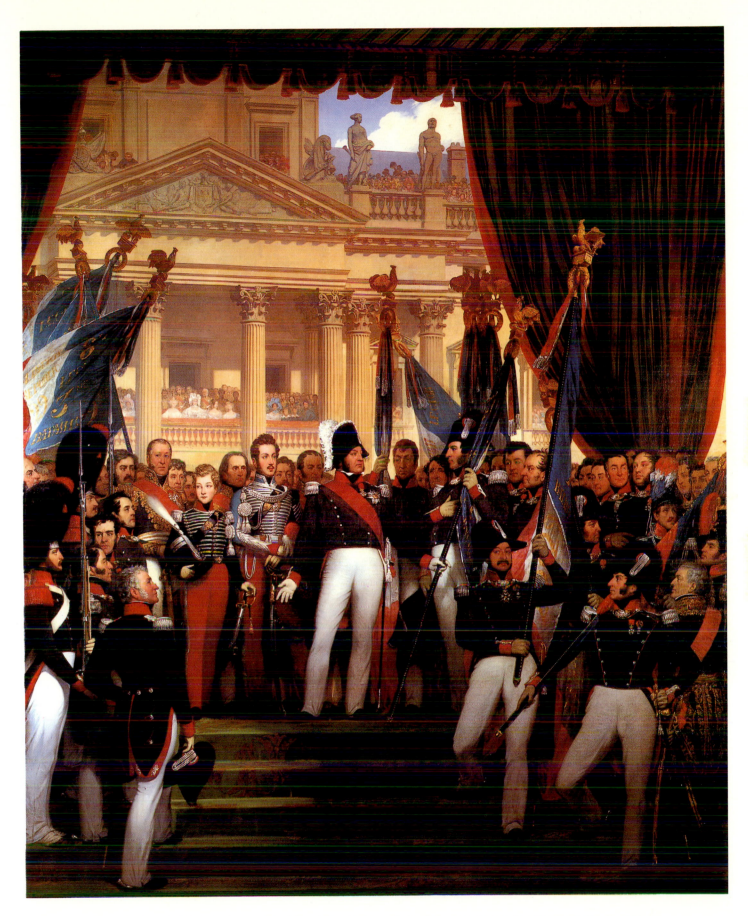

Plate 3. Joseph-Désiré Court: *The King Distributing Battalion Standards to the National Guard, 29 August 1830,* Salon of 1836. Versailles, Musée National du Château.

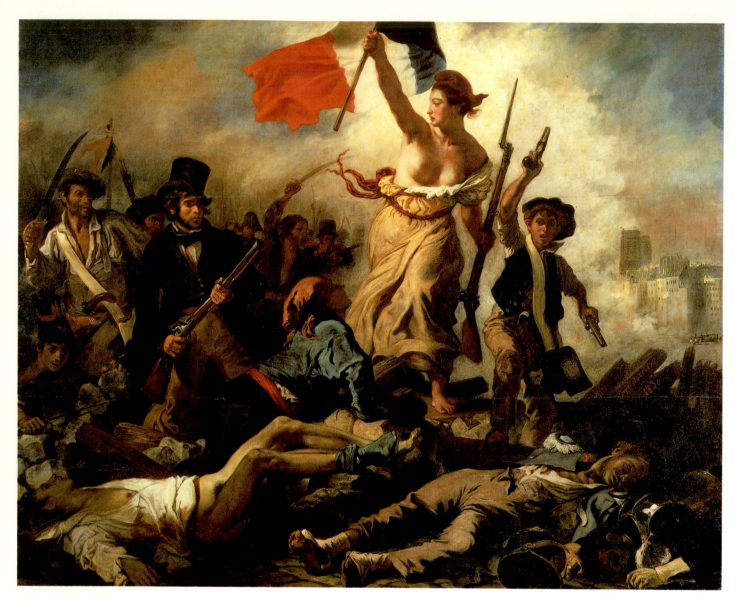

Plate 4. Eugène Delacroix: *The 28th of July: Liberty Leading the People,* Salon of 1831. Paris, Musée du Louvre.

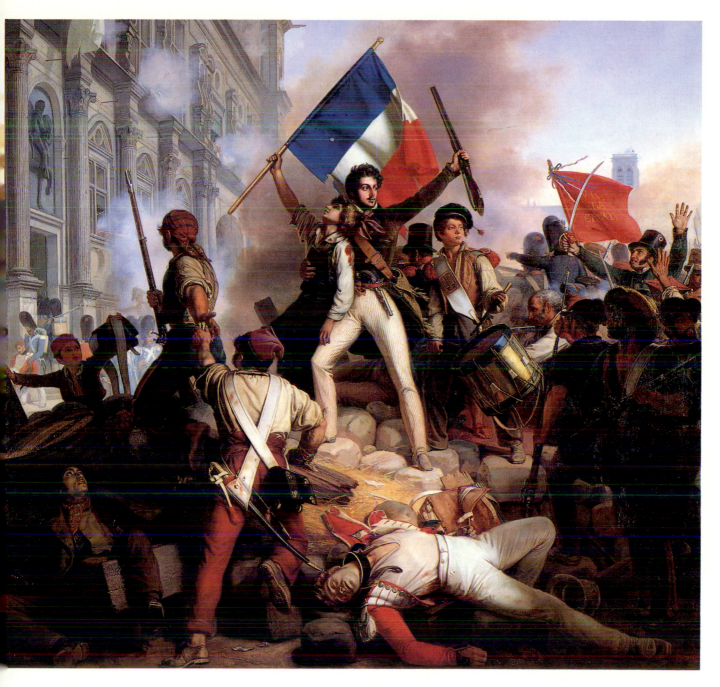

Plate 5. Jean-Victor Schnetz: *The Fight for the Hôtel-de-Ville, 28 July 1830,* Salon of 1834. Paris, Musée du Petit Palais.

Plate 6. Léon Cogniet: *The Parisian National Guard Leaves for the Front in September 1792*, Salon of 1836. Versailles, Musée National du Château.

Plate 7. Auguste Couder: *The Oath of the Tennis Court,* Salon of 1848. Versailles, Musée National du Château.

Plate 8. Horace Vernet: *The Battle of Friedland,* Salon of 1836. Versailles, Musée National du Château.

Two Revolutions in View: Historical Conditions of a Style Louis-Philippe

1. OFFICIAL ICONOGRAPHY AND THE POLITICAL CLIMATE OF 1847

IN THE FALL OF 1830, an English caricaturist produced a print entitled *The Awfull Dream* which summarized the political situation in France after the July Revolution (fig. 233).[1] He portrayed Louis-Philippe in the throes of a nightmare, unable to prevent the crown and scepter of authority from eluding his grasp. An ogre-like figure of Discord brandishing a torch emerges from under the bed and tugs at the sheets to disturb the king's slumber. Charles X and a group of Jesuits from the château of Holyrood—over which flutters the Bourbons' flag—have gathered near Louis-Philippe's headboard and grasp at the elusive crown. Other figures all around compete for control of the emblems of power: at the center, young Henri V, held by Chateaubriand and bathed in the glow of *legitimacy*, reaches for the crown; to the left, the duc de Reichstadt (Napoléon II) seems ready to grasp the scepter, and he points to the cloud-borne image of his illustrious father (in the guise of the *petit caporal*) to justify his deed; at the far left, an *homme du peuple*, who wields an axe and a flag emblazoned *Liberté ou la Mort*, seems ready to charge across a barricade (or perhaps the frontier) in search of new conquests for the principles of the Great Revolution. This half-serious image of late 1830 demonstrates that even foreigners believed the newly established Orléans dynasty would face stiff opposition from three competing political factions: legitimists, Bonapartists, and republicans. Indeed, throughout the eighteen years of Louis-Philippe's reign this triumvirate of political opposition continued to harass Orléans authority with a tenacity fueled less by the king's ineptitude than by two inescapable facts: his throne had been erected on the rubble of an antimonarchic revolution, and his constituency harbored strong sentimental attachments to the political legacies of the Great Revolution and the Empire. In short, Louis-Philippe's problems were existential, not experimental.[2]

Our investigation has shown that Louis-Philippe also understood this situation, and he worked to subdue these rival factions by appropriating and neutralizing their imagery during the 1830s and 1840s. Perhaps his attempt to reshape public opinion through the arts

was doomed to fail from the outset; that it *had* failed can be shown by an examination of four works produced in 1847, just months before an exasperated public dumped the monarchy itself. In these works we rediscover the political forces illustrated by *The Awfull Dream* in 1830 and uncover the seeds of the revolution which would oblige Louis-Philippe to flee France in February 1848.

Hippolyte Flandrin exhibited at the 1847 Salon a large picture of *Napoléon as Lawgiver* which had been commissioned for a conference room in the old Palais d'Orsay.[3] Flandrin's original was destroyed when the Palais was burned by the Commune in 1871, but a replica—executed in 1853 by an artist named Guillaume and only recently identified—can serve to illustrate our discussion (fig. 234).[4] Guillaume's copy reveals that Flandrin had endowed Napoléon with a rather fierce monumentality: the Emperor, dressed in his imperial robes and crowned with a laurel wreath, stands close to the picture plane upon a massive stone throne and displays a volume labeled CODE. "In what world does this take place?" asked Théophile Gautier before this picture. "Is it on Saturn or Mercury? It is certainly not on our sublunary globe. This is the point to which a man of talent can be lead astray by the extreme consequences of dogmatic thinking."[5]

Few of Gautier's readers would have missed the sense of his allusion to dogmatism, for the design of Flandrin's stern, iconic representation of Napoléon was immediately understood as owing a debt to the portrait executed in 1806 by Flandrin's mentor, Jean-Auguste-Dominique Ingres (fig. 235).[6] Like Ingres before him, Flandrin portrayed Napoléon as an imperious, disembodied presence—an impression which prompted Gustave Planche to remark that "there is not the thickness of a hand between the chest and backbone."[7] Everyone recognized that Flandrin had invested Napoleonic imagery with the neo-Byzantine schema of compressed spaces, immobile poses, and hieratic compositional structures of his recently completed murals in the choir of Saint-Germain-des-Prés.[8] In one sense, then, Flandrin's *Napoléon as Lawgiver* can be understood as a rather inventive image, especially since the commission had specified neither the subject nor its elaboration. Flandrin had dared to posit a new representation of Napoléon, one which broke sharply with the pictorial formulas valorized by repeated usage.[9] I suggested previously that the imagery of the Napoleonic legend constituted a visual lexical system sufficiently fixed in form to carry complex (and sometimes contrary) meanings.[10] It seems logical that much of the critics' rancor toward the *Napoléon as Lawgiver* was directed against Flandrin's arbitrary reorientation of the legend's visual grammar—an antisocial breach of code most easily explained by invoking the legendary intransigence of his master.

Few observers at the 1847 Salon pressed their analyses beyond declamatory name-calling, but Paul Mantz clearly understood and articulated the experimental character of Flandrin's painting:

> M. Hippolyte Flandrin's *Napoléon as Lawgiver* is not, as one might think, the isolated and passing mistake of a talented artist: it is the mistake of an entire school. The disciples share the responsibility with their master on this point and, moreover, demonstrate it because they admire him. For this strange Napoléon, it would already be a grave question to ask whether the time has come to use symbolic rather than realist art forms for the popular hero's glorification. In your opinion, which is better: a Napoléon surrounded by the aureole of apotheosis, like this one by M. Flandrin; or

the Napoléon of history—human, personal, true? . . . Napoléon is a man; you have no right to tamper with that. Folklore has taken over this sovereign character and will preserve him in its living memory just as Charlet painted him and Béranger praised him in song. Do you think that their Napoléon has less *style* than M. Flandrin's? Everything is impossible in this peculiar picture. What is this throne, this pallid terrain, this purplish sky? In what region does the light fall like it does here, and what is the meaning of this inert statue? What should we think of a Napoléon that old soldiers do not recognize?[11]

It is immediately apparent that Flandrin's cerebral, allegorical Napoléon, against whom Mantz set the lively, anecdotal figure of the petit caporal, conforms exactly to the institutionalized and politically neutralized Emperor who had presided over the *retour des cendres*. This Napoléon—cold, inactive, and frozen in history—became the July Monarchy's official type after 1840. The hostile reception accorded Flandrin's picture suggests, however, that the ceremonies of 1840 had failed to work their magic: Napoléon continued to spark the nation's imagination with a vivacity which would be fully revealed in 1849, with the election of Louis-Napoléon Bonaparte as president of the Republic.[12]

More attuned to the accepted norms of Napoleonic imagery in 1847 was *The Awakening of Napoléon*, a monument executed by François Rude and inaugurated on 19 September of that year (fig. 236).[13] The sculpture, placed near Dijon on a high, wooded site overlooking the Jura Mountains, was commissioned by Claude Noisot, a fervently Bonapartist veteran who had accompanied Napoléon to the island of Elba in 1814. For an enthusiast like Noisot, no ordinary statue of Napoléon would suffice: the old soldier convinced Rude to renounce a first project for the sculpture (which statically displayed Napoléon like a medieval *gisant*) in favor of a dramatic, active representation of the Emperor rising from captivity and death toward the heavens and immortality.[14] Rude established this dynamic expression by situating a life-sized figure of Napoléon, whose physical mass is exaggerated by the shroud-like bivouac blanket, upon a base which seems altogether too small. The resulting shift in scale undermines the force of gravity to suggest that the hero's body is already airborne. The rough-hewn rocks and waves of the pedestal make direct reference to Napoléon's island prison, while Rude's juxtaposition of a dead eagle crashed on the rocks against the rising corpse implies that the Emperor's fame would continue to live even though the Empire was finished.

At first glance, the meaning of Rude's monument might appear even more arcane than Flandrin's *Napoléon as Lawgiver*. But, where Flandrin systematically eschewed popular Napoleonic iconography, Rude masterfully orchestrated it: Napoléon appears in the costume of the petit caporal (including the famous hat and Austerlitz sword modeled from the originals lent by General Marchand): the dead imperial eagle recalls the catastrophic defeat at Waterloo; and the small, rocky base evokes Victor Hugo's romantic crag clothed in the foam of crashing waves.[15] Finally, Rude's idea to depict Napoléon at the moment he attains immortality was well represented in the Napoleonic legend: Georgin's woodblock print (fig. 190) and the painting by Mauzaisse (fig. 191) are examples of existing configurations which would have insured the intelligibility of Rude's symbolism. It seems clear that *The Awakening of Napoléon* addressed viewers with a vocabulary more familiar and sympathetic than the icy immutability of Flandrin's bloodless icon, while the incom-

patibility of expression between the two works demonstrates that the alternative iconography adopted by the administration for the *retour des cendres* had not dislodged the established imagery and its cultural coding of romantic allure and effervescent enthusiasms. Rather, the government's endorsement of a surrogate vocabulary only served to alienate adherents of the Napoleonic legend over the explosive issue of how to pay homage to the Emperor and the nation's imperial past.

Further evidence of a breach in 1847 between the historical concerns of official imagery and the myths of popular culture can be detected with the help of a painting by François-Marius Granet, *A Mass during the Terror* (fig. 237).[16] Although quite old by this time, Granet had sustained his reputation with pictures of quiet, evocatively lighted views of monasteries, church interiors, and romantic ruins, and Louis-Philippe occasionally enlisted him to portray those events of contemporary history particularly suited to that inimitable style.[17] Granet altered his standard formula very little when painting *A Mass during the Terror*: a filtered, oblique light enters via a single window at the left and plays softly over objects and actors. The scene unfolds around a makeshift altar hidden under the mansards of the Louvre, and our expectations concerning the political allegiances of these clandestine Catholics of 1793 are corroborated by the portrait of Louis XVI prominently propped against the back wall.[18] Granet juxtaposed this royal effigy to an embodiment of revolutionary radicalism, for a group of armed men wearing red Phrygian caps has just appeared at the top of the stairs. None of the faithful, except for the single highlighted face at the far right who nervously eyes the door, seem to notice the sans-culottes about to disrupt the service and arrest them all. We suspect that the simple faith of these worshippers will sustain them through this indignity, even as we realize that religious and political persecution—including the specter of the guillotine—lie beneath the tranquil surface of Granet's homage to improvised piety.

Several pictures discussed in part III of our study represented the tragedy and horror of the Terror in even more graphic terms than this Granet: *An Episode of 1793 at Nantes* (fig. 157) by DeBay and Verdier's *Mlle de Sombreuil* (fig. 158) were two outstanding examples. Compared to such works, Granet's image is quite tame, but this obvious point only obscures the broader significance of his picture. More pertinent is the fact that Granet broached such a subject at all, and that he did so in 1847. Although the old painter (who died two years later) had lived through the Terror, he was far from revolutionary, and he left Paris for the peace and safety of his native Aix-en-Provence when the 1848 Revolution threw the capital into a state of turmoil.[19] Nor, for that matter, could we call the style and subject of *A Mass during the Terror* anything but conservative.

When Granet executed his major composition inspired by the annals of the Terror, he was indexing the renewed interest in revolutionary history which occurred in France at just this time. Three major literary works about the French Revolution were published in 1847: the first volumes of Jules Michelet's *Histoire de la Révolution française*; the nearly contemporary first volume of Louis Blanc's history with the same title, and Alphonse de Lamartine's complete, eight-volume *Histoire des Girondins*.[20] Lamartine especially enjoyed an immense success, partly in admiration of his virtuoso productivity, and partly because his text was written like an historical novel which frequently digressed from fact to indulge in pure drama and intrigue.[21] The *Girondins* gathered such a large and immediate readership

that Lamartine exclaimed in a letter to a friend on 20 March—the day his first two volumes went on sale—that "the publisher wrote to me at midnight that such a success has *never* been seen in bookselling, that the book was creating a revolution, that it would surpass in a few months Thiers' twenty years of publicity."[22] The journal of Eugène Delacroix offers an incidental but useful record of the historical interests spawned by this spate of impassioned texts. In early 1847 the politically conservative Delacroix was frequently in the company of such left-wing politicians as Thiers, Vieillard, Marrast, and Rivet, and in April he lent a copy of Michelet's first volume to Vieillard.[23] Like so many others, Delacroix was attracted to read of revolution in 1847, but one year later he would flee in horror from the tumult of the February revolution and seek refuge amidst the quiet of his estate at Champrosay.[24]

Living in Paris during 1847, Granet could not have avoided a familiarity with the *Girondins* even if he never read it through, and he was probably motivated to paint his picture of the Terror by the same fascination with stories of the Great Revolution which had seduced Delacroix and his friends. Lamartine's text is rife with tragic stories of the Terror's victims, and it contains lurid descriptions of how priests were humiliated, shrines desecrated, and churches sacked by the extreme radicals of 1793.[25] These tales, which jump from the page with drama and verve, certainly would have impressed a pious, reflective spirit like Granet. The very existence of *A Mass during the Terror* (an eccentricity in Granet's total oeuvre) suggests that the historical reevaluation of the Great Revolution had moved to center stage just those aspects which were conspicuously absent from Louis-Philippe's carefully groomed and politically cleansed vision of it at Versailles. Once again, it seems that by 1847 an important sector of official imagery was dangerously out of step with French public opinion.

A fitting way to close our discussion of art and politics during the July Monarchy's last year of existence is to return to the equestrian portrait of *Louis-Philippe and His Sons Riding Out from the Château of Versailles* exhibited by Vernet at the 1847 Salon (fig. 17). This work, described in part I as an optimistic and wishful vision of the Orléans dynasty's future, looks even more anachronistic now that we understand its immediate context and the official imagery which had come before. After years of pictorial programs consciously designed to situate Louis-Philippe and his heirs in the tradition of liberal politics founded in 1789, Vernet's stark image of an old-fashioned dynasty—complete with fleurs-de-lys and Louis XIV in the background—is indeed a surprise. For the first time since the 1830 Revolution, a portrait of Louis-Philippe dispensed with evoking the barricades, the Hôtel-de-Ville, the Charter, and the king's oath before the Chamber of Deputies. Louis-Philippe's dominant place in Vernet's portrait is supported by the emblems and effigy of the Ancien Régime, the splendor of the Sun King's palace, and a host of legitimate heirs. The tragedy of this image— if I might be allowed to use that word—lies in its misguided belief that retreating into the formulas and icons of the past would permit Louis-Philippe to weather the stormy present and uncertain future. Not so surprising is the fact that the picture's rhetorical strategy found expression in the political sphere: witness the king's refusal to consider electoral reform and his increased dependence upon the political counsel of arch-conservative François Guizot. Meanwhile, a revolution—perhaps unseen, certainly unacknowledged—festered on the frustration and discontent generated by Louis-Philippe's intractability.[26]

There is, finally, an epilogue to the tale of Vernet's portrait. If we remember that

Frédéric Nepveu, the architect at Versailles, had been rebuked in 1834 for proposing that the Salle de 1830 recount the most important events of Louis-Philippe's life, we can imagine his reaction to the announcement in February 1848 that the king's biography would soon be illustrated with a cycle of sixty pictures.[27] Such a project was clearly the next step in defining the dynastic basis of Orléans rule after its first bold affirmation with Vernet's equestrian portrait. The project died less than one week later, when the people's victory of 24 February put an end to the monarchy itself, but its short life incontestably demonstrates that Louis-Philippe was embarking upon a major reorientation of official imagery during the twilight days of his reign. The pictorial programs which we have traced broke new ground in their attempts to shape the story of post-1789 France into historical support for the monarchy of 1830. By 1847, the old and ever more rigid Roi des Français—profoundly worried about passing the crown to a young boy—doubtless felt the need to affirm his family's claim to the throne in a more absolute manner. Predictably, he turned to the cult of personalities, bloodlines, and inherited privilege which kings had used for centuries. The paradox is that the innovative official imagery sponsored by Louis-Philippe since 1830 had sapped the strength of that traditional iconography: the 1848 Revolution proved dramatically that a dynasty molded in the old style could no longer command the nation's respect.

2. *THE* JUSTE-MILIEU *AND THE HISTORY OF ART*

We have closed the circle of discourse proposed at the outset of our study and arrived at the point where we must attempt to locate the official commissions of the July Monarchy within the history of nineteenth-century painting. It will be useful to begin by surveying the terrain as it has been mapped by predecessors. Two overlapping historical evaluations occupy the intellectual arena: recent scholarship claims that this art was so open-ended in its ambition as to be chronically impotent; older studies tend to see it as denatured and creatively stillborn, an artistic dead end.[28] We will discuss each of these viewpoints in turn.

The first position argues that an intellectual symmetry exists among the so-called *juste-milieu* political policies of Louis-Philippe's government, Eclectic philosophy as articulated by Victor Cousin, and a compromise manner of painting which sought a "middle ground"—in both style and subject-matter—between the Romantics and the Classicists.[29] The linchpin of this analysis is Cousin, who, it is claimed, "mesmerized a generation of students who came of age during the July Monarchy and went on in turn to teach eclecticism or adapt its theoretical model for every phase of their activity."[30] Such a culture, where the processes of compromise and synthesis reign supreme, will ostensibly produce an "official art" concerned with little more than forging a vague political consensus.[31] Furthermore, the argument rests upon the imprecise (and essentially untranslatable) notion of *Zeitgeist*, a conceptual and critical framework which inevitably describes Versailles as an "eclectic fantasy" simply because Louis-Philippe dedicated it "to all the glories of France."[32] This evaluation necessarily minimizes the museum's cultural function: our steps through the galleries have shown that Louis-Philippe's propagandistic concerns at Versailles were not merely expressions of a culturally informed synthetic vision but were, on the contrary, politically self-serving programs manipulating a precisely focused, astutely selective historicism.

One can test the theory that *juste-milieu*, "eclectic," and "official" are interchangeable aesthetic terms by locating a picture which fulfills the theoretical conditions and then asking if it compares favorably with what we know of official art produced during Louis-Philippe's reign. The perfect vehicle for such a comparative analysis is Thomas Couture's unfinished picture of *The Voluntary Enlistments of 1792* (fig. 238), a painting which has been described as a "vast eclectic synthesis embracing the Revolution of 1789 with that of 1848 and symbolically linking all social classes, tradition and modernity, classicism and romanticism, the real and the ideal."[33] Couture merged a prodigious range of pictorial sources—including Géricault and Ingres, Greuze and David, Rubens and Poussin, classical antiquity and contemporary life studies—into an image which duly merits the label "eclectic." Modern-day workers and flying allegorical figures are strung across the canvas in a shallow, relief-like space and linked together with the rather conventional artifice of a single, large triangle. The picture does indeed strike the viewer as "a hybrid machine in which ideality and reality run counter to each other," and we might reasonably wonder just what it is that we see: where, when, and how could such a scene take place?[34]

Those questions need not concern us here. Rather, let us ask if we have seen anything quite like Couture's amalgam in Louis-Philippe's commissions of the same subject: De-Bay's painting for the Palais-Royal or Cogniet's picture of *The Parisian National Guard Leaves for the Front in September 1792* in the more complex installation of the Salle de 1792 at Versailles (figs. 140, 143). Neither of these images incorporates broad allegorical meanings into the historical narrative although both, as we discovered, relate versions of the event especially attuned to the contemporary political situation. Our analysis in part III of the Versailles program revealed a high seriousness of purpose in which the gallery was systematically designed to fashion a vision of 1792 which would forget—if not forgive—prison massacres, civil unrest, and the abolition of the monarchy. To be sure, Couture's painting makes no more reference to these disturbing historical facts than either the Salle de 1792 or DeBay's picture, but Couture marshaled a standard allegorical grammar and a syntax of tried-and-true, Academically approved compositional schemes to invest his canvas with an upbeat nationalism. The Salle de 1792, on the contrary, never appears to be other than factual. We have argued that this willful shunning of a conventional pictorial language represents a break in the tradition of how art may be used to shape propagandistic meaning: in comparison to Couture's "cookbook" assemblage of received strategies, the Salle de 1792 (including the picture by Cogniet) appears to be a real innovation. We have also suggested that the stylistic characteristics of Cogniet's painting—its attractive cast of characters, its easy-to-read and nonhierarchical structure, and its wealth of discrete and charming episodes—were perfectly synchronized with the overall propagandistic purposes of the installation precisely because they masked its historical fiction with a seeming sincerity and everyday directness. This effect is so far removed from the rhetorical bombast of Couture's monumental canvas that to equate the two pictures defies common sense. Finally, the Salle de 1792 was an official project which Louis-Philippe followed with a close personal interest. The Couture—independently conceived in 1847 and not sponsored by the government until after the 1848 Revolution—can be said to "reflect the taste of the period for *grandes machines*, for large-scale, almost cosmic ideas" only if we ignore the most "official" art of the July Monarchy: the works commissioned by the king himself.[35]

This is not to deny that something resembling an "eclectic vision" existed in the 1830s and 1840s. Nor should we limit it to Couture, because other artists also entertained ambitions of achieving an intellectual synthesis in their work: on 1 May 1847, for example, Delacroix noted in his journal that he would like to make "for the stairway of the Luxembourg Palace some scenes of the Revolution and the Empire with allegorical characters: The Nation leading the Volunteers, Glory crowning Napoléon, etc."[36] Had Delacroix executed these projects, one imagines that they would have had more than a passing affinity with Couture's *Voluntary Enlistments*. I must once again emphasize, however, that Louis-Philippe was only marginally interested in such cosmic schemes; any historical explanation which links cultural manifestations of an eclectic vision, contemporary political issues, and official art must remain within the perimeter described by historical facts.

Even more important, the specific type of patronage must be investigated with care. When the Crown (*Maison du Roi*) acquired or commissioned a work of art, it was usually subject to the king's personal approval. The Fine Arts Division of the Interior Ministry, on the other hand, could and did operate independently of the Crown: we have seen that deputies occasionally pressured the government into purchasing pictures whose themes were, in effect, politically troublesome—witness the acquisition of Janet-Lange's *Abdication of Napoléon at Fontainebleau*, which was sent to Tours (fig. 214). We also know that the Interior Ministry had bought *The 28th of July* from Delacroix in 1831, even though the picture's politicized public reception did not enhance Louis-Philippe's precarious claim to the throne (fig. 87). Later, when the king finally decided to commemorate the July Revolution at Versailles, he spurned Delacroix's masterpiece in favor of a politically more tractable (and even more journalistic) sequence of images. Among these images acquired by the government, which relates the "official" version of the July Revolution? Since France was a monarchy between 1830 and 1848, I have elected to follow the king's lead wherever possible when searching for the "official" line. Our study of his preferred imagery has revealed a remarkably coherent aesthetic—quite unlike the grandiose, synthetic vision of Couture—which truly seems to merit the appellation "official."

A final pictorial example reinforces my reluctance to accept an overly simple linkage between the July Monarchy's official art and a zeitgeist of Eclecticism. Jean-Baptiste Mauzaisse exhibited a cryptically titled *Allegory* at the 1839 Salon which can be identified— thanks to the detailed sarcasm of certain critics—as the picture now rolled and stored in the reserves of Versailles under the title *Allegory of the History of King Louis-Philippe* (fig. 239).[37] If I were asked to specify a case where eclectic synthesis seems to have run out of control, this particular canvas would be a leading candidate, for it reads like an encyclopedia of borrowed ideas and plagiarized characters. The central figure of Louis-Philippe, his arm extended in a gesture of oath-taking, recalls the prominent public images of his oath: Devéria's at Versailles or the Coutan/Court in the Chamber of Deputies (figs. 77, 129). France, a rich cloak embroidered with gold fleurs-de-lys slipping from her shoulders (the symbol of rejecting the Bourbons in 1830), offers the crown to Louis-Philippe with an imploring gesture suspiciously akin to the Thetis of Ingres' famous picture.[38] The distant towers of Notre-Dame (at the left), the uniformed cadavers, and the barricade timbers (behind the king) conjure up memories of both the Parisian street battles in July 1830 and Delacroix's notorious painting (fig. 87). The little girl in the lower right who reaches toward

her dead mother evokes the pathos of civil war—and the sentimentality of *The Young Patriots* by Jeanron (fig. 50). To Louis-Philippe's right, a fluttering tricolor, old soldiers who kiss the banner fondly, and the Vendôme statue of the petit caporal allude to the republican and Bonapartist effusions which welcomed the cherished banner's return: how many images have we seen which address those sentiments! Allegorical figures in the lower left—a cloaked skeleton of Death, Discord with her snakes, a fork-tongued Deceit, and a blindfolded, knife-wielding figure of Hypocrisy—cower before the central grouping of Force, France, and Louis-Philippe. Finally, torch-bearing Furies flee from the scene at the upper right while Immortality appears in a clearing of the clouds above the king's head. As might be expected, these creatures of pure imagination invoke the same time-honored iconology used by Blondel and Picot in their allegories of the 1830 Revolution (figs. 62, 82).

Insofar as Mauzaisse combined elements culled from diverse pictorial traditions to represent the union of antagonistic political positions around Louis-Philippe, we might correctly describe the imagery of his picture as eclectic. The same term could apply to the work's ideology, for it is apparent that its iconography posits a reconciliation of just those political factions articulated by *The Awfull Dream* (fig. 233). We have seen that the principal themes of Louis-Philippe's pictorial programs were orchestrated to dispel the same nightmare. If the king had truly been searching to encode a grand thematic and stylistic synthesis with his official commissions, we would expect him to have acquired without hesitation this major painting so doggedly designed to achieve that end. What actually occurred was quite different: Louis-Philippe expressed no interest in the picture. The Interior Ministry eventually offered to buy the picture from Mauzaisse for six thousand francs, with plans to send the work to Bordeaux.[39] Mauzaisse felt the offer was too low, but he finally agreed to a price of eight thousand francs on 10 April 1840.[40] The tale does not end with this financial dickering, because the picture never reached Bordeaux: it was found in June 1860—still rolled and ready for shipment—in the warehouse of an expeditor on the rue Bonaparte.[41] Should we claim that the picture was terribly important to the king or to the bureaucrats of the Interior Ministry? After comparing the carefully conceived and lavishly funded programs at Versailles to the shabby treatment accorded this consummately eclectic Mauzaisse so pointedly favorable to the king, is it useful to believe that Louis-Philippe's principal concern was to establish an official art shaped by the philosophy of Eclecticism? The evidence suggests that we should respond in the negative to both of these questions.

Modern attempts to situate eclectic thought during the July Monarchy at the wellspring of French culture are designed to counteract the venerable and more disparaging art-historical evaluation of Léon Rosenthal.[42] Rosenthal never subscribed to the view that a nearly involuntary impulse to synthesize cultural diversity marked the age. "The eclecticism needed by a historian," he wrote, "allayed none of the passions which it renounced, and it left the young generation without guidance in the face of doctrinal conflicts." He found a similar lack of conviction in Salon criticism: "Among the writers who did not despair over the future of painting were those who thought they had found, in a universal reconciliation, an answer to annoying rivalries. They preached eclecticism a bit from weariness, like Théophile Gautier, whose criticism each year was increasingly comprehensive and also increasingly indifferent."[43] Rosenthal's strategy "decoupled" eclecticism from the mainstream of criticism and artistic production, leaving him free to relegate to the

margins of his story those painters who seemed to embody stylistic compromise—painters he called *juste-milieu*:

> They were not at all doctrinaires who subjugated their works to dominating formulas . . . nor did they understand those strong passions which stamp everything they touch with an indelible personality. The principal trait of their physiognomy is, perhaps, this lack of any clear-cut character. Whereas the slightest work by Delacroix or Ingres leads our thoughts back toward the personality with which it is permeated, a piece signed by one of these timid masters can only reveal ingenuity and virtuosity; according to an oft-repeated phrase, they frequently paint well, never better: they have no style.[44]

Because Rosenthal believed that strong personalities and passions provide the motor energy for artistic "evolution" (a word used in the subtitle of his book), he searched for the threads of an art history firmly committed to the ideology of innovation which we now call the avant-garde.

Rosenthal's position is an extremely attractive one, for it rewards "romantic" genius and daring with the esteem of history. It is also difficult to challenge, because we "moderns" prefer to think of the greatest artists as people "apart" from the crowd and splendid in their creative isolation. As discussed above, one possible response to Rosenthal would argue that the painters he scorned were so thoroughly of their time that their cultural authenticity commands our respect—if not our admiration. Another tactic, perhaps more useful, would ask whether the pictures and issues we have been discussing played some sort of role in the development of mid-century Realism. Rosenthal dismissed this possibility for the same reason that he condemned these pictures—a lack of verve.[45] I will argue that the pictures which hung in the Salons during the twenty years prior to Courbet's first major paintings cannot be discounted in a history of the period. This analysis will first require, however, that we rethink a recurring and problematic aesthetic term, the *juste-milieu*.

Although art historians disagree about the relative importance of so-called *juste-milieu* painting, they generally take that term to mean a "compromise" style or manner existing "between" the major stylistic poles of Classicism and Romanticism.[46] Many critics of the 1830s and 1840s did indeed use *juste-milieu* in this way, but I argued in part I that they seemed to be groping for an intellectual construct and a vocabulary to describe appropriately the breakdown of pictorial categories traditionally maintained by the Academy. The well-known conflict between Classics and Romantics was, to be sure, one term of this discourse of redefinition—but only one. When tracing the emergence of genre historique as an element of the critical lexicon, we touched upon a debate which seems to describe the situation more accurately than the polemic of personalities around juste-milieu, because it involved issues of subject-matter, format, and function as well as style. The fact that genre historique figures only peripherally in most art-historical discussions suggests a failure to recognize the extent to which cultural expectations of what constituted serious painting were undergoing rapid and radical transformation during these decades. We have presupposed this transformation to show that when Louis-Philippe invested the genre historique picture-type with the political and propagandistic self-interests of his dynasty, he forced, in effect, the development of a new kind of painting. When the accessible, didactic, and

journalistic formulas of small-scale *genre historique* compositions were reformatted to a heroic scale and infused with the persuasive power of popular art for the grand public gallery spaces of Versailles, Louis-Philippe created—with a premeditated, selectively focused fusion of pragmatic, noncosmic concerns—a history picture which might appropriately be called *juste-milieu*.

More than a semantic shell-game, to think of the term *juste-milieu* in this way locates it within a complete cultural matrix: the configuration is tied to the rise of *genre historique* (a rise dependent upon shifting social and patronal pressures) and it functions within the propagandistic constraints of contemporary politics. From this perspective, juste-milieu painting is not victimized by personalities and schools, nor does it float freely in cultural zeitgeist. In addition, we can begin to place it more precisely in the history of nineteenth-century painting: to bind the term to a particular set of historical conditions precludes any attempt to lump together indiscriminately those artists of the July Monarchy, Second Empire, and Third Republic who supposedly "compromised" between "advanced" and "Academic" representational practice. Separate terms may be needed for each of these epochs, but historical evidence argues most strongly that we reserve *juste-milieu* for those pictures which respond in both their style *and* content to the ideology and the patronage of the July Monarchy. With these pictures firmly connected to the reign of Louis-Philippe, and situated for political reasons at the intersection of "high" and "low" culture, we can return to the question of whether they played a role in the development of early modernism and the work of Courbet.

Despite his dismissal of the juste-milieu, Rosenthal was sensitive to the complex cultural adjustments which marked the 1830s and 1840s.[47] Most important, it seems, is his observation that the Romantic/Classic stalemate did not give way to a mindless eclectic fusion but yielded to an urgent question concerning the "legitimate relationships between art and society."[48] Critics of the time generally articulated their understanding of the social function of art by demanding that it renounce its status as a "luxury" item and embrace the social responsibility of public instruction.[49] Although didacticism sometimes meant that painters retreated from the contemporary world (especially when serving religious or utopian ideologies), Rosenthal correctly points out that during the July Monarchy "the most widely held opinion [was] that art should draw its inspiration directly from contemporary events."[50] This does not imply, however, that artists and critics agreed with Baudelaire's eloquent call in 1845 for paintings which would celebrate "the heroism of modern life" and sing of "the poetry in our neckties and polished boots," for his aesthetics of dandyism embraced an unusually narrow interpretation of what constituted modern life (*la vie moderne*).[51]

During the July Monarchy, many of the critics who would one day welcome Courbet's pictures regularly invoked David, Gros, and Géricault as role models for artists who aspired to paint contemporary life.[52] Episodes of post-1789 France remained heroic and "modern" because observers of the 1830s and 1840s had actually lived them. Retelling these episodes fulfilled a serious didactic purpose which sought to recover a history that had been systematically suppressed under the restored Bourbons. When Louis-Philippe took up this history at Versailles, he was not only constructing political props for his regime but also investing official art with the culturally approved social function of instructing the nation about its

recent past.[53] While we have discussed the former at length, Louis-Philippe's commitment to the latter is underscored by his personal sponsorship of a project to reproduce the historical picture galleries of Versailles in volumes of line engravings, each accompanied by an explanatory historical text.[54] In the "Prospectus" announcing this enormous publishing venture (fifteen volumes of plates were projected), Charles Gavard claimed that "this book is destined, above all else, to be a book for everyone"—an unlikely goal given its elaborate, folio-sized presentation.[55] But, thanks to the king's largess, copies of each volume were sent to every library in France, making—in the words of Montalivet—"the new museum accessible even to those who could not come from the far corners of France to admire it."[56] This distribution guaranteed an even wider audience for the historical program installed at Versailles and underscored the ambitions of the king's didactic intentions.

Pictures designed to instruct viewers in history must appear factually accurate and narrate their events with clarity, and these are precisely the qualities which characterized the paintings done for Versailles. Encouraged to make works which would not alienate an audience of nonspecialists, painters renounced much of the ennobling artifice of traditional high art in favor of a direct, accessible representation utilizing devices rooted in the theater, popular imagery, and strategies of genre painting—the didactic picture-type with which they were most familiar. The king's political designs for Versailles synchronized official art with the cultural forces shaping the rise of genre historique and pushed that art to support the socially responsible didacticism which was emerging as a major critical concern. Obviously, the government interpreted the social role of official imagery as reinforcing the status quo rather than developing a critique of it. The important issue, however, is not the particular political coloration of these works, but that instruction—or more accurately, indoctrination—constituted their raison d'être and affected their form. To the extent that this is true of the works we have called juste-milieu history painting, we can extend Rosenthal's perception about a socially engaged art to its logical conclusion: contrary to what he claimed, the July Monarchy's official art did indeed generate important stylistic and thematic pressures on the pictorial transformations which culminated in mid-century Realism.

By encouraging artists to explore a new range of subjects, compositional strategies, and manners of representation, Romanticism is usually credited with breaking the stranglehold in which Davidian (or Academic) doctrine held ambitious painting.[57] Yet if we compare almost any of Louis-Philippe's commissioned pictures to the great works of a Romantic persuasion—such as *The Raft of "La Méduse"* by Géricault (fig. 91) or Delacroix's pictures of *Greece on the Ruins of Missolonghi* (fig. 96) and *The 28th of July* (fig. 87)—the latter retain, despite a boldness of execution, an air of willful ordering quite unlike the "artless" journalism of Gosse (fig. 64), Couder (fig. 146), Blondel (fig. 193), or Vernet (fig. 17). I have argued that genre historique emerged triumphant after the 1830 Revolution in response to a historically conditioned need to recount the story of modern France for a new class of viewers—and that its idiom of material accuracy and nonconventional vision became an autonomous mode of representation which demanded a name and a place among the traditional categories of painting. Without devaluing the importance of a "romantic" aesthetic in the liberation of painting from its doctrinal biases, I would see the

development of genre historique as an intervening step between the Romantics of the 1820s and the Realists of 1848: my reasons for stressing this point will become clear below.

If the didactic, reportorial vocabulary of genre historique was to become an effective tool of government propaganda, it had to be invested with the power to reference systems of meaning lying beyond the confines of narration. In earlier periods, artists regularly achieved this semantic extension by adopting the rhetorical infrastructure of the "grand" tradition: thus, we recognize that the Napoléon of Gros's *Plague Victims of Jaffa* (fig. 67) resonates with the religious iconography of Christ healing the lepers, and that David effected a partisan sympathy for the victim of his *Marat Dying* (fig. 165) by self-consciously reconstructing *Pietà* imagery with a Caravaggesque materialism. The situation is rather different in the 1830s and 1840s, however, when the contemporary demand for narrative truth presupposed an avoidance of such overt quotations of tradition.[58] We have discovered that the apparently documentary works of the July Monarchy did indeed refer to a system of signs endowed with a public and political signification. As we know, the pictorial configurations of popular prints were used repeatedly by painters when designing works for the king's galleries. The inflections of emphasis and the political nuances embedded within the historical programs of these "official" spaces did not depend upon an imagery manipulating the elitist lexicon of high art but generated their political meaning within the visual argot of the ordinary citizen.

It has long been understood that popular art forms—especially after the introduction of lithography—profoundly affected the direction of painting, and that the spontaneity and directness found in the work of the best lithographers (such as Daumier, Gavarni, or Charlet) established visual models for new kinds of image making.[59] Moreover, the subjects favored by publishers (or, more precisely, encouraged by their market) tended to be drawn from contemporary experience: witness the predominance of political satires, caricatures of modern manners, and episodes of the Revolution and Empire. The eventual effect of this explosion of imagery was, as Rosenthal observed, profound: "The general public got into the habit of examining visual images, and they became an essential part of public life. The repetition and even the craze for images dictated subjects to which one had conceded only a distracted attention not long before. Their intrinsic quality became evident and, little by little, their true greatness."[60] The evolution sketched broadly by Rosenthal did not occur overnight, of course, and historians naturally will want to examine in detail the process of exchange in which the critical expectations for popular imagery and high art were in flux. Our discussion of the ways official imagery used popular art forms has revealed an important aspect of that exchange: if we agree that the process was seminal to the development of mid-century Realism, we must also conclude that juste-milieu history painting (as we have defined it) performed an essential role in that development.

Courbet has been much admired for his self-conscious references to popular imagery after 1848.[61] We can now grasp rather clearly the historical background to his tactic of working the forms and ambitions of popular art against those of Salon painting. It may be true that this historical perspective tends to depreciate somewhat the innovation of Courbet's achievement, at least the way that achievement has been characterized by some historians. Thus, T. J. Clark admits that popular art "was already accepted as a source of

imagery and inspiration, as one way to revive the exhausted forms of 'high art'," but he argues that Courbet's borrowing "was profoundly subversive" and "exploited high art—its techniques, its size, and something of its sophistication—in order to revive popular art. His painting was addressed not to the connoisseur, but to a different, hidden public; it stayed close to the pictorial forms and the types of comedy which were basic to popular tradition."[62] It is difficult to claim that Courbet invented this strategy when we know that the paintings executed for Louis-Philippe's galleries had not been addressed to connoisseurs who had trouble calling them History Paintings (*peintures d'histoire*), but to an audience versed in the pictorial grammar of popular prints, theater, and genre paintings.

This line of reasoning opens onto a rethinking of Courbet's achievement in 1848–50. The very neat symmetry which art historians usually draw between the 1848 Revolution and the "revolutionary" canvasses of Courbet requires that we read those pictures as if their subversive low art strategies had toppled the Academy's hierarchy of privilege and value.[63] I have suggested that such a hierarchy was more mythic than actual, and that the privilege of History Painting had succumbed to subversion well before February 1848. I have also argued that the paintings done for the government of Louis-Philippe derived their political power not from a lingering potency of the traditional hierarchy but from an effective mediation of the complex interface between government ideology and cultural consensus. These images were inextricably and seamlessly connected to the mechanisms of cultural power: historical discourse, popular imagery, high art practice, contemporary politics, and even descriptive (that is, reportorial) language.

As imagery became increasingly invested with complex ideological codings, most of the markers which might signify that the picture was the product of an *individual* were squeezed out of its close-fitting matrix of meaning—an effect especially apparent when the pictures are seen in their intended viewing space, within the architectural and historical framework at Versailles. The works we now call "Realist" fit imperfectly into this semantic system, and they frustrated a seamless reading with markers that established a narrative ambiguity and asserted the personality of their makers. The trace of the palette knife on the picture surface, the attention-making grit of that surface, the painter's bold self-references (whether a large red signature or a self-portrait), and the impossibility of framing the subject in a stable discourse of fixed value all served to stake out a new bit of turf around the work. It was turf which resisted interpretative penetration yet was imprinted with a personality. It could be *appropriated*, of course, and in 1848 the works of Courbet (and, to a lesser extent, of Millet) were indeed appropriated.[64] But it seems clear that the first move in this game belonged to the painter, and Courbet plotted that move to cut the work of art free from its straitjacketed suturing to ideology: he reasserted, *within* the Salon's closed system of reading, the identity and individuality of the image maker.

Characterizing Courbet in this way suggests that his opening moves were less heroically "revolutionary" than is usually argued, but it does tally with what we know of his ego and his early, neo-Romantic self-portraits.[65] Skeptics might ask, however, why Realism (as it has come to be known) exploded upon the scene just *after* the 1848 Revolution if many of its qualities had been part and parcel of juste-milieu history painting. Although not complete, my response is quite simple. The particular combination of historical veracity, didactic elaboration, propagandistic function, and a rhetorical appeal rooted in popular art

forms is not found so consistently in any sector of official patronage outside the Crown (*Maison du Roi*). Between 1830 and 1848 these particular qualities were united and orchestrated for the express purpose of serving the king. When Louis-Philippe fled France in February 1848, this hybrid pictorial strategy lost its patron and raison d'être. The ensuing patronal vacuum and exploded cultural codes encouraged painting to proceed outward in two directions at once: toward either the reconstitutive, eclectic bathos of Couture or the rugged, neo-Romantic individualism of Millet and Courbet.

The above schema requires me to say that the 1848 Revolution quite literally signaled the death-knell of juste-milieu history painting, and one might wonder if this conclusion is too extreme. But, in light of the uncertainties, dashed hopes, and dismal artistic achievements of the Second Republic, it is no exaggeration to claim that the situation after 24 February 1848 lacked the single vision needed to shape official programs and dictate taste.[66] As Clark notes, the Fine Arts Division of the Interior Ministry fumbled along much as it had in the past.[67] I must point out, however, that an entire system of *parallel* patronage had withered away: with the disappearance of the *Maison du Roi*, a coherent taste and a focused, programmatic vision of the social function of painting had ceased to exist. French artists were never again asked to produce pictures whose scope, scale, and purpose were so pointedly dictated by a single patron as those they had made for Louis-Philippe. In a very real sense, juste-milieu history painting did die—along with the dynasty which had created it—on the barricades of February 1848.

3. ON LOUIS-PHILIPPE: CONCLUSION

The focus on any study organized like this one—in which hundreds of artists and images have passed in review—must necessarily be to delimit and define general trends, even though specific works are often discussed in depth. What one loses in such an investigation is a sense of the individual personalities involved, since the search for relationships among various kinds of pictures supersedes a detailed consideration of the artists who created them. Obviously, this lacuna can only be bridged with a series of monographs which treat the period vertically rather than horizontally. I hope, however, that the reader has glimpsed at least *one* personality in the course of this book: the character and vision of the king, his fears and his ambitions are the threads which link together its seemingly disparate themes.

The image of Louis-Philippe which emerges from our story is that of a leader who understood quite clearly the *worth* of art in society (I mean the word in both a cultural and an economic sense). That he recognized the potential for social change within the shifting sands of public opinion is most evident from a passage of his memoirs written in 1848:

> It is this gathering together of views shaped by luminaries, education, readings, conversations, sometimes even by the fashions of the time which form what I call *opinion*, and when defined in this way it strikes me as an irresistible force. It penetrates every part of society, directs and controls everything; nothing is sheltered from its influence, and it smashes everything which does not bend before it: it alone makes and remakes revolutions. The French Revolution was brought about by *opinion*, and consequently only *opinion* could have stopped its march. Thus, it was first of all necessary to apply oneself to understanding completely the country's

opinion; next, one had to strive to make it favorable through concessions, capitulations, or—which is even better—by a sincerity in one's remarks and a fidelity to one's commitments. Finally, it was necessary in some way to put oneself in step with one's century and especially with the nation.[68]

Although the former Roi des Français was referring to the Great Revolution and what Louis XVI could have done to avert his untimely end, Louis-Philippe's sensitivity to the power of *opinion* was doubtless influenced by his own situation and the crown he had recently lost. During the 1830s and 1840s, Louis-Philippe demonstrated his understanding of a modern monarch's duty: our study has traced his attempts to gauge the nation's frame of mind, to fulfill the letter (if not the spirit) of his pledge to France in August 1830, and—especially with regard to his politics of patronage—to seek in painting and sculpture a way in which "to put himself in step with his century and especially with the nation."

I have sketched only briefly the extent to which Louis-Philippe's grasp of the national mood had gone awry by 1847, because social historians can best explain why his bid to launch a lasting dynasty had failed. Nevertheless, if we compare Louis-Philippe's surprisingly modern discussion of opinion to an excerpt from Victor Hugo's portrait of him in *Les Misérables*, we can glimpse some of the idiosyncracies which prevented Louis-Philippe from successfully turning the inevitable shifts of opinion to his advantage:

> . . . a brave soldier, a courageous thinker; worried only by the odds of a shakeup in Europe and ill-suited for large political risk-taking; always ready to risk his life, never his accomplishments; disguising his will as influence in order to be obeyed as a good mind rather than as a king; endowed with powers of observation but not intuition; little attentive to feelings, but a good judge of people, in other words, needing to see in order to judge; a quick and penetrating common sense, a practical wisdom, an eloquence, a prodigious memory—a constant dipping into this memory being his only similarity to Caesar, Alexander, and Napoléon; knowing the facts, details, dates and proper names; ignoring the tendencies, passions, varying characteristics of the crowd, the inner aspirations, the hidden and obscure heavings of the soul—in a word, everything one calls the invisible currents of conscious beings; accepted by France on the surface but having little in common with her from below . . .[69]

In the course of this study, nearly all of these traits have appeared at one time or another, and the mass of historical data concentrated on the walls of Versailles singularly supports Hugo's claim that the king was obsessed with correctly remembering his names and dates. Yet one of these lines seems especially telling: when Hugo wrote "always ready to risk his life, never his accomplishments," he not only captured Louis-Philippe's intransigence before political reform but also exposed an attitude which can be found hidden within the grand edifice of his museum dedicated *à toutes les gloires de la France*.

As early as March 1834, Louis-Philippe insisted—much to Nepveu's chagrin—that all of the pictures installed at Versailles be built into the woodwork of the gallery walls.[70] This meant, of course, that once the pictures were installed they could not be moved. The version (and vision) of history recounted in the galleries was expressly designed by the king to be forever fixed in place. It is a small, almost insignificant point, but one which reveals, I believe, an underlying intellectual rigidity that became increasingly apparent as Louis-

Philippe grew older. By 1848, the structure of Versailles mirrored that of the monarchy itself: correct but static; unyielding to change simply because the king refused to accommodate it; a brittle ossification of the effervescent élan which had reigned during the Trois Glorieuses of 1830. Small wonder, then, that the puff of civil unrest we now call the February revolution brought the *maison d'Orléans* crashing to the ground, and that later generations of Frenchmen—chilled by the glacially immobile narrative of Louis-Philippe's *galeries historiques*—have relegated hundreds of his paintings to darkened storerooms and diligently dismantled much of what he had so meticulously arranged.

Notes

Whenever possible, note references have been simplified and shortened; complete information is given in the Bibliography. Quoted texts have been translated into English. The titles of books and periodicals, publisher information taken from prints, and page headings of archival documents are retained in the original language and orthography.

The following abbreviations are used in the Notes:

AC	Archives Condé
AL	Archives du Louvre
AN	Archives Nationales
BN	Bibliothèque Nationale
CdV	*Collection de Vinck*
EST	Cabinet des Estampes
JdA	*Journal des Artistes et Amateurs*
MNC	Musée National du Château

1: INTRODUCTION

1. For an analysis of the country's economic growth during this period see Johnson, "The Revolution of 1830 in French Economic History."

2. The Arc de Triomphe, begun by Napoléon in 1806, was incomplete when the Bourbons returned to France in 1815. For obvious reasons, the work was suspended during the Restoration; Louis-Philippe's government reopened construction in 1832 and dedicated the arch in July 1836. The Madeleine, begun in 1764 as a church, restarted in 1806 when Napoléon decided to erect a Temple de la Gloire designed like a greek temple, and rededicated as a church by Louis XVIII in 1814, had an especially stormy history: it was still incomplete when Louis-Philippe assumed the throne in 1830, sculptors and painters worked on the decorations throughout the 1830s, and the structure was finally dedicated in March 1842. The king's plans for Versailles were first formulated on 29 August 1833 and made public in early September ("Rapport au Roi," *Le Moniteur Universel*, no. 248 [Jeudi 5 septembre 1833], p. 2043).

3. The king announced this important change in policy at the ceremony of 16 August 1831 to close the Salon ("Séance Royale pour la Clôture du Salon de 1831," *L'Artiste*, I [1831], pp. 25–26).

4. These figures from the Salon registers conserved at the Archives du Louvre (série *KK) are actually more representative of the total artistic output than the number of works in the Salon *livret*,

which reflected the jury's need to operate within the size limitations of the available exhibition space.

5. Rosenthal, *Du Romantisme au Réalisme*; hereafter referred to as Rosenthal.

6. Antal, "Remarks on the Method of Art History," in *Classicism and Romanticism*, pp. 185–86.

7. *Full-length Portrait of the King*. Salon of 1831, no. 1062. The pay order dated 8 April 1831 stipulates that the work had been commissioned in October 1830 (AN, O⁴1373, no. 617, 6,000 FF). It seems that the three examples of Hersent's portrait which had been in the Palais-Royal were destroyed during the 1848 sack of the palace (AN, 300 API 1113, "Inventaire de Tableaux du Palais-Royal"). Our illustration is an aquatint by Girard after the original (CdV, VI, no. 11.664 [59.5 × 46 cm]), published in 1832 (*Bibliographie de la France*, XXI, no. 39 [29 septembre 1832], p. 560, no. 655).

8. Royal decrees of 6 and 10 August 1830 reestablished the Gallic cock as emblem of the nation (its Republican associations had prompted the Bourbons to suppress it). See Girard, *Le coq*, p. 69 and Paris, Musée Carnavalet, *Juillet 1830*, no. 271.

9. Contemporary witnesses tell us that Louis-Philippe received hundreds of citizens during the first months of his reign and often joined them in singing *La Marseillaise* (e.g., Laffitte, *Mémoires*, pp. 228–29).

10. Quoted from the anonymously penned *Vie de Louis-Philippe Iᵉʳ, Roi des Français, par un vieux soldat de 1792*, p. 5. This is but one of many such biographies published in the 1830–31 period.

11. *Portrait of King Charles X*. Salon of 1827, no. 513. Toulon, Musée d'Art et d'Archéologie (250 × 200 cm). See Ginoux, *Musée-Bibliothèque de Toulon*, p. 25, no. 67.

12. *Portrait of King Louis XVI*. Salon of 1789, no. 63 (?). Clermont-Ferrand, Musée Bargoin, inv. no. INV 2398–875–1045–1 (246 × 192 cm). The picture is discussed in detail in New York, *The Age of Revolution*, no. 17.

13. Pillet noted in his review of the Salon: "The painter has very correctly rejected the ceremonial luxury of the old court in order to depict, in the costume of a National Guardsman, the monarch who is more of his century than any other king" ("Beaux-Arts: Salon de 1831," *Le Moniteur Universel*, no. 125 [Jeudi 6 mai 1831], p. 927).

14. See pt. II for a more detailed account of how this political infighting shaped official imagery other than portraiture.

15. Quoted (and variants discussed) in the exhibition catalogue Paris, Archives Nationales, *Louis-Philippe*, no. 300.

16. For a detailed description of Louis-Philippe's service in the armies of the Republic, and especially of his refusal to join the émigrés, consult his *Mémoires*, II, esp. pp. 422–28.

17. See the discussion of the tricolor's return in pt. II, sec. 1.

18. Writing about this critical moment in the establishment of the new government, Guizot tells us that "we were not at all selecting a King; we were negotiating with a prince whom we found close to the throne and who alone could guarantee our collective rights by mounting it." (*Mémoires*, II, p. 26).

19. One example of this text is the placard dated *31 Jᵉᵗ 1830* in the Archives de Paris, 6AZ112 (3). The entire text is published in Paris, Archives Nationales, *Louis-Philippe*, no. 304.

20. "Partie Officielle," *Le Moniteur Universel*, no. 226 (Samedi 14 août 1830), p. 899, where the king's ordinance of 13 August was officially published.

21. For a full discussion of the event and images of it see pt. II, secs. 1, 5.

22. For a detailed discussion of the operation and usage of the National Guard by the July Monarchy consult Girard, *La Garde nationale*, pp. 230–48. See also pt. II, sec. 5.

23. *Full-length Portrait of the King*, signed and dated "Gosse 1831." Salon of 1831, no. 951. Saint-Denis de la Réunion, Musée Léon Dierx, inv. no. 629 (255 × 190 cm). Another replica is in Limoges, Musée Municipal, inv. no. P.123 (260 × 180 cm). The pay order, dated 28 February 1831, indicates that Gosse received 2,000 FF for the original and that it was painted in only fifteen days—implying that the commission must have been awarded during the same month (AN, O⁴1373, no. 370).

24. The inventory of pictures in the Palais-Royal established after the 1848 Revolution lists two copies of this portrait: one had been completely destroyed by the looting crowds; the other was punctured but apparently salvageable (AN, 300 API 1113, "Inventaire de Tableaux du Palais-Royal").

25. Gosse was paid 2,000 FF on 10 August 1831 for two copies of his portrait "destined to be given as gifts" (AN, O⁴1373, no. 1321). In addition, the Crown commissioned Hersent to execute several signed copies of his picture: two in May 1831, including one for the Queen of England (AN, O⁴1373, no. 782, 8,000 FF); four in September 1831 (AN, O⁴1373, no. 1566,

12,000 FF); one in 1835 (AN, O⁴1588, no. 3381, 6,000 FF); and one in 1836 (AN, O⁴1643, no. 3022, 6,000 FF).

26. *Portrait of Louis-Philippe*, signed and dated "Francis C. 1830." Besançon, Musée de Granvelle, inv. no. D.833–1–1 (108 × 80 cm). The picture was not shown at the Salon, although museum records indicate that it was a gift of the Interior Ministry. The gesture was no doubt motivated by the fact that Besançon was the artist's home town.

27. *Louis-Philippe on Horseback*, n.d. Paris, private collection (64 × 53.5 cm). The attribution to Lami depends upon similarities between this canvas and a lithograph published by Delpech which ascribes the image to Lami (Lemoisne, *L'Oeuvre d'Eugène Lami*, p. 244, no. 1070). The lithograph cited by Lemoisne depicts Louis-Philippe before the Hôtel-de-Ville on 31 July, while the present painting situates him in a composed cityscape in which the town hall has been replaced by the Vendôme column.

28. It has been suggested that this picture actually represents Louis-Philippe returning to the Palais-Royal after meeting his son at the Barrière du Trône on 4 August—the day the prince had led his regiment of hussards into the capital and planted the tricolor atop the Vendôme column (Paris, Archives Nationales, *Louis-Philippe*, no. 310). However, the presence of barricades in the background—all but invisible in Paris on 4 August—tends to argue against this interpretation.

29. For a revealing discussion of who actually participated in the July uprising see the landmark article by Pinkney, "The Crowd in the French Revolution of 1830." The relevant imagery of this crowd is discussed in pt. II, sec. 2.

30. See pt. IV, sec. 1.

31. Thureau-Dangin emphasizes the popularity of Napoleonic manifestations and the close ties between Bonapartist and republican factions opposed to the Orléans dynasty (*Histoire de la Monarchie de Juillet*, I, pp. 595–601; hereafter referred to as Thureau-Dangin).

32. See, e.g., CdV, VI, nos. 11.377–11.382 and my discussion in pt. II, sec. 2.

33. Guizot, *Complément des mémoires*, I, pp. cvii–cviii.

34. *Equestrian Portrait of the King*. Salon of 1831, no. 2611. Versailles, MNC, inv. no. MV8442 (495 × 410 cm). As I will presently show, the picture was much smaller when exhibited at the Salon. Although the painting's past is unclear, it seems to

have been installed at Saint-Cloud about 1839 or 1840 (see n. 41 below).

35. The comte de Forbin recommended on 30 September 1831 that the work be purchased (AN, O⁴2821), and it was bought for 3,000 FF on 3 October 1831 (AN, O⁴1372, no. 1424).

36. For a vivid description of the unimpeded public access to the Palais-Royal during these days consult Joinville, *Vieux souvenirs*, pp. 48–50.

37. The recorded dimensions are 340 × 220 cm (AL, sér. *KK, 1831). These correspond to the innermost edge markings in the darker, central section of the photograph.

38. Inscribed under inventory number 58 on 27 September 1831, the dimensions were listed as 390 × 260 cm (AL, 2DD/4, p. 440). These dimensions cover an area from the bottom of the canvas to the visible seam about halfway between the king's head and the current upper edge (in a vertical direction), and horizontally from the rightmost area of darkened pigment to the soldier's cuff at the left.

39. "The horses, done in a disagreeable and overly contrasted manner, seem to hobble over the ground plane which is too steeply tipped," wrote one critic ("Lettres sur le Salon de 1831," *L'Artiste*, I [1831], p. 213).

40. For example, after criticizing the figure of the king, his horse, and the princes, one writer added that "the accessories which fill the left of the picture are handled well; but accessories count for little in a historical portrait" (*L'Artiste*, I [1831], p. 198).

41. In August 1839 an artist named Badin was paid 700 FF "for the enlargement of a picture by M. Scheffer (the elder) representing the *lieutenant-général* of the Kingdom entering Paris [fig. 7] and destined to be placed in the grand staircase of the Palace of Saint-Cloud" (AN, O⁴1832, no. 3406, dated 28 August 1839). Figure 8: *The Lieutenant-général of the Kingdom Welcomes at the Barrière du Trône the First Regiment of Hussars under the Command of the duc de Chartres, 4 August 1830*, 1835. Versailles, MNC, inv. no. MV2787 (550 × 298 cm). Scheffer received 9,000 FF for the picture (AN, O⁴1588, no. 4751, 18 September 1835).

42. Among other things, Scheffer taught painting and drawing to the Orléans children. On his relationship to the family and the king consult Kolb, *Ary Scheffer*, pp. 151–77.

43. The iconographic program developed in late 1830 for the Chamber of Deputies (discussed in

pt. III, sec. 3) offers the most explicit expression of this theme.

44. *Louis-Philippe I^er, King of the French,* signed and dated "Blondel 1832." Versailles, MNC, inv. no. MV5212 (228 × 190 cm). Although museum records indicate that this picture was originally placed in the Salle de la Paix of the Tuileries Palace (AL, 3DD/8, p. 112, no. 2662), I have been unable to find any trace of the original commission.

45. *The King at the Review of the National Guard, 29 August 1830,* signed and dated "N. Gosse 1831." Dreux, Musée d'Art et d'Histoire (73 × 60 cm).

46. For the meaning of this gesture in antiquity see Brilliant, "Gesture and Rank," pp. 154ff. On its use in the sixteenth century consult Mezzatesta, "Marcus Aurelius."

47. See pt. II, sec. 4. Two of the allegories which survive are by Blondel (figs. 61, 62).

48. Thureau-Dangin, I, pp. 565–80, provides an analysis of this growing discontent, while its pictorial manifestation—the proliferation of viciously satirical caricatures in the popular press—can be gauged from the number of images produced during the period 1831–33 (CdV, VI, nos. 11.868–12.077).

49. For an analysis of the problems faced by the July Monarchy during these years see Rule and Tilly, "Political Process in Revolutionary France," pp. 42–85.

50. On 25 August 1830, Brussels exploded in revolution against the Dutch rule imposed by the treaties of 1814. When Dutch troops failed to quell this uprising and Belgium proclaimed its independence, the kings of the Holy Alliance threatened armed intervention to restore order. Just as this crisis was peaking, a popular revolt broke out in Warsaw (29–30 November), and the Poles declared their independence from Russia on 25 January 1831. When the czar launched a repressive counterattack in early February, many French politicians demanded that Louis-Philippe go to the aid of the Polish republic. News of Warsaw's fall to the Russian invaders on 7 September 1831 provoked outrage among Louis-Philippe's opponents, who accused the July Monarchy of cowardice and complicity for the sake of maintaining the status quo. On Belgium see Thureau-Dangin, I, pp. 69–83; for the Polish revolution consult pp. 189–93.

51. Left-wing opposition is analyzed in detail (and with obvious distaste) in ibid., pp. 210–27.

52. On the economic crisis consult Johnson, "The Revolution of 1830 in French Economic History," pp. 147–59.

53. In spite of a transparent admiration for Périer, Thureau-Dangin discusses his rise to power quite usefully (I, pp. 396–425).

54. Montalivet, *Fragments et souvenirs*, II, p. 1 and Thureau-Dangin, I, p. 411.

55. Montalivet, *Fragments et souvenirs*, II, pp. 18–20.

56. "Rapport au Roi, ou Considérations sur la politique intérieure," dated 3 May 1832 (AN, 300 APIII 32).

57. *Full-length Portrait of the King,* signed and dated "Horace Vernet fecit Rome 1832." Salon of 1833, no. 2357. Versailles, MNC, inv. no. MV5222 (260 × 195 cm). Although I was unable to locate the payment records for this picture, archival documents indicate that Vernet was paid 6,000 FF (AL, 2DD/4, p. 485, 26 March 1833). For the original, which may still exist somewhere in Rome, Vernet also received 6,000 FF (AL, 2DD/23, p. 166, 30 August 1832).

58. Jal, *Salon de 1833*, p. 130.

59. Vernet wrote to Louis-Philippe from Rome on 5 July 1832: "For seven months a full-length, life-sized portrait depicting the King on his throne figures at the Embassy, to which it had been given in the name of the Royal Academy of France at Rome. The replica which the King ordered from me is done, with the changes which he indicated, and is going to be sent to Paris immediately" (cited in Suffel, "Le Roi des barricades," p. 374). If the first version could be discovered in Rome and compared to the picture now at Versailles, the exact nature of the changes requested by the king could easily be determined.

60. Viel-Castel, "Beaux-Arts: Salon de 1833, Premier Article," *Bagatelle* (1833), p. 229.

61. Judging from the opening lines of Vernet's letter to the king, Louis-Philippe had demonstrated some impatience over the delay: "I am very distressed," wrote the artist, "to learn via a letter from Madame la Comtesse de Valence to my wife that Your Majesty questions my desire and the eagerness I deploy to complete the pictures whose execution Your Majesty has deigned to entrust to me" (cited in Suffel, "Le Roi des barricades," p. 374).

62. For a discussion of the provinces consult Pinkney, *1830*, pp. 196–226.

63. The king traveled through Normandy in

May 1831. In June he visited the battlefield of Valmy (where he had commanded French troops in 1792) and then passed through Alsace-Lorraine. About these excursions refer to Blanc, *Dix Ans*, II, pp. 340–42; see also the letters written by Louis-Philippe to Queen Marie-Amélie, which recount these voyages in colorful detail (AN, 300 APIII 85).

64. F[arcy], "Le Portrait du Roi—M. Champmartin," *JdA*, V[e] année, vol. II, no. 11 (11 septembre 1831), pp. 195–96.

65. "Nouvelles des Arts," *JdA*, V[e] année, vol. II, no. 19 (6 novembre 1831), p. 328.

66. "1er à compte du portrait du Roi," AN, F⁴*505, no. 1068, 12 June 1832; and "Administration des Beaux-Arts: Exercice de 1835," AN, F²1559. The picture ought to be at Saint-Etienne in the Musée d'Art et d'Industrie, where it was placed on loan by the government in 1840 at the request of Jules Janin (see Gonnard, *Catalogue des collections*, p. 6, no. 9). When I visited this museum in December 1978 the curator informed me that the picture could not be found.

67. For a summary of the programs of art patronage during the Consulat and Empire, including data on regular commissions and prices paid for official portraits, consult Benoît, *L'Art français sous la Révolution et l'Empire*, pp. 162–65.

68. The measures taken by Périer to implement and ensure this shift of power are summarized in Thureau-Dangin, I, p. 411.

69. Witness Périer's vigorous campaign to instruct the provincial prefects on the rewards of obedience and the perils of ignoring government directives. These articles and circulars stressing the importance of order and authority were signed by Périer himself rather than Louis-Philippe (ibid., pp. 414–15).

70. The fullest account of the Lyon disorders is Bezucha, *The Lyon Uprising*; see also Thureau-Dangin, II, pp. 4–6; and Charléty, *La Monarchie de Juillet*, p. 67.

71. Letter from Louis-Philippe to his son at Lyon, dated 4 December 1831 (AN, 300 APIII 32).

72. The bureaucratic purges of 1830 are discussed in Pinkney, *1830*, pp. 276–89. About Périer's campaign in 1831 see Lucas-Dubreton, *La Manière forte*, pp. 132–34. Périer was especially inflexible in his demand that prefects be forced to choose between their government posts and membership in the leftist organization, *L'Association Nationale*.

73. Thureau-Dangin, II, pp. 116–21.

74. Ibid., pp. 130, 136.

75. *The King Encountering a Wounded Soldier, 6 June 1832*, signed and dated "A. DeBay 1835." Salon of 1835, no. 502. Eu, Musée Louis-Philippe (on loan), inv. no. INV3753 (152 × 200 cm). Commissioned by the Interior Ministry in 1832 for 2,000 FF (AN, F⁴*505, no. 1740, 1 September 1832, 1,000 FF; AN, F⁴*507, no. 2060, 25 March 1835, 1,000 FF). A reduced version of DeBay's painting was commissioned from an artist named Rubio in 1836 (AL, 2DD/4, p. 419, 20 October 1836; AN, O⁴1644, no. 5352, 25 November 1836, 1,200 FF). This smaller picture is now at Versailles, MNC, inv. no. MV1823 (117 × 119 cm).

76. For example, Blanc, *Dix Ans*, III, pp. 301–02.

77. About this recurring theme in French history painting see Rosenblum, *Transformations*, pp. 56–59 and, especially for Napoleonic interpretations, pp. 98–104.

78. Figure 13: *Clemency of His Majesty the Emperor in Favor of Mlle de Saint-Simon, Who Requests a Pardon for Her Father*, signed and dated "Lafond jeune 1810." Salon of 1810, no. 456. Versailles, MNC, inv. no. MV1736 (229 × 258 cm). Figure 14: *General Bonaparte's Entry into Alexandria, 3 July 1798; His Clemency in Favor of an Arab Family*, signed and dated "Colson 1812." Salon of 1812, no. 219. Versailles, MNC, inv. no. MV1682 (356 × 486 cm). This picture was shown at the 1830 exhibition under no. 39.

79. "Portrait en pied du Roi destiné à la Chambre des Pairs," AN, O⁴1472, no. 5046, 23 November 1833, 6,000 FF.

80. "Répétition du portrait du Roi (en pied) pour le grand Salon du Musée," AN, O⁴1524, no. 1266, 28 May 1834, 6,000 FF. The picture for the Hôtel-de-Ville was commissioned in 1834 by the Interior Ministry (AN, F⁴*507, no. 3, 2 January 1834). For Louis-Philippe's daughter, the documents indicate a "Répétition du portrait du Roi destinée à S.M. la Reine des Belges," AN, O⁴1525, no. 3635, 10 September 1834, 6,000 FF.

81. "Portrait du Roi, prototype," AL, 2DD/23, p. 63, 31 March 1834, 6,000 FF.

82. See, e.g., the numerous copies recorded in the budget of the Bureau des Beaux-Arts for 1834 (AN, F²14006). Evidence of the government's extensive program of distributing these copies is provided in the list of payments made by the Interior Ministry to shippers of art works (AN, F²1498).

83. Our illustration is a replica of the 1833 original: Versailles, MNC, inv. no. MV5210 (220 × 158 cm). The Musée Louis-Philippe at Eu currently exhibits another copy of Gérard's portrait, on loan from the Musée de Dieppe, inv. no. MD1470 (238 × 158 cm).

84. This gesture was part of an earlier, popular iconography of the king: for example, Louis-Philippe had been represented with his hand on the Charter in the "King of Hearts" image for a deck of playing cards produced just after the July Revolution (see fig. 88 and pt. II, n. 255).

85. In particular, the scathing criticism of the government contained in a report to their constituents published by 134 opposition deputies on 28 May 1834 (discussed in Thureau-Dangin, II, pp. 124–26).

86. AN, 300 APIII 32, dossier 5.

87. Even as the king was speaking on 6 June 1832, the city's silence was broken by the roar of cannons: Louis-Philippe calmly announced that he had ordered an attack on the cloister of Saint-Méry, where the last contingent of insurgents had taken shelter. For an opposition account of this meeting see Blanc, *Dix Ans*, III, pp. 302–05.

88. On the economic growth in France after 1840, government policies designed to spur this expansion, and the 1846–47 crisis, consult Clough, *France*, pp. 143–62 and Johnson, "The Revolution of 1830 in French Economic History," pp. 162–80.

89. An expedition to capture Constantine failed miserably in 1836 but was successful when reorganized in October 1837 (Thureau-Dangin, III, pp. 524–35). The French conquest of Algeria during the following years is described at length in Thureau-Dangin, V, pp. 251–363, and more summarily in Charléty, *La Monarchie de Juillet*, pp. 269–75.

90. Notably the ministerial flip-flopping of 1840, discussed in pt. IV, sec. 8 in connection with the return of Napoléon's remains to Paris in December.

91. On the characters and character of this ministry see Thureau-Dangin, IV, pp. 352–60. Marshal Soult was named Minister of War and was nominally the Council President (prime minister), but the ideological tone and practical direction of the ministry emanated from Guizot, who held the portfolio of Minister of Foreign Affairs.

92. On the very complicated diplomacy around this affair consult Thureau-Dangin, VI, pp. 203–58.

93. *Full-length Portrait of the King*, signed and dated "Fr. Winterhalter 1839." Salon of 1839, no. 2126. Versailles, MNC, inv. no. MV5219 (260 × 190 cm). The commission is dated 25 March 1839 (AL, 2DD/4, p. 500) and the payment 9 April 1840 (AN, O⁴1834, no. 8368, 5,000 FF).

94. See n. 2 above and pt. IV, n. 336.

95. Such as the portrait of Napoléon III by Flandrin: Salon of 1863, no. 704. Versailles, MNC, inv. no. MV6556 (212 × 147 cm). For a full history and a reproduction of this particular painting consult Philadelphia, Museum of Art, *The Second Empire*, no. VI–55.

96. Signed and dated "Ingres, an XII" (i.e., 1804). Liège, Musée des Beaux-Arts, inv. no. 1 (227 × 147 cm). For a complete bibliography refer to Paris, Petit Palais, *Ingres*, no. 8.

97. On Napoleonic portrait types see Rosenblum, "Painting under Napoléon," pp. 161–62.

98. "Salon de 1839: Quatrième Article," *L'Artiste*, 2ᵉ série, II, no. 19 (1839), pp. 256–57.

99. Hadjinicolaou characterizes the readership and editorial policy of *L'Artiste* in 1831 as liberal middle class (*bourgeoisie de gauche*) ("*La Liberté guidant*," pp. 16, 20). Rosenthal (p. 57) points out that although *L'Artiste* changed its editorial direction several times during the July Monarchy it remained a specialized, "luxury" art magazine.

100. "Although it has often been said," remarked Janin, "that this Winterhalter tint was not true, that this ray of sunlight had passed through a rose-colored scrim, that this terribly charming stylishness maybe lacked sincerity, no one wanted to hear it, especially the ladies" ("Salon de 1839: Quatrième Article," *L'Artiste*, 2ᵉ série, II, no. 19 [1839], p. 256).

101. Vaudoyer et Alfassa, "Les Salles de la Monarchie de Juillet," p. 56.

102. Desessarts, "Salon de 1839: Huitième et dernier Article," *Le Voleur*, XIIᵉ année, 2ᵉ série, no. 24 (30 avril 1839), p. 380.

103. Winterhalter received 3,000 FF from the Interior Ministry for a full-length portrait of the King on 2 May 1840 (AN, F⁴*512, no. 519). He was allotted 4,000 FF per year for his "supervision of the execution of copies after his portrait of the King" (AN, F⁴*512, no. 2103, 2 February 1841 and F⁴*513, no. 1811, 14 December 1841). A copyist was usually paid 800 FF, and one can gauge the number of duplicates commissioned by scanning the series F²¹12–60 at the Archives Nationales.

104. Thureau-Dangin, V, pp. 79–84.

105. Ibid., pp. 85–91, describes the profound effect of the prince's untimely death.

106. On this parliamentary maneuvering and its consequences consult ibid., pp. 108–13, and Charléty, *La Monarchie de Juillet*, pp. 301–03.

107. Thureau-Dangin, VI, pp. 15–17.

108. The importance of this development is especially stressed by Charléty, *La Monarchie de Juillet*, pp. 347–48.

109. Montalivet, *Fragments et souvenirs*, II, p. 96.

110. Thureau-Dangin, VII, pp. 25–34.

111. The scandal—involving the payment of a 100,000 franc "kickback" in 1842 to the Minister of Public Works (Teste) by a peer and former Minister of War (Cubières) in exchange for salt mining rights—is discussed in Thureau-Dangin, VII, pp. 52–53, 59–68. The murder/suicide of Choiseul-Praslin and the public's reaction to it are detailed in the same volume, pp. 90–98.

112. On the effects of the reform movement in the provinces during the second half of 1847 see Thureau-Dangin, VII, pp. 106–14.

113. *Louis-Philippe and His Sons Riding Out from the Château of Versailles*, signed and dated "Horace Vernet 1846." Salon of 1847, no. 1592. Versailles, MNC, inv. no. MV5218 (367 × 394 cm). Vernet received 25,000 FF for the painting (AN, O⁴2352, no. 2433, 17 June 1847). The commission was not registered on the museum's inventory until 28 January 1847 (AL, 2DD/5, p. 156), but Vernet began work on it during the summer of 1846 because Louis-Philippe had seen the newly completed, full-scale sketch at the artist's studio in mid-July ("368ᵉ Visite du Roi," AC, 91G–IV, 11 July 1846).

114. The pro-Bourbon critic for *La Mode* mischievously suggested that "the lack of perspective . . . makes the building seem to weigh upon the shoulders of the characters: the work of Louis XIV crushes Louis-Philippe and his heirs" (Galabor, "Chronique de la Mode," *La Mode*, XVIIIᵉ année, no. 8 [16 mars 1847], p. 517).

115. This statue was also a Louis-Philippe commission. The horse was sculpted by Cartellier, the king by Petitot, and the whole cast in bronze by Crozatier. It was unveiled on 22 June 1836 ("70ᵉ Visite du Roi," AC, 91G–I).

116. Article 67 of the *Constitutional Charter of 1830* clearly specifies that "France is taking up her colors again. In the future, no other cockade than the tricolor will be worn" (quoted from *Le Moniteur Universel*, no. 231 [Jeudi 19 août 1830], p. 921). While it is true, strictly speaking, that Louis-Philippe is not wearing the fleur-de-lys, its location in the portrait is hardly fortuitous.

117. Thoré, *Le Salon de 1847*, p. 49.

118. Ernest de Calonne, "Revue du Salon," *La Sylphide*, 8ᵉ année, 2ᵉ série, V, no. 12 (21 mars 1847), p. 155. The same insinuation colors Galabor's review for *La Mode* (see n. 114 above).

119. Louis-Philippe visited Vernet's studio to inspect the portrait on 11 July, 20 August, 28 August, 30 October, and 3 December 1846 (AC, 91G–IV).

120. Nepveu tells us that the king conversed "for some time with M. Horace about this family picture, in which the King wanted his eldest son, the recently deceased duc d'Orléans, to be included" (AC, 91G–IV, 11 July 1846). A small painted sketch of only the king and the duc d'Orléans, executed by Vernet when planning the large picture, further underscores the special care taken to include the deceased prince in the final picture (Paris, Archives Nationales, *Louis-Philippe*, no. 540).

121. Charles X (comte d'Artois) had assumed the throne upon the death of his brother, Louis XVIII (16 September 1824), because Louis had no heir when his wife died in 1810. Charles, it is true, had two sons: Louis-Antoine, duc d'Angoulême (the Dauphin), and Charles-Ferdinand, duc de Berry. The first, an ill-tempered, impotent nitwit, was thought unfit to rule even by his father. The second, the duc de Berry, had been assassinated by a Bonapartist fanatic on 13 February 1820: as if by miracle, his widow was left pregnant and gave birth to a son (Henri, duc de Bordeaux) on 29 September 1820. Many believed that this birth had been fabricated to insure a Bourbon heir, and Louis-Philippe (who had not been present at the birth, as was the custom) shared these doubts. When Henri's mother, the duchesse de Berry, was captured by Louis-Philippe's government in 1832 at Nantes after attempting to raise a pro-Bourbon uprising in the Vendée—and discovered to be pregnant by a secret marriage—her credibility and public support for Henri's claim evaporated (Thureau-Dangin, II, pp. 152–58, 183–87, 192–97). Thus, in contrast to the fecund Orléans branch of the family, the Bourbons already appeared to be an extinct breed.

122. Karr, *Les Guêpes illustrées*, p. 12. Vernet had first used the conceit of fully frontal horses in his mammoth canvas, *The Capture of the Smalah of*

Abd-el-Kader, Salon of 1845, no. 1628. Other critics who praised this bit of theater in Louis-Philippe's portrait included Gautier (*Salon de 1847*, p. 31), Guillot ("Exposition Annuelle des Beaux-Arts," p. 526), Planche ("Le Salon de 1847," p. 356), and Thoré (*Le Salon de 1847*, p. 48).

123. For Montalivet's account of Louis-Philippe's threats to abdicate see n. 109 above. The king's last address to the two chambers, on 28 December 1847, was delivered in a near monotone by a visibly aged, tired, and gloomy Louis-Philippe (Thureau-Dangin, VII, pp. 16–17, 342).

124. About the David see Rosenblum, "Painting under Napoléon," pp. 161–62.

125. Ernest de Calonne, "Revue du Salon: les Ateliers," *La Sylphide*, 8ᵉ année, 2ᵉ série, V, no. 10 (7 mars 1847), p. 120.

126. Trying to translate the oft-repeated term *la grande peinture* into English reveals the imprecisions implied by the formulation. That it was understood as the most noble form of representation is generally accepted, but upon what that nobility depended was left in doubt. Contemporary writers used the convenient rubric *grande* to blur and avoid the crucial distinctions which needed to be made concerning the scale, the subject, and the style of pictures. When the critic for *L'Artiste* wrote that "historical painting no longer guarantees anything to anyone because there are no more rich collectors, and because the constitutional government— frugal by nature—is fairly indifferent about the fine arts, which are only able to exist with generous incentives," he seems to imply that cost and square meters of canvas were the crucial issues ("Salon de 1831," *L'Artiste*, I [1831], p. 158). Two years later, we find the complaint that trivial subjects are being treated in a large format (*une grande page*), implying that size alone was not the essential issue (Laviron et Galbaccio, *Le Salon de 1833*, pp. 220–21). Still others at the same Salon observed that some complaints were misdirected: "There is a general complaint this year about the lack of large works [*grandes pages*] at the Salon, and one concludes from their absence that we no longer have artists capable of making them. This is wrong: it is not artists that are lacking, but rather encouragements. Besides, if you think about it, worth does not depend upon the size of works but upon their intrinsic value: a true artist reveals his character in even his least important productions" (Annet et Trianon, *Examen critique du Salon de 1833*, p. 1).

127. See Rosenthal, pp. 1–9 for a discussion of the changes in patronage brought about by the 1830 Revolution.

128. Jal, *Salon de 1831*, p. 236.

129. Anonymous, "Musée Royal: Exposition de 1831," *La Mode: Revue du Monde élégant*, 3ᵉ année, no. 1 (2 juillet 1831), p. 8.

130. See, for example, the article "Beaux-Arts: Récit d'un voyageur," *L'Echo de la jeune France*, I (juin 1833), p. 107, or "Beaux-Arts: Salon de 1833," *Bagatelle* (1833), p. 228.

131. Barbier, *Salon de 1836*, p. 38.

132. Gautier, "Salon de 1842," p. 119.

133. On this issue read Rosenthal, pp. 22–23, 32–35.

134. F[arcy], "Exposition de 1835: Deuxième Article," *JdA*, IXᵉ année, vol. I, no. 10 (8 mars 1835), p. 145.

135. See the discussion by Schnapper, "Painting during the Revolution," pp. 101–17. A recent Ph.D. dissertation by William Olander argues that the French Revolution actually did destroy the traditional academic hierarchy of picture types; Olander undercuts his own conclusion when noting (quite correctly) that with the reaction of Thermidor, "*ancien régime* prejudices and preoccupations, like royalism in the realm of politics, and genre hierarchy in the realm of art, came flying back" (Olander, "Pour transmettre," p. 336). I readily agree that the French Revolution had, as Olander contends, "firmly established in a position of prominence and authority" subjects drawn from contemporary history as national history and propaganda (p. 340), but I would argue that the strategies of how to *represent* these new subjects remained firmly entrenched within the formulas specified by the Academy for history painting. Only later, as a result of the pressures upon artistic production which came to the fore around 1830, were the strategies themselves irrevocably altered, and the hierarchy of genres definitively demolished.

136. Merruau, "Beaux-Arts: Salon de 1838," p. 341.

137. See n. 3 above.

138. See Rosenthal, pp. 48–50 on the institution and debate of annual Salons.

139. Calemard de Lafayette, *Salon de 1843*, p. 3. The same observation was echoed in Sazérac, *Salon de 1835*, p. 26; *JdA*, Xᵉ année, vol. I, no. 9 (28 février 1836), pp. 130–31; *La Nouvelle Minerve*, VIII (1837), p. 524; *Revue de Paris*, 4ᵉ série, IV (avril 1842), pp. 122–23; and *Journal des Beaux-Arts*, IXᵉ année, vol. I, no. 8 (19 mars 1842), p. 101.

140. Rosenthal, pp. 23–24.

141. The most recent and fullest account of this phenomenon, albeit one which tends to cast its net a bit too wide, is Pupil, *Le Style Troubadour*, esp. pp. 378–408. Also consult Jacoubet, *Le Genre troubadour*, pp. 188–221 and Rosenblum, "Painting during the Bourbon Restoration," pp. 235–36.

142. About the artists and preferred themes of this neo-Gothic tendency see: Pupil, *Le Style Troubadour*, pp. 410–524; the succinct and important discussion in Chaudonneret, *La Peinture Troubadour*, pp. 13–30; Bourg-en-Bresse, Musée de l'Ain, *Le Style troubadour*; Cuzin's review of this exhibition, "Y a-t-il une peinture troubadour?" pp. 74–81; Lacambre, "La Politique d'acquisition," pp. 337–38; and Rosenblum, "Painting under Napoléon," pp. 168–70.

143. See Rosenthal's discussion, pp. 79–83.

144. Discussed in pt. II, sec. 3.

145. This timely exhibition at the Luxembourg Palace, mounted for the benefit of those wounded during the Trois Glorieuses, opened on 14 October 1830 and figures importantly in pt. II.

146. This cycle of pictures and the *concours* instituted to determine the artists who would execute them is discussed in pt. III, sects. 2 and 3.

147. See pt. IV.

148. "Salon de 1834: Conclusion," *L'Artiste*, VII (1834), p. 162.

149. In addition to our analysis of Louis-Philippe's portraits just above, see pt. III, sec. 1.

150. Schoelcher, "Salon de 1835: 1er Article," *Revue de Paris*, 2e série, XV (1835), p. 330.

151. It is true that essentially the same social conditions had prevailed during the first five years of the Great Revolution and that attempts to produce new types of pictures resulted (see Olander, "Pour transmettre," esp. pp. 275–81). These attempts remained tentative, however, largely because—as Schnapper points out—a relative lack of interest in contemporary history subjects on the part of middle-class patrons, coupled with the rapid pace of political events, worked against any full-scale development of contemporary history painting (Schnapper, "Painting during the Revolution," p. 110). Benoît, who was aware of nearly all the relevant examples of contemporary history paintings from the 1790s, also assessed the net result of their effect as relatively small (*L'Art français sous la Révolution et l'Empire*, pp. 131–44, 338–90). Following our present analysis, we might add that the representational options present in 1830 (notably the experience of *style troubadour* and other historicist manifestations of Romanticism) were not available to painters in the 1790s.

152. This development is discussed by Chastenet, *Une Epoque de contestation*, pp. 136–41. The great innovator in this regard was Emile de Girardin.

153. Hadjinicolaou, *"La Liberté guidant,"* p. 19.

154. Closing an appeal for more pictures of contemporary history, de Nouvion wrote in 1836, "I would be more forceful should I protest against those who deny obstinately that curiosity draws us toward current events, and who maintain that especially in painting we are delighted more by the charms of a far distant past than by the representation of recent events. I would need only to take by the hand all those who still share this idea and lead them to the Louvre gallery. There, they would see that the crowd stops first of all before the few paintings of contemporary history, studies them by trying to discover the locale and the characters, comments upon all their details and circumstances, and only afterwards turns its attention to the surrounding works" ("Salon de 1836," pp. 287–88).

155. F[arcy], "Exposition du Louvre: Deuxième Article," *JdA*, VIIe année, vol. I, no. 10 (10 mars 1833), p. 154.

156. Ch[atelain], "Beaux-Arts: Salon de 1834, Deuxième Article," *Le Voleur*, 7e année, 2e série, vol. III, no. 14 (10 mars 1834), p. 218.

157. [Tardieu], *Salon de 1835*, p. 14. See also Ziff, *Delaroche*, pp. 146–53. The picture is now at Chantilly, Musée Condé, and a copy belongs to the château at Blois.

158. "Salon de 1836: Dixième Article," *Journal des Beaux-Arts*, 3e année, vol. I, no. 17 (8 mai 1836), p. 259.

159. Desessarts, "Salon de 1837: Sixième Article," *Le Voleur*, 10e année, 2e série, vol. I, no. 19 (5 avril 1837), pp. 300–02. See too the articles on the same Salon by Guyot de Fère (*Journal des Beaux-Arts*, 4e année, vol. I, no. 11 [12 mars 1837], pp. 161–67 and no. 15 [26 mars 1837], pp. 193–99).

160. Montalivet, *Le Roi Louis-Philippe*, p. 116.

II: THE JULY REVOLUTION

1. On the situation leading up to the 1830 Revolution refer to Pinkney, *1830*, pp. 44–72. Other useful texts on the events of July 1830 include Blanc, *Dix Ans*, I; Guizot, *Mémoires*, II, pp. 1–34; and

Thureau-Dangin, I, pp. 1–44 on the political maneuvers *after* the fighting.

2. "Rapport au Roi," *Le Moniteur Universel*, no. 207 (Lundi 26 juillet 1830), pp. 813–14.

3. For a discussion of the specific ends sought by the ordinances see Pinkney, *1830*, pp. 42–43.

4. Ibid., p. 43 and Pasquier, *Histoire de mon temps*, VI, pp. 242–45 on the secrecy maintained by the ministers.

5. Pinkney, *1830*, p. 76. Marmont claims he had to borrow a copy of *Le Moniteur* from his neighbor, the baron de Faguel of the Netherlands, in order to read the ordinances (Marmont, *Mémoires*, VIII, pp. 142–43).

6. Pinkney, *1830*, p. 82.

7. Ibid., pp. 91–92.

8. Ibid., pp. 93–94 on the drafting and publication of this "Protestation des Journalistes"; also Blanc, *Dix Ans*, I, pp. 187–88, 478–80, where the text of the protest is reprinted in full.

9. Pinkney, *1830*, pp. 99–108 and Blanc, *Dix Ans*, I, pp. 187–200 chronicle the events of 27 July.

10. Marmont, *Mémoires*, VIII, p. 147.

11. *Ragusard* was commonly used during the 1820s to mean "traitor." See Pinkney, *1830*, p. 101; Blanc, *Dix Ans*, I, p. 189; and Lucas-Dubreton, *Le culte*, pp. 277–78.

12. Newman, "What the Crowd Wanted," pp. 28–29. See also Blanc, *Dix Ans*, I, p. 202 and Gaudibert, "Delacroix et le romantisme révolutionnaire," pp. 9–12.

13. On the events of 28 July see Pinkney, *1830*, pp. 109–21 and Blanc, *Dix Ans*, I, pp. 201–43.

14. See Pinkney, *1830*, p. 129 on the situation and Marmont, *Mémoires*, VIII, pp. 155–56 on his defensive stance.

15. Consult Pinkney, *1830*, pp. 129–36; Blanc, *Dix Ans*, I, pp. 243–98; and Marmont, *Mémoires*, VIII, pp. 157–61.

16. On the importance of Laffitte's house as headquarters see Pinkney, *1830*, pp. 139–40 and Blanc, *Dix Ans*, I, pp. 268–70.

17. The two factions are discussed in Guizot, *Mémoires*, II, pp. 5–6.

18. The Municipal Commission was composed of Lafayette, Casimir Périer, Georges Lobau, Pierre Audry de Puyraveau, and Auguste-Jean de Schoenen. On the installation and the acts of the commission see Pinkney, *1830*, pp. 139–42; Blanc, *Dix Ans*, I, pp. 279–81; and Thureau-Dangin, I, pp. 5–6.

19. On the republican hopes for Lafayette and his indecision consult Pinkney, *1830*, pp. 156–57; Blanc, *Dix Ans*, I, pp. 319–25; and Rémusat, *Mémoires*, II, pp. 345–46.

20. About Bonapartist activity refer to Pinkney, *1830*, pp. 153–54; Blanc, *Dix Ans*, I, pp. 327–32; and Lucas-Dubreton, *Le Culte*, pp. 276–77.

21. Pinkney, *1830*, pp. 145, 154–55 discusses the resources available to Charles X. For accounts of the attempts at reconciliation consult ibid., pp. 147–49; Guizot, *Mémoires*, II, pp. 8–9; and Laffitte, *Mémoires*, pp. 171–73.

22. For a good summary of Orléanist plans see Laffitte, *Mémoires*, pp. 146–47. About the parallels with England in 1688 (a comparison we will return to in pt. III) consult Guizot, *Mémoires*, II, pp. 18–20. Pinkney, *1830*, pp. 150–53 summarizes the power-grabbing moves of the Orléanists and their dismay at Louis-Philippe's failure to appear.

23. For Thiers' version of this interview consult Halévy, *Le Courrier de M. Thiers*, pp. 23–30 and, more summarily, Pinkney, *1830*, pp. 146–47.

24. See pt. I, n. 15 and associated text for this declaration.

25. These measures, dated 31 July 1830, were published in *Le Moniteur Universel*, no. 213 (Dimanche 1 août 1830), p. 829.

26. Pinkney, *1830*, pp. 151–53; Blanc, *Dix Ans*, I, pp. 316–18; Thureau-Dangin, I, pp. 11–13; Laffitte, *Mémoires*, pp. 179–83; and Guizot, *Mémoires*, II, pp. 9–11. The text of the deputies' "invitation" is reproduced in Guizot, p. 9.

27. The complete text of Louis-Philippe's declaration to the inhabitants of Paris is reproduced in Paris, Archives Nationales, *Louis-Philippe*, no. 304. Ten thousand copies of this message were printed and posted throughout the city (see Pinkney, *1830*, pp. 157–59 and Blanc, *Dix Ans*, I, pp. 339–42).

28. Pinkney, *1830*, pp. 159–60 and Blanc, *Dix Ans*, I, pp. 342–44. The text of the deputies' proclamation is reproduced in Guizot, *Mémoires*, II, pp. 371–72.

29. "Commission Municipale—Paris le 31 juillet 1830—Habitans de Paris!" *Le Moniteur Universel*, Supplément extraordinaire au nº du 31 juillet (Edition du Soir). See also the tract entitled "Le Comité central du XIIᵉ arrondissement de Paris à ses concitoyens," cited in Guizot, *Mémoires*, II, pp. 27–28. Other incidents are discussed in Pinkney, *1830*, pp. 160–61.

30. Blanc, *Dix Ans*, I, pp. 346–48 describes the

tactics used by Orléanist supporters to sway Lafayette.

31. For accounts of the crowd's reception consult Pinkney, *1830*, p. 162 and Thureau-Dangin, I, p. 19.

32. The "official" version of this famous scene was printed in *Le Moniteur Universel*, no. 213 (Dimanche 1er août 1830), p. 829, where Lafayette is said to have taken the initiative by moving toward the balcony. Barrot insisted that Louis-Philippe made the first move (*Mémoires*, I, p. 125), while Laffitte claimed that the gesture was entirely mutual (*Mémoires*, pp. 204–05).

33. Pinkney, *1830*, pp. 169–72 and Thureau-Dangin, I, pp. 26–28.

34. Witness Guizot's attitude: "The complete fixity of the Charter, proclaimed immediately following the Revolution, certainly would have been much better for political freedom as well as the country's tranquillity. But no one dared propose it" (*Mémoires*, II, p. 23). For the legislative debate consult Pinkney, *1830*, pp. 183–88 and Thureau-Dangin, I, pp. 29–36.

35. Pinkney, *1830*, pp. 191–94 and Thureau-Dangin, I, pp. 39–40.

36. The ceremony of 9 August is discussed in Pinkney, *1830*, p. 194; Blanc, *Dix Ans*, I, pp. 443–46; and Thureau-Dangin, I, pp. 42–44.

37. For a catalogue of popular histories of the July Revolution see Tavernier, "Iconographie des Trois Glorieuses," pp. 270–72. Other textual accounts (stage works, fictions, poetry) are listed on pp. 276–80.

38. For example, the anonymous *Histoire de la révolution de Paris depuis le 26 juillet jusqu'au 31 août 1830*, p. 181 and Lamothe-Langon, *Une Semaine de l'histoire de Paris*, pp. 157–58.

39. Figure 18: *It's a Woman!*, 1830. Signed lower right "Ed. Swebach." CdV, VI, no. 11.061 (14.4 × 19.7 cm). Figure 19: *The 27th of July—The First Victim*, 1830. CdV, VI, no. 11.062 (22.9 × 31.3 cm).

40. *An Episode from the 1830 Revolution*, signed and dated "Decamps 1830." Paris, Musée Victor Hugo (50 × 39.5 cm). For a discussion consult Mosby, *Decamps*, pp. 76–80 and checklist no. 325.

41. "M. Bordier," wrote Farcy, "represented this young baker before a battalion of soldiers, carrying the cadaver of a woman who had just been struck by a bullet and reproaching them for their deadly dutifulness" ("Exposition du Louvre," *JdA*, IVe année, vol. II, no. 12 [19 septembre 1830], p. 198). Fragonard's lost painting was described as "a canvas of large size, a kind of apotheosis of the unforgettable revolution of 1830. He seized upon one of the first and most noteworthy episodes of the 28th. A baker with an athletic build picks up a young woman struck by a bullet; he carries her over his head like a banner of vengeance. This sight inflames the people's courage at the same time that it casts terror among the soldiers. M. Fragonard has handled his subject poetically from the point of view of both composition and color. He has given his Parisians a larger-than-life scale: it is a noble and ingenious way to paint the magnificent people of July" ("Peinture: Musée Cosmopolite," *JdA*, IVe année, vol. II, no. 26 [26 décembre 1830], pp. 447–48).

42. For example, the histories by Raisson, *Histoire populaire*, pp. 89–90 and Lamothe-Langon, *Une Semaine de l'histoire de Paris*, p. 250. Figure 21: *Act of Courage (28 July 1830)*, 1830. Paris, BN-EST, série Qb1, 28 juillet 1830 (23.5 × 37.2 cm). Figure 22: *Capture of an Artillery Piece*, 1831. Paris, BN-EST, série Qb1, 28 juillet 1830 (27 × 40.3 cm).

43. "Sujets des Tableaux," *JdA*, IVe année, vol. II, no. 6 (8 août 1830), p. 99. A *Barricade Scene* was exhibited by Philibert Rouvière at the Salon of 1831, no. 1856. The dimensions of this now-lost painting were registered at the Louvre as 300 × 355 cm (AL, série *KK, 1831). The same painting was shown at the 1830 Luxembourg exhibition (*livret* no. 573).

44. Hamilton discusses variants of this episode ("The Iconographical Origins," pp. 61–62). In some versions the young man is named Durocher and in others Fournier (see the text accompanying fig. 24 or the comments in Paris, Musée Carnavalet, *Juillet 1830*, nos. 52–56). The fortuitous appearance of an "Arcole" in 1830 demonstrates how memories of Napoléon's military exploits shaped the mythology of the 1830 Revolution (see pt. IV).

45. For this episode see such anonymous histories as *La Grande Semaine ou la guerre des trois jours*, pp. 5–6; *La Liberté française reconquise ou la grande semaine du peuple*, pp. 40–42; *Le Reveil du peuple français*, pp. 9–11; or Lamothe-Langon, *Une Semaine de l'histoire de Paris*, pp. 237–44. Figure 23: *Capture of the Hôtel-de-Ville of Paris, 28 July 1830*, 1830. Paris, Musée Carnavalet, série P.C.Hist. 43F (19.3 × 27.3 cm).

46. Figure 24: *28 July 1830, Incident at the Place de la Grève*, c. 1830–31. Paris, BN-EST, coll. Hennin, t. CLXIV, no. 14395 (22.1 × 31.3 cm). Engraving "Dessiné et gravé par un témoin oculaire" and published by "Leclère, rue des Mathurins St-

Jacques, Nº 10." Figure 25: *The New Pont d'Arcole*, 1830. CdV, VI, no. 11.172 (19.6 × 28.2 cm). Figure 26: *Pont d'Arcole, 28 July 1830*, 1830. Paris, Musée Carnavalet, série P.C.Hist. 43C (20.7 × 31.3 cm).

47. *Capture of the Hôtel-de-Ville.* Salon of 1831, no. 3053. Versailles, MNC, inv. no. MV5186 (145 × 195 cm).

48. Decision of 27 September 1831 (AL, 2DD/4, p. 24; AN, O⁴2821); payment of 1,000 FF in October (AN, O⁴1372, no. 1732, 29 October 1831).

49. For a credible description see Joinville, *Vieux souvenirs*, pp. 46–47.

50. *Revolution of 1830 (29 July): Forming Barricades*, signed and dated "hᵗᵉ Bellangé 1830." CdV, VI, no. 11.218 (32.9 × 42.8 cm).

51. Witness the "camaraderie among workers, the youthful elite, and former army officers; this communal and fraternal existence" noted in the memoirs of Dr. François-Louis Poumiès de la Siboutie, *Souvenirs d'un médecin de Paris* (cited in Bertier de Sauvigny, *La Révolution de 1830*, p. 143). The fraternization of social classes on the barricades is an important theme of the anonymous *Relation des événements de Paris depuis le 26 juillet jusqu'à ce jour*, p. 18.

52. Pinkney's researches—notably his 1964 article, "The Crowd in the French Revolution of 1830"—have demonstrated that by far the greatest number of combatants were neither bourgeois nor simple laborers, but skilled artisans such as stone masons, printers, and tanners.

53. Figure 29: *Shoot the Leaders and the Horses, Young Men . . . to Hell with the Rest*, 1830. Signed "Raffet." Paris, BN-EST, série Dc189, t. 2 (19.4 × 30.9 cm). Figure 30: *Capture of the Porte St. Martin in Paris (28 July 1830)*, 1831. Paris, BN-EST, série Qb1, 28 juillet 1830 (20.5 × 31 cm). Figure 31: *The Three Glorious Days of Paris: 27, 28, and 29 July 1830*, signed and dated in the block "Georgin 1830." Paris, Musée Carnavalet, série G.C.Hist. XV (32 × 53.7 cm).

54. For example, Lamothe-Langon, *Une Semaine de l'histoire de Paris*, pp. 293–94. See also the memoirs of Dr. Ménière, surgeon at the hospital of the Hôtel-Dieu, on the variety of ages, sexes, and social classes which he treated during the fighting (*L'Hôtel-Dieu de Paris en juillet et août 1830*, pp. 168–72).

55. Eymery, *Les Enfans de Paris, ou les petits patriotes.*

56. Pinkney, *1830*, p. 269 and Blanc, *Dix Ans*, I, p. 204.

57. Blanc, *Dix Ans*, I, pp. 194–95 and 204–05.

58. Figure 33: *Porte St-Martin, 28 July 1830*, 1830. Paris, BN-EST, série Qb1, 28 juillet 1830 (31 × 48.4 cm). Figure 34: *Capture of the Marché des Innocents during the Memorable Day of 28 July*, 1831. Paris, BN-EST, série Qb1, 28 juillet 1830 (20.2 × 27.2 cm). Figure 35: *Thursday 29 July: Attack of the Louvre*, 1830. Paris, Musée Carnavalet, série P.C. Hist. 44C (16.2 × 21.4 cm). Lithograph designed by Eugène Levasseur as plate no. 2 of *La Grande Semaine* published "à Paris, chez E. Ardit, éditeur, rue Vivienne nº 2." Figure 36: *Capture of the Château des Tuileries during the Memorable Day of 29 July*, 1830. Paris, BN-EST, série Qb1, 29 juillet 1830 (18.4 × 26.4 cm).

59. Figure 37: Signed and dated in the plate "hᵗᵉ Bellangé 1830." CdV, VI, no. 11.106 (41.1 × 37.2 cm). The French title of this lithograph—*Charbonnier est maître chez lui*—is a proverb dating from the time of François Iᵉʳ with roughly the same meaning as "a man's home is his castle" in English. Figure 38: Signed in the block "J.-B. Thiébaut." Paris, BN-EST, *s.n.r.*, "J.B. Thiébaut" (34.5 × 50 cm). This colored woodblock print was published at Nancy by "la Fabrique de P. Lacour, Graveur, Faubourg Saint-George" and announced in the *Bibliographie de la France*, XX, no. 4 (22 January 1831), p. 53, no. 43. The Bellangé had been announced somewhat earlier (idem., XIX, no. 35 [28 August 1830], p. 582, no. 855) and was copied at Nancy for resale to the locals—an episode which clearly documents how popular imagery was invented and distributed at this time.

60. Lithograph signed in the plate "Julien" and published in 1830. CdV, VI, no. 11.107 (28.5 × 21.7 cm).

61. Illustration from Eymery, *Les Enfans de Paris, ou les petits patriotes*, under the heading "Les Inséparables."

62. Notably, the two studies by Hadjinicolaou: "L'Exigence du Réalisme au Salon de 1831" and "*La Liberté guidant le peuple* de Delacroix devant son premier public." Much the same ideological stance propels Clark's analysis in *The Absolute Bourgeois*, pp. 18–20.

63. Figure 41: *The Kid's Right . . . Those Are the Guys Who Eat . . . (the cake)*, 1830. Signed in the plate "h. Daumier." Paris, BN-EST, série Dc180b réserve, t. I (21 × 18.2 cm). See Delteil, *Le Peintregraveur illustré*, XX (Daumier, I), no. 8. As previously mentioned, the work of Pinkney has been crucial to the recent revision of received truths

about the July Revolution. See also Merriman's introductory essay to *1830 in France*, pp. 1–11.

64. See Newman, "What the Crowd Wanted," pp. 27–29.

65. On this shift consult Rule and Tilly, "Political Process in Revolutionary France," pp. 66–67.

66. Figure 42: *Fighting at the Porte St-Denis*, signed and dated "Hte Lecomte 1830." Salon of 1831, no. 1277. Paris, Musée Carnavalet, inv. no. P.214 (43 × 60 cm). Purchased from a M. Kouck in 1886 for 800 FF. Figure 43: *Fighting in the rue de Rohan*, signed and dated "Hte Lecomte 1831." Salon of 1831, no. 2973. Paris, Musée Carnavalet, inv. no. P.213 (43 × 60 cm). Bought in 1881 from a M. Dandois for 1,500 FF.

67. Both prints were announced in the *Bibliographie de la France*, XX, no. 22 (28 mai 1831), p. 388, no. 481. Examples exist in Paris, BN-EST, série Ef296g (f°4) as recorded in the *Inventaire du fonds français*, XI, pp. 297–98, "Jazet," no. 155.

68. The role of character types in popular imagery is not unrelated to the way stock characters function in the *Commedia dell'Arte* where, as Bryson has noted, the acting is "less verbal and script-dominated and far more closely bound to somatic character-typing, and to physical exertion" than classic French theater. The resulting theatrical form—offering fragmented vignettes rather than one continuous narrative—is not unrelated to the disjointed narrative structures of the imagery we are discussing (see Bryson, *Word and Image*, pp. 77–79).

69. Salon of 1831, no. 1398. Versailles, MNC, inv. no. MV6310 (142 × 163 cm). Purchased by the museum in 1889 (AL, V°, letter dated 1 February 1890).

70. Blanc, *Dix Ans*, I, pp. 257–58. See too the detailed account by Coutan, *Rapport sur les événements* (Bibliothèque Nationale, Département des Imprimés, 8°Lb⁴⁹1664).

71. *Capture of the Babylone Barracks*, 1830. Paris, BN-EST, série Qb1, 29 juillet 1830 (19.2 × 27.6 cm). Lithograph designed by Victor Adam and catalogued by Tavernier, p. 267, "Caserne de Babylone," no. 4.

72. Tardieu, *Salon de 1831*, p. 197.

73. *An Episode near the Louvre during the 1830 Revolution*, signed and dated "Bézard 1832." Salon of 1833, no. 163. Paris, Musée Carnavalet, inv. no. P.5 (175 × 245 cm). Purchased from a M. Baur in 1890 for 500 FF.

74. Paris, Musée Carnavalet, inv. no. P.5ᵇⁱˢ (81 × 106 cm).

75. Pinkney, *1830*, pp. 233–34.

76. *The July Dead*, signed and dated "Peron 1834." Salon of 1835, no. 1705. Paris, Musée Carnavalet, inv. no. P.256 (131 × 164 cm). Purchased from a M. Tartas in 1887 for 300 FF.

77. *The 30th of July*, signed and dated "Al. Roehn fils 1831." Salon of 1831, no. 1813. Paris, Musée Carnavalet, inv. no. P.300 (191 × 272 cm). Acquired sometime before 1870, but apparently no records of the transaction survive.

78. "The prospect of its background lacks atmosphere," wrote Tardieu, "the width of the Seine is not perceived between the Louvre and the Institut" (*Salon de 1831*, p. 111).

79. Ibid.

80. For an analysis of the importance ascribed by Romantics of the 1820s to eighteenth-century painting see Duncan, "Persistence and Re-Emergence," pp. 49–54, 61–130.

81. Lenormant, *Les Artistes contemporains*, I, p. 73.

82. *L'Observateur aux Salons de 1831*, p. 10.

83. Signed "G. Courbet." Painted in 1849 and shown at the Paris Salon of 1850, no. 1661. Paris, Musée d'Orsay, inv. no. RF325 (315 × 668 cm). For a discussion of Courbet's critics see Clark, *Image of the People*, pp. 136–38, and for samples of their venom consult Riat, *Courbet*, pp. 86–88.

84. Pillet, for example, praised the Roehn even as he noticed that "secondary figures nevertheless spread out across the near ground of the picture, where they seem busy with private concerns: there are widows who mourn their spouses; and mothers, unable to tolerate the spectacle of inhumation, who begin to move away in order to give freer rein to the tears they choke back. All of this is felt and rendered with talent" ("Beaux-Arts: Salon de 1831—6ᵉ article," *Le Moniteur Universel*, no. 150 [Lundi 30 mai 1831], p. 1024). Obviously, the empathy produced more than excused Roehn's disjointed composition.

85. Signed and dated "Jeanron 1830." Salon of 1831, no. 1121. Caen, Musée des Beaux-Arts (100 × 80 cm).

86. See the commentary in Paris, Archives Nationales, *Louis-Philippe*, no. 320.

87. For a description of the urchins of Paris during the Trois Glorieuses—in particular their cold-blooded courage—refer to the eyewitness account offered by the duc de Broglie (*Souvenirs*, III,

pp. 298–99). An even more accurate image of these youngsters than the one offered by Jeanron would have been the now-lost painting by J. Alphonse Testard shown at the Luxembourg gallery in 1831 (no. 245): it represented a young boy of about thirteen who, "walking calmly up to a Swiss officer who was leading soldiers against us, killed him with a pistol shot."

88. Lenormant, *Les Artistes contemporains*, I, p. 71. See too the admiration for Jeanron's picture expressed by Planche (*Salon de 1831*, p. 233) and Schoelcher (*L'Artiste*, I, [1831], p. 228).

89. For example, Greuze's picture of *The Broken Eggs* (exhibited at the Salon of 1757, no. 112), in which a young boy attempts to repair one of the cracked eggs while remaining naively indifferent to the real cause of his mother's anger (New York, Metropolitan Museum of Art, inv. no. 20.155.8 [73 × 94 cm]).

90. Jeanron was made director of the Louvre after the 1848 Revolution and renamed it the Palais du Peuple—needless to say, his tenure was short-lived. The only complete study of Jeanron is the unpublished 1935 thesis done by Madeleine Rousseau at the Ecole du Louvre. About the political themes of Jeanron's pictures during the early 1830s see Chaudonneret, "Jeanron et 'l'art social': *Une Scène de Paris*."

91. About this refused painting refer to the Salon review by Schoelcher in *L'Artiste*, I (1831), p. 228.

92. Purchased by the Interior Ministry for 800 FF (AN, F⁴*504, no. 2209, 8 September 1831).

93. *Episode from the Morning of 29 July 1830.* Salon of 1831, no. 283.

94. Signed and dated "Latil 1831." Salon of 1835, no. 1256. Tarbes, Musée Massey, inv. no. 878.1.10 (90 × 116.5 cm). The Musée Fabre at Montpellier owns a small sketch (11 × 16 cm) for this painting which has been incorrectly catalogued as *An Episode of the June Days in 1848* (Montpellier, *Catalogue des peintures*, p. 98, no. 341).

95. Figure 52: *29 July 1830: He stole!*, ca. 1830. Signed in the plate "Charlet." CdV, VI, no. 11.267 (14.9 × 16.6 cm). Blanc, *Dix Ans*, I, p. 272 describes these ad hoc executions.

96. On the moral lessons and didactic compositional clarity of Greuze's paintings consult Rosenblum, *Transformations*, pp. 51–53.

97. *The 29th of July 1830*, signed "Senties."

Salon of 1831, no. 2986. Paris, Musée du Louvre, inv. no. INV20689 (392 × 418 cm). The history of this picture is unclear: it was returned to the Louvre from Chambéry on 18 June 1976, but a search of Parisian archives yielded no clues as to when or how the painting first entered the national collections.

98. Hippolyte Bellangé exhibited a watercolor at the 1831 Salon (no. 114), *Episode of 29 July 1830*, which represented the same story as the painting by Senties (see Tardieu, *Salon de 1831*, p. 208). According to Farcy, Adolphe Roëhn sent to the small exhibition at the Louvre in late 1830 a picture representing "one of the students of the Ecole Polytechnique killed inside the Tuileries Palace and laid upon the royal throne by those whom he had lead to victory" ("Exposition au Louvre dans le local des Amis des Arts," *JdA*, IVᵉ année, vol. II, no. 19 [19 septembre 1830], pp. 197–98). At the Musée Cosmopolite, on the other hand, Théophile Fragonard's picture recounted "the remarkable episode from the 29th which took place in the Throne Room of the Tuileries. Several students of the Ecole Polytechnique placed upon the throne itself the body of a young cavalry officer previously freed from the Abbaye Prison, where he had been put for insubordination. Fighting in concert with the people, he was mortally wounded in the rue de Rohan and died in the kings' palace" ("Peinture: Musée Cosmopolite," *JdA*, IVᵉ année, vol. II, no. 26 [26 décembre 1830], p. 447). Tavernier catalogues four popular print variants of this same episode (pp. 254–55, nos. 91–94).

99. The oath-taking tradition referenced here, and especially Hamilton's *Oath of Brutus*, is discussed in detail by Rosenblum, "Gavin Hamilton's *Brutus* and Its Aftermath," pp. 8–16.

100. "Salon de 1831," *L'Artiste*, I (1831), p. 292.

101. Tardieu, *Salon de 1831*, p. 208.

102. Salon of 1831, no. 353. Orléans, Musée des Beaux-Arts, inv. no. 215 (39 × 46 cm). Given to the museum in 1892 as part of the Cogniet-Thévenin bequest.

103. The story is repeated in Debraux, *Les Barricades de 1830*, pp. 190–93 and Maury, *Evénemens du 29 juillet 1830*, pp. 7–8.

104. Signed and dated "Peint par LeBarbier l'an II de la République." Salon of 1795, no. 303. Nancy, Musée des Beaux-Arts (317 × 453 cm). For a discussion of this picture consult Rosenblum, *Transformations*, pp. 91–92.

105. Lithograph signed in the plate "Charlet"

and published in 1818. Paris, BN-EST, série Dc102 (34.3 × 46.3 cm). Catalogued in De La Combe, *Charlet*, no. 39.

106. Signed and dated "J.B. Suvée f. 1787." Salon of 1787, no. 16. Dijon, Musée des Beaux-Arts, inv. no. INV465 (325 × 260 cm). For a complete bibliography refer to New York, *The Age of Revolution*, no. 169.

107. Purchased for 1,000 FF as authorized by decision dated 27 September 1831 (AL, 2DD/3, p. 67) and paid on 3 November 1831 (AN, O⁴1373, no. 1792).

108. The explanation of Cogniet's allegory is found in the article, "Exposition au Louvre dans le local des Amis des Arts," *JdA*, IVᵉ année, vol. II, no. 12 (19 septembre 1830), p. 197. I was unable to trace the present location of this original oil painting.

109. *Four Flags*, 1830. CdV, VI, no. 11.116ᵇⁱˢ (19.4 × 35.3 cm).

110. Lithograph published in 1831. CdV, VI, no. 11.368 (56.6 × 46.1 cm).

111. Salon of 1802, no. 907. Rueil-Malmaison, MNC (192.5 × 184 cm). For a complete catalogue entry consult New York, *The Age of Revolution*, no. 80. About Ossianic poetry as inspiration for artists refer to Hamburg, Kunsthalle, *Ossian und die Kunst um 1800*.

112. Lucas-Dubreton, *Le Culte*, p. 140.

113. Ibid., pp. 239–40; Vaulabelle, *Histoire des deux Restaurations*, VII, pp. 169–70; and Lamartine, *Restauration*, VIII, pp. 43–47.

114. Vaulabelle, *Histoire des deux Restaurations*, VII, pp. 306–11.

115. Thiers, *Révolution française*, I, p. 110.

116. Lamartine, *Restauration*, VIII, pp. 76–77.

117. We will discuss Bailly's role in 1789 and his execution as represented in paintings during the 1830s and 1840s in pt. III, secs. 4 and 9. About Charlotte Corday's imagery during the July Monarchy see pt. III, sec. 10.

118. Generalized allegories inspired by contemporary events were, of course, part of the tradition of history painting inherited from previous centuries. For eighteenth-century political allegories see Locquin, *La Peinture d'histoire*, pp. 281–82.

119. *Force Regained Her Noble Colors during the Three Memorable Days of July 1830*, signed "Blondel." Luxembourg exhibition of 1830, no. 319. Beauvais, Musée Départemental de l'Oise (78 × 59 cm). Purchased by the museum in 1971.

120. *The Charter of 1830*, undated oil sketch initialed "BL." Gray, Musée Baron Martin, inv. no. RF 1956–17 (32 × 23 cm). Purchased from the Blondel atelier sale in December 1853 by M. Dutilleul-Francoeur and given to the museum.

121. See pt. III, sec. 5 for a discussion of this slogan and the dispute as to whether "The Charter" or "A Charter" would be established.

122. The notion of a mold (*moule*) in this context is Delacroix's. For a discussion of the concept vis-à-vis his picture of *The 28th of July* consult Hofmann, "Sur la *Liberté* de Delacroix," pp. 63–65.

123. *The People, Victorious in July 1830*. Undated ink drawing. Montauban, Musée Ingres, inv. no. MI 867.2791 (27.3 × 22.8 cm).

124. See Schnapper's discussion of David's decorations for the Fête de la Fraternité celebrated in Paris on 10 August 1793 and, in particular, the Hercules figure erected on the place des Invalides (*David*, pp. 138–40). David reused Hercules as an emblem of the French people on the theater curtain he designed in 1794 for the Opéra (ibid., pp. 142–43 and Rosenblum, *Transformations*, pp. 80–81).

125. For relevant excerpts of Ingres' thoughts on this issue consult Delaborde, *Ingres*, pp. 150–51.

126. For a general review of this internal strife see Thureau-Dangin, II, pp. 1–7. Blanc, who tends to sympathize with these insurrections, describes them in detail in *Dix Ans*: for the Paris skirmishes see II, pp. 442–44; about the Lyon insurrection, III, pp. 45–80; concerning Grenoble, III, pp. 173–93; and for the June riots in Paris, III, pp. 265–315.

127. On the regrouping and activity of the *Société des droits de l'homme* in 1833 consult Thureau-Dangin, II, pp. 212–16 and Blanc, *Dix Ans*, IV, pp. 103–19.

128. Thureau-Dangin, II, pp. 232–33 and Blanc, *Dix Ans*, IV, pp. 197–200. See also our discussion in pt. III, sec. 6.

129. Viel-Castel, "Beaux-Arts: Salon de 1833," *Bagatelle* (1833), p. 230, where the Bézard is referred to as "a massacre-scene of Swiss Guards at the Louvre."

130. Thureau-Dangin, I, pp. 228–34 and Blanc, *Dix Ans*, II, pp. 266–75.

131. On anticlericalism after 1830 and the government's policies toward the Catholic Church consult Thureau-Dangin, I, pp. 246–59 and Pinkney, *1830*, pp. 310–11.

132. Formulas such as "by the grace of God" were strictly avoided in government texts (Thur-

eau-Dangin, I, p. 255). When the archbishop of Paris wrote to Queen Marie-Amélie on 20 November 1832 to express his shock at a recent attempt on the king's life, he added that "if well-known circumstances do not permit me to express them in person, I take the liberty to beg you, Madame, to please become our spokesman near the King and offer him the good wishes which religion sends to him" (AN, 300 APIII 46). The Queen's personal feelings about the state of affairs in 1831 are gleaned from this entry in her journal: "By going out onto the terrace, I had the misfortune to see destroyed the fleurs-de-lys which had decorated the balconies. Perhaps an initial outburst of pride made me too sensitive to this destruction of my family's coat-of-arms, but it was distressing to see that every popular whim was yielded to in that way. When the crucifix has been struck down, every other feeling should hold its tongue" (cited in Thureau-Dangin, I, p. 233).

133. Signed and dated "N. Gosse 1832." Salon of 1833, no. 1098. Versailles, MNC, inv. no. MV6866 (265 × 340 cm). The decision to purchase this work is dated 6 June 1833 (AL, 2DD/4, p. 154) and the price of 2,000 FF was paid on 29 June (AN, O⁴1471, no. 1767). A similar scene by Alexandre Caminade, *Visit of the Queen to the Hôtel-Dieu after the July Days of 1830* (Salon of 1834, no. 272), was commissioned in 1832 by the Interior Ministry for 3,000 FF (AN, F⁴*505, no. 1683, 25 August 1832, 1,000 FF; idem., no. 2539, 26 December 1832, 1,000 FF; idem., no. 3135, 7 August 1833, 1,000 FF). The picture was sent to Bordeaux on 18 June 1834 (AN, F²¹498). Unfortunately, the canvas—recorded in museum documents as 149 × 210 cm—was destroyed in a fire at the museum on 7 December 1870.

134. The Queen's visit to the Hôtel-Dieu was reported in *Le Moniteur Universel*, nº 217 (Jeudi 5 août 1830), p. 485. I was unable to find any newspaper report of a similar visit to the Bourse as recorded by Gosse.

135. Lyon, Musée des Beaux-Arts (112 × 146 cm). There is some question as to whether this picture dates from 1772 or 1775 (see Brookner, *Greuze*, pp. 119–20).

136. *Histoire de la révolution de Paris depuis le 26 juillet jusqu'au 31 août 1830*, pp. 195–96.

137. Ibid.

138. [Tardieu], *Salon de 1833*, pp. 73–75 names, along with M. Julien, nearly all the notables in this picture by Gosse.

139. According to Blanc, when the duchesse d'Orléans addressed a few words of consolation to a wounded royal guard, one of her aides reminded her that "this visit is not simply humanitarian, it is a political visit," and he steered her toward one of the wounded freedom-fighters of July (*Dix Ans*, I, pp. 379–80).

140. Signed and dated "Gosse 1830." Paris, Musée Carnavalet, inv. no. P.127 (27 × 35 cm). Gift to the museum in 1896 of M. Guillon, whose father had been the doctor in charge of the infirmary established at the Bourse during the Trois Glorieuses.

141. On the particular ire directed against the Jesuits see Thureau-Dangin, I, pp. 248–49. Caricatures of Charles X in exile frequently depicted him in the habit and hat of a Jesuit: e.g., CdV, VI, nos. 11.421, 11.471, 11.476, 11.485.

142. It continued unabated during the July Monarchy. Lina Vallier represented the duc d'Orléans visiting the sick in the hospital of Val-de-Grâce: Versailles, on loan to the Musée de Val-de-Grâce, inv. no. MV6713 (80 × 100 cm). Similarly, Alfred Johannot apparently planned but never executed a work which would have portrayed the duc d'Orléans visiting the sick during the cholera epidemic of 1832: see the signed and dated sketch in Paris, Musée Carnavalet, inv. no. P.603 (32.5 × 43 cm).

143. Signed and dated "Gros, 1804 à Versailles." Luxembourg exhibition of 1830, no. 108; Salon of 1804, no. 224. Paris, Musée du Louvre, inv. no. INV5064 (532 × 720 cm).

144. Rosenblum, *Transformations*, pp. 96–97.

145. See nn. 47–48 above.

146. Signed "Beaume & Mozin." Salon of 1831, no. 106. Versailles, MNC, inv. no. MV5187 (145 × 210 cm). Registered in the inventories of the *Domaine privé* on 27 September 1831 (AL, 2DD/3, no. 84) but actually acquired in July (AN, O⁴1373, no. 1077, 10 July 1831, 4,500 FF).

147. Pinkney, *1830*, p. 113.

148. Tardieu, *Salon de 1831*, p. 107.

149. The incident referred to is Greuze's bid for admission as a history painter (*peintre d'histoire*) on the merits of his picture *Emperor Septimus Severus Reproaches His Son Caracalla for Wanting to Have Him Killed*, and its rejection by the Academy: see Brookner, *Greuze*, pp. 65–70 and Crow, *Painters and Public Life*, pp. 163–74. The painting is now in Paris, Musée du Louvre, inv. no. INV5031 (124 × 160 cm).

150. "Salon de 1831," *L'Artiste*, I (1831), p. 270.

151. Increasing the present figures (about 20 cm tall) to a size of one meter would imply a magnification ratio of 5:1, or overall dimensions of approximately 725 × 1050 cm.

152. For a discussion of panoramas in Paris between 1800 and the end of the July Monarchy consult Oettermann, *Das Panorama*, pp. 113–28.

153. "Nouvelles," *JdA*, Vᵉ année, vol. I, no. 4 (24 janvier 1831), p. 71.

154. One critic, addressing the viewer, was sure that "in your delight, [you] will forgive M. Daguerre for having taken certain liberties which are called shortcuts [*partis*] in painting, and which often mean untruths; and you will not quarrel with him for having depicted a sun of six o'clock in the evening when the clock reads one-thirty in the afternoon" ("Nouveau tableau de M. Daguerre représentant le 28 juillet à l'Hôtel-de-Ville," *JdA*, Vᵉ année, vol. I, no. 5 [30 janvier 1831], p. 82). Pillet recorded that the viewpoint of the Beaume/Mozin painting was identical to Daguerre's panorama ("Salon de 1831: Peinture—Deuxième Article," *Le Moniteur Universel*, no. 22 [Samedi 22 janvier 1831], p. 143).

155. The royal visit took place on 20 January and was reported in *Le Moniteur Universel*, no. 22 (Samedi 22 janvier 1831), p. 143.

156. Figure 69: Vernet's original was shown at the Salon of 1834, no. 1894. Recorded in the Salon registers as 270 × 175 cm (AL, série *KK, 1834), the picture was destined for the galeries historiques of the Palais-Royal. The Vernet was apparently returned to the Orléans family in 1851 (AN, 300 API 1113, "Etat des 17 tableaux dont la reprise de possession a été fait au Louvre par M. Lefiot, le 17 septembre 1851," no. 8). I have been unable to confirm whether the picture is, indeed, in the possession of the Comte de Paris. Our illustration, therefore, is of a small replica executed in 1836 by Carbillet: Versailles, MNC, inv. no. MV1808 (121 × 87 cm). Commissioned on 16 September 1836 for 600 FF (AL, 2DD/4, p. 57) and paid for on 3 November (AN, O⁴1644, no. 4665). Figure 70: Salon of 1833, no. 2356. Versailles, MNC, inv. no. MV5185 (228 × 258 cm). The commission of 10,000 FF was paid to Vernet on 27 May 1833 (AN, O⁴1471, no. 1160). Vernet's relationship with Louis-Philippe dated from 1817, the year he was awarded a portrait commission. On their pre-1830 contacts see Dayot, *Les Vernets*, pp. 139–40 and Lagrange, "Artistes contemporains: Horace Vernet," pp. 304–06.

157. Fontaine's watercolor—apparently in a Parisian private collection—is reproduced in Mme David-Roy, "Fontaine: 'LeBrun' de Louis-Philippe," fig. 3. Consult pp. 168–70 of this article for excerpts from Fontaine's journal concerning the sketch. The letter in question from Louis-Philippe to his ambassador is dated 7 March 1831 and is published in Suffel, "Le Roi des barricades," p. 373.

158. In his letter of 5 July 1832 Vernet complains that "the two pictures—one representing the lieutenant-général of the Kingdom going to the Hôtel-de-Ville, and the other the arrival of His Majesty the duc d'Orléans at the Palais-Royal on the 30th of July 1830—would be finished if the few points of information which I asked for in vain had been supplied. Three letters written on the subject have remained unanswered" (see Suffel, "Le Roi des barricades," p. 374). This information contradicts the commission date of 26 March 1833 recorded in the archives (AL, 2DD/4, p. 485 and 2DD/23, p. 166). It is possible that a transcription error inadvertently changed "1832" to "1833" or that the archives date is when the pictures were actually received in Paris and inscribed on the inventories.

159. This gallery, although destroyed in the 1848 Revolution, is partially accessible today through the volume of lithographs and historical texts published by Vatout, Louis-Philippe's librarian, under the title *Histoire lithographiée du Palais-Royal*.

160. On 31 July 1830 the Municipal Commission had asked Parisians to place lamps in their windows so as to illuminate the city's streets, since nearly every street lamp had been broken in the fighting (Pinkney, *1830*, p. 231). The prince de Joinville remembered Paris that night as "very unusual: completely illuminated, with lanterns and flags at every window" (*Vieux souvenirs*, p. 46).

161. See n. 27 above.

162. Planche, "Salon de 1834," in *Etudes sur l'école française*, p. 254 and Decamps, *Salon de 1834*, p. 85. For a discussion of Vernet's *Camille Desmoulins* see pt. III, sec. 7.

163. "There is certainly the verve and know-how of the master in it," wrote Farcy, "but not enough interest in the composition, which seems a little disjointed" ("Salon de 1834: 3ᵉ article," *JdA*, VIIIᵉ année, vol. I, no. 11 [16 mars 1834], p. 169). "To the degree that events like those of the three days recede into the perspective of the past," observed

LeGo, "they usually grow larger and acquire a new poetry. Did M. Vernet, to the contrary, want to make the action of this great drama seem smaller? We find in his characters only some peddlers of exit passes" ("Salon de 1834: Quatrième Article," *Revue de Paris*, n.s., III [mars 1834], p. 328). See also Sazérac, *Salon de 1834*, pp. 66–67 and F. Ch[atelain], "Beaux Arts: Salon de 1834—Deuxième Article," *Le Voleur*, VIIᵉ année, 2ᵉ série, no. 14 (10 mars 1834), p. 220.

164. Although archival records of this transaction are incomplete, Louis-Philippe apparently paid 10,000 FF for the picture (AL, 2DD/23, p. 166 and AN, 300 API 1113, "Etat des tableaux . . ." dated January 1832). About the later copy see n. 156 above.

165. "Salon de 1834: Peinture," *L'Artiste*, VII (1834), p. 85.

166. Thureau-Dangin, II, p. 234 and the texts cited in n. 126 above.

167. Letter of Louis-Philippe to the comte de Saint-Aulaire, French ambassador to Rome, dated 7 March 1831 (cited in Suffel, "Le Roi des barricades," p. 373).

168. Blanc, *Dix Ans*, I, pp. 349–50; Broglie, *Souvenirs*, III, pp. 343–45; and Laffitte, *Mémoires*, pp. 198–200.

169. Broglie, *Souvenirs*, III, p. 343.

170. Planche, "Salon de 1833," in *Etudes sur l'école française*, pp. 195–206.

171. Jal, *Salon de 1833*, p. 130.

172. *Louis-Philippe d'Orléans Proclaimed Lieutenant-Général of the Kingdom.* Salon of 1833, no. 2828. Paris, Musée Carnavalet, inv. no. G.C.Hist. XV (42.2 × 53 cm). Lithograph by Aubry-le-Comte after Guillon Lethière.

173. Lethière (1760–1832) was a contemporary of David who had trained in the studio of Doyen and had been one of Ingres' professors at the French Academy in Rome. Vilain's comment that Lethière was a neoclassicist who "extended too far into the 19th century formulas which had already become outdated" is not entirely unjustified (New York, *The Age of Revolution*, p. 537).

174. E.g., the print *Here's the King We Needed!*, reproduced in Paris, Musée Carnavalet, *Juillet 1830*, no. 200, p. 75.

175. Signed and dated "J.L. David faciebat anno 1791." Paris, Musée du Louvre, Cabinet des Dessins, inv. no. RF1914 (65 × 105 cm). Placed on loan at Versailles, Musée National du Château.

176. "Nouvelles," *JdA*, Vᵉ année, vol. II, no. 17 (22 octobre 1831), p. 295.

177. The purchase of 60 prints at 15 FF each was recorded in detail by the king's bookkeeper (AN, O⁴1373, no. 1274, 2 août 1831, 900 FF). We learn from a post-1848 inventory that Lethière's sketch, measuring 214 × 164 cm, was hanging at Nº 179 of the Palais-Royal in a room overlooking the courtyard used by the princes, and that it survived the Revolution in good shape—perhaps it still exists among the Orléans family collections (AN, 300 API 1113, "Inventaire de tableaux du Palais-Royal").

178. On the plans for a Salle Gérard see Aulanier, *Histoire du Palais et du Musée du Louvre*, VII, pp. 95–96. Figure 195: Salon of 1810, no. 347. Versailles, MNC, inv. no. MV2765 (510 × 958 cm). Figure 73: Salon of 1817, no. 372. Versailles, MNC, inv. no. MV2715 (510 × 958 cm). About this picture see the article by Kaufmann, "François Gérard's *Entry of Henry IV into Paris*." Figure 74: Completed in 1835. Versailles, MNC, inv. no. MV2786 (550 × 442 cm).

179. *The State of National Emergency* and *Hôtel-de-Ville* were commissioned on 29 October 1831 at 25,000 FF each (AL, 2DD/5, p. 4). The final payment for the *Hôtel-de-Ville* was made on 6 July 1835 (AN, O⁴1607, no. 2875) and the first payment toward the other followed four months later (O⁴1607, no. 6170, 11 November 1835). Gérard died in 1837, however, and apparently left the picture unfinished, although his widow was paid 8,333.34 FF in 1839 for delivering the canvas to the Royal Museums on 7 June 1838 (AN, O⁴1775, no. 9092, 23 April 1839). I have been unable to locate the complete payment records for this canvas, but the fact that Gérard's picture was neither exhibited posthumously at the Salon nor hung in a public place suggests that it was incomplete and that the Crown paid Gérard's widow as a gesture of homage to her husband. Much later, in 1892, a picture of *The State of National Emergency*, attributed to Baron Gérard, was sent by the Ministry of Public Instruction to La Madeleine-les-Lille (AN, F²¹142, dossier "Gérard," 15 March 1892). At that time, a note was made that the picture "appears neither in the Archives nor on the departmental reports," and the attribution was left in doubt—indications, it seems, that the picture was not signed and never properly inventoried as a completed picture would have been. Unfortunately, no trace of the canvas has yet been found in La Madeleine, although the print published by Boime

in *Couture* (pl. VII.37) could indeed be of the lost Gérard painting.

180. Francastel, *La Création*, pp. 32–34 and Gaehtgens, *Versailles*, pp. 92–96, 285–86.

181. "3ᵉ Visite du Roi," AC, 91G-I, 18 January 1834 and Francastel, *La Création*, p. 32.

182. "19ᵉ Visite du Roi," AC, 91G-I, 18 October 1834.

183. Ibid. Also read Francastel, *La Création*, p. 33, for his analysis of the professional infighting between Nepveu and Fontaine, Louis-Philippe's chief architect.

184. "24ᵉ Visite du Roi," AC, 91G-I, 24 December 1834.

185. "19ᵉ Visite du Roi," AC, 91G-I, 18 October 1834.

186. "20ᵉ Visite du Roi," AC, 91G-I, 31 October 1834.

187. Pierre Franque performed the work ("l'agrandissement du tableau par M. Gérard des députés à l'Hôtel-de-Ville," AN, O⁴1644, no. 3225, 26 August 1836, 440 FF).

188. The complete declaration is reprinted in Guizot, *Mémoires*, II, pp. 371–72. Laffitte, who had begun to read the text but hesitated slightly, was supposedly deprived of his moment of glory by Viennet, who grabbed the paper and read it, thus usurping Laffitte's place in history (Laffitte, *Mémoires*, pp. 202–03). Laffitte's tale, and his plaint vis-à-vis Gérard's picture, reminds us how such images were "read" in the nineteenth century: "I would have appeared there in full length in the foreground, directly facing him [i.e., Louis-Philippe], the two of us making eyes at one another; it was an extremely good opportunity for me, for I had never had my portrait done. But since M. Viennet had read for me, I could not pose in his place, and our great-nephews will contemplate his face and not mine" (Laffitte, *Mémoires*, p. 199).

189. For a key to the personalities see CdV, VI, no. 11.598ᵗᵉʳ. It is more than curious to note that Laffitte, who had a falling out with Louis-Philippe in 1834–35, was placed *behind* the soon-to-be king: he is the high-collared, light-haired individual just midway between Louis-Philippe and Lafayette (who stands in profile near the left side).

190. My analysis emphasizing the picture's "covert" support of a particular view of the event owes a debt to Althusser's description of how the Ideological State Apparatus (ISA) functions in culture ("Ideology and the State," pp. 137–40).

191. Larivière's original was shown at the Salon of 1836, no. 1126. Versailles, MNC, inv. no. MV2785 (550 × 1205 cm). Commissioned on 8 November 1834 for 16,000 FF (AL, 2DD/4, p. 315) with 6,000 FF of supplementary compensation added to the commission on 2 December 1835 (AL, 2DD/23, p. 94). Work and payments proceeded for slightly more than one year (AN, O⁴1526, no. 5485, 1 December 1834, 4,000 FF; O⁴1527, no. 7403, 16 March 1835, 4,000 FF; O⁴1587, no. 2084, 3 June 1835, 4,000 FF; O⁴1589, no. 7760, 14 January 1836, 4,000 FF; O⁴1589, no. 8645, 21 February 1836, 6,000 FF). Rather than illustrating Larivière's full-sized picture (in bad shape and currently undergoing restoration), I reproduce a small replica by Eloi Féron: Versailles, MNC, inv. no. MV5796 (122 × 149 cm). Commissioned on 31 January 1837 for 700 FF (AL, 2DD/4, p. 131) and completed in March (AN, O⁴1705, no. 445, 9 March 1837).

192. For a key to these portraits consult CdV, VI, no. 11.383. The iconographic continuity with Vernet's picture makes sense, given the planned project to publish engravings of all these official images in book form.

193. "Finally," wrote de Nouvion, "the poorly understood background in no way defines a sufficiently great distance to justify this exaggerated accumulation of heads which diminish in size much too rapidly" ("Salon de 1836," p. 289).

194. "In M. Larivière's canvas," wrote Planche, "although there is a middle and two sides for those who read broadsheets, although the lieutenant-général is placed between Lafayette and Dupin, nevertheless every part of this canvas has the same pictorial importance and your glance does not know where to stop. I am not saying that the episode represented by M. Larivière is not accurately reproduced; I am saying that it is not reproduced in a pictorial manner" ("Beaux-Arts: Salon de 1836, Septième Article," *Chronique de Paris*, n.s., II, no. 5 [17 avril 1836], p. 72). Similarly, *L'Artiste* noted that "the enormous expanse directs your attention to many points and makes it difficult to focus on the interesting part" ("Salon de 1836: IVᵉ Article," *L'Artiste*, XI [1836], p. 97). Variants of this idea were repeated by nearly every critic who commented upon Larivière's picture.

195. On this process consult Moss, "Parisian Workers and the Origins of Republican Socialism" and Pilbeam, "The Emergence of Opposition to the Orléanist Monarchy."

196. The votes on the three laws were 212, 224, and 226 respectively for the measures and 72, 149, and 153 against. For a discussion of the legal steps taken after the assassination attempt on 28 July 1835 refer to Thureau-Dangin, II, pp. 318–329.

197. Quoted ibid., p. 323.

198. Alexandre Tardieu, "Beaux-Arts: Salon de 1836—Premier Article," *La Nouvelle Minerve*, IV (1836), pp. 322–23. Among the "disenchanted men" would have been not only Lafayette, but also Barrot, Laffitte, and their liberal colleagues.

199. Ibid., p. 318.

200. AL, 2DD/4, p. 444, 31 July 1835, 9,000 FF.

201. See pt. I, n. 41.

202. "43e Visite du Roi," AC, 91G-I, 17 August 1835. "I had just finished that very morning," wrote Nepveu in this report, "the installation of the six large pictures which decorate this new room, pictures which I had only received the day before."

203. *The duc d'Orléans at the Barrière du Trône, Accompanied by the duc de Chartres and the duc de Nemours, 4 August 1830*, 1836. Versailles, MNC, inv. no. MV1812 (118 × 88 cm). Commissioned on 2 July 1836 for 1,500 FF (AL, 2DD/4, p. 445 and 2DD/5, p. 54), Scheffer was paid on 4 August 1836 (AN, O⁴1643, no. 2873).

204. Payment of 500 FF to an artist named Badin for enlarging Scheffer's painting (AN, O⁴1705, no. 377, 3 March 1837). The king inspected the Salle de 1830, completely freed of scaffolding, on 29 October 1836 ("80e Visite du Roi," AC, 91G-I). One might ask why Badin was paid in March for work supposedly done during the previous October: I can only suggest that the Crown was very slow about paying its "common" workers. Badin, in fact, would have had to perform the work before 29 October because the Scheffer, like all the pictures in this gallery, was built into the woodwork of the walls.

205. Devéria's original was completed in 1836. Versailles, MNC, inv. no. MV2788 (550 × 940 cm). Commissioned on 8 November 1834 for 14,000 FF (AL, 2DD/4, p. 92), the payments are as follows: AN, O⁴1527, no. 7300, 5 March 1835, 4,666.66 FF; idem., no. 8938, 11 September 1835, 2,000 FF; idem., no. 9131, 26 October 1835, 3,333.34 FF; and O⁴1644, no. 4584, 8 November 1836, 4,000 FF. At the end of 1836 Devéria was awarded an extra 2,000 FF for final touches to the canvas after its installation in the Salle de 1830 (AL, 2DD/23, p. 45, 30 December 1836)—although he apparently was not paid until 1840 (AN, O⁴1833, no. 7800, 11 March 1840, 2,000

FF). Because the full-scale picture has not been properly photographed, our illustration is a reduced version of the original previously belonging to the prince de Joinville, today in the collection of the Comte de Paris (80 × 138 cm). This reduction was exhibited in Paris, Archives Nationales, *Louis-Philippe*, no. 316.

206. Salon of 1831, no. 576. Versailles, MNC, inv. no. MV5121 (77 × 110 cm). Purchased on 3 November 1831 for 1,000 FF (AN, O⁴1373, no. 1792). About the competition of 1830–31 see pt. III, sec. 2.

207. E.g., the declaration of 30 July 1830 cited in pt. I, n. 15.

208. On the contractual aspect of this monarchy consult Thureau-Dangin, I, p. 43 and n. 1. See also my pt. III, sec. 5.

209. Salon of 1836, no. 419. Versailles, MNC, inv. no. MV2789 (550 × 412 cm). Commissioned on 8 November 1834 for 10,000 FF (AL, 2DD/4, p. 54). Payment records are: AN, O⁴1526, no. 6958, 7 February 1835, 3,000 FF; idem., no. 8808, 7 August 1835, 1,000 FF; O⁴1588, no. 4042, 27 August 1835, 1,000 FF; O⁴1589, no. 6819, 3 December 1835, 2,000 FF; and idem., no. 8177, 11 February 1836, 3,000 FF.

210. *Distribution of Battalion Standards to the National Guard, 29 August 1830*. Salon of 1831, no. 2566. Versailles, MNC, inv. no. MV1816 (65 × 101 cm). Purchased by the Crown for 600 FF before the Salon opened (AN, O⁴1373, no. 523, 18 March 1831). Dubois also painted another version of this scene: Versailles, MNC, inv. no. MV1819 (65 × 101 cm). Commissioned on 20 December 1836 for 1,200 FF (AL, 2DD/4, p. 95) and paid for on 21 February 1837 (AN, O⁴1645, no. 7307).

211. Letter begun by Delacroix on 17 August 1830 and continued on 4 September, first published in Johnson, "Eugène Delacroix and Charles de Verninac," pp. 516–17.

212. Quoted in Girard, *La Garde nationale*, pp. 168–69, n. 1.

213. Thureau-Dangin, I, p. 106.

214. Ibid., p. 104 and Girard, *La Garde nationale*, p. 167.

215. Girard, *La Garde nationale*, pp. 231–43, 250–51.

216. Ibid., pp. 233–35, for a discussion of the often remarkable camaraderie which developed among units of the Guard. A charming visual record of the same is the painting by Jean Gassies, *The National Guard Bivouacking in the Courtyard of the Louvre during the Trial of the Ministers, 23 Decem-*

ber 1830: Salon of 1831, no. 2752. Versailles, MNC, inv. no. MV5188 (84 × 130 cm). Purchased by the Crown on 17 October 1832 for 1,200 FF (AL, 2DD/4, p. 153). Because this canvas in fact depicts the unit of the Guard from the neighborhood surrounding the Institut, many of the figures are portraits of artists or critics, including Isabey, Gudin, Mauzaisse, and Jal (see Tardieu, *Salon de 1831*, pp. 57–58).

217. Charles X had dissolved the civilian militia in 1827 after being greeted by catcalls during a review (Girard, *La Garde nationale*, pp. 142–47). See pp. 161–64 of the same volume for a résumé of how the National Guard was reassembled during the July Revolution. Article 69 of the Charter guaranteed "the organization of the National Guard, with guardsmen having a voice in the selection of their officers" ("La Charte Constitutionnelle de 1830," *Le Moniteur Universel*, no. 231 [Jeudi 19 août 1830], p. 921).

218. The quote is from Article 1 of the law. For the full text see "Partie Officielle: Loi sur la Garde Nationale," *Le Moniteur Universel*, no. 84 (Vendredi 25 mars 1831), pp. 608–11. Concerning the details of this legislation consult Girard, *La Garde nationale*, pp. 196–215.

219. Girard, *La Garde nationale*, p. 235. Nearly every issue of *Le Moniteur Universel* during August 1830 includes reports of the king greeting deputations of national guardsmen from the provinces.

220. The key to portraits included in this painting is found in CdV, VI, 11.598ter.

221. Girard, *La Garde nationale*, p. 189 and Thureau-Dangin, I, pp. 138–42.

222. The ceremony was officially described as follows: "M. de Lafayette, holding the four standards for each legion that he had received from the King, read out loud the words of the oath; the legion and battalion leaders responded, 'I swear it'" ("Intérieur: Paris le 29 août 1830," *Le Moniteur Universel*, no. 242 [Lundi 30 août 1830], p. 990).

223. Lafayette died on 20 May 1834. See Blanc, *Dix Ans*, IV, pp. 284–85, and Thureau-Dangin, II, pp. 250–51 for assessments of how his loss further weakened the republican political faction.

224. On the maneuvers of late 1830 to restrict Lafayette's influence consult Pinkney, *1830*, pp. 356–62; Girard, *La Garde nationale*, pp. 194–95; and Thureau-Dangin, I, p. 140.

225. Undated sketch signed "Court." Rouen,

Musée des Beaux-Arts, inv. no. 07–1–107 (22 × 19 cm).

226. Versailles, MNC, tripartite ceiling of the Salle de 1830, inv. nos. INV7213 (fig. 82), INV20133 (fig. 83), INV20134 (fig. 84). Commissioned on 20 January 1835 for 25,000 FF (AL, 2DD/4, p. 399) and completed in September, to judge from the payment records (AN, O⁴1587, no. 2085, 3 June 1835, 5,000 FF and O⁴1588, no. 4755, 18 September 1835, 20,000 FF).

227. "43e Visite du Roi," AC, 91G-I, 17 August 1835, Nepveu mentions in this entry that he will need to spend 200 FF to construct "the necessary scaffolding so that M. Picot, the painter, might finish in situ his ceiling painting." About the mixup in dimensions of the side panels and the need to redo them refer to Constans, "Quelques tableaux commandés par Louis-Philippe," pp. 179–82.

228. First version of *July 1830: France Defends the Charter*, 1835. Paris, Musée du Louvre, inv. no. INV20133 (225 × 452 cm).

229. Laffitte, *Mémoires*, pp. 174–75 outlines this thinking when recounting his conversation with Glandèves, governor of the Louvre, at four in the morning on 30 July 1830. We will return to this notion in pt. III, sec. 3 when discussing Guizot's 1830 program for the decoration of the Chamber of Deputies.

230. Cited from Blanc, *Dix Ans*, II, pp. 461–62. The conservative implications of Louis-Philippe's apologia to Nicholas are discussed on p. 71.

231. Ibid., pp. 95–96 and Thureau-Dangin, I, p. 68.

232. Thureau-Dangin, I, pp. 59–60.

233. Contrast, for example, Louis-Philippe's letter to Nicholas and the instructions given to Marshal Maison, the new French ambassador to Russia, on 28 October 1833—six weeks after the creation of Versailles was announced: "if it should happen that the displeasure of Emperor Nicholas ... gives rise to public comments to which the King's government would have the right to take offense, I do not need to tell you that you should demand your passports without waiting for a recall order and leave a deputy in charge of the embassy." This tough tone runs throughout the long letter of diplomatic instructions (cited from Guizot, *Mémoires*, IV, pp. 379–87).

234. Signed and dated "Eug. Delacroix 1830." Salon of 1831, no. 511. Paris, Musée du Louvre, inv. no. RF129 (259 × 325 cm). The most current bibli-

ography and catalogue entry can be found in Johnson, *The Paintings of Eugène Delacroix*, I, no. 144. The picture was also studied extensively in the catalogue prepared for an exhibition at the Louvre in 1982 (Toussaint, *La Liberté*). Both of these appeared after I had finished writing this book: I have incorporated new material from them into my discussion, but I draw somewhat different conclusions from the available data.

235. I am referring here to the purposefully Marxist interpretations offered by Hadjinicolaou in the two articles on the picture cited in n. 62 above.

236. "I have undertaken a modern subject, a barricade," wrote Delacroix, "and if I have not won battles for the nation, at least I will paint for it" (cited in Johnson, *The Paintings of Eugène Delacroix*, I, p. 147, among others). Toussaint has noted (*La Liberté*, p. 45) that archival records suggest Delacroix submitted the canvas to the Salon jury as a picture of *The 29th of July*, but I feel we should not lend too much credence to what was probably a simple transcription error.

237. Luxembourg exhibition *livret*, no. 508. See the discussion in Toussaint, *La Liberté*, p. 54.

238. Delacroix closed his letter of 6 December 1830 by saying: "To end, I have finished, or very nearly, my picture" (*Correspondance*, I, pp. 261–62). The fifth supplement of the Luxembourg *livret* appeared when the exhibition reopened *after* the late-December trial of the ministers of Charles X. The exact reopening date was 12 January 1831 ("Exposition à la Galerie du Luxembourg: Réouverture," *JdA*, Ve année, vol. I, no. 3 [16 janvier 1831], p. 50), and the same journal reported on 27 February that this special exhibition "is just about to end" (idem., no. 9 [27 février 1831], p. 154). Johnson independently arrived at the same conclusion concerning Delacroix's reluctance to exhibit at the Luxembourg (*The Paintings of Eugène Delacroix*, I, p. 151, n. 2).

239. Adhémar, *"La Liberté sur les barricades,"* p. 89 and Hadjinicolaou, *"La Liberté guidant,"* p. 26. Clark invokes this rhetorically useful notion in his discussion of the picture's problematic political meaning (*The Absolute Bourgeois*, p. 20).

240. Adhémar, *"La Liberté sur les barricades,"* p. 89. This fantasy was dropped from Lacambre's catalogue entry for the picture (New York, *The Age of Revolution*, no. 41) but was unjustifiably taken up again by Hadjinicolaou (*"La Liberté guidant,"* p. 26). Toussaint has most recently underscored the impossibility of this fiction (*La Liberté*, p. 61).

241. AN, F⁴*504, no. 2214, 8 September 1831, 3,000 FF. As far as I know, this is the first time that the exact date of the acquisition has been firmly established. Previous authors have placed it in October (Johnson, *The Paintings of Eugène Delacroix*, I, p. 144), while Toussaint suggests that the government never actually paid for the picture (*La Liberté*, p. 61).

242. This little-understood separation of patronage will become increasingly important during the course of our investigation. The practice actually began, however, under the Bourbon Restoration (see Lacambre, "La Politique d'acquisition," p. 334).

243. As we have seen, the only pictures of the Trois Glorieuses acquired by the Crown (Maison du Roi) were the canvases by Beaume/Mozin (fig. 68), Bourgeois (fig. 27), and Cogniet (fig. 54).

244. See Johnson, *The Paintings of Eugène Delacroix*, I, p. 151, n. 1 and Toussaint, *La Liberté*, pp. 61–62, on the picture's exhibition history.

245. As we will discover in pt. III, sec. 5, the evolving political situation similarly scuttled two major decorative programs because their imagery—of both the Great Revolution and the 1830 Revolution—came to be viewed as politically dangerous.

246. First published in Johnson, "Eugène Delacroix and Charles de Verninac," p. 517.

247. Ibid., from the section of this key letter written on 17 August 1830.

248. Adhémar, *"La Liberté sur les barricades,"* p. 87.

249. Most notable are Hamilton, "The Iconographical Origins"; Rudrauf, "Une Variation sur le thème du *Radeau de la Méduse*"; Vergnet-Ruiz, "Une Inspiration de Delacroix?" and Ringbom, "Guérin, Delacroix and the *Liberty*."

250. The similarities between these popular print images and Delacroix's canvas were first noted by Hamilton, "The Iconographical Origins," pp. 64–66. I am not convinced by Toussaint's argument (*La Liberté*, p. 50) that this particular figure has more to do with the pose of an art-school *académie*, sometimes called a "Hector," than with contemporary imagery of the 1830 Revolution.

251. These lines from Auguste Barbier's poem *La Curée* were already associated with Delacroix's *Liberty* by nineteenth-century writers (see Hamilton, "The Iconographical Origins," p. 60).

252. The best discussion of these issues is the excellent (and often ignored) article by Gaudibert,

"Delacroix et le romantisme révolutionnaire," esp. pp. 9–15.

253. As first proposed by Hamilton ("The Iconographical Origins," p. 61), Hadjinicolaou has insinuated that Hamilton's suggestion is characteristic of how conservative, bourgeois art historians prefer to dilute Delacroix's radical vision of Paris in revolt ("*La Liberté guidant*," p. 22, n. 61). I see no reason to be convinced by Hadjinicolaou's polemic, both because the striding figure of Liberty is so clearly an echo of stock-in-trade popular imagery of the 1830 Revolution and because the historical conditions outlined by Gaudibert (see n. 252) would have made such a fusion seem entirely natural.

254. *Les Héroïnes parisiennes, ou Actions glorieuses des dames, leurs traits d'esprit et d'humanité* (Paris: Impr. de Pinard, 1830) is one such anonymously penned history, which was published just as Delacroix began work on his canvas (*Bibliographie de la France*, XIX, no. 39 [25 septembre 1830], p. 639, no. 5123). Hamilton discusses Marie Deschamps ("The Iconographical Origins," p. 62). Women combatants inspired a number of artists: Hautier represented a woman braving a fusillade to aid a wounded fighter (Salon of 1831, no. 1042), and Aubois retold the story of a brave fighter who appeared to be a young man but was actually a woman in disguise (Salon of 1831, no. 45). In the *Société des Amis des Arts* exhibition at the Louvre, Jollivet exhibited the image of a young woman planting the tricolor on a barricade, while a painting by Mlle Pagès represented a woman holding her dead son and swearing to avenge his death ("Exposition au Louvre," *JdA*, IVe année, vol. II, no. 12 [19 septembre 1830], pp. 197–98). Unfortunately, I have been unable to locate any of these works.

255. Figure 88: *A Game of Heroes from the Memorable Days of July 1830*, 1831. Paris, Musée Carnavalet. The game was invented by E. F. V. Maniez and is discussed at length in Paris, Musée Carnavalet, *Juillet 1830*, p. 92. Figure 89: Lithograph by Delaporte published in 1830. Paris, BN-EST, série Qb1, 27–30 juillet 1830 (sheet size: 35 × 31.5 cm). The publication of this print coincided exactly with the start of Delacroix's picture, as it was announced in the *Bibliographie de la France*, XIX, no. 38 (18 septembre 1830), p. 629, no. 1035.

256. "Tableaux de Juillet," *JdA*, Ve année, vol. I, no. 20 (15 mai 1831), p. 377.

257. The most complete compilation and analysis of this body of criticism is the article by

Hadjinicolaou, "*La Liberté guidant*," especially the table on p. 16.

258. Delacroix, "Gros," p. 663.

259. Figure 90: Signed and dated "Gros 1808." Salon of 1808, no. 272. Paris, Musée du Louvre, inv. no. INV5067 (521 × 784 cm). Toussaint wants to see a specific reference to *Eylau* in the way the pose of Delacroix's young boy at the foot of Liberty echoes that of the Lithuanian placed by Gros before Napoléon (*La Liberté*, p. 50). The Luxembourg exhibition opened on 14 October 1830 ("Exposition du Luxembourg," *JdA*, IVe année, vol. II, no. 16 [17 octobre 1830], p. 284). In addition to the *Eylau* (no. 109), Gros was represented at this exhibition by his *Jaffa* (no. 108) and *Aboukir* (no. 110). Pictures by Gérard (*Austerlitz*, no. 101 and *The Tomb on Saint-Helena*, no. 102), Girodet (*Napoléon Receiving the Keys to Vienna*, no. 103), and Guérin (*Napoléon Pardoning the Cairo Rioters*, no. 116) rounded out the Napoleonic legend. See pt. IV for a discussion of this explosion of Napoleonism after July 1830.

260. Delacroix, "Gros," pp. 659–60.

261. Gaudibert points out, for example, that Delacroix wrote to Stendahl on 2 July 1830 about opening a subscription for a monument to Géricault "who, with Gros, is the greatest painter that France has produced since Poussin" (cited in Gaudibert, "Delacroix et le romantisme révolutionnaire," p. 9, n. 1). Planche had already joined the names of Gros and Géricault in his appreciation of Delacroix's picture of *The 28th of July* (*Salon de 1831*, p. 111). See, too, the way Gros and Géricault are linked by Delacroix on artistic grounds (excerpts published in Delacroix, *Oeuvres littéraires*, pp. 229–35).

262. Exhibited as *Shipwreck Scene* at the Salon of 1819, no. 510. Paris, Musée du Louvre, inv. no. INV4884 (491 × 716 cm). For an analysis of the formal and political links between the Géricault and *The 28th of July* see Rudrauf, "Une Variation sur le thème du *Radeau de la Méduse*" and Johnson, *The Paintings of Eugène Delacroix*, I, p. 147.

263. Jal, *Salon de 1831*, pp. 44–45. See also n. 250 above.

264. Contrary to what Lenormant reported, the foreground soldier in Delacroix's picture is not a Swiss Guard (*Les Artistes contemporains*, I, p. 195). Unfortunately, this fact was not mentioned when Lenormant's description was reprinted in the 1975 catalogue entry for the picture (New York, *The Age of Revolution*, p. 382), and the error was repeated by Toussaint (*La Liberté*, p. 51). For an accurate description of the differences between the uniform of

a Swiss Guard and a Royal Guardsman see Lienhart and Humbert, *Les Uniformes*, p. 70.

265. Delacroix wrote at length on the way Gros "had enormously exploited these oppositions" between the uniformed victims and their nude neighbors, the Europeans and the Orientals, the healthy and the sick. He then added that, "far from the European dress appearing more shabby [from this contrast], there are parts of his picture where, precisely because of its simplicity, this dress acquires a special interest . . . one finds a dragoon crouching on the floor, his back against the wall. He extends his arms with a frenetic gesture to get some bread. This man is completely clothed in his tight-fitting uniform, and he wears a nasty, twisted rag around his head. Under this military dress, his miserable body seems more stripped, more terrifying than the entirely or partially naked bodies which roll in the dust nearby" (Delacroix, "Gros," p. 657).

266. See his letter to "M. Fr. Villot" dated to the fall of 1830 in Delacroix, *Correspondance*, I, pp. 262–63. Also see Delacroix, *Lettres*, I, pp. 149–50.

267. *Portrait of a Carbineer Officer*, n.d. Rouen, Musée des Beaux-Arts, inv. no. 01–3 (64.5 × 54 cm). About this picture consult New York, *The Age of Revolution*, no. 73. Delacroix noted in his journal after visiting Géricault that "I came home completely enthused about his painting: *especially a head study of a carbineer*. Remember it, for it points the way" (*Journal*, I, pp. 40–41, 30 December 1823). Johnson also discusses this passage, but suggests the *Carbineer* now in the Louvre as the object of Delacroix's admiration (*The Paintings of Eugène Delacroix*, I, p. 147). It seems to me that the Rouen picture conforms more closely to Delacroix's description (i.e., *étude de tête*) than the Louvre canvas.

268. The glove-study drawing, currently in a private collection, was catalogued by Sérullaz, "Dessins inédits de Delacroix," p. 62, no. 17, fig. 20.

269. Delacroix, "Gros," p. 661.

270. Of the 24 known drawings listed by Johnson as relating to the picture, only 4 can be associated with the living figures who accompany Liberty in her charge over the barricade (*The Paintings of Eugène Delacroix*, I, pp. 149–51). I should also add that I accept Toussaint's convincing argument (*La Liberté*, pp. 7–26) that many of the 24 sheets traditionally associated with *The 28th of July* actually date from the early 1820s when Delacroix was planning his 1826 picture of *Greece on the Ruins of Missolonghi* (fig. 96).

271. Delacroix to his nephew, 17 August 1830 (published by Johnson, "Eugène Delacroix and Charles de Verninac," p. 517).

272. Delacroix, "Charlet," p. 237.

273. Ibid.

274. Signed and dated in the plate "Charlet 1830." CdV, VI, no. 11.090 (25.6 × 32.9 cm). Gaudibert was the first to suggest the importance of this Charlet for Delacroix's picture, but without text illustrations his point has remained little appreciated ("Delacroix et le romantisme révolutionnaire," p. 13, n. 1).

275. Toussaint notes that Delacroix's top-hatted combatant wields a hunting rifle, but she fails to see that the same type of rifle figures prominently in the Charlet (*La Liberté*, p. 49).

276. Both sheets are in a Paris private collection, catalogued by Sérullaz, "Dessins inédits de Delacroix," p. 60, nos. 9–10, figs. 12–13.

277. Cachet "ED." Paris, Musée du Louvre, Cabinet des Dessins, inv. no. RF9237 (20 × 13 cm). Sérullaz still believed in 1971 that his sheet of studies was done from Delacroix's own National Guard uniform ("Dessins inédits de Delacroix," p. 62), but the color notes made by the painter for the details render this impossible since they correspond to the regulations for a Royal Guardsman's equipment (see Lienhart and Humbert, *Les Uniformes*, p. 70).

278. Delacroix wrote that Charlet's figures "are so striking and so true, the degree to which he seizes his character, the setting of figures or accessories which he provides is so exactly that which clarifies the idea, that I do not hesitate to rank him alongside Molière and La Fontaine for the portrayal of characters" ("Charlet," p. 241). Delacroix and the painter Huet shared and discussed their mutual enthusiasm for the works of Charlet (Huet, *Correspondance*, pp. 336–37). Delacroix's will allocated "all my lithographs by Charlet to M. Huet" (Delacroix, *Lettres*, I, p. ix), and the inventory after his death mentions two lots of Charlet lithographs earmarked for Huet (Bessis, "L'Inventaire d'après décès d'Eugène Delacroix," under "Objets d'art," nos. 347, 425). Unfortunately, I was unable to ascertain if *The Allocution* was among these works.

279. Johnson, *The Paintings of Eugène Delacroix*, I, pp. 147–48 and Toussaint, *La Liberté*, pp. 36–38.

280. See esp. Hamilton, "The Iconographical Origins," pp. 56–60.

281. Study for *The Pont d'Arcole*, n.d. Cam-

bridge, Harvard University Museums (The Fogg Art Museum), Bequest-Grenville L. Winthrop, inv. no. 1943–816 (32.6 × 49.1 cm).

282. See Johnson, "Pierre Andrieu, un 'polisson'?" p. 69, n. 20. The Fogg drawing has tentatively been attributed to Raffet. Adhémar believed this drawing was done for an exhibition organized by the dealer Moyon, who owned a print shop in the rue de l'Université (Adhémar, *"La Liberté sur les barricades,"* p. 87). Although only a hunch (*très vraisemblablement* is Adhémar's phrase), the catalogue entry written by Lacambre in 1974 takes it as fact—at least in the English edition (New York, *The Age of Revolution*, p. 382). Actually, it is not at all certain that this work (whether or not by Delacroix) ever appeared at Moyon's exhibition. I might add that this special show did not occur in the shop on the rue de l'Université: artists were instructed to leave their works with Moyon, but the show was to be mounted at the Galerie LeBrun, rue de Gros-Chenet ("Nouvelles," *JdA,* IVᵉ année, vol. II, no. 7 [15 août 1830], p. 120). Later, the exhibition was moved to the offices of the *Société des Amis des Arts* at the Louvre, a locale "thought to be more centrally located and easier to reach from the various parts of Paris" (idem., no. 11 [12 septembre 1830], p. 192). Thus, Adhémar mistakenly reported there were two exhibitions (at Moyon's and at the *Société des Amis des Arts*) when in fact they were one and the same.

283. "The first and most important thing[s] in painting," wrote Delacroix in 1824, "are the contours. If they are present, however slack the rest might be, the painting is firm and finished" (*Journal*, I, p. 69, 7 April 1824). Years later, the same idea returned when Delacroix recalled, "I only began to make something passable during my trip to Africa, when I had sufficiently forgotten the small details in order to remember in my pictures only the striking and poetic aspect" (*Journal*, II, p. 92, 17 October 1853). For more about Delacroix's working habits refer to Trapp, *The Attainment of Delacroix*, pp. 317–19.

284. See Hofmann, "Sur la *Liberté* de Delacroix," pp. 63–64 and Toussaint, *La Liberté*, pp. 45–46.

285. Toussaint, *La Liberté*, pp. 7–9 and New York, *The Age of Revolution*, pp. 379, 383.

286. Signed "Eug. Delacroix." Exhibited at the Galerie LeBrun in 1826. Bordeaux, Musée des Beaux-Arts, inv. no. ANC439 (213 × 142 cm). For a complete bibliography consult Johnson, *The Paintings of Eugène Delacroix*, I, no. 98.

287. Toussaint groups four studies for Liberty among the sketches done by Delacroix in 1830 for the painting (*La Liberté*, pp. 27–28, nos. 22–25) and one for the profile of the figure at her feet (p. 31, no. 32). To this must be added: the seven sheets from the same notebook, probably done ca. 1821–22, which relate to Delacroix's picture of *Greece on the Ruins of Missolonghi* but which were obviously restudied and perhaps even retouched in 1830; a second sketchbook with several studies of a Liberty-like figure; and a painted sketch—all of which address the point where fact meets fiction in the image (idem., pp. 9–25, nos. 2–8, 14–21).

288. Hamilton points out that Delacroix referred to *Greece on the Ruins* as an allegory, an understanding which pushed his representation toward a generalized narrative ("Delacroix's Memorial to Byron"). While this tactic was suitable for a picture inspired by events far from France, it was less practical for a work like *The 28th of July*, which was rooted in the Paris revolution.

289. Cachet "ED." Paris, Musée du Louvre, Cabinet des Dessins, inv. no. RF4523 (29.1 × 19.6 cm). In one sheet of sketches reproduced by Toussaint (*La Liberté*, p. 29, no. 25) the drapery studies have a decidedly classical flavor—as if Delacroix were thinking of antique statuary rather than working-class garments. This point, as we shall discover, is not without interpretative significance.

290. Recent radiographic studies have proven that Liberty was originally depicted full-faced and that, as he worked, Delacroix made many adjustments to her garments, gestures, and coloration (Toussaint, *La Liberté*, pp. 69–72).

291. "It's really only with Rembrandt," wrote Delacroix, "that one sees in pictures the beginning of this agreement between accessories and the principal subject which seems, to my mind, one of the most important parts, if not the most important" (*Journal*, II, p. 212, 5 July 1854). On another occasion he remarked that "if every detail offers a perfection which I will call inimitable, the joining together of these details, on the other hand, rarely presents an effect equal to what results—in the work of a great artist—from the awareness of the whole and of the composition" (II, p. 86, 12 October 1853). Finally, let us not forget the important concept which Delacroix termed *liaison*: "the art of binding together the picture's parts through the

overall effect, color, drawing, reflections" (III, p. 17, 13 January 1857 and p. 41, 25 January 1857). For a discussion of these ideas consult Mras, *Eugène Delacroix's Theory of Art*, pp. 105–14.

292. Delacroix, born in 1798 just before Bonaparte's return from Egypt and seventeen years old when the Emperor was defeated at Waterloo, was literally weaned on the exploits and drama of the Empire. His father had been a member of the National Convention, had voted for the death of Louis XVI, and had later served Napoléon as prefect of Marseilles and then Bordeaux (until his death in 1805). One of the painter's brothers was killed in the battle of Friedland and another had been a baron of the Empire. After 1815, of course, such a family history would not have been viewed with benign indifference by the Bourbon government. But more important, it seems, was that the young artist had grown up in a milieu as committed to the service of Napoléon as Gros and Géricault had been—or as Charlet continued to be throughout the 1820s by keeping the public's memory of the Emperor alive. The importance of this biographical context is discussed in Gaudibert, "Delacroix et le romantisme révolutionnaire," pp. 11–13.

293. Delacroix, *Journal*, I, p. 97, 8 May 1824 and p. 99, 11 May 1824. About a month earlier he expressed "a desire to do subjects of the Revolution, such as *Bonaparte's Arrival amidst the Army of Egypt* and *The Farewell at Fontainebleau*" (p. 94, 19 April 1824).

294. Delacroix, *Oeuvres littéraires*, p. 226.

295. Ibid. See also Delacroix's letter to Soulier in which he summarized this same incident: "I recently had a small discussion with Le Sosthène. The gist is that I have nothing to expect from that side so long as I will not change my way. Heaven gave me the grace to maintain my composure during this conversation" (*Correspondance*, I, p. 217, letter of 26 April 1828).

296. Delacroix, *Oeuvres littéraires*, p. 226 (my italics). In fact, Delacroix exaggerated his plight, because he received a government commission in 1828 to paint *The Battle of Nancy*, and the duchesse de Berry ordered a *Battle of Poitiers* in 1829 (Johnson, *The Paintings of Eugène Delacroix*, I, pp. 138–42).

297. Obviously, I am referring to the Delacroix of 1830, *before* his trip to Morocco in 1832—an experience which profoundly affected both his style and his interests. For a discussion of the Mo-

roccan trip and its effect see Trapp, *The Attainment of Delacroix*, pp. 111–41.

III: HISTORY AS PROPAGANDA

1. On Restoration suppression of Napoleonic imagery consult Boyer, "Le sort sous la Restauration," pp. 271–81. About the political motivations of Bourbon patronage see Lacambre, "La Politique d'acquisition," pp. 331–44.

2. Thureau-Dangin, I, pp. 348–52 discusses the revival of these subjects on the stage. When *Les Comités révolutionnaires*—a popular work of 1795— was restaged at the Théâtre des Variétés in 1831, the conservative *Revue de Paris* reported that "this play draws a crowd to the Variétés, where every evening it receives lively applause because it conforms to the public's opinion, which is a horror of bloodshed and revolutionary excesses" ("Chronique," *Revue de Paris*, XXVIII [1831], p. 195). It is unlikely that all theater-goers agreed with this explanation of their enthusiasm, for the same journal had previously worried about a five-act play at the Théâtre-Français entitled *Camille Desmoulins*: "Personally, we think that the history of the revolution is not yet ready for the stage, that it cannot be represented there within the circumstances necessary to art, and that only an ambition for popular success by means of stirring up political passions can explain the current theatrical preoccupation with it" (ibid., XXVI [1831], p. 250). If a play was capable of "stirring up political passions," the audience had not come simply to manifest a horror of revolution!

3. Lefebvre, *Revolution*, I, pp. 256–63.

4. Howarth, *Citizen-King*, pp. 80–83; see also nn. 300–02 below.

5. Figure 98: Signed and dated "H. Vernet 1826." London, The National Gallery, inv. no. 2964 (175 × 287 cm). Figure 99: Signed and dated "Horace Vernet 1821." London, The National Gallery, inv. no. 2963 (177 × 288 cm).

6. Refer to Durande, *Vernet*, pp. 74–76 for a summary, and to Jouy and Jay, *Salon d'Horace Vernet*, for a contemporary review of this impromptu exhibition.

7. Salon of 1831, nos. 2076 and 2077 respectively.

8. *The duc d'Orléans Signs the Act Proclaiming a* Lieutenance-général *of the Kingdom, 31 July 1830*. Salon of 1836, no. 418. Versailles, MNC, inv.

no. MV1809 (372 × 536 cm). Commissioned on 21 February 1836 for 8,000 FF (AL, 2DD/4, p. 56) and paid for in June (AN, O⁴1643, no. 1875, 16 June 1836).

9. Figure 101: *The King Receiving at the Palais-Royal the Deputies of 1830, Who Present the Act by Which They Confer the Crown to Him.* Salon of 1834, no. 967. Versailles, MNC, inv. no. MV1814 (230 × 340 cm). This picture was commissioned on 27 July 1832 as the large-format replica of a canvas painted by Heim for the Palais-Royal and destroyed in 1848 (AL, 2DD/5, p. 4, 10,000 FF). Since the idea to make Versailles into a museum was more than a year away, Louis-Philippe must have planned to hang the larger picture in the Louvre or some other public space. When it was decided to place the painting in the new museum, Heim's commission was re-registered on the inventories (AL, 2DD/4, p. 194, 13 November 1833, 10,000 FF). I was only able to locate two of the payments in the archival records (AN, O⁴1427, no. 2517, 5 September 1832, 3333.33 FF and O⁴1426, no. 8966, 26 May 1834, 3333.34 FF). The original picture done in 1832 for the Palais-Royal was installed in the Galerie du Théâtre and measured 227 × 160 cm (AN, 300 API 1113, "Inventaire de Tableaux du Palais-Royal après 1848"), and Heim received 6,000 FF for painting it (AN, O⁴1427, no. 2522, 5 September 1832, 5,000 FF plus 1,000 FF extra compensation). Figure 102: *The duc d'Orléans Receives the Chamber of Peers at the Palais-Royal, 7 August 1830*, 1837. Versailles, MNC, inv. no. MV1815 (230 × 340 cm). Commissioned on 21 February 1836 for 10,000 FF (AL, 2DD/5, p. 50) and paid for in three installments (AN, O⁴1643, no. 2003, 21 June 1836, 2,500 FF; O⁴1705, no. 2499, 27 June 1837, 2,500 FF; O⁴1706, no. 4200, 23 September 1837, 5,000 FF).

10. *Philippe My Father Will Not Let Me Attain a Greater Glory!*, 1833. Signed in the plate "HD" (reversed). CdV, VI, no. 12.763 (22.9 × 28 cm). The de Vinck catalogue fails to note that this lithograph was designed by Daumier (Delteil, *Le Peintre-graveur illustré*, XX [Daumier, I], no. 77).

11. "Voyage du Roi—n° 3," *Le Moniteur Universel*, no. 162 (Samedi 11 juin 1831), pp. 1071–72. An even more picturesque account of this day is found in Louis-Philippe's letter of 8 June 1831 to Marie-Amélie (AN, 300 APIII 84, dossier 2).

12. *The King, on the Battlefield of Valmy, Giving the Legion of Honor Medal and a Pension to a Veteran Who Lost an Arm in This Glorious Event*, signed and dated "Mauzaisse 1833." Salon of 1834,

no. 1361. Carcassonne, Musée des Beaux-Arts (75 × 150 cm). Evidently awarded to Mauzaisse when Delacroix refused the commission (see n. 14 below) but I was unable to locate the relevant archival documentation. Mauzaisse was paid a first installment of 1,000 FF in November 1832 (AN, F⁴*505, no. 2227, 3 November 1832) and finished the picture six months later (AN, F⁴*506, no. 400, 15 April 1833, 2,000 FF). The painting was packed and sent on its way to Carcassonne in June 1834 (AN, F²¹498, "Transports d'Objets d'Art," 18 June 1834). A smaller version was commissioned on 10 December 1837 for 1,500 FF (AL, 2DD/5, p. 73) and paid for in February (AN, O⁴1707, no. 7778, 22 February 1838): Versailles, MNC, inv. no. MV1820 (90 × 88 cm).

13. Signed and dated "hersent/1817." Salon of 1817, no. 414. Versailles, MNC, inv. no. MV223 (171 × 227 cm). About this work consult New York, *The Age of Revolution*, no. 100.

14. The account register of the Interior Ministry for 1831 lists a payment of 1,500 FF to Delacroix as a "first installment for a picture representing the King visiting the cottage at Valmy" (AN, F⁴*504, no. 3311, 23 December 1831). This predates the first payment made to Mauzaisse by nearly one year.

15. The cornerstone of this renovation project was laid on 4 November 1829 ("Intérieur: Paris, le 4 novembre," *Le Moniteur Universel*, no. 309 [Jeudi 5 novembre 1829], pp. 1736–37).

16. For all the architectural details of this project consult the volume published by its architect, de Joly, *Plans, coupes, élévations et détails de la restauration de la Chambre des Députés*.

17. The Bourbon Restoration program is detailed in the documents classed under AN, F²¹752, "Chambre des Députés," and F²¹584, pièce 32.

18. "Rapport au Roi," AN, F²¹584, pièce 184. Published in *Le Moniteur Universel*, no. 272 (Mercredi 29 septembre 1830), p. 1181. Guizot's program has been the subject of two recent studies: Marrinan, "Resistance, Revolution, and the July Monarchy" in 1980 and Boime, "The Quasi-Open Competitions of the Quasi-Legitimate July Monarchy" in 1985.

19. Rosenthal, pp. 4–8.

20. "Rapport sur les tableaux de la Chambre des Députés," dated 27 April 1831 and signed by E.F. Bertin (AN, F²¹584, pièce 131). See also the letter of 26 August 1831 from Cailleux to Casimir Périer, then Minister of the Interior (idem., pièce 159);

"Lettre sur les concours," *L'Artiste*, I (1831), pp. 49–51; and Guizot, *Mémoires*, II, pp. 70–71.

21. "Ministère de l'Intérieur: Arrêté," *Le Moniteur Universel*, no. 275 (Jeudi 30 septembre 1830), p. 1189.

22. Boime, *Academy*, pp. 115–19.

23. Montalivet, who succeeded Guizot as Minister of the Interior in early November 1830, named Delaborde (a deputy) and Debourdy (Quaestor of the Chamber of Deputies) to the jury—along with Gérard, Guérin, Gros, Ingres, and Hersent (AN, F²¹584, pièce 156, dated 10 December 1830).

24. "Album: Concours d'esquisses," *Revue de Paris*, XXI (1830), p. 117.

25. "Peinture: Concours pour le tableau du Serment de Louis-Philippe Iᵉʳ—Premier Article," *JdA*, IVᵉ année, vol. II, no. 23 (5 décembre 1830), p. 390.

26. "Peinture: Concours pour le tableau du Serment—Deuxième Article," *JdA*, IVᵉ année, vol. II, no. 24 (12 décembre 1830), p. 410. Ansiaux's picture, apparently lost today, was shown at the Salon of 1831 (no. 33); a lengthy description in the *livret* enables us to imagine what it looked like.

27. *The Oath of Louis-Philippe*, 1830. Valenciennes, Musée des Beaux-Arts, inv. no. 184 (76 × 110 cm). The critical comments are found on p. 410 of the *JdA* review cited in n. 26.

28. "Album: Concours d'esquisses," *Revue de Paris*, XXI (1830), p. 120.

29. "Partie Officielle," *Le Moniteur Universel*, no. 222 (Mardi 10 août 1830), pp. 877–78.

30. Figure 107: *9 August 1830: Oath of the King*, 1830–31. CdV, VI, no. 11.575 (21.2 × 29.7 cm). Figure 108: *The Oath of Louis-Philippe*, 1830. Signed "Court." Saint-Germain-en-Laye, Musée Municipal (88 × 118 cm). Given to the museum in 1881 by Mme Court, widow of the painter.

31. "Album: Concours d'Esquisses," *Revue de Paris*, XXI (1830), p. 119.

32. Ibid., p. 118. About this picture refer to pt. 2, n. 206. Similar objections of fashionability were raised against Devéria in the article "Peinture: Concours—Deuxième Article," *JdA*, IVᵉ année, vol. II, no. 24 (12 décembre 1830), pp. 409–10.

33. *The Oath of Louis-Philippe*, 1837. Versailles, MNC, inv. no. MV5436 (485 × 680 cm). Coutan's sketch was selected by the jury on 19 December from a group of seven semifinalists ("Concours—4ᵉ Article," *JdA*, IVᵉ année, vol. II, no. 26 [26 décembre 1830], pp. 449–50). About Court finishing the canvas see n. 165 below.

34. The aesthetic issue of a "pre-photographic vision" is complex and only partially understood. See Peter Galassi's essay in New York, The Museum of Modern Art, *Before Photography*.

35. About this epoch consult Lefebvre, *The Coming of the French Revolution*, pp. 76–92 and Lefebvre, *Revolution*, I, pp. 109–14.

36. For a concise analysis of the attitudes and aspirations of the Third Estate refer to Lefebvre, *The Coming of the French Revolution*, pp. 41–50.

37. Godechot, *Bastille*, pp. 157–58.

38. A facsimile text of this oath is reproduced in Brette, *Serment*, pl. I. The definitive publication on the oath of 20 June and its imagery is now Bordes, *Le Serment du Jeu de Paume*.

39. Lefebvre, *La Séance du 23 juin 1789*, pp. 274–84.

40. Mirabeau, *Mémoires*, p. 88 and Godechot, *Bastille*, p. 165.

41. "It is a subject of words and not a subject of action," wrote Farcy; "Consequently, the greatest difficulties present themselves to the artist who tries to make the subject intelligible using only an arrangement of gesture" ("Concours pour le second tableau destiné à la Chambre des Députés," *JdA*, Vᵉ année, vol. I, no. 6 [6 février 1831], p. 104). This observation is echoed in "Exposition du concours pour le tableau de la Chambre des Députés," *Revue de Paris*, XXIII (1831), pp. 138–39.

42. Thirty-eight names are listed by the *JdA* (see n. 41), although others reported thirty-two entries ("Mirabeau à l'Ecole des Beaux-Arts," *L'Artiste*, I [1831], p. 4).

43. Figure 109: *Mirabeau and the marquis de Dreux-Brézé*, signed and dated "Eug. Delacroix 1831." Copenhagen, Ny Carlsberg Glyptothek, inv. no. I.N.1751 (77 × 101 cm). Figure 110: *Opening of the Estates-General*, 1790. CdV, II, no. 1429 (27.4 × 43.7 cm). Helman based this engraving on a drawing by Charles Monnet. A sheet of sketches by Delacroix in the collection of M. Maurice Sérullaz includes a penciled reminder to "borrow some engravings by Trumball and West—Moreau le Jeune" (Sérullaz, *Mémorial*, no. 146).

44. Preliminary sketch for *Mirabeau and Dreux-Brézé*, 1831. Paris, Musée du Louvre, inv. no. RF1953–41 (68 × 82 cm).

45. "We will point out again," wrote Farcy, "that M. Delacroix seems . . . to want to divorce Romanticism. His sketch is more finished than some works he called 'pictures' not long ago" ("Con-

cours—2ᵉ Article," *JdA*, Vᵉ année, vol. I, no. 7 [13 février 1831], p. 115).

46. Ibid., no. 6 (6 février 1831), p. 105.

47. "Mirabeau à l'Ecole des Beaux-Arts," *L'Artiste*, I (1831), p. 5.

48. Boime's suggestion that Delacroix felt compromised by his overworked Mirabeau sketch is convincing (*Academy*, pp. 118–19). However, the conclusions Boime draws vis-à-vis surface appearances seem to be only one part of the critical issues at stake in the analysis and judging of the competition.

49. Figure 112: *Mirabeau and Dreux-Brézé*, 1831. Signed "A. Fragonard." Paris, Musée du Louvre, inv. no. RF1984–18 (72 × 105 cm). Figure 113: *Opening of the Estates-General by Louis XVI*, 1790. CdV, II, no. 1430 (25 × 40.5 cm). This image was both designed and engraved by J.M. Moreau.

50. "Concours—2ᵉ Article," *JdA*, Vᵉ année, vol. I, no. 7 (13 février 1831), p. 118.

51. *Mirabeau and Dreux-Brézé*, 1831. Paris, Musée Carnavalet, inv. no. P.1376 (77 × 104 cm). Given to the museum in 1921 by M. Henri Lavedan, this picture has been variously attributed and is currently catalogued "artist unknown." The attribution to Chenavard can be established, however, by even a cursory comparison to a drawing of the same scene by Chenavard: Lyon, Musée des Beaux-Arts (70 × 112 cm). It is unlikely that the Lyon drawing was presented by Chenevard to the competition jury—as both Boime (*Academy*, p. 207) and Sloane (*Chenavard*, p. 50) argue—because contemporary critics specifically refer to his work as a *peinture* and a *tableau*.

52. "Exposition du concours," *Revue de Paris*, XXIII (1831), p. 139.

53. "Concours—2ᵉ Article," *JdA*, Vᵉ année, vol. I, no. 7 (13 février 1831), p. 120.

54. *Mirabeau and Dreux-Brézé*, 1831. Rouen, Musée des Beaux-Arts, inv. no. 866–2–2 (87 × 115 cm). Acquired by the museum at the sale of the artist's studio in February 1886.

55. "Mirabeau à l'Ecole des Beaux-Arts," *L'Artiste*, I (1831), p. 5, and p. 117 of the article cited in n. 53.

56. *Mirabeau and the marquis de Dreux-Brézé, 23 June 1789*. Salon of 1838, no. 922. Amiens, Musée de Picardie, inv. no. P.311 (427 × 635 cm).

57. *Portrait of Mirabeau*, 1790. Aix-en-Provence, Musée Granet-Palais de Malte, inv. no. INV12.1.1 (214 × 126 cm). For a complete bibliography and discussion of the attribution to Boze consult

New York, *The Age of Revolution*, no. 13. Hesse need not have seen the original canvas (which was in a private collection) because he could have consulted the engraving of it produced in 1790 by Etienne Beisson: CdV, II, no. 1862 (51 × 37 cm).

58. "This time," remarked one critic, "if the contestants fail to rise to the occasion it will be their own fault, because a subject both feasible and dramatic has been selected" ("Exposition: *Boissy-d'Anglas*," *Revue de Paris*, XXV [1831], p. 198). Similarly, Farcy observed that "the subject of Boissy-d'Anglas saluting the head of Deputy Féraud is, indeed, very dramatic and contains all the elements of a History Painting" ("Peinture: Concours pour le troisième tableau," *JdA*, Vᵉ année, vol. I, no. 14 [3 avril 1831], p. 258).

59. On 9 Thermidor see Lefebvre, *Revolution*, II, pp. 131–36 and Furet and Richet, pp. 210–14.

60. For an analysis of the political, economic, and social effects of this abrupt change in government refer to Lefebvre, *Revolution*, II, pp. 137–41; Furet and Richet, pp. 226–33; and Hampson, pp. 232–36.

61. About the economic collapse of 1795 see Lefebvre, *Revolution*, II, pp. 142–44 and Furet and Richet, pp. 243–44.

62. Thiers, *Révolution française*, VII, pp. 387–89 describes the black market bazaar which operated in the garden of the Palais-Royal. I frequently invoke the history by Thiers—generally considered outdated today—because Thiers' text was the standard account during the 1830s and 1840s. The biases and anecdotes of Thiers were taken at face value by the historians, artists, and general readers of the July Monarchy.

63. About these maneuvers as little more than instances of the rich oppressing the poor consult Furet and Richet, pp. 245–48 and Hampson, pp. 240–43.

64. On the planning of these riots see Thiers, *Révolution française*, VII, pp. 399–401.

65. For accounts of the uprising consult ibid., pp. 401–17 or Furet and Richet, pp. 248–52.

66. As Lefebvre observed, "This is the date which should be taken as the end of the Revolution. Its mainspring was now broken" (*Revolution*, II, p. 145).

67. Guizot's strategy of using the history of revolutionary France was well established among Liberals thinkers before 1830. The classic text on this phenomenon is Mellon, *The Political Uses of History*.

68. "Peinture: Concours pour la troisième tableau," *JdA*, V^e année, vol. I, no. 14 (3 avril 1831), p. 258, where all of the contestants are listed.

69. A forthcoming article by Marie-Claude Chaudonneret in the *Revue du Louvre et Musées de France* will discuss most of the extant sketches.

70. Figure 117: *The Historic Day of 1 Prairial, Year III*, 1797. CdV, III, no. 6574 (27.2 × 42.6 cm). Copperplate engraving by Helman after a drawing by Charles Monnet. Figure 118: *Assassination of the Deputy Ferraud in the National Convention*, 1796. CdV, III, no. 6576 (20 × 25.3 cm). Copperplate engraving by Berthault after a drawing by Duplessi-Bertaux.

71. Figure 119: *Boissy-d'Anglas*, signed and dated "Roëhn 1831." Tarbes, Musée Massey, inv. no. 856.4.24 (78 × 110 cm). Figure 120: Competition sketch of *Boissy-d'Anglas*, 1831. Tours, Musée des Beaux-Arts (87 × 112 cm).

72. "Peinture: Concours—Deuxième Article," *JdA*, V^e année, vol. I, no. 15 (10 avril 1831), p. 266.

73. Thiers, *Révolution française*, VII, pp. 404, 408.

74. Vinchon was not the only artist to embellish the scene in this grisly manner: an artist named Goyet also portrayed Boissy-d'Anglas saluting, "with an unwavering impassibility, the head of Férraud that one of the insurgents, in a fit of rage, has pulled from the pike on which it was carried in order to bring it closer to Boissy-d'Anglas' face" (from p. 267 of the *JdA* article cited in n. 72 above). I was unable to ascertain the present whereabouts of Goyet's sketch.

75. From pp. 268–69 of the *JdA* article cited in n. 72 above. Farcy's reference to Dulaure pertains to the latter's *Esquisses historiques de principaux événemens de la Révolution française*, in which the author quotes unnamed individuals to prove that the rioters of 1795 were stirred up by royalist and enemy agents (Dulaure, III, pp. 487 and 497–99). This theory, rather discredited today, was popular in the 1820s and 1830s as a way both to explain and to excuse the Parisians of 1793–95: witness Farcy's final line of the excerpt, quoted in the text. About Dulaure as a historian of the Revolution consult Mellon, *The Political Uses of History*, pp. 19–20.

76. *Boissy-d'Anglas*, 1831. Reims, Musée Saint-Denis (78 × 108 cm). Farcy noted that Maillot "has nevertheless introduced every element likely to produce simultaneously this feeling [of grief] and that of terror: a *tricoteuse*, a child who pulls a little guillotine like a kind of toy, and the body of the unfortunate Férraud" (from p. 270 of the *JdA* article cited in n. 72 above). Obviously, such vivid—and politically reactionary—imagery suggests that Maillot understood his task as one of portraying the sans-culottes as the most hideous and despicable beings imaginable.

77. *Boissy-d'Anglas*, 1831. Signed "Tellier." Versailles, MNC, inv. no. MV5516 (84.5 × 108 cm). Purchased by the Ministry of Public Instruction and Fine Arts from a M. Camatte in 1900 for 400 FF (AL, V^6, *arrêté* dated 12 December 1900).

78. For a discussion of how the Rococo came to be viewed by artists of the 1820s and 1830s as a "revival" style—and not simply a long-lasting survivor of the Ancien Régime—consult Duncan, "Persistence and Re-Emergence," pp. 209–21.

79. *Boissy-d'Anglas*, 1831. Paris, Galerie Pardo (79 × 100 cm). The owners formerly attributed this canvas to Daumier, who did not participate in the competition—at least not under his own name.

80. In fact, the lush, painterly surface and extensive use of white highlighting would suggest an attribution to an artist well-versed in the methods of Rococo painting. Among those competing in this concours, the name of Octave Tassaert stands out in this regard, for Duncan's study has shown him to be a great devotee of eighteenth-century painting at just this time ("Persistence and Re-Emergence," pp. 110–17). Moreover, Farcy's description of Tassaert's entry accords well with the Pardo picture: "an expansive sketch which has movement; but one feels that the president seems to be making a proclamation at the same time that he salutes the deputy's head, and this deviates from the character which the picture ought to have" ("Peinture: Concours—Deuxième Article," *JdA*, V^e année, vol. I, no. 15 (10 avril 1831), p. 270). At the same time, Tassaert's sketch must have been a strong contender—and the Pardo picture is certainly not unattractive—because his entry was among the thirteen semifinalists ("Nouvelles," *JdA*, V^e année, vol. I, no. 17 [24 avril 1831], pp. 319–20). All of this points, I believe, toward Tassaert as a plausible attribution for the Pardo painting.

81. "Another drawback of competitions," wrote E.F. Bertin, an employee of the Bureau des Beaux-Arts, "and one which has never been questioned, except by those who pay little attention to the means and processes of art, is the impossibility

of really judging the worth of an artist, and of the picture which he is destined to execute, from the sketch of this picture—the sketch being only an extremely imperfect and usually very false glimpse of the whole. Any painter can have a chance idea and rashly toss off a very striking sketch, figuring on it to seduce the public and judges with its look, and yet be utterly incapable of executing a large-scale work" (AN, F²¹584, pièce 131, "Rapport sur les tableaux de la Chambre des Députés," dated 27 April 1831). For a discussion of this issue refer to Boime, *Academy*, pp. 115–17.

82. Painted for the 1831 competition. Clermont-Ferrand, Musée Bargoin, inv. no. 2425 (80.5 × 154.5 cm). Degeorge entered David's studio in 1802. See the exhibition catalogue Clermont-Ferrand, Musée Bargoin, *Thomas Degeorge*.

83. "Peinture: Concours—Deuxième Article," *JdA*, Vᵉ année, vol. I, no. 15 (10 avril 1831), p. 272.

84. "*Boissy-d'Anglas*: Concours," *L'Artiste*, I (1831), p. 123 and "Exposition: *Boissy-d'Anglas*," *Revue de Paris*, XXV (1831), p. 200.

85. *Boissy-d'Anglas*, signed and dated "A. Fragonard 1830." Paris, Musée du Louvre, inv. no. RF1984–19 (72 × 105 cm).

86. "Peinture: Concours—Deuxième Article," *JdA*, Vᵉ année, vol. I, no. 15 (10 avril 1831), p. 269.

87. Signed and dated "Eug. Delacroix 1831." Bordeaux, Musée des Beaux-Arts, inv. no. 7016 (79 × 104 cm). For a complete bibliography consult Johnson, *The Paintings of Eugène Delacroix*, I, no. 147.

88. See the discussions in Boime, *Academy*, pp. 118–19 and Boime, "The Quasi-Open Competitions," p. 100.

89. *The Meeting Hall of the National Convention at the Tuileries* (drawing for *Boissy-d'Anglas*), 1831. Cachet "ED." Paris, Musée Carnavalet (30.2 × 49.8 cm). Catalogued in Sérullaz, *Mémorial*, no. 144.

90. About eye movements and patterns of perception consult Buswell, *How People Look at Pictures*, esp. p. 115, where the author notes: "A particular characteristic to which the attention is called here is the very general tendency for the eye to move first to the left and then to the right. Whether or not this is a carry-over from the ordinary process of reading cannot be known from the data available. However, there is a considerable body of evidence to lend strength to this hypothesis."

91. "The majority of painters," wrote Delacroix in 1847, "and I've done the same in the past, begin with the details and furnish the overall effect at the end. Whatever chagrin you might experience in seeing the first effect of a beautiful sketch disappear to the degree that you add details to it, there still remains much more of this original effect than you could manage to put in if you had proceeded in the opposite manner" (*Journal*, I, p. 196, 1 March 1847).

92. See Rosenthal, pp. 110–14 for a summary.

93. "*Boissy-d'Anglas*: Concours," *L'Artiste*, I (1831), p. 122.

94. "Peinture: Concours—Deuxième Article," *JdA*, Vᵉ année, vol. I, no. 15 (10 avril 1831), p. 268.

95. "Exposition: *Boissy-d'Anglas*," *Revue de Paris*, XXV (1831), p. 199.

96. *Boissy-d'Anglas*. Salon of 1835, no. 2137. Annonay, Hôtel-de-Ville, Salle de Réunion du Conseil Municipal (approx. 400 × 600 cm). I am especially grateful for the kind assistance offered by M. Paul Allard, vice-president of the Syndicat d'Initiative d'Annonay, who obtained photographs for me and arranged to open the *mairie* on a Saturday so that I might see the picture in person.

97. Two separate fires have threatened the picture (31 December 1870 and 22 August 1926), and it has been trimmed along all four edges as well as heavily overpainted (information from files at Annonay).

98. The article by Grate, "La Critique d'art et la bataille romantique," succinctly chronicles the various critical tendencies which circulated in the art world of Paris in the 1820s and set the stage for the 1830s. Even though Grate's analysis strives a bit too hopefully to prove that the juste-milieu emerged victorious from the purely aesthetic conflict between classicists and romantics (a notion with which I sharply disagree), his study usefully portrays the contemporary diversity of artistic and critical discourse.

99. AN, F²¹584, pièce 162.

100. The tactic of historically reevaluating the French Revolution in order to support the claim for a liberal, constitutional monarchy was already a well-established practice among liberal politicians and historians (most notably Guizot) during the Bourbon Restoration. For a discussion see Mellon, *The Political Uses of History*, pp. 47–53.

101. Guizot, *Mémoires*, II, p. 374.

102. "Rapport au Roi," AN, F²¹584, pièce 162, 25 September 1830.

103. Mellon, *The Political Uses of History*, pp. 54–57.

104. Guizot, *Mémoires*, I, p. 352.

105. Ibid., I, p. 357 and II, p. 15.

106. Excerpted from the *Souvenirs du comte de Montbel*, quoted in Bertier de Sauvigny, *La Révolution de 1830*, p. 23. Polignac invoked the same logic when he wrote: "Did not '89 at one time lead to '93, in spite of the majority's will even among those who greeted the arrival of the first of these numbers with wishes for success? Let's say it: it would be a misunderstanding of the situation to see only a simple question of parliamentary majority in the debates which developed in 1830 between the elected Chamber and the Throne; this question once resolved, the social question still remained in its entirety" (*Réponse à mes adversaires*, also cited from Bertier de Sauvigny, p. 45).

107. Guizot, *Mémoires*, II, p. 9.

108. "Proclamation adressée aux Peuple français par les députés des départemens réunis à Paris," *Le Moniteur Universel*, no. 213 (Dimanche 1 août 1830), p. 829.

109. "Déclaration de la Chambre des Députés," *Le Moniteur Universel*, no. 220 (Dimanche 8 août 1830), p. 863.

110. Guizot, *Mémoires*, II, p. 16.

111. Laffitte, *Mémoires*, p. 168 and Halévy, *Le Courrier de M. Thiers*, pp. 23–30. For the proclamation of 31 July see pt. II, n. 27.

112. See pt. 1, n. 33 and associated text.

113. AN, F²¹584, pièce 381, memo from Guizot to Louis-Philippe dated 20 October 1830. These two statues were commissioned from James Pradier on 12 November 1830 for 15,000 FF each (AN, F²¹752, pièce 157).

114. Our cross-section drawing of the Salle des Séances is from de Joly, *Plans, coupes, élévations et détails de la restauration de la Chambre des Députés*, pl. 13.

115. Commission awarded to Jean-Baptiste Roman on 12 November 1830 for 30,000 FF (AN, F²¹752, pièce 157). The relief is still in place in the Salle des Séances.

116. For line drawings of the reliefs by Ramey and Petitot see pl. 23 of the volume by de Joly cited in n. 114. Each sculptor received 12,000 FF (AN, F²¹752, pièce 157), and both works were removed after the 1848 Revolution.

117. AN, F²¹584, pièce 381.

118. I might add as a postscript that Petitot, who had placed Lafayette next to Louis-Philippe in his relief, was asked in 1832 to recut the figure and convert it into a portrait of the duc de Nemours—a downgrading of Lafayette's presence at the ceremony which prefigures that of Court's painting (fig. 79) for the Salle de 1830 at Versailles (see pt. II, sec. 5). Petitot was paid an extra 2,000 FF in February 1833 for effecting this politically important change (AN, F²¹584, pièces 450, 452, 458).

119. "Nouvelles," *JdA*, IVᵉ année, vol. II, no. 7 (15 août 1830), p. 119. The artists named in this announcement were Paul Delaroche, Ary Scheffer, Jean-Victor Schnetz, and Charles Steuben.

120. Barrot was named prefect on 20 August ("Partie Officielle: Ordonnances du Roi," *Le Moniteur Universel*, no. 235 [Lundi 25 août 1830], p. 945). He claimed that the appointment was made to reward his services as head of the commission which had escorted Charles X to Cherbourg and put him aboard a ship bound for England (*Mémoires*, I, p. 191). During the next three months the suite of pictures for the Hôtel-de-Ville was reorganized, and four different artists—Cogniet, Delaroche, Drolling, and Schnetz—were announced in late November ("Nouvelles," *JdA*, IVᵉ année, vol. II, no. 21 [21 novembre 1830], p. 371). Unfortunately, the documents which might chronicle these developments perished in the 1870 fire at the Hôtel-de-Ville. Although details of the commission are sketchy, a volume published in 1871—just after the fire—does confirm the program as we will outline it (Bullemont, *Catalogue raisonné*, pp. 24–25).

121. Figure 132: Signed and dated "Paul Delaroche 1839." Paris, Musée du Petit Palais, inv. no. 521 (458 × 500 cm). Delaroche evidently received 12,000 FF for the picture (Préfecture du Département de la Seine, *Inventaire Générale*, II, pp. 140–41). Figure 133: Ivry, Dépôt des Oeuvres d'Art de la Ville de Paris, inv. no. 523 (400 × 455 cm). Also commissioned for 12,000 FF (idem.). Since its transfer to Ivry from Paris in December 1976, this picture has disappeared and could not be located during my visit to the storehouse in 1980. I extend my sincere thanks to Mlle Burollet, Curator of the Musée Cognac-Jay in Paris, who arranged for workmen to search for the extant pictures and to move them out of storage so that I might photograph them. Figure 134: Signed and dated "Vᵒʳ Schnetz 1833." Salon of 1834, no. 1759. Paris, Musée de Petit Palais, inv. no.

522 (458 × 500 cm). Schnetz also received 12,000 FF for his picture (*Inventaire Générale*, pp. 138–39). Figure 135: Paris, Musée Carnavalet, inv. no. P.106 (32.5 × 40.5 cm). Currently catalogued by the museum as "artist unknown," this undated canvas is inscribed on the back "Drolling offert à Carnavalet par M. Viollat." Gaehtgens attributes this work to Gérard (*Versailles*, p. 297), but I can see no reason to doubt that it is, in fact, a sketch executed by Drolling for the full-sized canvas.

122. Ziff reiterates the importance of historical accuracy in the works of Delaroche in his conclusion (*Delaroche*, pp. 267–68).

123. Bailly, *Mémoires*, II, p. 149.

124. Thiers, *Révolution française*, I, p. 108.

125. Ibid.

126. Godechot, *Bastille*, pp. 243–44.

127. Ibid., pp. 197–98 and Thiers, *Révolution française*, I, pp. 108–09. Delaunay, governor of the Bastille, was reportedly carrying a note signed by de Flesselles which read: "Hang on while I amuse the Parisians with cockades."

128. See Godechot, *Bastille*, pp. 249–53 on how the news of the Bastille's fall affected Louis XVI and the members of his Court.

129. About the king's actions on 15 July see Buchez et Roux, *Histoire parlementaire*, II, pp. 117–19 and Bailly, *Mémoires*, II, pp. 166–72.

130. Bailly, *Mémoires*, II, p. 170.

131. Ibid., pp. 174, 182–85.

132. "While we were seated and even afterward," recalled Bailly, "it was difficult to stop or interrupt either the applause or the manifestation, too lively not to be tumultuous, of public joy" (ibid., p. 185).

133. Ibid., pp. 189–90.

134. Ibid., p. 191.

135. Ibid., pp. 190–92 and Thiers, *Révolution française*, I, pp. 113–14.

136. First idea for the *Bailly Proclaimed Mayor of Paris*, n.d. Lille, Musée des Beaux-Arts, inv. no. PL.1162 (21.3 × 39.6 cm). There is a penciled reference to Thiers' history in the upper right corner of this sheet.

137. Lille, Musée des Beaux-Arts, inv. no. PL.1164 (18 × 12 cm).

138. Orléans, Musée des Beaux-Arts (32 × 40.5 cm).

139. Compare, for example, the physical appearance and the uniform worn by Cogniet's figure to the engraving by Debucourt of Lafayette as commander of the National Guard in 1790: Paris, BN-EST, série Ef98 rés. (48.5 × 40.5 cm).

140. See n. 118.

141. The sack is discussed in pt. II, sec. 4 and nn. 130–32.

142. "It is more difficult," observed Vergnaud about the Schnetz, "to work lifesize or over lifesize than to introduce a general unity and harmony in a small frame. This reflection applies completely to the painting we are examining: unfortunately, it looks like the final scene of a melodrama after the audience has left, and yet there is in all of this a strength of coloring and a skillful drawing style" (*Examen du Salon de 1834*, p. 44).

143. "The administration was wrong," remarked *L'Artiste*, "not to commission pictures from M. Schnetz, but to give him such a subject to handle. It forced him to depart from the habits of his refined, steady, serious, and calm talent which usually knows how to select its subjects and harmonize them with the artist's special qualities" ("Salon de 1834: Peinture," *L'Artiste*, VII–VIII [1834], p. 87).

144. Bullemont believed that this was due to Drolling's death (*Catalogue raisonné*, p. 24); in fact, Drolling died in 1851, three years after the fall of Louis-Philippe's government. I will argue that the most plausible reasons for cancelling the entire program were political—it is likely that Drolling's work was so little advanced that it was cancelled altogether.

145. For this text refer to pt. II, n. 27.

146. About the controversy within the Orléanist ranks consult Guizot, *Mémoires*, II, pp. 22–23. For more extensive discussion of the factions which emerged refer to Thureau-Dangin, I, pp. 84–85 and Beik, *Louis-Philippe*, p. 44.

147. Barrot is quoted in Thureau-Dangin, I, p. 143. Barrot tended to credit himself with convincing Lafayette that the Republic was a hopeless cause and that the only viable option was to support Louis-Philippe as king (Barrot, *Mémoires*, I, pp. 127–29).

148. Thureau-Dangin, I, p. 89 and n. 120 above.

149. During one of the many civil disorders around the Palais-Royal in October 1830, Louis-Philippe and Barrot appeared together on the balcony of the palace and were greeted by cries of "Long live Barrot!" (Blanc, *Dix Ans*, II, pp. 121–22).

150. On the disorders of October 1830 refer to Thureau-Dangin, I, pp. 122–24; Blanc, *Dix Ans*, II, pp. 119–22; and Pinkney, *1830*, pp. 318–24.

151. For details of this cabinet shuffle consult

Thureau-Dangin, I, p. 125; Blanc, *Dix Ans*, II, pp. 122–26; and Pinkney, *1830*, pp. 324–25. When Guizot explained his side of this story—and his feelings about Barrot—he managed to make it seem that everyone involved agreed with him (*Mémoires*, II, pp. 128–34). For Barrot's side of the controversy see his *Mémoires*, II, p. 240.

152. Mellon, *The Political Uses of History*, pp. 52–53 and Pinkney, *1830*, p. 53. Cousin later incorporated this analogy into his thinking on political philosophy (*Fragments philosophiques*, p. 93), and Barrot emphasized its compelling logic when explaining why his colleagues could not compromise with the Bourbons in 1830: "England had only been able to take full possession of its parliamentary institutions by moving the Crown from the family which reigned by birthright to another lineage named by the Parliament, one ruling in virtue and within the limits of the contract; everything about this example irresistibly swept people toward a solution different from that proposed by Charles X" (*Mémoires*, I, p. 118).

153. For a complete history of English politics in 1688 refer to Trevelyan, *The English Revolution, 1688–89*, or Gruber, *The English Revolution: A Concise History and Interpretation*.

154. Trevelyan, p. 78.

155. Ibid., pp. 154–55.

156. Gruber, p. 142.

157. "I figured that France in 1830," wrote Broglie, "should follow judiciously the example she received from England in 1688" (*Souvenirs*, III, p. 393). Bérard reported that Louis-Philippe echoed the same sentiments on 31 July when noting that "Charles X strongly resembles the unfortunate Stuart, and I am afraid to have soon more than one affinity with William" (cited in Bertier de Sauvigny, *La Révolution de 1830*, p. 226). We have already seen (n. 152 above) that Barrot fully ascribed to this analogy. Finally, an article entitled "Le Parallélisme des Révolutions," published in *Le Globe* on 1 August 1830, outlined in detail the analogies between England in 1688 and France in 1830 (cited in Paris, Musée Carnavalet, *Juillet 1830*, no. 163).

158. Thureau-Dangin, I, p. 143. Barrot explained his position in a memo to Louis-Philippe: "the majority wanted to take over the revolution and direct it: they were wrong. The majority should have restricted itself to proclaiming the general wish for a new royalty, and then backed off. The King would have convoked the constituent assem-

blies and requested a representative body which, born of the revolution, would have been able to direct it more surely and organize it broadly" (reprinted in Barrot, *Mémoires*, II, pp. 207–08).

159. In the voting to adopt the *Charte de 1830*, 219 deputies out of an elected 415 approved the measure, 33 were opposed, and 163 abstained (Pinkney, *1830*, p. 192; Thureau-Dangin, I, pp. 39–40; and Blanc, *Dix Ans*, I, pp. 430–39).

160. Compare, for example, the explanations offered by Guizot stressing the dangers of anarchy (*Mémoires*, II, pp. 23–24) and the combined anger and disillusionment expressed by a group of young republicans during an interview with Louis-Philippe at the Palais-Royal on the evening of 31 July (recounted in Laffitte, *Mémoires*, pp. 190–92 and Blanc, *Dix Ans*, I, pp. 358–62).

161. See sec. 9.

162. On 7 December 1831, E. F. Bertin, an inspector for the Bureau des Beaux-Arts, certified that both Coutan and Hesse had finished their full-scale sketches (AN, F^{21}584, pièces 307, 181). By that time they each had received two installments of the total commissions (to Coutan, AN, F^{4*}504, no. 1005, 4 May 1831, 2,500 FF and no. 3366, 28 December 1831, 7,500 FF; to Hesse, idem., no. 1006, 4 May 1831, 2,500 FF and no. 3365, 28 December 1831, 7,500 FF). Although a similar note pertaining to Vinchon's picture is not found among the surviving documents, the fact that he had also received two payments argues for a parallel rate of progress (AN, F^{4*}504, no. 1904, 13 August 1831, 2,500 FF and no. 2674, 28 September 1831, 5,500 FF).

163. See n. 96. The political climate of 1835 can be glimpsed in the critical comments of writers like Decamps, who remarked ruefully that the Salon crowds admiring Vinchon's *Boissy-d'Anglas* learned to "scorn the people so odiously disfigured by M. Vinchon's brush" ("Salon de 1835: III," *Revue Républicaine*, V [1835], p. 165). As we shall discover, the picture's ability to elicit such reactions—regardless of the specific politics involved—would ultimately doom the plan to place it in the Chamber of Deputies.

164. AN, F^{21}584, pièce 304, dated 16 September 1833 and idem., pièce 404, 8 May 1836.

165. Coutan's death was announced in April ("Nouvelles," *JdA*, XIe année, vol. I, no. 14 [2 avril 1837], p. 224). The picture was turned over to Court in June with the understanding that he would receive the remaining 11,000 FF never paid to Coutan

(AN, F²¹584, pièce 293, dated 30 June 1837). The Quaestors of the Chamber of Deputies were informed on 13 September 1837 that the picture was finished and could be installed (AN, F²¹584, pièce 399), and Court received payment shortly thereafter (AN, F⁴*510, no. 1604, 21 December 1837, 3,000 FF and no. 1854, 15 March 1838, 8,000 FF).

166. See n. 56 above. Hesse received a third installment on the picture's total price of 20,000 FF in 1837 (AN, F⁴*509, no. 1862, 17 June 1837, 5,000 FF) and final payment the following May (AN, F⁴*510, no. 1951, 9 May 1838, 5,000 FF).

167. As early as 1836 the bureaucrats of the Interior Ministry had concluded that the *Mirabeau* was too far advanced to be abandoned (AN, F²¹584, pièce 395, internal memo dated 11 October 1836). In 1838 a letter was sent to the Quaestors noting that the picture by Hesse was finished and shown at the last exhibition. It also asked, since "the decoration of the assembly hall of the Chamber was changed in 1836," what they wanted to do with the painting (AN, F²¹584, pièce 394, letter of 31 May 1838).

168. "The large picture executed by M. Schnetz for the Grand Salon of the Hôtel-de-Ville was installed this week" ("Nouvelles," *JdA*, VIIᵉ année, vol. II, no. 4 [28 juillet 1833], p. 61). See also n. 121 for fig. 134.

169. Ziff incorrectly claimed that the Cogniet was never executed (*Delaroche*, p. 85). Unfortunately, the picture has been misplaced among the holdings of the Ville de Paris and cannot be examined for a dated signature.

170. Ibid., n. 11, and n. 144 above.

171. In the ministerial shuffle of 11 October 1832 Guizot returned to the cabinet as Minister of Public Instruction—a less visible post in which his arch-conservative opinions would cause fewer political difficulties (Thureau-Dangin, II, pp. 176–77). The text of Barrot's letter of resignation—dated 28 December 1830 and effective 21 February 1831—is reprinted in Barrot, *Mémoires*, p. 596.

172. "Salon de 1834: 4ᵉ Article," *JdA*, VIIIᵉ année, vol. I, no. 12 (23 mars 1834), pp. 190–91.

173. About the activities of public criers and the government's inability to obtain jury convictions see Thureau-Dangin, II, pp. 228–31. Concerning the law and its discussion by the Chamber of Deputies see p. 234.

174. Ibid., pp. 235–39 and Paris, Archives Nationales, *Louis-Philippe*, no. 392.

175. Thureau-Dangin, II, pp. 241–45 and Moss, "Parisian Workers and the Origins of Republican Socialism," pp. 211–12.

176. The most infamous episode of this uprising was the massacre by government troops of a complete household in the rue Transnonain, an incident immortalized by Daumier's lithograph, *Rue Transnonain, 15 April 1834* (Delteil, *Le Peintre-graveur illustré*, XX, [Daumier, I], no. 135).

177. Thureau-Dangin, II, p. 246 and Guizot, *Mémoires*, III, p. 237.

178. The day after hearing of the government's double victory over the insurrections at Paris and Lyon (15 April), the cabinet proposed two new laws designed to achieve a more reliable social control: one allocated funds to raise and equip a regular army specifically designed to insure internal tranquility; the other provided for severe penalties against any citizen caught harboring war-quality weaponry (Thureau-Dangin, II, pp. 249–50 and Guizot, *Mémoires*, III, pp. 249–50).

179. AN, F²¹584, pièce 133.

180. In one letter of this exchange, the Quaestors raised the issue of "the pictures, which we only mention here as a reminder, because we reserve the right to discuss them with you personally" (AN, F²¹584, pièce 401, letter of 20 August 1836). At about the same time, rumors began to circulate in the art press concerning the fate of the program: for example, a short news item in *L'Artiste* remarked that "M. Thiers, with that quickness of mind which has not forsaken him in his new career [he had just resigned as Prime Minister], had been sufficiently edified by viewing the engraving of *Boissy-d'Anglas*, and—whatever your opinion about the sincerity of his respect for the elected chamber—you must admit that from this moment on he was afraid of attacking the assembly's dignity by authorizing the commissioned pictures to be added to the two reliefs, already quite irreverent, which flank the speaker's rostrum" ("Le Ministère de M. de Montalivet," *L'Artiste*, XII [1836], p. 17). Finally, a letter from the Minister of the Interior to the Quaestors informed them that "of the five pictures originally destined for the Assembly Hall only one, that of the *Oath of the King . . .* will be installed at the end of the summer" (AN, F²¹584, pièce 400).

181. AN, F²¹60, dossier "Vinchon," letter dated 3 April 1843. The news that Vinchon's picture had been sent to Annonay was reported somewhat incredulously in November 1838 ("Nouvelles," *JdA*, XIIᵉ année, vol. II, no. 19 [4 novembre 1838], p. 282).

Records at Annonay indicate that the transfer was authorized in January 1838, and the work was actually crated and shipped in August (AN, F²1498, 22 August 1830). The painting of *Mirabeau* by Hesse was transported from the Louvre to the Chamber of Deputies on 9 August 1838 (AN, F²1584, pièces 392, 393), but its exact emplacement was not specified. The picture was transferred from Paris to Amiens in 1891 (AN, F²14500/2—my thanks to Marie-Claude Chaudonneret for providing me with this document). The important point is that the *Mirabeau* was never hung in the Salle des Séances.

182. See n. 118 above.

183. See pt. II, sec. 5.

184. "You have said," wrote Montalivet in 1833, "that, without depriving the Louvre of any masterpieces of painting or sculpture, you wanted Versailles to offer France a collection of souvenirs of its history taken from the works of art, both ancient and modern, currently owned by the crown, and that monuments of all our national glories would be deposited there and thus surrounded by the splendor of Louis XIV" ("Rapport au Roi," *Le Moniteur Universel*, no. 248 [Jeudi 5 septembre 1830], p. 2043).

185. "The portrait of Camille Desmoulins, among others, will be placed in the historical museum of Versailles," reported one journal; "It seems that no epoch will be excluded" ("Nouvelles," *JdA*, VIIIᵉ année, vol. II, no. 15 [12 octobre 1834], p. 240). One discovers this mixture of astonishment and admiration throughout the critical literature concerned with the museum at Versailles: "Neither the spirit of the Restoration," wrote Jal in 1845, "which erased from monuments erected by the Empire the symbols which the Emperor had had inscribed upon them, nor the spirit of the Republic, which worked hard to annihilate every evidence of France's former grandeur, could support the lofty moderation of the king's plan, its dignified fairness, its exemplary composure. But the nation, indeed Europe, has understood all that is grand and truly royal in this composure, this fairness, this moderation" ("Musée historique de Versailles," pp. 89–90).

186. Several historians are currently investigating the rhetorical underpinnings of Louis-Philippe's historical project at Versailles: Claire Constans, Conservateur au Musée de Versailles, is preparing a study on the Salles des Croisades, and Thomas Gaehtgens has just completed a book on the iconographic program of the Galerie des Ba-

tailles (*Versailles: De la résidence royale au musée historique*, 1984). For my part, a separate discussion of the rooms dedicated to the wars in North Africa—originally planned as part of this book—is forthcoming.

187. Almost completely destroyed during the sack of the Palais-Royal in 1848, this gallery is preserved in the plates of Vatout, *Histoire lithographiée du Palais-Royal*.

188. Salon of 1831, no. 3209 (recorded in a hand-written, unpublished seventh supplement to the *livret*). The dimensions of this canvas were 227 × 160 cm (AN, 300 API 1113, "Inventaire de Tableaux du Palais-Royal, Galerie du Théâtre," in which it was noted that only a fragment remained). Vernet received 6,000 FF for the work (AN, O⁴1373, no. 1267, 1 August 1831). Our illustration is the lithograph published in Vatout (cited n. 187).

189. Godechot, *Bastille*, pp. 187–92.

190. Thiers, *Révolution française*, I, p. 95.

191. Tardieu remarked that the Vernet had "arrived from Rome only a few days before the Salon closed" (*Salon de 1831*, p. 60).

192. "Salon de 1831," *L'Artiste*, I (1831), p. 31.

193. Planche, *Salon de 1831*, pp. 275–76.

194. Heine, who did not specifically comment on the *manner* with which Vernet depicted this scene of the Great Revolution, nevertheless did respond to the fashion-plate quality of the *Camille Desmoulins* and related it to contemporary politics: "This picture was rather interesting with regard to the fashions of 1789. Over here one still saw powdered curls, ladies' dresses with pinched waists and padded hips, dress coats striped in festive colors, coachman-like greatcoats with small collars, and twin watch chains hanging parallel above the waist. Over there one saw those waist coats with wide lapels worn during the Terror, which have come back into fashion today among the republican youth of Paris and which are known as *gilets à la Robespierre*" ("Gemäldeausstellung in Paris 1831," p. 15).

195. Tardieu, *Salon de 1831*, p. 60.

196. Ibid.

197. Vernet's pictures of *Valmy* (fig. 98) and *Jemmapes* (fig. 99) were publicly exhibited at the 1831 Salon (nos. 2076, 2077). Structurally and narratively embodying the qualities of genre historique—and predating 1830 by almost a decade—their clandestine existence during the Restoration hampered the development of a critical discourse concerning their mode of representation, a dis-

course which only became public in 1831. It is important to note, however, that in 1822, when these pictures were exhibited by Vernet in his studio, the critical response had been as bewildered and confused as it would be in 1830 (see Rome, Académie de France, *Horace Vernet*, pp. 62–64).

198. Salon of 1834, no. 444. The dimensions of this canvas were 227 × 160 cm (AN, 300 API 1113, "Inventaire de Tableaux du Palais-Royal, Galerie du Théâtre," where it is listed as completely destroyed in the 1848 sack of the Palace). DeBay apparently received 5,000 FF for the picture (idem., "Etat des tableaux ... achetés pour le Compte du Domaine Privé," dated January 1832). Our illustration is the lithograph published in Vatout (see n. 187 above).

199. About the declaration of war and the failure of French strategy see Lefebvre, *Révolution*, I, pp. 218–29; Thiers, *Révolution française*, III, pp. 85–86; and Godechot, *Counter-Revolution*, pp. 160–62.

200. Thiers, *Révolution française*, III, pp. 169–70 and Furet and Richet, p. 141.

201. Thiers, *Révolution française*, III, p. 197.

202. Chassin et Hennet, *Les volontaires*, I, pp. 325–27.

203. The text of this declaration (reprinted ibid., p. 327) does not designate the Palais-Royal as one of these centers, leading us to conclude that DeBay's picture is doubly fictional.

204. Text reprinted ibid., p. 326.

205. One example chronologically and compositionally close to the DeBay is Scheffer's *Saint Thomas Aquinas Preaching a Trust in God during the Storm*: Signed and dated "A. Scheffer 1823." Salon of 1824, no. 1539. Paris, Chapelle de l'Hôpital Laënnec but currently exhibited at the Petit Palais (353 × 295 cm).

206. "Salon de 1834: 7e Article," *JdA*, VIIIe année, vol. I, no. 15 (13 avril 1834), p. 242.

207. ... [Hilaire L. Sazérac], p. 151.

208. Lefebvre, *Révolution*, I, pp. 206–13 and Thiers, *Révolution française*, I, p. 339.

209. The legislative session had opened on 10 October 1791 and was led by the Gironde party. About the party and their political concerns consult Lefebvre, *Révolution*, I, pp. 213–16.

210. Thiers, *Révolution française*, II, pp. 87–93.

211. Ibid., pp. 93–98.

212. "Is Your Majesty capable today of openly allying yourself with those who claim to reform the Constitution," asked Jean-Marie Roland in the course of a letter to Louis XVI dated 10 June 1792, "or should you generously devote yourself without reservations to make it triumph? That is the real question for which the current state of affairs demands an answer. Concerning this answer, the very metaphysical discussion of whether Frenchmen are ready for liberty counts for little, because it is not a question of imagining what we will be in a hundred years, but rather of seeing what the current generation can do" (excerpted from Thiers, *Révolution française*, II, p. 103). This letter was actually written by Mme Roland.

213. On the growing political activism of the sans-culottes, their demands, and the response of the National Assembly to their pressure consult Hampson, pp. 138–44 and Lefebvre, *Révolution*, I, pp. 230–32.

214. Thiers, *Révolution française*, II, pp. 145–53.

215. Ibid., pp. 160–61 and Hampson, p. 145.

216. Thiers, *Révolution française*, II, pp. 183–85 discusses Vergniaud's speech of 3 July 1792 before the National Assembly, in which he raised the abdication issue. About the country's predicament at that time see ibid., pp. 173–74 and Lefebvre, *Révolution*, I, pp. 227–32.

217. Thiers, *Révolution française*, II, pp. 189–90.

218. Furet and Richet, p. 142.

219. Louis-Philippe, *Mémoires*, II, pp. 43–59. About the ceremonies in July he wrote: "The Assembly escorted this announcement of the formal declaration of the state of national emergency. It was promulgated with great pomp in all the neighborhoods of Paris by municipal officials on horseback on the 22nd and 23rd of July" (ibid., p. 87).

220. Ibid., pp. 257–58.

221. Ibid., pp. 259, 261.

222. "4e Visite du Roi," AC, 91G-I, 6 March 1834. Louis-Philippe was not the first to be interested politically in the history of 1792. Mellon has shown that during the 1820s it was a crucial dividing line in the Liberals' account of the Revolution (*The Political Uses of History*, pp. 25–27). My thinking about the Salle de 1792 has benefited greatly from Mellon's analysis. See also the text and numerous color illustrations of the gallery in Gaehtgens, *Versailles*, pp. 259–83.

223. The copy of *Valmy* was executed by

Mauzaisse: Versailles, MNC, inv. no. MV2335 (296 ×
678 cm). Commissioned on 10 May 1834 for 8,000 FF
(AL, 2DD/23, p. 102), the picture was completed by
October (AN, O⁴1525, no. 2916, 14 August 1834,
2,000 FF; no. 3077, 26 August 1834, 2,000 FF; and no.
3999, 30 September 1834, 4,000 FF). Henri Scheffer
was charged with the copy of *Jemmapes*: Versailles,
MNC, inv. no. MV2336 (296 × 678 cm). Presumably
commissioned at the same time as the *Valmy* copy
(the archives are incomplete on this point), Scheffer
was also paid 8,000 FF total before October (AN,
O⁴1525, no. 2937, 16 August 1834, 2,000 FF; no. 3441,
5 September 1834, 2,000 FF; no. 3994, 30 September
1834, 2,000 FF; and no. 4000, 30 September 1834,
2,000 FF).

224. *Louis-Philippe d'Orléans, duc de Char-
tres, in 1792*, painted by Léon Cogniet in 1834. Ver-
sailles, MNC, inv. no. MV2344 (135 × 95 cm). Com-
missioned on 19 May 1834 for 800 FF (AL, 2DD/4,
p. 52) and paid for on 9 July (AN, O⁴1524, no. 2202).

225. "4ᵉ Visite du Roi," AC, 91G-I, 6 March
1834. The general disposition of the Salle de 1792
and the strategic placement of this picture in it are
obvious from our photo of the gallery (fig. 141). The
painting over the doors, which extends the full
width of the room, is the copy of *Valmy* by Mau-
zaisse.

226. Salon of 1836, no. 364. Versailles, MNC,
inv. no. MV2333 (189 × 204 cm). The picture was
commissioned on 10 May 1834 for 7,000 FF (AL,
2DD/4, p. 55) and payments continued until late
1835 (AN, O⁴1525, no. 2936, 16 August 1834,
2,333.33 FF; O⁴1527, no. 7296, 5 March 1835,
2,333.33 FF; and no. 9082, 10 October 1835, 2,333.34
FF).

227. Louis-Philippe, *Mémoires*, II, p. 261.

228. Chassin et Hennet, *Les Volontaires*, I, pp.
334 and 388.

229. Ibid., pp. 335–36.

230. Ibid., p. 347.

231. *Proclamation of the State of National
Emergency, 22 July 1792*, early 1794. CdV, III, no.
4478 (19.4 × 25.4 cm). This engraving was pro-
duced by Berthault after a drawing by Prieur.

232. The ceremony was meticulously out-
lined by a decree dated 19 July 1792 and signed by
the *Conseil Général de la Commune de Paris*. It is
reprinted in Chassin et Hennet, *Les volontaires*, I,
pp. 325–27.

233. For example, the *Departure of a Volun-
teer* from ca. 1792 by the genre painter François

Watteau de Lille (discussed in Rosenblum, *Trans-
formations*, pp. 88–89, fig. 91).

234. "The Parisians rush to the borders as if
running to a festival," noted *L'Artiste*, "the wives,
mothers, and sisters of these soldier-citizens ap-
plaud their patriotic zeal" ("Salon de 1836: Vᵉ Ar-
ticle," *L'Artiste*, XI [1836], p. 109).

235. Lefebvre, *Revolution*, I, pp. 241–44 and
Thiers, *Révolution française*, III, pp. 62–91 describe
these gruesome events. For Louis-Philippe's under-
standing and opinions of the prison massacres see
his *Mémoires*, II, pp. 133–37.

236. Thiers, *Révolution française*, III, p. 69.

237. Louis-Philippe, *Mémoires*, II, p. 137.

238. "Beaux-Arts: Salon de 1836 (5ᵉ Article),"
Le Moniteur Universel, no. 88 (Lundi 28 mars 1836),
p. 560. Pillet was not the only writer to underscore
the disjunction between Cogniet's style and subject.
"I know very well that '92 is not the terrible and
resounding year '93," admitted de Beauvoir, "that
this Pont-Neuf, the picture's point of departure, the
Pont-Neuf which leads to the place de la Grève, has
not yet seen a king's head fall! But, I ask you, did
these *tricoteuses* (one must call them by their
name), these terrorists, and these Caius-Gracchi in
jackets and caps massed on the bridge, need to be
dressed like bourgeois women going to the Por-
cherons' Ball, the men like members of a political
club dressed for a formal harangue?" ("Salon de
1836: Deuxième Article," *Revue de Paris*, 2ᵉ série,
XXVIII [1836], pp. 109–10). If de Beauvoir—writing
in the artistically and politically conservative *Revue
de Paris*—complained that Cogniet did not make
1792 seem horrible *enough*, we should not be sur-
prised to find at the other end of the political spec-
trum a leftist critic like Buchez condemning the
picture because it denies "the people" their rightful
place in the Revolution. He felt that the picture was
"pitifully false. For this very serious subject he
[Cogniet] has used the coquettish and flickering
coloration suitable for bedroom paintings. We will
not elaborate on the slack drawing style, nor the
generally grey and dull tonality, but we will say that
when it is a question of rendering a scene so close to
us, so grand, so honorable for our fathers, one
should make the effort to consult contemporary
documents. We will note that M. Cogniet had only to
imitate the powerful and majestic means by which
the Paris Commune had roused the people and pro-
voked fifty thousand voluntary enlistments. He
must have been terribly uninspired to replace the

magnificence of a large, unanimous popular movement with the pettiness of a parade of young marquis. We will note further that the artist who does history owes truthfulness to the public. When the state of national emergency was declared, it was 'the people' who went to spill their blood at the frontiers and not, as M. Cogniet would have us believe, the nobles: 'the people' did not remain behind, as he shows us, with their arms crossed watching the gentlemen depart" ("Du Salon de 1836," *L'Européen, journal de morale et de philosophie*, I, no. 6 [Mars 1836], p. 192).

239. "Salon de 1836: V^e Article," *L'Artiste*, XI (1836), p. 109.

240. On the causes and episodes of the revolt of 10 August 1792 consult Lefebvre, *Revolution*, I, pp. 235–41; Thiers, *Révolution française*, II, pp. 256–81 and III, pp. 3–14; Furet and Richet, pp. 143–46; and Hampson, pp. 146–48.

241. See Hampson, p. 148 and Thiers, *Révolution française*, III, pp. 25–26 on the increased power and influence of the Paris Commune.

242. About the sans-culottes as a group refer to Hampson, pp. 139–40. For a discussion of the political aspirations of the radical sections in Paris see Lefebvre, *Revolution*, I, pp. 236–37, and for rather colorful sketches of some of their leaders—Danton, Marat, Robespierre, et al.—refer to Thiers, *Révolution française*, II, pp. 212–22. The most accurate portrayal of David's politics seems to be the one offered by Bordes, *Le Serment*, pp. 45–54 (on David and the Jacobins) and pp. 77–83 (on the rapprochement of David and Robespierre during the period January to September 1792).

243. The removal of these statues was recorded in several popular engravings. See CdV, III, nos. 4917–25 (esp. no. 4921) for the removal of Henri IV from the Pont-Neuf.

244. Louis-Philippe, *Mémoires*, II, p. 179. About the military importance of Jemmapes consult Lefebvre, *Revolution*, I, p. 261 and Thiers, *Révolution française*, II, pp. 260–61.

245. Godechot, *Counter-Revolution*, pp. 166–67.

246. Louis-Philippe, *Mémoires*, II, p. 226.

247. Ibid., p. 227; Lefebvre, *Revolution*, I, pp. 264–65; and Thiers, *Révolution française*, III, p. 159.

248. This highly specialized and politically manipulative invocation of the departure of the volunteers in 1792 predates by over a decade both Michelet's celebration of it (1847) and the painting

by Couture (1847 ff). Boime's discussion of the Couture virtually ignores Louis-Philippe's earlier attempts to dislodge the received historical meaning of the event (Boime, *Couture*, p. 193).

249. See sec. 6.

250. Thureau-Dangin, II, pp. 214, 221–23 and Moss, "Parisian Workers and the Origins of Republican Socialism," pp. 211–13.

251. Salon of 1844, no. 410. Versailles, MNC, inv. no. MV1951 (421 × 847 cm). Commissioned on 30 April 1838 for 14,000 FF, the price was increased by 10,000 FF on 7 May 1840 (AL, 2DD/5, p. 80). We will discover presently that the picture actually cost quite a bit more.

252. Thiers, *Révolution française*, I, pp. 258–67 and the detailed description of this day as recorded by the marquis de Ferrières (reprinted ibid., pp. 406–14).

253. Figure 149: *The General Federation Effected at Paris, 14 July 1790*, early 1793. CdV, II, no. 3779 (20.1 × 27.1 cm). Figure 150: *Festival of the Federation on the Champ-de-Mars, 14 July 1790*, signed and dated "H. Robert 1790." Versailles, MNC, inv. no. MV4603 (52 × 96 cm). Couder apparently gave the picture to the king in 1847 (Constans, *Catalogue des Peintures*, p. 115, no. 3957), but the date was not recorded on the inventories of the July Monarchy (AL, 2DD/4, p. 435).

254. This pictorial problem was discussed by Thénot, "Salon de 1844: Suite et fin," *Echo de la littérature et des Beaux-Arts*, V (octobre 1844), p. 318 and Thoré, *Le Salon de 1844*, pp. 10–11.

255. *The Oath of Federation, 14 July 1790*, 1790. CdV, II, no. 3761 (33.8 × 27.2 cm). This aquatint was printed by Louis LeCour from a composition by Swebach-Desfontaines. "In order to show the details of this patriotic scene," explains the caption with a bit of political irony, "a vantage point from the side facing the king's tribune was adopted, it being the only one not covered. From this vantage point, we could not depict the throne where the monarch swore to uphold the Constitution with all his might and to carry out the laws."

256. Montalivet, *Le Roi Louis-Philippe*, pp. 118–19.

257. Ibid., p. 120. Variants of this story were rumored in the periodical press, lending credence to Montalivet's rather picturesque account. "One assures me," wrote Lemer about Couder, "that he had been obliged to restart a first picture that was well advanced" ("Salon de 1844—à Madame P.G.:

Première lettre," *La Sylphide*, IX [1844], p. 267). Similarly, Huard concluded his comments by noting: "We will say, by echoing studio gossip, that this picture had been redone four or five times and that it cost the Civil List more than 50,000 FF" ("Salon de 1844: Ouverture," *JdA*, XVIIIᵉ année, vol. I, no. 11 [17 mars 1844], p. 162).

258. Louis-Philippe, *Mémoires*, I, p. 136. Certain Leftist critics reported the king's intervention with a more politicized (and not impossible) coloration: "M. Couder knows as well as us," remarked the *Revue Indépendante*, "everything that is artistically faulty about this composition. It is said that he had conceived it quite differently, that he had even restarted his picture two times. At first he had chosen the national altar as the center of action and the rest of the composition was joined together there. This gave too much importance to a forgotten cult. The Civil List requested another project. M. Couder then made Louis XVI's oath-taking the main subject, but a king who takes an oath to the people's freedom is not good to see: he had to renounce this second idea. At this point the Civil List asked for the minutes of the Federation, pure and simple. Like it was said, that's how it was made" (Saint-Martin, "Salon de 1844: Premier Article," *Revue Indépendante*, XIII (mars-avril 1844], pp. 422–23).

259. Montalivet, *Le Roi Louis-Philippe*, pp. 120–21.

260. Documents show that Couder received only 20,000 FF more for the picture we have today (AL, 2DD/5, p. 80). Payments on this additional amount were made throughout 1843 (AN, O⁴2117, no. 5153, 21 July 1843, 3,000 FF; O⁴2118, no. 7353, 4 November 1843, 6,000 FF; and no. 8754, 15 December 1843, 11,000 FF).

261. Thoré, *Le Salon de 1844*, pp. 10–11.

262. Peisse protested, for example, that the Couder "is not, properly speaking, a History Painting; it is a panorama painting, a general topographic view of the Champ-de-Mars, the way it might have looked from afar to a spectator positioned on a hill the 14th of July 1790 near noon. The figures are only partial elements of an overall effect, they only participate in the composition as masses: individually, they have no particular signification; this one no more than that" ("Le Salon: La Sculpture et la peinture française en 1844," p. 360).

263. Desbarolles, "Quelques Mots sur le Salon," *L'Ami des Arts*, II (1844), p. 354 and anonymous, "Diderot au Salon de 1844," *La Chronique*, IIIᵉ année, V (1844), p. 101.

264. Thoré, *Le Salon de 1844*, p. 11.

265. Blanc, "Salon de 1844," *L'Almanach du Mois*, I (1844), pp. 198–99.

266. Salon of 1848, no. 1004. Versailles, MNC, inv. no. MV1950 (421 × 580 cm). Originally commissioned from Court on 30 April 1838 for 10,000 FF, the picture was awarded to Couder on 21 August 1839 (AL, 2DD/4, p. 80). Couder only received a first payment for the picture in 1846 (AN, O⁴2241, no. 10690, 14 August 1846, 4,000 FF), probably because he was busy working on several paintings commemorating the exchange of visits between Louis-Philippe and Queen Victoria in 1843–44. The payment records trace Couder's progress: AN, O⁴2184, no. 10571, 17 June 1847, 4,000 FF; O⁴2352, no. 4110, 8 September 1847, 2,000 FF. At about this same time the artist obtained a handsome supplement of 10,000 FF (AL, 2DD/5, p. 158, 9 July 1847) which was paid in two parts (AN, O⁴2352, no. 4036, 6 September 1847, 4,000 FF and O⁴2353, no. 7034, 16 December 1847, 6,000 FF, where it is noted that the picture had been delivered). For the historical context of the deputies' oath on 20 June 1789 refer to the discussion of the *Mirabeau et Dreux-Brézé* in pt. III, sec. 2.

267. Jazet's engraving was published in 1823. BN-EST, série Ef236f, I, f⁶ (72.8 × 104.4 cm). See Bordes, *Le Serment*, pp. 235–36 for the publication details. David's drawing was brought to public attention in 1835, when the artist's heirs placed many of his canvases on auction; see, for example, the letter by Decamps which discusses the *Marat Dying*, the picture of LePeletier de Saint-Fargeau, and the *Oath of the Tennis Court* in the context of contemporary art (*L'Artiste*, IX [1835], pp. 102–04). Couder acknowledged the importance of David's image for his own picture in a letter of 29 March 1848 to David d'Angers (cited in Bordes, *Le Serment*, p. 89 and n. 342).

268. See Bordes, *Le Serment*, pp. 57–59 for a related discussion.

269. The unfinished canvas is presently at Versailles, MNC, inv. no. MV5841 (400 × 660 cm). It was purchased by the Crown for 2,400 FF (along with two sketchbooks at 240 FF each) from the David sale on 11 March 1835 (AL, 2DD/4, p. 88) and paid for in May (AN, O⁴1587, no. 1791, 23 May 1835, 2,880 FF).

270. Lee, "Versailles Sketchbook, Part I," pp.

204–08; idem., "Part II," pp. 364–66; and Bordes, *Le Serment*, pp. 59–62.

271. If we can believe Bailly's own account of that day, Couder was no more accurate than David with regard to Bailly's physical placement, for Bailly remembered that "a chair was offered to me, but I refused it. I could not be seated before a standing group, and I remained standing throughout this difficult day. We had only five or six benches and one writing table for the entire meeting, but the place became greater from the grandeur it contained" (*Mémoires*, I, pp. 238–39). What we must recognize, it seems, is that Couder was ultimately responding to (and altering) the scene as David had imaged it—a case of art imitating art in the interest of recreating history. Insofar as that is true, the difference between the Couder and its Davidian model are all the more startling.

272. For a complete discussion and reproduction of the picture (now in Bremen) see New York, *The Age of Revolution*, no. 117. David's phrase in his sketchbook for *Le Serment du Jeu de Paume*, "Mr. Barrère taking notes for his morning newspaper," allows us to identify securely the young man who writes in the foreground of his composition and, by extension, the young man holding a quill pen near the center of Couder's picture (see Lee, "Versailles Sketchbook, Part I," pp. 198, 200).

273. Louis-Philippe, *Mémoires*, I, p. 46. On David's studies of *père* Gérard see Bordes, *Le Serment*, pp. 187–88.

274. F. de Genevais [Frédéric de Mercey], "Salon de 1848: La Peinture," *Revue des Deux Mondes*, XVIIIᵉ année, n.s., XX (15 avril 1848), p. 293.

275. Exhibited in the painter's studio, 1777. Paris, Musée du Louvre, inv. no. INV5038 (130 × 162 cm).

276. Thiers, *Révolution française*, I, opposite p. 69.

277. See n. 269 above.

278. See n. 266 above.

279. Figure 147: Salon of 1840, no. 132. Versailles, MNC, inv. no. MV1952 (421 × 401 cm). Commissioned on 30 April 1838 for 9,000 FF (AL, 2DD/5, p. 80) and paid in three installments (AN, O⁴1831, no. 1644, 31 May 1839, 3,000 FF; O⁴1833, no. 7535, 19 February 1840, 3,000 FF; and O⁴1834, no. 8795, 8 May 1840, 3,000 FF). Our illustration does not reflect the actual proportions of this canvas because the photograph supplied by the Musées Nationaux is cropped at the left and right. Figure 148: Salon of

1842, no. 1851. Versailles, MNC, inv. no. MV1954 (421 × 576 cm). Also commissioned on 30 April 1838, but for 10,000 FF (AL, 2DD/5, p. 80), the picture was paid in two installments (AN, O⁴1900, no. 8119, 20 April 1841, 5,000 FF and O⁴1959, no. 7062, 5 March 1842, 5,000 FF).

280. AL, 2DD/5, p. 80, 9,000 FF. Langlois died on 28 December 1838, and on 31 December the Crown awarded his widow 1,500 FF for the preparatory work he had done (note in margin of AL, 2DD/5, p. 80). The commission was transferred to Couder (AL, 2DD/4, p. 291 and 2DD/23, p. 207), who had not finished the picture at the time of the 1848 Revolution; in 1852 he obtained permission to retain the commission but change the subject to *The Installation of the* Conseil d'Etat *in the Petit Luxembourg Palace*—a theme much more in tune with the politics of the Second Empire. Couder eventually received 8,000 FF and delivered the picture in 1856 (AN, F²172, dossier "Couder").

281. Soulié, *Notice du Musée Impérial de Versailles*, II, nos. 1950–54, "Salle nº 101."

282. The most complete account of the power struggles between the Crown and the parliament just before the French Revolution is Egret, *Prerevolution*, pp. 93–112; more briefly, see Lefebvre, *Révolution*, I, pp. 99–101 or Thiers, *Révolution française*, I, pp. 17–19.

283. See pt. IV, sec. 3.

284. Charléty, *La Restauration*, pp. 26–31 discusses the nation's attitude toward the imposed Bourbon government. As he observes, "the nation was not consulted and had no means of making its feeling known. It neither approved nor disapproved of the monarchy's restoration; it held its tongue."

285. See pt. I, sec. 2.

286. Cited in Thureau-Dangin, VII, pp. 88–89.

287. Ibid., pp. 109–11. See also pt. V, sec. 1.

288. Thureau-Dangin, III, pp. 245–48, 273–74.

289. The text of this address delivered on 17 December 1838 was published in *Le Moniteur Universel*, no. 352 (Mardi 18 décembre 1838), p. 2581.

290. The economic problems stemmed, in large part, from a poor harvest in the fall of 1846. The subsequent increases in food costs—especially bread—and shortages in some parts of the interior led to the usual cycle of events: panic, hoarding, civil disorders, and armed intervention. The government's attempt to subsidize bread costs with massive grain purchases from abroad drained the

monetary system of liquid assets, and a credit panic was added to the nation's problems: high interest rates, bankruptcies, and unemployment were the result. Opponents of the Orléans dynasty had little difficulty finding sympathetic audiences under these conditions (see Thureau-Dangin, VII, pp. 25–39).

291. Louis-Philippe, *Mémoires*, II, p. 435.

292. From a letter written by Louis-Philippe in August 1794 to General François de Montesquiou-Fezensac, also a refugee in Switzerland (Paris, Archives Nationales, *Louis-Philippe*, no. 163).

293. Louis-Philippe, *Mémoires*, II, p. 131.

294. A first edition of Thiers' history was published in 1823–27, and the definitive second edition (10 vols., published by Lecointe) appeared in 1828.

295. See pt. V, sec. 1 and nn. 20–25.

296. Thiers, *Révolution française*, I, pp. 1–2.

297. *The Arrest of the comte de Beaujolais at the Palais-Royal, 4 April 1793*, 1834. The dimensions of this canvas were 227 × 160 cm (AN, 300 API 1113, "Inventaire de Tableaux du Palais-Royal, Galerie du Théâtre," where it is recorded as torn up). Commissioned on 20 September 1833 for 4,000 FF (AL, 2DD/5, p. 8), Mauzaisse received a second payment on the picture in January 1834 (AN, O⁴1472, no. 5886, 21 January 1834, 1,250 FF). I was unable to find records of the first payment in the archives, but it is certain that the picture was completed by June, the date of the final payment (AN, O⁴1524, no. 1559, 23 June 1834, 1,250 FF). Our illustration is the lithograph published in Vatout, *Histoire lithographiée du Palais-Royal*.

298. When General Beurnonville, Minister of War, and four members of the National Convention appeared at the headquarters of Dumouriez to arrest him on suspicion of treason, they were apprehended and turned over to the Austrians. The Bourbons were to be held as hostages until the five Convention emissaries were freed by the enemy (Thiers, *Révolution française*, IV, pp. 121–26). On the various laws enacted at this time against the Bourbons, Dumouriez, and his officers (Louis-Philippe was thus twice indicted) see Louis-Philippe, *Mémoires*, II, pp. 404–06 and notes.

299. At least two sketches for the work are known: one was exhibited in 1975 (Paris, Archives Nationales, *Louis-Philippe*, no. 147), where the catalogue entry mentions a second sketch in a private collection. Unfortunately, I was unable to see these sketches.

300. Thiers, *Révolution française*, IV, pp. 102–05.

301. Ibid., p. 104 and Pariset, *La Révolution (1792–1799)*, p. 63.

302. Louis-Philippe, *Mémoires*, II, pp. 386–88.

303. Ibid., p. 405.

304. See sec. 6 above.

305. "Exposition de la Galerie Colbert," *L'Artiste*, IX (1835), p. 140. See also the article by Decamps, "Salon de 1835: III," *Revue Républicaine*, V (1835), p. 168.

306. *The Floor of the National Convention after Voting to Execute Louis XVI*, ca. 1835. Lyon, Musée des Beaux-Arts, inv. no. B-405 (73 × 115 cm). Because both *L'Artiste* and Decamps refer to a drawing (*dessin*) by Chenavard (see preceding note), it is unlikely that the Lyon oil sketch is the actual piece refused in 1835. Decamps also refers to "a large assembly" of figures and "a few incorrect details in the background," as if the work shown at the Galerie Colbert was more thoroughly elaborated than the Lyon sketch. In 1846 Thoré recalled "two noteworthy drawings [*dessins*] by M. Chenavard, *A Meeting of the Constituent Assembly* and *The Judgment of Louis XVI*" (*Le Salon de 1846*, p. 188). This pairing suggests that the piece refused in 1835 (and apparently lost today) was similar to Chenavard's competition sketch of *Mirabeau and Dreux-Brézé* discussed earlier (fig. 114). At any rate, the Lyon picture probably provides a fair idea of how Chenavard's original drawing represented Louis-Philippe's father.

307. Decamps, "Salon de 1835: III," *Revue Républicaine*, V (1835), p. 168.

308. "Exposition de 1835: 3ᵉᵐᵉ Article," *JdA*, IXᵉ année, vol. I, no. 11 (15 mars 1835), p. 167. See also Rosenthal, p. 39, n. 2.

309. *The Death of Bailly*, 1831. Compiègne, Musée Vivenel (420 × 522 cm). This picture, for many years rolled and stored in the Hôtel-de-Ville of Compiègne, has not been properly photographed; our illustration is only a detail of the center section of Boulanger's composition. Relative to the picture's history at the Salon of 1831, the registers preserved at the Louvre do indeed reveal that the work was refused by the jury (AL, série *KK, 1831, no. 3717, marked *refusé*), thereby verifying the report that "M. Boulanger's picture depicting the death of Bailly was definitely kept out of the last Salon, even though this artist had sent it to the Museum, where it still remains" ("Nouvelles," *JdA*, Vᵉ année, vol. II, no. 11 [11 septembre 1831], p. 200).

310. Thiers, *Révolution française*, I, pp. 332–36.

311. Ibid., V, pp. 410–12.

312. "Exposition de Tableaux, de Sculpture, etc., au Profit des habitans de la Guadeloupe: Premier Article," *Journal des Beaux-Arts*, Xe année, vol. I, no. 18 (7 mai 1843), pp. 285–86. Coincidentally, Jean-François Brémond sent his own version of the *Death of Bailly* (present whereabouts unknown) to the 1843 Salon, but he received no more favorable a response than Boulanger had been accorded in 1831 (AL, série *KK, 1843, no. 2314; listed as 375 × 310 cm and marked *refusé*). Undaunted, Brémond exhibited his picture at an independent gallery in 1844 (see *Promenade au Salon de 1844*, p. 30, where the Brémond is described among the pictures exhibited at the Galerie des Beaux-Arts on the Boulevard Bonne-Nouvelle) and finally exhibited it at the Salon of 1849 (no. 267).

313. Signed and dated "Ate DeBay 1838." Salon of 1850–51, no. 734. Nantes, Musée des Beaux-Arts, inv. no. 891 (275 × 174 cm). DeBay's original idea must have come from Guépin's first edition of 1832, entitled *Essais historiques sur le progrès de la Ville de Nantes*. Despite the change in his title from 1832 and 1839, Guépin stated that the later imprint was essentially an augmented edition of the 1832 original (*Histoire de Nantes*, p. 2).

314. About Carrier at Nantes see Thiers, *Révolution française*, VI, pp. 381–85. He was tried and executed for his crimes in December 1794 (Lefebvre, *Revolution*, II, p. 140 and Thiers, *Révolution francaise*, VII, p. 179). Guépin recounts many of the atrocities committed by Carrier and his men in *Histoire de Nantes*, pp. 461–70.

315. Guépin, *Histoire de Nantes*, p. 467.

316. Michel, "Salon de 1839: 2e Article," *L'Art en Province*, IV (1839), p. 82.

317. *Inventaire général des richesses d'art de la France: Province, monuments civils*, II, "Musée de Nantes," p. 24.

318. *Mlle de Sombreuil Saves Her Father by Drinking a Glass of Blood*, ca. 1841. Signed "Verdier." Bagnères-de-Bigorre, Musée Salies, inv. no. 371. This picture is not exhibited at Bagnères, but is stored in the museum's warehouse at the nearby town of Diogène. I was unable to see the painting at the time of my visit in 1978, and I cannot specify (nor do museum inventories record) its dimensions. I do want to express my gratitude to M. Castera at the *mairie* and to Studio Alix—a photographic house in Bagnères—for providing me with photos of this and other unexhibited pictures and for kindly answering my questions. Verdier sent his picture of Mlle de Sombreuil to the special exhibition mounted in 1843 to benefit the victims of an earthquake in Guadeloupe ("Exposition au Profit des Victimes de la Guadeloupe: 2e Article," *Journal des Beaux-Arts*, Xe année, vol. I, no. 20 [21 mai 1843], p. 317—where the author notes that the picture "had been refused two years ago").

319. Thiers, *Révolution française*, III, p. 75.

320. Ségur, *Les Femmes*, III, pp. 105–06. Figure 159 is taken from Thiers, *Révolution française*, III, opposite p. 75.

321. Signed and dated "David fbat anno 1799." Salon of 1808, no. 146 (but on exhibit at the Louvre already in 1800). Paris, Musée du Louvre, inv. no. INV3691 (385 × 522 cm). For a good reproduction see Schnapper, *David*, p. 185, pl. 110.

322. *Louvet and Barbaroux, Nearly Yielding to Their Despair, Are Stopped Short by Valady*. Salon of 1831, no. 1640. Bagnères-de-Bigorre, Musée Salies, inv. no. 400 (128 × 160 cm). The picture is stored in the museum's reserves at Diogène.

323. Louvet de Couvray, *Mémoires*, pp. 201–03. On the political assault upon the Gironde party leadership by the Jacobins in June 1793 refer to Thiers, *Révolution française*, IV, pp. 268–87 and Lefebvre, *Revolution*, II, pp. 40–54.

324. Louvet de Couvray, *Mémoires*, p. 202.

325. Salon of 1840, no. 605. Registered at the Louvre as 110 × 120 cm (AL, série *KK, 1840). The citation is from Charles Blanc, "Salon de 1840: Troisième Article," *Revue du Progrès politique, social et littéraire*, III (1840), p. 366.

326. The Delaroche, first exhibited at the Salon of 1831 (no. 522), was on view throughout the 1830s and 1840s at the Musée du Luxembourg and is today in Paris, Musée du Louvre, inv. no. INV3834 (181 × 215 cm). For a complete bibliography consult New York, *The Age of Revolution*, no. 44. Commentators about Robert-Fleury's picture at the 1840 Salon noted that "there is a lot of interest in this composition, very much feeling and expression in these two heads so sad, so sorrowfully afflicted" (Anonymous, "Salon de 1840: 8e Article," *Journal des Beaux-Arts*, VIIe année, vol. I, no. 15 [26 avril 1840], p. 228), or remarked that the picture was "full of sensibility and handled with an equal amount of talent" (Enault, "Salon de 1840: IIe Article," *L'Art en Province*, V [1840], p. 58).

327. Salon of 1841, no. 1225. Recorded in the registers of the jury as 110 × 120 cm (AL, série *KK,

1841). A picture of the same theme had been exhibited by Pierre-Jérome Lordon at the Salon of 1817 (no. 543) and is reproduced as a line engraving in Landon, *Salon de 1817*, pl. 51.

328. Tenint, *Salon de 1841*, p. 48.

329. Anonymous, "Salon de 1841: 7e Article," *Journal des Beaux-Arts*, VIIIe année, vol. I, no. 15 (2 mai 1841), p. 229.

330. The reasons for this, as Harris has pointed out, was that in the eighteenth century women never became full-fledged members of the academies, since they were denied access to drawing classes with live models and excluded from competitions—both of which were essential to the training of a history painter ("Women Artists and the Academies in the Eighteenth Century," pp. 36–38, 42–43). Nochlin has demonstrated that this de facto prejudice against women artists remained part and parcel of the Academy's ideology even after its reorganization in the 1790s, and that it continued well into the nineteenth century ("Women Artists after the French Revolution," pp. 45–50).

331. Salon of 1843, no. 663. Recorded in the registers of the Salon as 100 × 88 cm (AL, série *KK, 1843). I have been unable to trace this painting, although it was reported as sold at auction on 11 January 1848 ("Nouvelles," *JdA*, XXIIe année, 3e série, I, no. 3 [16 janvier 1848], p. 16). The Musée Municipal of Brest supposedly owns a small still-life (32 × 42 cm) of laboratory equipment, signed by Journet and dated 1842, but I have not seen the picture (Hombron, *Catalogue des tableaux... du musée de la Ville de Brest*, p. 45, no. 146).

332. "Salon de 1843: M. Léon Cogniet, Mlle Journet," *L'Artiste*, 3e série, III (1843), pp. 210–11 and Janin, "Salon de 1843," *Les Beaux-Arts*, I (1843), p. 92.

333. The Salon *livret* indicates that Journet was inspired by the *Leçons sur la philosophie chimique* of Dumas, where the episode is recounted on pp. 151–53. Modern historians have generally regarded the tale as apocryphal: for example, French, *Torch and Crucible*, pp. 255–56.

334. Janin, "Salon de 1843," *Les Beaux-Arts*, I (1843), p. 92.

335. "To add further interest to this story," wrote Janin, "she worked hard to reproduce with the most scrupulous exactitude certain chemical instruments which belonged to Lavoisier: his balances, his alembic, his crucible, a flask whose contents had actually been distilled in the Concièrgerie prison—precious and holy relics which could not have fallen into better hands than those of M. Dumas, the biographer, student, and continuer of Lavoisier's work" (ibid.).

336. "Salon de 1843: M. Léon Cogniet, Mlle Journet," *L'Artiste*, 3e série, III (1843), pp. 210–11.

337. Figure 161: Signed and dated "Louise Desnos 1846." Salon of 1846, no. 528. Saint-Etienne, Musée d'Art et d'Industrie (115 × 130 cm). Figure 162: *Reading the Evening Paper, or the Roll Call of Persons Condemned to Death*, taken from Thiers, *Révolution française*, VI, opposite p. 379.

338. Thiers, *Révolution française*, VI, p. 379.

339. Signed and dated "Louise Desnos 1846." Salon of 1846, no. 527. Saint-Etienne, Musée d'Art et d'Industrie (115 × 137 cm).

340. Thiers, *Révolution française*, III, pp. 85–87. Evidence of popular interest in the plight of the princesse de Lamballe is suggested by the fact that two illustrations devoted to it are placed back-to-back in the 1834 edition of Thiers: one by Tony Johannot represents *The Death of the princesse de Lamballe* and the other, by Ary Scheffer, is titled *The Queen Faints upon Seeing the Head of the princesse de Lamballe* (idem., between pp. 86–87).

341. Ibid., p. 86.

342. Ibid.

343. M***, "Salon de 1846: III," *Moniteur des Arts*, III, no. 10 (5 avril 1846), p. 73. Similarly, *L'Artiste* reported that "the crowd stopped with pleasure" before the pictures by Desnos, "without, I swear, showing much bad taste" ("Salon de 1846: Tableaux d'histoire," *L'Artiste*, 4e série, VI [1846], p. 63). It is equally interesting, I think, to consider the negative comments about these pictures, for they frequently dwell upon her gender as much as the paintings. One critic complained that "her compositions fall flat. A strong and manly touch is needed to reproduce the great scenes of the Revolution on canvas, and Madame Desnos lacks this strength. I would ask this artist why she felt obliged to make the republicans as ugly as caterpillars. It is an unnecessary ugliness. Madame Desnos should better understand her particular talent and work with gracefulness and naiveté, but she should never attempt demanding subjects" (*Diogène au Salon—1846*, pp. 31–32).

344. Maurice de Vaines, "Le Salon de 1846: Deuxième Article," *La Revue Nouvelle*, VIII (1 mai 1846), p. 501.

345. Signed and dated "H. Scheffer 1830."

Luxembourg exhibition of 1830, *livret* no. 313; Salon of 1831, no. 1901. Grenoble, Musée de Peinture et de Sculpture, inv. no. 938 (130 × 163 cm). Placed on loan at Grenoble by the government in 1892. Scheffer produced several replicas of this picture: one is in Liverpool, Walker Art Gallery, inv. no. 2885 (129.5 × 162.5 cm); a second is at Versailles, Musée Lambinet (uncatalogued); yet a third was at Brest, Musée Municipal (128 × 162.5 cm) before being destroyed by a fire in 1941. Finally, the painting was engraved by Sixdeniers, who exhibited his print at the Salon of 1841, no. 2250.

346. See Marrinan, "Images and Ideas of Charlotte Corday," for a discussion of the changing historical assessment of Marat's assassin.

347. Signed and dated "A Marat, David—l'An Deux." Brussels, Musées Royaux des Beaux-Arts de Belgique, inv. no. 3260 (165 × 128 cm). A good summary of this picture's history is found in London, Royal Academy, *The Age of Neo-Classicism*, pp. 45–46. See also Lankheit, *Der Tod Marat*; Herding, "Davids *Marat* als 'dernier appel à l'unité révolutionnaire' "; and Sauerländer, "Davids *Marat à son dernier soupir* oder Malerei und Terreur." Olander ("Pour transmettre," p. 250 and note) argues that David's partisan politics were "shared by many within the Convention, the Commune, and the nation at large." Surviving texts do suggest that the Commune generally shared David's pro-Marat sentiments, but to impose this localized phenomenon upon the Convention as a whole (where Marat had many enemies) is logically problematic. To insist further upon a national consensus strikes me as both incorrect and oblivious to anti-Convention activity in the west and southeast of France during the 1792–95 period (see Godechot, *Counter-Revolution*, pp. 201–45).

348. *Marie Anne Charlotte Corday, Formerly d'Armans, 25 Years Old*, 1793. CdV, III, no. 5347 (14.5 × 9.7 cm).

349. For prints of LePeletier's murder see CdV, III, nos. 5018–25. A single print shows LePeletier's assassin committing suicide at the time of his arrest (catalogued idem., no. 5031).

350. AN, W277, dossier 82 (Corday), pièce 18. A profile of the public's sentiment concerning Corday can be gleaned from the extraordinary number of prints published at the time of her crime and trial, very many of which are sympathetic portrayals (for example, CdV, III, nos. 5347–94).

351. Published in 1793. CdV, III, no. 5291 (30.6 × 40 cm). A painting identical to this print is at Versailles, Musée Lambinet, inv. no. P.901 (32.5 × 40.5 cm).

352. Paris, Musée du Louvre, inv. no. 749 (148 × 205 cm). For complete information about this picture consult Wethey, *The Paintings of Titian*, I, no. 36. A neo-antique example would be the large drawing by David which dates from 1778, now owned by the E. B. Crocker Art Gallery in Sacramento (see Howard, *A Classical Frieze*).

353. Chenier, for example, dedicated Ode IX "à Marie-Anne-Charlotte Corday," and ended his poem with the lines:

Un scélérat de moins rampe dans cette fange
La Vertu t'applaudit: de ce mâle louange,
Entends, belle Héroïne! entends l'auguste voix.
O Vertu! le poignard, seul espoir de la terre,
Est ton arme sacrée, alors que le tonnerre
Laisse régner la Crime, et se vend à ses lois.

[One less villain crawls in this muck
Virtue applauds you: Listen, beautiful Heroine,
Listen to this virile praise, to the august voice.
Oh Virtue! The dagger, sole hope of the earth,
Is your sacred weapon when stormy events
Permit Crime to rule, and sell out to her laws.]
("Ode IX," in *Oeuvres Posthumes*, pp. 275–78.)

An even more graphic instance of contemporary admiration for Charlotte Corday is provided by the tale of Adam Lux. Distressed by the Jacobin-directed arrest of the Girondin deputies on 2 June 1793 (see n. 323), Lux published a pamphlet supporting their cause which won him few friends among the Jacobins ("Avis aux citoyens français," reprinted in Lux, *Deux mémoires*, a copy in the Bibliothèque Nationale, Département des Imprimés, 8ºLa³³.80). His eulogy entitled *Charlotte Corday* (BN, 8ºLb⁴¹.748) was the final straw: Lux not only claimed that Corday was "greater than Brutus," but also attacked the Jacobins as criminal oppressors. For his crimes, Lux was brought before the revolutionary tribunal, accused of counter-revolutionary sedition, and guillotined on 5 November 1793.

354. Ségur discusses Charlotte Corday and the historical importance of her act (*Les Femmes*, III, pp. 47–60).

355. Thiers, *Révolution française*, V, pp. 78–90; the quotation is from p. 90.

356. "Exposition à la Galerie du Luxembourg:

2ᵉ Article," *JdA*, IVᵉ année, vol. II, no. 19 (7 novembre 1830), p. 321.

357. The decision to purchase Scheffer's picture for 4,000 FF was made on 27 September 1831 (AL, 2DD/4, p. 440) and the artist was paid shortly thereafter (AN, O⁴1372, no. 1423, 3 October 1831, 4,000 FF).

358. "Salon de 1831," *L'Artiste*, I (1831), p. 292.

359. Schoelcher's acknowledged sympathy for the political Left plays an important role in the way Hadjinicolaou interprets his comments at the 1831 Salon vis-à-vis Delacroix's picture of *The 28th of July* (Hadjinicolaou, "*La Liberté guidant*," p. 20). Yet we would be hard pressed to account for Schoelcher's response to the *Charlotte Corday* by invoking his political preferences: this example is but one reminder that our present-day attempts to link a critic's politics to his writings on imagery must be done with care.

360. The transcript of Corday's interrogation on 16 July 1793 amply displays her calm composure in the face of hostile questioning (AN, W277, dossier 82 [Corday], pièce 32). It is a point emphasized throughout the Corday "folklore" and reiterated in Thiers, *Révolution française*, V, pp. 88–89.

361. "Salon de 1831," *L'Artiste*, I (1831), p. 198. Similarly, Jal mentioned briefly the "rather good picture of *Charlotte Corday*, where the main character is a figure worthy of note both for its expression and for its sentiment" (*Salon de 1831*, p. 225).

362. Newman, "What the Crowd Wanted," pp. 26–28.

363. Thureau-Dangin, I, p. 350 summarizes this "revival."

IV: SHADOWBOXING NAPOLEON'S GLORY

1. See pt. II, sec. 2, and n. 64.

2. Prints often show veterans instructing barricade colleagues in the art of war (figs. 29, 30), and their active participation is confirmed by the large number of veterans among those wounded or cited for bravery (see Pinkney, *1830*, p. 271).

3. Ibid., p. 268; Lucas-Dubreton, *Le Culte*, pp. 273–75; and Newman, "What the Crowd Wanted," pp. 28–30 discuss these popular outbursts of pro-Napoléon sentiments.

4. Lucas-Dubreton, *Le Culte*, p. 278.

5. About the disorganized Bonapartist faction consult Pinkney, *1830*, pp. 51, 293–94 and Lucas-Dubreton, *Le Culte*, pp. 276–77.

6. Pinkney, *1830*, pp. 286–93 and Lucas-Dubreton, *Le Culte*, pp. 279–81.

7. Bluche, *Le Bonapartisme*, pp. 167–204 offers the most current and complete description of the legend.

8. Pinkney, *1830*, p. 50 (with bibliography) and Lucas-Dubreton, *Le Culte*, pp. 129, 183–84, 242 discuss this clandestine imagery. For examples of these objects during the Bourbon Restoration see Paris, Bibliothèque Nationale, *La Légende napoléonienne*, pp. 37–55.

9. Lucas-Dubreton, *Le Culte*, pp. 186–90 and Dechamps, *Sur la légende de Napoléon*, pp. 65–83 describe the unexpected thriving of the cult of Napoléon among the English, Austrians, Germans, and Russians of the 1820s—all of them former enemies of the Emperor.

10. On this process refer to Dechamps, *Sur la légende de Napoléon*, pp. 55–56.

11. Napoléon's death was first known in France on 5 July 1821. For an account of how the news affected the country see Lucas-Dubreton, *Le Culte*, pp. 172–92.

12. From the first stanza of "Il n'est past mort! [He is not dead!]" written between 1833 and 1838 and published in Béranger, *Derniers chansons*, p. 89.

13. Lucas-Dubreton, *Le Culte*, pp. 238–39.

14. Heine, "Ideen: Das Buch Le Grand," pp. 172–73. Similarly, Chateaubriand—arch-royalist and avowed opponent of Napoléon's imperial despotism—admitted with discomfort that death had not loosened the Emperor's grasp when he wrote, "the world belongs to Bonaparte. What the ravager had not been able to achieve by force is usurped by his renown: alive, the world escaped him; dead, he owns it" (*Mémoires d'Outre-Tombe*, I, p. 1008).

15. Barry Edward O'Meara, *Napoléon en exil, ou l'Echo de Sainte-Hélène*, published in 1822; Dr. Francesco Antommarchi, *Mémoires du docteur F. Antommarchi, ou les derniers momens de Napoléon*, published in 1825; comte Charles-Tristan Montholon et général Gaspard Gourgaud, *Mémoires pour servir à l'histoire de France sous Napoléon, écrites à Sainte-Hélène*, 6 vols. published between 1823 and 1825; and Sir Frederick Lewis Maitland, *Relation du capitaine Maitland, ex-commandant du "Bellerophon," concernant l'embarquement et le séjour de l'Empereur Napoléon à bord de ce vaisseau*, published in 1826.

16. The original edition was published in

8 vols. *chez l'auteur* (a copy in Paris, Bibliothèque Nationale, Département des Imprimés, 8ºLb⁴⁸. 1954). I have used the edition prepared by André Fugier (including a very useful introduction) and published in 2 vols. by Garnier frères in 1961; all page references are keyed to this edition. About the impact of the *Mémorial* when it appeared consult Bluche, *Le Bonapartisme*, pp. 162–66; Lucas-Dubreton, *Le Culte*, pp. 247–48; and Rozelaar, "Le *Mémorial* et le Romantisme."

17. Fugier, "Introduction," pp. v–vi.

18. Ibid., pp. xix–xx, xxxi–xxxviii.

19. Ibid., pp. xlvii–xlix.

20. Ibid., pp. xxxviii–xlvi. Also see Fisher, *Bonapartism*, pp. 70–71 and the references listed in n. 16 above.

21. To cite just one example: Las Cases's entry for 28 October 1816 observed that on Saint-Helena "water is, in general, quite scarce. But for some time this scarcity has increased conspicuously, and it is presently a major undertaking simply to be able to obtain a bath for the Emperor. We are no better off with regard to other medical needs. Yesterday the doctor spoke in the Emperor's presence of drugs, instruments, and essential medicines, but at each point he added: 'Unfortunately, there are none on the island' "(*Mémorial*, II, p. 468). Similar plaints are liberally strewn throughout the text. Bonaparte seemed fully aware of the rhetorical potential which the story of his captivity might hold when he exclaimed to Las Cases: "Our situation can even have some attractions! The universe watches us carefully! We remain the martyrs of an immortal cause! Millions of men weep for us, the nation sighs, and Glory is in mourning! Here we struggle against the hostility of gods, and nations hope for our success!" (I, p. 252, 29–30 November 1815).

22. See in particular the detailed discussion in Bluche, *Le Bonapartisme*, pp. 172–92.

23. "He was especially concerned," noted Fisher, "to exhibit four propositions which the malignity and blindness of opponents had too often obscured: he stood for the Revolution, he defended the principle of nationality, he never deviated from his love of peace, he respected the influence of religion in society" (*Bonapartism*, pp. 70–71). See also Rozelaar, "Le *Mémorial* et le Romantisme," pp. 211–12.

24. Las Cases, *Mémorial*, I, p. 495, 9–10 April 1816.

25. Ibid., II, p. 220, 24 August 1816.

26. Ibid., I, p. 778, 7–8 June 1816.

27. Ibid., I, pp. 777–78.

28. Lucas-Dubreton, *Le Culte*, pp. 133–34 and Gonnard, "La Légende napoléonienne et la press libérale." The latter emphasizes (pp. 256–57) that much of what appeared in the liberal press as emanating from Napoléon was, in fact, invented by politicians in France. Bluche has recently questioned the idea of a "liberal-Bonapartist" faction by arguing that liberals never endorsed the Bonapartist political program (i.e., the reestablishment of the Empire): his analysis seems to split hairs to no purpose, since he later admits that liberals of Bonapartist persuasion did exist and generally read newspapers like *Le Constitutionnel*, *Le Minerve*, and the *Bibliothèque historique* (Bluche, *Le Bonapartisme*, pp. 158–62).

29. Bluche, *Le Bonapartisme*, pp. 156–58 and Lucas-Dubreton, *Le Culte*, p. 177.

30. Lucas-Dubreton, *Le Culte*, p. 242.

31. Ibid., p. 237.

32. Ibid., p. 253. In contrast to Charles X, Louis XVIII had made a point of remembering to his officers the anniversaries of battles in which they had served under Napoléon.

33. Ibid., pp. 265–66 and Pinkney, *1830*, pp. 6–9.

34. Fisher stresses the fact that "the French nation had remained Napoleonic without being conscious of the fact. The machine of government was that same administrative engine which Napoléon had constructed, and no party in the State, with the exception of the aristocrats, really desired any measure of decentralization" (*Bonapartism*, pp. 76–77). About the less tangible but equally pervasive emotional attachment to the tricolor refer to Gaudibert, "Delacroix et le romantisme révolutionnaire," pp. 13–15 and Lucas-Dubreton, *Le Culte*, pp. 273–74.

35. For discussions of the profusion of Napoleonic imagery after the July Revolution see Lucas-Dubreton, *Le Culte*, pp. 286–91; Thureau-Dangin, I, pp. 594–96; and Chassé, *Napoléon par les écrivains*, pp. 105–06, 109, 115.

36. *Bonaparte à l'Ecole de Brienne* opened at the Théâtre des Nouveautés on 9 October 1830, and *Napoléon à Berlin* premiered at the Variétés on 15 October. *Le Fils de l'Homme* by Eugène Sue appeared on the stage of the Théâtre des Nouveautés on 28 December 1830, and *Malmaison et Sainte-Hélène* opened at the Gaîté on 13 January 1831.

About this explosion of Napoleonic theatre see Thureau-Dangin, I, p. 595, n. 2; Chassé, *Napoléon par les écrivains*, pp. 105, 109, 115; and Lucas-Dubreton, *Le Culte*, p. 288.

37. The play opened at the Odéon on 10 January 1831 (see Lucas-Dubreton, *Le Culte*, p. 289 and Chassé, *Napoléon par les écrivains*, p. 115).

38. Lucas-Dubreton, *Le Culte*, pp. 286–87 and Thureau-Dangin, I, p. 595, n. 2 discuss some of these popular standins for the Emperor.

39. Heine, "Uber die französische Bühne: Fünfter Brief," p. 71, written in May 1837.

40. Lucas-Dubreton notes that Dumas lifted whole passages of his dialogue directly from the *Mémorial* of Las Cases (*Le Culte*, p. 289). Figure 168: *Napoléon in Bivouac*, 1822. Paris, BN-EST, série Dc102 (46.9 × 31.9 cm). Catalogued in De La Combe, *Charlet*, p. 210, no. 9.

41. "Nouvelles," *JdA*, Ve année, vol. I, no. 15 (10 avril 1831), p. 287, where it is reported that the king saw the Diorama on 7 April. For a review of Daguerre's spectacle consult ibid., no. 16 (17 avril 1831), pp. 289–91. I discuss the Vendôme column project in sec. 4.

42. Lucas-Dubreton, *Le Culte*, p. 298.

43. Chassé, *Napoléon par les écrivains*, p. 109. The several petitions to return Napoléon's body were received by the Chamber of Deputies on 7 October 1830 and buried in committee.

44. Hugo's "Ode à la Colonne," dated 9 October 1830, first appeared in "Les Chants du crépuscule" (reprinted in *Oeuvres Complètes: Poésie*, II, p. 196). Hugo, who had been a rather zealous Royalist in the early 1820s, was "converted" to the Napoleonic faith in 1827 (see Lucas-Dubreton, *Le Culte*, pp. 258–60).

45. On the situation in Belgium and French reaction to it consult Thureau-Dangin, I, pp. 69–88 and Blanc, *Dix Ans*, II, pp. 83–107. About the Polish developments see Thureau-Dangin, I, pp. 189–94 and Blanc, *Dix Ans*, II, pp. 153–68.

46. The impact in France of Russia's move on Warsaw in 1831 is described in Thureau-Dangin, I, pp. 483–87 and Blanc, *Dix Ans*, pp. 433–53.

47. Bluche, *Le Bonapartisme*, pp. 225–28; Lucas-Dubreton, *Le Culte*, p. 293; and Newman, "What the Crowd Wanted," p. 29.

48. On this iconographical and rhetorical joining of forces see Thureau-Dangin, I, pp. 598–601.

49. During the 1830s *Les Souvenirs du peuple* appeared in many different forms, most of them pirated; it is reprinted in Béranger, *Chansons*, II, pp. 186–88. About Béranger see Bluche, *Le Bonapartisme*, pp. 197–99.

50. *Les Souvenirs du peuple*, 1831. Paris, BN-EST, série Qb1, 3 février 1814 (19.1 × 26.2 cm).

51. *Napoléon in the Old Woman's Cottage*, ca. 1835. Paris, BN-EST, série Qb1, 10 février 1814 (32.6 × 43.8 cm). J.-L. Dulong's painting, *Napoléon and the Woman of Champagne* (Salon of 1835, no. 656), was registered at the Louvre as 115 × 100 cm (AL, série *KK, 1835).

52. *The Postilion's Silhouette-Drawing*, 1830. Paris, BN-EST, série Dc175, t. III (12.1 × 15.2 cm). Catalogued in *Inventaire du fonds français*, II, p. 98, "Bellangé," no. 72.

53. For a discussion and examples of the "origin of painting" theme see Rosenblum, "The *Origin of Painting*," esp. p. 286.

54. Published in 1833. Paris, BN-EST, série Qb1, 23 mars 1815 (19.5 × 27.9 cm). A second example exists in CdV, V, no. 9472.

55. Mark 10:13–16.

56. Las Cases, *Mémorial*, II, pp. 438–39, 16 October 1816. The eyewitness account comes from Lavalette, *Mémoires*, I, p. 139.

57. Louis-Napoléon Bonaparte could write in 1832 that he was guided by "wholly republican principles" (*Reveries politiques*, p. 382). For a complete analysis of the evolution of Louis-Napoléon's political philosophy see Bluche, *Le Bonapartisme*, pp. 229–58.

58. Balzac, *Le Médecin de campagne*, "III: Le Napoléon du peuple," in *Oeuvres Complètes*, XIII, pp. 432–48.

59. Ibid., pp. 440–41.

60. Ibid.

61. Ibid., p. 446.

62. Ibid., p. 447.

63. Signed and dated in the plate "Bellangé 1834." Paris, BN-EST, série Dc175, t. IV (17.3 × 20.4 cm). Print from the "15e Album lithographique de Bellangé" published in 1835 by Gihaut. Catalogued in *Inventaire du fonds français*, II, p. 101, "Bellangé," no. 90.

64. Signed and dated "Bellangé 1833," Salon of 1833, no. 135. Paris, Musée du Louvre, on loan to the Musée des Arts et Traditions populaires, inv. no. INV2477 (81 × 105 cm). The signed date may be misleading because Bellangé exhibited a work of the same title at the Luxembourg gallery in late

NOTES TO PAGES 150–152

1830 (*livret* no. 13). Jazet produced an engraving of the picture in 1835 entitled *The Old Soldier and His Family*, Paris, BN-EST, série Ef236e, t. II, gr. fol: f°5 (46.7 × 57.8 cm). Catalogued in *Inventaire du fonds français*, XI, p. 300, "Jazet," no. 182.

65. Decision of 6 June 1833 (AL, 2DD/4, p. 24), with payment in September (AN, O⁴1472, no. 3144, 14 September 1833, 1,200 FF).

66. Metternich, the mastermind of Austrian diplomacy who strongly opposed any Bonapartist revival, reportedly warned Louis-Philippe that fostering the memory of Napoléon could be politically dangerous (Lucas-Dubreton, *Le Culte*, p. 328).

67. Francastel, *La Création*, p. 25.

68. The decision of 29 August was publicly announced in *Le Moniteur Universel*, no. 248 (Jeudi 5 septembre 1833), p. 2043.

69. "4ᵉ Visite du Roi," AC, 91G-I, 6 March 1834.

70. "6ᵉ Visite du Roi," AC, 91G-I, 8 April 1834.

71. "7ᵉ Visite du Roi," AC, 91G-I, 7 May 1834.

72. Figure 175: Signed and dated "Gros 1806." Salon of 1806, no. 241. Versailles, MNC, inv. no. MV2276 (578 × 968 cm). Joachim Murat, a trusted general whom Napoléon had named king of the Neapolitan province, commissioned the picture to hand in his royal palace at Naples. When Murat learned of Napoléon's return to France from Elba in 1815, he attempted to rouse the entire Italian peninsula against the Austrian occupation forces, but was roundly defeated and forced to seek asylum in France during the Hundred Days. Murat, believing that the Italians would rally to him, returned to Naples after Waterloo to retake his throne by force. He was mistaken: Murat was captured, court-martialed, and shot on 13 October 1815. Gros's painting—having been removed from public view and placed in storage—was bought back by the painter for 15,000 FF and returned to his studio (see Tripier le Franc, *Gros*, pp. 245–46). Louis-Philippe purchased the work from Gros in 1833 for 25,000 FF (AN, O⁴1472, no. 5045, 23 November 1833 and Tripier le Franc, *Gros*, pp. 479–80). Figure 176: Signed and dated "L. David f^bat 1806 et 1807." Salon of 1808, no. 144. Paris, Musée du Louvre, inv. no. INV3699 (621 × 979 cm). David's original hung at Versailles until 1889, when it was replaced by a replica executed primarily by his students; the original was sent to the Louvre. Figure 177: Signed and dated "L. David f^bat 1810." Salon of 1810, no. 188. Versailles, MNC, inv. no. MV2278 (610 × 931 cm).

73. Salon of 1801, no. 49. Versailles, MNC, inv. no. MV3105 (500 × 616 cm).

74. "8ᵉ Visite du Roi," AC, 91G-I, 4 June 1834. Figure 179 of the Salle du Sacre (from Gavard, *Galeries historiques de Versailles*, I, série I, supplément) illustrates the placement of these pictures. Nepveu remarked in his notes that the museum owned a perfectly serviceable portrait by Robert Lefèvre of Napoléon in his imperial robes, which was installed in the gallery; Versailles, MNC, inv. no. MV2280 (277 × 184 cm). The Rouillard was exhibited at the Salon of 1836, no. 1624. Versailles, MNC, inv. no. MV2279 (277 × 184 cm). Rouillard was paid in late 1835 (AN, O⁴1527, no. 8937, 5 September 1835, 1,500 FF).

75. The Louvre's storerooms included major Napoleonic compositions by Gérard, Girodet, Gros, and Guérin (a list, drawn up in September 1824 by the vicomte de La Rochefoucauld, is published in Boyer, "Le Sort sous la Restauration," pp. 275–76).

76. For example, Ingres's *Napoléon Iᵉʳ upon the Imperial Throne* (Salon of 1806, no. 202) belonged to the Crown in 1832 and was transferred from the reserves of the Louvre to the Musée de l'Armée with Louis-Philippe's approval (New York, *The Age of Revolution*, no. 104, p. 500).

77. Thiers, *Révolution française*, X, chap. 2; Lefebvre, *Revolution*, II, pp. 218–21; and Pariset, *Le Consulat et l'Empire*, pp. 383–91 recount the story of the Egyptian campaign.

78. Letter of 22 August 1799 from Bonaparte's headquarters at Alexandria to Kléber (Bonaparte, *Correspondance de Napoléon Iᵉʳ*, V, no. 4374, p. 575). Among the "extraordinary events" about which Napoléon had recently learned were French military setbacks in Italy. Napoléon's version of his return to France is recounted in Las Cases, *Mémorial*, II, pp. 252–55.

79. About the army's skepticism see Thiers, *Histoire du Consulat et l'Empire*, II, pp. 3–5. In 1800 James Gillray published a set of eight images printed on a single sheet entitled *Democracy—Or—A Sketch of the Life of Buonaparte*, including one called "Democratic Courage" that showed "Buonaparte deserting his Army in Egypt for fear of the Turks after boasting that he would extirpate them all": London, British Museum, Department of Prints and Drawings, inv. no. BM9534 (44 × 26.7 cm, dimensions of the ensemble). Finally, Georges Lefebvre—perhaps the most authoritative modern historian of this period—bluntly remarked that

"Bonaparte deserted his army to Kléber and left to seek adventure in France" (*Revolution*, II, p. 221).

80. Jal emphasized, for example, that where Napoléon had always insisted upon being the most important character in government imagery, Louis-Philippe's even-handed historicism had rendered "a brilliant, impartial appreciation of every famous Frenchman who had contributed so much to the glory of France and Napoléon" ("Musée historique de Versailles," p. 97).

81. Thiers, *Révolution française*, X, pp. 447–506; Pariset, *Le Consulat et l'Empire*, pp. 423–33; and Lefebvre, *Revolution*, II, pp. 252–56.

82. Both of these medallions were painted by Pierre-Joseph Dedreux-Dorcy: *Joséphine*, inv. no. MV2281 (120 cm diam) and *Marie-Louise*, inv. no. MV2282 (120 cm diam). The painter received only 600 FF for the two canvases (AN, O⁴1643, no. 1954, 20 June 1836).

83. About the Bonapartist character of the republican movement in the early 1830s see the works cited in nn. 45–48 above.

84. See, for example, the circuitous and quasi-mystical explanation offered by Thiers, *Révolution française*, X, pp. 505–06.

85. About Napoléon's coup d'état see Bessand-Massenet, *Le 18 Brumaire*, and the references cited in n. 81 above.

86. Laurent de l'Ardèche, *Napoléon*, pp. 168–69.

87. Pariset, *La Révolution (1792–1799)*, p. 432.

88. Figure 180: *The Events at Saint-Cloud, 18 Brumaire Year 8*, 1802. CdV, IV, no. 7414 (26.8 × 43.7 cm). Copper-plate engraving by Helman after a drawing by Monnet. This print was republished in 1838. Figure 181: *Meeting of the Legislative Body at the Orangerie of St. Cloud: Bonaparte's Appearance and the Day of Liberation, 19 Brumaire Year 8*, 1800. CdV, IV, no. 7406 (22.1 × 35.1 cm).

89. Lefebvre, *Revolution*, II, p. 256 and the discussion in CdV, IV, no. 7406. Thiers left the question of Napoléon's sincerity open (*Révolution française*, X, p. 499). Bonaparte played up the incident, however, and awarded Thomé a pension of 600 FF for having saved him from "the dagger of assassins": the citation of heroism signed by Bonaparte is reproduced in Bourguignon, *Napoléon Bonaparte*, I, p. 204.

90. Janin, "Le Salon de 1840: Deuxième Article," *L'Artiste*, 2ᵉ série, V (1840), pp. 187–88.

91. Blanc, "Salon de 1840: Iᵉʳ Article," *Revue du Progrès politique, social et littéraire*, III (1840), p. 220.

92. Tenint, "Salon de 1840: Deuxième Article," *La France littéraire*, 2ᵉ série, XXVII (janvier-mars 1840), p. 240.

93. Barbeste, "Salon de 1840: Tableaux d'histoire," *Revue du XIXᵉ Siècle*, VI (janvier-mars 1840), p. 820.

94. Planche, "Salon de 1840," p. 107.

95. AN, 300 APIII 38, 1 June 1838.

96. Ibid., 3 July 1838. Montalivet was Minister of the Interior at the time.

97. About Bonaparte's attempted coup d'état at Strasbourg consult Thureau-Dangin, II, pp. 125–31; Guizot, *Mémoires*, IV, pp. 199–203; Lucas-Dubreton, *Le Culte*, pp. 335–39; and Bluche, *Le Bonapartisme*, pp. 215–18.

98. On the trial see Lucas-Dubreton, *Le Culte*, pp. 342–44.

99. Just before being deported, Louis-Napoléon wrote to Barrot and asked that he look after the defense of those who had been arrested at Strasbourg (AN, 271 AP 5, letter from Bonaparte written in Lorient on 15 November 1836).

100. Cited in Lucas-Dubreton, *Le Culte*, p. 344. About the attempts of the Left to capitalize on the acquittals see Thureau-Dangin, III, pp. 156–57.

101. Thureau-Dangin, III, pp. 282–84; Lucas-Dubreton, *Le Culte*, pp. 345–46; and Bluche, *Le Bonapartisme*, pp. 218–220.

102. Laity, *Relation historique des événements du 30 octobre 1836, le prince Napoléon à Strasbourg* (BN, Département des Imprimés, 8ºLb⁵¹.2603).

103. The verdict was reached on 10 July 1838 ("Cour des Pairs: 2ᵉ Audience du 10 juillet," *Le Moniteur Universel*, no. 192 [Mercredi 11 juillet 1838], p. 1929).

104. Cited in Thureau-Dangin, III, p. 284. On the ensuing diplomatic strain with Switzerland see ibid., pp. 284–87; Guizot, *Mémoires*, IV, p. 266; and Lucas-Dubreton, *Le Culte*, pp. 347–49.

105. The conservative *Gazette de France* registered an oft-repeated concern: "This young man has been provided with the prominence of persecution. All the ministerial worries increase his authority. Is it possible to imagine a policy which would work more directly against itself? . . . An éclat has been attached to the person of prince Louis which will follow him everywhere. Up to now the public

thought he was crazy; the government has just made him a hero" (quoted in Lucas-Dubreton, *Le Culte*, p. 348).

106. The other images of this commission are discussed in pt. III, sec. 8.

107. Cited in Thureau-Dangin, III, p. 284.

108. See Lefebvre, *Napoléon*, I, pp. 214–31 and Bourguignon, *Napoléon Bonaparte*, II, pp. 19–44 on the composition, command, and esprit of Napoléon's army.

109. Bonaparte's idea to reward merit with a single, egalitarian honor encountered stiff resistance during the years 1801 to 1804 (see Mazas, *La Légion d'honneur*, pp. 1–20). In 1808 the original egalitarianism of the Legion of Honor was set aside when the award became the cornerstone of the newly minted Imperial nobility (pp. 167–69).

110. Las Cases, *Mémorial*, I, p. 118.

111. Figure 182: Salon of 1808, no. 257. Versailles, MNC, inv. no. MV1549 (380 × 532 cm). Figure 183: *Meeting in Moravia between the Emperor of the French and the Emperor of Austria*. Salon of 1812, no. 444. Versailles, MNC, inv. no. MV1551 (380 × 532 cm).

112. Published in 1828. Paris, BN-EST, série Dc102, t. VIII (36.9 × 45.4 cm). Aquatint engraving by Debucourt after a drawing by Charlet. Catalogued in *Inventaire du fonds français*, VI, p. 78, "Debucourt," no. 109.

113. Paris, BN-EST, série Dc189 rés. fol., t. V, "Raffet" (17.5 × 25.5 cm). Plate no. 8 of the album of Raffet's lithographs published in 1832 by Gihaut frères (Giacomelli, *Raffet*, no. 359).

114. "Rapport au Roi" dated 8 April 1831, *Le Moniteur Universel*, no. 101 (Lundi 11 avril 1831), p. 761.

115. Hénard, "Les Trois Statues de la colonne," pp. 359–62.

116. From the report cited in n. 114 above.

117. "Rapport au Roi" dated 13 April 1831, *Le Moniteur Universel*, no. 105 (Vendredi 15 avril 1831), p. 799.

118. "Ministère du Commerce et des Travaux Publics: Arrêté," *Le Moniteur Universel*, no. 105 (Vendredi 15 avril 1831), p. 801, "Article 5." Artists were instructed to submit their plaster sketches before 1 June 1831.

119. Thirty-six sculptors participated in the competition (*Le Moniteur Universel*, no. 160 [Jeudi 9 juin 1831], p. 1056). The jury was composed of the comte de Bondy (prefect of the Seine), baron Fain, Hippolyte Royer-Collard, Edouard Bertin, the sculptors Cortot, David d'Angers, Pradier, Ramey père, and Nanteuil, and the architects Fontaine, Hayot, and Lepère (*Le Moniteur Universel*, no. 163 [Dimanche 12 juin 1831], p. 1077). The jury's decision was announced in *Le Moniteur Universel*, no. 166 (Mercredi 15 juin 1831), p. 1087.

120. Figure 186: Statue of *Napoléon*, 1833. Paris, Hôtel National des Invalides (400 cm in height). For the story of how the work finally arrived at the Invalides consult Hénard, "Les Trois Statues de la colonne," pp. 370–72. Figure 187: *The Master's Eye*. Paris, BN-EST, série Dc189, t. VI (20.3 × 28.1 cm). Plate no. 8 of the album of Raffet's lithographs published in 1833 by Gihaut frères (Giacomelli, *Raffet*, no. 372).

121. Hénard, "Les Trois Statues de la colonne," p. 364, n. 1.

122. Ibid., pp. 364–65 and Thureau-Dangin, II, p. 219 for descriptions of the ceremony.

123. *And Standing upon the Bronze of Their War-making Thunderbolts*, 1833. CdV, VI, no. 12.384 (22.2 × 28.7 cm).

124. The iconic episodes of Napoléon's life illustrated in this print are: leading the snowball fight in grade school; directing the battles of Toulon, Arcole, the Pyramids, and Austerlitz; crossing the St. Bernard Pass; visiting the tomb of Frederick of Prussia in October 1806 on the eve of his triumphal entry into Berlin; personally pointing a cannon in the battle of Montereau during the defense of France in 1814; exiled on Elba; leaving the field of battle at Waterloo; and finally, at the lower right, watching the passage of distant ships from a rocky perch on the island of Saint-Helena.

125. See, for example, the prints catalogued in CdV, VI, nos. 12.378, 12.379, 12.381, and 12.385.

126. *The Column and the Statue*, ca. 1832. CdV, VI, no. 12.375 (27 × 21.4 cm). Printed by Delaunois and sold "à Paris, chez Ostervald aîné, Rue Christine, Nº 3." The publication date of this colored lithograph poses a problem: neither of the examples at the Bibliothèque Nationale (a second copy in BN-EST, Nº Napoléon, t. XIV) is marked with a registration number from the *dépôt légal*, and I was unable to find its publication in the *Bibliographie de la France* during the period 1832–34. Ostervald's print shop moved to the rue Christine during the summer of 1833, and his new address is

listed on this print, so it is likely that the image dates from just after the dedication of Napoléon's statue atop the Vendôme column.

127. The response of the French to the death of Napoléon's son is discussed in Thureau-Dangin, II, p. 159 and Lucas-Dubreton, *Le Culte*, pp. 312–15.

128. Thureau-Dangin, II, pp. 126–36 and Blanc, *Dix Ans*, III, pp. 265–315 discuss the June riots.

129. Lucas-Dubreton, *Le Culte*, pp. 317–18.

130. Signed in the plate "Georgin D.—J.-B. Thiébault SC." Paris, BN-EST, série Li59 (41.8 × 61 cm). Publication of this print was announced on 16 July 1834 in the *Bibliographie de la France*, XXIII, no. 30, p. 486, no. 472. Its design, as is so often the case with Epinal imagery, was copied almost directly from a more "sophisticated" print published earlier at Paris: CdV, V, no. 10.373; announced in the *Bibliographie de la France*, XXIII, no. 4 (25 janvier 1834), p. 63, no. 67. Among the historical dignitaries welcoming Napoléon are (from left to right) Sesostris, Alexander, Caesar, Genghis Khan, Bayard, Turenne, and Frederick II. For a discussion see Descaves, *L'Humble Georgin*, p. 154.

131. Signed and dated "Mauzaisse 1832" (on Napoléon's tablet) and "Mauzaisse" (at the upper left). Salon of 1833, no. 3130. Malmaison, MNC, inv. no. MM.40–47–8.401 (131 × 160 cm).

132. Signed and dated "Lud. David opus/ 1812." Washington, National Gallery of Art, Samuel H. Kress Collection, inv. no. 1374 (205 × 125 cm). For a complete bibliography consult New York, *The Age of Revolution*, no. 36[bis]. David's inclusion of the Napoleonic Code (lying on the Emperor's desk), the nearly burnt-down candles, and a clock which reads 4:15 A.M. suggests that the hard-working leader has passed the night composing the laws of the Empire.

133. We will return to the issue of Eclecticism in pt. V, sec. 2. The "low arts" offer a very close variant of the Mauzaisse in an engraving published by Dubreuil at Paris in August 1833: *The Glory and Genius of the Great Man*. Paris, BN-EST, N² Napoléon, t. XIV (19 × 27.3 cm). Announced in the *Bibliographie de la France*, XXXVI, no. 32 (samedi 10 août 1833), p. 502, no. 463.

134. Signed and dated "Blondel 1834." Salon of 1834, no. 148. Paris, Musée du Louvre, inv. no. RF1595 (227 × 163 cm). Commissioned on 20 September 1833 for 4,000 FF (AL, 2DD/4, p. 25) and paid for in June (AN, O⁴1473, no. 7866, 13 June 1834,

1,333.34 FF; O⁴1524, no. 1808, 25 June 1834, 2,666.66 FF). The work apparently survived the revolution of 1848 (AN, 300 API 1113, "Inventaire de tableaux du Palais-Royal"), but then disappeared from the Palais-Royal. It resurfaced in 1903 when it was given (returned?) to the state by a Mme Lefuel (dossier at the Musée du Louvre, Service de Documentation). See pt. III, sec. 7 for a discussion of other images in the Palais-Royal project.

135. Thiers, *Histoire du Consulat et l'Empire*, VIII, pp. 137–38, 160.

136. Ibid., pp. 169–70 and Thibadeau, *Le Consulat et l'Empire*, VI, pp. 133–36. Napoléon's disregard for parliamentary process was illustrated in the Galeries Historiques of the Palais-Royal with a painting by Jean Gassies entitled *The Dissolution of the Tribunat*, Salon of 1831, no. 2751. Commissioned by Louis-Philippe shortly after the July Revolution for 5,000 FF, the work measured 227 × 160 cm and was installed in the Galerie du Théâtre of the palace (AN, 300 API 1113). Like most of its companion pieces, the Gassies was destroyed in the 1848 Revolution and is known only through a print in Vatout's *Histoire lithographiée du Palais-Royal*.

137. Laurent de l'Ardèche, *Napoléon*, p. 405.

138. [Sazérac], *Salon de 1834*, p. 102. Tardieu also complained that "such a subject is not very appropriate for painting, and even less for what we know of M. Blondel's aptitude; thus he has more or less bungled it. His principal character falls far short of recalling the extraordinary man who shook Europe and dethroned so many kings" (*Salon de 1834*, p. 8).

139. "Rapport au Roi," *Le Moniteur Universel*, no. 248 (Jeudi 5 septembre 1830), p. 2043.

140. "40ᵉ Visite du Roi," AC, 91G-I, 28 June 1835. About the gallery's construction history consult Francastel, *La Création*, pp. 64–65 and Gaehtgens, *Versailles*, pp. 92–111, where many architectural renderings are reproduced.

141. For a discussion of each image in the gallery and a political reading of the entire program see Gaehtgens, *Versailles*, pp. 113–255.

142. Figure 195: Salon of 1810, no. 347. Versailles, MNC, inv. no. MV2765 (510 × 958 cm). For a modern analysis of Napoléon's brilliant tactical strategy consult Dupuy, *The Battle of Austerlitz: Napoléon's Greatest Victory*. Thiers reiterated the standard nineteenth-century understanding of the battle and its importance (*Histoire du Consulat et l'Empire*, VI, pp. 304–22). In fact, the description of

Rapp's announcement presented by Thiers (p. 324) so closely mirrors Gérard's picture that his text was probably influenced by the painting.

143. About the original installation of Gérard's *Austerlitz* consult Gérard, *Correspondance*, p. 13.

144. Figure 196: *The Battle of Iéna*, signed and dated "H. Vernet 1836." Salon of 1836, no. 1804. Versailles, MNC, inv. no. MV2768 (465 × 543 cm). Figure 197: *The Battle of Friedland*. Salon of 1836, no. 1805. Versailles, MNC, inv. no. MV2772 (465 × 543 cm). Figure 198: *The Battle of Wagram*. Salon of 1836, no. 1806. Versailles, MNC, inv. no. MV2776 (465 × 543 cm). All three pictures were commissioned on 1 May 1835 at 12,000 FF each (AL, 2DD/5, p. 41). Vernet received payments in 1835 for most of the total (AN, O⁴1527, no. 9027, 5 October 1835, 2,000 FF; O⁴1588, no. 5859, 4 November 1835, 13,000 FF; O⁴1589, no. 6303, 18 November 1835, 12,000 FF), but I was unable to locate the final payments among the archive documents.

145. "Salon de 1836: Deuxième Article," *Journal des Beaux-Arts*, IIIᵉ année, vol. I, no. 9 (15 mars 1836), p. 130.

146. The 1836 Salon *livret* informed viewers that "Napoléon, on the battlefield of Friedland, orders General Oudinot to pursue the enemy."

147. "The Emperor observes the results achieved by the battery of 100 cannons commanded by the comte de Lauriston," read the Salon *livret*. "As the duc d'Istrie was readying for the cavalry attack, a bullet strikes his saddle, wounds him slightly in the thigh, and kills his horse."

148. Quoted from the Salon *livret*, which follows with an explanation that "it was, in fact, one of the footsoldiers, whose youthful courage was eager to make itself known."

149. Musset, "Salon de 1836," p. 158.

150. Farcy, "Salon de 1836: 3ᵉᵐᵉ Article," *JdA*, Xᵉ année, vol. I, no. 11 (13 mars 1836), pp. 165–66. See also de Beauvoir, "Salon de 1836: Premier Article," *Revue de Paris*, 2ᵉ série, XXVII, p. 173 and Buchez, "Du Salon de 1836," *L'Européen*, I, no. 6 (mars 1836), p. 191.

151. de Nouvion, "Salon de 1836," pp. 295–96. Barbier echoed the same accusation in his *Salon de 1836*, pp. 17–19.

152. "Salon de 1836: IIᵉ Article," *L'Artiste*, XI (1836), pp. 78–79.

153. Pillet, "Salon de 1836: 2ᵉᵐᵉ Article," *Le Moniteur Universel*, no. 67 (Lundi 7 mars 1836), p. 417.

154. de Beauvoir, "Salon de 1836: Premier Article," *Revue de Paris*, 2ᵉ série, XXVII, p. 174.

155. de Nouvion, "Salon de 1836," p. 296. Another critic noted: "I can, without any scruples, mix up Iéna, Friedland, and Wagram by changing around the titles and crossing out the *livret*'s explanation; I see nothing in the compositions which might differentiate them" ("Salon de 1836," *Le Voleur*, IXᵉ année, 2ᵉ série, V, no. 16 [20 mars 1836], p. 282).

156. Planche, "Salon de 1836: Cinquième Article," *Chronique de Paris*, n.s., II, no. 2 (7 avril 1836), pp. 22–23.

157. "It would seem," pointedly observed a critic, "that the size of a canvas selected for the representation of an historical event would be related to the importance of that event. Well, very often events of great interest have been recounted on small canvases while large canvases have been selected for episodes of secondary importance. These unhappy results would never have occurred if the works for the Museum at Versailles had not been left to the discretion of a single man who takes only his own advice, and who has a confidence in his personal abilities which many people do not at all share" ("Salon de 1836: Dixième Article," *Journal des Beaux-Arts*, IIIᵉ année, vol. I, no. 17 [8 mai 1836], p. 258).

158. "The King," recorded Nepveu, "before arriving at the Palace, stopped at the former stage-coach office on the avenue de Sceaux and went into the studio set up for M. Horace Vernet" ("42ᵉ Visite du Roi," AC, 91G-I, 12 July 1835). The Salon criticism written in 1836 was the first to be published under the strict press laws of September 1835 (see pt. II, sec. 5, esp. nn. 195–96).

159. Beginning with the visit of 12 July 1835 cited above, the king saw Vernet on every excursion to Versailles until the end of November.

160. "I repeat," wrote Musset, "this is certainly not the battle of Iéna, but it is the subject—such as it is—cleverly conceived and clearly rendered. Would you like to see an open plain? The army? What do I know? Why not the enemy? The Emperor lost in the middle of all that? Ha! If he was so small and so far away, you would not hear what he is saying. . . . Since the actor is Napoléon, and since the action is accurate, what would you want

represented between the legs of his horse?" (Musset, "Salon de 1836," pp. 158–59).

161. I follow here a notion of "lexicon" suggested by Barthes, "Rhétorique de l'image," p. 48.

162. Salon of 1836, no. 1114. According to the registry of the Salon jury, Lansac's picture measured 110 × 135 cm (AL, série *KK, 1836). I was unable to locate the original painting, but reproduce a copy executed by Edouard Wayer: Bar-le-Duc, Musée Barrois, inv. no. 63 (80 × 110 cm), given to the museum by Wayer in 1848.

163. *Napoléon on Horseback*, signed and dated "h^te Bellangé 1836." London, The Wallace Collection, inv. no. P.671 (42 × 34 cm).

164. As Barthes argues, "if the connotation has signifiers typified by the media employed (image, word, objects habits), it shares in all of its signifieds at once: one will find the same signifieds in published form, in visual imagery, or in the gestures of an actor (this is why semiology is only conceivable within a framework we might call holistic). This shared domain of the signifieds of connotation is the domain of *ideology*, of which there can be only one for a given society and a given history, whatever might be the signifiers of connotation to which that ideology has recourse" ("Rhétorique de l'image," p. 49).

165. *1807*, signed and dated in the plate "Raffet 1836." Paris, BN-EST, série Dc189j, t. IV (13.7 × 20.4 cm). Plate no. 8 of the album of Raffet's lithographs published in 1837 by Gihaut frères (Giacomelli, *Raffet*, no. 425).

166. Signed and dated "Philippoteaux 1844." Salon of 1845, no. 1334. Versailles, MNC, inv. no. MV2756 (465 × 543 cm). The commission was originally awarded to Cogniet on 5 July 1834 and only transferred to Philippoteaux on 13 December 1843 (AL, 2DD/4, p. 408 and 2DD/5, p. 14). The price was fixed at 12,000 FF, but I was unable to locate the payment records in the archives.

167. *Portrait of General Bonaparte at Arcole.* Salon of 1801, no. 163. Versailles, MNC, inv. no. MV6314 (130 × 94 cm). Painted by Gros for Bonaparte in 1796 and given to Versailles by the Empress Eugénie in 1879.

168. "His *Battle of Rivoli*," wrote Guillot of Philippoteaux's picture, "is one of those large works in which the painter, contrary to appearances, was not free to express himself as he wanted. It is nearly always the same thing, and everyone knows the recipe: the commanding general takes up three-quarters of the picture by himself with two or three

officers further back, a few prisoners, a few victims, a rout in the distance, and there you have it" ("Salon de 1845: Quatrième Article," *La Revue Indépendante*, XX [10 mai 1845], p. 65). De Calonne referred explicitly to the family resemblance between the Philippoteaux and Vernet's pictures ("Salon de 1845: 3^e Article," *Le Voleur*, 2^e série, XIV, no. 23 [25 avril 1845], p. 377).

169. Salon of 1837, no. 167. Versailles, MNC, inv. no. MV2761 (465 × 543 cm). Commissioned on 1 May 1835 for 12,000 FF, with 500 FF added to the price on 2 December 1835 so that Bouchot might travel to Zurich (AL, 2DD/4, p. 31 and AN, O^41605, no. 8837, 21 February 1836, 500 FF). Bouchot was paid in three installments (AN, O^41589, no. 8319, 21 February 1836, 2,000 FF; O^41643, no. 2885, 4 August 1836, 2,000 FF; O^41705, no. 1058, 27 April 1837, 8,000 FF).

170. Farcy, "Salon de 1837: 3^e Article," *JdA*, XI^e année, vol. I, no. 12 (19 mars 1837), p. 181.

171. Rosenthal, p. 218.

172. As Rosenthal claims, pp. 205–09.

173. For the story of Napoléon's remarkable return to France in 1815 consult Houssaye, *1815*, I, pp. 200–369; for a more recent and less scholarly account see MacKenzie, *The Escape from Elba*.

174. Houssaye, *1815*, I, p. 190. The handbill which Napoléon brought from Elba for distribution to the army is reproduced in Bourguignon, *Napoléon Bonaparte*, II, p. 265.

175. Houssaye, *1815*, I, pp. 209–10.

176. MacKenzie, *The Escape from Elba*, p. 212.

177. Ibid., p. 233 and Houssaye, *1815*, I, pp. 236–37 on Emery's mission to Grenoble.

178. Houssaye, *1815*, I, pp. 240–44 and MacKenzie, *The Escape from Elba*, pp. 245–46.

179. Houssaye, *1815*, I, p. 244 (and n. 1) concerning the variants of this dramatic episode.

180. Ibid., pp. 248–55.

181. *The Return from the Island of Elba*, signed and dated "Steuben f^t 181?" (the last digit of the date is not clear). Salon of 1831, no. 1957 (98 × 130 cm). Steuben's original was sold at auction on 8 May 1985 (see London, Christie, Manson & Woods, *Napoléon, Nelson and Their Time*, no. 123, reproduced in color). Our illustration is the aquatint engraving executed by Jazet in 1830: Paris, BN-EST, série AA6 "Steuben" (77 × 98.8 cm). Catalogued in *Inventaire du fonds français*, XI, p. 297, no. 154.

182. Lenormant, "Salon de 1831," in *Les Artistes contemporains*, I, p. 26.

183. Salon of 1831, no. 2350. Jazet's print was

announced in two formats—three feet wide by two feet, two inches high; two feet wide by one foot, six inches high—in the *Bibliographie de la France*, XIX, no. 33 (14 août 1830), p. 549, no. 760.

184. Signed and dated "C. Meynier pt. 1808." Salon of 1808, no. 429. Versailles, MNC, inv. no. MV1547 (360 × 524 cm). For a complete catalogue entry consult New York, *The Age of Revolution*, no. 129. Meynier's canvas was among the Napoleonic paintings exhibited at the Luxembourg in late 1830 (*livret* no. 178).

185. *Return from the Island of Elba*. Salon of 1834, no. 94. Amiens, Musée de Picardie, inv. no. P.2783 (227 × 276 cm).

186. "Salon de 1834: Peinture," *L'Artiste*, VII–VIII (1834), p. 99.

187. The definitive text on this landscape tradition is Rosenblum, *Modern Painting and the Northern Romantic Tradition*. For a recent study of this interest among French landscape painters of the 1830s and 1840s see Matilsky, "Sublime Landscape Painting in 19th Century France."

188. Ch[atelain] found that "the grandeur of the site, the subdued tonality of the picture, adds to the principal action, itself so noble, so poetic. Everything works together to produce a magical effect on our senses" ("Salon de 1834: Deuxième Article," *Le Voleur*, VIIe année, 2e série, III, no. 14 [10 mars 1834], p. 219). Tardieu also felt that "the slightly grey and somber coloration of this picture accords well with the subject insofar as it provides it with an imposing aspect" (*Salon de 1834*, p. 73).

189. The best-known examples are the pictures by Caspar David Friedrich, but a sense of the sublime also informs such French works as the 1839 picture by François-Auguste Biard, *Eskimos Battling Polar Bears*: Bayeux, Musée Baron Gérard, inv. no. 44P (98 × 130 cm).

190. Decamps, *Salon de 1834*, p. 86.

191. Pillet, "Salon de 1834: 6e Article," *Le Moniteur Universel*, no. 97 (Lundi 7 avril 1834), p. 814.

192. LeGo, "Salon de 1834: Quatrième Article," *Revue de Paris*, n.s., III (mars 1834), pp. 328–29.

193. Lee, "*Ut Pictura Poesis*: The Humanistic Theory of Painting," especially the discussions of "invention," pp. 210–17 and "unity of action," pp. 255–60. Also see Bryson, *Word and Image*, pp. 32–33 on the concept of *dispositio*.

194. From p. 328 of the article cited in n. 192 above.

195. "Salon de 1834: Peinture," *L'Artiste*, VII–VIII (1834), p. 99.

196. AL, 2DD/5, p. 49 and AN, O⁴1643, no. 1834, 13 June 1836, 4,500 FF.

197. Completed in 1836. Versailles, MNC, inv. no. MV1777 (164 × 275 cm), currently on loan to Antibes, Musée Naval et Napoléonien. Documents for the commission and payment are: AL, 2DD/5, p. 49, 4 February 1836 and AN, O⁴1644, no. 5350, 25 November 1836, 4,500 FF.

198. *The Landing of His Majesty Napoléon Ier, Emperor of the French, in the Harbor of Cannes, 1 March 1815*, 1815. CdV, V, no. 9348 (24.9 × 40.7 cm). Designed by Courvoisier and engraved by Dubois.

199. Salon of 1817, no. 392. Versailles, MNC, inv. no. MV1778 (405 × 525 cm). Gros's picture was brought to Versailles in late June or early July 1835 (AN, O⁴1588, no. 2908, 8 July 1835, 319.45 FF reimbursement to Cailleux for expenses incurred when moving the picture).

200. About the Strasbourg coup see sec. 2 and Bluche, *Le Bonapartisme*, pp. 215–18.

201. The picture was registered and accepted by the Salon jury, but the words *non exposé* (written in pencil next to the entry) indicate it was withdrawn from the exhibition at the last minute (AL, série *KK, 1837, no. 778).

202. Records at Amiens indicate that Bellangé's painting of the *Return from the Island of Elba* was placed on loan by the government in 1854, but I was unable to confirm this date with documents in the Archives Nationales.

203. On the cult of genius see Shroder, *Icarus*, pp. 28–31.

204. Chateaubriand, *Mémoires d'Outre-Tombe*, I, p. 6.

205. Ibid., pp. 996, 1004.

206. Ibid., pp. 1009–10.

207. Hugo, "Les Orientales, XL: LUI," p. 750; written in December 1828. About Hugo's Romanticism and his admiration for Napoléon consult Shroder, pp. 60–92.

208. This was especially the case for Stendahl, who had served in Napoléon's army from Italy to Moscow (see Brookner, *Genius of the Future*, pp. 35–55). Also consult Richardson, "The Military Hero in the Romantic Imagination."

209. Signed in the plate "Raffet." Paris, BN-EST, série Dc189j, t. III (15.4 × 17 cm). Plate no. 4 of the album of Raffet's lithographs published in 1834 by Gihaut frères (Giacomelli, *Raffet*, no. 381).

210. Fain, *Manuscrit*, p. 126. When Raffet il-

lustrated the story of the Emperor's stay at Châtres for the 1839 edition of a popular biography of Napoléon, he used a variant of *The Idea* (see Norvins, *Histoire de Napoléon*, p. 529).

211. Figure 211: *Michelangelo in His Studio* by Delacroix, usually dated c. 1850. Montpellier, Musée Fabre (41 × 33 cm). About 1839 Delacroix had painted *Tasso in the Madhouse*: Winterthur, Sammlung Oskar Reinhart am Römerholz (60 × 50 cm). Also see Honour, "L'Image de Christophe Colomb"; for a general discussion of the theme of misunderstood and persecuted genius as inspiration for artists consult Honour, *Romanticism*, pp. 262–67.

212. *Napoléon on Saint-Helena*, n.d. Dijon, Musée Magnin (36 × 29 cm). According to the museum's catalogue the sketch was acquired from the heirs of the artist in 1934 and subsequently given to the museum (Magnin, *Musée Magnin*, p. 27, no. 62).

213. Published in 1829. CdV, V, no. 9787 (27.6 × 20.3 cm). Engraving by the Englishman Samuel-William Reynolds after a design by Horace Vernet.

214. Imagery of Napoléon on his island prison was produced regularly during the Bourbon Restoration and July Monarchy; for a sampling see CdV, V, nos. 9781–85.

215. Signed "Janet." Salon of 1844, no. 964. Tours, Musée des Beaux-Arts (260 × 195 cm).

216. Fain, *Manuscrit*, pp. 248–49.

217. "Salon de 1844: 4e Article," *Journal des Beaux-Arts*, XIe année, vol. I, no. 14 (7 avril 1844), p. 209.

218. Several letters urging purchase of the picture are among the archival documents. Janet-Lange's father wrote to Mme de Vatry (wife of a deputy) soliciting her influence to close the deal; she, in turn, wrote to the Minister of the Interior (Duchâtel) that "you promised me this favor." The authorization for 1,500 FF is dated 1 August 1844 (AN, F²137, dossier "Janet-Lange"). The young painter was paid in October (AN, F⁴*516, no. 1428, 9 October 1844, 1,500 FF).

219. Signed and dated "Paul Delaroche 1845." Leipzig, Museum der bildenden Künst, inv. no. 55 (178 × 134 cm). About this picture and the several copies made by Delaroche see Ziff, *Delaroche*, pp. 214–16.

220. Fain, *Manuscrit*, pp. 208–13.

221. Ziff, *Delaroche*, p. 215.

222. Fain, *Manuscrit*, p. 213.

223. Nietzsche was born in 1844 at Röchen, a town not far from Leipzig. The Delaroche was given to the museum of Leipzig in 1853 and it is proba-

ble—although impossible to prove—that Nietzsche knew the picture. The name and reputation of Napoléon wind, with a mixture of admiration and disapproval, through Nietzsche's writings: Nietzsche never really thought of Napoléon as an *übermensch* (he felt the Emperor had been corrupted by evil), but he ranked Napoléon and Goethe as the two individuals who most influenced the nineteenth century. About Nietzsche's view of Napoléon consult Kaufmann, *Nietzsche*, pp. 313–16).

224. *Abdication of the Emperor Napoléon at Fontainebleau*. Salon of 1843, no. 420. Versailles, MNC, inv. no. MV1774 (134 × 158 cm).

225. The commission dates from 28 June 1840 (AL, 2DD/5, p. 111, 2,400 FF), and the *livret* for the Salon of 1844 noted that Ferri's picture was "based on the composition of François Bouchot, recently deceased." Bouchot had received a first payment for the picture (AN, O⁴1900, no. 7338, 17 February 1841, 1,500 FF), but Ferri waited several years before he was paid (AN, O⁴2241, no. 8207, 6 March 1846, 1,400 FF).

226. Fain, *Manuscrit*, pp. 233–34.

227. Reprinted in Bonaparte, *Correspondance de Napoléon Ier*, XXVII, no. 21555, p. 358. The *livret* for the Salon of 1844 specifically noted that the image represented 4 April 1814.

228. See the analysis of this situation in Houssaye, *1814*, pp. 597–601.

229. Ibid., pp. 591–94.

230. Versailles, MNC, inv. no. MV1775 (98 × 158 cm), currently on loan to the Château de Fontainebleau.

231. The gift is recorded in AL, 2DD/4, p. 361. Vernet's original was sold at auction on 8 May 1985 (see London, Christie, Manson & Woods, *Napoléon, Nelson and Their Time*, no. 124, reproduced in color).

232. The most frequently cited account of this scene is Fain, *Manuscrit*, pp. 265–67.

233. CdV, IV, no. 8969 (49.6 × 65 cm).

234. It should be apparent from the subject, sentiment, and formal characteristics of this picture that Vernet had brought together the principal elements of genre historique well before 1830. Needless to say, the painting remained a private cabinet-piece during the Bourbon Restoration because such subjects were barred on political grounds from public exhibitions.

235. Versailles, MNC, inv. no. MV1782 (325 × 265 cm).

236. For example, the description of the bur-

ial site provided by Antommarchi, *Mémoires*, II, pp. 175–77.

237. AL, 2DD/5, p. 63, 30 April 1837, 5,000 FF and AN, O⁴1705, no. 2676, 6 July 1837, 5,000 FF.

238. AN, O⁴1645, no. 7579, 7 March 1837, 67.60 FF for purchase of lithographs. Figure 219: Published in 1830. Paris, BN-EST, série Ef236d, t. I, gr. fol: f5 (53.4 × 79 cm). Engraving by Jazet after the painting by Horace Vernet. Catalogued in *Inventaire du fonds français*, XI, p. 297, no. 146. The original oil is in London, The Wallace Collection, inv. no. P.575 (55 × 81 cm). Figure 220: Paris, BN-EST, série AA5, supp. rel. (45.4 × 64 cm). Engraving published in 1826 by François Garnier after Gérard's oil. Catalogued in *Inventaire du fonds français*, VIII, p. 378, no. 3. Gérard's original, exhibited at the Luxembourg in 1830 (*livret* no. 102), is now at Malmaison, Musée National du Château de Malmaison, inv. no. MM7287 (94 × 132.5 cm). The duc d'Orléans had bought the work in 1834 for 10,000 FF (AN, 300 API 2389, no. 38, 5 July 1834) and it was acquired by Malmaison in 1853 at the sale of his collection.

239. Thureau-Dangin, IV, pp. 95–101.

240. Ibid., pp. 108–11.

241. Ibid., pp. 116–18 concerning the support offered this cabinet by the Left and pp. 124–27 about the policies and program planned by Thiers.

242. Thiers first used the term *transaction* on 4 March 1840. For a discussion of what he meant by it see Allison, *Thiers*, pp. 275–77. About Thiers' apparent victory in the first test of his cabinet's strength on 26 March 1840 see Thureau-Dangin, IV, pp. 130–31.

243. For a detailed discussion of this episode of parliamentary battling see Thureau-Dangin, IV, pp. 146–53.

244. Ibid., pp. 153–68 and Lucas-Dubreton, *Le Culte*, pp. 353–59.

245. Guizot, *Lettres*, II, p. 72, no. 376, 7 April 1840.

246. Ibid., p. 77, no. 380, 11 April 1840.

247. At that time May 1 was the feast of Saint Philip (the king's patron), and he announced his assent to the cabinet as a kind of present in honor of the saint (Thureau-Dangin, IV, pp. 157–59).

248. AN, 42 AP 246, "Correspondance de Guizot avec Thiers," 4 May 1840.

249. Driskell, "Eclecticism and Ideology," p. 121 overstates the scope of the negotiations.

250. Guizot, *Lettres*, II, p. 117, no. 421, 10 May 1840 and AN, 42 AP 246, 11 May 1840.

251. Guizot, *Lettres*, II, p. 127, no. 431, 14 May 1840.

252. Dorothée de Lieven recounted to Guizot a tête-à-tête with the comte de Montrond: "We talked about everything. I asked him this question: 'Between these two opposing versions of the story— that Thiers invented the transferral of Napoléon's remains and wrested the King's assent with difficulty, or that the King had conceived it and Thiers obeyed—which should I believe?' He replied, 'Believe the most likely: the deed is Thiers'!" A few lines later, Lieven adds that the comte de Bourqueney had told her: "The 1st of May, when Thiers called with the Cabinet to congratulate the King on his feast day, the King responded by granting him the remains of Napoléon. Bouquet for bouquet" (Guizot, *Lettres*, II, p. 141, no. 438, 20 May 1840).

253. "Chambre des Députés: Séance du Mardi 12 mai," *Le Moniteur Universel*, no. 134 (Mercredi 13 mai 1840), pp. 1034–35.

254. Letter from Thiers to Guizot, AN, 42 AP 246, 13 May 1840. Lieven's letter is published in Guizot, *Lettres*, II, p. 122, no. 428, 14 May 1840.

255. Thureau-Dangin, IV, pp. 160–61 and Cahuet, *Napoléon délivré*, pp. 62–63.

256. Cited in Thureau-Dangin, IV, pp. 161–62, where the rhetorical sparring is discussed. See also Cahuet, *Napoléon délivré*, pp. 63–65 and Lucas-Dubreton, *Le Culte*, pp. 357–59.

257. Thureau-Dangin, IV, pp. 162–67 and Cahuet, *Napoléon délivré*, pp. 67–76.

258. "Chambre des Députés: Séance du Mardi 26," *Le Moniteur Universel*, no. 148 (Mercredi 27 mai 1840), p. 1189.

259. Rémusat, *Mémoires*, III, p. 318.

260. Ibid.

261. In the words of Lamartine (from his speech of 26 May cited in note 258 above), the place Vendôme "would be a permanent assembly: it would be a standing speakers' platform for every kind of sedition." About other opinions as to where Napoléon should be buried see Cahuet, *Napoléon délivré*, pp. 98–103.

262. Rémusat, *Mémoires*, III, p. 315.

263. A facsimile of Napoléon's will is reproduced in Bourguignon, *Napoléon Bonaparte*, II, p. 44. De Carné echoed the general approval of the Invalides: "We congratulate the government for having understood with dignity what it owed both to Napoléon and to its public commitment," he wrote; "the Emperor will rest in a temple sanctified alike by religion and glory, in the care of his old soldiers,

happy and proud to pray near his remains. In the sheltering solitude of the Invalides, amidst this abundant greenery and under the glittering dome which the traveler hails from afar, will rise an imposing tomb of great mass and grand simplicity" ("De la popularité de Napoléon," p. 864).

264. Louis-Philippe informed Joinville of his mission while the latter was in bed with the measles. The prince was less than enthusiastic. "I was not at all flattered," he later wrote, "by the comparison which I made between the military campaign undertaken by my brothers in Algeria and the undertaker's trade I was sent to perform in the other hemisphere. But I was a soldier and I did not need to discuss an order" (Joinville, *Vieux souvenirs*, p. 207).

265. Rémusat, *Mémoires*, III, p. 318. The mission to Saint-Helena included several who had shared Napoléon's exile: Henri Bertrand and his son, Arthur (born on Saint-Helena in 1817); Gaspard Gourgaud; Emmanuel de Las Cases, son of the author discussed earlier; Louis Marchand, former *valet de chambre* of the Emperor; Archambault, former imperial groom; Ali Saint-Denis, Napoléon's librarian; Abram Noverraz, former valet; and finally Pierron, the Emperor's chef. About this group and the personalities it comprised see Cahuet, *Napoléon délivré*, pp. 105–67.

266. Guizot, *Lettres*, II, p. 145, no. 441, 21 May 1840. See also Guizot, *Mémoires*, V, pp. 114–15.

267. AN, 42 AP 246, 23 May 1840.

268. "His presence on Saint-Helena in the capacity as the King's commissioner," observed Thiers about Rohan-Chabot, "should suit the English cabinet, who knows him" (AN, 42 AP 246, 20 June 1840).

269. Joinville, *Vieux souvenirs*, pp. 209–10.

270. For an account of the voyage see Cahuet, *Napoléon délivré*, pp. 185–214.

271. Joinville, *Vieux souvenirs*, p. 212.

272. Cahuet, *Napoléon délivré*, pp. 211–13.

273. Thureau-Dangin, IV, pp. 51–58 discusses French interests in Egypt and the alliance with Méhémet-Ali.

274. Ibid., p. 59.

275. Charléty, *La Monarchie de Juillet*, p. 168.

276. Thureau-Dangin, IV, pp. 192–96 for a summary of Thiers' foreign policy.

277. Thiers' letters to Guizot of 21 March and 28 April 1840 make clear that he was perfectly aware of the stakes in these maneuvers (Guizot, *Mémoires*, V, pp. 206–07).

278. Letter from Guizot to Thiers dated 11 July 1840 (ibid., pp. 211–18).

279. Ibid., pp. 457–67 for the text of this treaty. Its terms are summarized in Thureau-Dangin, IV, pp. 222–23.

280. Heine, "Lutezia," Erster Teil, p. 94.

281. French reaction to the treaty is discussed in Thureau-Dangin, IV, pp. 230–35.

282. Cited ibid., p. 234.

283. AN, 300 APIII 50, dossier 8 (the italicized words are in English in Louis-Philippe's original).

284. About the exhumation see Cahuet, *Napoléon délivré*, pp. 260–76 and Laumann, *L'épopée napoléonienne: Le Retour des Cendres*, pp. 50–63.

285. I should mention the theory of Sten Forshufvud, recently elaborated with a compelling argumentation, that Napoléon was actually murdered by means of arsenic poisoning (Weider and Hapgood, *The Murder of Napoléon*). The authors argue that death by arsenic would account for the remarkable preservation of Napoléon's body (p. 256).

286. Joinville, *Vieux souvenirs*, pp. 219–20.

287. Thureau-Dangin, IV, pp. 247, 271–74.

288. Orléans, Ferdinand-Philippe duc d', *Lettres*, p. 285.

289. Thureau-Dangin, IV, pp. 326–36.

290. Ibid., pp. 346–50.

291. On the disagreement between Louis-Philippe and his cabinet over this text see Rémusat, *Mémoires*, III, pp. 482–88 and Guizot, *Mémoires*, V, pp. 404–06. The speech prepared by Thiers and refused by the king is reprinted in full on pp. 510–12 of the latter volume.

292. "Discours du Trône," *Le Moniteur Universel*, no. 311 (Vendredi 6 novembre 1840), p. 2201. On the new cabinet's measures to quell public passions see Thureau-Dangin, IV, pp. 360–62.

293. This print was announced in the *Bibliographie de la France*, XXIX, no. 44 (31 octobre 1840), p. 599, no. 1497. Catalogued in De La Combe, *Charlet*, p. 368, no. 977. Other lithographs of the same political tenor published during the fall of 1840 are catalogued ibid., pp. 366–68, nos. 967–78.

294. Signed in the plate "Charlet" and published in 1840. Paris, BN-EST, série Dc102 fol., t. VII (38.8 × 27.3 cm). Catalogued in De La Combe, *Charlet*, p. 368, no. 980.

295. See De La Combe, *Charlet*, pp. 368–70, nos. 979–85 about the artist's difficulties with government censors in November and December 1840.

296. Archival documents concerning the naval expedition and funeral ceremony are col-

lected in AN, F²¹741–742. A very useful article to consult is Hachette, "Le Dossier de la journée du retour des Cendres," especially because the actual documents are quite mixed up and difficult to follow.

297. Hachette, p. 245.

298. See Langlé, *Funérailles de l'Empereur Napoléon*, a small brochure which served as the official account of the ceremony (copy in the Bibliothèque Nationale, Département des Imprimés, 4°Lb⁵¹.3316). Louis-Philippe's government purchased 500 copies of Langlé's booklet on 25 December 1840 as a gesture of support for its unsubsidized publication (Hachette, p. 275). In fact, the ceremony did not follow these original plans.

299. Several albums of prints illustrated the retour des cendres from beginning to end, and a good number of them are catalogued in CdV, VI, pp. 499–549.

300. *The Landing at Courbevoie of Napoléon's Remains*, n.d. Signed "F. Philippoteaux." Exhibited at Salon of 1867, no. 1212. Rueil-Malmaison, MNC, inv. no. MM.8086 (125 × 200 cm).

301. Audot, *Funérailles de l'empereur Napoléon*, pp. 42–43. The decorations at Courbevoie are also discussed by Laumann, pp. 129–30.

302. On the materials and belated completion of this column see Hachette, p. 262 and Laumann, p. 129.

303. *Obsequies of Napoléon—The Funeral Wagon*, 1841. Signed in the plate "A. Provost." CdV, VI, no. 12.913 (13.1 × 20.3 cm). For documents relative to the road-testing and completion of the funeral wagon see Hachette, pp. 264–66.

304. Hugo, *Choses vues*, I, p. 44.

305. Cited in Dechamps, "Alphonse Karr et le retour des Cendres," p. 32.

306. The architect of decorations for the Arc de Triomphe was Abel Blouet, who spent 13,573.60 FF on the effort (see Hachette, pp. 246, 248). For a detailed description of the ensemble refer to Laumann, pp. 96, 129.

307. *Entrance of Napoléon's Cortège into Paris through the Arc de Triomphe de l'Etoile, 15 December 1840*, 1841. CdV, VI, no. 12.904 (27 × 38.3 cm). Hugo's commentary is from *Choses vues*, I, pp. 48–49.

308. *March of the Cortège down the Champs-Elysées*, 1841. Signed in the plate "Lafosse." Paris, BN-EST, *s.n.r.*, "Lafosse" (16.2 × 24.3 cm).

309. For descriptions of the avenue des Champs-Elysées see Hugo, *Choses vues*, I, p. 48; Hachette, p. 247; and Laumann, pp. 96, 129.

310. An idea of how avidly places at the Invalides were sought can be gleaned from the sampling of requests for tickets published by Hachette, pp. 276–78. Victor Hugo, for example, was seated upon the first platform at the left (*Choses vues*, I, p. 48).

311. *The Catafalque Barge*, 1841. CdV, VI, no. 12.884 (18.8 × 27 cm). Lithograph designed by Dumouza and figures executed by Lehnert.

312. For descriptions of the esplanade des Invalides consult Hugo, *Choses vues*, I, pp. 40–41; Hachette, pp. 246–47; Laumann, p. 128; and Cahuet, *Napoléon délivré*, pp. 307–08.

313. That the government paid only 1,200 FF for each of these large figures also suggests that iconography was more important than material sophistication. For the commission documents see AN, F²¹742, pièces 5–22.

314. *The Arrival of Napoléon's Remains at the Invalides*, 1840. Paris, Musée Carnavalet, inv. no. P.1460 (21.5 × 34 cm). Previously attributed to Eugène Lami but currently inventoried as author unknown.

315. Cahuet, *Napoléon délivré*, pp. 320–22.

316. *Interior of the Invalides Church during the Religious Ceremony, 15 December 1840*, 1841. Paris, BN-EST, *s.n.r.*, "Dumouza" (27.2 × 19.5 cm). Lithograph designed by Dumouza and figures executed by Lehnert. Catalogued in *Inventaire du fonds français*, VII, p. 185, "Dumouza," no. 12.

317. See the description in Laumann, pp. 126–27.

318. Hugo reported that the catafalque was only half-decorated at 8:00 on the morning of the 15th, and that workmen were feverishly applying final touches even as the crowd began to arrive (*Choses vues*, I, p. 47).

319. From a letter written by Mme Mollien to the duchesse de Dino, cited in Dino, *Chronique*, II, p. 436.

320. Cahuet, *Napoléon délivré*, pp. 348–49.

321. "Intérieur: Paris, le 15 décembre," *Le Moniteur Universel*, no. 351 (Mercredi 16 décembre 1840), p. 2444. Joinville later recounted an unofficial—but probably true—version of the ceremony: "It seems that the Cabinet had prepared a short speech which I was supposed to deliver when meeting my father, as well as the reply he should make to me. But no one had told me about this, and so upon arriving I was happy to offer a saber salute and then stand aside. I clearly sensed that this silent salute

followed by withdrawal upset something, but my father, after a moment's hesitation, improvised an appropriate phrase; the incident was later tidied up in *Le Moniteur*" (*Vieux souvenirs*, p. 223). Indeed, the official report must have been altered because no mention is made of Joinville's faux pas.

322. The closing parts of the ceremony are described in Laumann, p. 150; Guizot, *Mémoires*, VI, p. 20; and Thureau-Dangin, IV, p. 410.

323. Joinville, *Vieux souvenirs*, p. 220.

324. Hugo, *Choses vues*, I, p. 48.

325. Ibid., p. 50.

326. Letter to baron Mounier cited in Guizot, *Mémoires*, VI, p. 21.

327. Gudin was to receive 12,000 FF for his picture, while Vernet's was commissioned for 24,000 FF (AL, 2DD/5, p. 117, 21 December 1840).

328. With predictable consistency, these same two episodes are the only nonallegorical subjects in the entire sculptural program of the Emperor's permanent tomb at the Invalides: *The Tomb on Saint-Helena at the Moment of Exhumation*, by Auguste Dumont (230 × 320 cm); *Arrival of Napoléon's Body at the Invalides*, by François Jouffroy (230 × 320 cm). These two marble reliefs were completed in 1851 but were not installed, owing to their prominent display of Louis-Philippe and his sons (exiled by the 1848 Revolution). It was not until 1910 that the works were finally placed at the Invalides (Niox, *Napoléon et les Invalides*, p. 24 and n. 2).

329. *Arrival of the Imperial Flotilla at Maisons-Laffitte, Sunday 13 December 1840.* Salon of 1841, no. 164. Maisons-Laffitte, Musée du Château de Maisons, inv. no. ML128 (100 × 140 cm). Other pictures at the 1841 Salon (whereabouts unknown to me) were *View of the Arc de Triomphe de l'Etoile* (no. 1344) by Lucas and *Souvenir of Napoléon's Funeral Ceremony* (no. 1644) by Provost.

330. Joinville, *Vieux souvenirs*, p. 221.

331. *Departure from Jamestown.* Salon of 1841, no. 1422. The picture was purchased for 400 FF (AL, 2DD/4, p. 360, 8 June 1841) and was recorded in the inventories as 44 × 68 cm.

332. Signed "Morel-Fatio." Salon of 1841, no. 1471. Versailles, MNC, inv. no. MV6997 (130 × 195 cm). One of two pictures acquired by the government on 8 June 1841 (AL, 2DD/4, p. 360, 2,000 FF) and paid for in September (AN, O⁴1958, no. 3555, 15 September 1841).

333. *Transfer of the Remains of Emperor Napoléon*, 1840. CdV, VI, no. 12.878 (19.8 × 28 cm).

334. Signed "Guiaud." Salon of 1841, no. 938. Versailles, MNC, inv. no. MV5125 (105 × 117 cm). The work was earmarked for purchase from the Salon (AL, 2DD/4, p. 180, 8 June 1841) and paid for in September (AN, O⁴1958, no. 3561, 15 September 1841, 1,200 FF). A second version of this same scene on a slightly larger canvas (81 × 165 cm) currently belongs to the Comte de Paris (see Paris, Archives Nationales, *Louis-Philippe*, no. 438 and illustration).

335. "Salon de 1841: 7ᵉ Article," *Journal des Beaux-Arts*, VIIIᵉ année, vol. I, no. 15 (2 mai 1841), p. 227.

336. The place de la Concorde was officially completed and dedicated on 1 May 1840. The exterior of the Madeleine church was essentially finished by 1840, and the obelisk of Luxor had been erected and dedicated on 24 October 1836. See Granet, "La Place de la Concorde," pp. 105–17 and Kemp, "Der Obelisk auf der Place de la Concorde."

337. The picture's full title is: *The 15th of October 1840: His Majesty the prince de Joinville, Commander of the Frigate* Belle-Poule, *Anchored at Saint-Helena, Has the Body of Napoléon Loaded Aboard His Ship to Bring It Back to France*, signed "E. Isabey." Salon of 1842, no. 988. Versailles, MNC, inv. no. MV5124 (239 × 371 cm). It was acquired for 8,000 FF (AN, O⁴2028, no. 3206, 4 August 1842).

338. Dauvergne, "Salon de 1842," *L'Art en Province*, VI (5 avril 1842), p. 210.

339. Karr, "Exposition du Louvre," *Les Guêpes* (avril 1842), p. 28 and D.L., "Salon de 1842: Troisième Article," *La Phalange*, XIᵉ année, 3ᵉ série, V, no. 46 (17 avril 1842), p. 742.

340. Peisse, "Le Salon de 1842," *Revue des Deux Mondes*, 4ᵉ série, XXX (15 avril 1842), p. 243.

341. Tenint, *Salon de 1842*, p. 11.

342. See especially Joinville, *Vieux souvenirs*, p. 219.

343. Gudin received an advance of 1,800 FF for his picture (AN, O⁴1957, no. 955, 19 avril 1841), but this one small payment is the only record I was able to locate in the archives. Moreover, the picture's entry in the inventory (AL, 2DD/5, p. 117) was never assigned a number, an indication that it was never delivered.

344. Boime, *Couture*, p. 3 and Driskell, "Eclecticism and Ideology," p. 121.

345. Conversation of the Austrian ambassador with Louis-Philippe reported by Dorothée de Lieven (Guizot, *Lettres*, II, p. 144, no. 440, 21 May 1840).

346. Hugo, *Choses vues*, I, p. 48.

347. Cited in Dechamps, "Alphonse Karr et le retour des Cendres," p. 27.

348. Chateaubriand, *Mémoires d'Outre-Tombe*, I, pp. 1031–32.

349. Heine, "Lutezia," Erster Teil, p. 146, written on 11 January 1841.

350. Guizot, *Mémoires*, VI, p. 21. Heine actually harbored a rather unflattering opinion of Guizot as a kind of philistine (see Heine, "Lutezia," Zweiter Teil, pp. 268–70, written in 1843).

351. *Napoléon at the Bridge of Arcis-sur-Aube*, signed and dated "Adolphe Beaucé 1843." Salon of 1843, no. 54, currently on loan to Troyes, Musée Municipal, inv. no. INV2441 (125 × 160 cm). Acquired for 1,000 FF (AL, 2DD/4, p. 41) and paid for in August (AN, O⁴2118, no. 5251, 1 August 1843, 1,000 FF). The other work was the *Landing of General Bonaparte in France upon His Return from Egypt* by Louis Meyer. Salon of 1843, no. 868. Versailles, MNC, inv. no. MV1438 (270 × 380 cm), currently on loan to the National Assembly. The purchase was authorized at 2,000 FF (AL, 2DD/4, p. 362) and paid for in July (AN, O⁴2117, no. 5154, 21 July 1843).

352. Cited in Dechamps, "Alphonse Karr et le retour des Cendres," p. 32.

V: TWO REVOLUTIONS IN VIEW

1. Colored drypoint probably published in late 1830. CdV, VI, no. 11.392 (30.1 × 43 cm).

2. For a summary analysis of these three opposition groups as well as relevant bibliography consult Charléty, *La Monarchie de Juillet*, pp. 36–41.

3. Salon of 1847, no. 604, recorded in the Salon register as 400 × 300 cm (AL, série *KK, 1847). Documents relative to the commission are found in AN, F²¹30, dossier "Flandrin." The price was fixed at 5,000 FF and final payment made in March 1847 (AN, F⁴*519, no. 323, 6 March 1847, 3,000 FF). See also L. Flandrin, *Hippolyte Flandrin*, p. 137.

4. Lorient, Musée Municipal (322 × 318 cm). The copy was commissioned on 24 July 1852 by the Interior Ministry at the request of the mayor of Lorient (all relevant documents in AN, F²¹85, dossier "Guillaume"). Although no mention is made of Guillaume's first name, it is likely that the artist was Louis Guillaume, native of Nantes and student of Paul Delaroche. I wish to thank most warmly M. Eric Bonnet, Conservateur Adjoint aux Archives Départementales du Morbihan, for his help in locating this picture and expediting a photograph.

5. Gautier, *Salon de 1847*, p. 41.

6. *Napoléon Iᵉʳ on the Imperial Throne*, signed and dated "Ingres Pẍit/Anno 1806." Salon of 1806, no. 272. Paris, Musée de l'Armée, inv. no. INV5420 (260 × 163 cm). For a complete bibliography consult New York, *The Age of Revolution*, no. 104.

7. Planche, "Le Salon de 1847," p. 357. Contemporary critics tended to blame Ingres for Flandrin's peculiarities: see, for example, *L'Artiste*, 4ᵉ série, IX, no. 2 (14 mars 1847), p. 34 and no. 4 (28 mars 1847), p. 59 or Guillot, "Exposition Annuelle des Beaux-Arts," pp. 384–85.

8. On the murals executed by Flandrin between 1842 and 1846 in the choir of Saint-Germain-des-Prés see the two recent publications by Horaist: "Hippolyte Flandrin à Saint-Germain-des-Prés" and "Saint-Germain-des-Prés (1839–1863)." Also consult L. Flandrin, *Hippolyte Flandrin*, pp. 127–36 and Driskell, "Icon and Narrative," who discusses these neo-Byzantine tendencies in the work of Ingres and his pupils.

9. The letter of 4 July 1844 to Flandrin announcing the commission makes it clear that the artist "should submit the subject and the sketch for this picture to the Minister for approval." On 10 October Flandrin was informed that "the Minister of the Interior has approved your choice of subject, *Napoléon as Lawgiver*, for the picture commissioned from you." Flandrin was not very prompt about submitting a sketch, however, for a letter dated 25 March 1845 exhorts him to "please send this sketch to me as soon as possible" (all documents cited from AN, F²¹30, dossier "Flandrin").

10. Following Barthes, we might describe the lexical system of the Napoleonic legend as arbitrary and motivated, but partially "naturalized" through repetition to a less-than-arbitrary state. See Barthes, *Elements of Semiology*, pp. 50–54 (secs. II.4.2–3) and the passages mentioned therein from *The Savage Mind* by Lévi-Strauss.

11. Mantz, *Salon de 1847*, pp. 57–59.

12. Bonaparte's election to the Presidency was not greeted with enthusiasm by Flandrin, who wrote on 13 December that "we voted for Cavaignac so as not to head for a new revolution which would give rise to plenty of others." Two days later, after the ballots were counted, he wrote: "I say:

'Long live the Constitution!' I also submit with the most complete sincerity to what universal suffrage—the only possible foundation of a political structure today—will lead. Then, like you, I say: 'Let the Good Lord protect France!' and I hope" (cited from L. Flandrin, *Hippolyte Flandrin*, p. 198).

13. The life-sized bronze was inaugurated in September 1847 and is still installed in the Parc Noisot at Fixin. For discussions consult Calmette, *François Rude*, pp. 120–23; Fourcaud, *François Rude*, pp. 290–307; Lucas-Dubreton, *Le Culte*, pp. 406–08; and Honour, *Romanticism*, pp. 237–38. Interestingly, Noisot had met Rude in 1840 during the retour des cendres ceremonies at Paris.

14. Rude's first project is now in Dijon, Musée des Beaux-Arts (29 × 54 cm). Bronze. Rude was working during these same months on his monument to Godefroy Cavaignac (where the hero is laid out starkly on a simple slab)—a work which certainly informed his first idea for the Napoléon. About the Cavaignac see Nochlin, *Realism*, p. 65 and fig. 29.

15. Hugo, "A la Colonne," verse 6, from "Les Chants du crépuscule," pp. 200–01. The complete stanza is built around this turbulent image of desolate nature:

Hélas! hélas! garde ta tombe!
Garde ton rocher écumant,
Où t'abbatant comme la bombe
Tu vins tomber, tiède et fumant!
Garde ton âpre Sainte-Hélène
Où de ta Fortune hautaine
l'oeil ébloui voit le revers;
Garde l'ombre où tu te recueilles,
Ton saule sacré dont les feuilles
S'éparpillent dans l'univers!

[Alas! Alas! Keep your tomb!
Keep your foaming rock
Where, crashing down like a bomb,
You came to fall, smoking and warm to the touch!
Keep your harsh Saint-Helena
Where, of your haughty good fortune
The dazzled eye now sees the other side;
Keep the shade where you meditate,
Keep your sacred willow whose leaves
Scatter throughout the universe!]

16. Signed and dated "Granet 1847." Aix-en-Provence, Musée Granet-Palais de Malte, inv. no. 848–1–13 (152 × 195.5 cm). This work entered the museum's collection in 1849 as part of the Granet bequest.

17. Some of Granet's stock-in-trade images from the 1830s and 1840s included: *The Redemptorist Fathers Ransoming Slaves at Tunis* (Salon of 1833, no. 1132); *Benedictine Monks Kissing the Ring of Their Abbot* (Salon of 1840, no. 752); and *Hermits Building a Small Chapel* (Salon of 1843, no. 541). An example of the work he did for Louis-Philippe would be the *Baptism of His Highness the duc de Chartres in the Chapel of the Tuileries, 14 November 1840 at 7 o'Clock in the Evening*, Salon of 1843, no. 537. Versailles, MNC, inv. no. MV5161 (116 × 167 cm). The picture was commissioned on 21 December 1840 for 5,000 FF (AL, 2DD/5, p. 117) and paid for on 24 November 1842 (AN, O⁴2044, no. 5249).

18. The portrait in question seems to be Callet's 1789 picture of the king (compare to fig. 3 above). On the anticlericism and de-Christianization of 1793 consult Lefebvre, *Revolution*, II, pp. 76–81.

19. Toussaint, *Granet*, pp. 102–03. Granet, who had been chief curator of Versailles and an intimate of Louis-Philippe, could hope for little sympathy from the government after 24 February 1848.

20. Michelet's first volume appeared on 13 February 1847, the second on 20 November. Blanc's volume one was released on 6 March, volume two on 31 October. The first volume of Lamartine's text appeared on 20 March, and the last on 12 June. For a discussion of the political effect of these histories refer to Thureau-Dangin, VII, pp. 41–51.

21. Alexandre Dumas reportedly said that Lamartine "has raised history to the grandeur of the novel" (cited in Thureau-Dangin, VII, p. 48).

22. Letter of 20 March 1847 addressed to a M. Ronot at Mâcon (Lamartine, *Correspondance*, VI, p. 232).

23. Delacroix noted the book loan on 29 April 1847 (*Journal*, I, p. 218). Scanning his entries for this period reveals many dinners, soirées, and appointments with Thiers and other politicians of the same circle: six in February (2, 3, 21, 23, 24, 28); two in March (11, 14); and 28 April, 27 May, and 6 June. That Delacroix was not always in agreement with these friends is suggested by his entry for 11 March, in which he notes that he and Vieillard "had chatted at length about the eternal question of progress which we understand so differently" (I, p. 203).

24. About Delacroix's reaction to the 1848

Revolution and his "flight" to Champrosay read Clark, *The Absolute Bourgeois*, pp. 126–31. On 15 June 1847 Delacroix copied an excerpt from a lengthy review of the recently published histories by Michelet, Blanc, and Lamartine written for the *Revue des Deux Mondes* (Delacroix, *Journal*, I, p. 231).

25. In particular, Livre 52, sects. XX–XXIII of the *Girondins*.

26. For a discussion of the legislative stupor exhibited by the government in 1847 and the king's part in it refer to Thureau-Dangin, VII, pp. 12–20.

27. "The life of Louis-Philippe is definitely not going to be raffled off, but turned into pictures," sarcastically noted a Paris periodical. "It is a question of no less than sixty compositions, for which the Museum Administration has already concluded a number of fixed-price deals with the contractors" (*JdA*, XXIIe année, 3ème série, vol. I, no. 7 [13 février 1848], p. 56). The commissions were officially registered on 19 February 1848 (AL, 2DD/5, pp. 163–66). About the Salle de 1830 in 1834 see pt. II, sec. 5, notes 182–83.

28. For the more recent view see Boime, *Academy*, pp. 15–21 and Boime, *Couture*, pp. 3–35. The canonical older study is Rosenthal, *Du Romantisme au Réalisme*, pp. 202–31.

29. Boime, *Academy*, p. 10 and *Couture*, p. 29.

30. Boime, *Couture*, p. 11.

31. Boime, *Academy*, p. 13, pp. 15–16 and *Couture*, p. 29.

32. See Boime, *Couture*, p. 10 for an argumentation of *Zeitgeist* (without actually using the word). Later, the author admits that "there was no necessary alignment between the artistic and political categories," but claims the two are "analogous" since both served an official policy striving for a "consensus" (p. 29). See pp. 30–31 for his comments on Versailles.

33. Begun in 1847 and never completed. Beauvais, Musée Départemental de l'Oise (915 × 480 cm). The quote is from Boime, *Couture*, p. 194. For additional essays and bibliography see Springfield, Museum of Fine Arts, *Enrollment of the Volunteers*.

34. Boime, *Couture*, p. 198.

35. Ibid., p. 194.

36. Delacroix, *Journal*, I, p. 195. Nor should we forget that Rude's sculpture of *La Marseillaise*—executed for the Arc de Triomphe de l'Etoile between 1833 and 1836—also represents the volunteers of 1792, and does so with a mix of allegory and reality, contemporary, medieval, and antique details, the whole organized into a coherent structure under the flying figure at the apex of a compositional triangle.

37. Salon of 1839, no. 1482. Versailles, MNC, inv. no. MV5431 (325 × 485 cm). The following contemporary descriptions facilitate the identification: Etienne Huard, *JdA*, XIIIe année, vol. I, no. 17 (28 avril 1839), pp. 257–58; Laurent-Jan, *Salon de 1839*, pp. 11–12; and Adolphe Michel, "Salon de 1839–2e Article," *L'Art en Province*, IV (1839), p. 82.

38. *Jupiter and Thetis*, signed and dated "Ingres/Rome 1811." Aix-en-Provence, Musée Granet-Palais de Malte (327 × 260 cm). For an illustration and complete bibliography refer to New York, *The Age of Revolution*, no. 105.

39. AN, F219, dossier "Mauzaisse." A letter offering 6,000 FF and dated 20 April 1839 is annotated "M. Mauzaisse does not accept our offer."

40. Ibid., letter dated 10 April 1840. Payment was made in two parts: AN, F4*512, no. 1413, 27 June 1840, 4,000 FF and idem., no. 1993, 12 January 1841, 4,000 FF.

41. AL, P10, "Mauzaisse," document dated 7 June 1860.

42. Rosenthal, pp. 202–31.

43. Ibid., p. 360.

44. Ibid., pp. 202–03.

45. Ibid., p. 360.

46. For example, Rosenblum, *19th-Century Art*, pp. 162–63. For a historical discussion of the term see Haskell, "Art and the Language of Politics," pp. 219–21.

47. Rosenthal, pp. 345–98.

48. Ibid., p. 348.

49. Ibid., pp. 369–75.

50. Ibid., p. 373.

51. Baudelaire, *Salon de 1845*, p. 72.

52. Rosenthal, p. 375.

53. About the importance and character of pedagogy in the design of Versailles see Gaehtgens, *Versailles*, pp. 65–85.

54. Charles Gavard, *Galeries historiques de Versailles*, 13 vols. and *Histoire de France servant de texte explicatif aux tableaux des galeries de Versailles*, 4 vols. About the publication of these volumes see Montalivet, *Le Roi Louis-Philippe*, pp. 83–85.

55. Gavard, "Prospectus," *Galeries historiques de Versailles*, I (1838).

56. Montalivet, *Le Roi Louis-Philippe*, p. 83. According to this text, 960 examples of Gavard's volumes were distributed to libraries at the king's expense.

57. Rosenthal, pp. 357–58.

58. The implications of my argument are at odds with that of Michael Fried, who concludes: "The development that I have called the theatricalization of action and expression is complete in Gros's *Plague-House* and *Eylau* . . . and nothing that happens in French painting after that time may be said to undo that theatricalization; on the contrary, the work of the most ambitious painters of the next decades, including Couture, confirms its universality" ("Thomas Couture and the Theatricalization of Action," p. 43). It is clear, nonetheless, that Gros's paintings continue to emphasize a single focus of attention (notably, Napoléon—a point Fried concedes in n. 39), and achieve this end by manipulating configurations rooted in the grand tradition. It is *just that tradition* which disappears from the works we have been discussing. I would grant that a sense of "theater" informs the compositional and narrative structure of genre historique (and, by extension, what we have called juste-milieu painting). Yet the question which remains is how, without the conventions and associations of "high art" configurations, might paintings generate propagandistic meaning? The fact that artists of the July Monarchy resolved this issue with "low art" strategies of genre and popular imagery should make us ask if theatricality (or its antipode) is really the crux of the matter. I reexamine the issue of Gros's Imperial pictures in a forthcoming article entitled "Literal/Literary/'Lexie': History, Text, and Authority in Napoleonic Painting."

59. See Rosenthal, pp. 354–57 for his discussion of lithography and its influence. Many of the painters who worked on and off as lithographers have appeared in our study: for example, the Scheffers (Ary and Henri), Hippolyte Bellangé, Horace Vernet, and Eugène Lami.

60. Ibid., p. 356.

61. The classic study is Meyer Schapiro's "Courbet and Popular Imagery: An Essay on Realism and Naiveté." See also Linda Nochlin, "Gustave Courbet's *Meeting*."

62. Clark, *Image of the People*, p. 140.

63. As early as 1856 Courbet's friend Max Buchon had argued that "the most inexorable protest against the professors and pastiches is popular art," and in 1869 Champfleury similarly argued for the inherent honesty of popular art (quoted from Schapiro, "Courbet and Popular Imagery," pp. 172, 178). Although modern art historians are more subtle than Courbet's early defenders and may write from an array of ideological viewpoints, their arguments inevitably converge upon a "revolutionary" Courbet who stands more or less at the threshhold of modernity: compare, for example, Rosenblum, *19th-Century Art*, pp. 241–43; Nochlin, *Realism*, pp. 46–48; and Clark, *Image of the People*, pp. 147–54.

64. See Clark, *Image of the People*, pp. 86–95 for a discussion of how the political battle for control of the countryside shaped the debate about rural imagery during 1849–50. Also see Clark's analysis of how that imagery was connected to socialism during 1850–51 (pp. 133–36), the ambiguities of this connection (pp. 140–47), and his account of contemporary attempts to read Millet politically (*The Absolute Bourgeois*, pp. 94–98).

65. Courbet's early Romanticism is outlined in Clark, *Image of the People*, pp. 40–43. It is also manifest in such works as *The Desperate Man* of about 1843, *The Lovers* of 1844, or *The Violoncellist* shown at the 1848 Salon (reproduced and discussed in Paris, Grand Palais, *Gustave Courbet*, nos. 5, 11, and 16 respectively).

66. For a detailed discussion see Clark, *The Absolute Bourgeois*, pp. 31–71.

67. Ibid., p. 49.

68. Louis-Philippe, *Mémoires*, I, p. 333.

69. Hugo, *Les Misérables*, 4ᵉ partie, "l'Idylle Rue Plumet, III: Louis-Philippe," in *Oeuvres Complètes: Romans*, t. V, p. 14. A letter written on 8 July 1862 by the duc d'Aumale to General Le Flo noted with emotion the accuracy of Hugo's portrait: "These eloquent pages do a brilliant justice to the character of my father . . . some of the personality traits moved us to tears" (cited in Paris, Archives Nationales, *Louis-Philippe*, p. 14, n. 1).

70. "4ᵉ Visite du Roi," AC, 91G-I, 6 March 1834. "The King still wishes," wrote Nepveu, "that in the large galleries all the pictures, large or small, should be arranged somehow to be part of the woodwork. I am therefore going to carry out the King's orders, yet this task is, by its nature, essentially time-consuming and costly." See also Francastel, *La Création*, p. 40 on the consequences of adopting this form of installation.

Bibliography

The bibliography is arranged alphabetically by author (or place of origin if a catalogue reference) and does not contain archival documents, Salon reviews serialized over several issues of a periodical, or museum catalogues consulted while researching the locations of specific pictures. The archival material is referenced in the notes. Salon reviews are similarly cited, but they are also catalogued quite thoroughly (with a few exceptions) in Maurice Tourneux, *Salons et expositions d'art*. Almost all the museum catalogues can be found at the Bibliothèque d'Art et d'Archéologie (Fondation Doucet) in Paris.

Adhémar, Hélène. "*La Liberté sur les barricades* de Delacroix, étudiée d'après des documents inédits." *Gazette des Beaux-Arts*, 6ᵉ période, XLIII (février 1954), pp. 83–92.

Adhémar, Jean et Nicole Villa. "La Légende napoléonienne sous la Restauration: Estampes et objets. . . ." *Revue du Louvre*, XIXᵉ année, no. 3 (1969), pp. 179–85.

Ajaccio, Musée Fesch. *Napoléon et la famille Impériale*, exhibition catalogue. Paris: Réunion des Musées Nationaux, 1969.

Album du Salon de 1844. Paris: Challamel éditeur, 1844.

"Album: Concours d'esquisses pour le tableau représentant le serment du Roi des Français." *Revue de Paris*, XXI (1830), pp. 115–20.

Allison, John M. S. *Thiers and the French Monarchy*. 1926; rpt. Hamden, Conn.: Archon Books, 1968.

Almeras, Henri d'. *Charlotte Corday*. Paris: Librairie des "Annales Politiques et Littéraires," 1910.

Althusser, Louis. "Ideology and the State," in *Lenin and Philosophy and Other Essays*, trans. Ben Breuster. London: New Left Books, 1971.

Amans de Ch[avagneux]. *Examen du Salon de 1839*. Paris: Bureau intermédiaire des Journaux, 1839.

Angeville, Adolphe, comte d'. *La Vérité sur la question d'Orient et sur M. Thiers*. Paris: Delloye, 1841.

Ann Arbor, University of Michigan. *Reflections on an Era of Change: Art in France, 1774–1830*, exhibition catalogue. Ann Arbor: University Museum, 1975.

Annet, A. et H. Trianon. *Examen critique du Salon de 1833*. Paris: Delaunay, 1833.

Antal, Frederick. *Classicism and Romanticism.* New York: Harper and Row, 1973.

Antommarchi, Dr. Francesco. *Mémoires du docteur F. Antommarchi, ou les derniers momens de Napoléon,* 2 vols. Paris: Barrois, 1825.

Audot, Louis-Eustache. *Funérailles de l'empereur Napoléon.* Paris: Audot, 1841.

Aulanier, Christine. *Histoire du Palais et du Musée du Louvre,* 9 vols. Paris: Editions des Musées Nationaux, 1947–64.

Baden-Baden, Staatliche Kunsthalle. *Französische Bilderbogen de 19. Jahrhunderts,* exhibition catalogue. Baden-Baden: Staatliche Kunsthalle, 1972.

Bailly, Jean-Sylvain. *Mémoires d'un témoin de la Révolution,* 3 vols, Paris: Levrault, Schoell, An XII [1804].

Balabine, Victor de. *Paris de 1842–1852: La Cour, la société, les moeurs.* Paris: Emile-Paul, 1914.

Balzac, Honoré. *Le Médecin de campagne,* in *Oeuvres Complètes.* Paris: Furne, Dubochet, Hetzel, 1845. XIII, pp. 305–509.

Barbier, Alexandre. *Salon de 1836: Suite d'articles publiés dans le "Journal de Paris".* Paris: Paul Renouard, 1836.

Barrot, Odilon. *Mémoires posthumes,* 4 vols. Paris: Charpentier, 1875–76.

Barthes, Roland. *Elements of Semiology,* trans. Annette Lavers and Colin Smith. Boston: Beacon Press, 1970.

———. "Rhétorique de l'image." *Communications,* 4 (1964), pp. 40–51.

Baudelaire-Dufays, Charles. *Salon de 1845.* Paris: Jules Labitte, 1845.

Beik, Paul H. *Louis-Philippe and the July Monarchy.* New York: van Nostrand, 1965.

Benoît, François. *L'Art français sous la Révolution et l'Empire.* Paris: Société Française d'éditions d'art, 1897.

Béraldi, Henri. *Les Graveurs du XIXᵉ siècle,* 12 vols. Paris: Conquet, 1885–92.

Béranger, Pierre-Jean. *Chansons de Béranger,* 2 vols. Paris: Garnier, 1849.

———. *Derniers chansons de Béranger de 1834 à 1851.* Paris: Garnier, 1875.

Bérard, Simon. *Souvenirs historiques sur la révolution de 1830.* Paris: Perrotin, 1834.

Bertier de Sauvigny, Guillaume de. "La Conspiration des légitimistes et de la duchesse de Berry contre Louis-Philippe." *Etudes d'histoire moderne et contemporaine,* III (1950), pp. 1–125.

Bertier de Sauvigny, Guillaume de. *La Révolution de 1830 en France.* Paris: Colin, 1970.

Bessand-Massenet, Pierre. *Le 18 Brumaire.* Paris: Hachette, 1965.

Bessis, Henriette. "L'Inventaire d'après décès d'Eugène Delacroix." *Bulletin de la Société de l'Histoire de l'Art Français,* année 1969 (published 1971), pp. 199–222.

√ Bezucha, Robert J. *The Lyon Uprising of 1834: Social and Political Conflict in the Early July Monarchy.* Cambridge: Harvard University Press, 1974.

Blanc, Louis. *Histoire de la Révolution française,* 12 vols. Paris: Langlois et Leclercq, 1847–62.

———. *Révolution française: Histoire de Dix Ans,* nouvelle édition, 5 vols. Paris: Félix Alcan [1878].

———. "La Royauté en France." *Revue du Progrès politique, social et littéraire,* I, no. 4 (1 mars 1839), pp. 202–20.

Bluche, Frédéric. *Le Bonapartisme.* Paris: Nouvelles Editions Latines, 1980.

Boime, Albert. *The Academy and French Painting in the Nineteenth Century.* London: Phaidon, 1971.

———. "The Quasi-Open Competitions of the Quasi-Legitimate July Monarchy." *Arts Magazine,* 59, no. 8 (April 1985), pp. 94–105.

———. *Thomas Couture and the Eclectic Vision.* New Haven: Yale University Press, 1980.

Bonaparte, Louis-Napoléon. *Des Idées napoléoniennes.* Paris: Paulin, 1839.

———. *Reveries politiques,* in *Oeuvres de Napoléon III.* Paris: Henri Plon et Amyot, 1856. I, pp. 371–87.

Bonaparte, Napoléon. *Correspondance de Napoléon Ier*, 32 vols. Paris: Henri Plon et J. Dumaine, 1858–70.

———. *Mémoires pour servir à l'histoire de France en 1815*. Paris: Barrois, 1820.

Bordes, Philippe. "Jacques-Louis David's *Serment du Jeu de Paume*: Propaganda without a Cause?" *The Oxford Art Journal*, III, no. 2 (October 1980), pp. 19–25.

———. *Le Serment du Jeu de Paume de Jacques-Louis David*. Paris: Editions de la Réunion des musées nationaux, 1983.

Bory, Jean-Louis. *La Révolution de Juillet*. Paris: Gallimard, 1972.

Boudin, Amédée. *Histoire de Louis-Philippe*, 2 vols. Paris: Au bureau de la Publication, 1847.

Bourg-en-Bresse, Musée de l'Ain. *Le Style troubadour*, exhibition catalogue. Bourg-en-Bresse: Musée, 1971.

Bourgin, Georges. "La Crise ouvrière à Paris dans la seconde moitié de 1830." *Revue Historique*, CXCVIII (1947), pp. 203–14.

Bourguignon, Jean. *Napoléon Bonaparte*, 2 vols. Paris: Les Editions Nationales, 1936.

———. *Le Retour des Cendres*. Paris: Plon, 1941.

Boyer, F. "Le Sort sous la Restauration des tableaux à sujets napoléoniens." *Bulletin de la Société de l'Histoire de l'Art Français*, année 1966 (published 1967), pp. 271–81.

Bréhier, Emile. *The Nineteenth Century: Period of Systems, 1800–1850*, trans. Wade Baskin. Chicago: University of Chicago Press, 1968.

Brette, Armand. *Le Serment du Jeu de Paume*. Paris: Société de l'Histoire de la Révolution française, 1893.

Brière, Gaston. "L'Exposition au Luxembourg au profit des blessés de juillet 1830." *Bulletin de la Société de l'Histoire de l'Art Français* (1918–19), pp. 246–50.

———. "Notes sur les tableaux conservés au Musée du Val-de-Grâce." *Bulletin de la Société de l'Histoire de l'Art Français* (1918–19), pp. 34–48.

Brilliant, Richard. "Gesture and Rank in Roman Art," in *Memoirs of the Connecticut Academy of Arts and Sciences*, XIV. New Haven: Connecticut Academy of Arts and Sciences, 1963.

Broglie, Achille-Charles-Léonce Victor, duc de. *Souvenirs du feu duc de Broglie: 1785–1870*, 2e édition, 4 vols. Paris: Calmann Lévy, 1886–87.

Brookner, Anita. "An Assessment of Couture." *Burlington Magazine*, CXII, no. 932 (November 1980), pp. 768–71.

———. *Greuze: The Rise and Fall of an Eighteenth-Century Phenomenon*. London: Paul Elek, 1972.

———. *The Genius of the Future: Studies in French Art Criticism*. New York: Phaidon, 1971.

———. *Jacques-Louis David*. New York: Harper and Row, 1980.

Bry, Auguste. *Raffet et ses Oeuvres*. Paris: Baur, 1874.

Bryson, Norman. *Word and Image: French Painting of the Ancien Régime*. Cambridge: Cambridge University Press, 1981.

Buchez, P.-J.-B. et P.-C. Roux. *Histoire parlementaire de la Révolution française*, 2e édition, 2 vols. Paris: Hetzel, 1846.

Bullemont, A. de. *Catalogue raisonné des peintures, sculptures et objets d'art qui décoraient l'Hôtel-de-Ville de Paris avant sa déstruction*. Paris: Vve Morel, Août 1871.

Busch, Günter. *Eugène Delacroix: Die Freiheit auf den Barrikaden*, in *Werkmonographien zur bildenden Kunst, Reclams Universal-Bibliothek*, Nr. 52. Stuttgart: Philipp Reclam, 1960.

Buswell, Guy Thomas. *How People Look at Pictures*. Chicago: University of Chicago Press, 1935.

Cahuet, Abéric. *Napoléon délivré*. Paris: Emile-Paul, 1914.

Calemard de Lafayette, Charles. *Examen critique du Salon de 1843*. Paris: Bourgogne et Martinet, 1843.

Calmette, Joseph. *François Rude*. Paris: Floury, 1920.

Calvet-Sérullaz, Arlette. "A propos de l'exposition Baudelaire: L'Exposition du Bazar Bonne-Nouvelle de 1846 et le Salon de 1859." *Bulletin de la Société de l'Histoire de l'Art Français*, année 1969 (published 1971), pp. 123–34.

Castille, Hippolyte. *Les Hommes et les moeurs sous Louis-Philippe*. Paris: Hanneton, 1853.

Castillon du Perron, Marguerite. *Louis-Philippe et la Révolution française*, 2 vols. Paris: Perrin, 1963.

Challamel, Augustin. *L'Histoire-musée de la République française*. Paris: Challamel, 1842.

Challamel, Augustin et Wilhelm Tenint. *Les Français sous la Révolution*. Paris: Challamel, 1843.

Chalmin, P. "Les Crises dans l'armée française, 1830–1840," *Revue Historique de l'Armée* (1962), no. 2, pp. 65–82 and no. 4, pp. 46–62.

Charléty, S. *La Monarchie de Juillet*, in *Histoire de France contemporaine*, V. Paris: Hachette, 1921.

————. *La Restauration*, in *Histoire de France contemporaine*, IV. Paris: Hachette, 1921.

"Charlotte Corday." *Revue de Paris*, XXVI (1831), p. 72.

Chartres, Musée des Beaux-Arts. *Exigence de réalisme dans la peinture française entre 1830 et 1870*, exhibition catalogue. Chartres: Musée des Beaux-Arts, 1983.

————. *Notice des peintures, dessins, sculptures . . . que compose le musée de Chartres*, 3e édition. Chartres: Garnier, 1882.

Chassé, Charles. *Napoléon par les écrivains*. Paris: Hachette, 1921.

Chassin, C.-L. et L. Hennet. *Les Volontaires nationaux pendant la Révolution*, 3 vols. Paris: Quantin, 1899.

Chastenet, Jacques. *Une Époque de contestation: La Monarchie bourgeoise*. Paris: Perrin, 1976.

Chateaubriand, François-René, Vte de. *Mémoires d'Outre-Tombe*, 2 vols. Paris: Gallimard, 1951.

Chaudonneret, Marie-Claude. *Fleury-Richard et Pierre Révoil: La Peinture troubadour*. Paris: Arthena, 1980.

————. "Jeanron et 'l'art social': *Une Scène de Paris*." *Revue du Louvre et des Musées de France*, XXXVI, nos. 4–5 (Octobre 1986), pp. 317–19.

Chautard, J. et Th. Lejeune. *Description du tombeau de l'Empereur*. Paris: Ledoyen, 1853.

Chenier, André. *Oeuvres Posthumes*. Paris: Guillaume, 1826.

Chennevières, Philippe de. *Notice historique et descriptive sur la galerie d'Apollon au Louvre*. Paris: Pillet, 1851.

Clark, T. J. *The Absolute Bourgeois: Artists and Politics in France, 1848–1851*. Princeton: Princeton University Press, 1982.

————. *Image of the People: Gustave Courbet and the 1848 Revolution*. Princeton: Princeton University Press, 1982.

Clément de Ris, Louis. *Les Musées de province: Histoire et description*, 2e édition. Paris: Vve Renouard, 1872.

————. *Notice du musée historique de Versailles: Supplément*, 2e édition. Paris: de Mourgues, 1881.

Clermont-Ferrand, Musée Bargoin. *Thomas Degeorge (1786–1854)*, exhibition catalogue. Clermont-Ferrand: Siman, 1979.

Clough, Shephard Bancroft. *France: A Study of National Economics, 1789–1939*. New York: Charles Scribner's Sons, 1939.

Cobban, Alfred. "The Middle Class in France, 1815–1848," *French Historical Studies*, V (Spring 1967), pp. 39–52.

Collection de Vinck. See Paris, Bibliothèque Nationale, Département des Estampes.

Compiègne, Musée National du Château de Compiègne. *Louis-Philippe—Napoléon III*, exhibition catalogue. Paris: Musées Nationaux, 1928.

Constans, Claire. "A propos de l'exposition Louis-Philippe." *L'Information d'Histoire de l'Art*, XXe année, no. 5 (novembre-décembre 1975), pp. 234–40.

———. "Quelques tableaux commandés par Louis-Philippe pour Versailles." *Revue du Louvre et des Musées de France*, XXIIe année, no. 3 (mai-juin 1972), pp. 179–84.

———. "Le Style néo-gothique sous Louis-Philippe: Deux commandes officielles." *L'Information d'Histoire de l'Art*, XIXe année, no. 2 (mars-avril 1974), pp. 66–73.

———. *Musée national du Château de Versailles: Catalogue des Peintures*. Paris: Editions de la Réunion des musées nationaux, 1980.

Courbevoie, Musée Roybet-Fould. *Le Retour des Cendres*, exhibition catalogue. Courbevoie: Musée, 1963.

Cousin, Victor. *Fragments philosophiques*, 2e édition. Paris: Ladrange, 1833.

Coutan, Emile. *Rapport sur les événements de Paris pendant la dernière semaine de juillet 1830*. Genève: Bargezat, 1830.

Coville, A. *Les Premiers Valois et la Guerre de Cent Ans*, in *Histoire de France depuis les origines jusqu'à la Révolution*, IV. Paris: Hachette, 1902.

Crow, Thomas E. *Painters and Public Life in Eighteenth-Century Paris*. New Haven: Yale University Press, 1985.

Cubberly, Ray Ellsworth. *The Role of Fouché during the Hundred Days*. Madison: University of Wisconsin, Department of History, 1969.

Cuzin, J.-P. "Y a-t-il une peinture troubadour? Notes à propos d'une exposition récente." *L'Information d'Histoire de l'Art*, XIXe année, no. 2 (mars-avril 1974), pp. 74–81.

Dansette, Adrien. *Louis-Napoléon à la conquête du pouvoir*. Paris: Hachette, 1961.

———. *Napoléon: Pensées politiques et sociales*. Paris: Flammarion, 1969.

Daudet, Ernest. *Les Grandes Episodes de la Monarchie de Juillet: Le Procès des ministres*. Paris: Quantin, 1877.

Daumard, Adeline. *La Bourgeoisie parisienne de 1815 à 1848*. Rennes: Oberthur, 1963.

David-Roy, Mme Marguerite. "Fontaine: 'LeBrun' de Louis-Philippe." *Gazette des Beaux-Arts*, 6e période, LIX (mars 1962), pp. 165–72.

Dayot, Armand. *Charlet et son Oeuvre*. Paris: Librairies-Imprimeries Réunis, n.d.

———. *Journées révolutionnaires, 1830–1848*. Paris: Flammarion, 1897.

———. *Napoléon*. Paris: Flammarion, 1926.

———. *Napoléon raconté par l'image*. Paris: Hachette 1895.

———. *Les Vernets: Joseph—Carle—Horace*. Paris: Armand Magnier, 1898.

Debidour, Antonin. *Histoire des rapports de l'Eglise et de l'Etat en France de 1789 à 1870*. Paris: F. Alcan, 1898.

Debraux, Paul-Emile. *Les Barricades de 1830, scènes historiques*. Paris: Boullard, 1830.

Decamps, Alexandre. *Le Musée—Revue du Salon de 1834*. Paris: Abel Ledoux, 1834.

De Carné. L. "De la popularité de Napoléon." *Revue des Deux Mondes*, 4e série, XXII (1er juin 1840), pp. 857–69.

Dechamps, Jules. "Alphonse Karr et le retour des Cendres." *Revue des Etudes Napoléoniennes*, XVIIIe année, XXIX (juillet 1929), pp. 24–35.

———. *Sur la légende de Napoléon*, in *Bibliothèque de la Revue de littérature comparée*, LXXIII. Paris: Champion, 1931.

Delaborde, Henri. *Ingres: Sa vie, ses travaux, sa doctrine*. Paris: Plon, 1870.

De La Combe. *Charlet: Sa vie, ses lettres*. Paris: Paulin et Le Chevalier, 1856.

"De la critique et de ses effets sur les Arts." *Journal des Artistes et Amateurs*, VIIIe année, vol. I, no. 18 (5 mai 1834), pp. 301–07 and no. 19 (14 mai 1834), pp. 321–27.

Delacroix, Eugène. "Charlet." *Revue des Deux Mondes*, XXXIIe année, 2e période, XXXVII (1 janvier 1862), pp. 234–42.

———. *Correspondance générale*, publiée par André Joubin, 5 vols. Paris: Plon, 1935–38.

———. *Journal*, nouvelle édition, 3 vols. Paris: Plon, 1932.

———. *Lettres d'Eugène Delacroix* recueillies et publiées par M. Philippe Burty. Paris: Quantin, 1878.

———. *Oevures littéraires*. Paris: Bibliothèque Dionysienne, 1923.

———. "Peintres et Sculpteurs modernes, III: Gros." *Revue des Deux Mondes*, XVIIIᵉ année, n.s., XXIII (1ᵉʳ septembre 1848), pp. 649–73.

"De la royauté de 1830." *Revue de Paris*, XXI (décembre 1830), pp. 229–35 and XXII (janvier 1831), pp. 250–56.

De La Vaissière, Pascal. "La *Fédération des Français* peint par P.-A. de Machy: Essai d'ico-nographie de la fête de Juillet 1790." *Bulletin du Musée Carnavalet*, XXVIIIᵉ année, no. 2 (1975; published 1977), pp. 16–35.

Delteil, Löys. *Le Peintre-graveur illustré*, 32 vols. Paris: chez l'auteur, 1906–70.

Descaves, Lucien. *L'Humble Georgin: Imagier d'Epinal*. Paris: Firmin-Didot et Albin Michel, 1932.

Descotes, Maurice. *La Légende de Napoléon et les écrivains du XIXᵉ siècle*. Paris: Lettres Mod-ernes/Minard, 1967.

Dijon, Musée des Beaux-Arts. *See* Quarré, Pierre.

Dijon, Musée Magnin. *See* Magnin, Jean.

Dino, Dorothée de Courlande, duchesse de. *Chronique de 1831 à 1862*, 4 vols. Paris: Plon, Nourrit et Cie, 1909–10.

Diogène au Salon—Première Année—1846. Paris: Gustave Sandré, 1846.

Domaine de la Couronne, 7 vols. Paris: Pihau Delaforest, 1837.

Driskell, Michael Paul. "Eclecticism and Ideology in the July Monarchy: Jules-Claude Ziegler's Vision of Christianity at the Madeleine." *Arts Magazine*, LVI, no. 9 (May 1982), pp. 119–29.

———. "Icon and Narrative in the Art of Ingres." *Arts Magazine*, LVI, no. 4 (December 1981), pp. 100–07.

Drouin, Jean-Claude. "Les Utopies de droite au lendemain de la révolution de 1830," in *Romantisme et Politique: Colloque à l'Ecole Normale Supérieure de Saint-Cloud* (1966; published 1969), pp. 199–211.

Duchartre, Pierre and René Saulnier. *L'Imagerie Parisienne: L'Imagerie de la rue Saint-Jacques*. Paris: Gründ, 1944.

Dulaure, J.-A. *Esquisses historiques des principaux événemens de la Révolution française*, 5 vols. Paris: Baudouin, 1823–25.

Dumas, Alexandre. *Le Dernier Roi*, 8 vols. Paris: Souverain, 1852.

Duncan, Carol Greene. "The Persistence and Re-Emergence of the Rococo in French Romantic Painting." Ph.d. diss., Columbia University, 1969.

Dupuy, Trevor N. *The Battle of Austerlitz: Napoléon's Greatest Victory*. New York: Macmillan, 1968.

Durande, Amédée. *Joseph, Carle et Horace Vernet, correspondance et biographie*. Paris: Hetzel, 1864.

Egret, Jean. *The French Prerevolution, 1787–88*, trans. Wesley D. Camp. Chicago: University of Chicago Press, 1977.

Eisenstein, Elizabeth L. "The Evolution of the Jacobin Tradition in France, the Survival and Revival of the Ethos of 1793 under the Bourbon and Orléanist Regimes," Ph.D. diss., Radcliffe College, 1952.

"Exposition à Lyon du tableau de *Boissy-d'Anglas* peint par M. Court." *Journal des Artistes et Amateurs*, VIIIᵉ année, vol. I, no. 10 (9 mars 1834), pp. 161–62.

"Exposition du concours pour le tableau de la Chambre des Députés." *Revue de Paris*, XXIII (1831), pp. 138–40.

"Exposition pour le tableau de la Chambre des Députés: *Boissy-D'Anglas*." *Revue de Paris*, XXV (1831), pp. 198–200.

Eymery, Alexis [A. de Saintes, pseud.]. *Les Enfans de Paris, ou les petits patriotes*. Paris: Nepveu, 1831.

Fain, le baron Agathon-Jean-François. *Manuscrit de Mil Huit Cent Quatorze trouvé dans les voitures impériales prises à Waterloo*. Paris: Bossange, 1823.

F[arcy, Charles]. "Les Beaux-Arts sous Louis-Philippe." *Journal des Artistes et Amateurs*, V^e année, vol. II, no. 9 (28 août 1831), pp. 153–69.

———. "Nouveau tableau de M. Daguerre . . . le 28 juillet à l'Hôtel-de-Ville." *Journal des Artistes et Amateurs*, V^e année, vol. I, no. 5 (30 janvier 1831), pp. 81–82.

———. "Peinture-Diorama: Tombeau de Napoléon à l'île de Sainte-Hélène." *Journal des Artistes et Amateurs*, V^e année, vol. I, no. 16 (17 avril 1831), pp. 289–91.

Festy, Octave. *Le Mouvement ouvrier au début de la Monarchie de Juillet*. Paris: Cornély, 1908.

Fisher, H. A. L. *Bonapartism: Six Lectures Delivered in the University of London*. Oxford: Clarendon Press, 1908.

Flandrin, Louis. *Hippolyte Flandrin: Sa vie et son oeuvre*. Paris: Librairie Renouard—H. Laurens, 1902.

[Fontaine, Pierre]. *See Domaine de la Couronne*.

Fourcaud, L. de. *François Rude, ses oeuvres et son temps*. Paris: Librairie de l'art ancien et moderne, 1904.

Francastel, Pierre. *La Création du musée historique de Versailles et la transformation du palais, 1832–1848*. Paris: Les Presses modernes, 1930.

François, Achille. *Examen politique des quatre parties qui divisent la France, ou le carlisme, le bonapartisme, le républicanisme et le libéralisme*. Soissons: Barbier, 1830.

French, Sidney J. *Torch and Crucible: The Life and Death of Antoine Lavoisier*. Princeton: Princeton University Press, 1941.

Fried, Michael. *Absorption and Theatricality: Painting and Beholder in the Age of Diderot*. Berkeley: University of California Press, 1980.

———. "Thomas Couture and the Theatricalization of Action in 19th Century French Painting." *Artforum*, VIII, no. 10 (June 1970), pp. 36–46.

Fugier, André. *See Las Cases, Mémorial de Sainte-Hélène, introduction*.

Furet, François and Denis Richet. *The French Revolution*, trans. Stephen Hardman. New York: Macmillan, 1970.

Gaehtgens, Thomas W. "Antoine-Jean Gros' *Einnahme von Capri*." *Pantheon*, XXXV, no. 1 (Januar-März 1977), pp. 29–40.

———. *Versailles, de la résidence royale au musée historique: La Galerie des Batailles dans le musée historique de Louis-Philippe*. Antwerpen: Mercatorfonds, 1984.

———. "Versailles: Monument National," in Haskell, *Saloni, gallerie, musei e logo influenza sullo sviluppo dell'arte del secoli 19 e 20*, pp. 55–61.

Gaudibert, Pierre. "Delacroix et le romantisme révolutionnaire." *Europe*, XLI, no. 408 (avril 1963), pp. 4–21.

Gautier, Théophile. "Salon de 1842." *Le Cabinet de l'amateur et de l'antiquaire*, I (1842), pp. 119–28.

———. *Salon de 1847*. Paris: Hetzel, Warnod et Cie, 1847.

Gavard, Charles, ed. *Galeries historiques de Versailles*, 13 vols. Paris: Gavard, 1838–45.

———. *Histoire de France servant de texte explicatif aux tableaux des galeries de Versailles*, 4 vols. Paris: Gavard, 1838–41.

Gérard, François. *Correspondance de François Gérard, peintre d'histoire*, publiée par M. Henri Gérard, son neveu, et précédée d'une Notice sur la vie et les oeuvres de Gérard par M. Adolphe Viollet-le-Duc. Paris: Lainé et Havard, 1867.

Giacomelli, H. *Raffet: Son oeuvre lithographique et ses eaux-fortes.* Paris: Bureau de la Gazette des Beaux-Arts, 1862.

Ginoux, Charles. *Musée-Bibliothèque de Toulon: Notice des tableaux, des sculptures et autres objets d'art dans les galeries.* Toulon: Roman Liautaud, 1900.

Girard, André. *Le Coq: Personnage de l'histoire.* Lyon: Lescuyer, 1976.

Girard, Louis. *La Garde nationale, 1814–1871.* Paris: Plon, 1964.

Gisquet, Henri. *Mémoires d'un préfet de police,* 4 vols. Paris: Marchant, 1840.

Godechot, Jacques. *The Counter-Revolution: Doctrine and Action, 1789–1804,* trans. Salvator Attanasio. London: Routledge and Kegan Paul, 1972.

———. *The Taking of the Bastille,* trans. Jean Stewart. London: Faber and Faber, 1970.

Gonnard, Henri. *Catalogue des collections du musée de Saint-Etienne.* Vienne: Savigné, 1876.

Gonnard, Philippe. "La Légende napoléonienne et la presse libérale (1817–1820)." *Revue des Etudes Napoléoniennes,* I (mars 1912), pp. 235–58.

———. *Les Origines de la légende napoléonienne.* Paris: Lévy, 1906.

Gourgaud, général Gaspard. *Campagne de Dix-Huit Cent Quinze,* ou relation des opérations militaires qui ont eu lieu en France et en Belgique pendant les Cent Jours, écrite à Sainte-Hélène. Paris: Mongie, 1818.

Grand-Carteret, John. "La Légende napoléonienne par l'image." *Revue des Etudes Napoléoniennes,* XX (janvier-février 1923), pp. 28–46.

La Grande Semaine ou la guerre des trois jours. Paris: Normant, 1830.

Granet, Solange. "La Place de la Concorde." *La Revue Géographique et Industrielle de France,* numéro spécial (juillet 1963).

Grate, Pontus. "La Critique d'art et la bataille romantique." *Gazette des Beaux-Arts,* LIV (1959), pp. 129–48.

Gray, Musée Baron Martin. *See* Mirimonde, A.-P. de.

Gruber, Michael. *The English Revolution: A Concise History and Interpretation.* New York: Ardmore Press, 1967.

Guépin, Ange. *Essais historiques sur le progrès de la Ville de Nantes.* Nantes: Sebire, 1832.

———. *Histoire de Nantes,* 2ᵉ édition. Nantes: Sebire, 1839.

Guerre des trois jours. Paris: Gautier, 1830.

Guillaume, Germaine. "Merry-Joseph Blondel et son ami Ingres." *Bulletin de la Société de l'Histoire de l'Art Français* (1936), pp. 74–91.

Guillot, Arthur. "Exposition Annuelle des Beaux-Arts." *Revue Indépendante,* 2ᵉ série, VIII (1847), pp. 237–47; 380–88; 523–33.

Guizot, François. *Complément des mémoires de mon temps,* 5 vols. Paris: Michel Lévy, 1863.

———. *Etudes sur les Beaux-Arts en général.* Paris: Didier, 1852.

———. *Lettres de François Guizot et de la princesse de Lieven,* 3 vols. Paris: Mercure de France, 1963.

———. *Mémoires pour servir à l'histoire de mon temps,* 8 vols. Paris: Michel Lévy, 1858–67.

Guyot de Fère. "La Politique et le Salon du Louvre." *Journal des Artistes et Amateurs,* Vᵉ Année, vol. II, no. 6 (7 août 1831), pp. 106–07.

Hachette, Alfred. "Le Dossier de la journée du retour des Cendres (Archives Nationales F²¹ 741–742)." *Revue des Etudes Napoléoniennes,* XXIV (mai-juin 1925), pp. 239–80.

Hadjinicolaou, Nicos. "Art in a Period of Social Upheaval: French Art Criticism and Problems of Change in 1831." *The Oxford Art Journal,* 6, no. 2 (1984), pp. 29–37.

———. "L'Exigence du Réalisme au Salon de 1831." *Histoire et Critique des Arts,* nos. 4–5 (mai 1978), pp. 21–33.

———. *"La Liberté guidant le peuple* de Delacroix devant son premier public." *Actes de la Recherche en Sciences Sociales,* no. 28 (juin 1979), pp. 3–26.

————. "La Revanche de Charles X: *Juillet 1830* au Musée Carnavalet." *Histoire et Critique des Arts*, no. 11 (1979), pp. 63–75.

Halévy, Daniel. *Le Courrier de M. Thiers au Département des Manuscrits de la Bibliothèque Nationale*. Paris: Payot, 1921.

Hamburg, Kunsthalle. *Ossian und die Kunst um 1800*, exhibition catalogue. München: Prestal Verlag, 1974.

Hamilton, George Heard. "Delacroix's Memorial to Byron." *Burlington Magazine*, XCIV, no. 594 (September 1952), pp. 257–61.

————. "The Iconographical Origins of Delacroix's *Liberty Leading the People*," in *Studies in Art and Literature for Belle da Costa Greene*. Princeton: Princeton University Press, 1954, pp. 55–66.

Hampson, Norman. *A Social History of the French Revolution*. London: Routledge and Kegan Paul, 1970.

Harris, Ann Sutherland. "Women Artists and the Academies in the Eighteenth Century," in Los Angeles, Los Angeles County Museum, *Women Artists: 1550–1950*, pp. 36–44.

Haskell, Francis. "Art and the Language of Politics." *Journal of European Studies*, IV (1974), pp. 215–32.

————. *Saloni, gallerie, musei e loro influenza sullo sviluppo dell'arte del secoli 19 e 20*, in *Atti del XXIV Congresso C.I.H.A.*, 7 (1979) [Bologna: CLUEB, 1981].

————. "Un Monument et ses mystères: L'Art français et l'opinion anglaise dans la première moitié du XIXe." *Revue de l'Art*, no. 30 (1975), pp. 61–76.

Hatin, Eugène. *Bibliographie historique et critique de la presse périodique française*. Paris: Firmin-Didot, 1866.

Haucour, Louis d'. *L'Hôtel-de-Ville de Paris à travers les siècles*. Paris: Giard et Scière, 1900.

Haussonville, Joseph-Othénin-Bernard de Cléron, Cte d'. *Histoire de la politique extérieure du gouvernement français, 1830–1848*, 2 vols. Paris: Michel-Lévy, 1850.

Heine, Heinrich. "Gemäldeausstellung in Paris 1831," in *Heines Sämtliche Werke*. Leipzig: Insel-Verlag, 1912. VII, pp. 3–59.

————. "Ideen: Das Buch Le Grand (1826)," from *Reisebilder*, II in *Heines Sämtliche Werke*. Leipzig: Insel-Verlag, 1912. IV, pp. 133–213.

————. "Lutezia: Berichte über Politik, Kunst und Volksleben," in *Heines Sämtliche Werke*. Leipzig: Insel-Verlag, 1910. IX, pp. 1–355.

————. "Uber die französische Bühne," in *Heines Sämtliche Werke*. Leipzig: Insel-Verlag, 1913. VIII, pp. 37–126.

Hénard, Robert. "Les Trois Statues de la colonne." *Revue des Etudes Napoléoniennes*, I (mai 1912), pp. 349–72.

Herding, Klaus. "Davids *Marat* als 'dernier appel à l'unité révolutionnaire.'" *Idea*, II (1983), pp. 89–112.

Les Héroïnes parisiennes, ou actions glorieuses des dames, leurs traits d'esprit et d'humanité. Paris: Pinard, 1830.

Histoire authentique des glorieuses journées des 28 et 29 juillet 1830, rédigée d'après le récit de plusieurs témoins oculaires. Paris: Carpentier-Méricourt, 1830.

Histoire de la révolution de Paris depuis le 26 juillet jusqu'au 31 août 1830. Paris: Lébigre, 1830.

Historique de la révolution de 1830. Paris: Rosen, 1930.

Hodde, Lucien de la. *L'Histoire des sociétés sécrètes et du parti républicain de 1830 à 1848*. Paris: Julien, Lanier et Cie, 1850.

Hofmann, Werner, "Sur la *Liberté* de Delacroix." *Gazette des Beaux-Arts*, 6e période, LXXXVI (septembre 1975), pp. 61–70.

Holtman, Robert. *Napoleonic Propaganda*. Baton Rouge: Louisiana State University Press, 1950.

Hombron, M.H. *Catalogue des tableaux . . . du musée de la Ville de Brest*, 2ᵉ édition. Brest: Kaigre, 1895.

Honour, Hugh. "L'Image de Christophe Colomb." *Revue du Louvre et des Musées de France*, XXVIᵉ année, no. 4 (1976), pp. 255–67.

———. *Romanticism*. London: Allen Lane, 1979.

Horaist, Bruno. "Hippolyte Flandrin à Saint-Germain-des-Près." *Bulletin de la Société de l'Histoire de l'Art Français* (1979), pp. 211–32.

———. "Saint-Germain-des-Près (1839–1863)," in Paris, Musée du Luxembourg, *Hippolyte, August et Paul Flandrin*, pp. 125–32.

Houssaye, Henri. *1814*, 21ᵉ édition. Paris: Perrin, 1895.

———. *1815*, 21ᵉ édition, 3 vols. Paris: Perrin, 1895–1905.

Howard, Seymour. *A Classical Frieze by Jacques-Louis David*. Sacramento, Calif.: E. B. Crocker Art Gallery, 1975.

Howarth, Thomas E.B. *Citizen-King: The Life of Louis-Philippe*. London: Eyre and Spottiswoode, 1961.

Huart, Suzanne d'. "Louis-Philippe et Guizot d'après leur correspondance." *Bulletin de la Société de l'histoire de protestantisme français* (1976), pp. 159–69.

Huet, Paul. *Correspondance*. Paris: Renouard, 1911.

Hugo, Victor. "Les Chants du crépuscule," in *Oeuvres Complètes: Poésie*. Paris: Imprimerie Nationale, 1909. II, pp. 173–308.

———. *Choses vues*, 2 vols. in *Oeuvres Complètes*, VI¹⁻². Paris: Imprimerie Nationale, 1933.

———. *Les Misérables*, 6 vols. in *Oeuvres Complètes: Romans*, I–VI. Paris: Imprimerie Nationale, 1909.

———. "Les Orientales," in *Oeuvres Complètes: Poésie*. Paris: Imprimerie Nationale, 1912. I, pp. 611–755.

Inventaire du fonds français. *See* Paris, Bibliothèque Nationale, Département des Estampes.

Inventaire général des richesses d'art de la France: Province, monuments civils, 8 vols. Paris: Plon, Nourrit et Cie, 1878–1908.

Jacoubet, Henri. *Le Genre troubadour et les origines françaises du Romantisme*. Paris: Société d'Edition "Les Belles Lettres," 1929.

Jal, A. "Musée historique de Versailles." *Moniteur des Arts*, II (1845), pp. 89–91, 97–99, 105–07, 113–15.

———. *Salon de 1831: Ebauches critiques*. Paris: Denain, 1831.

———. *Salon de 1833*. Paris: Charles Gosselin, 1833.

Joannides, Paul. "Couture in Context?" *Art History*, IV, no. 3 (September 1981), pp. 332–34.

Johnson, Christopher. "The Revolution of 1830 in French Economic History," in Merriman, *1830 in France*, pp. 139–89.

Johnson, Lee. "Eugène Delacroix and Charles de Verninac: An Unpublished Portrait and New Letters." *Burlington Magazine*, CX, no. 786 (September 1968), pp. 511–18.

———. *The Paintings of Eugène Delacroix*, 2 vols. Oxford: Clarendon Press, 1981.

———. "Pierre Andrieu, un 'polisson'?" *Revue de l'Art*, no. 21 (1973), pp. 66–69.

Joinville, François, prince de. *Vieux souvenirs, 1818–1848*, 4ᵉ édition. Paris: Calmann Lévy, 1894.

de Joly, Jules. *Plans, coupes, élévations et détails de la restauration de la Chambre des Députés, de sa nouvelle salle des séances, de sa bibliothèque, suivis de la salle provisoire*. Paris: Adrien Le Clère, 1840.

Jones, William T. *The Romantic Syndrome*, 2d edition. The Hague: Martinus Nijhoff, 1973.

de Jouy, Etienne et Antoine Jay. *Salon d'Horace Vernet*. Paris: Ponthieu, 1822.

Karr, Alphonse. *Les Guêpes illustrées (mars)*. Paris: Hetzel, Warnod et Cie, 1847.

Kaufmann, Ruth. "François Gérard's *Entry of Henry IV into Paris*: The Iconography of Constitutional Monarchy." *Burlington Magazine*, CXVII, no. 873 (December 1975), pp. 790–802.

Kaufmann, Walter. *Nietzsche*, 4th edition. Princeton: Princeton University Press, 1974.

Kemp, W. "Der Obelisk auf der Place de la Concorde." *Kritische Berichte*, VII, no. 2–3 (1979), pp. 18–29.

Kolb, Marthe. *Ary Scheffer et son temps, 1795–1858*. Paris: Boivin, 1937.

Lacambre, Geneviève et Jean Lacambre. "A propos de l'exposition Baudelaire: Les Salons de 1845 et 1846." *Bulletin de la Société de l'Histoire de l'Art Français*, année 1969 (published 1971), pp. 107–21.

———. "La Politique d'acquisition sous la Restauration: Les Tableaux d'histoire." *Bulletin de la Société de l'Histoire de l'Art Français*, année 1972 (published 1973), pp. 331–44.

Lacroix, Paul. "Salon de 1845." *Bulletin de l'Alliance des Arts*, III, no. 22 (10 mai 1845), pp. 337–39.

Laffitte, Jacques. *Mémoires de Laffitte*. Paris: Firmin-Didot, 1932.

Lagrange, Léon. "Artistes contemporains: Horace Vernet." *Gazette des Beaux-Arts*, 2e série, V (1863), pp. 297–327, 439–65.

Laity, Armand. *Relation historique des événements du 30 octobre 1836, le prince Napoléon à Strasbourg*. Paris: Thomassin, 1838.

Lamartine, Alphonse de. *Correspondance de Lamartine, publiée par Mme Valentine de Lamartine*, 6 vols. Paris: Hachette, 1876.

———. *Histoire de la Restauration*, 8 vols. Paris: Pagnerre—Lecon—Furne, 1851–52.

———. *Histoire des Girondins*, 8 vols. Paris: Furne, Coquebert, 1847.

[Lamothe-Langon, baron Etienne]. *Une Semaine de l'histoire de Paris, par M. le baron L***-L****. Paris: Mame et Delaunay-Vallée, 1830.

Landon, C. P. *Annales du Musée: Salon de 1810*. Paris: Chaignieau, 1810.

———. *Annales du Musée: Salon de 1817*. Paris: Chaignieau, 1817.

Langlé, Ferdinand [Joseph-Adolphe-Ferdinand Langlois, pseud.]. *Funérailles de l'Empereur Napoléon*, relation officielle de la translation de ses restes . . . et description du convoi funèbre. Paris: Curmer, 1840.

Lankheit, Klaus. *Der Tod Marat*, in *Werkmonographien zur bildenden Kunst, Reclams Universal-Bibliothek*, Nr. 74. Stuttgart: Reclams, 1962.

Lapauze, Henri. *Ingres: Sa vie et son oeuvre*. Paris: Georges Petit, 1911.

Las Cases, Emmanuel de. *Le Mémorial de Sainte-Hélène* présenté par André Fugier, 2 vols. Paris: Garnier, 1961.

Laumann, E.-M. *L'Epopée napoléonienne: Le Retour des Cendres*, 2e édition. Paris: Daragon, 1904.

Laurent-Jan. *Salon de 1839*. Paris: Bureau du Charivari, 1839.

Laurent de l'Ardèche, Paul-Mathieu. *Histoire de l'Empereur Napoléon*, illustrée par H. Vernet. Paris: Dubochet, 1840.

Lavalette, Antoine-Marc. *Mémoires et souvenirs du comte Lavalette*, 2 vols. Londres: Edward Bull, 1831.

Laviron, Gabriel. *Le Salon de 1834*. Paris: Louis Janet, 1834.

Laviron, G. et B. Galbaccio. *Le Salon de 1833*. Paris: Abel Ledoux, 1833.

Lee, Rensselaer W. "*Ut Pictura Poesis*: The Humanist Theory of Painting." *Art Bulletin*, XXII, no. 4 (December 1940), pp. 197–269.

Lee, Virginia. "Jacques-Louis David: The Versailles Sketchbook, Part I." *Burlington Magazine*, CXI, no. 793 (April 1969), pp. 197–208; "Part II." no. 795 (June 1969), pp. 360–69.

Lefebvre, Georges. *The Coming of the French Revolution*, trans. R. R. Palmer. Princeton: Princeton University Press, 1967.

———. *Napoleon*, trans. Henry Stockhold, 2 vols. New York: Columbia University Press, 1969.

————. *The French Revolution*, trans. Elizabeth Evanson, John Stewart, and James Friguglietti, 2 vols. New York: Columbia University Press, 1962–64. (Cited in the notes as Lefebvre, *Revolution.*)

————. *La Séance du 23 juin 1789*, in *Recueil des documents relatifs aux séances des Etats-Généraux*, vol. I². Paris: Editions du Centre National de Recherche Scientifique, 1962.

Lemoisne, Paul-André. *L'Oeuvre d'Eugène Lami*. Paris: Champion, 1914.

Lemonnier, Henry. *Les Guerres d'Italie, la France sous Charles VIII, Louis XII et François Iᵉʳ*, in *Histoire de France depuis les origines jusqu'à la Révolution*, V. Paris: Hachette, 1903.

Lenormant, Charles. *Les Artistes contemporains*, 2 vols. Paris: Alexandre Mesnier, 1833.

————. *Beaux-Arts et voyages*. Paris: Michel Lévy, 1861.

Lerminier. "Les Nouveaux Historiens de la Révolution française." *Revue des Deux Mondes*, n.s., XVIII (15 juin 1847), pp. 1048–70.

Lhomme, F. *Charlet*. Paris: Allison, [1892].

Lhomme, Jean. *La Grande Bourgeoisie au pouvoir*. Paris: Presses Universitaires de France, 1960.

La Liberté française reconquise ou la grande semaine du peuple. Paris: Caillot, 1830.

Lienhart, Dr. and René Humbert. *Les Uniformes de l'armée française depuis 1690 jusqu'à nos jours*. Leipzig: Ruhl, 1895–1906.

Lieven, Dorothée, princesse de. *See* Guizot, *Lettres*.

Locquin, Jean. *La Peinture d'histoire en France de 1774 à 1785*. 1912; rpt. Paris: Arthena, 1978.

London, Christie, Manson & Woods, Ltd. *Napoleon, Nelson and Their Time: The Calvin Bullock Collection*, sale catalogue for Wednesday 8 May 1985. London: Christie, Manson & Woods, Ltd., 1985.

London, Royal Academy and Victoria and Albert Museum. *The Age of Neo-Classicism*, exhibition catalogue. London: Arts Council of Great Britain, 1972.

London, The Wallace Collection. *Catalogues: Pictures and Drawings*, 16th edition, 2 vols. London: Trustees of the Collection, 1968.

Los Angeles, Los Angeles County Museum. *Women Artists: 1550–1950*, exhibition catalogue. Los Angeles: Museum Associates of the L.A. County Museum, 1976.

Louis-Philippe Iᵉʳ, *Roi des Français*. *See* Orléans, Louis-Philippe d'.

Louvet de Couvray, Jean-Baptiste. *Mémoires de Louvet de Couvray*. Paris: Baudouin, 1823.

Lucas-Dubreton, Jean. *Le Culte de Napoléon, 1815–1848*. Paris: A. Michel, 1959.

————. *La Grande Peur de 1832: La Choléra et l'émeute*. Paris: Gallimard, 1932.

————. *Louis-Philippe*, 10ᵉ édition. Paris: Fayard, 1938.

————. *La Manière forte: Casimir Périer et la révolution de 1830*. Paris: Bernard Grasset, 1929.

————. *La Royauté bourgeoise, 1830*. Paris: Hachette, 1930.

Lüdecke, Heinz. *Eugène Delacroix und die Pariser Julirevolution*. Berlin: Dt. Akad. Künste, 1965.

Lux, Adam. *Charlotte Corday*. Paris: n.p. [1793].

————. *Deux mémoires pour servir à l'histoire de la Révolution française*, publiées par G. Wedekind. Réimprimées à Strasbourg: G.-F. Pfeiffer, An III [1794].

MacKenzie, Norman. *The Escape from Elba*. New York: Oxford University Press, 1982.

Madelin, Louis. *Fouché, 1759–1820*, 2 vols. Paris: Plon, Nourrit et Cie, 1903.

Magnin, Jean. *Musée Magnin: Peintures et dessins de l'école française*. Dijon: Jobard, 1938.

Maisons, Château Laffitte. *Jacques Laffitte et la révolution de 1830*, exhibition catalogue. Paris: Musées Nationaux, 1930.

Maitland, Sir Frederick Lewis. *Relation du capitaine Maitland, ex-commandant du "Bellerophon," concernant l'embarquement et le séjour de l'Empereur Napoléon à bord de ce vaisseau*, traduit de l'anglaise par J.-T. Parisot. Paris: Baudouin, 1826.

Mantz, Paul. *Salon de 1847*. Paris: Ferdinand Sartorius, 1847.

Marchand, Jean. *Le Palais-Bourbon*. Paris: Baudry, 1975.

Marmont, Auguste de, duc de Raguse. *Mémoires du maréchal Marmont, duc de Raguse*, 9 vols. Paris: Hallé, 1857.

Marrinan, Michael. "Images and Ideas of Charlotte Corday: Texts and Contexts of an Assassination." *Arts Magazine*, LIV, no. 8 (April 1980), pp. 158–76.

———. "Nineteenth Century Art." *Art in America*, 72, no. 6 (Summer 1984), pp. 29–31.

———. "Resistance, Revolution and the July Monarchy: Images to Inspire the Chamber of Deputies." *The Oxford Art Journal*, III, no. 2 (October 1980), pp. 26–37.

Matilsky, Barbara. "Sublime Landscape Paintings in 19th Century France: Alpine and Arctic Iconography and their Relationship to Natural History." Ph.D. diss., New York University, 1983.

Maumené, Charles et L. d'Harcourt. *Iconographie des Rois de France*, 2 vols. Paris: Colin, 1928–31.

Maury, membre du bureau de charité du 20ᵉ arrondissement. *Evènemens [sic] du 29 juillet 1830 dans une partie de la rue de Richelieu*. n.p., n.d. (B.N., Imprimés, côte 8°Lb⁴⁹.1663).

Mazas, Alexandre. *La Légion d'honneur*. Paris: Dentu, 1854.

Meisel, Martin. *Realizations: Narrative, Pictorial, and Theatrical Arts in Nineteenth-Century England*. Princeton: Princeton University Press, 1983.

Meister, Maureen. "To All the Glories of France: The Versailles of Louis-Philippe," in Providence, Brown University, *All the Banners Wave*, pp. 21–26.

Mellon, Stanley. "The July Monarchy and the Napoleonic Myth." *Yale French Studies*, XXVI (Fall-Winter 1960), pp. 70–78.

———. *The Political Uses of History*. Stanford: Stanford University Press, 1958.

Meneval, baron Claude-François de. *Napoléon et Marie-Louise*. Paris: Amyot, 1845.

Ménière, Dr. Prosper. *L'Hôtel-Dieu de Paris en juillet et août 1830*. Paris: Barbier, 1830.

Merriman, John M., ed. *1830 in France*. New York: New Viewpoints, 1975.

Merruau, Paul. "Beaux-Arts: Salon de 1838." *Revue Universelle*, II (1838), pp. 246–59; 340–51; 488–98.

Mezzatesta, Michael. "Marcus Aurelius, Fray Antonio de Guevara, and the Ideal of the Perfect Prince in the Sixteenth Century." *Art Bulletin*, LXVI, no. 4 (December 1984), pp. 620–33.

Michelet, Jules. *Histoire de la Révolution française*, 7 vols. Paris: Chamerot, 1847–53.

———. *Le Peuple*, 2ᵉ édition. Paris: Hachette et Paulin, 1846.

Mirabeau, Gabriel-Honoré. *Mémoires biographiques, littéraires et politiques*. Paris: Delaunay, 1835.

Mirimonde, A.-P. de. *Catalogue du Musée Baron Martin à Gray*. Gray: Roux [1957].

Montalembert, Charles-Forbes-René, comte de. "Exposition de 1838." *Revue Française*, V (1838), pp. 315–33.

Montalivet, Marthe-Camille, comte de. *Fragments et souvenirs*, 2 vols. Paris: Calmann-Lévy, 1899–1900.

———. *Le Roi Louis-Philippe: Liste civile*. Paris: Michel Lévy, 1851.

Montauban, Musée Ingres. *Peintures: Ingres et son temps*, in *Inventaire de collections publiques*, XI. Paris: Editions des musées nationaux, 1965.

Montholon, Charles-Tristan, comte de, et général Gaspard Gourgaud. *Mémoires pour servir à l'histoire de France sous Napoléon, écrites à Sainte-Hélène*, 6 vols. Paris: Firmin-Didot, 1823–25.

Montpellier, Musée Fabre. *Catalogue des peintures . . . exposés dans les galeries du Musée Fabre*, 11ᵉ édition. Montpellier: Roumégons et Déhan, 1910.

Mosby, Dewey F. *Alexandre-Gabriel Decamps*, 2 vols. New York: Garland Press, 1977.

Moss, Bernard H. "Parisian Workers and the Origins of Republican Socialism, 1830–1833," in Merriman, *1830 in France*, pp. 203–21.

Moulin, Jean. "The Second Empire: Art and Society," in Philadelphia, Museum of Art, *The Second Empire, 1852–1870*, pp. 11–16.

Mras, George P. *Eugène Delacroix's Theory of Art*. Princeton: Princeton University Press, 1966.

Musset, Alfred de. "Salon de 1836." *Revue des Deux Mondes*, 4e série, VI (1836), pp. 144–76.

Nancy, Musée des Beaux-Arts. *Tableaux, dessins et objets d'art: Catalogue descriptif et annoté*. Nancy: Crépin-LeBlond, 1904.

Nantes, Palais Dobrée. *La Révolution à Nantes et la Vendée militaire*, exhibition catalogue. Paris: Presses artistiques, 1967.

Napoléon Ier, *Empereur des Français. See* Bonaparte, Napoléon.

Napoléon III, *Empereur des Français. See* Bonaparte, Louis-Napoléon.

Needham, H.-A. *Le Développement de l'esthéthique sociologique en France et en Angleterre au XIXe siècle*. Paris: Champion, 1926.

Nettement, Alfred. *Histoire de la littérature française sous le gouvernement de juillet*, 2e édition, 2 vols. Paris: Lecoffre, 1859.

Newman, Edgar Leon. "L'Image de la foule dans la Révolution de 1830." *Annales historiques de la Révolution française*, 52, no. 242 (1980), pp. 499–509.

———. "What the Crowd Wanted in the French Revolution of 1830," in Merriman, *1830 in France*, pp. 17–40.

New York, Metropolitan Museum of Art. *French Painting, 1774–1830: The Age of Revolution*, exhibition catalogue. New York: The Metropolitan Museum of Art, and Detroit: The Detroit Institute of Art, 1975. (Cited in the notes as New York: *The Age of Revolution*.)

New York, The Museum of Modern Art. *Before Photography: Painting and the Invention of Photography*. New York: The Museum of Modern Art, 1981.

Niox, Gustave Léon. *Napoléon et les Invalides*. Paris: Delagrave, 1911.

Nochlin, Linda. "Gustave Courbet's *Meeting*: A Portrait of the Artist as a Wandering Jew." *The Art Bulletin*, XLIX, no. 3 (September 1967), pp. 209–22.

———. *Realism*. Harmondsworth: Penguin, 1971.

———. "Women Artists after the French Revolution," in Los Angeles, Los Angeles County Museum, *Women Artists: 1550–1950*, pp. 45–50.

Norvins, M. de. *Histoire de Napoléon*, vignettes par Raffet. Paris: Furne, 1839.

Notice historique sur Louis-Philippe Ier, Roi des Français. Bar-le-Duc: Gigault d'Olincourt, 1830.

Nouvion, Victor de. *Histoire du règne de Louis-Philippe Ier, roi des français*, 2e édition, 4 vols. Paris: Didier, 1858–61.

———. "Salon de 1836." *La France littéraire*, XXIV (mars-avril 1836), pp. 277–320.

L'Observateur aux Salons [sic] de 1831. Paris: Gautier, 1831.

Oettermann, Stephan. *Das Panorama: Die Geschichte eines Massenmediums*. Frankfurt-am-Main: Syndikat Autoren-und Verlagsgesellschaft, 1980.

Olander, William. "'Pour Transmettre à la Postérité': French Painting and Revolution, 1774–1795." Ph.D. diss., New York University, 1983.

O'Meara, Barry Edward. *Napoléon en exil, ou l'écho de Sainte-Hélène*, traduit de l'anglais par Mme Fanny Collet, 2 vols. Paris: Les marchands de nouveautés, 1822.

Orléans, Ferdinand-Philippe, duc d'. *Lettres, 1825–1842*, 4e édition. Paris: Calmann Lévy, 1889.

Orléans, Louis-Philippe d'. *Mémoires, 1773–1793*, 2 vols. Paris: Plon, 1973.

———. *Mon journal: Evénements de 1815*, 2 vols. Paris: Michel Lévy, 1849.

———. *Pensées et opinions de Louis-Philippe sur les affaires de l'Etat*, 2e édition. Paris: Cotillon, 1850.

✓ "Palais et musée de Versailles." *L'Artiste*, XI (1836), pp. 177–78.

Paris, Archives Nationales. *Louis-Philippe: L'Homme et le roi*, exhibition catalogue. Paris: La documentation française, 1974.

Paris, Bibliothèque Nationale. *La Légende napoléonienne, 1796–1900*. Paris: Bibliothèque Nationale, 1969.

———. *La Révolution de 1848*. Paris: Dumoulin, 1948.

Paris, Bibliothèque Nationale, Département des Estampes. *Inventaire du fonds français après 1800*, 14 vols. Paris: Bibliothèque Nationale, 1939– .

———. *Un Siècle d'histoire de France par l'estampe, 1770–1871: Collection de Vinck*, 8 vols. Paris: Imprimerie Nationale, 1909–79.

Paris, Galerie Bonne Nouvelle. *Explication des ouvrages . . . exposés dans la Galerie Bonne Nouvelle*. Paris: n.p., 1846.

Paris, Grand Palais. *Gustave Courbet*, exhibition catalogue. Paris: Editions des musées nationaux, 1977.

———. *Le Musée du Luxembourg en 1874*, exhibition catalogue. Paris: Editions des musées nationaux, 1974.

———. *Napoléon*, exhibition catalogue. Paris: Editions des musées nationaux, 1969.

Paris, Hôtel Jean Charpentier. *Louis-Philippe*, exhibition catalogue. Paris: Jean Charpentier, 1926.

Paris, Luxembourg, Galerie du Palais. *Explication des ouvrages de peinture, sculpture, architecture et gravure, dessin et lithographie exposés dans la galerie de la Chambre des Pairs, au profit des blessés des 27, 28 et 29 juillet 1830*, 2ᵉ édition (avec cinq suppléments). Paris: Vinchon, 1831.

Paris, Musée des Arts Décoratifs. *Equivoques: Peintures françaises du XIXᵉ siècle*, exhibition catalogue. Paris: Union centrale des arts décoratifs, 1973.

Paris, Musée Carnavalet. *Juillet 1830*, exhibition catalogue. Alençon: Imprimerie Alençonnaise, 1980.

———. *La Révolution française dans l'histoire, dans la littérature, dans l'art*, exhibition catalogue. Paris: Musée Carnavalet, 1939.

Paris, Musée Colbert. *Explication des ouvrages de peinture, sculpture, architecture, et gravure exposés à la galerie du Musée Colbert le 6 mai 1832, par MM. les artistes, au profit des indigens des douze arrondissements de la Ville de Paris, atteints de la maladie épidémique*. Paris: Dezauche, 1832.

Paris, Musée du Luxembourg. *Hippolyte, Auguste et Paul Flandrin: Une Fraternité picturale au 19e siècle*, exhibition catalogue. Paris: Editions de la Réunion des musées nationaux, 1984.

Paris, Petit Palais. *Ingres*, exhibition catalogue. Paris: Réunion des musées nationaux, 1967.

Pariset, G. *La Révolution (1792–1799)*, in *Histoire de France contemporaine*, II. Paris: Hachette, 1920.

———. *Le Consulat et l'Empire*, in *Histoire de France contemporaine*, III. Paris: Hachette, 1921.

Pasquier, Etienne Denis, duc de. *Histoire de mon temps*; mémoires publiées par M. le duc d'Audiffret, 6 vols. Paris: Plon, Nourrit et Cie, 1894–96.

Peisse, Louis. "Le Salon: La Sculpture et la peinture française en 1844." *Revue des Deux Mondes*, XIVᵉ année, n.s., VI (15 avril 1844), pp. 338–65.

Philadelphia, Museum of Art. *The Second Empire, 1852–1870: Art in France under Napoleon III*, exhibition catalogue. Philadelphia: Philadelphia Museum of Art, 1978.

Picot, Georges. *Histoire des Etats-Généraux*, 2ᵉ édition, 5 vols. 1888; rpt. New York: Burt Franklin, 1969.

Pilbeam, Pamela. "The Emergence of Opposition to the Orléanist Monarchy: August 1830–April 1831." *English Historical Review*, LXXXV, no. 334 (1970), pp. 12–28.

Pillet, Fabien. "Beaux-Arts: Diorama." *Le Moniteur Universel*, no. 122 (Lundi 2 mai 1831), p. 912.

Pinkney, David H. "The Crowd in the French Revolution of 1830." *American Historical Review*, LXX, no. 1 (October 1964), pp. 1–17.

————. *The French Revolution of 1830*. Princeton: Princeton University Press, 1972. (Cited in the notes as Pinkney, *1830*.)

————. "Laissez-faire or Intervention? Labor Policy in the First Months of the July Monarchy." *French Historical Studies*, VIII (1963), pp. 123–28.

————. "The Myth of the French Revolution of 1830," in *A Festschrift for Frederick B. Artz*, David H. Pinkney and Theodore Ropp, eds. Durham, N.C.: Duke University Press, 1964.

Planat de la Faye, Nicolas-Louis. *Vie de Planat de la Faye: Souvenirs, lettres et dictées*, recueillis et annotés par sa veuve. Paris: Paul Ollendorff, 1895.

Planche, Gustave. *Etudes sur l'école française*. Paris: Michel Lévy, 1855.

————. *Salon de 1831*. Paris: Pinard, 1831.

————. "Salon de 1840." *Revue des Deux Mondes*, 4e série, XXII (1er avril 1840), pp. 100–21.

————. "Le Salon de 1847." *Revue des Deux Mondes*, XVIIe année, n.s., XVIII (1847), pp. 354–56, 538–53.

Préfecture du département de la Seine, Direction des travaux. *Inventaire général des oeuvres appartenant à la Ville de Paris: Edifices civils*, 2 vols. Paris: A. Chaix, 1878–89.

Promenade au Salon de 1844 et aux Galeries des Beaux-Arts. Paris: Desloges, 1844.

Providence, Brown University, Department of Art. *All the Banners Wave: Art and War in the Romantic Era, 1792–1851*, exhibition catalogue. Providence: Brown University, Department of Art, 1982.

Pupil, François. *Le Style Troubadour, ou la nostalgie du bon vieux temps*. Nancy: Presses Universitaires de Nancy, 1985.

Quarré, Pierre. *Le Musée de Dijon: Catalogue des peintures françaises*. Dijon: Palais des Etats de Bourgogne, 1968.

Raffet, Auguste. *Musée de la Révolution*. Paris: Perrotin, 1834.

Raisson, Horace Napoléon. *Histoire populaire de la révolution de 1830*. Paris: Jules Lefebvre, 1830.

Relation des événements de Paris depuis le 26 juillet jusqu'à ce jour. Paris, 1830.

Relation historique des journées mémorables des 27, 28, 29 juillet 1830, en l'honneur des Parisiens. Paris: Tastin, 1830.

Rémusat, Charles de. *Mémoires de ma vie*, 5 vols. Paris: Plon, 1958–67.

Le Reveil du peuple français. Paris: Au Cabinet littéraire, 1830.

La Révolution de 1830, ou Histoire des événemens qui ont lieu dans Paris les 27, 28, 29 et 30 juillet. Par un témoin oculaire. Paris: Poussin, 1830.

Riat, Georges. *Gustave Courbet, peintre*. Paris: Les maîtres de l'art moderne, 1906.

Richardson, Holly. "The Military Hero in the Romantic Imagination," in Providence, Brown University, *All the Banners Wave*, pp. 8–19.

Ringbom, Sixten. "Guérin, Delacroix and the *Liberty*." *Burlington Magazine*, CX, no. 782 (May 1968), pp. 270–274.

Rochette, Désiré-Raoul, *dit* Raoul-Rochette. "Du Concours en fait d'ouvrages d'art et de travaux publics." *Revue de Paris*, XX (1830), pp. 177–92 and XXI (1830), pp. 14–24.

Le Roi Louis-Philippe Ier et la grande semaine du peuple. Paris: C.-H. Baudouin, 1830.

Rome, Académie de France. *Horace Vernet*, exhibition catalogue. Rome: DeLuca, 1980.

Rosen, Charles and Henri Zerner. *Romanticism and Realism*. New York: Viking Press, 1984.

————. "The Unhappy Medium." *New York Review of Books*, XXIX, no. 9 (May 27, 1982), pp. 49–54.

Rosenblum, Robert. "Gavin Hamilton's *Brutus* and Its Aftermath." *Burlington Magazine*, CIII, no. 694 (January 1961), pp. 8–16.

———. *Modern Painting and the Northern Romantic Tradition: Friedrich to Rothko*. New York: Harper and Row, 1975.

———. "The *Origin of Painting*: A Problem in the Iconography of Romantic Classicism." *Art Bulletin*, XXXIX, no. 4 (December 1957), pp. 279–90.

———. "Painting during the Bourbon Restoration," in New York, *The Age of Revolution*, pp. 231–44.

———. "Painting Under Napoléon," in New York, *The Age of Revolution*, pp. 161–73.

———. *Transformations in Late Eighteenth Century Art*. Princeton: Princeton University Press, 1974.

Rosenblum, Robert and H. W. Janson. *19th-Century Art*. New York: Harry N. Abrams, 1984.

Rosenthal, Léon. *Du Romantisme au Réalisme: Essai sur l'évolution de la peinture en France de 1830 à 1848*. 1914; rpt. Paris: Macula, 1987. (Cited in the notes as Rosenthal.)

———. *La Peinture romantique: Essai sur l'évolution de la peinture française de 1815 à 1830*. Paris: Editions L.–Henry May, 1900.

Rousseau, Madeleine. "La Vie et l'oeuvre de Philippe-Auguste Jeanron, peintre, écrivain, directeur des musées nationaux, 1808–1877." Unpublished thesis, Paris: Ecole du Louvre, 1935.

Roussel, Jules. *Monographie des Palais et Parcs de Versailles et des Trianons*. Paris: Armand Guérinet.

Rozelaar, Louis A. "Le *Mémorial de Sainte-Hélène* et le Romantisme." *Revue des Études Napoléoniennes*, XVIIIe année, n.s., XXIX (Octobre 1929), pp. 203–26.

Rudé, George. *The Crowd in History: A Study of Popular Disturbances in France and England, 1730–1848*. New York: Wiley, 1964.

Rudrauf, Lucien. "Une Variation sur le thème du *Radeau de la Méduse*," in *Actes du deuxième congrès international d'Esthétique et des Sciences de l'Art*. Paris: Alcan, 1937. II, pp. 500–05.

Rule, James and Charles Tilly. "1830 and the Un-natural History of Revolution." *Journal of Social Issues*, XXVIII (1972), pp. 58–74.

———. "Political Process in Revolutionary France, 1830–32," in Merriman, *1830 in France*, pp. 139–89.

Saint-Etienne, Musée d'Art et d'Industrie. *See* Gonnard, Henri.

Saint-Hilaire, Emile-Marc. *Histoire populaire, anecdotique et pittoresque de Napoléon et de la Grande Armée*, illustrée par Jules David. Paris: Kugelmann, 1843.

Saint-Tropez, Musée de l'Annonciade. *Le Drapeau*, exhibition catalogue. Cogolin: Impr. de Cogolin, 1977.

Sarrans, Jean-Bernard. *Lafayette et la Révolution de 1830, histoire des choses et des hommes en juillet*, 2 vols. Paris: Thoisnier-Desplaces, 1830.

———. *Louis-Philippe et la contre-révolution de 1830*, 2 vols. Paris: Thoisnier-Desplaces, 1834.

Sauerländer, Willibald. "Davids *Marat à son dernier soupir* oder Malerei und Terreur." *Idea*, II (1983), pp. 49–88.

Sawyer, John. "The Return of the Emperor: Bonapartism in Art and Politics," in Providence, Brown University, *All the Banners Wave*, pp. 15–19.

[Sazérac, Hilaire L.]. *Lettres sur le Salon de 1834*. Paris: Delaunay, 1834.

Sazérac, Hilaire L. *Lettres sur le Salon de 1835*. Paris: chez l'auteur, 1835.

Schindler, Richard. "Raffet and the Role of the Military Print," in Providence, Brown University, *All the Banners Wave*, pp. 27–32.

Schapiro, Meyer. "Courbet and Popular Imagery: An Essay on Realism and Naiveté." *Journal of the Warburg and Courtauld Institutes*, IV (April–June 1941), pp. 164–91.

Schenk, H. G. *The Mind of the European Romantics*. Garden City, N.Y.: Doubleday, 1969.

Schnapper, Antoine. *David: Témoin de son temps*. Fribourg: Office du Livre, 1980.

————. "Painting during the Revolution," in New York, *The Age of Revolution*, pp. 101–17.

Ségur, Alexandre-Joseph-Pierre, Vte de. *Les Femmes, leur condition et leur influence dans l'ordre social*, 3 vols. Paris: Treuttel et Wurtz, An X–1803.

Sérullaz, Arlette et Maurice Sérullaz. "Dessins inédits de Delacroix pour la 'Liberté guidant le peuple.'" *Revue de l'Art*, no. 14 (1971), pp. 57–62.

Sérullaz, Maurice. *Mémorial de l'exposition Eugène Delacroix*, exhibition catalogue. Paris: Editions des musées nationaux, 1963.

Seward, Desmond. *The Bourbon Kings of France*. London: Constable, 1976.

Shroder, Maurice Z. *Icarus: The Image of the Artist in French Romanticism*. Cambridge: Harvard University Press, 1961.

Simches, Seymour O. *Le Romantisme et le goût esthétique du XVIIIe siècle*. Paris: Presses Universitaires de France, 1964.

Simond, Charles (pseud.). *See* Van Cleemputte, Paul A.

Sloane, Joseph C. *Paul Chenavard: Artist of 1848*. Chapel Hill: University of North Carolina Press, 1962.

Soule, Claude. *Les Etats-Généraux de France, 1302–1789: Etude historique, comparative et doctrinale*. Heule, Belgium: Editions administratives UGA, 1968.

Soulié, Eudore. *Notice du Musée Impérial de Versailles*, 2e édition, 3 vols. Paris: Charles de Mourgues, 1859–61.

————. *Notice des peintures et sculptures placées dans les appartements et dans les jardins des Palais de Trianon*. 1852; rpt. Paris: Charles de Mourgues, 1878.

Springfield, Museum of Fine Arts. *Enrollment of the Volunteers: Thomas Couture and the Painting of History*, exhibition catalogue. Springfield, Mass.: Springfield Library and Museum Association, 1980.

Starzinger, Vincent E. *Middlingness: Juste-Milieu Political Theory in France and England, 1815–1848*. Charlottesville: University Press of Virginia, 1965.

Stoeckl, Agnes de. *King of the French: A Portrait of Louis-Philippe*. New York: Putnam, 1957.

Suffel, Jacques. "Le Roi des barricades: Louis-Philippe, Guizot et Horace Vernet, lettres inédites," in "Mélanges d'art et littérature offerts à Julien Cain," *Humanisme Actif*, I (1968), pp. 369–74.

Tardieu, Ambroise. *Salon de 1831*. Paris: Pillet, 1831.

[Tardieu, Ambroise]. *Salon de 1833*. Paris: Pillet, 1833.

————. *Salon de 1834*. Paris: Pillet, 1834.

————. *Salon de 1835*. Paris: Pillet, 1835.

Tavernier, Bruno. "Iconographie des Trois Glorieuses." *Arts et Traditions Populaires*, XV, nos. 3–4 (juillet-décembre 1967), pp. 193–283.

Tenint, Wilhelm. *Album du Salon de 1841*. Paris: Challamel, 1841.

————. *Album du Salon de 1842*. Paris: Challamel, 1842.

Thibaudeau, A. C. *Le Consulat et l'Empire, ou histoire de la France et de Napoléon Bonaparte de 1799 à 1815*, 10 vols. Paris: Jules Renouard, 1834–35.

Thiers, Adolphe. *Histoire de la Révolution française*, 4e édition, 10 vols. Paris: Lecointe, 1834.

————. *Histoire du Consulat et l'Empire*, 20 vols. Paris: Lheureux et Cie libraires-éditeurs, 1845–1862.

Thirria, Hippolyte. *Napoléon III avant l'Empire*, 2 vols. Paris: Plon, Nourrit et Cie, 1895.

Thoré, T. *Le Salon de 1844*, précédé d'une lettre à Théodore Rousseau. Paris: Alliance des Arts, 1844.

————. *Le Salon de 1846*, précédé d'une lettre à George Sand. Paris: Alliance des Arts, 1846.

————. *Le Salon de 1847*. Paris: Alliance des Arts, 1847.

Thureau-Dangin, Paul. *Histoire de la Monarchie de Juillet*, 4ᵉ édition, 7 vols. Paris: Plon, Nourrit et Cie, 1905–09. (Cited in the notes as Thureau-Dangin.)

————. *Le Parti libéral sous la Restauration*. Paris: Plon, 1876.

Touchard, Jean. *La Gloire de Béranger*, 2 vols. Paris: Colin, 1968.

Toulon, Musée-Bibliothèque. *See* Ginoux, Charles.

Tourneux, Maurice. *Bibliographie de l'histoire de Paris pendant la Révolution française*, 5 vols. Paris: Imprimerie Nouvelle, 1890–1913.

————. *Salons et expositions d'art à Paris (1801–1870): Essai bibliographique*. Paris: Jean Schemit, 1919.

Toussaint, Gabriel. *Granet: Peintre provençal et franciscain*. Aix-en-Provence: Dragon et Makaire, 1927.

Toussaint, Hélène. La Liberté guidant le peuple *de Delacroix*, exhibition catalogue. Paris: Editions de la Réunion des musées nationaux, 1982.

Trapp, Frank Anderson. *The Attainment of Delacroix*. Baltimore: John Hopkins University Press, 1971.

Trevelyan, George Macaulay. *The English Revolution, 1688–89*. New York: Henry Holt, 1939.

Tripier le Franc, J. *Histoire de la vie et de la mort du baron Gros*. Paris: Jules Martin et J. Baur, 1880.

Tudesq, André-Jean. "L'Influence du romantisme sur le légitimisme sous la Monarchie de Juillet," in *Actes du colloque "Romantisme et Politique (1815–1851)" à l'Ecole Normale Supérieure de Saint-Cloud* (1966). Paris: Colin, 1969, pp. 26–36.

Tulard, Jean. *Le Mythe de Napoléon*. Paris: Colin, 1971.

————. *Napoléon ou le mythe du sauveur*. Paris: Fayard, 1977.

Vaines, Maurice de. "Salon de 1847." *La Revue Nouvelle*, IIIᵉ année, XIV (1847), pp. 15–36, 236–76.

Van Cleemputte, Paul A. *Paris de 1800 à 1900*, 2 vols. Paris: Plon, Nourrit et Cie, 1900.

Van der Kemp, Gérald. *Versailles et Trianon*. Paris: Editions d'Art Lys, 1975.

Vatel, Charles. *Charlotte Corday et les Girondins*, 3 vols. Paris: Henri Plon, 1864–72.

Vatout, Jean. *Catalogue historique et descriptif des tableaux appartenants à S.A.S. Mᵍʳ le duc d'Orléans*, 4 vols. Paris: Gaultier-Laguionie, 1823–26.

————. *Le Château d'Eu illustré, depuis son origine jusqu'au voyage de Sa Majesté Victoria*. Paris: Goupil et Vibert, Firmin-Didot, 1844.

————. *Galerie lithographiée de S.A.R. Mᵍʳ le duc d'Orléans*, 2 vols. Paris: Charles Motte, n.d.

————. *Histoire lithographiée du Palais-Royal*. Paris: Charles Motte, n.d.

————. *Souvenirs historiques des résidences royales de France*, 7 vols. Paris: Didot, 1837.

Vaudoyer, Jean-Louis et Paul Alfassa. "Les Salles de la Monarchie de Juillet au Musée de Versailles." *Revue de l'Art*, XXVIII (1910), pp. 49–66, 123–38.

Vaulabelle, Achille. *Histoire des deux Restaurations jusqu'à l'avènement de Louis-Philippe*, 4ᵉ édition, 8 vols. Paris: Perrotin, 1857–58.

Vergnaud, A.-D. *Examen du Salon de 1834*. Paris: Delaunay, 1834.

————. *Petit Pamphlet sur quelques tableaux du Salon de 1835*. Paris: Roret et Delaunay, 1835.

Vergnet-Ruiz, Jean. "Une Inspiration de Delacroix? La 'Jeanne Hachette' de Lebarbier." *Revue du Louvre et des Musées de France*, XXI, no. 2 (1971), pp. 81–85.

Vergnet-Ruiz et Michel Laclotte. *Petits et grands musées de France*. Paris: Editions cercle d'art, 1962.

Versailles, Musée national du Château de Versailles. *See also* Clément de Ris, Louis; Constans, Claire; Gavard, Charles; and Soulié, Eudore.

————. *Catalogue géneral des Galeries Historiques de Versailles par salles et par lettres alphabé-tiques.* Paris: Ch. Gavard, 1846.

————. *Galeries Historiques du Palais de Versailles.* Paris: Fain et Thunot, 1842.

————. *Nouveau Guide au Musée, Château, et Jardins de Versailles.* Versailles: Kléfer, 1848.

————. *Nouveau Guide au Musée, Château, et Jardins de Versailles.* Versailles: Kléfer, 1851.

Vidalenc, Jean. *Les Demi-solde, étude d'une catégorie sociale.* Paris: Rivière, 1955.

Vie anecdotique de Louis-Philippe d'Orléans, lieutenant-général du Royaume, par un grenadier de la Garde Nationale. Paris: Mansart, 1830.

Vie de Louis-Philippe Ier, roi des Français. Avignon: Pierre Chaillot, 1830.

Vie de Louis-Phillipe Ier, Roi des Français, par un vieux soldat de 1792. Paris: Au bureau de la Sentinelle du Peuple, 1831.

Vigier, Philippe. *La Monarchie de Juillet.* Paris: Presses Universitaires de France, 1962.

Viollet-le-Duc, Adolphe. *See* Gérard, *Correspondance*, introduction.

Weider, Ben and David Hapgood. *The Murder of Napoleon.* New York: Congdon and Lattès, 1982.

Weisberg, Gabriel P. *The Realist Tradition: French Painting and Drawing, 1830–1900*, exhibition catalogue. Cleveland: Cleveland Museum of Art, 1980.

Welschinger, Henri. *Le Roi de Rome.* Paris: Plon, Nourrit et Cie, 1897.

Wethey, Harold. *The Paintings of Titian*, 3 vols. London: Phaidon, 1969.

White, H. C. and C. A. White. *Canvases and Careers: Institutional Change in the French Painting World.* New York: Wiley, 1965.

Ziff, Norman. *Paul Delaroche: A Study in Nineteenth-Century French Painting.* New York: Garland, 1977.

Index

Illustrations

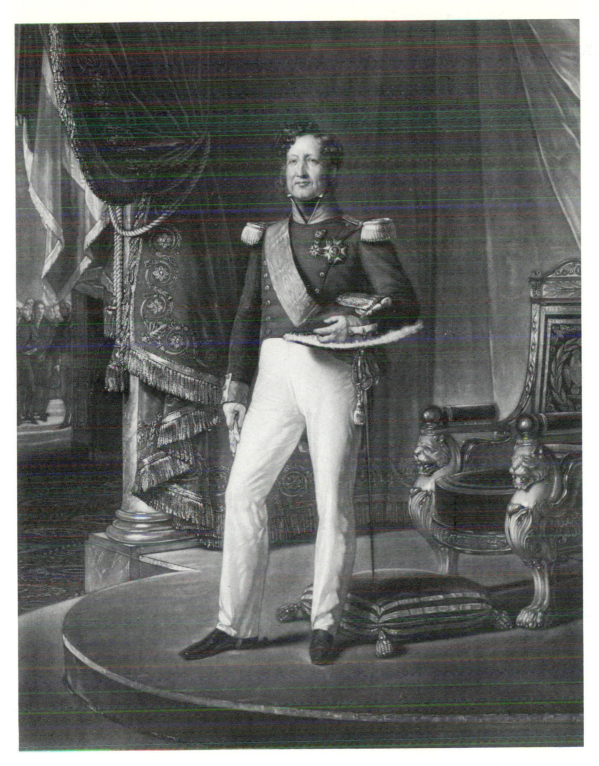

1. Louis Hersent (aquatint by François Girard): *Full-length Portrait of the King,* original exhibited at Salon of 1831. Paris, Bibliothèque Nationale, Cabinet des Estampes.

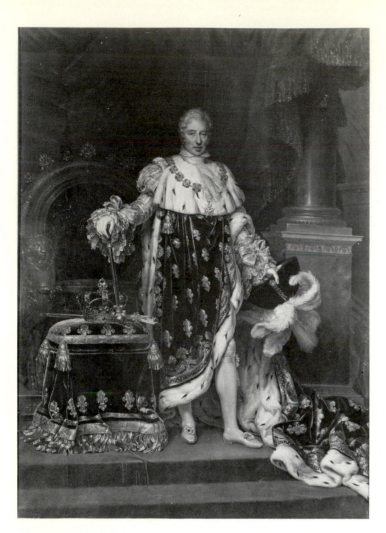

2. Paulin Jean-Baptiste Guérin (dit Paulin-Guérin): *Portrait of King Charles X*, Salon of 1827. Toulon, Musée d'Art et d'Archéologie.

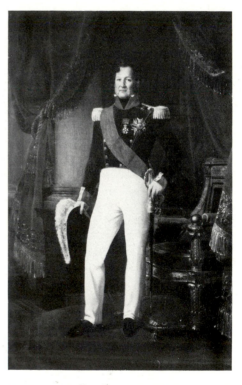

4. Nicolas Gosse: *Full-length Portrait of the King*, Salon of 1831. Saint-Denis de la Réunion, Musée Léon Dierx.

3. Antoine-François Callet: *Portrait of King Louis XVI*, Salon of 1789(?). Clermont-Ferrand, Musée Bargoin.

6. Eugène Lami: *Louis-Philippe on Horseback*, n.d. Paris, private collection.

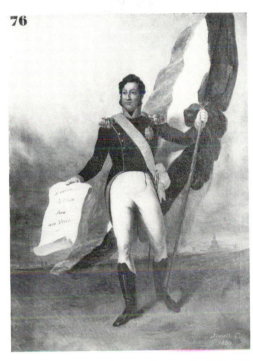

5. Francis Conscience: *Portrait of Louis-Philippe*, 1830. Besançon, Musée de Granville.

7. Ary Scheffer: *Equestrian Portrait of the King*, Salon of 1831. Versailles, Musée National du Château.

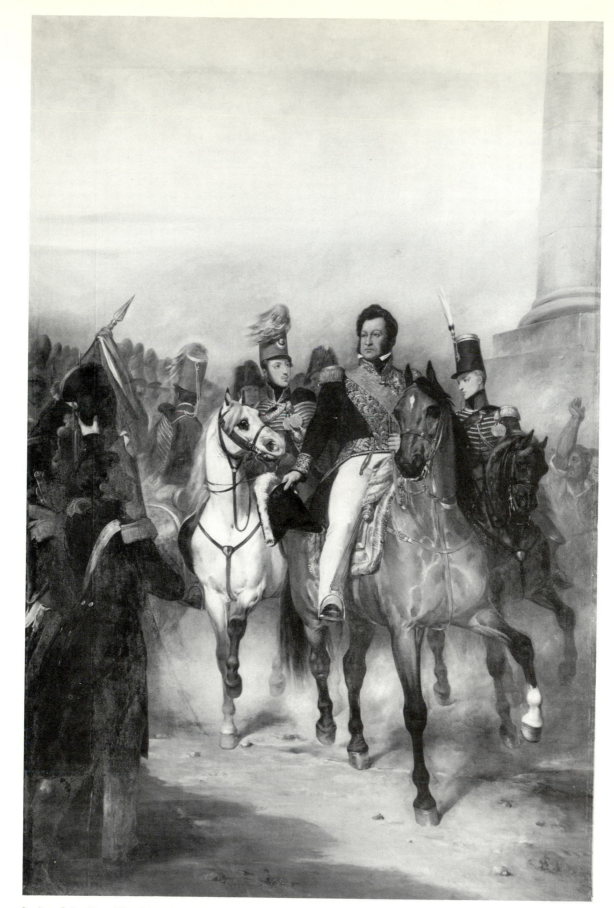

8. Ary Scheffer: *The Lieutenant-général of the Kingdom Welcomes at the Barrière du Trône the First Regiment of Hussars under the Command of the duc de Chartres, 4 August 1830*, 1835. Versailles, Musée National du Château.

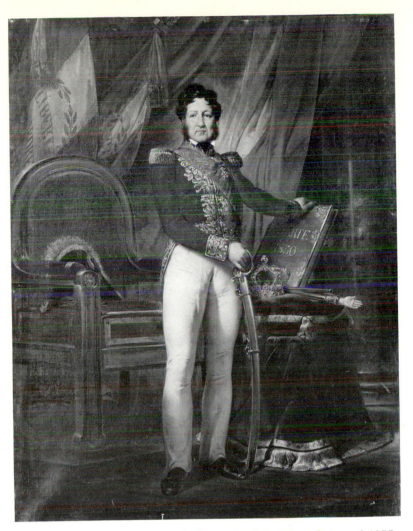

11. Horace Vernet: *Full-length Portrait of the King*, Salon of 1833. Versailles, Musée National du Château.

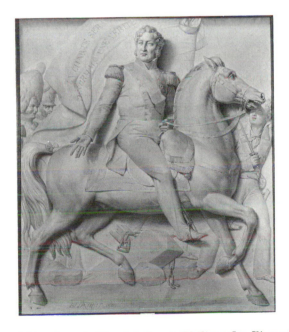

9. Méry-Joseph Blondel: *Louis-Philippe I^er, King of the French*, 1832. Versailles, Musée National du Château.

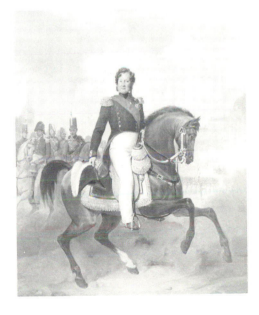

10. Nicolas Gosse: *The King at the Review of the National Guard, 29 August 1830*, 1831. Dreux, Musée d'Art et d'Histoire.

12. Auguste DeBay: *The King Encountering a Wounded Soldier, 6 June 1832*, Salon of 1835. Eu, Musée Louis-Philippe.

13. Charles Lafond: *Clemency of His Majesty the Emperor in Favor of Mlle de Saint-Simon, Who Requests a Pardon for Her Father*, Salon of 1810. Versailles, Musée National du Château.

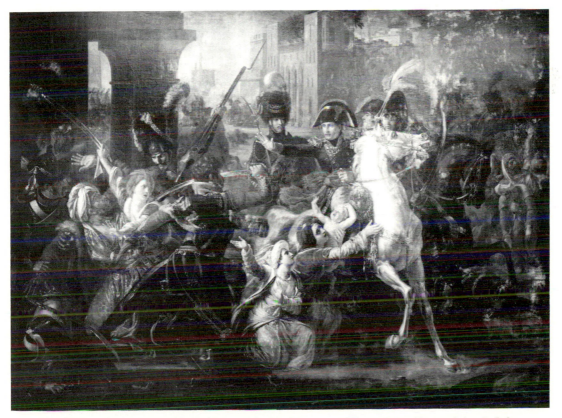

14. Guillaume-François Colson: *General Bonaparte's Entry into Alexandria, 3 July 1798; His Clemency in Favor of an Arab Family*, Salon of 1812. Versailles, Musée National du Château.

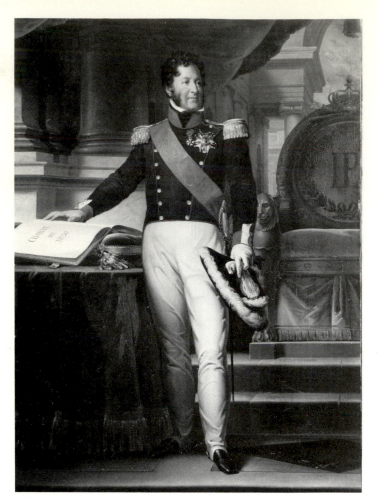

15. François Gérard: *Louis-Philippe I^er^, King of the French*, replica of original painted in 1833. Versailles, Musée National du Château.

16. François Winterhalter: *Full-length Portrait of the King*, Salon of 1839. Versailles, Musée National du Château.

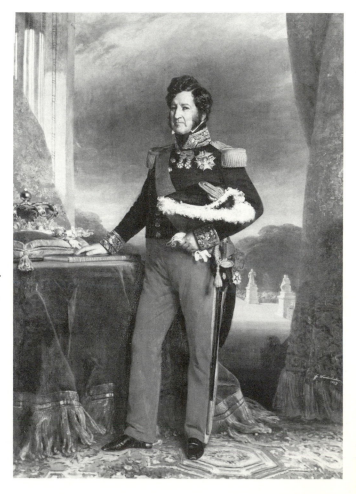

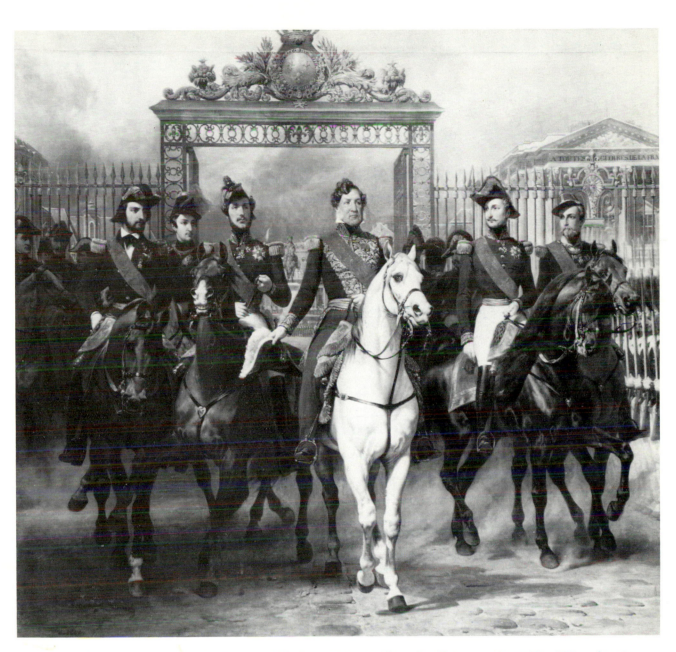

17. Horace Vernet: *Louis-Philippe and His Sons Riding Out from the Château of Versailles*, Salon of 1847. Versailles, Musée National du Château.

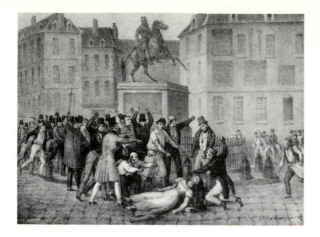

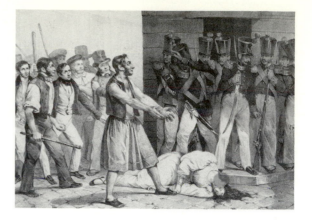

18. Edouard Swebach: *It's a Woman!*, 1830. Paris, Bibliothèque Nationale, Cabinet des Estampes.

19. Delaporte: *The 27th of July—The First Victim*, 1830. Paris, Bibliothèque Nationale, Cabinet des Estampes.

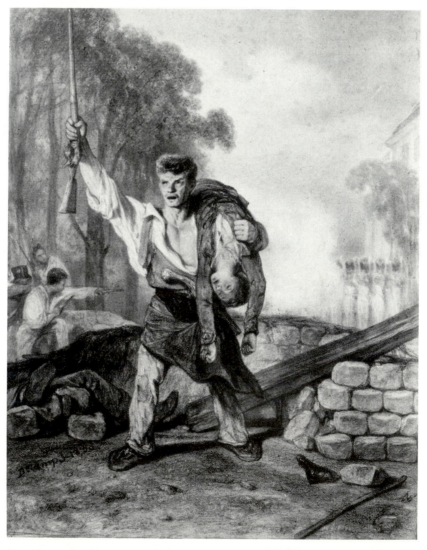

20. Alexandre Decamps: *An Episode from the 1830 Revolution*, 1830. Paris, Musée Victor Hugo.

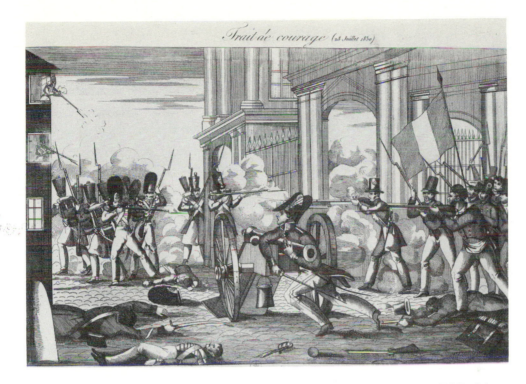

21. Anonymous engraving: *Act of Courage (28 July 1830)*, 1830. Paris, Bibliothèque Nationale, Cabinet des Estampes.

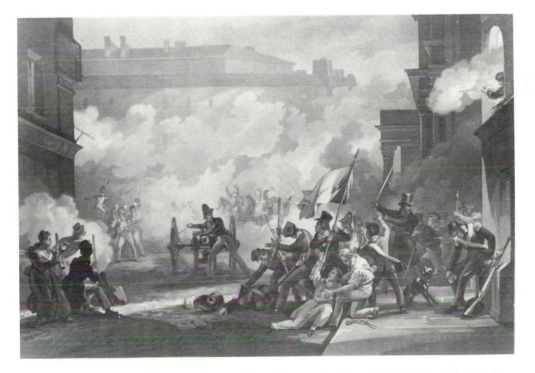

22. Pierre Martinet: *Capture of an Artillery Piece*, 1831. Paris, Bibliothèque Nationale, Cabinet des Estampes.

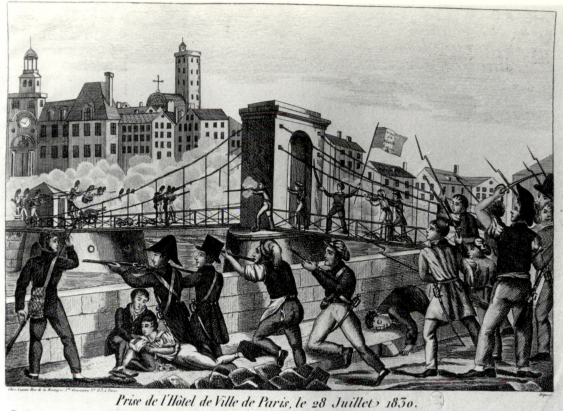

Prise de l'Hôtel de Ville de Paris, le 28 Juillet 1830.

Tandis que le peuple de Paris affrontait la mort sur la Place de l'Hôtel de Ville les habitans de la rive gauche de la Seine se portèrent au Pont de fer qui est vis à vis cette Place, et malgré la mitraille et les feux de peloton des gardes royales, ils firent une si forte resistance que jamais cette garde ne put s'en rendre maitre. C'est au milieu de ce carnage qu'un jeune homme qui portait un drapeau tricolore s'avance à dix pas de la garde royale, en disant à ses camarades: "Je vais vous montrer comment on sait mourir" si je meurs, souvenes vous que je me nomme DARCOLE, il tombe à l'instant même percé de plusieurs balles. Le Pont que Napoleon passa en italie se nommait Arcole d'où l'on dit le pont d'Arcole, Celui de l'Hôtel de Ville se nomme DARCOLE nom de celui qui se présenta avec le plus d'intrépidité sur le Pont.

23. Anonymous engraving: *Capture of the Hôtel-de-Ville of Paris, 28 July 1830*, 1830. Paris, Musée Carnavalet.

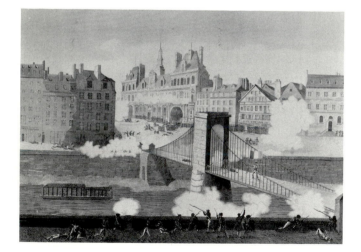

24. Anonymous engraving: *28 July 1830, Incident at the Place de la Grève*, c. 1830–31. Paris, Bibliothèque Nationale, Cabinet des Estampes.

25. Anonymous engraving: *The New Pont d'Arcole*, 1830. Paris, Bibliothèque Nationale, Cabinet des Estampes.

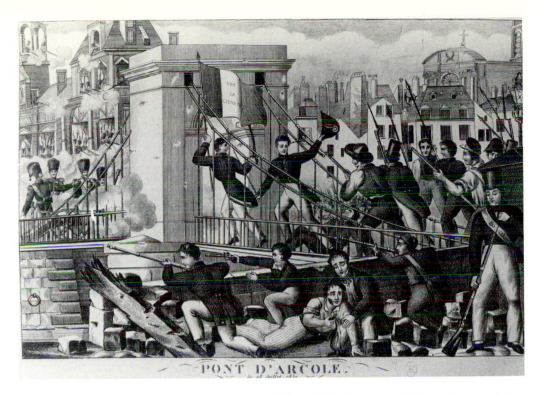

26. Anonymous engraving: *Pont d'Arcole, 28 July 1830*, 1830. Paris, Musée Carnavalet.

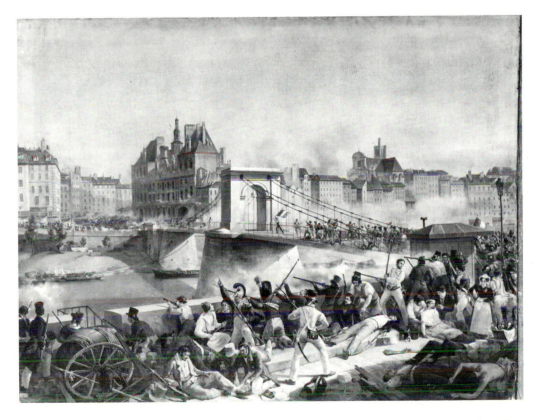

27. Amédée Bourgeois: *Capture of the Hôtel-de-Ville*, Salon of 1831. Versailles, Musée National du Château.

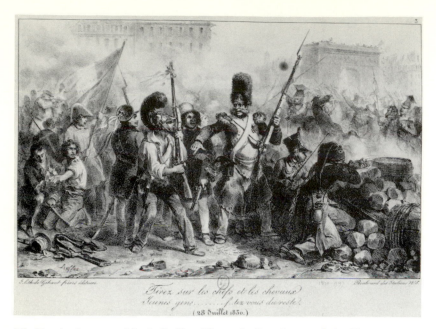

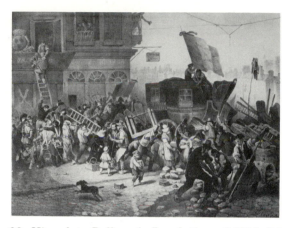

29. Denis-Auguste-Marie Raffet: *Shoot the Leaders and the Horses, Young Men . . . to Hell with the Rest*, 1830. Paris, Bibliothèque Nationale, Cabinet des Estampes.

28. Hippolyte Bellangé: *Revolution of 1830 (29 July): Forming Barricades*, 1830. Paris, Bibliothèque Nationale, Cabinet des Estampes.

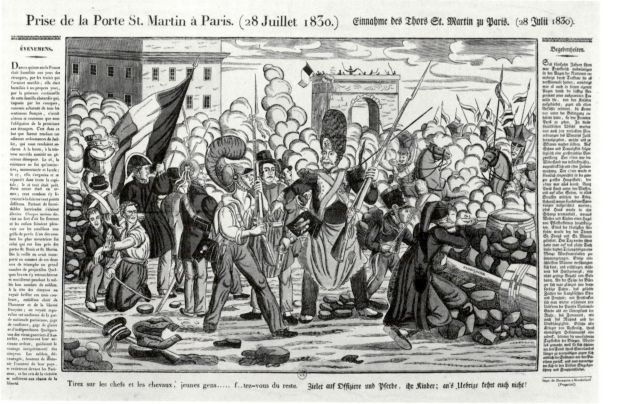

30. Anonymous colored woodblock print: *Capture of the Porte St. Martin in Paris (28 July 1830)*, 1831. Paris, Bibliothèque Nationale, Cabinet des Estampes.

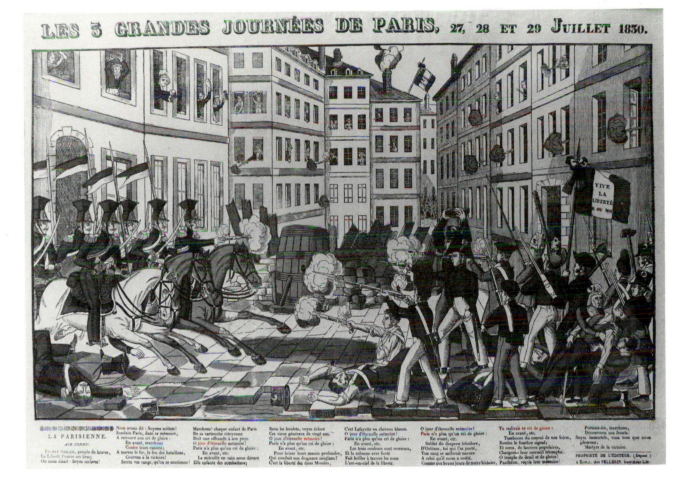

31. Epinal woodblock print by François Georgin: *The Three Glorious Days of Paris: 27, 28, and 29 July 1830*, 1830. Paris, Musée Carnavalet.

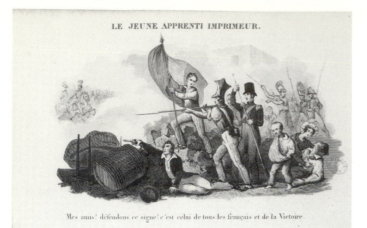

32. *The Young Printer's Apprentice*, illustration from Eymery, *Les Enfans de Paris*, 1831. Paris, Bibliothèque Nationale, Département des Imprimés.

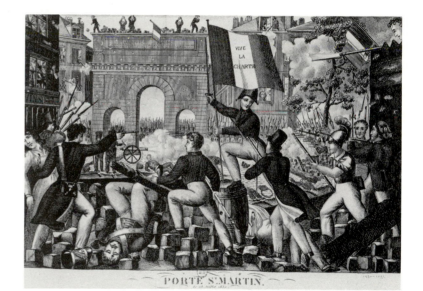

33. Anonymous engraving: *Porte St-Martin, 28 July 1830*, 1830. Paris, Bibliothèque Nationale, Cabinet des Estampes.

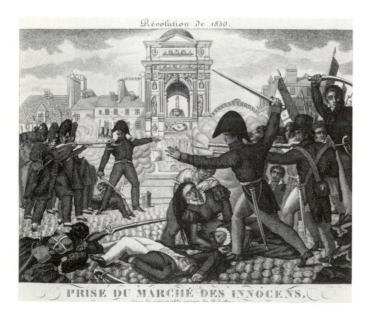

34. Anonymous engraving: *Capture of the Marché des Innocents during the Memorable Day of 28 July*, 1831. Paris, Bibliothèque Nationale, Cabinet des Estampes.

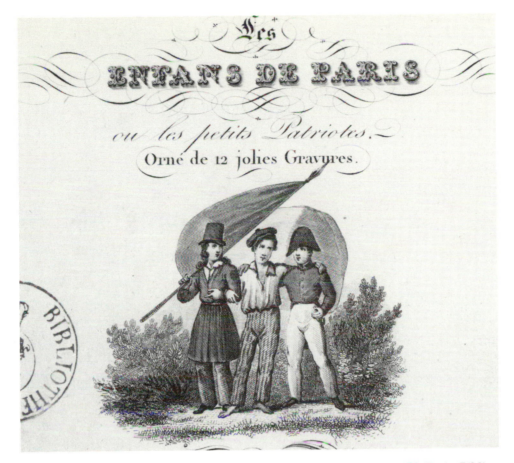

40. *Young Patriots*, illustration from Eymery, *Les Enfans de Paris*, 1831. Paris, Bibliothèque Nationale, Département des Imprimés.

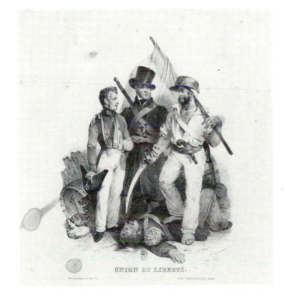

39. Julien(?): *Solidarity and Liberty*, 1830. Paris, Bibliothèque Nationale, Cabinet des Estampes.

41. Honoré Daumier: *The Kid's Right . . . Those Are the Guys Who Eat . . . (the Cake)*, 1830. Paris, Bibliothèque Nationale, Cabinet des Estampes.

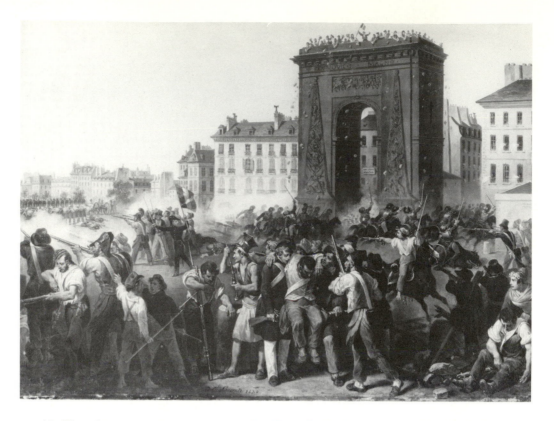

42. Hippolyte Lecomte: *Fighting at the Porte St-Denis*, Salon of 1831. Paris, Musée Carnavalet.

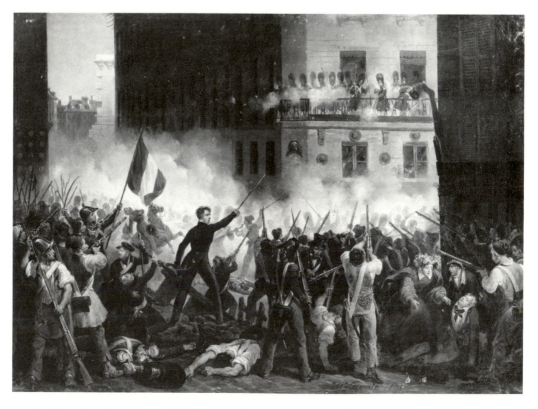

43. Hippolyte Lecomte: *Fighting in the rue de Rohan*, Salon of 1831. Paris, Musée Carnavalet.

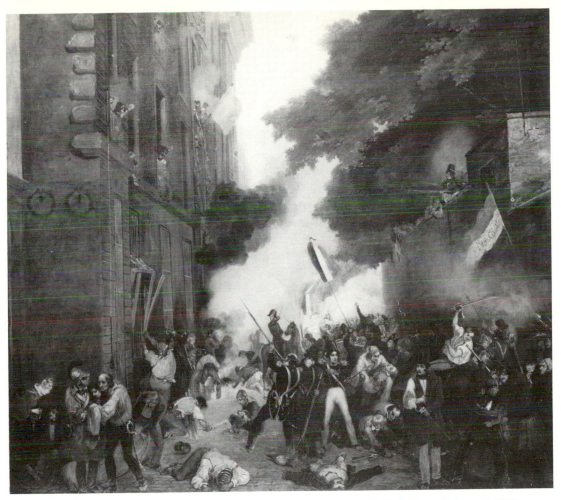

44. Jean-Abel Lordon: *Assault on the Barracks in the rue de Babylone*, Salon of 1831. Versailles, Musée National du Château.

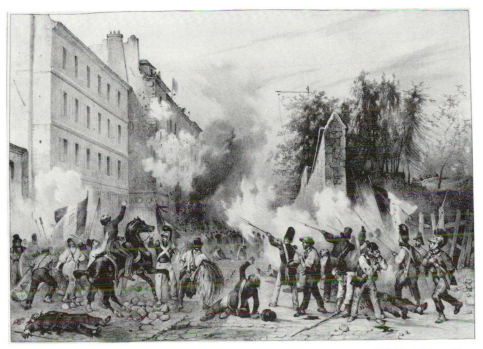

45. Victor Adam: *Capture of the Babylone Barracks*, 1830. Paris, Bibliothèque Nationale, Cabinet des Estampes.

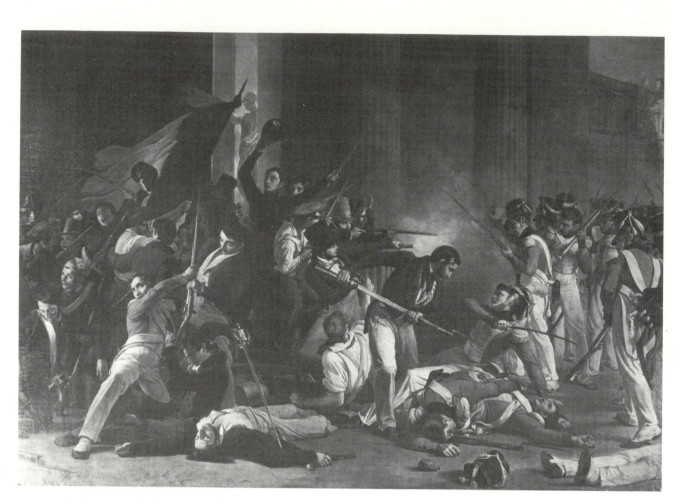

46. Jean-Louis Bézard: *An Episode near the Louvre during the 1830 Revolution*, Salon of 1833. Paris, Musée Carnavalet.

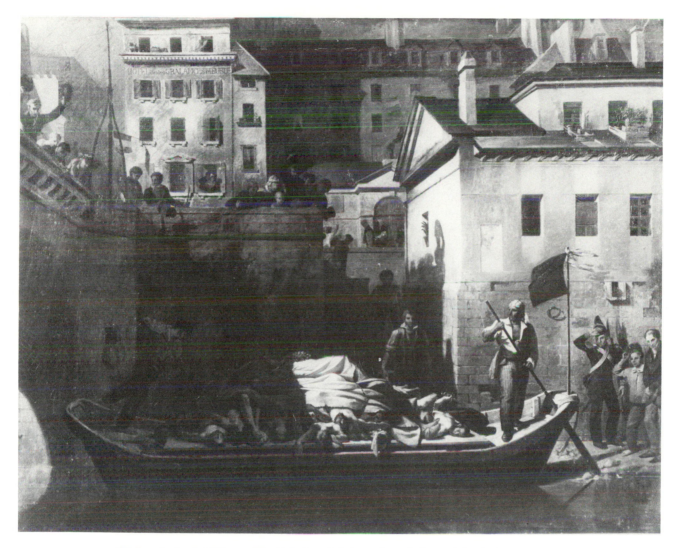

47. Louis-André Péron: *The July Dead*, Salon of 1835. Paris, Musée Carnavalet.

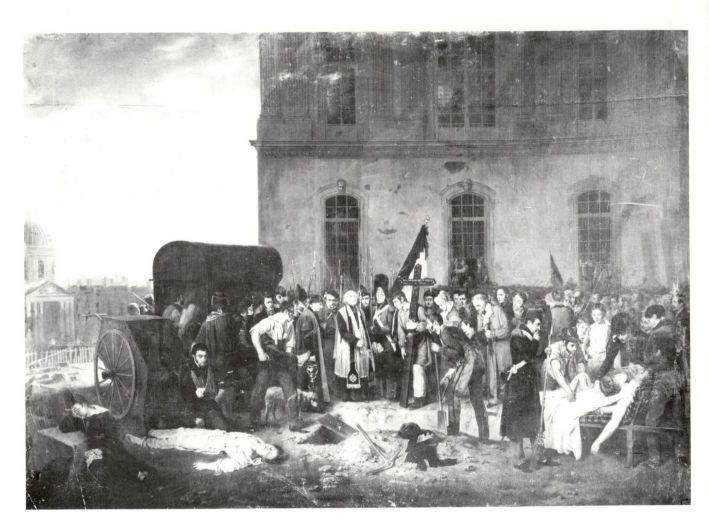

48. Jean-Alphonse Roehn: *The 30th of July*, Salon of 1831. Paris, Musée Carnavalet.

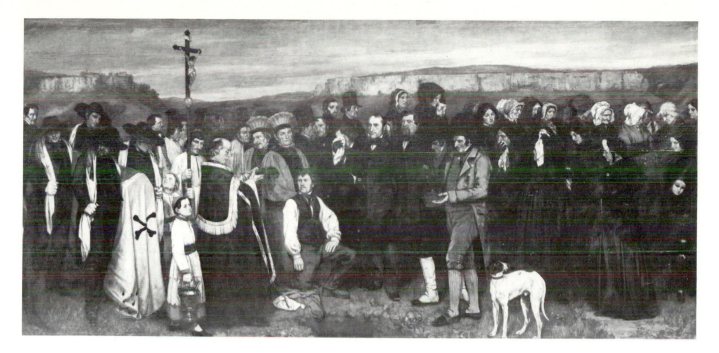

49. Gustave Courbet: *A Burial at Ornans*, Salon of 1850. Paris, Musée d'Orsay.

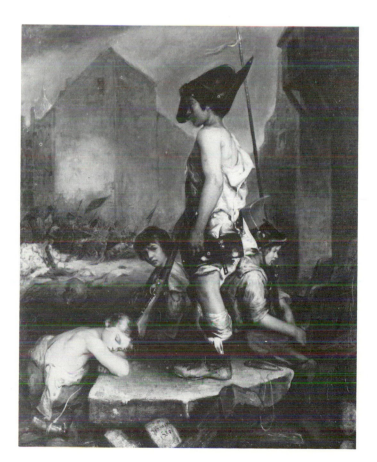

50. Philippe-Auguste Jeanron: *The Young Patriots*,
Salon of 1831. Caen, Musée des Beaux-Arts.

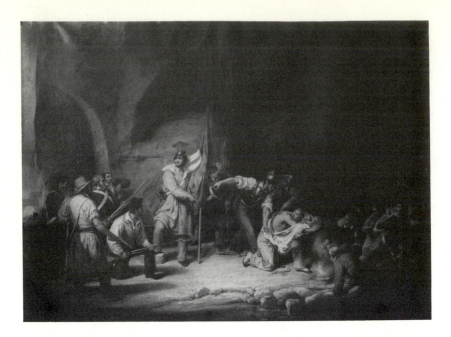

51. François Latil: *Morality of the People in a Moment of Lawlessness: July 1830*, Salon of 1835. Tarbes, Musée Massey.

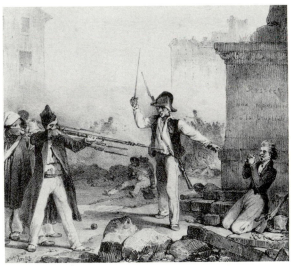

52. Nicolas-Toussaint Charlet: *29 July, 1830: He Stole!*, ca. 1830. Paris, Bibliothèque Nationale, Cabinet des Estampes.

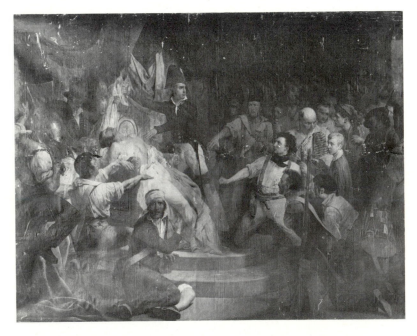

53. Pierre Senties: *The 29th of July 1830*, Salon of 1831. Paris, Musée du Louvre.

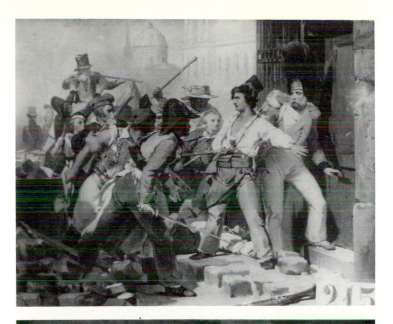

54. Léon Cogniet: *July 1830*, Salon of 1831. Orléans, Musée des Beaux-Arts.

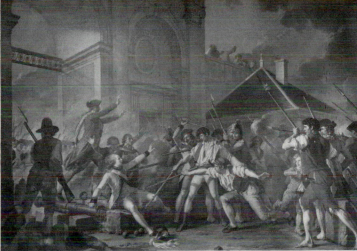

55. Jean-Jacques-François LeBarbier: *Heroic Bravery of Désilles during the Uprising at Nancy on 30 August 1790*, Salon of 1795. Nancy, Musée des Beaux-Arts.

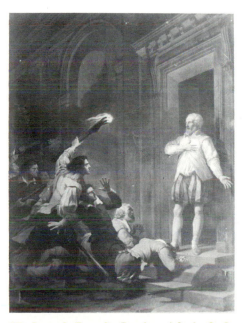

57. Joseph-Benoît Suvée: *Admiral de Coligny Confronts His Murderers*, Salon of 1787. Dijon, Musée des Beaux-Arts.

56. Nicolas-Toussaint Charlet: *The Waterloo Grenadier*, 1818. Paris, Bibliothèque Nationale, Cabinet des Estampes.

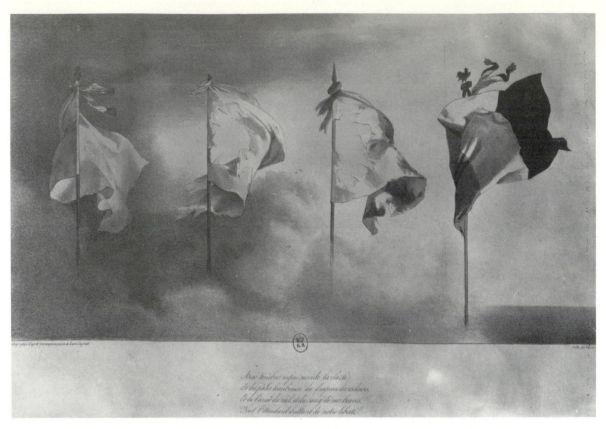

58. Léon Cogniet (colored lithograph by Villain): *Four Flags*, 1830. Paris, Bibliothèque Nationale, Cabinet des Estampes.

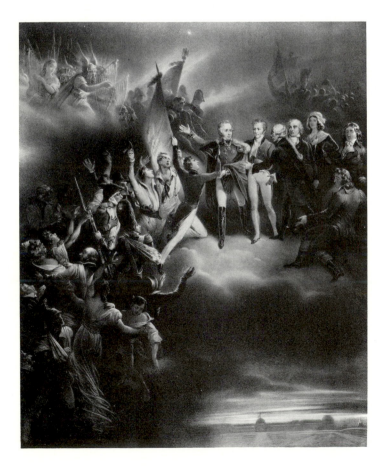

59. Octave Tassaert: *Apotheosis of the Victims of 27 and 28 July*, 1831. Paris, Bibliothèque Nationale, Cabinet des Estampes.

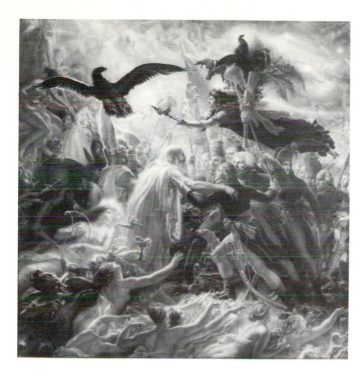

60. Anne-Louis Girodet de Roucy-Trioson: *Apotheosis of French Heroes Killed Serving the Nation during the War of Liberation*, Salon of 1802. Rueil-Malmaison, Musée National du Château.

61. Méry-Joseph Blondel: *Force Regained Her Noble Colors during the Three Memorable Days of July 1830*, 1830. Beauvais, Musée Départemental de l'Oise.

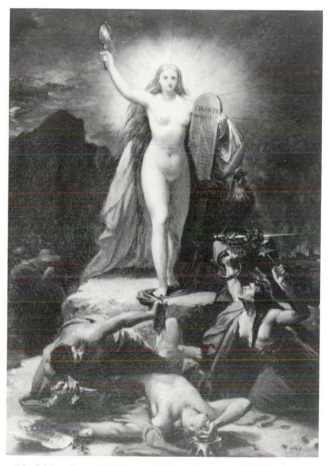

62. Méry-Joseph Blondel: *The Charter of 1830*, n.d. Gray, Musée Baron Martin.

63. Jean-Auguste-Dominique Ingres: *The People, Victorious in July 1830*, n.d. Montauban, Musée Ingres.

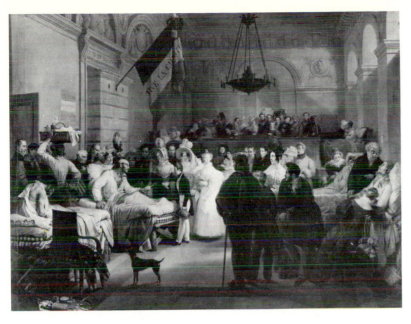

64. Nicolas Gosse: *The Queen of the French Visiting Those Wounded in July*, Salon of 1833. Versailles, Musée National du Château.

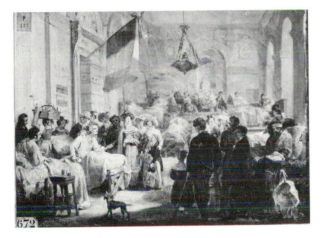

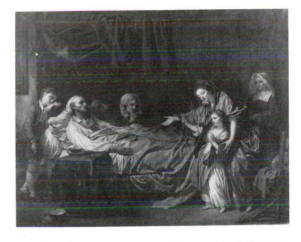

65. Nicolas Gosse: Sketch for *The Queen of the French Visiting Those Wounded in July*, 1830. Paris, Musée Carnavalet.

66. Jean-Baptiste Greuze: *A Young Lady Learns Charity*, 1772 or 1775. Lyon, Musée des Beaux-Arts.

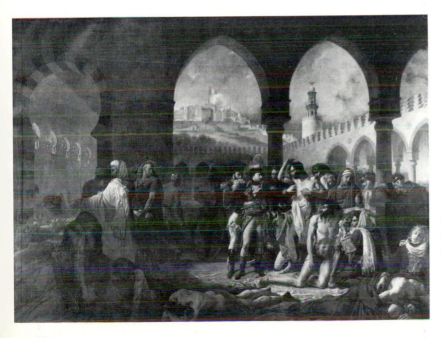

67. Baron Antoine-Jean Gros: *The Plague Victims of Jaffa*, Salon of 1804. Paris, Musée du Louvre.

68. Joseph Beaume and Charles Mozin: *The 28th of July at the Hôtel-de-Ville*, Salon of 1831. Versailles, Musée National du Château.

69. Jean-Baptiste Carbillet (after Horace Vernet): *The Duc d'Orléans Arrives at the Palais-Royal, 30 July 1830*, replica of original exhibited at Salon of 1834. Versailles, Musée National du Château.

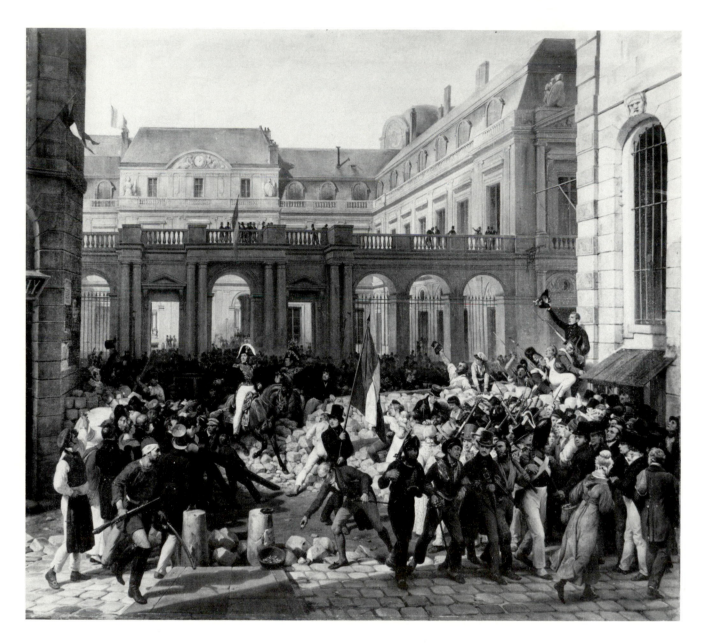

70. Horace Vernet: *The duc d'Orléans Proceeds to the Hôtel-de-Ville, 31 July 1830*, Salon of 1833.
Versailles, Musée National du Château.

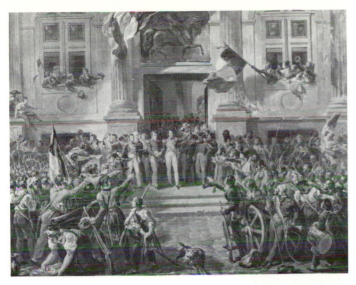

71. Guillon Lethière (lithograph by Aubry-le-Comte): *Louis-Philippe d'Orléans Proclaimed Lieutenant-Général of the Kingdom*, Salon of 1833. Paris, Musée Carnavalet.

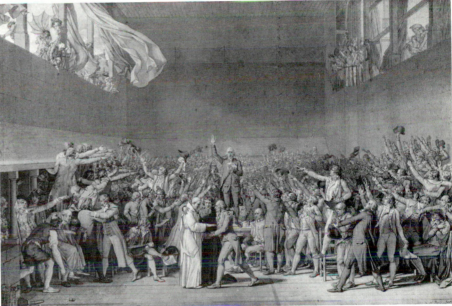

72. Jacques-Louis David: Drawing for *The Oath of the Tennis Court*, 1791. Paris, Musée du Louvre.

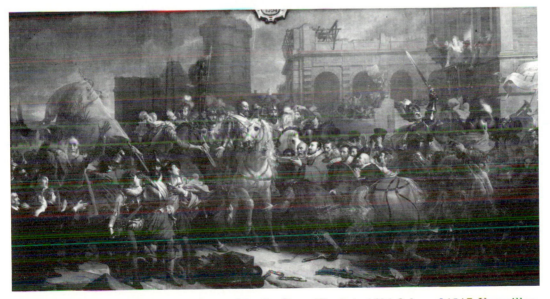

73. François Gérard: *Henri IV Welcomed by the City of Paris in 1594*, Salon of 1817. Versailles, Musée National du Château.

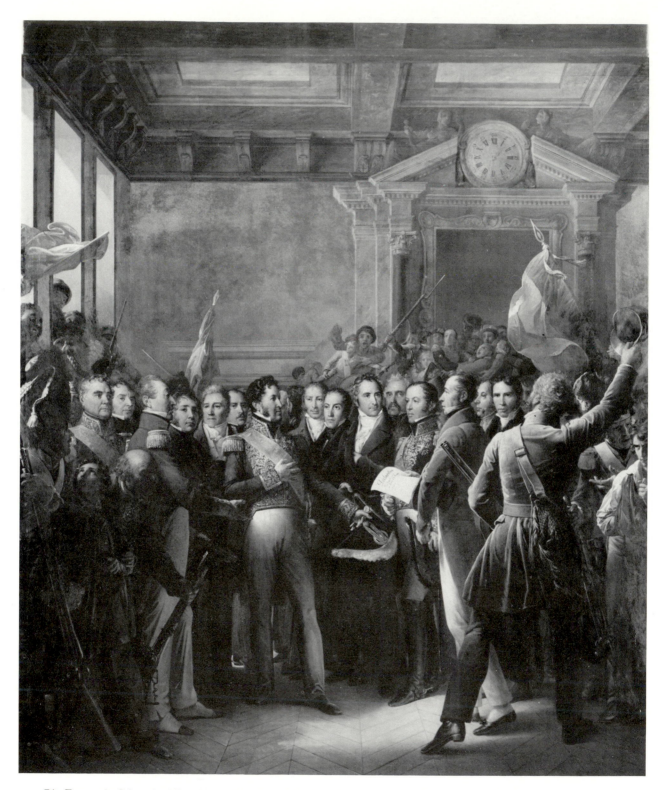

74. François Gérard: *A Reading of the Deputies' Resolution and Proclamation of the Lieutenant-général of the Kingdom at the Hôtel-de-Ville, 31 July 1830*, 1835. Versailles, Musée National du Château.

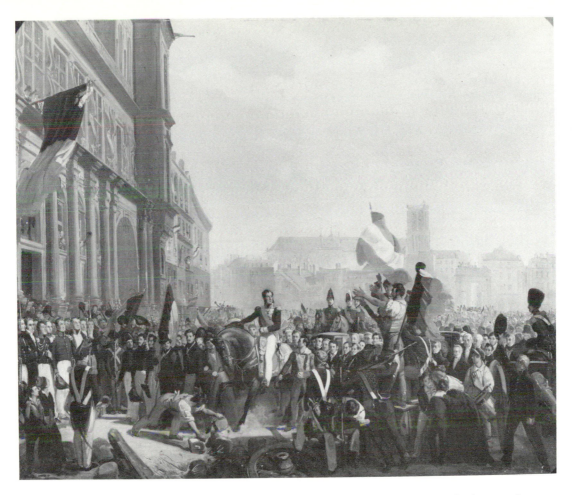

75. Eloi Féron (after Charles-Philippe Larivière): *The duc d'Orléans Arrives at the Hôtel-de-Ville, 31 July 1830*, replica of original exhibited at Salon of 1836. Versailles, Musée National du Château.

76. Ary Scheffer: *The duc d'Orléans at the Barrière du Trône, Accompanied by the duc de Chartres and the duc de Nemours, 4 August 1830*, replica of original completed in 1836. Versailles, Musée National du Château.

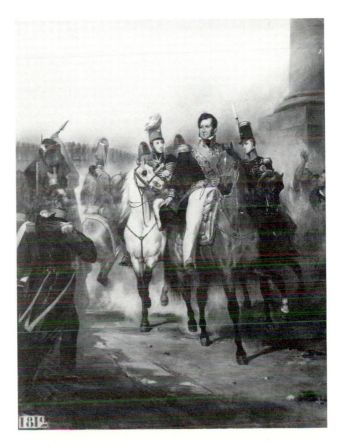

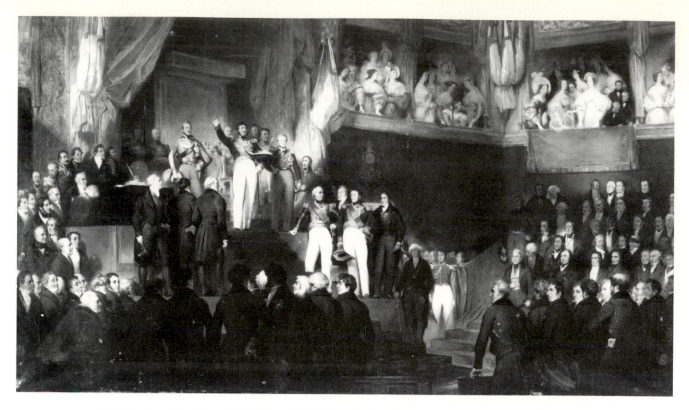

77. Eugène Devéria: *Oath of Louis-Philippe before the Peers and Deputies*, replica of original completed in 1836. Paris, collection M^{gr} le Comte de Paris.

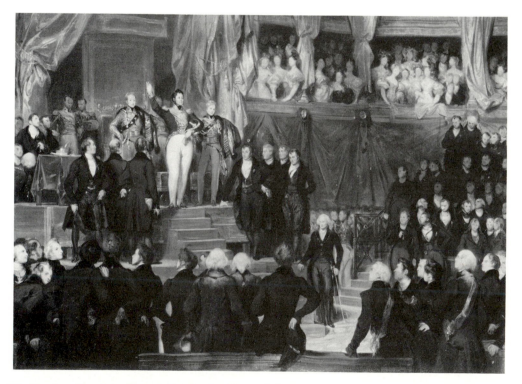

78. Eugène Devéria: Sketch for *Oath of Louis-Philippe before the Peers and Deputies*, Salon of 1831. Versailles, Musée National du Château.

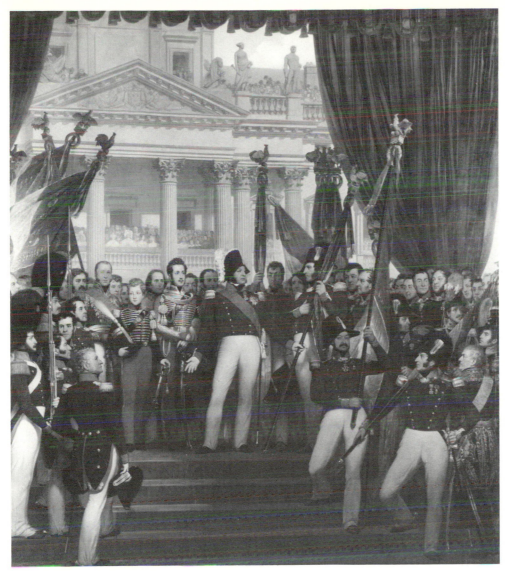

79. Joseph-Désiré Court: *The King Distributing Battalion Standards to the National Guard, 29 August 1830*, Salon of 1836. Versailles, Musée National du Château.

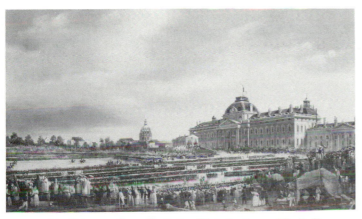

80. Etienne-Jean Dubois: *Distribution of Battalion Standards to the National Guard, 29 August 1830*, Salon of 1831. Versailles, Musée National du Château.

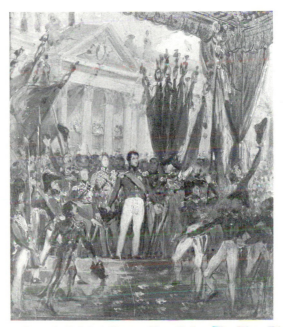

81. Joseph-Désiré Court: Sketch for *The King Distributing Battalion Standards to the National Guard, 29 August 1830*, n.d. Rouen, Musée des Beaux-Arts.

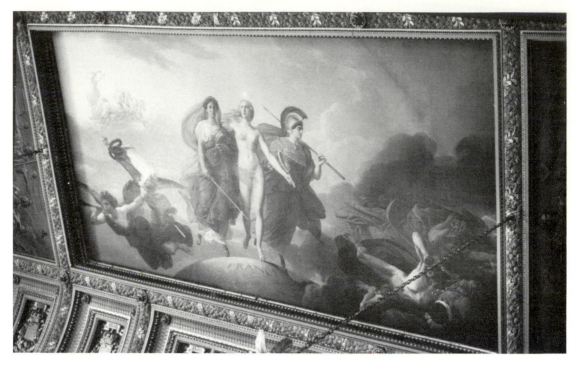

82. François-Edouard Picot: *Truth, Flanked by Justice and Wisdom, Protecting France from Hypocrisy, Extremism, and Discord*, 1835. Versailles, Musée National du Château.

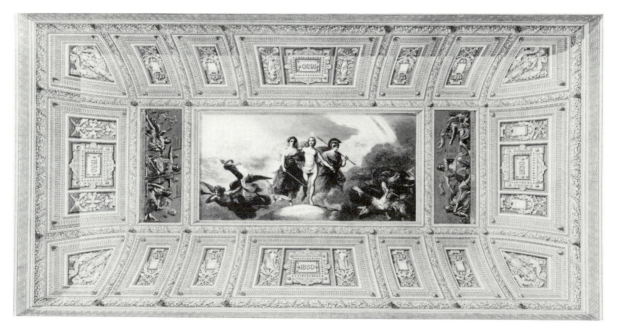

86. Engraving of the ceiling in the Salle de 1830 as originally installed, from Gavard, *Galeries historiques de Versailles*.

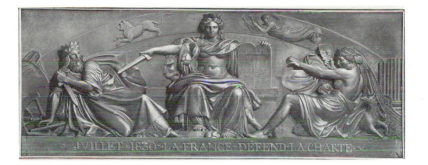

83. Jean-Louis Bézard: *July 1830: France Defends the Charter*, 1835. Versailles, Musée National du Château.

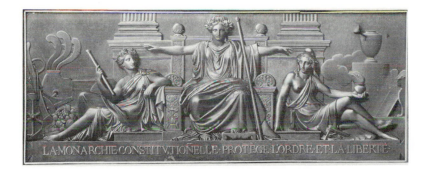

84. Jean-Louis Bézard: *The Constitutional Monarchy Preserves Order and Liberty*, 1835. Versailles, Musée National du Château.

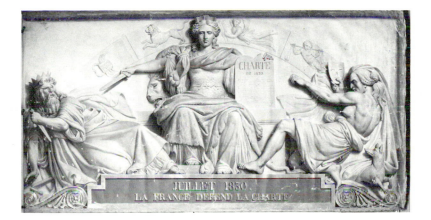

85. François-Edouard Picot: First version of *July 1830: France Defends the Charter*, 1835. Paris, Musée du Louvre.

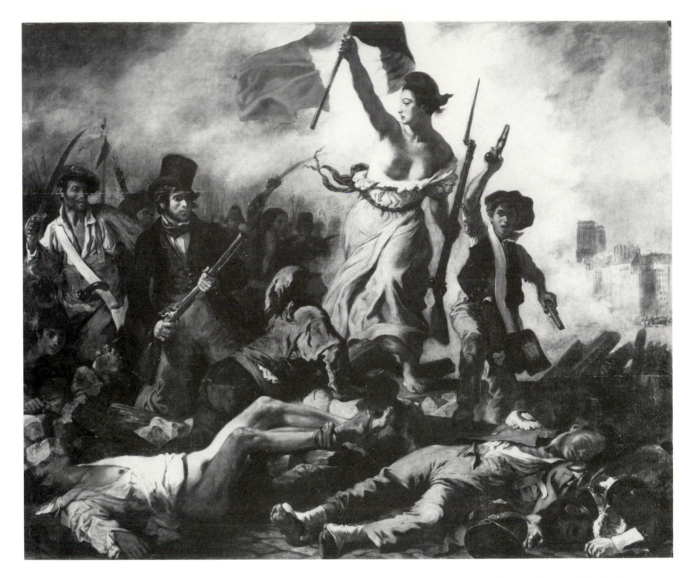

87. Eugène Delacroix: *The 28th of July: Liberty Leading the People*, Salon of 1831. Paris, Musée du Louvre.

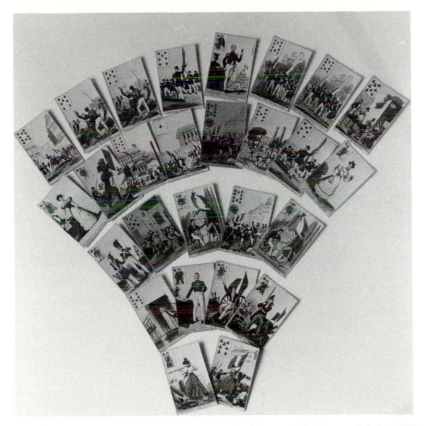

88. E. F. V. Maniez: *A Game of Heroes from the Memorable Days of July 1830*, 1831. Paris, Musée Carnavalet.

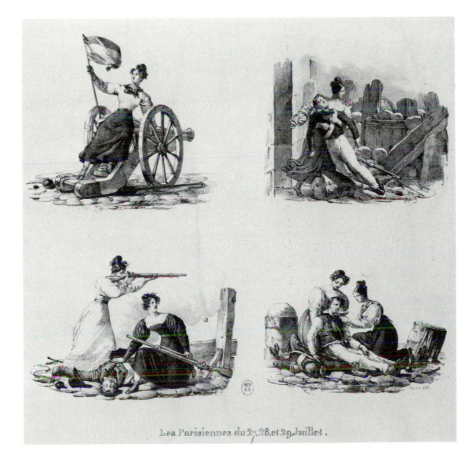

Les Parisiennes du 27, 28, et 29 Juillet.

89. Delaporte: *Parisian Women of 27, 28, and 29 July*, 1830. Paris, Bibliothèque Nationale, Cabinet des Estampes.

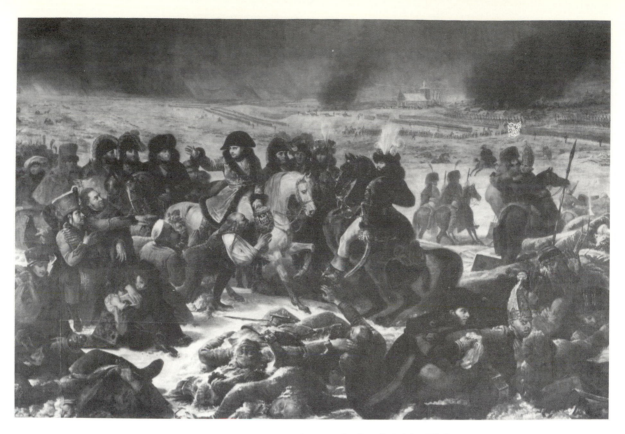

90. Baron Antoine-Jean Gros: *Napoléon Visiting the Battlefield of Eylau*, Salon of 1808. Paris, Musée du Louvre.

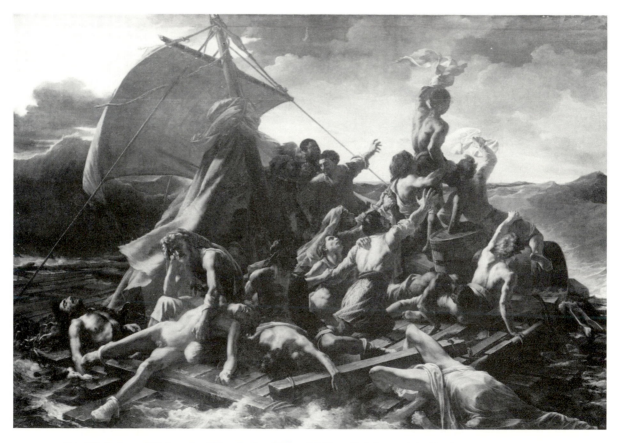

91. Théodore Géricault: *The Raft of "La Méduse,"* Salon of 1819. Paris, Musée du Louvre.

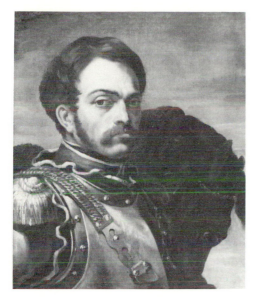

92. Théodore Géricault: *Portrait of a Carbineer Officer*, n.d. Rouen, Musée des Beaux-Arts.

94. Eugène Delacroix: Study for *The 28th of July*, 1830. Paris, Musée du Louvre, Cabinet des Dessins.

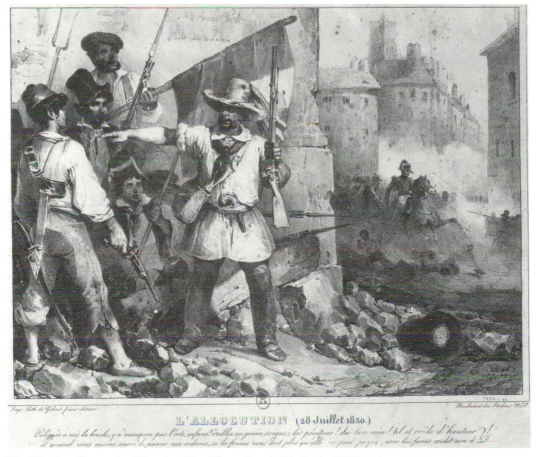

93. Nicolas-Toussaint Charlet: *The Allocution*, 1830. Paris, Bibliothèque Nationale, Cabinet des Estampes.

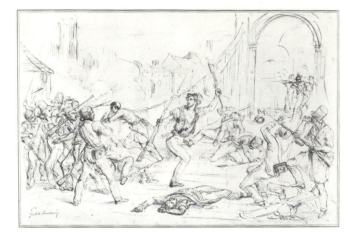

95. Denis-Auguste-Marie Raffet(?): Study for *The Pont d'Arcole*, n.d. Cambridge, Harvard University Museums (The Fogg Art Museum), Bequest—Grenville L. Winthrop.

97. Eugène Delacroix: Study for *The 28th of July*, 1830. Paris, Musée du Louvre, Cabinet des Dessins.

96. Eugène Delacroix: *Greece on the Ruins of Missolonghi*, ca. 1826. Bordeaux, Musée des Beaux-Arts.

98. Horace Vernet: *The Battle of Valmy*, 1826. London, The National Gallery.

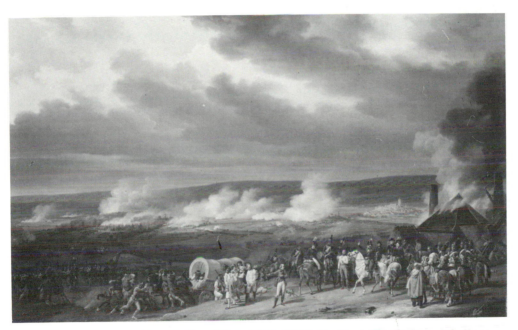

99. Horace Vernet: *The Battle of Jemmapes*, 1821. London, The National Gallery.

100. Joseph-Désiré Court: *The duc d'Orléans Signs the Act Proclaiming a Lieutenance-général of the Kingdom, 31 July 1830*, Salon of 1836. Versailles, Musée National du Château.

101. François-Joseph Heim: *The King Receiving at the Palais-Royal the Deputies of 1830, Who Present the Act by Which They Confer the Crown to Him,* Salon of 1834. Versailles, Musée National du Château.

102. François-Joseph Heim: *The duc d'Orléans Receives the Chamber of Peers at the Palais-Royal, 7 August 1830,* 1837. Versailles, Musée National du Château.

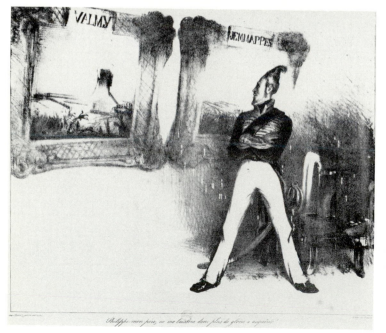

103. Honoré Daumier: *Philippe My Father Will Not Let Me Attain a Greater Glory!,* 1833. Paris, Bibliothèque Nationale, Cabinet des Estampes.

104. Jean-Baptiste Mauzaisse: *The King, on the Battlefield of Valmy, Giving the Legion of Honor Medal and a Pension to a Veteran Who Lost an Arm in This Glorious Event,* Salon of 1834. Carcassonne, Musée des Beaux-Arts.

105. Louis Hersent: *Louis XVI Distributing Alms to the Poor,* Salon of 1817. Versailles, Musée National du Château.

106. Félix Auvray: *The Oath of Louis-Philippe*, 1830. Valenciennes, Musée des Beaux-Arts.

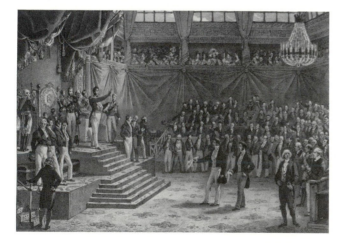

107. Blanc: *9 August 1830: Oath of the King*, 1830–31. Paris, Bibliothèque Nationale, Cabinet des Estampes.

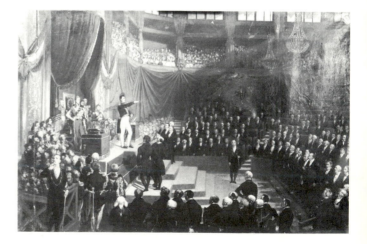

108. Joseph-Désiré Court: *The Oath of Louis-Phi-lippe*, 1830. Saint-Germain-en-Laye, Musée Municipal.

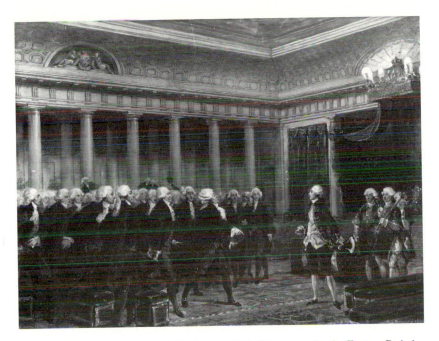

109. Eugène Delacroix: *Mirabeau and the marquis de Dreux-Brézé*,
1831. Copenhagen, Ny Carlsberg Glyptothek.

111. Eugène Delacroix: Preliminary sketch for
Mirabeau and Dreux-Brézé, 1831. Paris, Musée du
Louvre.

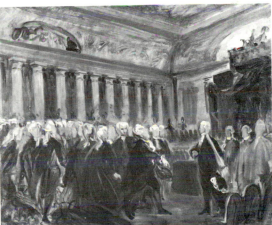

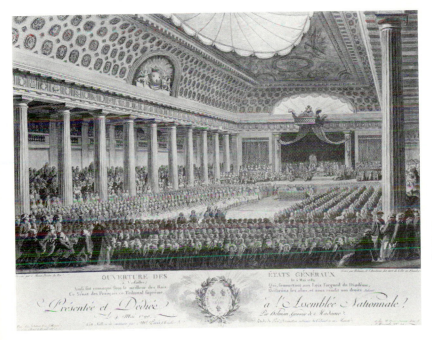

110. Isidore-Stanislas Helman: *Opening of the Es-
tates-General*, 1790. Paris, Bibliothèque Nationale,
Cabinet des Estampes.

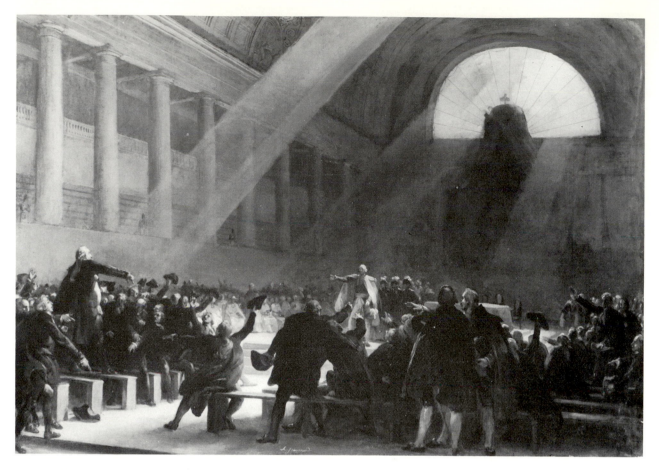

112. Alexandre-Evariste Fragonard: *Mirabeau and Dreux-Brézé*, 1831. Paris, Musée du Louvre.

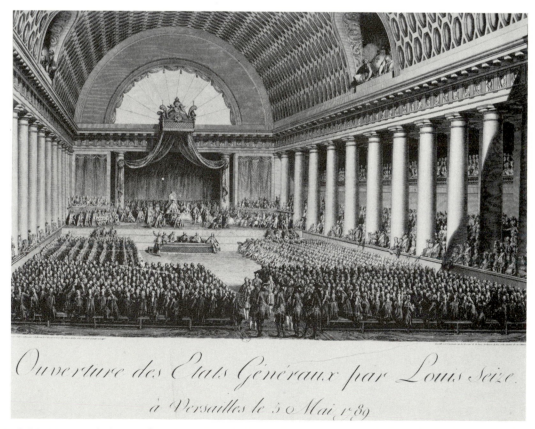

Ouverture des Etats Généraux par Louis Seize.
à Versailles le 5 Mai 1789

113. J. M. Moreau *le jeune*: *Opening of the Estates-General by Louis XVI*, 1790. Paris, Bibliothèque Nationale, Cabinet des Estampes.

114. Paul-Marc-Joseph Chenavard: *Mirabeau and Dreux-Brézé*, 1831. Paris, Musée Carnavalet.

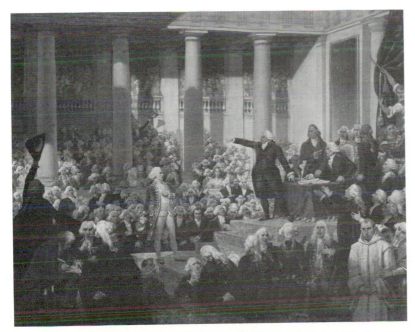

115. Joseph-Désiré Court: *Mirabeau and Dreux-Brézé*, 1831. Rouen, Musée des Beaux-Arts.

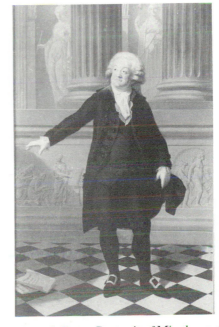

116. Joseph Boze: *Portrait of Mirabeau*, 1790. Aix-en-Provence, Musée Granet-Palais de Malte.

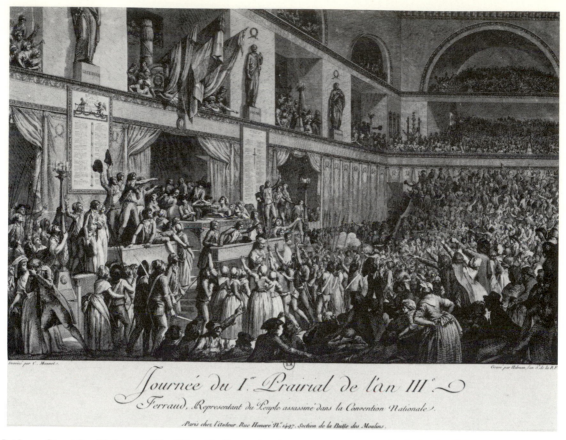

117. Isidore-Stanislas Helman: *The Historic Day of 1 Prairial, Year III*, 1797. Paris, Bibliothèque Nationale, Cabinet des Estampes.

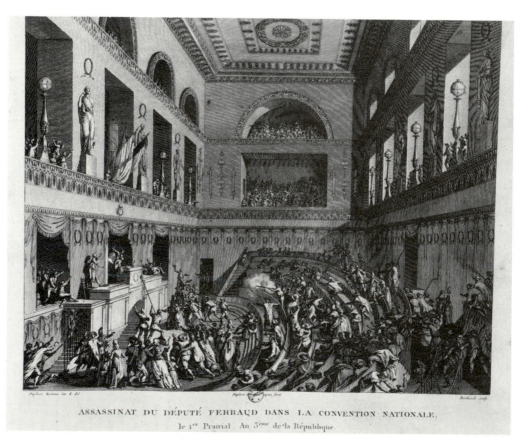

118. Pierre-Gabriel Berthault and Jean Duplessi-Berteaux: *Assassination of the Deputy Ferraud in the National Convention*, 1796. Paris, Bibliothèque Nationale, Cabinet des Estampes.

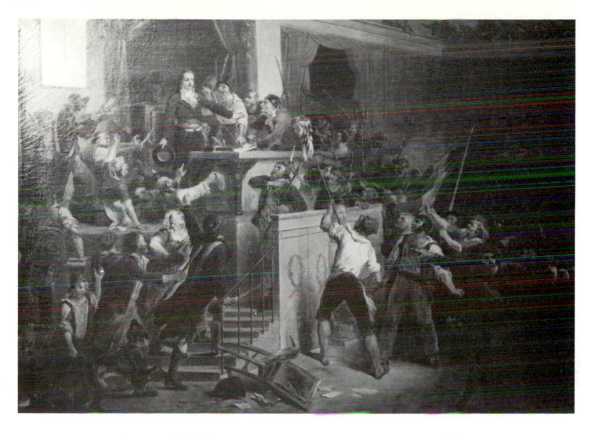

119. Adolphe Roëhn: *Boissy-d'Anglas*, 1831. Tarbes, Musée Massey.

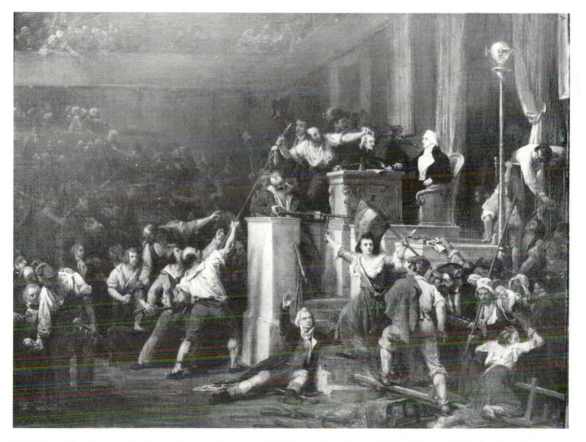

120. Auguste Vinchon: Competition sketch of *Boissy-d'Anglas*, 1831. Tours, Musée des Beaux-Arts.

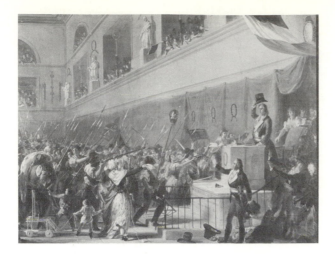

121. Nicolas-Sébastien Maillot: *Boissy-d'Anglas*, 1831. Reims, Musée Saint-Denis.

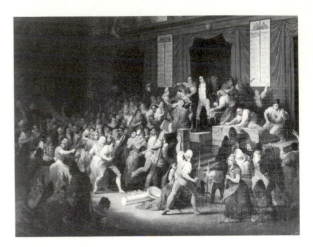

122. Benoît-Benjamin Tellier: *Boissy-d'Anglas*, 1831. Versailles, Musée National du Château.

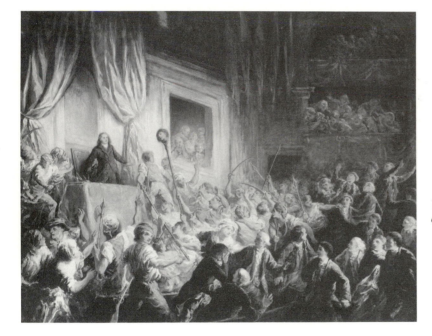

123. Octave Tassaert (here attributed): *Boissy-d'Anglas*, 1831. Paris, Galerie Pardo.

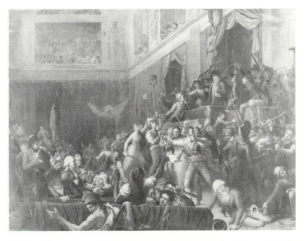

124. Thomas Degeorge: *Boissy-d'Anglas*, 1831. Clermont-Ferrand, Musée Bargoin.

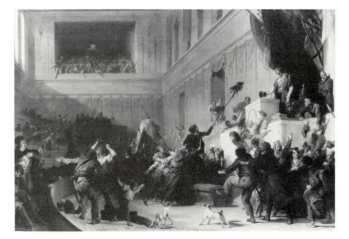

125. Alexandre-Evariste Fragonard: *Boissy-d'Anglas*, 1830. Paris, Musée du Louvre.

126. Eugène Delacroix: *Boissy-d'Anglas*, 1831. Bordeaux, Musée des Beaux-Arts.

127. Eugène Delacroix: *The Meeting Hall of the National Convention at the Tuileries* (drawing for *Boissy-d'Anglas*), 1831. Paris, Musée Carnavalet.

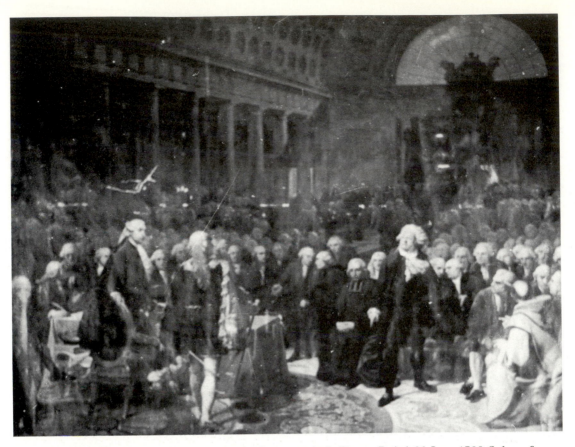

128. Auguste Hesse: *Mirabeau and the marquis de Dreux-Brézé, 23 June 1789,* Salon of 1838. Amiens, Musée de Picardie.

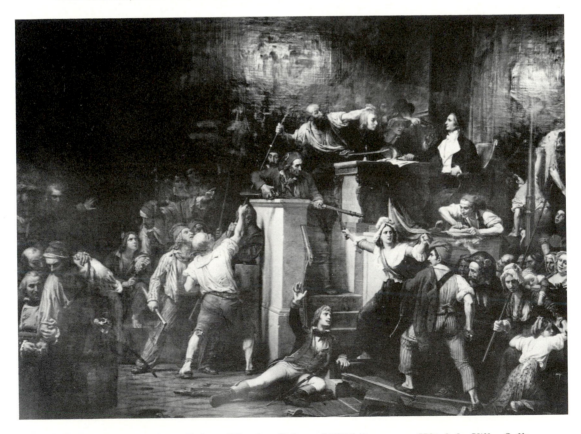

130. Auguste Vinchon: *Boissy-d'Anglas,* Salon of 1835. Annonay, Hôtel-de-Ville, Salle de Réunion du Conseil Municipal.

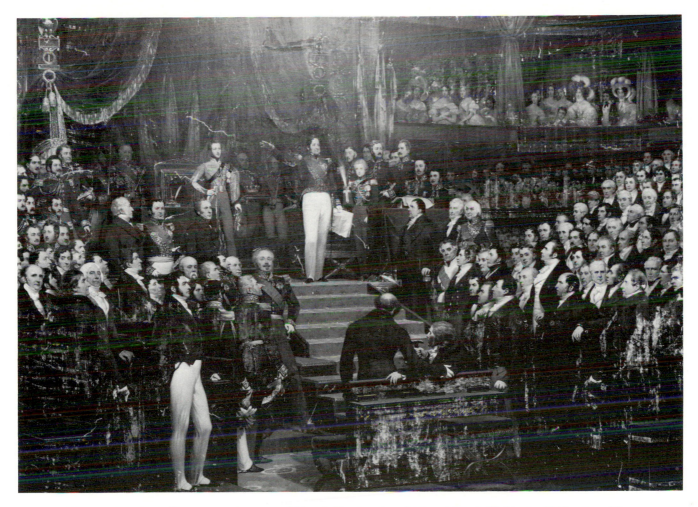

129. Amable-Paul Coutan and Joseph-Désiré Court: *The Oath of Louis-Philippe*, 1837. Versailles, Musée National du Château.

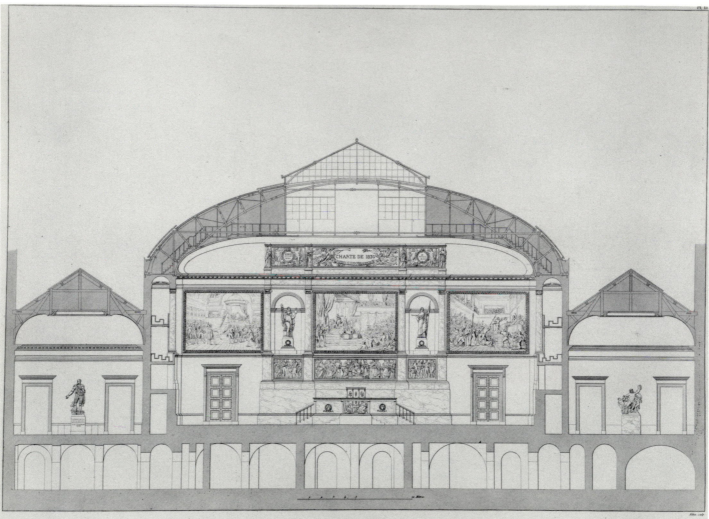

COUPE DANS L'AXE TRANSVERSAL DE LA SALLE DES SÉANCES COTÉ DU PRÉSIDENT.

131. Jules de Joly: Elevation of the Salle des Séances of the Chamber of Deputies.

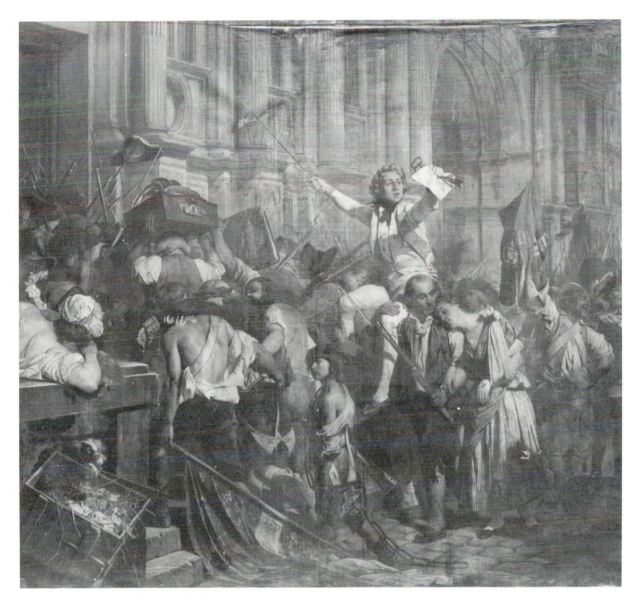

132. Paul Delaroche: *The Takers of the Bastille at the Hôtel-de-Ville*, 1839. Paris, Musée du Petit Palais.

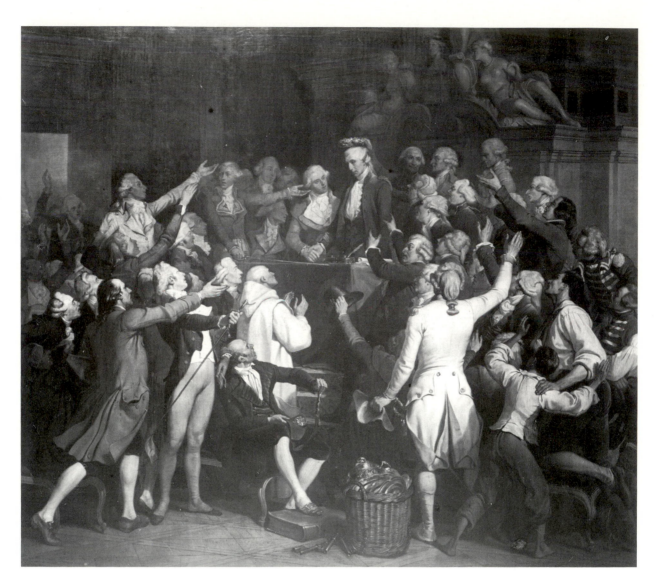

133. Léon Cogniet: *Bailly Proclaimed Mayor of Paris*, c. 1832–35. Ivry, Dépôt des Oeuvres d'Art de la Ville de Paris.

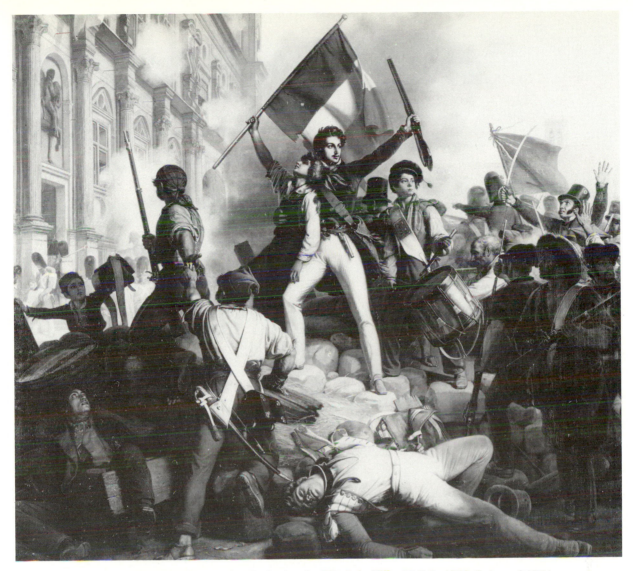

134. Jean-Victor Schnetz: *The Fight for the Hôtel-de-Ville, 28 July 1830*, Salon of 1834.
Paris, Musée du Petit Palais.

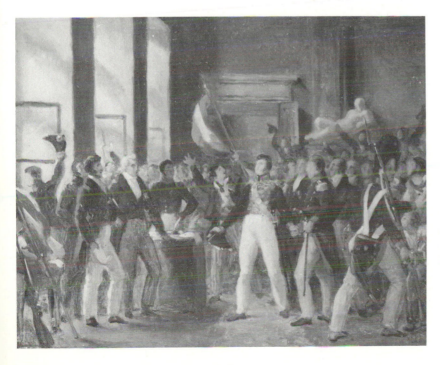

135. Michel-Martin Drolling (here attributed): *The Meeting between the duc d'Orléans and General Lafayette at the Hôtel-de-Ville*, n.d. Paris, Musée Carnavalet.

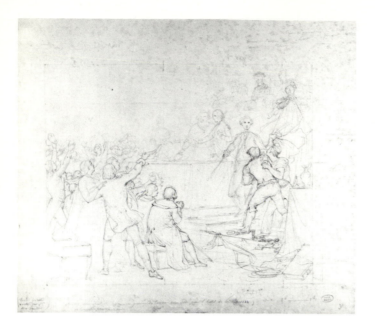

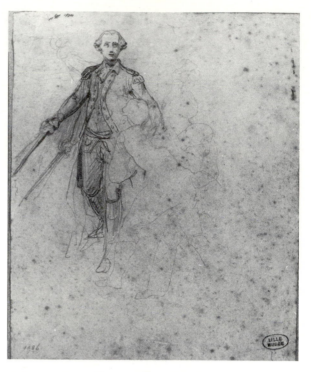

136. Léon Cogniet: First idea for the *Bailly Proclaimed Mayor of Paris*, n.d. Lille, Musée des Beaux-Arts.

137. Léon Cogniet: Study for the *Bailly Proclaimed Mayor of Paris*, n.d. Lille, Musée des Beaux-Arts.

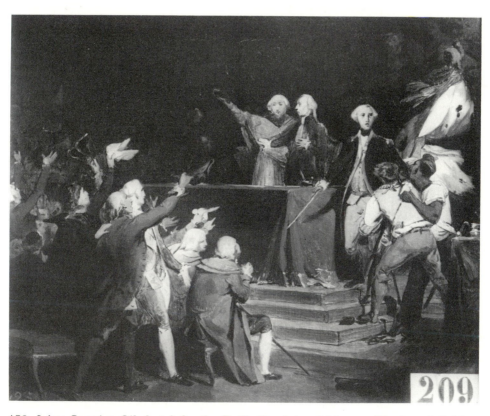

138. Léon Cogniet: Oil sketch for the *Bailly Proclaimed Mayor of Paris*, n.d. Orléans, Musée des Beaux-Arts.

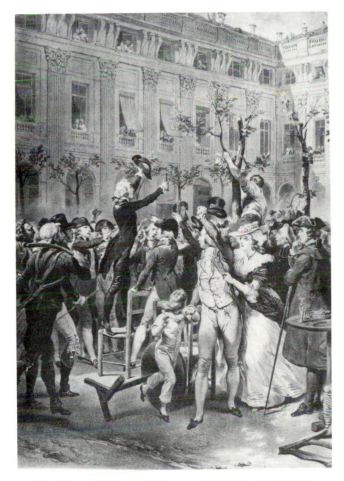

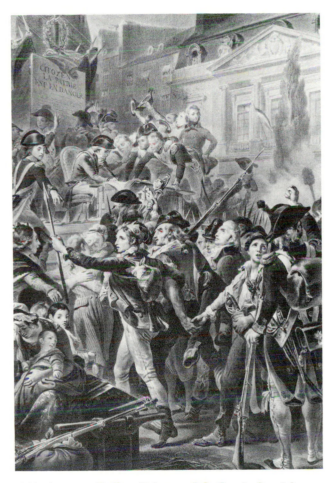

139. Horace Vernet (lithograph by Louis-Stanislas Marin-Lavigne): *Camille Desmoulins Haranguing the Crowd at the Palais-Royal, 12 July 1789*, original exhibited at Salon of 1831.

140. Auguste DeBay (lithograph by Louis-Stanislas Marin-Lavigne): *The Nation in Danger, or the Voluntary Enlistments of 1792*, original exhibited at Salon of 1834.

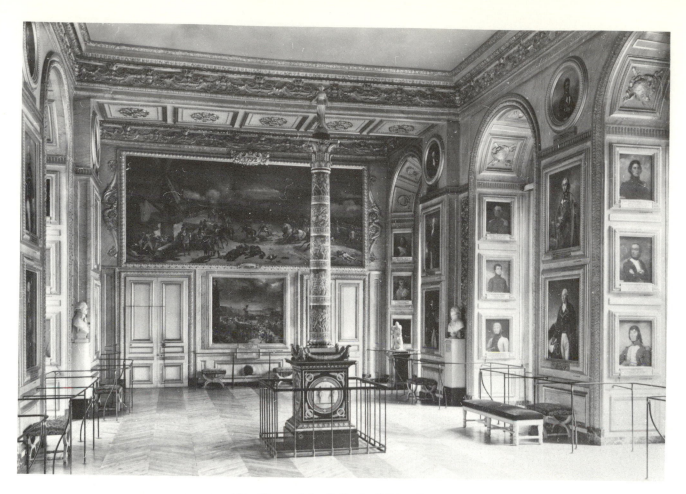

141. View of the Salle de 1792 at Versailles.

142. Léon Cogniet: *Louis-Philippe d'Orléans, duc de Chartres, in 1792*, 1834. Versailles, Musée National du Château.

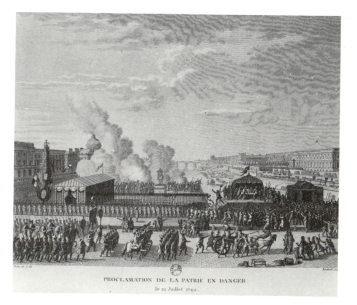

144. Pierre-Gabriel Berthault and Jean-Louis Prieur: *Proclamation of the State of National Emergency, 22 July 1792*, early 1794. Paris, Bibliothèque Nationale, Cabinet des Estampes.

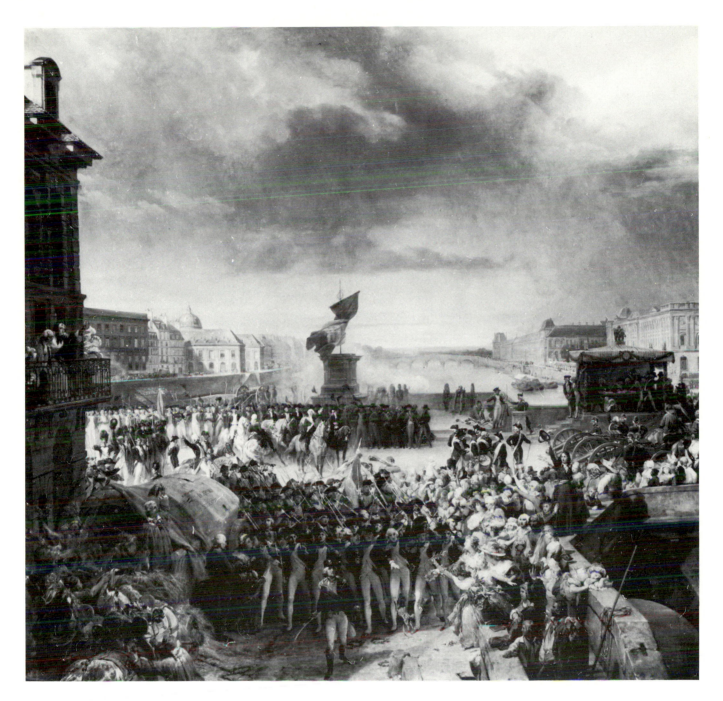

143. Léon Cogniet: *The Parisian National Guard Leaves for the Front in September 1792*, Salon of 1836. Versailles, Musée National du Château.

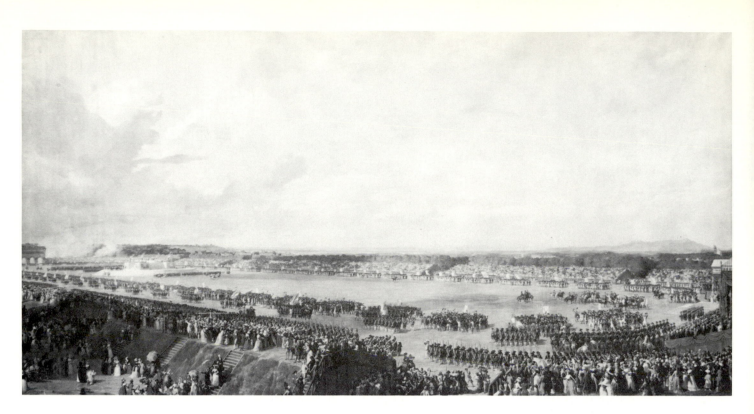

145. Auguste Couder: *Federation of National Guardsmen and the Military on the Champ-de-Mars at Paris, 14 July 1790*, Salon of 1844. Versailles, Musée National du Château.

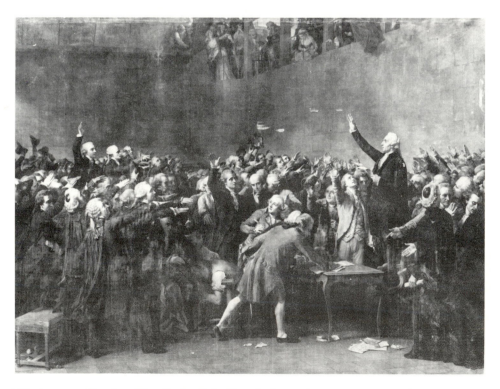

146. Auguste Couder: *The Oath of the Tennis Court*, Salon of 1848. Versailles, Musée National du Château.

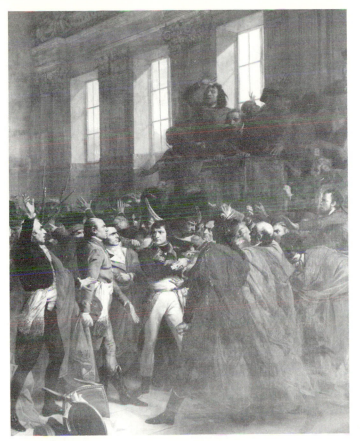

147. François Bouchot: *The 18th of Brumaire*, Salon of 1840. Versailles, Musée National du Château.

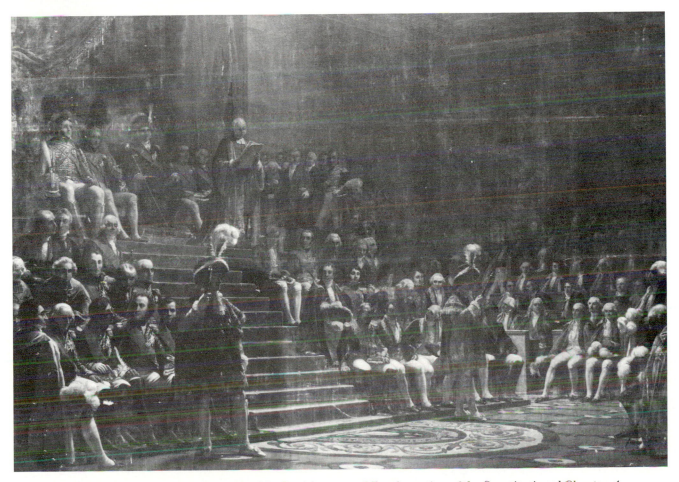

148. Auguste Vinchon: *The Opening of the Legislature and Proclamation of the Constitutional Charter, 4 June 1814*, Salon of 1842. Versailles, Musée National du Château.

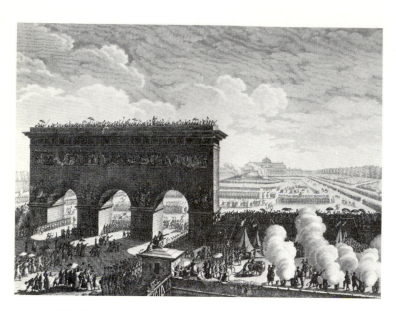

149. Pierre-Gabriel Berthault and Jean-Louis Prieur: *The General Federation Effected at Paris, 14 July 1790*, early 1793. Paris, Bibliothèque Nationale, Cabinet des Estampes.

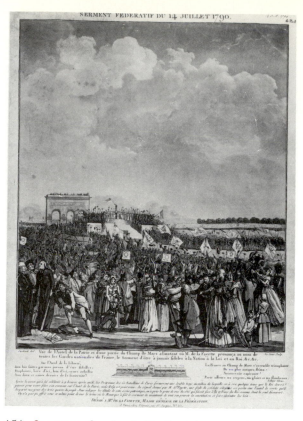

151. Jacques Swebach-Desfontaines and Louis LeCour: *The Oath of Federation, 14 July 1790*, 1790. Paris, Bibliothèque Nationale, Cabinet des Estampes.

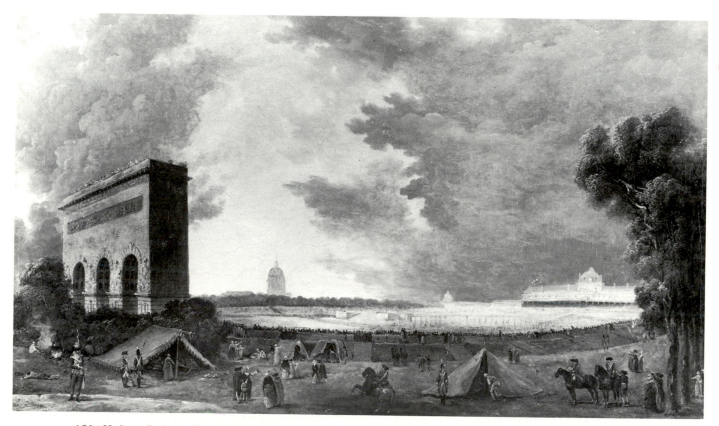

150. Hubert Robert: *Festival of the Federation on the Champ-de-Mars, 14 July 1790*, 1790. Versailles, Musée National du Château.

152. Jean-Baptiste Greuze: *The Father's Curse*,
1777. Paris, Musée du Louvre.

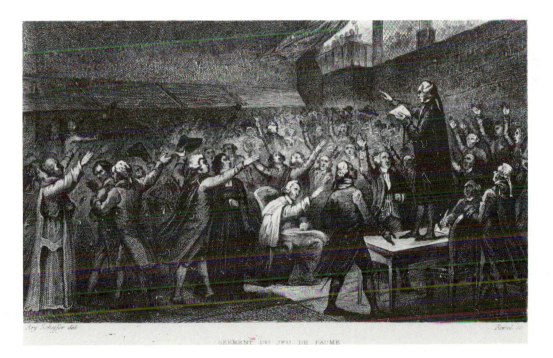

SERMENT DU JEU DE PAUME

153. Ary Scheffer: *The Oath of the Tennis Court*, illustration from the 1834 edition of
Histoire de la Révolution française by Adolphe Thiers.

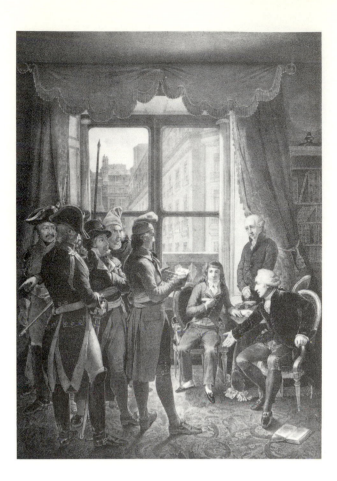

154. Jean-Baptiste Mauzaisse (lithograph by Louis-Stanislas Marin-Lavigne): *The Arrest of the comte de Beaujolais at the Palais-Royal, 4 April 1793*, original of 1834.

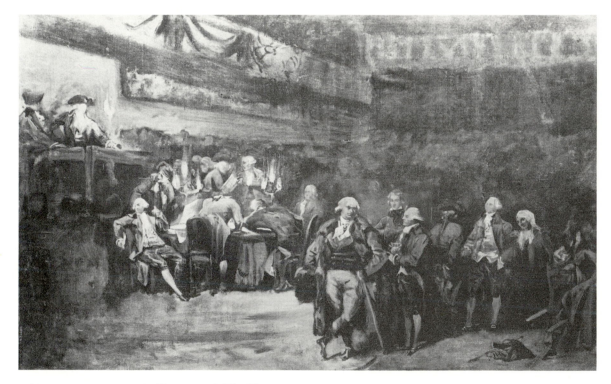

155. Paul-Marc-Joseph Chenavard: *The Floor of the National Convention after Voting to Execute Louis XVI*, ca. 1835. Lyon, Musée des Beaux-Arts.

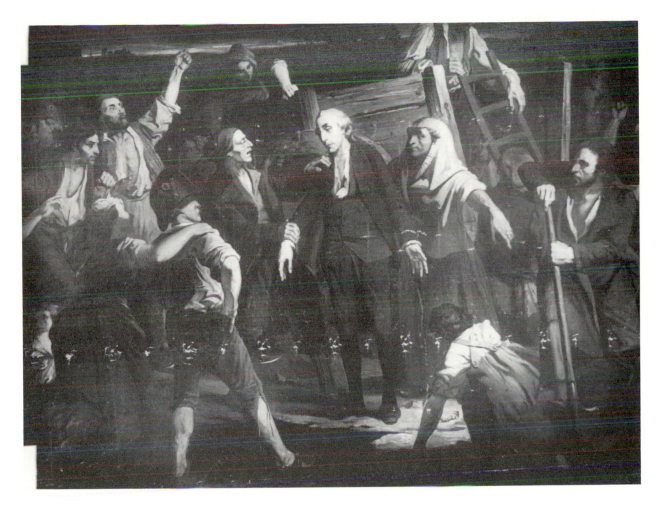

156. Louis Boulanger: *The Death of Bailly* (detail), 1831. Compiègne, Musée Vivenel.

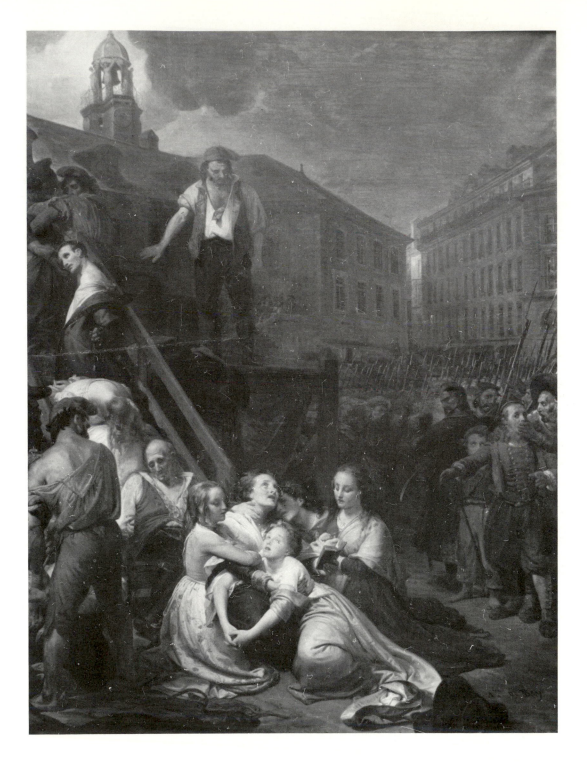

157. Auguste DeBay: *An Episode of 1793 at Nantes*, 1838. Nantes, Musée des Beaux-Arts.

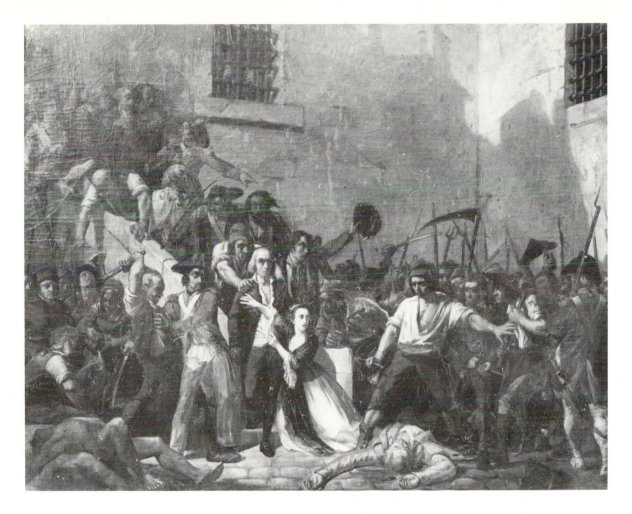

158. Marcel Verdier: *Mlle de Sombreuil Saves Her Father by Drinking a Glass of Blood*, ca. 1841. Bagnères-de-Bigorre, Musée Salies.

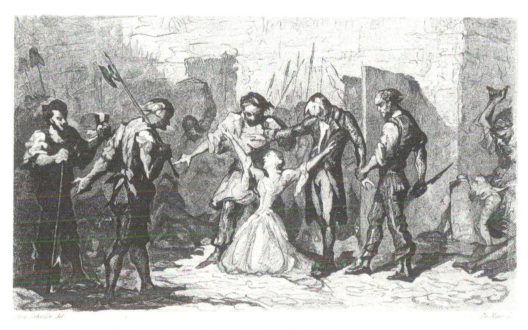

159. Ary Scheffer: *Mlle de Sombreuil Saves Her Father*, illustration from the 1834 edition of *Histoire de la Révolution française* by Adolphe Thiers.

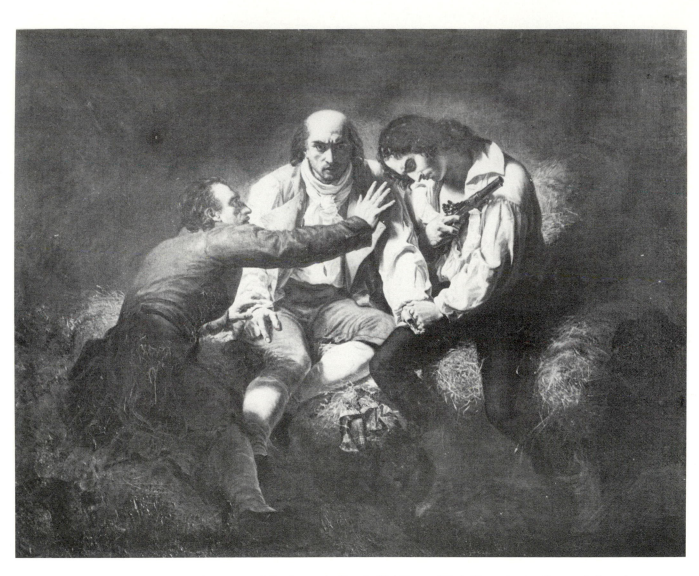

160. Melchior Péronard: *Louvet and Barbaroux, Nearly Yielding to Their Despair, Are Stopped Short by Valady*, Salon of 1831. Bagnères-de-Bigorre, Musée Salies.

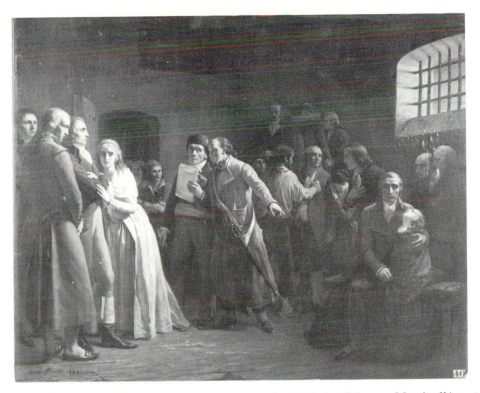

161. Louise Desnos: *The Evening Paper*, Salon of 1846. Saint-Etienne, Musée d'Art et d'Industrie.

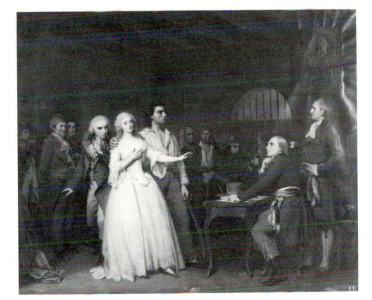

163. Louise Desnos: *Interrogation and Condemnation of the princesse de Lamballe*, Salon of 1846. Saint-Etienne, Musée d'Art et d'Industrie.

162. Alfred Johannot: *Reading the Evening Paper, or the Roll Call of Persons Condemned to Death*, illustration from the 1834 edition of *Histoire de la Révolution française* by Adolphe Thiers.

164. Henri Scheffer: *Charlotte Corday*, Salon of 1831. Grenoble, Musée de Peinture et de Sculpture.

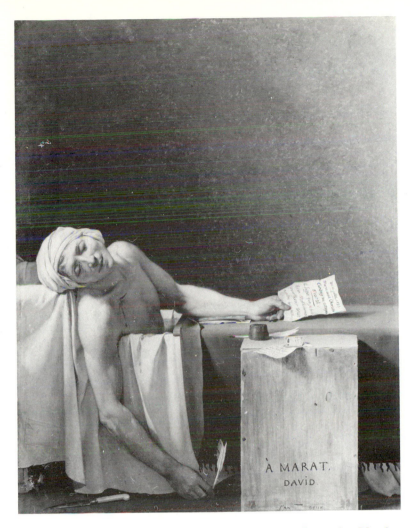

165. Jacques-Louis David: *Marat Dying*, 1793. Brussels, Musées Royaux des Beaux-Arts de Belgique/Koninklijke Musea voor Schone Kunsten.

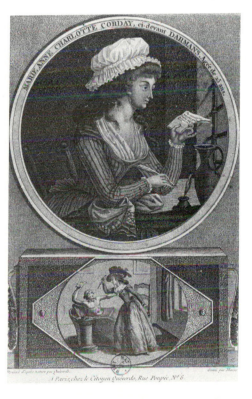

166. Quéverdo: *Marie Anne Charlotte Corday, Formerly d'Armans, 25 Years Old*, 1793. Paris, Bibliothèque Nationale, Cabinet des Estampes.

167. Louis Brion de la Tour: *Assassination of J. P. Marat*, 1793. Paris, Bibliothèque Nationale, Cabinet des Estampes.

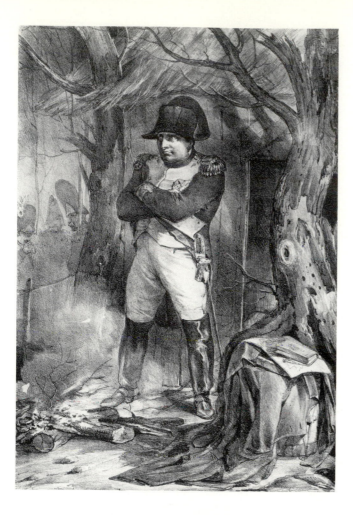

168. Nicolas-Toussaint Charlet: *Napoléon in Bivouac*, 1822. Paris, Bibliothèque Nationale, Cabinet des Estampes.

169. Anonymous lithograph: *Les Souvenirs du peuple*, 1831. Paris, Bibliothèque Nationale, Cabinet des Estampes.

LES SOUVENIRS DU PEUPLE.

170. Anonymous woodblock print: *Napoléon in the Old Woman's Cottage*, ca. 1835. Paris, Bibliothèque Nationale, Cabinet des Estampes.

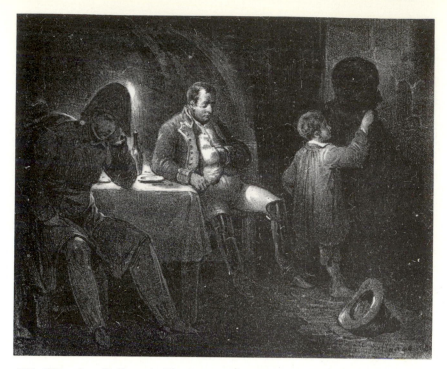

171. Hippolyte Bellangé: *The Postilion's Silhouette-Drawing*, 1830. Paris, Bibliothèque Nationale, Cabinet des Estampes.

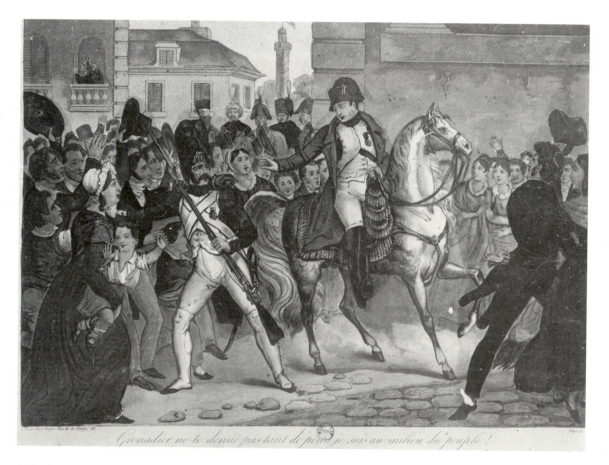

Grenadier ne te donne pas tant de peine je suis au milieu du peuple!

172. Anonymous aquatint engraving: *Soldier Spare the Effort, for I Am amidst the People*, 1833. Paris, Bibliothèque Nationale, Cabinet des Estampes.

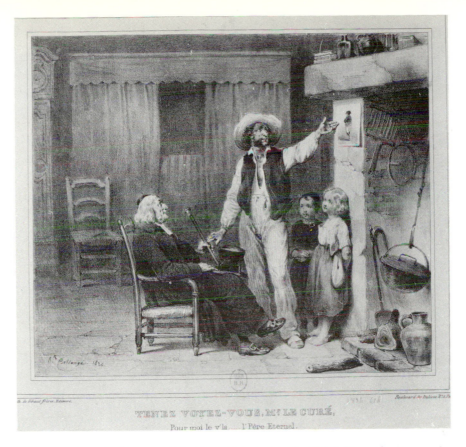

173. Hippolyte Bellangé: *Look Here Father, for Me That's Him, the Heavenly Father*, 1835. Paris, Bibliothèque Nationale, Cabinet des Estampes.

174. Hippolyte Bellangé: *The Peddler of Plaster Figurines*, Salon of 1833. Paris, Musée du Louvre.

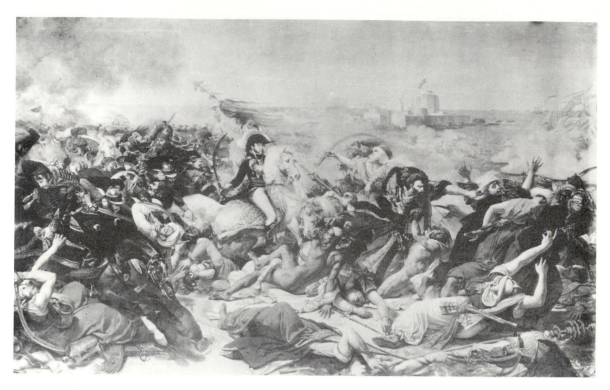

175. Baron Antoine-Jean Gros: *The Battle of Aboukir*, Salon of 1806. Versailles, Musée National du Château.

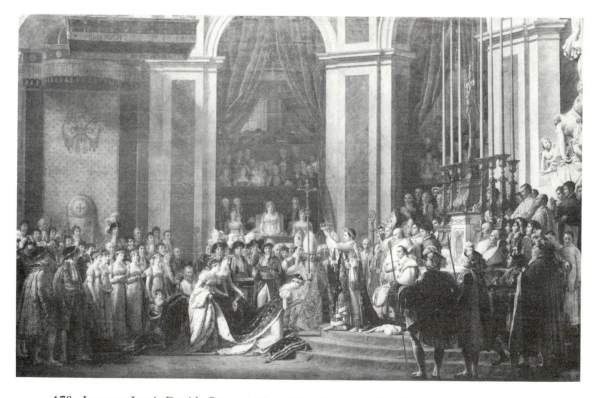

176. Jacques-Louis David: *Consecration of the Emperor Napoléon and Coronation of the Empress Josephine in the Church of Notre-Dame de Paris, 2 December 1804*, Salon of 1808. Paris, Musée du Louvre.

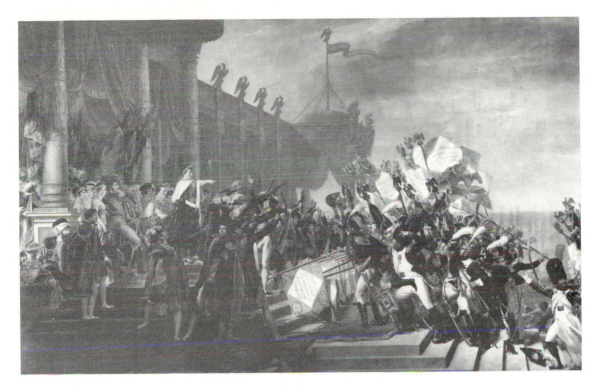

177. Jacques-Louis David: *The Oath of the Army Made to the Emperor after the Distribution of Eagles on the Champ-de-Mars, 5 December 1804*, Salon of 1810. Versailles, Musée National du Château.

178. Antoine-François Callet: *The 18th of Brumaire*, Salon of 1801. Versailles, Musée National du Château.

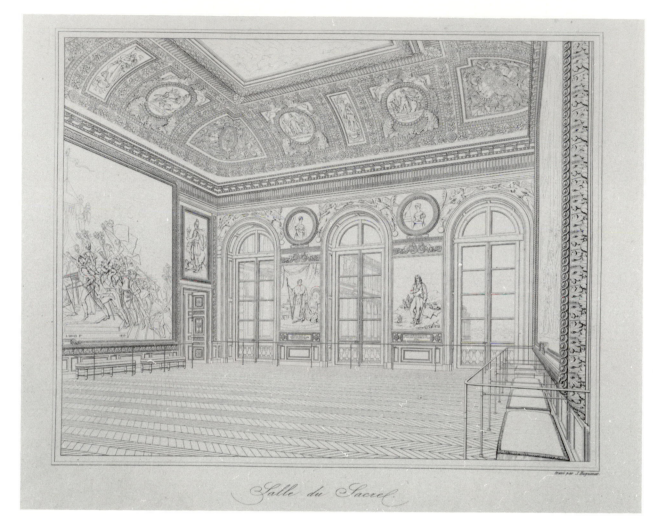

Salle du Sacre

179. Engraving of the Salle du Sacre at Versailles, from Gavard, *Galeries historiques de Versailles*.

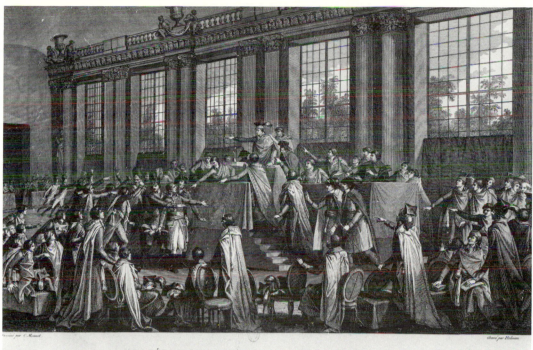

JOURNÉE DE SAINT-CLOUD, LE 18 BRUMAIRE AN 8, (9 NOVEMBRE 1799.)

180. Isidore-Stanislas Helman: *The Events at Saint-Cloud, 18 Brumaire Year 8*, 1802.
Paris, Bibliothèque Nationale, Cabinet des Estampes.

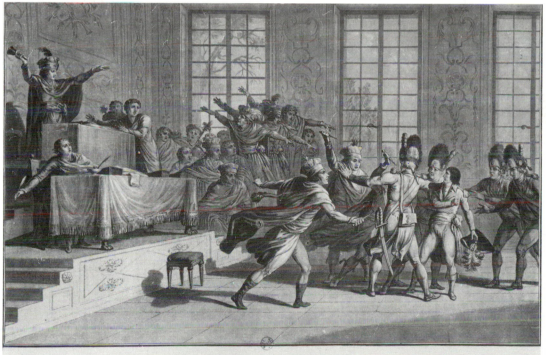

Séance du Corps-Législatif à l'Orangerie de S.^t Cloud (.

Apparition de Bonaparte et Journée libératrice du 19 brum.re an 8. (10. 9bre 1799.)

181. Charles-Melchior Descourtis: *Meeting of the Legislative Body at the Orangerie of
St. Cloud: Bonaparte's Appearance and the Day of Liberation, 19 Brumaire Year 8*, 1800.
Paris, Bibliothèque Nationale, Cabinet des Estampes.

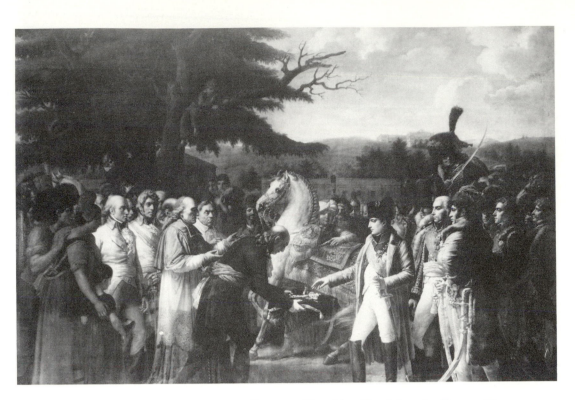

182. Anne-Louis Girodet de Roucy-Trioson: *Napoléon Receiving the Keys to Vienna*, Salon of 1808. Versailles, Musée National du Château.

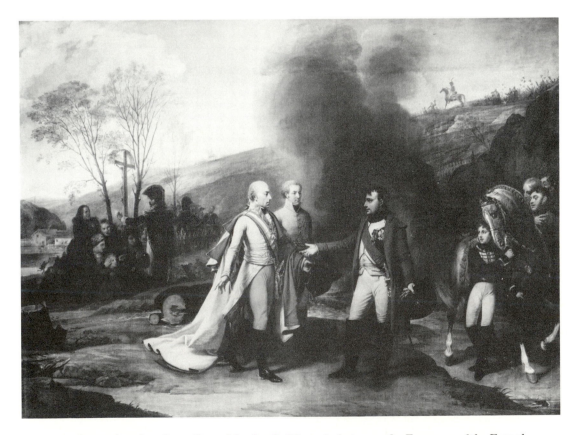

183. Baron Antoine-Jean Gros: *Meeting in Moravia between the Emperor of the French and the Emperor of Austria*, Salon of 1812. Versailles, Musée National du Château.

184. Louis-Philibert Debucourt: *No Passage!*, 1828. Paris, Bibliothèque Nationale, Cabinet des Estampes.

185. Denis-Auguste-Marie Raffet: *My Emperor, It's the Most Cooked!*, 1832. Paris, Bibliothèque Nationale, Cabinet des Estampes.

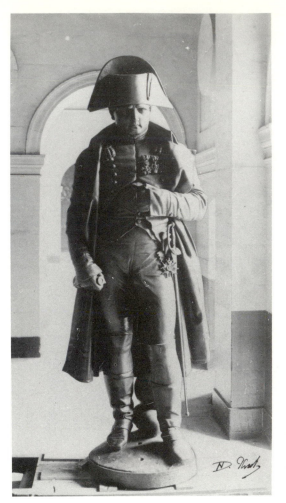

186. Emile Seurre: Statue of *Napoléon* for the
Vendôme column, 1833. Paris, Hôtel National des
Invalides.

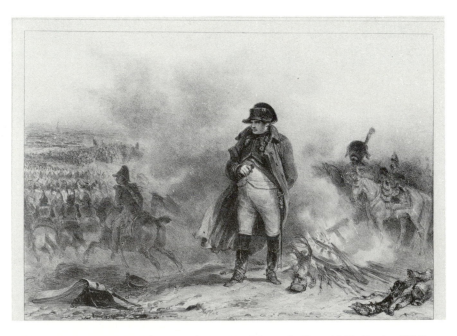

187. Denis-Auguste-Marie Raffet: *The Master's Eye*, 1833. Paris, Biblio-
thèque Nationale, Cabinet des Estampes.

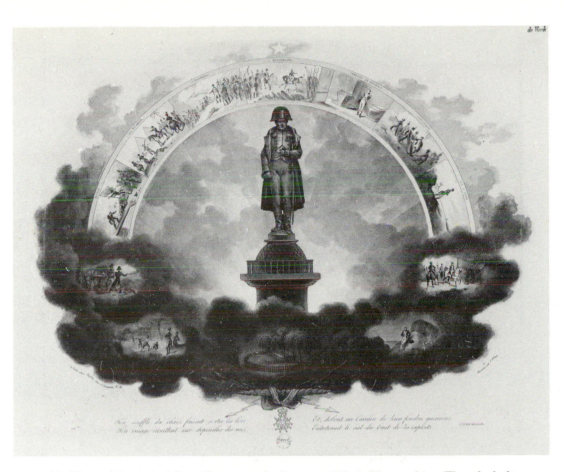

188. Victor Adam: *And Standing upon the Bronze of Their War-making Thunderbolts*, 1833. Paris, Bibliothèque Nationale, Cabinet des Estampes.

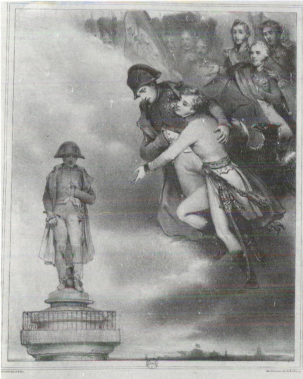

189. Octave Tassaert: *The Column and the Statue*, ca. 1832. Paris, Bibliothèque Nationale, Cabinet des Estampes.

APOTHÉOSE DE NAPOLÉON.

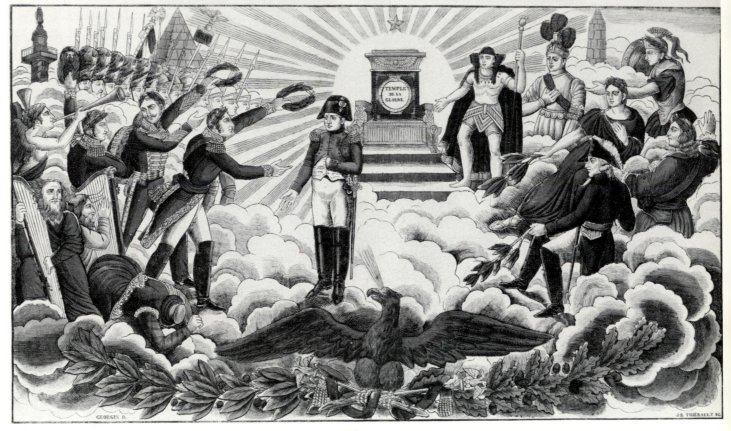

190. François Georgin and J.-B. Thiébault: *The Apotheosis of Napoléon*, 1834. Paris, Bibliothèque Nationale, Cabinet des Estampes.

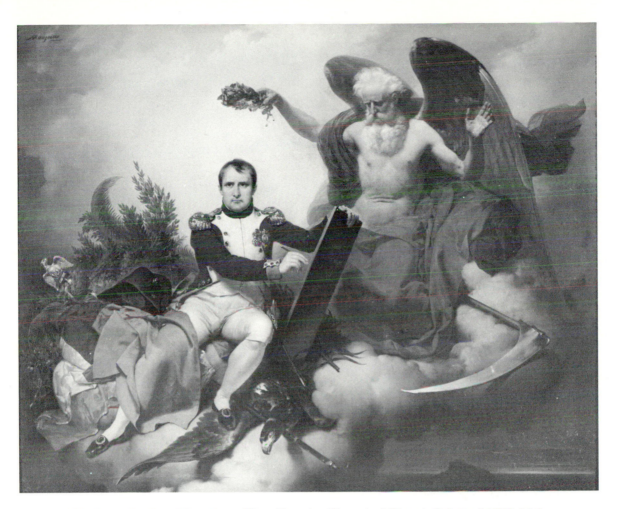

191. Jean-Baptiste Mauzaisse: *Napoléon: An Allegorical Picture*, Salon of 1833. Malmaison, Musée National du Château.

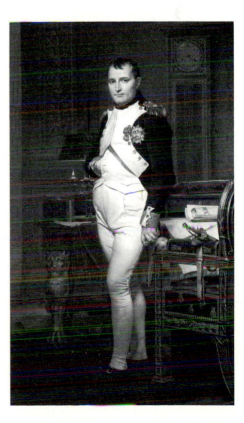

192. Jacques-Louis David: *Napoléon in His Study*, 1812. Washington, National Gallery of Art, Samuel H. Kress Collection.

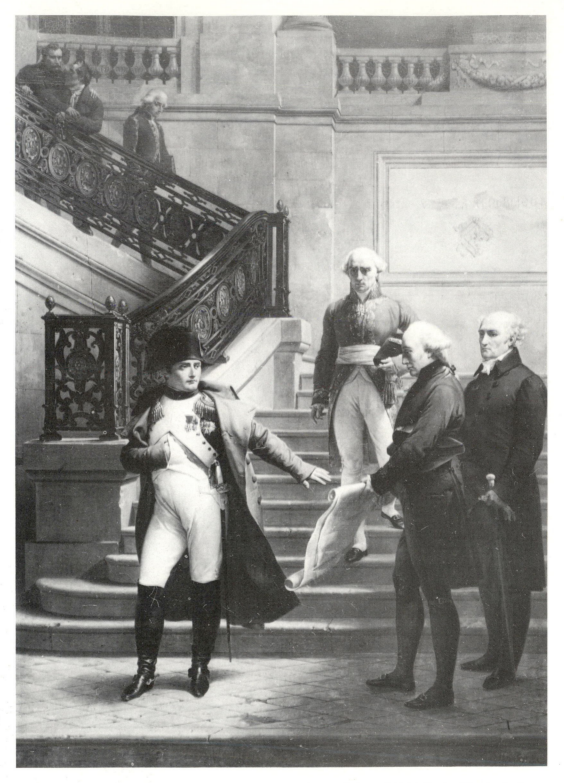

193. Méry-Joseph Blondel: *Napoléon Visits the Palais-Royal*, Salon of 1834. Paris, Musée du Louvre.

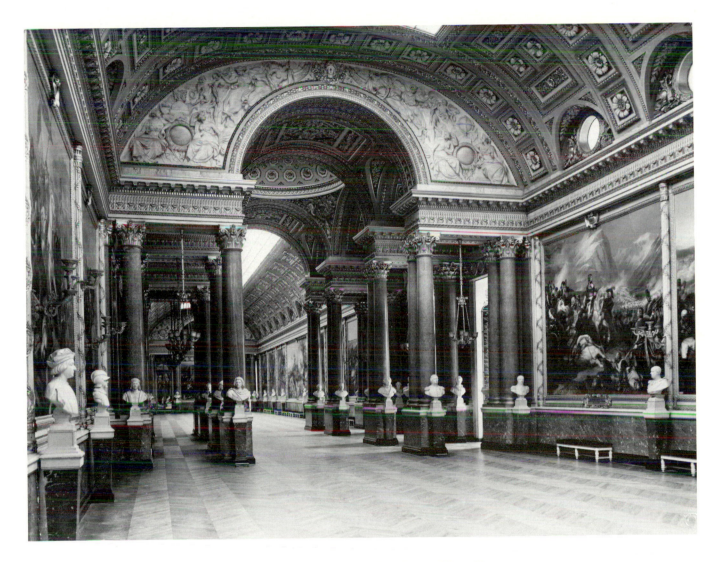

194. View of the Galerie des Batailles at Versailles.

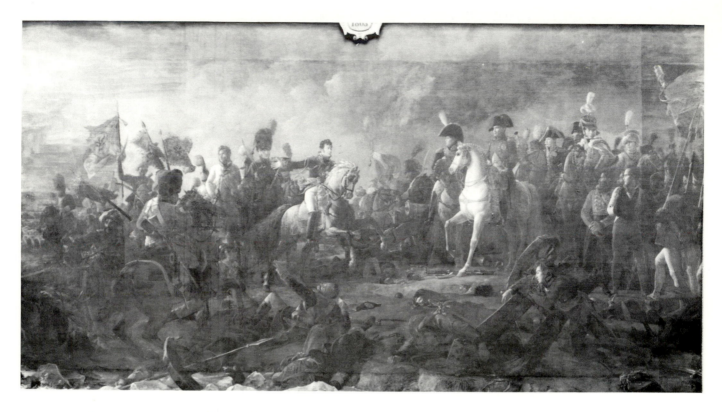

195. François Gérard: *The Battle of Austerlitz*, Salon of 1810. Versailles, Musée National du Château.

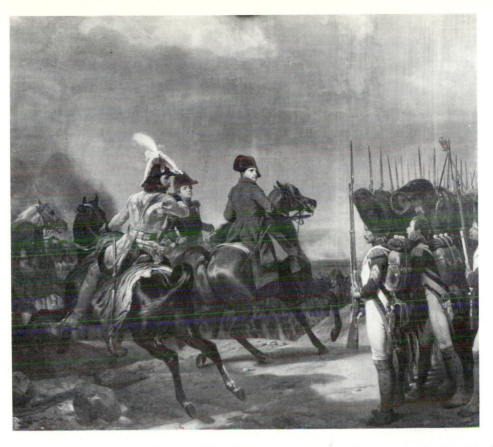

196. Horace Vernet: *The Battle of Iéna*, Salon of 1836. Versailles, Musée National du Château.

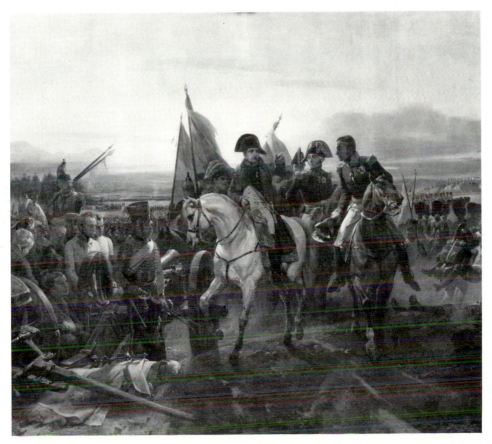

197. Horace Vernet: *The Battle of Friedland*, Salon of 1836. Versailles, Musée National du Château.

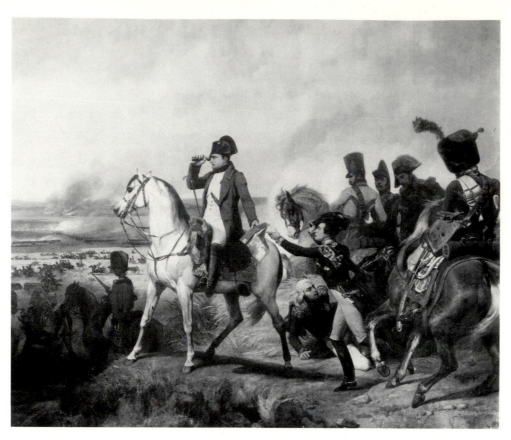

198. Horace Vernet: *The Battle of Wagram*, Salon of 1836. Versailles, Musée National du Château.

199. Edouard Wayer (after Emile de Lansac): *The Campaign of France*, replica of original exhibited at Salon of 1836. Bar-le-Duc, Musée Barrois.

200. Hippolyte Bellangé: *Napoléon on Horseback*, 1836. London, The Wallace Collection.

201. Denis-Auguste-Marie Raffet: *1807*, 1837. Paris, Bibliothèque Nationale, Cabinet des Estampes.

202. Félix Philippoteaux: *The Battle of Rivoli*, Salon of 1845. Versailles, Musée National du Château.

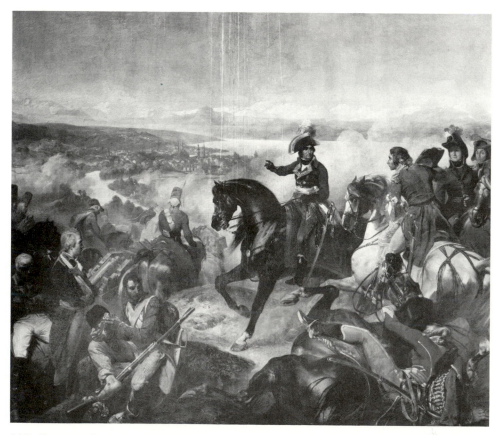

203. François Bouchot: *The Battle of Zurich*, Salon of 1837. Versailles, Musée National du Château.

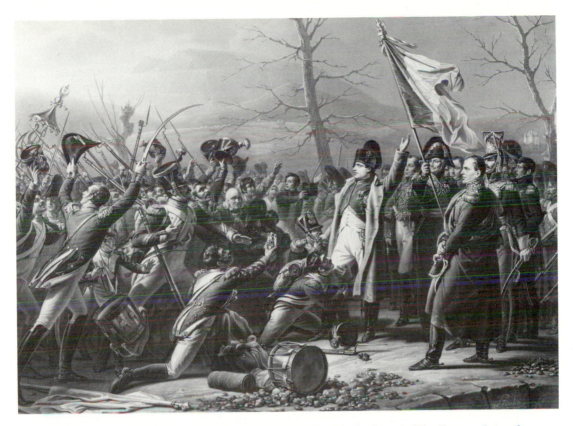

204. Charles Steuben (engraving by Jean-Pierre-Marie Jazet): *The Return from the Island of Elba*, original exhibited at Salon of 1831. Paris, Bibliothèque Nationale, Cabinet des Estampes.

205. Charles Meynier: *Marshal Ney Returns to the Soldiers of the 76th Regiment Their Banners Recovered from the Armory at Innsbruck*, Salon of 1808. Versailles, Musée National du Château.

206. Hippolyte Bellangé: *Return from the Island of Elba*, Salon of 1834. Amiens, Musée de Picardie.

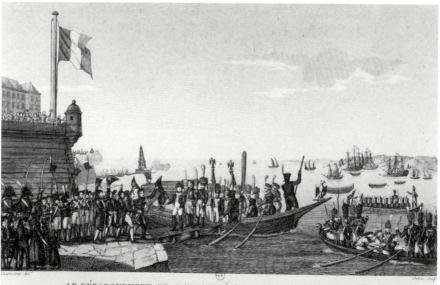

208. Courvoisier and Dubois: *The Landing of His Majesty Napoléon I^{er}, Emperor of the French, in the Harbor of Cannes, 1 March 1815*, 1815. Paris, Bibliothèque Nationale, Cabinet des Estampes.

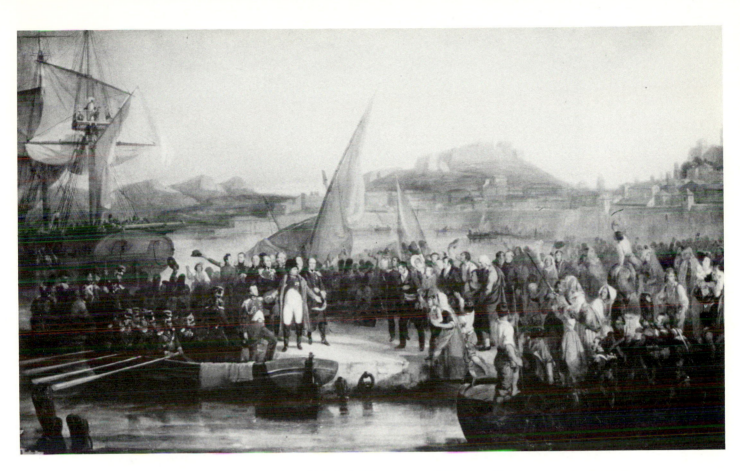

207. Joseph Beaume: *Departure from the Island of Elba*, 1836. Versailles, Musée National du Château.

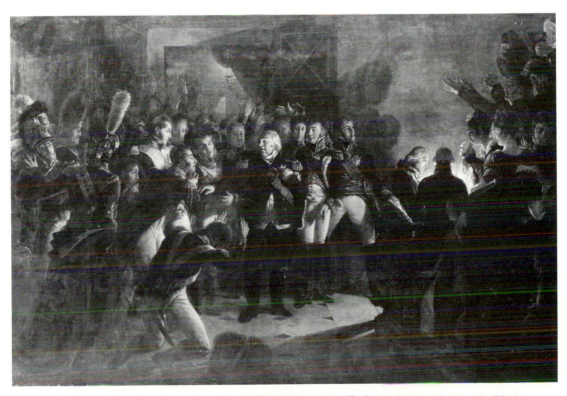

209. Baron Antoine-Jean Gros: *Louis XVIII Leaves the Tuileries Palace during the Night of 20 March 1815*, Salon of 1817. Versailles, Musée National du Château.

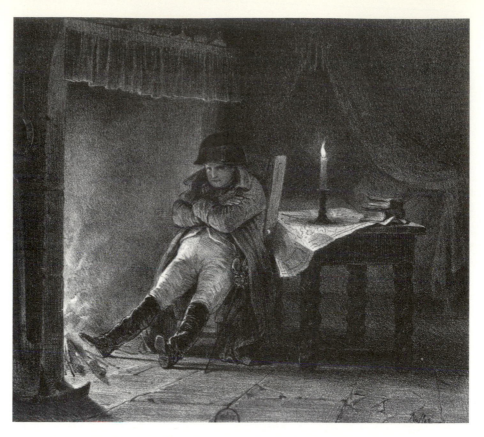

210. Denis-Auguste-Marie Raffet: *The Idea*, 1834. Paris, Bibliothèque Nationale, Cabinet des Estampes.

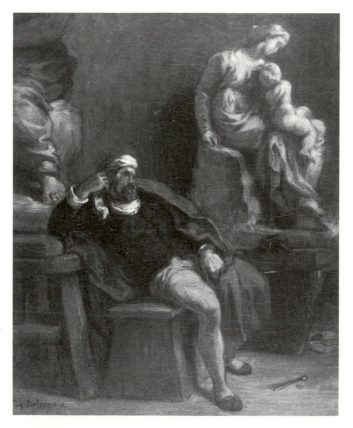

211. Eugène Delacroix: *Michelangelo in His Studio*, c. 1850. Montpellier, Musée Fabre.

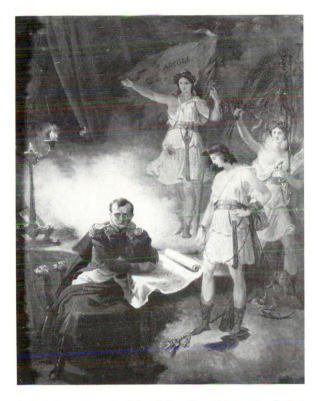

212. Méry-Joseph Blondel: *Napoléon on Saint-Helena*, n.d. Dijon, Musée Magnin.

213. Horace Vernet (engraving by Samuel-William Reynolds): *Napoléon on Saint-Helena*, 1829. Paris, Bibliothèque Nationale, Cabinet des Estampes.

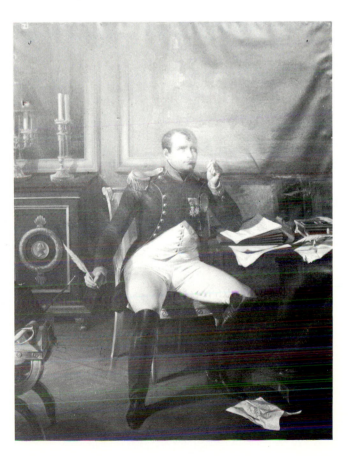

214. Louis Janet-Lange: *Abdication of Napoléon at Fontainebleau*, Salon of 1844. Tours, Musée des Beaux-Arts.

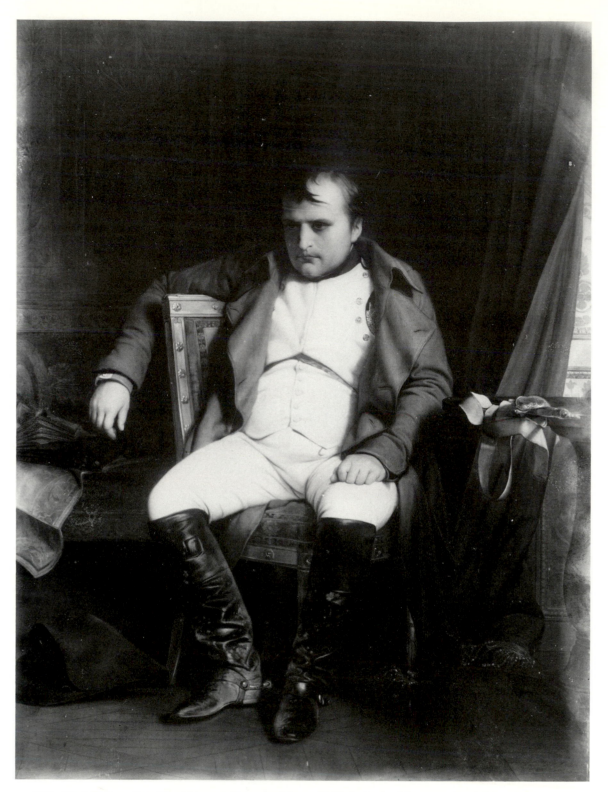

215. Paul Delaroche: *Napoléon at Fontainebleau*, 1845. Leipzig, Museum der bildenden Künst.

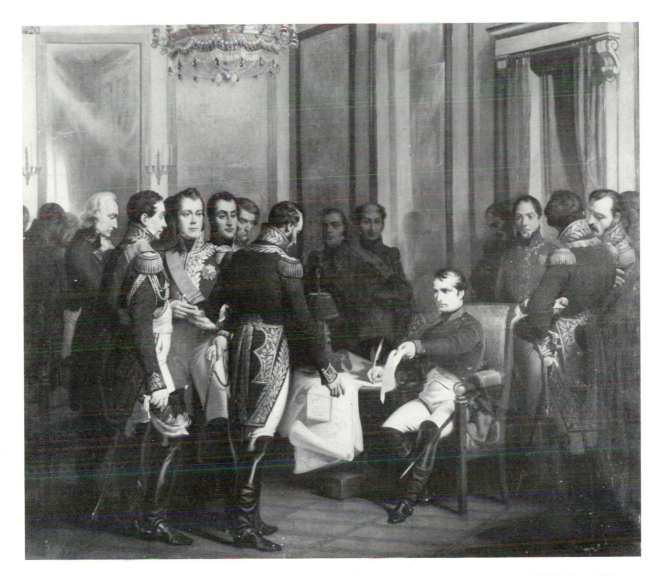

216. Gaëtano Ferri: *Abdication of the Emperor Napoléon at Fontainebleau*, Salon of 1843. Versailles, Musée National du Château.

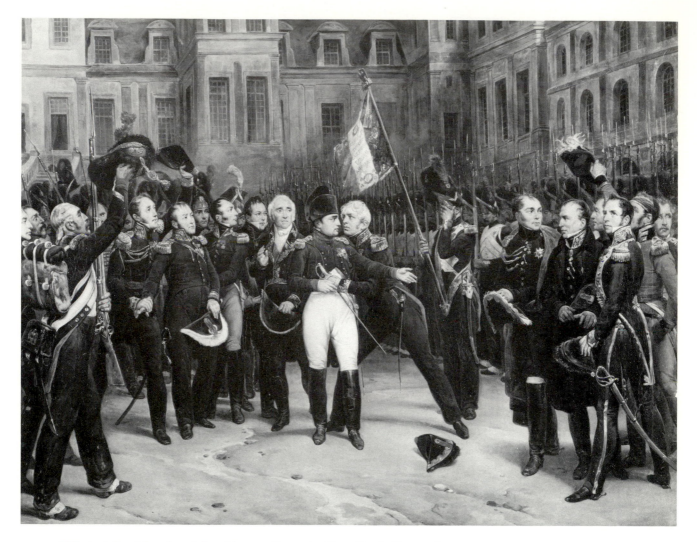

217. Antoine Montfort (after Horace Vernet): *Napoléon's Farewell to the Imperial Guard*, replica of original painted in 1825. Versailles, Musée National du Château.

218. Jean Alaux: *The Apotheosis of Napoléon*, 1837. Versailles, Musée National du Château.

219. Horace Vernet (engraving by Jean-Pierre-Marie Jazet): *The Apotheosis of Napoléon*, 1830. Paris, Bibliothèque Nationale, Cabinet des Estampes.

220. François Gérard (engraving by François Garnier): *The Tomb on Saint-Helena*, 1826. Paris, Bibliothèque Nationale, Cabinet des Estampes.

221. Nicolas-Toussaint Charlet: *To Arms Citizens! Form Your Battalions!*, 1840. Paris, Bibliothèque Nationale, Cabinet des Estampes.

222. Félix Philippoteaux: *The Landing at Courbevoie of Napoléon's Remains*, n.d. Rueil-Malmaison, Musée National du Château.

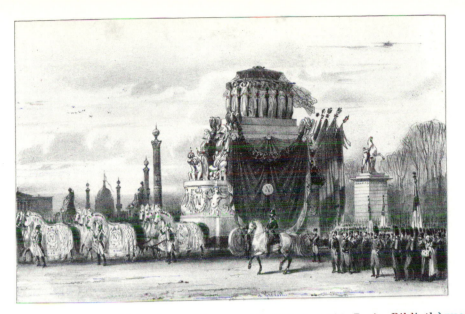

223. A. Provost: *Obsequies of Napoléon—The Funeral Wagon*, 1841. Paris, Bibliothèque Nationale, Cabinet des Estampes.

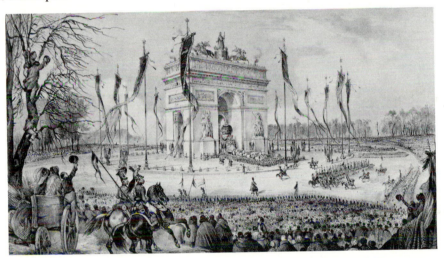

224. Victor Adam: *Entrance of Napoléon's Cortège into Paris through the Arc de Triomphe de l'Etoile, 15 December 1840*, 1841. Paris, Bibliothèque Nationale, Cabinet des Estampes.

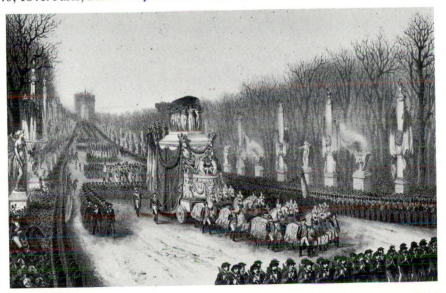

225. Adolphe Lafosse: *March of the Cortège down the Champs-Elysées*, 1841. Paris, Bibliothèque Nationale, Cabinet des Estampes.

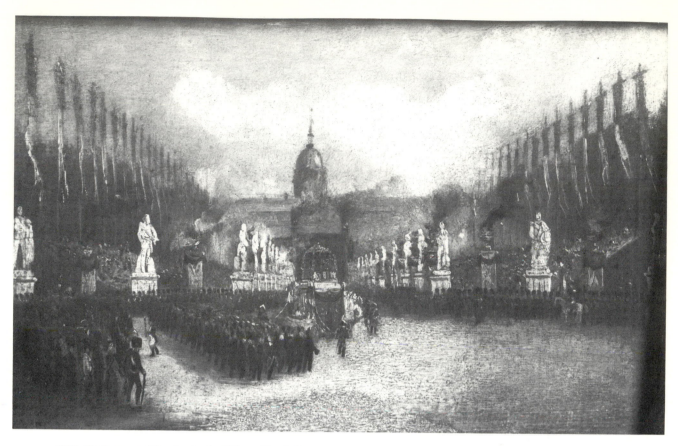

227. Unknown: *The Arrival of Napoléon's Remains at the Invalides*, 1840. Paris, Musée Carnavalet.

226. Dumouza: *The Catafalque Barge*, 1841. Paris, Bibliothèque Nationale, Cabinet des Estampes.

228. Dumouza: *Interior of the Invalides Church during the Religious Ceremony, 15 December 1840*, 1841. Paris, Bibliothèque Nationale, Cabinet des Estampes.

229. Pharamond Blanchard: *Arrival of the Imperial Flotilla at Maisons-Laffitte, Sunday 13 December 1840*, Salon of 1841. Maisons-Laffitte, Musée du Château de Maisons.

230. Louis Morel-Fatio: *Transfer of the Remains of Emperor Napoléon at Cherbourg*, Salon of 1841. Versailles, Musée National du Château.

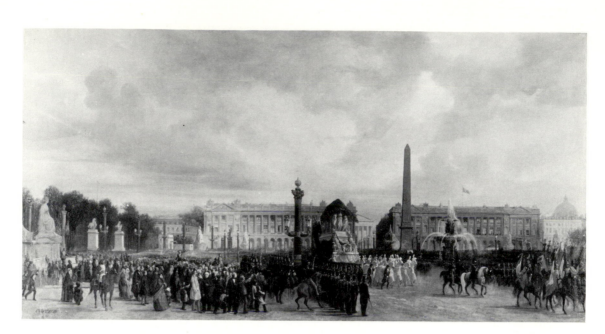

231. Jacques Guiaud: *Transferral of the Remains of Emperor Napoléon*, Salon of 1841. Versailles, Musée National du Château.

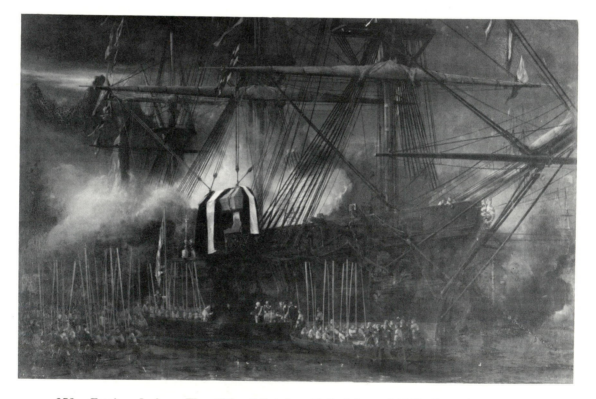

232. Eugène Isabey: *The 15th of October 1840*, Salon of 1842. Versailles, Musée National du Château.

233. Anonymous English engraving: *The Awfull Dream*, 1830. Paris, Bibliothéque Nationale, Cabinet des Estampes.

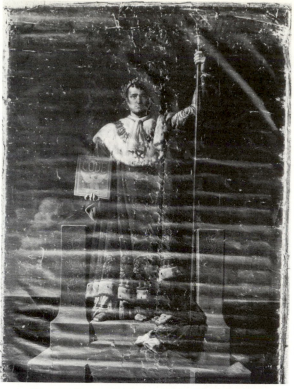

234. Louis(?) Guillaume (after Hippolyte Fland-
rin): *Napoléon as Lawgiver*, replica of original ex-
hibited at Salon of 1847. Lorient, Musée Municipal.

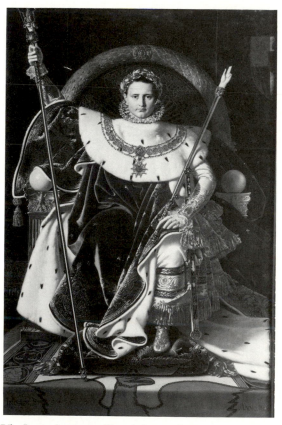

235. Jean-Auguste-Dominique Ingres: *Napoléon
I^er on the Imperial Throne*, Salon of 1806. Paris,
Musée de l'Armée.

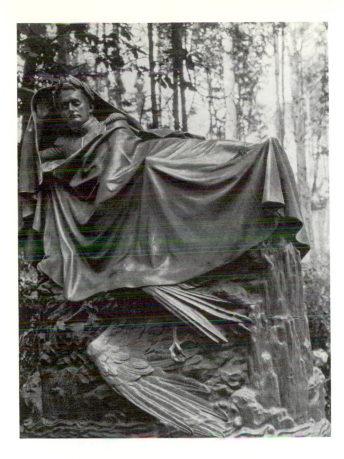

236. François Rude: *The Awakening of Napoléon*,
1847. Fixin, Parc Noisot.

237. François-Marius Granet: *A Mass during the Terror*, 1847. Aix-en-Provence,
Musée Granet–Palais de Malte.

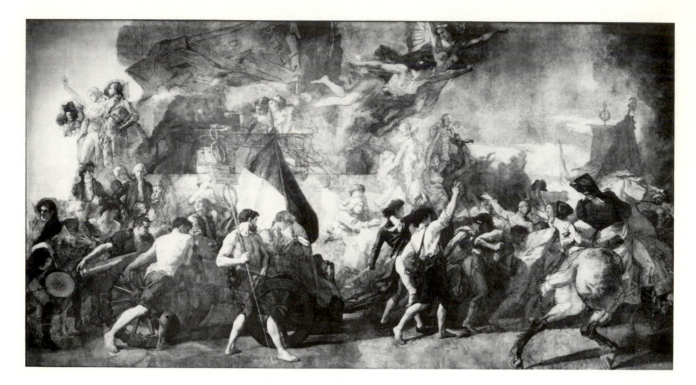

238. Thomas Couture: *The Voluntary Enlistments of 1792*, 1847 ff. Beauvais, Musée Départemental de l'Oise.

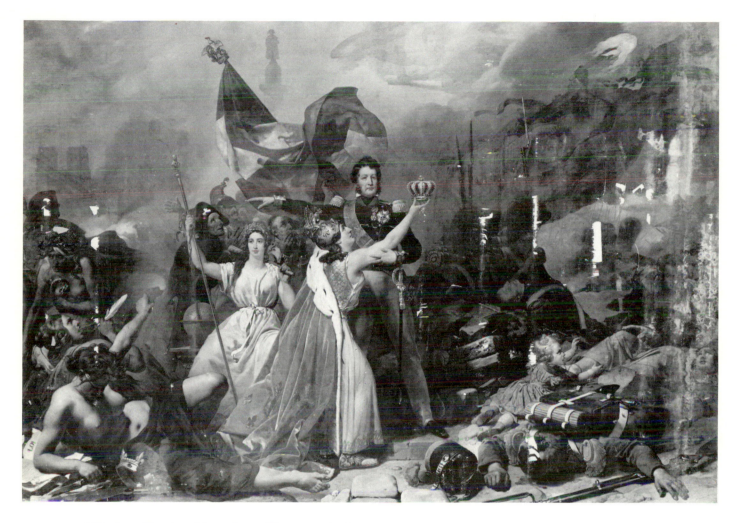

239. Jean-Baptiste Mauzaisse: *Allegory of the History of King Louis-Philippe*, Salon of 1839. Versailles, Musée National du Château.

Photographic Credits